Political Socialization in a Media-Saturated World

POLITICAL COMMUNICATION

FRONTIERS IN

Mary E. Stuckey and Mitchell S. McKinney
General Editors

Vol. 29

The Frontiers in Political Communication series
is part of the Peter Lang Media and Communication list.
Every volume is peer reviewed and meets
the highest quality standards for content and production.

PETER LANG
New York • Bern • Frankfurt • Berlin
Brussels • Vienna • Oxford • Warsaw

Political Socialization in a Media-Saturated World

Edited by Esther Thorson,
Mitchell S. McKinney, and Dhavan Shah

PETER LANG
New York • Bern • Frankfurt • Berlin
Brussels • Vienna • Oxford • Warsaw

Library of Congress Cataloging-in-Publication Data

Names: Thorson, Esther, editor. | McKinney, Mitchell S., editor. | Shah, Dhavan, editor.
Title: Political socialization in a media-saturated world /
edited by Esther Thorson, Mitchell S. McKinney, Dhavan Shah.
Description: New York: Peter Lang, 2016.
Series: Frontiers in political communication; vol. 29 | ISSN 1525-9730
Includes bibliographical references.
Identifiers: LCCN 2016015061 | ISBN 978-1-4331-2572-0 (hardcover: alk. paper)
ISBN 978-1-4331-2571-3 (paperback: alk. paper) | ISBN 978-1-4539-1763-3 (ebook pdf)
ISBN 978-1-4331-3571-2 (epub) | ISBN 978-1-4331-3572-9 (mobi)
Subjects: LCSH: Political socialization. | Political science—Study and teaching.
Youth—Political activity. | Mass media—Political aspects. | Mass media and youth.
Classification: LCC JA76 .P592836 2016 | DDC 306.2—dc23
LC record available at https://lccn.loc.gov/2016015061

Bibliographic information published by **Die Deutsche Nationalbibliothek**.
Die Deutsche Nationalbibliothek lists this publication in the "Deutsche
Nationalbibliografie"; detailed bibliographic data are available
on the Internet at http://dnb.d-nb.de/.

The paper in this book meets the guidelines for permanence and durability
of the Committee on Production Guidelines for Book Longevity
of the Council of Library Resources.

Contents

Introduction

Theorizing Political Socialization in a Media-Saturated World

ESTHER THORSON, MITCHELL S. McKINNEY, AND DHAVAN SHAH

Political socialization is the developmental process whereby children and youth learn to relate to their polity—to democratic principles, to political parties, and to the ideas and values associated with the political realm. This book brings together a unique cluster of recent studies examining youth political development during a critical time for such socialization. Specifically, the chapters that follow explore a rapidly changing period when digital communication channels and devices continue to emerge almost on a daily basis, where political content is now available 24/7 thanks to these omnipresent channels and devices, and with political communication content now far more diverse than in the days when only network television, radio and television news, and news magazines constituted our dominant political media.

Also during the period of time when the studies found in this book were conducted (from 2007–2014), the American electorate witnessed the rapid growth of a generation of citizens called Millennials (those individuals born between 1980 and 1997), who represent the first generation to come of age in the new millennium and our very first generation of "digital natives" who have been completely immersed in digital technologies throughout their entire lives. As Palfrey and Gasser (2008) pointed out, "These kids are different. They study, work, write, and interact with each other in ways that are very different from the ways that [other generations] did growing up" (p. 7). In fact, at 53.5 million strong, this peer group—those 18 to 34 years of age—now constitutes our largest cohort of voters; and in 2015 this burgeoning group even surpassed the once-dominant Baby

Boom generation in size (Fry, 2015). The portrait of Millennials that is just now beginning to emerge suggests they are distinctly different from other generations in many important ways, including their political attitudes and civic behaviors (Fingerhut, 2016; Kiley & Dimock, 2014; Thompson, 2014). The collection of research studies found in this book provides crucial understanding of this increasingly influential generation of citizens by offering the very first and most comprehensive investigation of the Millennial generation's politically formative period, a close examination of the adolescent years during which these youth were being socialized politically.

Another important contribution of the present volume is that many of its chapters examine data that include the parent/child dyad, a study design that greatly enriches our understanding of youth political socialization, but, surprisingly, an approach that has been seldom employed in the current political socialization literature. Investigating the attitudes and behaviors of both parents and their children provides a unique opportunity to examine different demographic variables as well as how the classic variables of political socialization—social structures that include the family, peers, school, and media—affect the socialization process across different generations. As noted, the youth examined in these studies are among the Millennials—that wholly "digital" generation fully immersed in digital devices since the moment they were born. In contrast, their parents are "digital immigrants" (Palfrey & Gasser, 2008) who somewhat later in life have come to adopt such technologies as smartphones and tablets, social media including Facebook and Twitter, hundreds, if not thousands, of cable channels, live-streaming content of all sorts, as well as numerous other digital innovations as they have appeared. Thus, the political socialization of the parents and children that we examine in this book provides a pairing of perhaps the most radically different media experiences of any generation.

The studies that comprise this book provide a unique perspective on youth political socialization during a pivotal period in which the U.S. political climate and electoral system have experienced momentous change. In 2008, the US elected its first African American president, a victory by Barack Obama that was fueled, in part, by a large number of young voters whose engagement in the electoral process was largely facilitated through digital technologies and social media. As McKinney and Banwart (2011) documented, approximately 51% of young citizens (18- to 29-year-olds) cast their ballot in 2008, representing the third highest rate of participation by young voters in a presidential election since 1972.[1] Also worth noting, at the same time that young voters increased their 2008 turnout, the rate of older citizens voting (those 30 and over) actually declined from their 2004 level of participation; and this was the very first time since 1972, when 18-year-olds first voted in a presidential election, that young voter participation increased while older citizens' participation decreased (McKinney & Banwart, 2011, p. 2). While

the youth vote declined slightly in the 2012 presidential election (with an approx-imately 48% turnout, down from their 51% participation in 2008), voting across all ages in 2012 actually declined (with 62% of all eligible voters participating in the November 2012 election, down from 64% in 2008) (Rill & McKinney, 2014).

With our youngest voters now sustaining more than a decade of improved electoral engagement in U.S. presidential elections, McKinney and Bolton (2016) pointed out that this period of increased voting by young citizens "also coincides with the decade in which political candidates and their campaigns have increas-ingly adopted new communication technologies and digital media as important tools of campaign communication" (p. 152). Indeed, we find it no coincidence that our youngest citizens—those representatives of the Millennial generation who have been the earliest adopters of all things digital—have become increasingly engaged in the electoral process during this same period. In many of the follow-ing studies, a careful examination of youth and their parents' media use and the influence of media on political attitudes and behaviors provides a comprehensive understanding of the role that so-called "new" and more traditional media play in the political socialization process.

Yet another noticeable change in the U.S. political climate that has intensified throughout the past decade is the rise of a hyperpartisan politics and a markedly polarized electorate (e.g., Abramowitz, 2010; Iyengar, Sood, & Lelkes, 2012). In their examination of political campaign communication, McKinney and Bystrom (2014) described our nation's growing political alienation and ever-widening political fault lines characterized by a political "discourse of division, difference, and separation" that seeks to:

> Construct a political enemy or suggest some other segment of society must be opposed and defeated to protect one's own interest or values in order to gain or maintain power. Con-sider just this partial inventory of our many political divides: from red versus blue states; conservatives versus liberals; and young versus older voters; the Occupy movement's 99% versus the 1% (much like Mitt Romney's 47% of those "who pay no taxes" vs. those who "take personal responsibility and care for their lives"); or, perhaps the well-established gen-der gap in American politics pitting female versus male voters; or our regular versus irreg-ular and even non-church-attending neighbors; to our nation's growing number of ethnic and racial minorities versus Bill O'Reilly's longed for "traditional white establishment." Clearly, we have no shortage of differences, divisions, and separations in contemporary American politics. (p. 4)

Particularly during a time of such significant changes in our political landscape, a political-socialization perspective is most helpful in revealing how our current condition may not persist indefinitely. We are beginning to understand, for exam-ple, that Millennials' citizenship norms differ from those of earlier generations, with findings related to this point developed in a number of the studies that make up this book. First, among all citizens, Millennials are least likely to identify with

political parties, as half of all these young citizens describe themselves as politically independent (compared to approximately one third of the citizens of other generations). Also, perhaps reflecting their willingness to reject political party affiliation, Millennials have great disdain for the hyperpartisanship they believe characterizes contemporary politics, and they particularly dislike the political polarization of today's "either/or" politics ("Young voters supported Obama less," 2012, p. 5). In describing this generation's general view and approach to politics, Kiesa et al. (2007) pointed out that Millennials feel "the political system is full of unnecessary conflict [and] they seek more middle ground with regard to both policies and political parties" (p. 24). Perhaps, therefore, as Millennials become the replacement voters for older generations, we could find that our current condition of political divisions and polarization might well dissipate. Again, a starting point for comprehending what the future of our political culture and electoral processes may be like is to understand the political socialization of our future voters—the very basis of this book.

Readers of the following chapters should not be surprised, given the uniqueness and vast changes that marked the period during which these studies were conducted, to find the application of a number of new and developing theories as well as the introduction of a number of new variables to guide exploration of adolescents' political attitudes and behaviors and analysis of cross-generational differences. The conceptual, theoretical, and methodological innovations that characterize this scholarship are particularly valuable for those interested in understanding how today's youth develop their ideas of the political, how they become part of political environments and electoral processes, and what this socialization may portend for our nation's politics in future years.

THE FUTURE VOTERS PANEL STUDY OF 2008–2009: SURVEY DESIGN AND SAMPLING

Many of the following chapters report analyses of data from a three-wave national survey collected among parents and youth measuring political interest, attitudes, communication behaviors, and media use during the 2008 U.S. presidential election. The collection of these data was coordinated by a consortium of communication and political science faculty from six major universities throughout the U.S., and the shared dataset is referenced throughout this book as the Future Voters Study.[2] Each chapter utilizing one or more of the three waves of survey responses from the national panel study will note that its data were drawn from the Future Voters Study; and to limit repetition throughout these chapters, particularly to save space within the various chapters' Method sections, we provide here as part of the book's Introduction a detailed description of the national survey's study design

and sampling method. This general description of the Future Voters Study should be used to supplement each chapter's more detailed methodological description and explanation of analysis.

The Future Voters Study survey data were collected from a single panel of respondents in two waves during 2008 and a third wave in 2009. The first wave was gathered between May 20 and June 25, 2008, by Synovate, a commercial survey research firm, using a four-page mailed questionnaire. The second wave was gathered from these same respondents between November 5 and December 10, 2008, immediately after the presidential election and again using a four-page mailed questionnaire. The third wave was collected between May and June 2009, 6 months following the presidential election.

Synovate employs a stratified quota-sampling technique to recruit its respondents. Initially, the survey firm acquires contact information for millions of Americans from commercial list brokers who gather identifying information from drivers' license bureaus, telephone directories, and other centralized sources. Large subsets of these people are contacted via mail and asked to indicate whether they are willing to participate in periodic surveys. Small incentives are offered, such as pre-paid phone cards, for participation.

Rates of agreement vary widely across demographic categories. For example, 5% to 10% of middle class recruits typically consent, compared with less than 1% of urban minorities. It is from this pre-recruited group of roughly 500,000 people that demographically balanced samples are constructed for collection of data. To achieve a representative pool of respondents, stratified quota sampling procedures are employed. That is, the sample is drawn to reflect the properties of the population within each of the nine census divisions in terms of household income, population density, age, and household size. This starting sample is then adjusted within a range of subcategories that include race, gender, and marital status in order to compensate for expected differences in return rates (for details see Shah, Cho, Eveland, & Kwak, 2005; Shah et al., 2007).

For the purposes of our Future Voters Study, this technique was used to generate a sample of households with children age 12–17. A parent in each selected household was contacted via mail and asked to complete an introduction portion of the survey, and then to pass the survey to the 12–17-year-old child in the household who had most recently celebrated a birthday. This child answered a majority of the survey content and then returned the survey to the parents to complete. Of the 4,000 mail surveys distributed, 1,325 responses were received in Wave 1, which represents a response rate of 33.1% against the mailout. A handful of responses was omitted due to incomplete or inconsistent information. As a result of these omitted responses, 1,255 questionnaires were mailed November 4 (Wave 2). Of the re-contact surveys distributed, 738 were returned, for a panel retention rate of 55.7% and a response rate against the mailout of 60.4%. Due to some mismatches

in the age of the child within the household who completed the first and second survey, 163 surveys were dropped (and about a third of the mismatches were due to the adolescent respondents failing to provide information on their age). Thus, the final sample for the 12–17-year-old Wave 2 panel was N = 575. Finally, the third panel of the study was fielded in May and June of 2009, 6 months after Barack Obama's election. Of the recontact surveys distributed, 305 were returned, for an overall panel retention rate of 41%.

Assumptions and Background of Youth Political Socialization Research

This volume of scholarship is grounded on the primary assumption that research must extend beyond a sole focus on the adolescence life stage and consider how dynamics *between* generations occur if reliable and actionable models of civic and political socialization are developed. Almost all chapters in this book focus on the political interest, perceptions, knowledge, media use, and participation of youth 11–18 years of age, and also of their parents, during the 2008 presidential, 2010 mid-term, and 2012 presidential elections. Throughout these studies, the broader view of political socialization research developed over the last 40 years is integrated, at times questioned, and updated based on the findings of the research presented in the following chapters. In fact, this book—containing work by several of our most noted political communication scholars—represents the authoritative statement on our current understanding of political socialization research.

An updating of previously accepted models of political socialization is particularly needed as our once "traditional" environment of official news sources for political information has drastically changed. For example, with a strong tendency toward televised entertainment, youth—and their parents—are now exposed to high doses of political and campaign messaging that appear in the form of celebrity endorsements, TV dramas, movies, soap operas, talk shows, political satire, and other entertainment programming. Such ubiquitous political communication may well spur further information-seeking behaviors and activities, including political conversation with peers and also political discussion in the classroom and at home. Indeed, our media-saturated world is one saturated with political messages of all types and forms.

The broad model of socialization that helps organize the work represented in this book is a learning process that traverses from social structural variables through media, communication, and psychological variables to responses that have been included under the general rubric of "political." Whereas becoming "political" involves a myriad of responses, we consider socialization into the political as a hierarchy of responses, with some youth traversing to the highest levels of the hierarchy (e.g., high levels of behavioral participation in campaigns and elections),

while others remain uninterested in politics and fairly ignorant of political processes such as elections, political issues and policies, and democratic political values. Within this overall view of the political socialization process, the following chapters introduce a number of theories and many new and important variables.

Organization and Overview of the Book

Section I: Theories of political socialization. The first of the book's five sections features chapters that focus on various theories that guide our understanding of political socialization processes, including a newly advanced Hierarchy Model of Political Socialization, theories employing notions of deliberative democracy, knowledge gap theory, and meta-level theory that explores the links between state requirements for civic education in high schools and youth political activity. Five of the six chapters included in Section I study socialization processes at the level of the individual; that is, looking at parental and/or child variables. Chapter 6, however, explores socialization in terms of sociological variables; that is, an examination of state policies guiding the teaching of civics education in public schools. Several of the chapters found in Section I also develop the importance of both interpersonal and mediated communication in the socialization process, exploring how these variables interact with one another and with other variables.

Chapters 1, 2, and 3 advance a new theoretical perspective on political socialization, the Hierarchy Model of Political Socialization. Chapter 1 posits that because "being political" can express itself in so many ways (e.g., talking to others about politics, sharing political opinions via social media, attending political events), these various activities need to be conceptually organized. The "hierarchy" model of socialization posits that the political expressions of youth responsiveness and participation in politics can be measured in terms of how much time and effort different activities may involve. At the "least effortful" level, youth are exposed in the home to family-produced and media-produced information and attitudes about politics. While it is clear that different families have very different practices of interpersonal and mediated communication, the child enters a familial environment and becomes a participant in this ongoing system (see, for example, Chapter 10 of this volume for greater description of this process). Of course, the familial environment now contains many digital media opportunities, and clearly some of these activities may involve more effort, such as creating a political meme and sharing it with friends in a social network. Still, the everyday participation in familial communication and the mediated communication that the family is exposed to are relatively low-effort events.

At a next level of effort, the child may engage in school-based activities. Like any other kind of classroom activity, this behavior involves talking with teachers and others in class, doing civics homework, and, in many cases, having experiences

that involve such special activities as classroom debates or working at the polls on voting day (see, for example, Chapters 4 and 8 of this volume). These activities require more of an "intentional" or "effortful" focus by youth on the political realm, and such activities may also increase the amount of within-family political communication (e.g., McDevitt & Chaffee, 2000, 2002). Finally, school civics education may also increase the likelihood that youth will pay attention to political media content such as news, and the likelihood of engaging in greater political talk with peers. Thus we expected—and found—an interaction between school political activities and the influence of family and media variables (see, for example, Chapters 4 and 12 of this volume).

Further, within the hierarchy of political activities, the meaning of "political" is broadened to include not just political campaign and electoral behaviors such as engagement with political parties and candidates but also attention to such politicized social issues as the environment, police violence, or immigration. Finally, at perhaps one of the highest levels of effort, youth may develop their own self-motivated political activities. They may, for example, run for office at school, engage in political reporting at their school newspaper, volunteer for social and political causes, attend political events, or raise money for a campaign; and they may even create their own political content on Twitter or Facebook. When one undertakes these types of activities, effort is high, as is self-initiation of that effort.

Not only does Chapter 1 describe and test the hierarchical model of political socialization, it demonstrates that two of the lower-effort levels of the hierarchy, political interest and political knowledge, are differentially related to demographics that define family life (e.g., age, gender, race, parental education, and parental party affiliation). Findings in this chapter also point to a different influence of print and TV political news exposure, along with different motivations for the link between self and politics (with motivations including the desire to connect with others, to gain information, and to be entertained). Finally there are different effects of school political experiences and interpersonal talk with family members about politics.

Chapter 2 also employs the hierarchical model of socialization, and consistent with the results reported in Chapter 1, this chapter demonstrates that the causes of the different "levels" of the hierarchy themselves vary. For example, a youth's self-reported interest in political civics education increases political interpersonal communication with peers, seeing oneself as more involved in civics class activities, and being involved in local charities. However, interest in politics does not relate to online political activities, or more general political participation. The contribution of this study is to provide further supportive evidence that the part of the hierarchy of political effort that we look at; that is, just what youth are actually doing in the political realm, determines what the socialization causal process will look like. Not all "political activity" is equivalent; and what one views as "political" will determine the political socialization model of causes and effects.

Chapter 3 combines the Hierarchy Model of Political Socialization with a media choice model, a theoretical perspective that belongs to the family of uses and gratifications approaches. Variables such as demographics, school, and interpersonal interaction affect three levels of the hierarchy—political interest, political knowledge, and political talk—differently. Again, the predictors of these kinds of responses to politics vary across the three levels. Also importantly, this chapter introduces the concept of news "voice," which was originally theorized as part of the media choice model. In this context, "voice" is a function of the nature of the news "speaker." Authoritative voice comes from news as traditionally defined. Opinionated voice was measured as conservative and liberal political blogs and conservative talk radio. Advertising voice was measured in terms of youth exposure to political candidates' websites, presidential candidate attack ads, and ads that provide the viewer with reasons to vote for a candidate. Interestingly, only the authoritative voice was a significant predictor of one of the three levels of political responses, and it strongly predicted political interest.

Chapter 4 focuses its attention on the role of interpersonal and mediated political communication. This chapter theorizes that both types of political communication involvement are important to socialization, but again it suggests that the role of the two types of communication will vary depending on what measure of "socialization" is employed—although it does not posit a hierarchy among these responses. The measures of political responses explored in this chapter include three relatively new ones. First, political consumerism is measured in terms of boycotting and buycotting as indexed by youth agreement that they boycotted products or companies that offended their values and bought products from companies whose values aligned with the youth's values. Political tolerance was measured in terms of how much youth agreed that it is important to hear others' ideas even when they are different from one's own. And finally, the concept of "Trying Out Opinions" was measured in terms of youth agreement that they talked about politics and public issues with those who disagreed with them and talked about politics and public issues with adults outside their family. The results of this study provide clear evidence that interpersonal and mediated political communication differently affected these three newer measures of youth political socialization.

Chapter 5 employs the frequently used theoretical concept of knowledge gap. This longstanding concept suggests that individuals with lower socio-economic backgrounds will differentially respond to all kinds of communication inputs and certainly to the input of political information. The results reported in this chapter show clear support for "gap" processes. For example, youth with parents who actively participated in politics used television news far more to obtain all kinds of information, and they also made much greater use of newspapers to gather information. This chapter demonstrates strongly how important it is to take account of

key demographic and parental behavior differences when considering what youth political socialization may look like.

Chapter 6 takes a very different theoretical perspective on socialization, emphasizing causes at a group level; that is, effects on youth living in states with differing curriculum policies about civic education. The chapter provides ample evidence that school experiences are critically important for youth socialization, but its analysis goes beyond the individual level to explore what happens across the states. Interestingly, states' civics course requirements, civics tests, standards, and the content of state social studies tests had no detectable impact on likelihood of voting and political knowledge. To further explore why state policies did not significantly explain youth socialization, the authors surveyed 8000 high school civics teachers, a sample of almost half of all such teachers. The results showed that the content of civics courses differs greatly depending on whether they are honors/advanced placement courses, or more typical graduation-requirement courses. The honors classes were more likely to involve discussing current events and critical analysis of news stories. The authors indicate that the honors classes typically covered more contemporary and controversial issues and taught core civics skills such as deliberation. The overall conclusion of this study suggests that it matters less what your state requires in terms of high school civics education, and much more the level of content and pedagogy employed in civics courses.

Section II: Parents and children. The five chapters that comprise Section II are no less theoretical in their approach than those found in Section I, yet they do share a close focus on the parent-child relationship. From the very beginning of the study of youth political socialization, there has been a strong and consistent focus on the influence of parents. The most simplistic conception of this perspective is that there will be a direct transmission of parental politics onto youth. As will be seen in the chapters found in Section II, however, this is no longer the case. Theorizing about parental impact on political socialization starts with the bedrock finding that "adolescents look to their parents for advice, typically hold similar values to those of their parents on political, social, and religious issues, and report that they admire their parents" (Smetana, 2010, p. 30). This fundamental principle notwithstanding, there are still many interesting questions to ask about how, and to what extent, political orientations of children come from their parents and how long they last.

Chapter 7 further develops our understanding of the particular parent-child interaction termed evaluative parental mediation (Hively & Eveland, 2009; Valkenburg et al., 1999). Evaluative parental mediation is a way of sharing the experience of media with a child so as to encourage attention and to foster discussion, even if the child does not agree with the parent. This concept is measured with five items that include: "I talk with my child to help him/her understand what is on the news"; "I often encourage my child to follow the news"; "I suggest

to my child that he/she learn more about the political issues seen in the news"; "I often encourage my child to talk about politics"; and "I tell my child when I see something I don't like in the news." Consistent with previous studies, findings reported in this chapter indicate that higher levels of evaluative parental mediation had salutary effects on youth political interest, knowledge, communicating with others in person, communicating with others via digital channels, and being active politically in one's community. What the chapter adds to our understanding of evaluative parental mediation is that it operates both directly on these dependent variables but is also mediated through other variables we know to be important, including political talk with others, news use, and school civic activities. Yet, as we have learned to expect in terms of the Hierarchy Model of Political Socialization, the mediated relationships between evaluative parental mediation vary depending on what indicator or level of youth political socialization is being examined.

Chapter 8 explores the classic measures of parent-child communication first articulated more than 40 years ago by McLeod and Chaffee (1972). When what they called a "concept orientation" occurs within the family, youth are mostly influenced by their parents' ideas and concepts in formation of the child's information-processing and subsequent decision-making. These families prefer open discussions even when family members offer differing opinions. In contrast, where "socio-orientation" occurs, families are more likely to prefer harmonious parent-child relationships, and they avoid conversations where parents and children disagree with each other. This chapter extensively controls other causal variables before determining if a child's family scores on concept and socio-communication orientations affect political interest and political knowledge. For political interest, higher scores on both types of communication produce an increase. For political knowledge, however, neither of the two parent-child orientations are found to be significant. It is intriguing that both communication styles positively affect political interest, although concept orientation's effects are greater. The chapter also explores the question of whether parent-child communication styles interact with other socialization variables to impact interest and knowledge.

Chapter 9 is different from many of the other chapters in the book in that it examines panel responses that span more than a decade—including observations in 1997, 2003, and 2009—utilizing data generated from a national study that examined parents and children in general, not just specifically aimed at questions of political socialization. The central focus of this chapter is whether parental political participation (e.g., volunteering with civic or political action groups or how often parents donated to such a group) influences their children's likelihood of voting in the 2008 presidential election. That year, of course, is particularly interesting because there was such a high youth voting turnout in the presidential election in which Barack Obama won his first term in office. Parental education,

newspaper use, and frequency of talking about the news with one's child increased their likelihood of voting in 2008. Interestingly, the youth's own media use in 2003 was not predictive of his/her voting in 2008. These results are discussed in terms of various theories that explain how parental effects on youth socialization occur. Finally, this chapter is particularly important because it examines socialization processes over time, rather than looking at a single point in time as most of the chapters in this volume do.

Chapter 10 takes a slightly different approach to characterizing parental communication with their children. While most of the other studies in this book focus on adolescent and pre-college youth, this chapter examines college-age youth and their parents during the 2012 U.S. presidential election. This study found that when a parent is more interested in politics, political communication between the parent and child increased, and the child expressed significantly higher external efficacy and somewhat greater political cynicism. Highly consistent with the findings reported in Chapter 9, these results provide support for socialization via parental influence.

Chapter 11 further develops the idea of youth influencing the political orientation of their parents ("trickle up theory"), an idea first introduced by McDevitt and Chaffee (2002). The chapter first explores differences between Latino American youth and non-Latinos as expressed in 2012 survey data. This comparison showed that Latinos grew up in homes with fewer books, interacted with parents who had less formal education, conversed less frequently with parents about politics, and received less encouragement to express opinions. Next, the chapter analyzes the political commercials featured during the 2012 presidential election that addressed the Dream Act, proposed legislation that would have helped immigrants become citizens. While, as might be expected, there was significant attention to the immigration issue and more interest by Latinos than non-Latinos, young Latinos nevertheless lagged behind non-Latinos in voting. Thus, the authors conclude that the immigration issue failed to motivate Latinos to vote.

Section III: Interactions with peers and others. Section III of the book includes three chapters that explore the effects of adolescents' peers in the socialization process. First, Chapter 12 approaches the issue using the Hierarchy Model of Political Socialization. Rather than compare the various dependent variables at each level of the hierarchy, however, this chapter identifies the specific variables that influence talking with peers about politics. It posits, and then demonstrates, support for a process that starts with news exposure, which affects thinking more deeply about political issues (elaboration) and activates feelings that one can actually make a difference in politics (efficacy). The next stage of the process involves increased talking about politics at school and at home. Finally, the last stage includes talking about politics with people outside of school and home, including with relative strangers. Indeed, the observed process follows this model well,

although the effects of news media exposure (except for Web news use) mostly disappear in the final stages of the model.

Chapter 13 is unusual among the studies in this volume as it employs all three panels of the 2008 Future Voters Study. Investigating the same people over a sustained period of time, of course, increases how compelling the case is for identifying causal relationships. The study posits that youth political knowledge results first from news exposure—and this process is mediated by thinking about the content of the news (elaboration)—and next from talking with others about politics, and the interaction between these two activities (news elaboration and discussion of politics). News use did not have direct effects on knowledge as measured at times 1, 2, or 3. Instead, news media use had direct effects on elaboration and discussion, and these two variables in turn predicted knowledge at all three times. It should be noted that political knowledge was measured differently at all three time points, and, in fact, nearly a full year had passed between times 1 and 3. This result provides strong evidence that media exposure effects on political knowledge are clearly mediated through elaboration and discussion.

Chapter 14 introduces the Communication Mediation Model of Communication Competence. Essentially, this model identifies the cultural value structures that provide a context for the political socialization structural variables that most of the other studies in this volume examine, including school, peers, and family. Of special focus in the chapter are norms, which "regulate the form, the content, and the processes of communication allowed within a social group (or network)." Family communication norms were operationalized in terms of concept and socio-oriented patterns of family communication, just as in Chapter 8. Two peer communication norms are explored, including one that values being informed about politics and a second that allows disagreement with others. The effects of the norms were tested by first controlling background variables, and then looking at how well the norms, measured at time 2 of the Future Voters Study, predicted communication behaviors at time 3. Even after controls were applied, both of the peer norms were good predictors of frequency of political discussions with others, thinking about those discussions after they occurred, and attempts to integrate what was learned from the discussions with previous political knowledge or beliefs.

Section IV: Youth and political knowledge. Section IV of the book turns its focus to political knowledge. Knowledge, of course, was one of the first measures to be developed in the political socialization literature. It is certainly hard to imagine how youth could navigate the political realm without knowledge of many different types. Chapter 15 examines the acquisition of three types of knowledge: Civics, Issue, and Political Player knowledge. As with so many of the other studies in this volume, all three of these knowledge variables were related in different patterns to the variables that have most commonly been identified as stimuli for political learning: school-based political experiences, political discussions with

others, news media exposure, and time spent with entertainment television. In this particular study, youth were tested right after the congressional election of 2010. As expected, all three types of knowledge were highly intercorrelated with each other. Also consistent with the pattern we have seen repeatedly in many of the other chapters, different demographic and structural variables predicted each of the three kinds of knowledge. For example, news exposure only predicted knowledge of specific candidates seeking office. Exposure to greater amounts of entertainment media predicted diminished Civics knowledge, but had no effect on the other types. The bottom line of this chapter is that while knowledge is almost always treated as a single variable in the extant literature, there is clear evidence that this may be inappropriate for a complete understanding of how youth "learn" about the political realm.

Chapter 16 explores the variables that predict five major indices of political participation: class campaign engagement (a variable measured with the following items: "Wrote a letter or email to a news organization"; "Worked for a political party or candidate"; "Displayed a political campaign button, sticker, or sign"; "Participated in a political protest activity"; "Contributed money to a political campaign"; and "Attended a political meeting, rally, or a speech"); political talk outside of the family; charity activities (measured with the following items: "Did volunteer work," "Worked on a community project," and "Raised money for a charitable cause"); political consumerism (including boycotting and "buycotting" for political reasons); and political knowledge. In addition to the usual controls for demographics, familial and school communication, and media consumption, two new variables were added, including civic mindedness (measured with the following items: "I think it is important to get involved improving my community," "I think it is important to hear others' ideas even if they are different from mine," and "People should speak up when they oppose government's action") and persuasion efficacy (measured with the two items: "I am influential among my friends," and "My friends often seek my opinion about politics"). In this study, unlike any of the other chapters in the book, the relationships were tested three times; that is, for each of the three panels of the Future Voters Study. Consistent with the findings of many of the other studies, predictors of the five criterion variables were different. Interestingly, although all five criterion variables were predicted for each of the three waves, the variables that predicted each changed over time.

Chapter 17 addresses the fundamental question of whether older (15, 16, and 17 years of age) and younger (12, 13, and 14 years of age) teens differ in their patterns of political socialization. It is especially important to explore this specific question, particularly as many of the socialization studies have found age to be a significant predictor of the various levels and types of political response. From a descriptive point of view, older and younger youth differ in that the older youth use more Internet news, report learning more about politics in school, have higher

political knowledge scores, and higher online political participation (e.g., follow political tweets, post political comments on Facebook, etc.). However, predictors of knowledge and offline political participation in older and younger teens are virtually identical. They differ, nevertheless, for online participation, which is not too surprising given the higher level of online participation by older youth. This study also reports differences in the variables that predict perceptions of the youths' own political efficacy. Exploring differences between the two age groups provides the opportunity to theorize changes in adolescents' political socialization as they grow older.

Section V: Media changes. Section V turns the magnifying glass on the role of media in youth political socialization. Chapter 18 asks how college students, our youngest voters, use media to get their political information and how this relates to their campaign interest, their partisanship, and their external political efficacy (perceptions of whether they can influence political processes) and their political information efficacy (feelings of confidence in the political knowledge they possess). An innovation in the study is the identification of blends of media dependency that actually represent new combinations of media that college students are now using. For example, "engaged Millennials" use cable TV, televised debates, and TV news talk shows very heavily. Indeed, the different patterns of political news use are strong predictors of political ideology, campaign interest, and the two measures of efficacy.

Chapter 19 addresses a highly controversial issue in political communication. Over the last several years there is mounting evidence that time spent with entertainment programming is growing, while time spent with news programming is decreasing (Prior, 2005). In research subsequent to Postman's (1985) concern about the increase in time spent with entertainment media, the ratio of time with entertainment to time spent with news programming has become increasingly important. However, there has not been much examination of this issue among youth. This chapter asks which of the political socialization variables predict "relative entertainment preferences" (REP). After controlling for demographics, the results strongly show that REP for youth is reduced by having friends who value news, by talking about news, and by using social media for political communication. The chapter goes on to show that these relationships continue when predictions are made from time 1 to time 2 measurements in the Future Voters Study. This finding is particularly important as it demonstrates the strength of the causal relationships between predictive variables and having a lower REP score.

Chapter 20 examines the impact on youth of news exposure that matches one's own perspectives (safe news) as opposed to news that is inconsistent with one's perspectives (dangerous news). The issue of how people choose news with slanted (e.g., Fox News) or generally balanced news (e.g., local newspapers) and what impact this choice has on their political perspectives has received extensive

examination in the last few years (e.g., Sunstein, 2009); but, again, there has been almost no examination of this issue for youth. The theoretical approach adopted in this chapter suggests that youth are more stimulated to elaborate (think about) news sources that are dangerous rather than safe news. The study also posits that elaboration increases political interest, political knowledge, offline and online political participation. These hypotheses were tested with the second panel of the Future Voters Study, which was fielded immediately after the 2008 Obama election. Surprisingly, both safe and dangerous news consumption increased elaboration; and, equally surprisingly, elaboration only increased political interest, not the other dependent variables. These intriguing results are discussed in terms of the development of safe and dangerous news as part of youth media repertoires.

Chapter 21 explores how youth decide what news is accurate and what news is biased. This, of course, is critically important for the population as a whole, but scantily studied in young people. An important measure used in this study is the idea of an "echo chamber" communication environment. The study posits that for some youth, their information and discussion occur in a "closed" space where only one partisan perspective dominates. Measures included degree of use of conservative talk radio, Fox News, conservative blogs, and the extent to which talking with others about politics mainly involved like-minded others. This investigation is also one of the few to examine the same youth over time as part of the Future Voters Study, using both the first and second waves of panel data. Perceived news accuracy and news bias were measured at both times, and thus could be predicted within waves, with change over time also predicted. As expected, conservative radio and Fox News consumption strongly predicted within-wave negative perceptions of news accuracy. Conservative radio consumption predicted that perceived news inaccuracy would become stronger over time, but Fox News use predicted diminishing perceived news inaccuracy between waves. Conservative radio consumption showed the same effect on perceived news bias, but Fox News had no significant effect on this variable. Because youthful perceptions of news accuracy and bias may predict eventual adult news perceptions, this study and its detailed findings are quite significant.

Chapter 22 further spotlights the concept of news "voice," a variable introduced in Chapter 3. The dependent variables of central interest here are political self-efficacy and political knowledge in youth. Authoritative voice, as defined in Chapter 3, was indexed in terms of traditional and online mainstream media use. Opinionated news voice included conservative and liberal political blogs, conservative talk radio, and humorous Internet videos about political candidates such as those from *The Daily Show* or *Saturday Night Live*. Direct-to-the consumer (DTC) voice included three measures of exposure to candidate websites and ads. This study employed the second wave of data from the Future Voters Study. Again,

after extensive controls of demographics and media exposure, only DTC voice increased political knowledge; and this variable remained significant even after the degree to which youth elaborated on the news was added to the regression equation. In contrast, however, political efficacy was significantly increased by exposure to both opinionated news voice and DTC voice. The strength of this finding suggests that exposure to "news" that takes a position may help youth become more confident about playing their own personal role in politics, while exposure to mainstream news does not. Also, political knowledge and news elaboration both increased youth political self-efficacy.

Finally, Chapter 23 adopts an issue approach to examining youth political attitudes, exploring young citizens' self-identification as environmentalists. A particularly relevant issue among Millennials, this study questions whether those who identify as an environmentalist are more politically and civically engaged, and also whether they are more likely to engage in greater political consumerism, including boycotting and buycotting. Analyzing the first survey of the Future Voters Study, strong support was found for the role of environmentalist self-identification for both civic engagement and political consumerism, but less so for more traditional political engagement (again, perhaps reflecting Millennials' tendency to eschew traditional electoral political activity). This study concludes with observations that suggest progress on the very serious environmental concerns that now face our world could well result from the engagement, activism, and consumerism of our youth as they continue to grow into adulthood.

CONCLUSION

Collectively, the following studies synthesize, often confirm, and, in a number of important areas, question and update our knowledge of political socialization that has accumulated from the past 40 years of related research. The scholarship featured in the 23 chapters that make up this book advances innovative theoretical perspectives and develops new models of the socialization process that revolve around the key social structures of family, media, peers, and school. The Hierarchy Model of Political Socialization, in particular, provides a conceptual framework for organizing and analyzing youth responses to the political. With research that spans multiple election cycles across nearly a decade and data drawn from a national panel study that allows for cross-generational comparison, the findings and models of political socialization presented in these pages provide the most comprehensive and in-depth examination of youth political socialization that exists to date. This volume of research provides a foundation and agenda for examining the Millennial generation in the coming years as they mature to adults and become the driving force of society and our polity.

NOTES

1. When 18-year-olds were first allowed to vote in 1972, young voters (18 to 29) achieved their "high-water mark" of electoral participation at 55.4%. In 1992, with an increase in young citizens turning out to vote for Bill Clinton, youth voting was at 52% ("New Census Data Confirm Increase in Youth Voter Turnout in 2008 Election," 2009).

2. The data collected as part of the Future Voters Study were undertaken by a consortium of communication and political science faculty from the following universities: University of Arkansas (Todd Shields and Robert Wicks), University of Kansas (David Perlmutter), University of Michigan (Erika Franklin Fowler), University of Missouri (Esther Thorson), University of Texas (Dustin Harp and Mark Tremayne), and University of Wisconsin (Barry Burden, Ken Goldstein, Hernando Rojas, and Dhavan Shah). Shah organized this team of scholars and served as the principal investigator for the survey panel. These researchers are grateful for the support received from the following sources: The Diane D. Blair Center for Southern Politics at the University of Arkansas; the William Allen White School of Journalism and Mass Communications and the Robert J. Dole Institute of Politics at the University of Kansas; the Robert Wood Johnson Foundation Scholars in Health Policy Research Program at the University of Michigan; the Reynolds Journalism Institute at the University of Missouri; the University of Texas Office of the Vice President for Research; and the Hamel Faculty Fellowship, the Graduate School, and the Department of Political Science at the University of Wisconsin.

REFERENCES

Abramowitz, A. (2010). *The disappearing center: Engaged citizens, polarization, and American democracy.* New Haven, CT: Yale University Press.

Fingerhut, H. (2016). *Millennials' views of news media, religious organizations grow more negative.* Retrieved from Pew Research Center website: www.pewresearch.org

Fry, R. (2015). *Millennials surpass GenXers as the largest generation in U.S. labor force.* Retrieved from Pew Research Center website: www.pewresearch.org

Hively, M. H., & Eveland, W. P. (2009). Contextual antecedents and political consequences of adolescent political discussion, discussion elaboration, and network diversity. *Political Communication, 26,* 30–47.

Iyengar, S., Sood, G., & Lelkes, Y. (2012). Affect, not ideology: A social identity perspective on polarization. *Public Opinion Quarterly, 76,* 405–431.

Kiesa, A., Orlowski, A. P., Levine, P., Both, D., Kirby, E. H., Lopez, M. H., & Marcelo K. B. (2007). Millennials talk politics: A study of college student political engagement. Retrieved from The Center for Information & Research on Civic Learning and Engagement (CIRCLE) website: www.civicyouth.org

Kiley, J., & Dimock, M. (2014). *The GOP's Millennial problem runs deep.* Retrieved from Pew Research Center website: www.pewresearch.org

McDevitt, M., & Chaffee, S. (2000). Closing gaps in political communication and knowledge: Effects of a school intervention. *Communication Research, 27*(3), 259–292.

McDevitt, M., & Chaffee, S. (2002). From top-down to trickle-up influence: Revisiting assumptions about the family in political socialization. *Political Communication, 19,* 281–301.

McKinney, M. S., & Banwart, M. C. (2011). The election of a lifetime. In M. S. McKinney & M. C. Banwart (Eds.), *Communication in the 2008 U.S. election: Digital natives elect a president* (pp. 1–9). New York, NY: Peter Lang.

McKinney, M. S., & Bolton, J. P. (2016). Youth and elections in American campaigns. In B. Benoit (Ed.), *Praeger handbook of political campaigning in the United States, vol. 2* (pp. 171–189). Santa Barbara, CA: Praeger.

McKinney, M. S., & Bystrom, D. G. (2014). An alieNATION of the U.S. electorate: The divide and conquer election of 2012. In D. G. Bystrom, M. C. Banwart, & M. S. McKinney (Eds.), *alieN-ATION: The divide & conquer election of 2012* (pp. 1–11). New York, NY: Peter Lang.

McLeod, J. M., & Chaffee, S. H. (1972). The construction of social reality. In J. T. Tedeschi (Ed.), *The social influence process* (pp. 50–99). Chicago, IL: Aldine-Atherton.

New census data confirm increase in youth voter turnout in 2008 election. (2009, August 17). Retrieved from The Center for Information & Research on Civic Learning and Engagement (CIRCLE) website: www.civicyouth.org

Palfrey, J., & Gasser, U. (2008). *Born digital: Understanding the first generation of digital natives*. New York, NY: Basic Books.

Postman, N. (1985). *Amusing ourselves to death: Public discourse in the age of show business*. New York, NY: Viking Press.

Prior, M. (2005). News vs. entertainment: How increasing media choice widens gaps in political knowledge and turnout. *American Journal of Political Science, 49*, 577–592.

Rill, L. A., & McKinney, M. S. (2014). Defying expectations: Young citizens' political attitudes and participation in the 2012 election. In D. G. Bystrom, M. C. Banwart, & M. S. McKinney (Eds.), *alieNATION: The divide & conquer election of 2012* (pp. 260–276). New York, NY: Peter Lang.

Shah, D. V., Cho, J., Eveland, W. P., & Kwak, N. (2005). Information and expression in a digital age: Modeling Internet effects on civic participation. *Communication Research, 32*, 531–565.

Shah, D. V., Cho, J., Nah, S., Gotlieb, M. R., Hwang, H., Nam, J. L., … McLeod, D. M. (2007). Campaign ads, online messaging, and participation: Extending the communication mediation model. *Journal of Communication, 57*, 676–703.

Smetana, J. G. (2010). *Adolescents, families, and social development: How teens construct their worlds*. Hoboken, NJ: Wiley-Blackwell.

Sunstein, C. R. (2009). *Republic.com 2.0: Revenge of the blogs*. Princeton, NJ: Princeton University Press.

Thompson, D. (2014, July 15). Millennials' political views don't make any sense. *The Atlantic*. Retrieved from www.theatlantic.com

Valkenburg, P. M., Krcmar, M., Peeters, A. L., & Marseille, N. M. (1999). Developing a scale to assess three styles of television mediation: "Instructive Mediation," "Restrictive Mediation," and "Social Coviewing." *Journal of Broadcasting & Electronic Media, 43*, 52.

Young voters supported Obama less, but may have mattered more. (2012). Retrieved from Pew Research Center website: www.people-press.org

Theories OF Political Socialization

The Role OF Media Use Motives IN THE Classic Structural Model OF Youth Political Socialization

ESTHER THORSON, HANS MEYER, AND MI JAHNG

This study explores how news media use, exposure to school political curriculum, political conversation with parents, and, most importantly, motivations for media use impact political socialization, which is operationalized here as political interest and knowledge. To provide a rationale for our study, we integrate five related literature areas under the explanatory context of the Media Choice Model, a variation on the uses and gratifications approach. The focus of this model is on how people make choices about media and how the impact of that media use is mediated through people's motivations for using particular media. As background, we consider what is known about the following impacts on political socialization: parental communication patterns, political socialization training in school, exposure to television and print news, and adolescent news motivations directed at connectivity, information, and entertainment.

THE MOTIVES FOR MAKING MEDIA CHOICES

In the Media Choice Model, uses and gratifications theory guides an approach that specifically addresses how people, both adults and teens, choose media. The Media Choice Model suggests that new media features (immediacy, mobility, ease of use, presence of video or audio, dependence on text) influence the way people fill their communication needs and, as a result, develop preferred patterns of media use but modify those patterns as the media environment changes.

Uses and gratifications theory (Katz, Gurevitch, & Haas, 1973) posits that every communication behavior is caused by a need that can be fulfilled in a number of ways. Humans choose the communication act that best gratifies that need. The communication behavior may occur face to face or it may be mediated through a communication medium (newspapers, radio, television, iPod, etc.). As new media are introduced into their environment, people will pick and choose among the alternatives, favoring a communication act that maximally satisfies a particular need.

Katz, Blumler, and Gurevitch (1974, p. 20) suggested that uses and gratifications research should focus on a handful of central concepts: (a) the social and psychological origins of (b) needs that generate (c) expectations of (d) the mass media or other communication sources, which lead to (e) different media choices, resulting in (f) gratification of the needs. Rosengren (1974) added two important additional aspects of the process: (g) individual differences such as demographics and lifestyles, and (h) particular situations in which the needs must be filled. Unlike many competing theories of media use, this approach assumes that media users are active, picking and choosing to maximize desired gratifications.

The uses and gratifications approach has led to the development of many taxonomies of communication needs. Excellent summaries of the large literature on communication need articulation can be found in Rubin (1983; 1984) and in Ruggiero (2000). This theory has been applied to understanding antecedents of choice of every medium, including newspapers (Elliott & Rosenberg, 1987); television (Babrow, 1987; Conway & Rubin, 1991); and newer media such as cable television (Heeter & Greenberg, 1985), e-mail (Dimmick, Kline, & Stafford, 2000), and, most recently, the Internet (Beaudoin & Thorson, 2004; Kaye & Johnson, 2002; Papacharissi & Rubin, 2000; Rodgers & Thorson, 2001).

Uses and gratifications theory has also been used in models that attempt to identify how people choose one medium over another. A good example of such work is Lacy (2000), who suggested that five communication needs (surveillance, diversion, social-cultural interaction, decision-making, and self-understanding) combine with other variables such as quality of news and media features (such as cost) to determine how much time people will spend with various media.

In the current study, three motives were examined: **connectivity**, the need to engage with other human beings; **information**, the need to identify, understand, and cope with happenings in the environment; and **entertainment**, the need to be diverted, pleasured, or relaxed. These are overarching communication need states that subsume many subsets of tasks that each person must complete each day. Some examples of need state fulfillment behaviors might include the following:

- *Connectivity*: Use of social networking Internet sites, downloading personalized ringtones, or belonging to an online affinity group.

- *Information*: Searching for a map online, checking the weather for a travel destination, checking local news.
- *Entertainment*: Watching television, or listening to an iPod while working out.

Of course, these need states overlap and it is clear that for some, seeking information is an entertaining activity and one might gain certain types of information from an online affinity group. There is also much to be learned about the complexities of the need states, and research in this area is desperately needed.

The same complexity applies to information needs. Thorson, Thorson, & Sridhar (2011) have shown that responses to the questions, "makes me feel smarter," and "supports my point of view" are important dimensions of the need for information and help to predict which news medium young adults will prefer. Likewise, an important aspect of the connectivity need in this study was "providing news to share with others." The upshot of this research is that it demonstrates that connectivity and information needs as they relate to news source choice are complex ones and would benefit from extensive further study. This is no doubt also true for entertainment as well as shopping communication needs.

There has recently been significant recognition that uses and gratifications is an important perspective for understanding adolescent media use. Arnett, Lawson, and Offer (1995), in the introduction to a special issue of *Journal of Youth and Adolescence* overviewed how important it is to understand youth as active selectors of media, just as they take an active role in creating and defining many of the relationships in their lives, including those at school, with their parents, and with significant others (e.g., Lerner & Kaufman, 1985; Scarr, 1993; Scarr & McCartney, 1983). Not only do adolescents choose from various media, they mold the use of these media to their own motives. Some examples of the uses to which adolescents put the media include personal definition and individuation, identification of self-status in school or other social environments, or deriving information about sex, relationships, and romance. Much of the media content studied in this research field is entertainment, while there has been little examination of how youth use news and political news.

Bringing the adolescent literature together with the Media Choice Model, we suggest that adolescent use of the news media is driven by active application of the three motives or desired gratifications. Clearly, when young people want to get information about politics, political candidates, or an election, the information motive is a crucial determinant of which media they choose. Less obviously, politics can play an important role in connecting with others. Whether it is demonstrating expertise to teachers and parents, or serving as the "go-to" person in one's social circle, knowing about politics is often an important means of connecting with others in a desired way. Eveland (2004) referred to this kind of motivation as "anticipatory elaboration."

The entertainment motive, however, is even more complex. While watching a YouTube video of Katie Couric interviewing Sarah Palin can be entertaining in and of itself, the motive to use media primarily for entertainment has been shown in adults to mitigate against even consuming news. Putnam (1995) has argued that television consumption damaged how well people participated in their own communities. In response to this notion, many researchers looked in a more detailed way at how television was being used (Fleming, Thorson, Peng, 2005; Milner, 2002; Norris, 1996; Shah, 1998; Shah, McLeod, & Yoon, 2001). What these researchers found was that use of television for entertainment did indeed damage community participation, as well as knowledge about and interest in politics. But use of television for news, and indeed use of news in general, increased knowledge and political interest and participation (McLeod, Scheufele, & Moy, 1999).

Eveland (1997) has also suggested that the gratifications that people seek from the media (i.e., information, entertainment, connectivity) drive the information processing of media content. For example, the person seeking information will attend more closely to news items on politics and likely elaborate on those items. The person seeking connectivity, however, may attend primarily to content that would make good fodder for conversation. That person might also be more likely to watch the late-night satirical news programs. Indeed, at a micro psychological level, there are many ways that the gratifications would lead to media selection, program selection, and the kind of attention to various content that results from the selection.

What is clear, however, is that the motives should actually be more important in predicting knowledge than even which media are selected. We thus hypothesize:

H1: Exposure to television, Internet, and newspapers about politics will have a positive impact on political knowledge.

H2: The motives will completely mediate the impact of news media use on political knowledge; that is, media use will affect political knowledge indirectly through the motives for media use.

In McLeod, Scheufele, & Moy's (1999) review of the literature on the relationship between media exposure and political interest, the two variables have reciprocal relations. Nevertheless, the preponderance of findings suggests the dominant causal direction is from media exposure to political interest. Although there is not much research to guide the connection to gratifications, it would seem that the motives would be as likely to mediate the effects of media exposure on political interest as suggested for political knowledge. Therefore, we expect the following:

H3: Exposure to television, Internet, and newspapers about politics will have a positive impact on political interest.

H4: The motives will completely mediate the impact of news media use on political interest, that is, media use will affect political interest indirectly through the motives for media use.

Family Communication and Political Socialization

Political socialization represents the "period during which children become oriented toward the values, beliefs, knowledge, and opinion of the political culture (Hess & Torney, 1968, p. 1). Generally, political socialization of adolescents is operationalized as the political knowledge, political interest, frequency of political discussion, and exposure to political information in the mass media (Kim & Kim, 2007; Meadowcroft, 1986). Studies linking parental influence on political sophistication of adolescents have tried to see how parenting instills political trust and allegiance in younger children (McDevitt & Chaffee, 2002). These results are in line with studies from cognitive development theory, which argues that young adults are constructing meaning and knowledge through social interaction with their parents about the political world (Haste & Torney-Purta, 1992).

Traditionally, studies in political socialization of adolescence have conceptualized it as a top-down process in which children acquired political attitudes, information, and behavior from their parents through observation and modeling (Butler & Stokes, 1974; McDevitt, 2005; McDevitt & Chaffee, 2000). McLeod and Chaffee (1972) found that children from concept-oriented families are more interested in politics, know more about politics, and are exposed to political information more than the socio-oriented families. Parents' party affiliation has been a strong indicator of the children's partisanship, with adolescents more likely to follow the party affiliation of the parents (Desmond & Donohue, 1981; McDevitt, 2005). Parents' political activities were found to be a strong indicator of how involved in politics the children are (Desmond & Donohue, 1981). Also, parents with higher socioeconomic status were found to talk more to their children about politics, which led to the children having more political knowledge than lower SES families (McDevitt & Chaffee, 2000; McLeod & Chaffee, 1972; Meirick & Wackman, 2004). Most recently, McIntosh, Hart, and Youniss (2007) found that parent political knowledge and youth-parent political discussion were an important predictors in youth political knowledge. That is, the knowledge of the parent was transmitted to the youth, and its effect was increased by parent-child political discussion.

In the literature of family communication and adolescence political socialization, the role of the parent has been acknowledged. It is reasonable, therefore, to expect that the more the parents know and the more they encourage the youth to discuss politics, express their opinion, and be politically involved, the more politically socialized the child will be. When growing up in a family environment in which the parents know a lot about politics, pay more attention to political information, and encourage the expression of opinions, adolescents are more likely to follow their parents' political interest and knowledge. We summarize these expectations in this hypothesis:

H5: There will be a direct positive effect of family communication on adolescent political interest and knowledge.

School and Youth Political Socialization

Recently, studies have taken a different route in looking at the role of family, especially parents, to explain political socialization of adolescents. Defined as "trickle-up" socialization, this view of political participation looks at how children in the family can be the initiators of political discussion within the family. Instead of top-down parental influence on political socialization, the trickle-up perspective focuses on what school education can do for political socialization of adolescents. The assumption behind the trickle-up approach is that children are not merely receptive to civic development provided by the parents, they also proactively socialize with agents outside of home, especially in school. This socialization then leads to adolescents taking more proactive roles in the political environment in the family, even affecting parents' political involvement.

According to studies looking at schools' civics curriculum effects (McDevitt & Chaffee, 2002), adolescents learn and participate in the political socialization process at school, and because of the increased political self-efficacy, they become initiators in family communication about politics. For example, *Kids Voting USA*, one well-known school intervention to stimulate gains in political development among students in fifth through 12th grades, has had a remarkable impact through its election-centered strategy. Exposure to *Kids Voting USA* curriculum has been linked to higher attention to news media and more frequent discussion with family and friends about politics (Simon & Merrill, 1998), increased political knowledge (Meirick & Wackman, 2004), and increased voter turnout, averaging about 3% in communities where it was adopted in schools (Merrill, Simon, & Adrian, 1994). Furthermore, this direct effect of school intervention led to an indirect effect on parents. Specifically, parent information-seeking, opinion formation, and stimulation of "concept-oriented communication" created a home environment that stimulated more political sophistication than typical socio-oriented communication (McDevitt & Chaffee, 1998).

Schools can potentially provide social interaction that represents a level of political stimulation and communication that may not be available from parents at home (Kiousis & McDevitt, 2008). For low SES families, schools can help surmount the problem of activating mass media messages in politics and mitigate social structural disparities outside of the classroom. School interventions, such as the *Kids Voting USA* curriculum, encourage our future voters to be politically interested and knowledgeable, leading to a more motivated discussion in school and in the family (McDevitt, 2005; McDevitt & Chaffee, 2002). While family and home environments are perceived as the primary agents of political socialization,

school has played an important part as a secondary agent, along with mass-media exposure (Atkin, 1981). It is possible, thus, to hypothesize that school is a second important factor in predicting the political socialization of adolescence.

> **H6:** There will be a direct positive effect of exposure of political curricula in school on adolescent political interest and knowledge.

METHOD

To examine the effects of media use, motivations, and exposure to political talk at home and in school, we surveyed teenagers and their parents between May 20 and June 25, 2008. Synovate, a commercial survey research firm, administered the four-page mailed questionnaire. Synovate employs a stratified quota sampling technique to recruit respondents. Initially, the survey firm acquires contact information for millions of Americans from commercial list brokers, who gather identifying information from drivers' license bureaus, telephone directories, and other centralized sources. Large subsets of these people are contacted via mail and asked to indicate whether they are willing to participate in periodic surveys. Small incentives, such as pre-paid phone cards, are offered for participation.

Rates of agreement vary widely across demographic categories. For example, 5% to 10% of middle class recruits typically consent, compared to less than 1% of urban minorities. It is from this pre-recruited group of roughly 500,000 people that demographically balanced samples are constructed for collection. To achieve a representative pool of respondents, stratified quota sampling procedures are employed. That is, the sample is drawn to reflect the properties of the population within each of the nine census divisions in terms of household income, population density, age, and household size. This starting sample is then adjusted within a range of subcategories that include race, gender, and marital status in order to compensate for expected differences in return rates (see Shah, Cho, Eveland, & Kwak, 2005; Shah et al., 2007, for details).

For the purposes of this study, this technique was used to generate a sample of households with children aged 12–17. A parent in the selected households was contacted via mail, asked to complete an introductory portion of the survey and then to pass the survey to the 12–17-year-old child in the household who most recently celebrated a birthday. This child answered a majority of the survey content and then returned the survey to the parents to complete and return. This sampling method was used to generate the initial sample of 4,000 respondents for the 2002 Life Style Study. Of the 4,000 mail surveys distributed, 1,325 responses were received, which represents a response rate of 33.1% against the mail-out. A small number of these responses were omitted due to incomplete or inconsistent information, resulting in a slightly smaller final sample.

In all, our analysis examines 1,291 teens between the ages of 12 and 17. To test our hypotheses, we created hierarchical linear regression equations with four levels of independent variables. The first level included demographic variables such as age, gender, and political affiliation, followed by access to TV and print news at the second level, media choice motivations at the third, and political talk at home and at school in the final level. The regressions predicted two dependent variables: the child's political interest and political knowledge.

RESULTS

In the first block of demographics, each age group had nearly equal representation. The largest group was 14-year-olds, constituting 19% of the sample, while the smallest was 12-year-olds and constituted almost 14%. There was an almost equal distribution of boys (49%) and girls (48%), with 3% not responding. Racially, the population was predominantly white (77%), with 8% black. More than 7% of respondents reported themselves as multi-racial, and only 5% reported themselves as Hispanic. The children in the study also allied themselves almost equally with the two political parties. Thirty percent said they were Democrat, while 25% said they were Republican. Thirty-two percent reported they were independent.

Their parents, on the other hand, seemed more conservative. Thirty-seven percent of parents said they were Republican, while 34% said they allied with the Democratic party. Only 23% of the parents said they were independent. The parents also reported a diverse educational background. All but 2% said either one or both parents had completed high school. More than 52% said they had completed at least some trade school or a college education, while 25% had completed either a bachelor's or advanced college degree. Nearly 75% reported they were married, while another 15% said they were divorced.

In all the families surveyed, more than 50% said they had at least a local newspaper delivered to their homes each day, while only 5% had a national newspaper at home. More than 43% said they had neither. In addition, nearly 70% had at least basic cable or satellite television in their homes, and 87% had Internet access at home.

Even though nearly half of the respondents had at least one newspaper in their home and most had access to cable TV news options, they did not use either more than 2 days a week. For the second block, we created aggregate media use measures for TV by averaging the number of days each week respondents reported they watched local, national, or cable TV news, and for print by averaging the number of days a week they said they read national and local newspapers. TV news scored highest with an average of nearly two days a week, while print use averaged a bit more than one day a week.

In the third block, we examined motivations behind their media choice through an exploratory factor analysis on questions that asked the teenage respondents to rate their level of agreement with a number of statements about the media and politics (see Table 1 for a list of mean scores of dependent and independent variables). Three questions loaded together (Cronbach's α = .576) to explain connectivity: "I am influential among my friends," "My friends often seek my opinion about politics," and "Among my friends, it's important to know what's going on in the world." Seven questions measuring how important the characteristics of political information are in determining whether respondents use it loaded together to form the information motive (Cronbach's α = .941). These included: "Is available when I want it," "Is tailored to my interests," "Gives me the facts to back up my opinions," "Exposes me to different points of view," and "Gives me up-to-date information." We derived the entertainment motive from one question in the same block that asked how important "is entertaining" when determining if respondents will use a political information source.

The final dependent variables—political talk at home and at school—were aggregate measures as well. Political talk at home was an average score of how often parents said they encouraged their children to talk about politics at home and how often the teens said they talked about news and current events at home. These two measures had a statistically significant correlation at the $p < .01$ level (r = .38). Another confirmatory factor analysis suggested the extent to which the youth talked about politics at school. Questions that asked respondents to rate

Table 1. Summary of Hierarchical Regression Analysis for Variables Predicting Child's Political Knowledge (N = 1,291).

	N	Range	Minimum	Maximum	Mean	SD	Variance
TV News use (local and network)	1257	7.0	.0	7.0	1.533	1.6770	2.812
Print use (national and local)	1255	7.00	.00	7.00	1.1657	1.43090	2.047
Connectivity Motive	1256	4.00	1.00	5.00	2.9358	.81012	.656
Information Motive	1249	7.00	1.00	8.00	4.2468	2.03591	4.145
Entertainment Motive	1248	7.00	1.00	8.00	3.6683	2.34626	5.505
Learned about politics in school	1258	7.00	1.00	8.00	3.5067	1.88909	3.569
Child's political interest	1257	4.00	1.00	5.00	2.7729	1.11157	1.236
Political knowledge scale	1291	3.00	.00	3.00	.9775	1.00632	1.013

how often they "followed the news as part of a class assignment," "learned about how government works in class," "discussed/debated political or social issues in class," "participated in political role playing in class," and "encouraged to make up your own mind about issues in class" loaded together (Cronbach's α = .863) to create the political talk in school factor.

Finally, we created two dependent variables to predict teens' political interest and knowledge. Political interest was an aggregate measure of how much respondents agreed with the following statements that correlated positively (r = .68, p < .01): "I am interested in the presidential campaign," and "I am interested in politics." We measured political knowledge by asking respondents three general questions: Which political party is more conservative? Which political party controls the House of Representatives? Which political party did Ronald Reagan belong to when he was president? A correct answer was scored 1, while incorrect responses were 0. On a scale of 1–3, the mean student average was less than one.

In the first hierarchical linear regression analysis, we predicted political knowledge with four models that added another set of dependent variables each time. The first set was demographics, followed by media use, media choice motives, and political talk (see Table 2). The complete model explained more than 22% of the variance. Across all four models, age, gender, parents' education, and the child's political affiliation were significant predictors. Only print news use, however, was a significant predictor of political knowledge when analyzed apart from motives and political talk. This offers partial support for H1, which said that TV and print use will have a positive effect on knowledge, accounting for 13% of the variance. The predictive power of print use, however, drops out when the media use motivations are added in the third model, offering support for H2, that motives will completely mediate the impact of news media use. The third model adds 6% to the variance explained. Only information is a positive significant predictor at this stage, while the entertainment motive is a significant negative predictor. When adding political talk at home and at school in model four, information and entertainment remain significant predictors, while only talking about politics with family is a significant predictor of a child's political knowledge. This partially supports H5, that family talk will have a positive impact on knowledge, and fails to support H6, that learning about politics in school will increase knowledge. In the final model, the information motive is the strongest predictor, followed closely by parents' education and talking about politics at home. The final model explains 21% of the variance. This suggests the important impact parents have in how their children learn about politics. The final model also suggests children learn more about politics as they get older and that boys learn more about politics than girls, as age is a positive predictor and gender is a negative predictor (boys were coded as 0, while girls were coded as 1).

Table 2. Summary of Hierarchical Regression Analysis for Variables Predicting Child's Political Knowledge (N = 1,291).

Variable	Model 1 (demographics)			Model 2 (media use)			Model 3 (media choice motives)			Model 4 (other sources)		
	B	SE(B)	β	B	SE(B)	β	B	SE(B)	β	B	SE(B)	β
Child's Age	.08	.02	.13**	.079	.019	.13**	.063	.018	.10**	.06	.02	.10**
Child's Gender[a]	-.16	.06	-.08**	-.162	.060	-.08**	-.175	.058	-.09**	-.17	.06	-.09**
Child's Political Affiliation[b]	.13	.05	.13**	.14	.045	.13**	.142	.044	.13**	.13	.04	.12**
Child's Race	.02	.02	.02	.02	.021	.020	.006	.021	.01	.01	.02	.02
Parent's Education	.26	.03	.25**	.26	.030	.25**	.223	.029	.22**	.20	.03	.19**
Parent's Political Affiliation	.07	.04	.08	.08	.040	.08	.070	.038	.08	.07	.04	.08
TV News Watching (local and national)				.03	.016	.05	.009	.016	.02	-.00	.02	-.01
Print use (national and local)				.05	.022	.07*	.019	.022	.03	.01	.02	.02
Connectivity							.114	.038	.09**	.07	.04	.06
Information							.131	.018	.26**	.10	.02	.20**
Entertainment							-.043	.015	-.10**	-.04	.02	-.09**
Learned about politics in school										.03	.02	.05
Talked about politics with family										.08	.02	.14**
R²	.132			.141			.205			.22		
Adjusted R²	.127			.135			.196			.21		
F for R² change	25.573			20.786			23.580			22.32		

[a]Non-female (0) – female (1). [b]Strongly Democrat (1) – Strongly Republican (5)

* p < .05; ** p < .01.

Next, we predicted political interest based on the same four blocks of dependent variables (see Table 3). In the first block, parents' education and gender were significant predictors and remained significant across all four models tested, while age was only significant when not accounting for the media use motives or political talk at home and in school. The first model explained just 3% of the variance. When TV and print news use were added in the second model, they were also significant, adding an additional 4% to the variance explained. This supports H3, that exposure to TV and print news will have a positive impact on political interest. When adding the motives in the next step, however, both print and TV news use are no longer significant while the information and connectivity motives are, explaining nearly 30% of the variance in political interest. This supports H4, that the motives will completely mediate the effect of media use. The motives remain the strongest predictors in the final model, which adds political talk at home and at school, even though both forms of talk are significant predictors, and this final model only adds an additional 5% to the variance explained. This supports H5 and H6, which explain that political talk at home and at school will have significant effects on political interest. In the final model, however, the connectivity motive is by far the strongest predictor of political interest, suggesting how political interest is closely tied to teens' social connections. The next strongest predictors are the information motive and political talk at home, which suggest that teens that want to know about politics seek information that is available when they want it, is tailored to their interests, and gives them something to talk about with others. Those others are often family members.

DISCUSSION

The goal of this research was to examine how news media use, exposure to school political teaching, political conversation with parents, and, most importantly, motivations for media use impact teenagers' political socialization, operationalized here as political interest and knowledge. Through hierarchical regression analyses that demonstrated the mediated effects of the independent variables, this study suggests the important role that motives—or the reasons why a teen chooses to use the media—have in political socialization. In the first model that predicted knowledge, the demographic independent variables were significant initially, accounting for more than 13% of the variance explained. However, the significance of these variables decreased as the media motives and political talk at home and school were added in subsequent steps. The information-seeking motive remained the strongest predictor of political knowledge, even when accounting for learning about politics in school and talking about politics at home. The entertainment motive remained a significant negative predictor, indicating that the stronger a

Table 3. Summary of Hierarchical Regression Analysis for Variables Predicting Child's Political Interest (N = 1,291).

Variable	Model 1 (demographics)			Model 2 (media use)			Model 3 (media choice motives)			Model 4 (other sources)		
	B	SE(B)	β	B	SE(B)	β	B	SE(B)	β	B	SE(B)	β
Child's Age	.06	.02	.08*	.05	.02	.07*	.01	.02	.01	.00	.02	.01
Child's Gender[a]	-.11	.07	-.05	-.12	.07	-.06	-.15	.06	-.07*	-.15	.05	-.07*
Child's Political Affiliation	-.03	.05	-.03	-.03	.05	-.03	-.01	.04	-.01	-.02	.04	-.02
Child's Race	.05	.03	.07*	.05	.02	.07*	.03	.02	.04	.04	.02	.05
Parent's Education	.16	.03	.14**	.16	.03	.14**	.12	.03	.10**	.09	.03	.08**
Parent's Political Affiliation	.04	.05	.04	.05	.05	.05	.04	.04	.04	.04	.04	.04
TV News Watching (local and national)				.07	.02	.12**	.03	.02	.05	.02	.02	.02
Print use (national and local)				.11	.03	.14**	.04	.02	.05	.03	.02	.03
Connectivity							.60	.04	.44**	.55	.04	.40**
Information							.13	.02	.23**	.09	.02	.17**
Entertainment							-.02	.01	-.03	-.01	.01	-.03
Learned about politics in school										.04	.02	.07*
Talked about politics with family										.08	.02	.14**
R^2	.033			.077			.350			.372		
Adjusted R^2	.027			.070			.343			.364		
F for R^2 change	5.78**			10.58**			49.20**			45.77**		

[a]Non-female (0) – female (1). [b]Strongly Democrat (1) – Strongly Republican (5)

* p < .05; ** p < .01.

respondent's desire to find something entertaining, the less political knowledge they were likely to have. While the information-seeking motive was the strongest, the next two predictors might indicate where that information motive comes from. Both the parents' education level and the frequency with which they talked about politics at home had beta scores above .14, putting them at a much higher level than any of the other significant demographic variables. All told, this regression accounted for a significant 22% of the variance. In other words, this study suggests that as far as teens are concerned, political knowledge increases as educated parents instill in their children a need to find relevant information.

But with media choice, motives accounted for an even greater percentage of the variance in political interest. The final model revealed that the connectivity motive was far and away the most significant predictor of political interest, accounting for 37% of the variance. The beta alone for connectivity was .40, more than .20 above any of the other significant predictors. The media choice motives, especially connectivity and information, accounted for nearly 28% of the variance. While some demographic variables were significant in the first step, their impact was almost completely mediated by the information motives. Only parents' education was significant in the final step. In addition, while talking about politics at school and at home was significant, placing them in the model added only 2% to the variance explained.

In other words, this study suggests that teens' interest in politics depends largely on whether this interest will connect them with their peers. Parents still play an important role in setting the tone for political interest at home, and schools can also stimulate a teen's desire to know more about a presidential election, for example. In the end, though, wanting to connect with others and gain information in formats that speak to teens and that they find pertinent to life around them determines how interested teens will be in politics.

Both of these findings have interesting implications for education, home life, and the media. This study suggests the important role parents have in encouraging their children's interest in, and knowledge of, politics. It also suggests the media and schools should find ways to present information to young people that strengthen their relationships with peers. This could mean finding ways to make politics have an impact on a teen's daily life and, therefore, be something he or she would want to talk about with friends.

Examining political interest and knowledge at this time in America presents challenges. The 2008 presidential campaign that featured Barack Obama generated more interest than normal, even among teens. This study's findings could be a product of that environment, and future studies should test more directly how media choice motives mediate other variables that lead to media use and political socialization. The significant negative effect of entertainment on political knowledge could also be operationalized through more in-depth questions.

However, this study makes a significant contribution not just to understanding how teens gain political socialization, but also to how people choose the media. While uses and gratifications provides a useful framework to explain an individual's information and entertainment needs, the Media Choice Model suggests a more detailed causal relationship between motives and needs. Future studies should examine how other aspects of the model, such as the interactive features of the Internet or the aperture that determines when and where people use the media, impact political socialization. Regardless, this study underscores how important it is to understand the information and connectivity motives for this sample of American teenagers today. The explosion in the amount of political information available has made finding news that you can use even more vital and the need to connect with others outside of a computer-mediated environment even more pertinent.

REFERENCES

Arnett, J. J., Lawson, R., & Offer, D. (1995). Beyond effects: Adolescents as active media users. *Journal of Youth & Adolescence, 24*(5), 511–518.

Atkin, C. (1981). Communication and political socialization. In D. Nimmo & K. Sanders (Eds.), *Handbook of political communication* (pp. 299–328). Beverly Hills, CA: Sage.

Babrow, A. S. (1987). *Student motives for watching soap operas.* New York, NY: Taylor & Francis.

Beaudoin, C. E., & Thorson, E. (2004). Social capital in rural and urban communities: Testing differences in media effects and models. *Journalism & Mass Communication Quarterly, 81*(2), 378–399.

Butler, D., & Stokes, D. (1974). *Political change in Britain* (2nd ed.). London, England: Macmillan.

Conway, J. C., & Rubin, A. M. (1991). Psychological predictors of television viewing motivation. *Communication Research, 18*(4), 443–463.

Desmond, R. J., & Donohue, T. R. (1981). The role of the 1976 televised presidential debates in the political socialization of adolescents. *Communication Quarterly, 29*(4), 302–308.

Dimmick, J., Kline, S., & Stafford, L. (2000). The gratification niches of personal e-mail and the telephone competition, displacement, and complementarity. *Communication Research, 27*(2), 227–248.

Elliott, W. R., & Rosenberg, W. L. (1987). The 1985 Philadelphia newspaper strike: A uses and gratifications study. *Journalism and Mass Communication Quarterly, 64*(4), 679.

Eveland, W. P. (1997). Interactions and nonlinearity in mass communication: Connecting theory and methodology. *Journalism & Mass Communication Quarterly, 74*(2), 400–416.

Eveland, W. P. (2004). The effect of political discussion in producing informed citizens: The roles of information, motivation, and elaboration. *Political Communication, 21*(2), 177–193.

Fleming, K., Thorson, E., & Peng, Z. (2005). Associational membership as a source of social capital: Its links to use of local newspaper, interpersonal communication, entertainment media, and volunteering. *Mass Communication & Society, 8*(3), 219–240.

Haste, H., & Torney-Purta, J. (1992). Introduction. In H. Haste & J. Torney-Purta (Eds.), *The development of political understanding: A new perspective* (pp. 1–10). San Francisco, CA: Jossey-Bass.

Heeter, C., & Greenberg, B. S. (1985). Profiling the zappers. *Journal of Advertising Research, 25*(2), 15–25.

Hess, R. D., & Torney, J. (1968). *The development of political attitudes in children*. Chicago, IL: Aldine.

Katz, E., Blumler, J. G., & Gurevitch, M. (1974). The uses and gratifications approach to mass communication. Beverly Hills, CA: Sage.

Katz, E., Gurevitch, M., & Haas, H. (1973). On the use of the mass media for important things. *American Sociological Review, 38*(3), 164–181.

Kaye, B. K., & Johnson, T. J. (2002). Online and in the know: Uses and gratifications of the web for political information. *Journal of Broadcasting & Electronic Media, 46*(1), 54–71.

Kim, K. S., & Kim, Y. C. (2007). New and old media uses and political engagement among Korean adolescents. *Asian Journal of Communication, 17*(4), 342–361.

Kiousis, S., & McDevitt, M. (2008). Agenda setting in civic development: Effects of curricula and issue importance on youth voter turnout. *Communication Research, 35*(4), 481–502.

Lacy, S. (2000). Commitment of financial resources as a measure of quality. *Measuring Media Content, Quality and Diversity: Approaches and Issues in Content Research*. Turku, Finland: Turku School of Economics and Business Administration, 25–50.

Lerner, R. M., & Kaufman, M. B. (1985). The concept of development in contextualism. *Developmental Review, 5*(4), 309–333.

McDevitt, M. (2005). The partisan child: Developmental provocation as a model of political socialization. *International Journal of Public Opinion Research, 18*(1), 67–88.

McDevitt, M., & Chaffee, S. (1998). Second chance political socialization: "Trickle-up" effects of children on parents. In T. J. Johnson, C. E. Hays, & S. P. Hays (Eds.), *Engaging the public: How government and the media can reinvigorate American democracy* (pp. 57–66). Lanham, MD: Rowman & Littlefield.

McDevitt, M., & Chaffee, S. (2000). Closing gaps in political communication and knowledge: Effects of a school intervention. *Communication Research, 27*(3), 259–292.

McDevitt, M., & Chaffee, S. (2002). From top-down to trickle-up influence: Revisiting assumptions about the family in political socialization. *Political Communication, 19*(1), 281–301.

McIntosh, H., Hart, D., & Youniss, J. (2007). The influence of family political discussion on youth civic development: Which parent qualities matter? *Political Science and Politics*, 495–499.

McLeod, J. M., & Chaffee, S. H. (1972). The construction of social reality. In J. Tedeschi (Ed.), *The social influence processes* (pp. 50–99). Chicago, IL: Aldine-Atherton.

McLeod, J. M., Scheufele, D. A., & Moy, P. (1999). Community, communication, and participation: The role of mass media and interpersonal discussion in local political participation. *Political Communication, 16*(3), 315–336.

Meadowcroft, J. M. (1986). Family communication patterns and political development: The child's role. *Communication Research, 13*(4), 603–624.

Meirick, P. C., & Wackman, D. B. (2004). Kids voting and political knowledge: Narrowing gaps, informing votes. *Social Science Quarterly, 85*(5), 1161–1177.

Merrill, B. D., Simon, J., & Adrian, E. (1994). Boosting voter turnout: The Kids Voting program. *Journal of Social Studies Research, 18*(3), 2–7.

Milner, H. (2002). *Civic literacy: How informed citizens make democracy work*. Hanover, NH: University Press of New England.

Norris, P. (1996). Does television erode social capital? A reply to Putnam. *PS: Political Science & Politics, 29*(3), 474–480.

Papacharissi, Z., & Rubin, A. M. (2000). Predictors of Internet use. *Journal of Broadcasting & Electronic Media, 44*(2), 175–196.

Putnam, R. D. (1995). Tuning in, tuning out: The strange disappearance of social capital in America. *PS: Political Science & Politics, 28*(4), 664–683.

Rodgers, S., & Thorson, E. (2001). The reporting of crime and violence in the *Los Angeles Times*: Is there a public health perspective? *Journal of Health Communication, 6*(2), 169–182.

Rosengren, K. E. (1974). Uses and gratifications: A paradigm outlined. In J. G. Blumler & E. Katz (Eds.), *The uses of mass communications: Current perspectives on gratifications research* (pp. 269–286). Beverly Hills, CA: Sage.

Rubin, A. M. (1983). Television uses and gratifications: The interactions of viewing patterns and motivations. *Journal of Broadcasting, 27*(1), 37–51.

Rubin, A. M. (1984). Ritualized and instrumental television viewing. *Journal of Communication, 34*(3), 67–77.

Ruggiero, T. E. (2000). Uses and gratifications theory in the 21st century. *Mass Communication & Society, 3*(1), 3–37.

Scarr, S. (1993). Biological and cultural diversity: The legacy of Darwin for development. *Child Development, 64*(5), 1333–1353.

Scarr, S., & McCartney, K. (1983). How people make their own environments: A theory of genotype environment effects. *Child Development, 54*(2), 424–435.

Shah, D. V. (1998). Civic engagement, interpersonal trust, and television use: An individual level assessment of social capital. *Political Psychology, 19*(3), 469–496.

Shah, D. V., Cho, J., Eveland, W. P., Jr., & Kwak, N. (2005). Information and expression in a digital age: Modeling Internet effects on civic participation. *Communication Research, 32*, 531–565.

Shah, D. V., Cho, J., Nah, S., Gotlieb, M. R., Hwang, H., Lee, N., … McLeod, D. M. (2007). Campaign ads, online messaging, and participation: Extending the communication mediation model. *Journal of Communication, 57*(3), 676–703.

Shah, D. V., McLeod, J. M., & Yoon, S. H. (2001). Communication, context, and community: An exploration of print, broadcast, and internet influences. *Communication Research, 28*(4), 464–506.

Simon. J., & Merrill, B. D. (1998). Political socialization in the classroom revisited: The Kids Voting program. *Social Science Journal, 35*(3), 29–42.

Thorson, E., Thorson, K. S., & Sridhar, H. (2011). Media choice repertoires. Paper presented at the annual meeting of the International Communication Association, Boston, MA.

A Hierarchy OF Political Participation Activities IN Pre-Voting-Age Youth

ESTHER THORSON, GLENN LESHNER, MI JAHNG,
AND MARGARET DUFFY

Youth voter turnout in the 2008 presidential election was one of the highest in recent national elections (49% for those 18–25, up significantly from 2004). This increased participation, together with the sea change in digital devices and channels that people are using for communication, makes this particular election crucial to our understanding of political socialization processes in young citizens.

A first main idea tested in the current study is whether we can define a hierarchy of different levels of "effortfulness" and intentionality among various kinds of political participation and then predict the occurrence of each of those types. For example, talking to others about an election is generally less effortful than attending a political rally. Likewise, participating in school civic exercises is generally required of teens and therefore does not require effortful intentionality. It is also more effortful to participate in what has come to be called consumer politics (Stolle & Hooghe, 2004; Vogel, 2004) where people make statements about political issues such as sweatshop manufacturing by refusing to buy products made in those sweatshops.

Attending a rally and insisting on the purchase of free-range eggs require knowledge, planning, and thus extensive intentionality and effort. These forms of political participation are also likely greatly aided by parental help, although school, media exposure, and beliefs and attitudes should also be predictive.

A second idea tested here concerns the role of some newly articulated, or at least differently defined, cognitive variables that we posit to be quite important for predicting various types of participation. The first is what we call **Perceived**

Hostility, that is, the perception that the media are unfair and biased. That this variable is important is suggested by the extensive literature on the hostile media effect (Vallone, Ross, & Lepper, 1985). In this effect, people evaluate ordinary news stories by organizations that pride themselves on being even-handed and objective in their coverage as biased against people's own beliefs or partisanship—Democrats, for example, see stories as biased against Democrats, and Republicans see the exact same stories as biased against Republicans.

A next variable is what we call **Civic Mindedness**. These are beliefs that underlie a willingness to take part in work that raises the level of all boats: listening to others, helping those less fortunate, being involved in community and standing up, even to opposition, for your values. These are called "democratic citizen" beliefs in that these features have been identified as important for people in order to perform cooperatively with others for the betterment of all (Habermas, 2006; Schudson, 1998).

A third variable, **Persuasion Efficacy**, has to do with the influence that people think they have on others. Specifically, this involves an individual's belief in his or her ability to understand others' minds and emotions and persuade them to agree with certain points of view.

A fourth variable, **Classroom Political Interest**, indexes not whether youth have experienced civics/political lessons in school, but how much they like and are enthusiastic about such activities—indicating receptivity to civics lessons in school. This variable can be considered an index much like "interest in politics," but it is focused more specifically on enjoyment and enthusiasm about encountering politics in the school environment.

A fifth variable, **Open Talk Attitude**, is the belief that talking to others about politics is a good thing, even if you disagree with those you are talking to. Talking politics with others can be punishing. Others may know more than you do and they may disagree, perhaps even violently, with your fundamental beliefs. Probably for these reasons, many may learn early to avoid the possibility of painful interpersonal experiences by never talking about politics (or religion or other domains that are likely to evoke deep disagreements). Thus this variable indexes one's willingness to be politically engaged even given the likelihood of possible negative experiences.

And finally, we looked at cognitive **Elaboration** levels that youth self-report. To what extent do people connect what they encounter in the media with what they already know? How much do they mull over what they encounter in the media? Elaboration as a cognitively effortful process has long been known to enhance development of knowledge, and we wondered how it would affect the measures of political participation.

Thus, there are two general thrusts in the present study. First, to explore differences and similarities in different kinds of participation, from very general community volunteering, to traditional political participation, to talking to others

about politics. Second, the chapter investigates the impact of several new variables on occurrence of various forms of participation. We look at these variables in a critical age group—those who would vote in the next presidential election.

POLITICAL SOCIALIZATION: A PROCESS MODEL

The model (Figure 1) guiding this research posits a process that traverses from social structural variables through personality/attitude to media variables (both content and channels) to responses that fall under a broad definition of "political." While this model is related to other recent models (e.g., Hively & Eveland, 2009; Shah, McLeod, & Lee, 2009), ours looks more closely at personality/attitude/cognitive variables and articulates political participation as a hierarchy of effortful behaviors rather than a single indicator of "political engagement."

<div align="center">

Socio-Structural Variables

↓

Communication
Media exposure
Traditional news
Traditional entertainment
Interactive media

Attitudes and Cognitions

↓

Political participation
Political talk
Civic classroom activity
Online political communication
Charity activity
Consumer Politics
Political participation

</div>

Figure 1. Political socialization process model.

Social/Structural Variables

The first stage in the model suggests that the development of political partic-
ipation is best understood in terms of how communication about the polity is
processed by people from social structures that differentiate them by demographic
variables such as age, race, education, and gender; as well as their experiences in
social structures such as the school system and the family. In the present study we
control for demographics but look specifically at indicators of parental political
participation at a time (6 months) prior to when our youth variables were mea-
sured. Thus we can ask about the impact of our communication and personality/
attitudinal variables with and without control for the impact of the crucial parental
structural variable.

Communication Variables

Communication is broadly defined as passage of all messages from source to
receiver, and in the present study we identify three types of communication: from
media to people, from people to people, and the internal psychological processes
involved when people engage in communication, including attitudes clustered on
"helping" or "understanding" others, attitudes about talking with others, self-per-
ceived persuasiveness, the likelihood of mentally elaborating and thinking over
incoming messages, and the degree to which political communication is consid-
ered interesting.

Media, of course, can be characterized in a large variety of ways, but here we
distinguish three dimensions of media content and channel: television and news-
paper news, entertainment media content, and online news.

A HIERARCHY OF POLITICAL PARTICIPATION

The general idea of youth political socialization is the learning of the young to
develop responses to their polity: knowing about it, developing attitudes toward
its various aspects, participating in its processes (such as voting, attending rallies or
community meetings). Clearly, political responses include a wide variety of indica-
tors. The most typical are interest in politics, knowledge about politics, and polit-
ical participation in behaviors that have been classified as "political." But there are
many other possible variables that are of clear significance, including amount of
politically focused talk with others, classroom-based political curriculum, connect-
ing online about politics through social media activities, community volunteering,
traditional political participation, and political boycotting.

Structural Variables: Family Influence on Youth Participation

Family communication, especially parental influence, has long been considered an important factor in determining the political socialization of adolescents (Easton & Dennis, 1969; Greenstein, 1965; Hyman, 1959). Traditionally, studies in political socialization of adolescence have conceptualized it as a top-down process in which children acquired political attitude, information, and behavior from their parents through observation and modeling (Butler & Stokes, 1974; McDevitt, 2005; McDevitt & Chaffee, 2000).

Parent's party affiliation has been a strong indicator of the children's partisanship, with adolescents more likely to follow the party affiliation of the parents (Desmond & Donohue, 1981; McDevitt, 2005). Parents' political activities were found to be a strong indicator of how involved in politics the children are (Desmond & Donohue, 1981). Also, parents with higher socioeconomic status were found to talk more to their children about politics, which led to the children having more political knowledge than in low SES families (Kim & Kim, 2007; McDevitt & Chaffee, 2000; McLeod & Chaffee, 1973; Meirick & Wackman, 2004).

More recently, McIntosh, Hart, and Youniss (2007) found that parent political knowledge and youth-parent political discussion were important predictors in youth political knowledge. That is, the knowledge of the parent was transmitted to the youth, and its effect was increased by the parent-child political discussion.

In the literature of family communication and adolescence political socialization, the role of the parent has been acknowledged. It is reasonable to expect that the more the parents know and the more they encourage youth to discuss politics, express their opinion, and be politically involved, the more politically socialized the child will be. Adolescents who grow up in a family environment where parents know a lot about politics, pay more attention to political news, and encourage the expression of opinions, are more likely to follow their parents' interests and knowledge. We summarize these expectations in this hypothesis:

> **H1:** Parental political participation will account for significant variance in youth political participation.

Media Exposure and Political Participation

Adolescents' use of media to obtain news. Mass media play an important role in people's perception of political issues and information. Although mass media have been evaluated as an important source for knowledge of political issues (Delli Carpini, 2000; McLeod, Rush, & Friederich, 1968), the overall effect of media is diversified depending on the type of medium as well as the purpose of using the

medium. For example, television use for entertainment has also been criticized as the cause of decreasing political engagement (Putnam, 2000). Television use for news, however, clearly shows a positive impact (Shah et al., 2009). Newspaper use, although low among teenagers, still shows a positive impact on political knowledge and interest (e.g., Eveland, McLeod, & Horowitz, 1998).

The Internet has emerged as an important additional medium for civic and political engagement ("Online Video," 2006). Nie and Erbring (2000) showed that Internet use was negatively related to time spent with other media, family, and friends, but other studies have found that heavy Internet users were more likely to have social relationships than light users (Uslaner, 2006). Internet use has been shown to positively affect political participation (Gibson, Howard, & Ward, 2000; Hill & Hughes, 1998; Kraut et al., 2002). However, it has also been shown to affect political engagement negatively or have no effect at all (Johnson & Kaye, 2003; Kraut et al., 2002). A likely explanation for this inconsistency in findings is the operation of mediating variables such as level of social capital, personal communication efficacy, and motivation to use the Internet (Kavanaugh & Patterson, 2001; Shah, McLeod, & Yoon, 2001). Entertainment Internet use is not positively correlated with indicators of political engagement (Shah et al., 2001).

An important question here is the extent to which youth use the Internet for political communication. According to Livingstone and his colleagues (Livingstone & Bober, 2004; Livingstone, Bober, & Helsper, 2004), adolescents had little interest in political participation on the Internet. On the other hand, Montgomery (2000) reported that adolescents used the Internet to express themselves in public forums. Lin, Kim, Jung, & Cheong (2005) showed that the level of Internet use of adolescents is positively related to their involvement in community service when they used the Internet for gaining information. In this vein, among the various usage patterns of the Internet and outcomes of media effects, the current study focused on the effect of adolescent's Internet news use (i.e., information use) on two aspects of political engagement: political interest and political knowledge. In fact, bloggers have claimed that Democratic candidate Barack Obama's success depended heavily on the campaign's utilization of social networking websites and blogs (Haas, 2008).

Given the weight of previous research on media use and political knowledge and interest, we expect that:

H2: News media use, including print, television, and online news, will increase at all levels of political participation.

Adolescent media use for entertainment. Certainly, much of our political information is now presented through entertainment media; and if one's primary motive for media use is for entertainment purposes this may well diminish overall news consumption. Putnam (1993; 1995), for example, has long argued that

entertainment television limits community and civic engagement. Other researchers (Fleming, Thorson, Peng, 2005; Milner, 2002; Norris, 1996; Shah et al., 2001) have also concluded that use of entertainment television does indeed limit community participation and decreases knowledge and interest in politics. Yet others have found that greater use of television for news, and greater news use in general, increases political knowledge, interest and participation (McLeod, Scheufele, & Moy, 1999). Thus, we expect to find the following:

> H3: Media use for entertainment will increase easier types of political participation but decrease a higher level of political participation.

Opinionated news. Thorson and Duffy's (2006) media choice model, which extends uses and gratifications theory to the online environment, identifies several types of news stories from which readers can choose. In their model, these different types are referred to as "voices." Traditional, authoritative news is but one option. People may instead prefer "opinionated" news, from the popular conservative Fox News Channel to blogs of every type, or "collaborative" news, in which journalists report working closely with their audience or readers as sources to cover a story.

Opinionated news may resonate particularly well with younger audiences. A 2005 Carnegie Foundation report claims that young audiences prefer to obtain news from a source whose politics and attitudes are known and made clear to audiences (Brown, 2005). The report points to the high perceived credibility of self-proclaimed "fake news" host Jon Stewart and rapidly increasing use of blogs for "news" among adolescents as signs of the rising popularity of non-traditional opinionated news formats. Given its high salience to youth, we expect:

> H4: Use of opinionated news will increase less effortful political participation (such as talking to others, or classroom activities) but decrease the more effortful types of political participation (such as traditional political participation or charity activities).

Cognitive Variables in Political Socialization

Classroom political interest. Schools can potentially provide social interaction that represents a level of political stimulation and communication that may not be available from parents at home (Kiousis & McDevitt, 2008). For low SES families, schools can help them surmount the problem of activating mass media messages in politics and mitigate social structural disparities outside of the classroom. School intervention, such as *Kids Voting USA*, encourages young future voters to be politically interested and knowledgeable, leading to a more motivated discussion in school and in the family (McDevitt, 2005; McDevitt & Chaffee, 2002). While family and home environment are perceived as the primary agents of political

socialization, school has played an important part as a secondary agent, along with mass media exposure (Atkin, 1981).

It seems reasonable, therefore, that the more youth enjoy, get involved in, and like school lessons having to do with the political, the more attention they will pay, the more they will learn, and hence:

H5: Classroom political interest will increase every type of political participation.

Elaboration. The ability to think deeply about politics begins in adolescence (Eveland & McLeod, 1998) as young people start to mentally process the abstract ideas and concepts that serve as the bases for politics. Eveland and Dunwoody (2002) defined cognitive elaboration as connecting separate pieces of information, whether it is from memory or material being processed, into a larger whole that provides a framework for understanding. Elaboration in terms of media use occurs when information from media is collected by the individual and compared with prior knowledge, allowing the individual to construct new frameworks for understanding the world. Elaboration is thus positively associated with knowledge.

Different media play different roles in elaboration. With the Web, it appears that the benefits that come with rich interconnected information resources aid frequent users' ability to elaborate on what they are consuming, whereas with less-frequent users the wealth of information might serve to confuse users and thus hinder elaboration (Eveland, Marton, & Seo, 2004). Newspapers have been found to be strongly associated with elaboration, and how the media are used also matters, as use for information and surveillance is positively associated with elaboration compared to use for entertainment (Beaudoin & Thorson, 2004; Eveland, 2001). Given these findings, we predict:

H6: Greater elaboration of political information will increase every type of political participation.

Perceived hostility. Since its explication in 1985, the Hostile Media Effect has been examined in multiple ways (Vallone et al., 1985). Defined as a "tendency for people who are highly involved in an issue to see news coverage of that issue as biased, particularly biased against their own point of view," most studies key on the effects of individual factors, media reach, and partisan issues (Choi, Yang, & Chang, 2009; Gunther & Liebhart, 2006; Gunther, Christen, Liebhart, & Chia, 2001, p. 296). Thus we hypothesize:

H7: Higher perceived media source hostility will decrease every type of political participation.

Civic Mindedness. Civic mindedness is a concept most closely associated with Habermas's (2006) concept of the public sphere. Dahlberg (2001) posited that

the concept involved six features, including two that were measured in the current study. The first is a sense of autonomy from government and economic power. To measure this autonomy we included two items: "to be a good citizen you need to stand up for your values," and, "people should speak up when they oppose our government's actions." The second is "respectful listening," which we operationalized with "I think it is important to hear others' ideas even if they are different from mine." To those items, however, we added a sense of civic responsibility: "I think it is important to get involved in improving my community," and "Those who are well off should help those who are less fortunate."

Given current streams of research (e.g., Zukin, Keeter, Andolina, Jenkins, & Delli Carpini, 2009) that suggest linkage between what is sometimes called civic engagement, we posit that:

H8: Higher civic mindedness will increase every type of political participation.

Persuasion efficacy. To our knowledge, the relationship between persuasion self-efficacy and political participation has not been explored. Although influential people are often called "opinion leaders," these people are usually identified by others and thus this differs from persuasion efficacy. Development of the concept was informed by both the popular and scholarly literature on traits and behaviors that successful salespeople possess or consciously develop. For decades, much of the sales and self-improvement literature emphasized self-esteem, motivation, confidence, competitiveness, likeability, and adaptability (see, for example, Weitz, 1981). Plank and Greene (1996) applied personal construct theory (PCT) for understanding how dimensions of personality influence sales performance. They argue that individuals constantly gather information to understand and predict other people's behavior and that the sales/persuasion process is built on this motivation and ability. As a salesperson communicates with her prospect, she is anticipating and responding to feedback. Krishnan, Netemeyer, & Boles (2002) found that an individual's confidence in her abilities to persuade was a good predictor of sales success. Ford, Churchill, and Walker (1985) also found that a person's "own perceptions of his or her competence and ability may have a major impact on performance" (p. xiv). Based on these findings, we suggest:

H9: Higher persuasion efficacy will increase every type of political participation.

Open Talk Attitude

Talking politics with others can be punishing. Others may know more than you do and they may disagree, perhaps even violently, with your fundamental beliefs. Probably for these reasons, many may learn early to avoid the possibility of painful

interpersonal experiences by never talking about politics (or religion or other domains held important). Thus this variable indexes willingness to engage even given the likelihood of possible negative experiences. Willingness to talk with others about politics should increase the likelihood of all of the measures of participation examined here:

H10: Higher open talk attitude will increase every type of political participation.

Participation Measures

Political talk. Political talk is an important aspect of deliberative democracy (Habermas, 2006). In defining political conversation, we believe all kinds of political talk, discussion, or argument should be included as long as they are voluntarily carried out by citizens. We think these types of political conversations happen before adolescents decide to take action on political activities and that it is important for adolescents to learn to talk about politics with others. Thus, we hypothesized that adolescent political news use would show similar influence in initiating political talk with those that one may not be familiar with.

Civic classroom participation. While some may argue that school is less voluntary than other types of political participation, because students have to go to school, many classroom participation activities used to educate kids about politics provide similar civic/political activities as those experienced by adults. For example, *Kids Voting USA* encourages high school seniors to register to vote as they graduate. Also, the *Kids Voting USA* program has its own voting booth next to the adults in several cities, and the local news media would report the *Kids Voting USA* voting results along with the voter turnouts and results for the adults (see McDevitt, 2003). As the next step in the political participation hierarchy, we believe that such classroom civic participation can be a bridge between political discussion and more adult-oriented or "harder" traditional political and civic participatory behaviors.

Online Political Activity and Traditional Political Participation

The wide use of the Internet in the political realm has made a new type of political activity online not only possible but also more prevalent. Best and Krueger (2005), for example, argued that different resources are required to participate in offline behaviors than with online behaviors. They found that age, especially, was a strong predictor of online political activities, in spite of the long held belief that younger citizens are less likely to vote, display interest in politics, or participate in non-voting activities. In regards to our hierarchy of adolescent political participation activities, online political activities are regarded as the step that precedes the typical non-voting political activities that occur outside of the Internet world.

Charity activity. Zukin et al. (2009) suggested that hands-on participation with others in activity directed toward the public good is closely related to more specific political participation. Even though what we will call charity activity usually occurs outside of political campaigns and political officials, it can have important impacts on political issues such as public safety, education, and community development. Indeed, McKinney, Kaid, and Bystrom (2005) argued that the driving force of democracy can be found in individual citizens' many acts of joining, volunteering, serving, attending, meeting, participating, giving, and, perhaps most importantly, cooperating with others (p. 6). For them, the singular—albeit important—act of voting is not the core value or practice fueling democracy. Instead, these actions of volunteerism are where the civic dialogues take place. Unlike traditional political campaign participation, volunteer activities most often require attention to one's local community and its needs. Thus, we argue that charity is also an important aspect of political socialization.

Consumer politics. Stolle, Hooghe, and Micheletti (2005) defined consumer politics as the selection of products "based on political or ethical considerations, or both" (Micheletti, Follesdal, & Stolle, 2003, p. 3). Consumer politics are part of a broader activity that Bennett (1998) described as "lifestyle" politics, in which people participate in more informal groups that share similar interests. In fact, Zukin et al. (2009) found that more Americans engage in some kind of consumer activism than in any other political activity except voter registration and voting (p. 77).

Political participation as a hierarchy of responses. In light of previous research on political socialization agents and different types of political participation, we argue that political participation is a multidimensional concept that includes many different socialization agents that play a role in equipping young people with the means to navigate citizenship. The socialization process of young people to adapt to the existing political system does not require a single primary agent that will teach one everything about politics, but rather different agents to teach different aspects of politics, starting from general interest to political participatory activities to voting in the future.

Given that so many people never develop an advanced interest in politics, involving such activities as voting, putting a political sign in one's yard, making phone calls, or volunteering for a candidate, we consider such traditional measures of participation as "higher" and more effortful. The same can be said of volunteer activities in general as well as with political consumerism such as targeted purchasing and boycotting. In contrast, talking to others about politics appears to be something that just about everyone does. For many American youth, school curricula often involve the formal study of politics; and if this is the case, youth would be likely to participate in this required political learning activity. Finally, online political activity, especially with smartphone access and extensive access to high-speed wireless, would be expected to be fairly likely to occur.

We expect three features of these political participation activities to occur. First, we expect that **(H11)** the percentage of youth who are involved in the less effortful levels to be high, while the percentage of youth who are involved in the more effortful levels to be low. We next expect that **(H12)** our process variables will be able to account for more of the variance in the less effortful than the more effortful activities of the hierarchy.

Finally, we expect that when we control for the occurrence of each of the political participation activities in the parent, that variable will so highly predict the activity in the youth that **(H13)** there will be little variance left for our process variables to account for. On the other hand, with the increased complexity of the more effortful participation variables, we expect **(H14)** the process variables to continue to account for a lot of the variance even when parental political participation variables are controlled.

METHOD

Survey data were collected from the third survey of the Future Voters Study (as described in the introduction), fielded in May and June, 2009.

Predictor Variables

Adolescent variables were measured in June 2009, except for gender and age, which were measured in the first wave of the panel conducted in May 2008. (See Table 1 on p. 34 for descriptive statistics and index reliabilities.)

Demographics. Adolescent gender and age were measured with typical survey questions, including "What is your gender?" and "What is your current age?" Party identification was measured by the question: "Of the two major political parties, which of the following best describes your party affiliation?" The response scale ranged from 1 (Strong Democrat) to 5 (Strong Republican).

Media use. Adolescents were asked about the number of days in a typical week they watched or read TV News, Print News, Conservative News, Entertainment, and Online News. *TV News* was a composite three-item index of responses to viewing local TV news, network TV news, and morning TV news programs (e.g., *The Today Show*, *Good Morning America*, or *The Early News*). *Print News* was a composite two-item index of responses to reading a print copy of a local newspaper and the school's student newspaper. *Conservative News* (Opinionated News) was a composite two-item index of responses to viewing Fox cable news programs (e.g., Bill O'Reilly, Hannity & Colmes) and to reading conservative blogs (e.g., Instapundit, Michelle Malkin). *Entertainment* was a composite four-item index of responses to watching primetime reality programs (e.g., *Survivor*, *American Idol*),

primetime comedy programs (e.g., *Two and a Half Men, The Office*), primetime cartoon programs (e.g., *Family Guy, The Simpsons*), and primetime drama programs (e.g., *Grey's Anatomy, CSI, Lost*). *Online News* was a three-item composite index of reading/viewing national newspaper websites, local newspaper websites, and TV news websites.

The following were indexes comprising statements measured on five-point Likert scales (1 = Strongly Disagree; 5 = Strongly Agree). *Perceived hostility* was a two-item index of responses: "Most news coverage is biased against my views," and "Most politicians can't be trusted." *Civic Mindedness* was a five-item index of the statements: "I think it is important to get involved in improving my community," "Those who are well off should help those who are less fortunate," "I think it is important to hear others' ideas even if they are different from mine," "People should speak up when they oppose our government's actions," and "To be a good citizen, you need to stand up for your values." *Open Talk Attitude* was a two-item index of the statements: "Among my friends, it is OK to talk about political issues," and "Among my friends, it is OK to disagree with one another over political issues." *Persuasion Efficacy* was a three-item index of the statements: "I am influential among my friends," "I am good at persuading people to see things my way," and "When I talk about politics I try to convince other people I am right." *Class Political Interest* was a four-item index of the statements: "I am interested in politics," "I enjoy it when teachers create class activities around political issues and current events," "I participate more than my classmates in class activities about politics and current events," and "To be a good citizen, you need to be knowledgeable about political issues." *Elaboration* was a four-item index of the statements: "My friends often seek my opinion about politics," "I try to connect what I see in the media to what I already know," "I often recall what I encounter in the media and later on think about it," and "I often refer to things I have learned from the news in conversation."

Criterion Variables

We created composite indexes for the following six criterion variables: "Political Conversation," "Civic Classroom," "Online Political Activity," "Classic Campaign Political Participation," "Charity Activity," and "Political Consumerism." All items that comprised these indexes were measured in response to how frequently the adolescent engaged in these activities during the past 3 months on eight-point response scales (1 = Not at all, 8 = Very Frequently). *Political Conversation* was a four-item index of the activities: "Talked about news and current events with family members," "Talked about news and current events with friends," "Talked about news and current events with adults outside your family," and "Talked about news and current events with people who disagree with you." *Civic*

Table 1. Reliability Estimates and Descriptive Statistics for Adolescents' Composite Indexes.

Composite Variables	No. of items in index	Cronbach's alpha	Mean (SD)
Parent Political Participation (scale: 1–8)	5	.85	1.49(1.10)
Persuasion Efficacy (scale: 1–5)	3	.64	3.03 (0.84)
Classroom Political Interest (scale: 1–5)	4	.81	2.88 (0.93)
Elaboration (scale: 1–5)	4	.77	2.97 (0.84)
Civic Mindedness (scale: 1–5)	5	.69	3.90 (0.64)
TV News (scale: 0–7)	3	.82	1.85 (1.85)
Entertainment (scale: 0–7)	4	.62	1.97 (1.40)
Online News Sites (scale: 0–7)	3	.65	0.53 (1.00)
Online Political Activity (scale: 1–8)	7	.92	1.63 (1.18)
Class Activity (scale: 1–8)	5	.92	3.46 (1.96)
Political Participation (scale: 1–8)	5	.91	1.38 (1.07)
Political Talk (scale: 1–8)	4	.91	3.48 (1.82)
Charity Activity (scale: 1–8)	3	.86	3.03 (2.05)

Two-item Variables	Pearson's r	p-value	Mean (SD)
Print (scale: 0–7)	.38	< .001	1.54 (1.64)
Consumer Politics (scale: 1–8)	.75	< .001	1.88 (1.63)
Open Talk Attitude (scale: 1–5)	.79	< .001	3.61 (0.96)
Perceived Hostility (scale: 1–5)	.27	< .001	2.94 (0.82)
Conservative News (scale: 0–7)	.41	< .001	0.35 (0.97)

Classroom Activities was a five-item index of the activities: "Followed the news as part of a class assignment," "Learned about how government works in class," "Discusses/debated political or social issues in class," "Participated in political role playing in class (mock trials, elections)," and "Encouraged to make up your own mind about issues in class." *Online Political Activity* was a seven-item index of the activities: "Read comments posted by readers on the news web," "Posted comments on a news website or political blog," "Exchanged political emails with friends and family," "Forwarded the link to a political video or news article," "Received a link to a political video or news article," "Watched video news stories online," and "Watched political/candidate videos online." *Traditional Political Participation* was a five-item index of the activities: "Contributed money to a political campaign," "Attended a political meeting, rally, or speech," "Worked for a political party or candidate," "Displayed a political campaign button, sticker, or

sign," and "Participated in a political protest activity." *Charity Activity* was a three-item index of the activities: "Raised money for a charitable cause," "Did volunteer work," and "Worked on a community project." Finally, *Political Consumerism* was a two-item index of these activities: "Boycotted products of companies that offend my values," and "Bought products from companies because they align with my values."

Control Variables

Five control variables based on parental attitudes and behavior were constructed from items measured in Wave 2, from November until December, immediately following the 2008 presidential election. Each index is a parallel index of the six adolescent criterion variables except "Political Conversation" and "Civic Classroom." Political conversation was measured by a single item on an eight-point scale that asked parents how much they "Talked about news and current events with family members (1 = Not at all, 8 = Very Frequently)." There were no parallel questions for parents about class activities, so the parents' "Political Participation" was used as the control variable for Civic Classroom Activities. Parent control variables are shown in Table 2.

Table 2. Reliabilities Estimates and Descriptive Statistics for Parent Composite Indexes.

Parent Control Variables (scales: 1–8)	No. of items in index	Alpha/*r*	Mean (*SD*)
Talked About News	1	n/a	5.84 (2.14)
Online Political Activity	7	.91	2.24 (1.72)
Traditional Political Participation	5	.85	1.50 (1.06)
Charity Activity	2	$r = .74^{***}$	3.12 (2.38)
Political Boycott	2	$r = .79^{***}$	2.77 (2.25)

$^{***}p < .001$.

RESULTS

To test the hypotheses, we set up hierarchical regression analyses where Block 1 included the demographic variables, Block 2 different news media use, Block 3 with cognitive variables, and finally Block 4 with Persuasion Efficacy, Class Political Interest, and Elaboration. The final model predicted 47% for political conversation, 34% for civic classroom activities, 36% for online political activities, 23% for youth political participation, 20% for community charity activity, and 18% for political consumerism.

Table 3. Hierarchical Regression Models for Adolescents (N = 305).

	Political Talk	Civic Classroom Activity	Online Political Activity	Political Participation	Charity Activity	Consumer Politics
Block 1						
Gender (F)	.07	.05	.05	.01	.08	.11*
Age	.02	.02	.01	−.01	−.06	.02
Party ID (R)	.01	.00	−.03	−.01	.02	.03
Race (W)	.03	.02	−.08	−.19***	.01	.03
R^2 Change	.019	.099	.041*	.073***	.011	.022
Block 2						
TV News	.15**	.16**	.07	.16*	.21***	.08
Print News	.12*	.12*	.00	.02	.06	.06
Conservative News	.08	−.09	.18**	.29***	.10	.18***
Entertainment	−.10*	−.04	.00	−.02	−.09	−.05
Online News	.12*	.06	.28***	−.04	.08	−.01
R^2 Change	.236***	.128***	.247***	.142***	.130***	.090***
Block 3						
Perceived Hostility	.00	−.02	.08	.03	−.12*	.03
Civic Mindedness	−.08	.00	−.06	−.08	.17**	.07
Open Talk Attitude	.14**	.12*	.03	.02	.01	.04
R^2 Change	.111***	.110***	.033*	.005	.039**	.044***
Block 4						
Persuasion Efficacy	.07	.14*	.08	.02	.05	.12
Class Political Int	.24***	.25***	.12	.06	.20**	.12
Elaboration	.20**	.09	.11	.06	−.20**	.00
R^2 Change	.108***	.091***	.037**	.008	.024*	.026*
Total R^2	.475***	.338***	.358***	.228***	.204***	.182***

Note. Cell entries are standardized regression coefficients, R^2 were noted.
*$p < .05$; **$p < .01$; ***$p < .001$.

We also conducted a hierarchical regression analysis (Table 4) including parental political participation as a control variable in the first block. This enabled us to observe the impact of our process variables beyond the direct impact of parental participation.

Table 4. Hierarchical Regression Models Controlling for Parental Political Participation (N = 304).

	Political Talk	Civic Classroom Activity	Online Political Activity	Political Participation	Charity Activity	Consumer Politics
Block 1						
Parent Controls[#]	.08	.04	.27***	.43***	.42***	.40***
R^2 Change	.060***	.016*	.157***	.259***	.232***	.205***
Block 2						
Gender (F)	.07	.05	.03	−.01	.09	.08
Age	.02	.02	.00	−.01	−.06	−.02
Party ID (R)	.01	−.01	−.05	−.07	.03	.02
Race (W)	.02	.02	−.07	−.12*	−.04	.01
R^2 Change	.018	.006	.032*	.034*	.019	.010
Block 3						
TV News	.15**	.16*	.08	.20***	.19***	.11
Print News	.11*	.12*	.00	.02	.03	.05
Conservative News	.08	−.10	.17*	.22***	.09	.14*
Entertainment	−.10*	−.04	.02	−.04	−.05	−.02
Online News	.12*	.05	.24***	−.08	.07	.01
R^2 Change	.206***	.123***	.188***	.091***	.080***	.071***
Block 4						
Perceived Hostility	.00	−.02	.08	.03	−.07	.01
Civic Mindedness	−.09	.00	−.04	−.07	.15**	.00
Open Talk Attitude	.14**	.12*	.02	.03	.02	.07
R^2 Change	.097***	.107***	.022*	.004	.017*	.024*
Block 5						
Persuasion Efficacy	.06	.14*	.08	.04	.01	.10
Class Political Interest	.24***	.24***	.04	−.02	.14*	.07
Elaboration	.20**	.09	.11	.05	−.19*	−.02
R^2 Change	.099***	.087***	.021*	.002	.017*	.015
Total R^2	.480***	.342***	.420***	.390***	.364***	.325***

Note. Cell entries are standardized regression coefficients, R^2 were noted.

*$p < .05$; **$p < .01$; ***$p < .001$.

[#] All Parent Controls were measured in Wave 2. All Parent Controls comprised identical items that correspond to child dependent variables except Talked About News, which was a single item that asked parents how much they talked about news and current events with family members.

H1 predicted that the indicators of parental political participation would account for significant variance in adolescents' political participation. This hypothesis was supported for all six criterion variables. When we ran the hierarchical regression model with parental participation index, the R^2 change was significant across all types of youth participation variables. The change in R^2 across the six participation variables is shown in Figure 3 on page 41. The largest R^2 change was for the youth political participation (R^2 change = .259, $p < .001$), accounting for more than a quarter of the total variance. The least R^2 change was for political talk (R^2 change = .06, $p < .001$).

H2 predicted that news media use, including print newspaper, television news, and online news would increase all youth political participation activities. This hypothesis was partially supported. First, television news use, print news use, and online news use significantly predicted the political conversation of youth (see Tables 3 and 4). For civic classroom activities, only television news and print news were significant predictors. Online political activities were significantly predicted only by online news use, and youth political participation and charity activities were only predicted by television news use. For political consumerism, none of the news media use was significant.

Next, we looked at two different types of media use, entertainment media and opinionated news. H3 was only partially supported. Entertainment news negatively influenced political talk significantly ($\beta = -.10$, $p < 05$), and this finding held even after controlling for parental participation. H4 predicted that opinionated news use would influence different types of political behaviors, and here we used the conservative news use index to represent opinionated news use. Conservative news use positively predicted online political activities, youth political participation, and political consumerism, but not the easier types of political participation (political conversation or civic classroom activities). This result showed that conservative news use positively influences the level of online political activities, political participation, and political consumerism activities of youth. Again, this pattern held after controlling for parent participation (Table 4).

H5 predicted that classroom political interest would increase every type of political participation. This hypothesis was partially supported. For the lower effort political participation indices, class political interest significantly predicted political conversation ($\beta = .24$, $p < .001$) and civics classroom activities ($\beta = .25$, $p < .001$) whereas for the higher effort participation, only community charity activities were significantly predicted by class political interest ($\beta = .20$, $p < .01$). These findings remained significant after controlling for parental participation.

The hierarchical model of political socialization that we posited suggested an influence of the different types of cognitive process variables, including perceived hostility and belief in democratic citizenship. We predicted that greater elaboration would increase every type of political participation (H6), but higher perceived

hostility (H7) would decrease political participation. Elaboration significantly and positively predicted political conversation (β = .2, p < .01), and negatively predicted community charity activities (β = -.2, p < .01). Perceived hostility negatively predicted community charity activities (β = -.12, p < .05), but none of the other youth participation measures.

H8 predicted that civic mindedness would significantly increase every measure of political participation. Contrary to this prediction, however, civic mindedness only influenced youth participating in charity activities, but not the other types of political participation.

H9 suggested that higher persuasion efficacy would increase every type of political participation, and H10 suggested that higher open talk attitude would do likewise. Persuasion efficacy only affected civic classroom activity, although this effect remained after parental control was applied. Open talk influenced both political talk and civic classroom activity, and these two effects also remained after parental control was applied.

Our final hypotheses concerned the differences in the low and high effort participation categories. H11 predicted that the percentage of youth involved in the lower hierarchy of participation would be higher than the percentage of youth involved in the higher hierarchy of participation. This hypothesis was supported. The mean for the three low effort forms of participation (political talk, civic classroom activity, and online political activity) was significantly higher than the mean for the three high effort forms of participation (low effort mean = 2.76; high effort mean = 2.06, t(303) = 11.48, p < .001). As can be seen in Table 1, however, the three highest means were for political talk, civic classroom, and charity activity. The other three variables showed lower means.

H12 suggested that the process variables would account for more of the variance in the low effort participation. As shown in Figure 2, the total R^2 for lower effort participation—including political talk, classroom political activities, and online political activities—was greater than the R^2 for higher effort participation.

Our process variables were entered in Block 3 and Block 4. In Block 3, perceived hostility, belief in demographic citizenship, and open talk attitude were entered in the model. Political interest, persuasion efficacy, and elaboration were entered in Block 4. The R^2 change from Block 2 to Block 3 was larger in less effortful activities, including political talk (R^2 change = .111, p < .001) and civic classroom activities (R^2 change = .110, p < .001), than online political activities (R^2 change = .033, p < .001), political participation (R^2 change = .005, ns), charity activity (R^2 change = .039, p < .01), and political consumerism (R^2 change = .044, p < .001). This pattern was similar for Block 4, with R^2 change from Block 3 to Block 4 being the largest in the political talk variable.

The R^2 change controlling for parental participation is shown in Figure 3. Here, we found (H13) that for the less effortful variables (political talk, civic

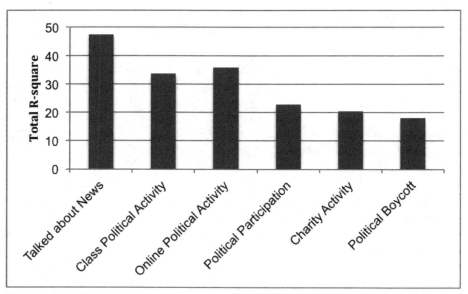

Figure 2. Total R² for child regression models.

classroom activities, and online political activities), parent control does not add much accuracy to the model. On the other hand, for more effortful political participation variables, such as classic political campaign participation, community charity activities, and political consumerism activities, parental participation does add accuracy to the model. From this result, we find that parents influence adolescents' more effortful political outcomes above and beyond all other political socialization influences, such as media, and other process variables.

H14 suggested that the process variables would account for significant variance in the participation scores even when parental political participation variables were controlled. That this was supported can be seen in Table 4 where Blocks 3 (media), 4, and 5 (cognitive and attitudinal variables) generally continued to show significant R^2 change even when the parent controls were added. Figure 3 shows graphically, however, that the change in R^2 was less for the low-effort participation variables.

DISCUSSION

Although Verba, Nie, and Kim (1978) and, more recently, Claggett and Pollock (2006), have posited that there are a number of "modes of political participation," their categories remain narrowly focused on a clearly electoral politics domain (e.g., voting and campaigning). Nevertheless, they, as well as Zukin et al. (2009),

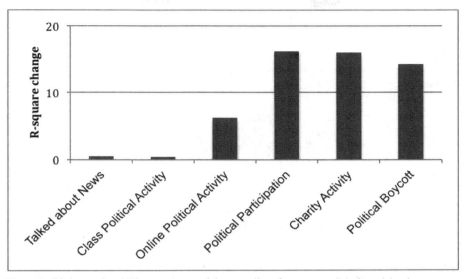

Figure 3. R^2 change for child regression models controlling for parent political participation.

have moved socialization research toward the idea that different kinds of political responses are affected by differing clusters of sociostructural, media, and cognitive/attitudinal variables. That is clearly a finding in the present study. The present study, however, goes beyond simply distinguishing among types of political responses to identifying a continuum of responses that represent the effortfulness of the various types. Lower-effort participation such as talking about politics, doing classroom political assignments, and talking with others online about politics had greater amounts of their variance accounted for the predictive variables. Higher-effort participation that includes traditional political behaviors such as putting up a lawn sign, community volunteering, and engaging in consumer politics had less variance accounted for the predictive variables. More importantly, parental behavior at a prior point in time was far more predictive of the higher effort participation than it was of the lower effort participation. For our young sample, parental impact on getting out and "doing" was large. For talking with others about politics, either in person or online, and participating in school political activities, the mass media and features of the youth themselves— including perceived media hostility, civic mindedness, open talk attitude, persuasion efficacy, class political interest, and elaboration—had far more impact. Of course, parents did influence these features of their children, but once these features are in place, many of the child's behaviors become more independent of direct parent impact.

Of the cognitive/attitudinal features of the teen, perceived hostility of the media had virtually no effect, which seems somewhat comforting. Civic mindedness had

no impact on the more traditional political categories of participation, but strongly affected charity activity. In spite of suggestions that community engagement is of a cluster with political participation categories (e.g., Zukin et al., 2009) and our own contention that civic mindedness is made up of features that would equip teens with attitudes consistent with active citizenship, we did not find the expected link with the political domain.

Open talk and interest in classroom civics work both positively affected political talk and civic classroom activity. Causal directionality is, of course, undecided. Class political interest also positively related to charity activity, which is suggestive that civic training affects a broader domain than just the political. Hopefully, further studies of these classroom efforts can identify just what kinds of topics and assignments lead to this broader effect.

Elaboration was positively associated with political talk, as many have found, but oddly, it was consistently negatively related to charity activity. Why would thinking more deeply about news and integrating it with what you already know be negatively associated with working in your community? Simplistically, it may be that there are "thinkers" and "doers," but we suspect the relationship is much more complex, perhaps involving mediators such as partisanship, race, and gender. Nevertheless, this link is deserving of further study.

Finally, in terms of the testing of our suggested model, hierarchical regression should perhaps give way to structural equation approaches to the data presented here. Interactions of our predictive variables and potential problems with multicollinearity also need further analysis.

Political socialization is increasingly seen as a process much more complex than children adopting the political partisanship and issue stances of their parents (e.g., Shah et al., 2009). Teens are clearly developing cognitive and attitudinal approaches to school, media, and others that lead to different levels of political participation. For pre-voting-age youth, the more effortful participation types are still greatly affected by parents, but even at this age, self-impact is clearly observed for the less effortful participation types.

REFERENCES

Atkin, C. (1981). Communication and political socialization. In D. Nimmo & K. Sanders (Eds.), *Handbook of political communication* (pp. 299–328). Beverly Hills, CA: Sage.

Beaudoin, C. E., & Thorson, E. (2004). Testing the cognitive mediation model: The roles of news reliance and three gratifications sought. *Communication Research, 31*(4), 446–471.

Bennett, W. L. (1998). The uncivil culture: Communication, identity and the rise of lifestyle politics. *PS: Political Science and Politics, 31*(4), 740–761.

Best, S. J., & Krueger, B. S. (2005). Analyzing the representativeness of Internet political participation. *Political Behavior, 27*(2), 183–216.

Brown, M. (2005). Abandoning the news. *Carnegie Reporter, 3*(2). Retrieved from https://www.carnegie.org/publications/carnegie-reporter-vol-3no-2/

Butler, D., & Stokes, D. (1974). *Political change in Britain* (2nd ed.). London, England: Macmillan.

Choi, J., Yang, M., & Chang, J. J. (2009). Elaboration of the hostile media phenomenon. The roles of involvement, media skepticism, congruency of perceived media influence, and perceived media opinion climate. *Communication Research, 36*(1), 54–76.

Claggett, W., & Pollock, P. H. (2006). The modes of participation revisited, 1980–2004. *Political Research Quarterly, 59*(4), 593–600.

Dahlberg, L. (2001). Computer-mediated communication and the public sphere: A critical analysis. *Journal of Computer-Mediated Communication, 7*(1), 1–15.

Delli Carpini, M. X. (2000). Gen.Com: Youth, civic engagement, and the new information environment. *Political Communication, 17,* 341–349.

Desmond, R., & Donohue, T. (1981). The role of the 1976 televised presidential debates in the political socialization of adolescents. *Communication Quarterly, 29*(4), 302–308.

Dryzek, J. (2002). *Deliberative democracy and beyond: Liberals, critics, contestations.* Oxford, England; New York, NY: Oxford University Press.

Easton, D., & Dennis, J. (1969). *Children in the political system.* New York, NY: McGraw-Hill.

Eveland, W. (2001). The cognitive mediation model of learning from the news. *Communication Research, 28*(5), 571–601.

Eveland, W. P. (2004). The effect of political discussion in producing informed citizens: The roles of information, motivation, and elaboration. *Political Communication, 21*(2), 177–193.

Eveland, W. P., & Dunwoody, S. (2002). An investigation of elaboration and selective scanning as mediators of learning from the web versus print. *Journal of Broadcasting & Electronic Media, 46*(1), 34.

Eveland, W., Marton, K., & Seo, M. (2004). Moving beyond "just the facts": The influence of online news on the content and structure of public affairs knowledge. *Communication Research, 31*(1), 82–108.

Eveland, W. P., & McLeod, J. M. (1998). Communication and age in childhood political socialization: An interactive model of political development. *Journalism & Mass Communication Quarterly, 75*(4), 699–718.

Eveland, W. P., Jr., McLeod, J. M., & Horowitz, E. M. (1998). Communication and age in childhood political socialization: An interactive model of political development. *Journalism & Mass Communication Quarterly, 75,* 699–718.

Fleming, K., Thorson, E., & Peng, Z. (2005). Associational membership as a source of social capital: Its links to use of local newspapers, interpersonal communication, entertainment media, and volunteering. *Mass Communication and Society, 3,* 219–240.

Ford, N., Churchill, G. A., & Walker, O. C. (1985). *Sales force performance.* Lexington, MA: Heath.

Gibson, R. K., Howard, P., & Ward, S. (2000). *Social capital, Internet connectedness and political participation: A four-country study.* Paper presented at the International Political Science Conference, Quebec, Canada.

Greenstein, F. (1965). *Children and politics.* New Haven, CT: Yale University Press.

Gunther, A. C., Christen, C. T., Liebhart, J. L., & Chih-yun Chia, S. (2001). Congenial public, contrary press, and biased estimates of the climate of opinion. *Public Opinion Quarterly, 65,* 295–320.

Gunther, A. C., & Liebhart, J. L. (2006). Broad reach or biased source? Decomposing the hostile media effect. *Journal of Communication, 56,* 449–466.

Haas, C. (2008). The Obama campaign—social media. Retrieved April 10, 2009 from http://www.barackobama.com

Habermas, J. (2006). Political communication in media society: Does democracy still enjoy an epistemic dimension? The impact of normative theory on empirical research. *Communication Theory, 16*, 411–426.

Hill, K. A., & Hughes, J. E. (1998). *Cyberpolitics: Citizen activism in the age of the Internet.* Lanham, MD: Rowman & Littlefield.

Hively, M. H., & Eveland Jr., W. P. (2009). Contextual antecedents and political consequences of adolescent political discussion, discussion elaboration, and network diversity. *Political Communication, 26*, 30–47.

Hyman, H. H. (1959). *Political socialization.* Glencoe, IL: Free Press.

Johnson, T. J., & Kaye, B. K. (2003). A boost or bust for democracy? How the web influenced political attitudes and behaviors in the 1996 and 2000 presidential elections. *The Harvard International Journal of Press/Politics, 8*(3), 9–34.

Kavanaugh, A. L., & Patterson, S. J. (2001). The impact of community computer networks on social capital and community involvement. *American Behavioral Scientist, 45*, 469–509.

Kim, K. S., & Kim, Y. C. (2007). New and old media uses and political engagement among Korean adolescents. *Asian Journal of Communication, 17*(4), 342–361.

Kiousis, S., & McDevitt, M. (2008). Agenda setting in civic development. *Communication Research, 35*(4), 481–502.

Kraut, R., Kiesler, S., Boneva, B., Cummings, J., Helgeson, V., & Crawford, A. (2002). Internet paradox revisited. *Journal of Social Issues, 58*(1), 49–74.

Krishnan, B. C., Netemeyer, R. G., & Boles, J. S. (2002). Self-efficacy, competitiveness and effort as antecedents of salesperson performance. *Journal of Personal Selling and Sales Management, 22*(4), 285–295.

Lin, Y., Kim, Y. C., Jung, J.-Y., & Cheong, P. H. (2005). *The Internet and civic engagement of youth: A case of East Asian cities.* Paper presented to Association of Internet Researchers Conference, Chicago, IL.

Livingstone, S., & Bober, M. (2004). *UK children go online: Surveying the experiences of young people and their parents.* London, England: London School of Economics and Political Science.

Livingstone, S., Bober, M., & Helsper, E. J. (2004). *Active participation or just more information? Young people's take up of opportunities to act and interact on the Internet.* London, England: London School of Economics.

McDevitt, M. (2003, July). *The civic bonding of school and family: How Kids Voting students enliven the domestic sphere* (Working Paper 07). Retrieved from The Center for Information & Research on Civic Learning and Engagement (CIRCLE) website: http://civicyouth.org/circle-working-paper-07-the-civic-bonding-of-school-and-family-how-kids-voting-students-enliven-the-domestic-sphere/

McDevitt, M. (2005). The partisan child: Developmental provocation as a model of political socialization. *International Journal of Public Opinion Research, 18*(1), 67–88.

McDevitt, M., & Chaffee, S. (2000). Closing gaps in political communication and knowledge: Effects of a school intervention. *Communication Research, 27*(3), 259–292.

McDevitt, M., & Chaffee, S. (2002). From top-down to trickle-up influence: Revisiting assumptions about the family in political socialization. *Political Communication, 19*, 281–301.

McIntosh, H., Hart, D., & Youniss, J. (2007). The influence of family political discussion on youth civic development: Which parent qualities matter? *PSOnline*, 495–499. Retrieved from www.apsanet.org

McKinney, M. S., Kaid, L. L., & Bystrom, D. G. (2005). The role of communication in civic engagement. In M. S. McKinney, L. L. Kaid, D. G. Bystrom, & D. B. Carlin (Eds.), *Communicating politics: Engaging the public in democratic life*. New York, NY: Peter Lang.

McLeod, J. M., & Chaffee, S. H. (1973). Interpersonal approaches to communication research. *American Behavioral Scientist, 16*, 469–500.

McLeod, J. M., Rush, R. R., & Friederich, K. H. (1968). The mass media and political information in Quito, Ecuador. *Public Opinion Quarterly, 32*, 575–587.

McLeod, J. M., Scheufele, D. A., & Moy, P. (1999). Community, communication, and participation: The role of mass media and interpersonal discussion in local political participation. *Political Communication, 16*, 315–336.

Meirick, P. C., & Wackman, D. B. (2004). Kids Voting and political knowledge: Narrowing gaps, informing votes. *Social Science Quarterly, 85*, 1161–1177.

Micheletti, M., Follesdal, A., & Stolle, D. (2003). *Politics, products, and markets: Exploring political consumerism past and present*. New Brunswick, NJ: Transaction Press.

Milner, H. (2002). *Civic literacy: How informed citizens make democracy work*. Hanover, NH: University Press of New England.

Montgomery, K. (2000). Youth and digital media: A policy research agenda. *Journal of Adolescent Health, 27S*, 61–68.

Nie, N., & Erbring, L. (2000). Internet and society. *Stanford Institute for the Quantitative Study of Society*.

Norris, P. (1996). Does television erode social capital? A reply to Putnam. *Political Science & Politics*, 474–480.

Online Video: 57% of internet users have watched videos online and most of them share what they find with others. (2006). Retrieved from the Pew Internet & American Life Project website http://www.pewinternet.org/PPF/r/219/report_display.asp

Plank, R. E., & Greene, J. N. (1996). Personal construct psychology and personal selling performance. *European Journal of Marketing, 30*(7), 25–48.

Putnam, R. D. (1993). The prosperous community: Social capital and public life. *The American Prospect, 13*, 35–42.

Putnam, R. D. (1995). Tuning in, turning out: The strange disappearance of social capital in America. *Political Science and Politics*, 664–683.

Putnam, R. D. (2000). *Bowling alone: The collapse and revival of American community*. New York, NY: Simon & Schuster.

Schudson, M. (1998). *The good citizen: A history of American civic life*. New York, NY: The Free Press.

Shah, D. V., McLeod, J. M., & Lee, N. (2009). Communication competence as a foundation for civic competence: Processes of socialization into citizenship. *Political Communication, 26*(1), 102–117.

Shah, D. V., McLeod, J. M., & Yoon, S. H. (2001). Communication, context, and community: An exploration of print, broadcast and Internet influence. *Communication Research, 28*, 464–506.

Simon, J., & Merrill, B. D. (1998). Political socialization in the classroom revisited: The Kids Voting program. *Social Science Journal, 35*, 29–42.

Stolle, D., & Hooghe, M. (2004). Consumers as political participants? Shifts in political action repertoires in Western societies. In M. Micheletti, A. Follesdal, & D. Stolle (Eds.), *Politics, products and markets* (pp. 265–288). New Brunswick, NJ: Transaction.

Stolle, D., Hooghe, M., & Micheletti, M. (2005). Politics in the supermarket: Political consumerism as a form of political participation. *International Political Science Review, 26*, 245–269.

Thorson, E., & Duffy, M. (2006). *A needs-based theory of the revolution in news use and its implications for the newspaper business*. Paper presented at the NAA Marketing Conference, Orlando, FL.

Uslaner, E. M. (2006). The civic state: Trust, polarization, and the quality of state government. In J. Cohen (Ed.), *Public opinion in state politics* (pp. 142–162). Stanford, CT: Stanford University Press.

Vallone, R. P., Ross, L., & Lepper, M. R. (1985). The hostile media phenomenon: Biased perception and perceptions of media bias in coverage of the Beirut massacre. *Journal of Personality and Social Psychology*, *49*, 577–585.

Verba, S., Nie, N. H., & Kim, J.-O. (1978). *Participation and political equality: A seven nation comparison*. New York, NY: Cambridge University Press.

Vogel, D. (2004). Tracing the American roots of the political consumerism movement. In M. Micheletti, A. Follesdal, & D. Stolle (Eds.), *Politics, products and markets* (pp. 83–100). New Brunswick, NJ: Transaction.

Weitz, B. A. (1981). Effectiveness in sales interactions; a contingency framework. *Journal of Marketing*, *45*(1), 85–103.

Zukin, C., Keeter, S, Andolina, M., Jenkins, K., & Delli Carpini, M. X. (2009). *A new engagement: Political participation, civic life and the changing American citizen*. Oxford, England; New York, NY: Oxford University Press.

Political Advertising AND THE Hierarchy OF Political Socialization IN Teens

ESTHER THORSON, EUNJIN KIM, AND MARGARET DUFFY

In the political socialization literature, family, school, the news media, and talking with others about politics are generally considered to have the most impact on how youth develop their interest, knowledge, and involvement in politics. More than thirty years of behavioral research, however, has also shown the significance of political advertising or direct persuasive messages (such as promotional e-mails) in the socialization process. This study attempts to add to our existing knowledge base by juxtaposing the impact of political advertising against the major structural causes of youth socialization, and comparing its impact to that of political news, both authoritative and opinionated.

The Media Choice Model (Thorson & Duffy, 2006; see Figure 1) suggests that all mass media messages have a "voice" that is expressed primarily in terms of who the source is and where they are located on the information-persuasion dimension. Traditional news, such as metropolitan newspapers or evening network television, is an "authoritative" source that presents its information as important and unbiased, and as being more informative than persuasive, sometimes even calling itself "objective," although that claim is largely rejected by scholars of news (e.g., Chomsky, 2002; Schudson, 1997). Opinionated news claims to provide information of importance to all, but from the speaker's point of view. Fox News, Bill O'Reilly, and MSNBC are good examples of opinionated news. Advertising is the voice of recognized attempts to persuade, including political advertisements and messages from candidates directly to citizens via television, e-mail, direct mail, tweets, and so on.

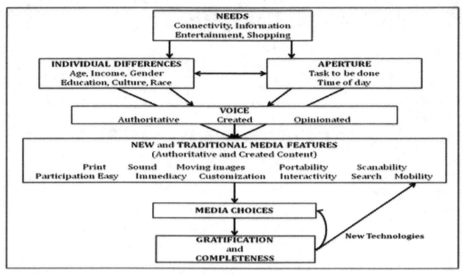

Figure 1. Media Choice Model (Thorson & Duffy, 2006).

We suspected that advertising voices might be especially influential on teens in light of research that suggests they want information from a point of view, often one that matches their own perspectives. Thus, this study first intends to look at the role of the advertising voice in the political socialization of teens.

Second, the political socialization literature looks at a number of different measures of what it means to be socialized. In some studies, socialization is defined in terms of being interested in politics; while in others, it means being knowledgeable about politics, or refers to participatory behaviors such as voting, attending rallies, or being active with political content online. Of course all of these activities are aspects of socialization, and the literature has developed to a point where the interconnections among these indicators are coming to be understood (e.g., see the special issue of *Political Communication*, 2009). Jahng, Meyer, and Thorson (2010) suggested that socialization is really a continuum of responses in youth, starting from interest, then acquiring knowledge, voicing one's political opinions to others and listening to their opinions, participating in school political education assignments, and, finally, becoming behaviorally involved in politics itself, i.e., volunteering for a candidate, putting a candidate sign in the yard, voting, attending rallies, blogging about politics, or contributing to candidates. This hierarchy is loosely conceptualized, and includes both the idea of development across time, and the idea that each successive level can be considered a more sophisticated one in terms of "good citizenship." Consistent with this approach, the present study examines the comparative role of the political advertising voice in terms of each level of these indictors of political socialization. Our

assumption is that the role of advertising would change throughout the hierarchy of socialization development.

The literature review will first look to define and articulate what is known about the major components of political socialization, including political interest, knowledge, participation in school-based political education programs, and behavioral participation in real-world politics. We next articulate the idea of voice and distinguish among the two news voices (authoritative and opinionated) and advertising voice. This literature aggregation leads to hypotheses that are tested with the second panel of the Young Voters Study (immediately after the 2008 presidential election).

A POLITICAL SOCIALIZATION HIERARCHY

Political socialization includes political interest, knowledge, and a variety of behaviors that define participating meaningfully, effectively, and in many different ways in public life (Shah, McLeod, & Lee, 2009). Jahng et al. (2010) treated political socialization as a hierarchy of stages of attention, learning, interpersonal communication behaviors, and political participatory behaviors, which is reminiscent of Piaget's (1960) theory of child socialization. Piaget suggested that evolving cognitive structures dictated a fairly predictable rolling out of skills and problemsolving in infancy (sensory-motor), preschool (pre-operational), childhood (concrete operational), and the teen years (formal operational). Each of these cognitive structures interacts with the child's environment in one of two ways: assimilation (the child's cognitive structures make the strange and new link with what is known and understood) and accommodation (the child's cognitive structures themselves change processing to fit with input from the environment).

Though we do not posit or test that cognitive structures determine how children develop political knowledge, attitudes, and behaviors, we think there is movement through stages of political dimensions that itself reflects increasing complexity. For instance, it is posited that a child's knowledge of, and attitudes toward, political entities such as the "president" or "laws" are simplest and formed earliest (Eveland, McLeod, & Horowitz, 1998). Age is also related to political knowledge (Eveland et al., 1998). As children mature and become knowledgeable, they begin to process more complex political information and speak, and even argue, about the knowledge they have acquired with family and peers. This political talk may mark the development of an independent political identity that will continue to develop over time. Shah et al. (2009) posited that talking with others about politics is part of one's "communication competence," which refers to a group of communication variables that include family communication patterns, school communication about politics, news media use, and interpersonal

discussion about politics. It is also likely that political talk is also enhanced by, as it possibly enriches, civic training in school (Kiousis & McDevitt, 2008).

As the capacity to think about political matters continues to develop in adolescence (Eveland et al., 1998), [young people start to mentally process the abstract ideas and concepts that serve as the bases for politics. Further, as adolescents' cognitive abilities enable them to elaborate on the news and feel efficacious about their political opinions, they will go through the process of not only developing a set of beliefs about political matters but also better understand what others' perspectives are. Initially, family communication and parental participation will guide adolescents and build interest in political behavior. Later, school curricula and the news that young people decide to follow can equip them to make political decisions that reflect their own attitudes (Meirick & Wackman, 2004).

Political participation is considered the highest level of political socialization because it requires all the previous processes—interest, knowledge, and competence in communicating with others about politics. It is also more effortful and requires self-generated intentionality. It is far more effortful to go out and vote, get a political sign for your yard, or attend a political caucus than it is to watch a political news story or talk with your friends about politics. Both political interest and political knowledge lead to political participation (Moy, Torres, Tanaka, & McCluskey, 2005; Wang, 2007). Additional studies have examined behaviors other than voting to index political participation, such as joining community work (McLeod, Scheufele, & Moy 1999) campaigning for a candidate, joining street rallies, or donating campaign funds (Brady, Verba, & Schlozman, 1995; Moy et al., 2005; Wang, 2007). The advent of the Internet has now provided many new outlets for political participation, and studies have used online behaviors, such as e-mailing officials or forwarding political videos and links, to index online political participation (e.g., Eveland & Hively, 2009).

The Media Choice Model

We now turn to a model that suggests what might influence people to choose certain media or certain kinds of messages over others. The Media Choice Model (Thorson & Duffy, 2006) is a variation of uses and gratifications theory (Blumler & Katz, 1974; Levy & Windahl, 1984; Ruggiero, 2000). The model suggests that news media features such as immediacy, mobility, ease of use, presence of video or audio, and dependence on text, among other factors, influence the way people fulfill their communication needs and develop preferred patterns of media use, modifying those patterns as the media environment changes. Most relevant for the present study, the model posits that people have different preferences for "voice," that is, the perceived intentionality behind the media message.

Arnett, Larson, and Offer (1995) emphasized that adolescents' use of media is motivated by the need to understand concepts of self. The introduction to a special issue of *Journal of Youth and Adolescence* argues that it is important to understand youth as being active selectors of media, just as they take an active role in creating and defining many of the relationships in their lives, including schools, parents, significant others, and so on (e.g., Lerner & Kauffman, 1985; Scarr, 1993). Thus, modeling how youth choose media and how that choice determines political socialization is important.

News Voices

As can be seen in Figure 1, "voice" plays a major role in the Media Choice Model. Hodgson (2000) argued there has been a steady loss of respect for what he calls the "grand narrative" voice of news, which he defined as news that represented a matter of life or death. For example, during World War II, reports on yesterday's battles were critical information to most Americans. Today, short of a national disaster or a terrorist attack, there is no common denominator for what is of life-and-death importance. As another indicator of the reduced status of news as the grand narrative, Thorson and Duffy (2006) reported in an analysis of lifestyle trend data that mean agreement with the statement "I need to get the news every day (national, international and local)" decreased 6% overall from 1995 to 2005. It should be noted that although the loss was greater among the young, it was significant for all age groups, even those 60 years or older. Patterson (2007) further documented reduced attention to news, particularly hard news, in those aged 12–17, compared with young adults 18–30, and those over the age of 30. In both self-reported news use and test scores on a news knowledge test, the youngest group achieved the lowest scores.

There is also evidence that the young are redefining news, at least the news they want. MTV News researcher Matt Catapano (2006) noted that youth do not want "facts" but rather facts embedded in a context that enables youth to make sense of themselves. Jeff Jarvis (in Brown, 2005) suggested that youth like "attitude" and "voice" in their news, a finding that is consistent with the growth of Fox News and other opinion-salient news programs. Jarvis said of Jon Stewart's *The Daily Show* that youth like it because it is a way of "bringing news down off its pedestal and presenting it at eye-level" (p. 3). There is clearly movement among young people, then, toward "opinionated news." We thus expect that:

> **H1:** Exposure to Opinionated News will have a strong positive impact on all measures of political socialization.

We do not expect that the use of Opinionated News will eliminate the use of Authoritative News. As we have seen, the news media play a crucial role for adolescents who actively ask questions about their political values and identities. Media

help adolescents start to seek autonomy and independence from their parents and look for sources outside of family. Adoni (1979) argued mass media serve as social-izing agents by providing a direct link to the content adolescents need to develop political values and contribute to the social contexts where they can exercise value orientations. Today the Internet provides a direct outlet that can be used whenever there is a need for information, and it has been found to be the most often used political news outlet for adolescents (Lenhart, Purcell, Smith, & Zickuhr, 2010). We thus expect that:

H2: Authoritative News Voice will have a positive impact on all measures of political socialization.

Advertising Voice Influences in the Political Socialization Hierarchy

More than 30 years ago, Patterson and McClure (1976) provided evidence that adults learned more about political issues from advertising than from television news. Zhao and Chaffee (1995), however, were critical of this generalization, and, using data from six different elections and geographic regions, showed that adver-tising was a predictor of political issue knowledge; but with the addition of more and more control variables, advertising eventually showed up as less consistent and strong an effect than television news. In a related study but with different data sets, Chaffee, Zhao, and Leshner (1994) showed that political issues and personal knowledge about candidates were predicted by newspaper and television news, but not by political advertising.

It should be noted that in these studies there was not a careful linking of just what information was contained in the political advertising and the questions asked in the surveys, and this limitation may account for the lack of advertising's effects. Chaffee and Kanihan (1997) pointed out that surveys measuring responses to political ads might also be flawed if respondents were consciously denying that they paid attention to advertisements because of perceived negative social norms about advertising.

More recently there has been an important innovation in measuring exposure to political advertising, and the results of studies using that innovation have again shown considerable impact of advertising. Shah et al. (2007) combined a measure of likelihood of watching specific political ads (a measure devised by Goldstein & Freedman, 2002) with survey data about political interest, knowledge, and polit-ical participation. The likelihood of watching political advertising was calculated by combining market-by-market and program-by-program tracking of political ads, along with detailed coding of ads' content (e.g., whether they were attack or support formats, for Republicans or Democrats, etc.) with indicators of how often people self-report watching the ads. This approach provides an indication

of advertising exposure that is claimed to be more accurate than traditional self-report measures. Shah et al. (2007) found differences in the effects of attack and support ads, which will not be summarized here. More relevant to our study, however, Shah et al. showed that exposure to political advertising had direct effects on political participation. Political advertising also had effects on civic and political participation that were mediated through (1) use of news media for hard news (online, television, and newspapers), and (2) online and (3) interpersonal discussion. Other studies using this approach have shown similar strong effects of political advertising on knowledge (e.g., Ridout, Shah, Goldstein, & Franz, 2004).

Political advertising has also been shown to have strong effects on knowledge when an election is near (Brians & Wattenburg, 1996). Recall of political ads, especially negative ones, was more significantly associated with knowledge of candidates' issue positions than newspaper use or watching television news (Brians & Wattenburg, 1996). In a meta-analysis, Benoit, Leshner, and Chattopadhyay (2007) found that political television advertising had significant, although small, effects on both learning about issues and on perceptions of candidates' characters. It is also argued that political ads are more informative than news coverage, which tends to treat election coverage as trivial by lumping it with other stories (Brians & Wattenburg, 1996).

Another area of research that suggests a particularly strong effect of advertising voice on the young is how new immigrants learn about politics. For these citizens who have little background about American politics and are challenged by English as their second language, exposure to campaign ads increased political knowledge (Zhao & Chaffee, 1995). The study showed that for this population, at least in one highly salient race, political advertising had the greatest media impact on knowledge about and interest in the race. It was posited that the simplicity and repetitiousness of the advertising messages made learning much easier for people with less background about U.S. politics. While this study did not look at impact on participation levels, other studies have established clear pathways from political interest and knowledge to political participation. It should be noted, however, that there has not been a great deal of research on how political advertising affects adolescents. Nevertheless, given the clear support for effects of political advertising on both knowledge and participation for adults, we posit that:

> **H3:** Advertising Voice will have the greatest impact on all measures of political socialization, especially knowledge and participation, both online and offline.

It is also likely that media use—in this study this includes consumption of opinionated news, authoritative news, and political advertising—stimulates political talk (Shah et al., 2007). Often, an additional goal of advertising is to encourage people to talk to others about the product or the message being promoted (e.g., Hughes, 2005; Sernovitz, 2006). In separating political talk from casual conversations,

Scheufele (2000) argued that media's influence on political participation "is to a large degree a function of people talking to each other first and, in the process, learning more and becoming more likely to participate in politics" (p. 734).

We have also noted that political talk with family and peers appears to be an activity correlated with school civic participation. For instance, McDevitt and Kiousis (2006) found that the civic training initiative Kids Voting USA stimulated political talk among adolescents. Schools also potentially provide social interaction that represents a level of political stimulation and communication that may not be available from parents at home (Kiousis & McDevitt, 2008). School interventions, such as the Kids Voting USA curriculum, have been found not only to encourage adolescent political interest and knowledge but also to lead youth to a more motivated discussion in school (McDevitt, 2005; McDevitt & Chaffee, 2002). Shah et al. (2009) also found that classroom deliberation "boosts civic engagement both directly and indirectly by stimulating further communication activities" among adolescents" (p. 113). What these studies demonstrate is a movement from political talk and school participation into what sits at the top of the political socialization hierarchy, that is, political participation. Additional political communication competency should lead to more effortful and intentional participation such as attending rallies, becoming involved in political organizations, and boycotting products considered politically unacceptable (McDevitt & Ostrowski, 2009). Thus, we test the following hypotheses:

H4a: Political talk and political school participation will influence adolescents' political interest, knowledge, and online and offline political participation.

H4b: Political talk and political school participation will mediate the effect of voice on adolescents' political interest, knowledge, and online and offline political participation.

Although in this study we are looking at the effects of news media exposure (both Authoritative and Opinionated Voice), political talk, and school political participation, our central goal is to examine **how political advertising effects** operate in concert with these other known influences. We also seek to examine how political advertising operates across the various measures of political socialization, those levels being what we call the hierarchy of political socialization.

METHOD

The Survey

The data analyzed here come from the second survey of the three-panel Future Voters Study administered November 5 through December 10, 2008, immediately after the presidential election. The sample included 711 respondents.

Variable Measures

Political interest. Political interest was measured by a single item "I am interested in politics" on a five-point Likert scale, ranging from strongly disagree to strongly agree.

Political knowledge. We developed an index for measuring respondents' accuracy in identifying the presidential candidate (i.e., Obama or McCain) that had each of the six features: "Which candidate opposed a timetable for withdrawal from Iraq?" "Which candidate supported raising taxes on the wealthiest Americans?" "Which candidate has an adopted daughter from Bangladesh?" "Which candidate has not served in the U.S. military?" "Which candidate has been divorced?" and "Which candidate began his political career as a community organizer?" Responses were scored 1 if correct, 0 if incorrect or if no response was recorded. Thus, political knowledge was measured in terms of the number of correct answers ranging from 0 to 6.

Behavioral political participation. Behavioral political participation was measured with a series of questions asking "how frequently the adolescent engaged during the past three months in each of the activities on eight-point response scales?" (1 = Not at all, 8 = Very Frequently). The 33 items were factor analyzed using principle axis factoring with Promax rotation because we theorized that the political participation variables were correlated with each other. Four factors emerged as a result of factor analysis, and they are summarized in Table 1.

The first factor was named *Online Participation* (Cronbach's α = .90). Items loaded high on this factor were "Read comments posted by readers on the news web," "Sent or received a text message about politics," "Exchanged political e-mails with friends and family," "Forwarded the link to a political video or news article," "Received a link to a political video or news article," "Watched video news stories online," and "Watched political/candidate videos online."

The second factor was labeled *Traditional Participation* (Cronbach's α = .91). Items loaded high on this factor were "Contributed money to a political campaign," "Attended a political meeting, rally, or speech," "Worked for a political party or candidate," "Participated in a political protest activity," and " Wrote a letter or e-mail to a news organization."

The third factor was labeled *School Political Program Participation* (Cronbach's α = .90). Items loaded high on this factor were "Discussed/debated political or social issues in class," "Learned about how government works in class," "Followed the news as part of a class assignment," "Participated in political role-playing in class (mock trials, elections)," and "Was encouraged to make up my own mind about issues in class."

The fourth factor was named *Political Talk* (Cronbach's α = .897). Items loaded high on this factor were "Talked about news and current events with

Table 1. Factor Analysis of Political Participation Items.

	Item	Factor loading	Alpha
Factor1	Forwarded The Link To A Political Video Or News Article	.820	
Online Participation	Received A Link To A Political Video Or News Article	.807	
	Exchanged Political Emails With Friends And Family	.751	.90
	Watched Political/Candidate Videos Online	.717	
	Sent Or Received A Text Message About Politics	.708	
	Watched Video News Stories Online	.695	
	Read Comments Posted By Readers On A News Website Or Political Blog	.560	
Factor 2	Contributed Money To A Political Campaign	.896	
Traditional Participation	Worked For A Political Party Or Candidate	.870	
	Participated In A Political Protest Activity	.821	.91
	Attended A Political Meeting, Rally, Or Speech	.818	
	Wrote A Letter Or Email To A News Organization	.696	
Factor 3	Discussed/Debated Political Or Social Issues In Class	.836	
School Political Program Participation	Learned About How Government Works In Class	.832	
	Followed The News As Part Of A Class Assignment	.793	.90
	Participated In Political Role-Playing In Class	.776	
	Encouraged To Make Up Your Own Mind About Issues In Class	.749	
Factor 4	Talked About News And Current Events With Friends	.836	
Political Talk	Talked About News And Current Events With People Who Disagree With You	.811	
	Talked About News And Current Events With Family Members	.795	.90
	Talked About News And Current Events With Adults Outside Your Family	.779	

71% of variance explained

Note. Each item was measured on an eight-point scale indicating how often the teen did each of the behaviors, from 1 = not at all to 8 = very frequently. Online political initiative was measured on a four-point scale indicating how often the teen did each of the activities, from 1 = never to 4 = regularly.

friends," "Talked about news and current events with people who disagree with you," "Talked about news and current events with family members," and "Talked about news and current events with adults outside your family."

Voice. Exploratory factor analysis using principle axis factoring with Promax rotation determined three profiles of voice among 13 items that respondents rated in terms of weekly media consumption. The results are summarized in Table 2. The first factor was labeled *Opinionated News Voice* (Cronbach's α = .71). Items loaded high on this factor were "conservative political blogs," "liberal political blogs," and "conservative talk radio."

Four items loaded onto the second factor, *Authoritative News Voice* (Cronbach's α = .72): "print and online versions of national newspapers such as the *New York Times* or *USA Today*," "local newspapers," "the teen's school student newspaper," and "TV news websites such as cnn.com. "

Finally, three items loaded on the third factor, representing *Advertising Voice* (Cronbach's α = .76): "political candidates' websites," "ads where presidential candidates attack each other," and "ads where candidates give the viewer reasons to vote for them."

Table 2. Factor Analysis of Items Designed to Measure Voice.

	Item	Factor loading	Alpha
Factor 1	Conservative Political Blogs	.875	
Opinionated News Voice	Liberal Political Blogs	.842	.71
	Conservative Talk Radio	.781	
Factor 2	TV News Websites	.789	
Authoritative News Voice	Local Newspaper Websites	.728	
	Your School's Student Newspaper	.705	.72
	Local Newspaper	.679	
	A Print Copy of A National Newspaper	.645	
	National Newspaper Website	.485	
Factor 3	Ads Where Candidates Tell Me Reasons To Vote For Them	.917	
Advertising Voice	Ads Where Presidential Candidates Attack Each Other	.910	.76
	Political Candidates' Websites	.597	

61% of variance explained

Note. Each item was measured on an eight-point scale indicating how often the teen did each of the behaviors, from 1 = not at all to 8 = very frequently.

RESULTS

In all, we examined data from 711 adolescents aged 12–18. Age was distributed fairly evenly, with the exception of the youngest and oldest teen respondents. Approximately 8% were aged 12, 16% aged 13, 17.5% aged 14, 18% aged 15, 19.5% aged 16, 15% aged 17, and 5% aged 18. Given the nearly equal distribution of age in the first wave of the survey, small groupings at the age endpoints likely reflect the aging process, with the youngest moving into the second category and the oldest moving into the 18-year age group, which we did not include in the original sample. The teenagers divided somewhat evenly into political party affiliations: 40% identified as Democrat, 30% as Republican, and 29% as Independent. Family income, which was measured as a self-reported open response, ranged from $31,000 to more than $57,000, with an average of more than $45,000. The mean household size was four people, and families lived in their current homes an average of 11 years, with a range from 0 to 59 years. A large majority of teens (76%) came from families with married parents or domestic partners, while 13% and 3% had divorced or separated parents, respectively, and 6.9% lived with parents who said they were never married. Thus, three quarters of the teens came from two-parent households.

Tests of the Hypotheses

To test the hypotheses, we set up hierarchical regression analyses where Block 1 included the demographic variables and political interest, Block 2 with voice variables, Block 3 with political talk and school program participation. The final model predicted 30% of the variance in political interest, 12% for political knowledge, 25% for political talk, 12% for school political program participation, 44% for traditional participation, and 14% for online participation. Table 3 presents descriptive statistics for all variables and Table 4 shows the correlations among the variables. As can be seen in Table 4, self-reported exposure to the three types of voice were highly positively intercorrelated. Higher exposure to any one type of voice means exposure to the other two types will also be higher. This intercorrelation must temper the impact of the three types of variables in the regressions. Tables 5 and 6 display the results of the hierarchical regression analyses.

Political interest. Political interest was predicted by political talk (β = .402, p = .000) and school political program participation (β = .192, p = .000). Among the voice variables, authoritative voice (β = .187, p = .000) and advertising voice (β = .093, p = .024) significantly predicted political interest. (Note that political interest was first treated as a DV but then entered as a control variable in subsequent regressions.)

Table 3. Descriptive Statistics for All Variables.

Variable	M	SD	n	Min	Max
Traditional participation	1.293	.919	705	1.00	8.00
Online participation	1.764	1.284	704	1.00	8.00
School political program participation	3.552	2.005	704	1.00	8.00
Political talk	3.956	1.897	703	1.00	8.00
Political knowledge	2.878	1.470	662	.00	6.00
Political interest	3.000	1.120	708	1.00	5.00
Opinionated voice	1.513	1.430	703	.00	7.00
Authoritative news voice	1.125	1.012	703	.00	7.00
Advertising voice	2.070	1.562	702	.00	7.00

Table 4. Correlation Matrix (Only Significant Correlations Are Shown).

	1	2	3	4	5	6	7	8	9
1. Political interest	−	.16**	.47**	.10*	.18**	.30**	.30**	.30**	.25**
2. Political knowledge		−	.18**		.09*	.12**			
3. Political talk			−				.24**	.17**	.09*
4. Traditional participation				−			.22**	.38**	.60**
5. Online participation					−		.30**	.31**	.26**
6. School participation						−	.22**	.20**	.10**
7. Advertising voice							−	.41**	.50**
8. Authoritative voice								−	.59**
9. Opinionated voice									−

*p < .05; **p < 0.01.

Political knowledge. Political knowledge was predicted by parent income (β = .269, p = .000), political talk (β = .154, p = .001), and school political program participation (β = .108, p = .012). Among the voice variables, only advertising voice was a significant predictor of political knowledge (β = .101, p = .035).

Political talk. Political talk was significantly influenced by political affiliation (β = .110, p = .004), political interest (β = .432, p = .000), and school political program participation (β = −156, p = .000). While advertising voice (β = .152, p = .000) had a significant positive influence on political talk, opinionated voice (β = −.130, p = .006) had a significant negative influence. For political affiliation, it was coded 1 if Democrat and 2 if Republican. The result indicates that teens whose identification is Republican are more likely to engage in political talk with others.

Table 5. Regression Predicting Political Interest, Political Knowledge, and Political Talk.

Final model	Political Interest		Political Knowledge		Political Talk	
	β	t Value	β	t Value	β	t Value
Household size	.009	.244	.02	.493	.042	1.128
Parent income	.033	.921	.269***	6.394	.016	.427
Age	-.029	-.809	.06	1.46	.079	2.152
Political affiliation	-.015	-.409	-.067	-1.583	.110**	2.900
Political interest			.001	.023	.432***	10.951
Authoritative voice	.187***	4.088	-.088	-1.638	.087	1.816
Opinionated voice	-.017	-.367	-.012	-.22	-.130**	-2.750
Advertising voice	.093*	2.269	.101*	2.115	.152***	3.582
Political talk	.402***	10.951	.154**	3.346		
School participation	.192***	5.274	.108*	2.512	-.156***	-4.080
R^2	.302 (F = 28.850***)		.11.8 (F = 8.315***)		.250 (F = 22.407***)	

*p < .05; **p < .01; ***p < .001.

Table 6. Regression Predicting School Political Program Participation, Traditional Participation, and Online Participation.

Final model	School Political Program Participation		Traditional Participation		Online Participation	
	β	t Value	β	t Value	β	t Value
Household size	.077	1.911	.067	2.086	-.025	-.616
Parent income	.047	1.151	-.012	-.376	.032	.808
Age	-.005	-.122	-.018	-.549	.042	1.074
Political affiliation	-.045	-1.09	-.069*	-2.111	-.043	-1.049
Political interest	.242***	5.274	-.008	-.239	.164***	3.542
Authoritative voice	.163**	3.158	.027	.641	.200***	3.889
Opinionated voice	-.166**	-3.261	.663***	16.313	-.012	-.228
Advertising voice	.178***	3.882	-.09*	-2.464	.219***	4.774
Political talk	-.182***	-4.08	-.022	-.608	-.157***	-3.517
School participation			-.048	-1.439	-.150***	-3.633
R^2	.121 (F = 9.819***)		.434 (F = 56.586***)		.144(F = 10.726***)	

*p < .05; **p < .01; ***p < .001.

School political program participation. School political program participation was significantly predicted by political interest (β = .242, p = .000) and political talk (β

= −.182, p = .000). All three voices significantly predicted school political program participation. Authoritative voice (β = −.163, p = .002) and advertising voice (β = .178, p = .000) positively predicted school political program participation. However, opinionated voice (β = −.166, p = .001) predicted school political program participation negatively. The negative effect was likely due to the high intercorrelation of the three voice variables because opinionated voice was not negatively related to any of the dependent variables.

Traditional participation. Traditional participation was explained mostly by opinionated voice (β = .663, p = .000) and political affiliation (β = −.069, p = .035). Advertising voice (β = −.09, p = .014) had a significant negative influence on traditional participation, again probably because of the multicollinearity in the voice variables.

Online participation. Online participation was positively predicted by political interest (β = .164, p = .000) and negatively predicted by political talk (β = −.157, p = .000) and school political program participation (β = −.150, p = .000). Opinionated voice did not have a significant impact on online participation, but advertising voice (β = .219, p = .000) and authoritative voice (β = .200, p = .000) had a significant positive influence on online participation.

Hypotheses 1–3, which predicted positive effects of exposure to all three types of voice, were completely supported in terms of first-order correlations. In terms of the regression analyses, advertising voice was a significant predictor in all six dependent variables. Further, advertising voice had the largest beta weight for all but two regressions, political interest and traditional participation. Political interest was most strongly predicted by authoritative voice and traditional participation was most strongly predicted by opinionated voice. Thus there was strong support for the importance of advertising voice (H3). Authoritative voice was significant in three regressions, political interest, school program participation, and online participation, partially supporting H1. Opinionated voice was significant for political talk, school program participation, and traditional participation, thus providing partial support for H2.

H4a suggested the impact of political talk and school participation. The hypothesis was strongly supported for political talk, which was significant for all regressions except traditional participation. In the first order correlations, political talk was significantly related to both political interest and political knowledge. It was not significantly correlated with school participation, and therefore the negative beta for its effect on school participation in Table 6 likely resulted from interactive effects with the variables in the prior two blocks.

School participation was a significant predictor for political interest, knowledge, talk, and online participation. Like political talk, it was only correlated with the two dependent variables, political interest and knowledge, and thus its significant entry into the other regressions again occurs because of its interactions

with the variables in prior blocks. Thus the strongest clear conclusion is that both political talk and school participation have direct effects on political interest and knowledge.

Mediation Analysis

H4b suggested that political talk and school participation would mediate the effects of voice on the four dependent variables. A simultaneous multiple-mediation model was tested using the bootstrapping method based on 1,000 bootstrap samples with bias-corrected confidence estimates in SPSS (Preacher & Hayes, 2004). The bootstrapping method was employed because it does not require the assumption that the sampling distribution of the indirect effect is normal (Preacher & Hayes, 2008). Moreover, Baron and Kenny's (1986) causal-step approach is not very useful when there are multiple mediating variables (Mackinnon, 2000), and it is also known to have low statistical power (Preacher & Hayes, 2004).

The two mediators were tested simultaneously while controlling for demographic variables. The results of mediation analysis are summarized in Table 7.

Table 7. Mediation of the Effect of Voices on Political Interest, Knowledge, and Traditional and Online Participation Through Political Talk and School Political Program Participation.

	Political Interest		
Advertising voice	Point estimate	*SE*	Bootstrapping 95% CI
Political Talk	.0872	.0166	.0473; .1349*
School Participation	.0611	.0221	.0324; .1009*
Authoritative voice	Point estimate	*SE*	Bootstrapping 95% CI
Political Talk	.0679	.0218	.0265; .1123*
School Participation	.0596	.0182	.0299; .1031*
Opinionated voice	Point estimate	*SE*	Bootstrapping 95% CI
Political Talk	−.0521	.0210	−.0946; −.0147*
School Participation	−.0220	.0143	−.0574; .0015
	Political Knowledge		
Advertising voice	Point estimate	*SE*	Bootstrapping 95% CI
Political Talk	.0287	.0143	.0084; .0693*
School Participation	.0359	.0157	.0098; .0714*
Authoritative voice	Point estimate	*SE*	Bootstrapping 95% CI
Political Talk	.0129	.0180	−.0034; .0408
School Participation	.0306	.0167	.0060; .0705*

Opinionated voice	Point estimate	SE	Bootstrapping 95% CI
Political Talk	−.0236	.0114	−.0525; −.0058*
School Participation	−.0489	.0107	−.0489; .0001

Traditional Participation			
Advertising voice	Point estimate	SE	Bootstrapping 95% CI
Political Talk	−.0022	.0054	−.0143; .0076
School Participation	−.0111	.0083	−.0289; .0038
Authoritative voice	Point estimate	SE	Bootstrapping 95% CI
Political Talk	−.0010	.0029	−.0096; .0028
School Participation	−.0099	.0084	−.0287; .0044
Opinionated voice	Point estimate	SE	Bootstrapping 95% CI
Political Talk	.0018	.0046	−.0062; .0123
School Participation	.0044	.0047	−.0014; .0193

Online Participation			
Advertising voice	Point estimate	SE	Bootstrapping 95% CI
Political Talk	−.0166	.0085	−.0389; −.0037*
School Participation	.0010	.0114	−.0179; .0312
Authoritative voice	Point estimate	SE	Bootstrapping 95% CI
Political Talk	−.0076	.0072	−.0279; .0028
School Participation	.0009	.0111	−.0179; .0314
Opinionated voice	Point estimate	SE	Bootstrapping 95% CI
Political Talk	.0139	.0078	.0024; .0358*
School Participation	−.0004	.0051	−.0141; .0085

*Indicates a significant indirect effect.

Examination of Table 7 shows that political talk significantly mediated the effect of advertising voice, authoritative voice, and opinionated voice on political interest, with point estimates of .0872, .0679, and −.0521 and 95% confidence intervals (CI) of .0473 to .1349, .0265 to .1123, and −.0946 to .−0147 respectively. School political program participation significantly mediated the effect of advertising voice and authoritative voice on political interest, with point estimates of .0611 and .0596 and with 95% confidence intervals (CI) of .0324 to .1009 and .0299 to .1031 respectively. In terms of political knowledge, both political talk and school political program participation significantly mediated the effect of advertising voice on political knowledge, with point estimates of .0289 and .0359 and with 95% confidence intervals (CI) of .0084 to .0693 and .0098 to .0714 respectively. Interestingly, authoritative voice was only mediated by school political program participation while opinionated voice was only mediated by political talk, with

point estimates of .0306 and −.0236 and with 95% confidence intervals (CI) of .0060 to .0705 and −.0525 to −.0058 respectively. There was no mediation effect of talk or school participation between voice variables and traditional participation. For online participation, political talk significantly mediated the effect of advertising voice and opinionated voice with point estimates of −.0166 and .0139 and with 95% confidence intervals (CI) of −.0389 to −.0037 and .0024 to .0358. School political program participation did not have any mediation voice effects for online participation.

DISCUSSION

As with the adult immigrants in the Zhao and Chaffee study (1995), the adolescents in this study were highly influenced by their exposure to the political advertising voice. Advertising voice had a significant direct effect on political interest, political knowledge, traditional participation, online participation, political talk and school participation. Suppression from the multicollinearity among the three measures of voice occasionally made the effect of advertising negative, but the first order correlations suggest that the effect is actually positive. In addition to its strong positive direct effects, advertising also had positive indirect effects. For political interest and political knowledge it had indirect effects through both political talk and school participation. For online participation, advertising voice had an indirect effect through political talk. Advertising voice had no indirect effects for traditional political participation. As the literature on what youth respond to in terms of mediated political messages suggests, political advertising provides a stimulus to every aspect of response to politics, from being interested in it to being knowledgeable and even to behavior—both online and real-world participation in politics. And the direct effects of political advertising are supplemented by healthy doses of indirect effects, through both stimulating more political talk and more active participation in school-based political activity. Indeed, the political advertising voice had more consistent effects than did either authoritative or opinionated news voice.

Exposure to the authoritative voice, that is, the voice of traditional news, had direct effects on three variables: political interest, school participation, and online participation. Authoritarian voice had indirect effects only on political interest (through both political talk and school participation) and on political knowledge through school participation. Thus, while exposure to political news is important to the development of political socialization in American youth, it is not as extensive or strong as the impact of political advertising. Although it remains for further research, it seems reasonable to suggest that political advertising is clearer, simpler, and more repetitive than news stories, and these features account for its greater impact.

Opinionated voice had significant direct effects on three variables also: political talk, school participation, and traditional participation. It had indirect effects on political knowledge and online participation mediated through political talk. Again, the occasional negative sign on those effects is likely due to multicollinearity. Although opinionated news sources such as Fox News do provide an obvious perspective on politics and political candidates, which we expect makes it easier for the young to understand, this source is also not as extensively influential as advertising voice. The repetitiveness and relative simplicity of political advertising offer advantages over opinionated news. The bottom line in this study, therefore, is the strong comparative impact of advertising voice on the political socialization of American youth—and that strong impact influences every dependent variable in the socialization hierarchy.

It is interesting that there is such a high correlation between political advertising voice and the use of traditional and opinionated news. Is this because a teen who is interested in politics pays attention to all mediated sources of political information? Or might it be that exposure to political advertising increases the interest in political news? Of course, the causal flow may go from news to advertising, but given the powerful effect of advertising demonstrated here, this seems less likely.

If the observation here of the critical importance of political advertising for youth political socialization is supported by subsequent research, it will be important to continue to monitor political advertising, as has been done in the last 20 years for truth and fairness. The results of the present study show just how important the quality of political advertising content is to the development of the whole hierarchy of politically socialized behaviors.

Finally, as the Media Choice Model suggested, voice of mediated information is important to distinguish when considering how young people become part of the political scene. Information about candidates and issues from different sources has varying impact on the various levels of political socialization, and their direct and indirect effects on the levels are different. Much remains to be understood about just why these differences occur. We posit here that political advertising's simplicity, repetitiveness, and clarity of opinion perspective make these messages of higher impact than the news. These features, however, will need to be studied specifically to determine just what it is about political advertising that makes it such a large influence on the young. Important questions also remain about whether there are age-related differences in advertising impact within the teen years.

The current study suffers the classic problems of conducting secondary analyses: there was only a single item that could be used to index political interest. In primary research, the three-voice measures could be more extensive and detailed.

Nonetheless, this study provides a small but important look at youth aged 12–17 who are a very important audience for political advertising. They are

on the verge of voting, and their knowledge, attitudes, and participation levels, developed during this youthful age are likely to make a difference as they become mature citizens. Given the many challenges of citizen participation in American democracy, understanding adolescent political socialization could hardly be more important.

REFERENCES

Adoni, H. (1979). The functions of mass media in the political socialization of adolescents. *Communication Research*, *6*(1), 84–106.

Arnett, J., Larson, R., Offer, D. (1995). Beyond effects: Adolescents as active media users. *Journal of Youth and Adolescence*, *24*(5), 511–518.

Baron, R. M., & Kenny, D. A (1986). The moderator-mediator variable distinction in social psychological research: Conceptual, strategic, and statistical considerations. *Journal of Personality and Social Psychology*, *51*, 1173–1182.

Benoit, W. L., Leshner, G. M., & Chattopadhyay, S. (2007). A meta-analysis of political advertising. *Human Communication, 10*, 507–521.

Blumler, J. G., & Katz, E. (1974). *The uses of mass communications: Current perspectives on gratifications research*. Beverly Hills, CA: Sage.

Brady, H. E., Verba, S., & Schlozman, K. L. (1995). Beyond SES: A resource model of political participation. *The American Political Science Review*, *89*(2), 271.

Brians, C. L., & Wattenburg, M. P. (1996). Campaign issue knowledge and salience: Comparing reception from TV commercials, TV news, and newspapers. *American Journal of Political Science*, *40*(1), 172.

Brown, M. (2005). Abandoning the news. *Carnegie Reporter*, *3*(2). Retrieved from http://www.carnegie.org/publications/carnegie-reporter-vol-3no-2/

Catapano, M. (2006, March 22). *Growing audience: New thinking for a new media age*. Paper presented at the NAA Marketing Conference, Orlando, Florida.

Chaffee, S., & Kanihan, S. F. (1997). Learning about politics from the mass media. *Political Communication, 14*(4), 421–430.

Chaffee, S. H., Zhao, X., & Leshner, G. (1994). Political knowledge and the campaign media of 1992. *Communication Research*, *21*(3), 305–324.

Chomsky, N. (2002). *Media control*. New York, NY: Seven Stories Press.

Eveland, W. P., & Hively, M. H. (2009). Political discussion frequency, network size, and "heterogeneity" of discussion as predictors of political knowledge and participation. *Journal of Communication, 59*(2), 205–224.

Eveland, W. P., Jr., McLeod, J. M., & Horowitz, E. M. (1998). Communication and age in childhood political socialization: An interactive model of political development. *Journalism & Mass Communication Quarterly*, *75*, 699–718.

Goldstein, K., & Freedman, P. (2002). Campaign advertising and voter turnout: New evidence for a stimulation effect. *The Journal of Politics*, *64*(3), 721–740.

Hodgson, G. (2000). The end of the grand narrative and the death of news. *Historical Journal of Film, Radio & Television*, *20*(1), 23–31.

Hughes, M. (2005). *Buzzmarketing: Get people to talk about your stuff*. New York, NY: Portfolio.

Jahng, R., Meyer, H., & Thorson, E. (2010, June). *Youngster's political talk with those outside school and family: The hierarchy of political socialization.* Paper presented at the 2010 Annual Meeting of the International Communication Association Singapore.

Kiousis, S., & McDevitt, M. (2008). Agenda setting in civic development. *Communication Research, 35*(4), 481–502.

Lenhart, A., Purcell, K., Smith, A., Zickuhr, K. (2010, February 3). *Social media and young adults.* Retrieved from the Pew Research Center website: http://pewresearch.org/pubs/1484/social-media-mobile-internet-use-teens-millennials-fewer-blog

Lerner, R. M., & Kauffman, M. B. (1985). The concept of development in contextualism. *Developmental Review, 5*, 309–333.

Levy, M. R., & Windahl, S. (1984). Audience activity and gratifications. A conceptual clarification and exploration. *Communication Research, 11*(1), 51–78.

MacKinnon, D. P. (2000). Contrasts in multiple mediator models. In J. S Rose, L. Chassin, C. C. Presson, S. J. Sherman (Eds.), *Multivariate applications in substance use research: New methods for new questions* (pp. 141–160). Mahwah, NJ: Lawrence Erlbaum.

McDevitt, M. (2005). The partisan child: Developmental provocation as a model of political socialization. *International Journal of Public Opinion Research, 18*(1), 67–88.

McDevitt, M., & Chaffee, S. (2002). From top-down to trickle-up influence: Revisiting assumptions about the family in political socialization. *Political Communication, 19*, 281–301.

McDevitt, M., & Kiousis, S. (2006). *Experiments in political socialization: Kids Voting USA as a model for civic education reform.* Retrieved from http://civicyouth.org/PopUps/WorkingPapers/WP49McDevitt.pdf

McDevitt, M., & Ostrowski, A. (2009). The adolescent unbound: Unintentional influence of civic curricula on ideological conflict seeking. *Political Communication, 26*(1), 11–29.

McLeod, J. M., Scheufele, D. A., & Moy, P. (1999). Community, communication, and participation: The role of mass media and interpersonal discussion in local political participation. *Political Communication, 16*, 315–336.

McLeod, J. M., & Shah, D. V. (2009). *Political Communication Special Issue: Communication and Political Socialization, 26*(1), 1–117.

Meirick, P. C., & Wackman, D. B. (2004). Kids Voting and political knowledge: Narrowing gaps, informing votes. *Social Science Quarterly, 85*(5), 1161–1177.

Moy, P., Torres, M., Tanaka, K., & McCluskey, M. R. (2005). Knowledge or trust? Investigating linkages between media reliance and participation. *Communication Research, 32*(1), 59–86.

Patterson, T. (2007). *Young people and news. A report from the Joan Shorenstein Center on the Press, Politics and Public Policy, John F. Kennedy School of Government, Harvard University.* Cambridge, MA: Joan Shorenstein Center on the Press, Politics and Public Policy.

Patterson, T., & McClure, R. D. (1976). *The unseeing eye: The myth of televison power in national elections.* New York, NY: Putnam.

Piaget, J. (1960). *The child's conception of the world.* Totowa, NJ: Littlefield, Adams.

Preacher, K. J., & Hayes, A. F. (2004). SPSS and SAS procedures for estimating indirect effects in simple mediation model. *Behavior Research Methods, Instruments, and Computers, 36*, 717–731.

Preacher, K. J., & Hayes, A. F. (2008). Asymptotic and resampling strategies for assessing and comparing indirect effects in multiple mediator models. *Behavior Research Methods, 40*, 879–891.

Ridout, T. N., Shah, D. V., Goldstein, K. M., & Franz, M. M. (2004, September). Evaluating measures of campaign advertising exposure on political learning. *Political Behavior, 26*(3), 201–225.

Ruggiero, T. E. (2000). Uses and gratifications theory in the 21st century. *Mass Communication and Society, 3*(1), 3–37.

Scarr, S. (1993). Biological and cultural diversity: The legacy of Darwin for development. *Child Development, 64*, 1333–1353.

Scheufele, D. A. (2000). Talk or conversation? Dimensions of interpersonal discussion and their implications for participatory democracy. *Journalism & Mass Communication Quarterly, 77*(4), 727–743.

Schudson, M. (1997). The sociology of news production. In D. Berkowitz (Ed.), *Social meaning of news: A text-reader* (p. 22). Thousand Oaks, CA: Sage.

Sernovitz, A. (2006). *Word of mouth marketing: How smart companies get people talking.* Chicago, IL: Kaplan.

Shah, D. V., Cho, J., Eveland, W. P., Jr., & Kwak, N. (2005). Information and expression in a digital age: Modeling Internet effects on civic participation. *Communication Research, 32*, 531–565.

Shah, D. V., Cho, J., Nah, S., Gotlieb, M. R., Hwang, H., Lee, N., ... McLeod, D. M. (2007). Campaign ads, online messaging, and participation: Extending the communication mediation model. *Journal of Communication, 57*, 676–703.

Shah, D. V., McLeod, J. M., & Lee, N. (2009). Communication competence as a foundation for civic competence: Processes of socialization into citizenship. *Political Communication, 26*(1), 102–117.

Thorson, E., & Duffy, M. (2006). *Citizenship and use of traditional and new media for information and entertainment.* Paper presented at the annual meeting of the International Communication Association, Dresden, Germany.

Wang, S. I. (2007). Political use of the internet, political attitudes and political participation. *Asian Journal of Communication, 17*(4), 381–395.

Zhao, X., & Chaffee, S. (1995). Campaign advertisements versus television news as sources of political issue information. *Public Opinion Quarterly, 59*(1), 41–65.

Peer Influence IN Adolescent Political Socialization

Deliberative Democracy Inside and Outside the Classroom

MI JAHNG, MITCHELL S. McKINNEY, AND ESTHER THORSON

Political socialization researchers have long focused on how children and teenagers become independent political actors. Decades of political socialization research have shown the importance of family, school, and media in this process and have established the interrelationship among these variables in shaping the political "self" of adolescents. Building on the well-established influence of family, school and mass media, this study focused on the important, yet neglected, role of peers in adolescent political socialization. The primary purpose of this study is to investigate the direct influence of peer interaction in adolescent political socialization. Using deliberative democracy as a guiding theoretical perspective, this study examined how talking about politics with peer members—both outside of the classroom in informal conversation and also within the formal classroom setting—can encourage adolescents to engage in different political behaviors.

DELIBERATIVE DEMOCRACY: DEFINITIONS AND APPLICATIONS

Deliberative democracy has long been a key concept for both political science and political communication scholars. Compared to the notion of participatory democracy, deliberative democracy represents a move "toward a view anchored in

accountability and discussion" (Chambers, 2003, p. 308). Kim, Wyatt, and Katz (1999, p. 362) defined deliberative democracy as "a process where citizens voluntarily and freely participate in discussions on public issues." They added that in a deliberative democracy citizens share information about public issues, talk about politics, form opinions, and participate in political processes. Deliberative democracy, according to Chambers (2003), is a move away from voting-centered notions of democracy and towards a more talk-centered democracy. In a deliberative democracy, citizens are held accountable by publicly articulating, explaining, and justifying their public policy positions. Instead of considering the infrequent casting of one's ballot as citizen responsibility, deliberative democracy is centered in the process of opinion formation *via* citizen-to-citizen discourse.

The preceding definitions of deliberative democracy all revolve around the concept of opinion formation grounded in dialogue, which is why deliberative democracy is frequently referred to as discursive democracy (Dryzek, 1994). Such conceptualizations of democracy, however, do not ignore voting behavior and other forms of citizen expression and action. Yet, as Delli Carpini, Cook, and Jacobs (2004) have argued, a full understanding of citizens' civic participation must include examination of the communicative processes of opinion and will-formation that precede voting. Different scholars adopt different definitions according to what they consider to be the essential features of the deliberative process. However, what remains central to most operational and conceptual definitions of deliberation is citizens' face-to-face discussion that crosses lines of political difference (Mutz, 2006).

Scholars have also advanced competing claims in defining what kind of citizen talk should be considered deliberation. Schudson (1997) claimed that casual conversation is fundamentally different from *political* talk. Denying the view that "conversation is the soul of democracy," he claimed that for conversation to have any democratic value, it needs to be rule-governed, civil, and involve problem solving. Similarly, in their effort to define deliberation, Burkhalter, Gastil, and Kelshaw (2002) stated that a discussion can be considered more deliberative when it incorporates accurate knowledge of relevant information and is set in a face-to-face small-group discussion. Chambers (2003) claimed that deliberation occurs in the form of debate and discussion aimed at producing reasonable, well-informed opinions in which participants are willing to revise preferences in light of discussion, new information, and claims made by fellow discussants. She also added that although consensus is not the ultimate goal of deliberation, the legitimacy of outcomes would ideally characterize successful or useful deliberation.

Other scholars have argued more broadly about what constitutes citizen deliberation. Based on the argument that the rather ideal communicative requirements suggested by political theorists are rarely found in daily life (Eliasoph, 1998; Sanders, 1997), Mutz (2006) contended that to adequately "test" a theory

of deliberative democracy, citizens' everyday conversations about politics should receive the same empirical attention from scholars as deliberation found in more formal public forums, town meetings, and deliberative opinion polls. She did not refute the benefits of these forms of deliberation but questioned the generalizability of these communicative behaviors and events to larger populations and issues. In her research, Mutz documented the benefits of citizen deliberation from her more minimalist theoretical definition of cross-cutting exposure and citizens' exposure to oppositional political perspectives through everyday political talk (Mutz, 2002, 2006; Mutz & Mondak, 2006). Similarly, Kim et al. (1999) claimed that political conversation should not be treated as an intervening variable with only secondary significance but instead needs to be treated as central to participatory democracy. Delli Carpini et al. (2004) defined discourse with other citizens—talking, discussing, debating, and/or deliberating—as public deliberation and saw such types of discourse as important forms of political participation.

While the literature varies on what constitutes deliberation, there seems to be wide consensus regarding the benefits of engaging in political discourse. Scholars have identified benefits from both rule-governed and informed discussions as well as casual political conversations. Informed, rule-governed, and goal-oriented political talk was found to influence one's level of political sophistication (Gastil & Dillard, 1999) and increase the coherence of ideological beliefs and policy (or candidate) choice (Gastil, Black, & Moscovitz, 2008), resulting in greater comprehension of others' views (Moy & Gastil, 2006). Comparing the influence of adults' political conversation and talk, Scheufele (2000) found that goal-oriented political talk was significantly related to political participation and increased factual knowledge, whereas casual political conversations did not have any influence on either of these specific outcomes.

On the other hand, Kim et al. (1999) found that casual political conversations have a positive influence on the quality of opinions and campaign-related participatory activities. Similarly, Mutz and Mondak (2006) found that adults' casual conversations about politics in the workplace increase understanding of oppositional viewpoints and also produce increased political tolerance. Contrasted with Scheufele's (2000) findings, Wyatt, Kim, and Katz (2000) found that ordinary political conversation (whether general political conversation or issue-specific talk) contributed to increased campaign participation. Thus, it seems that taking an either-or approach to defining deliberation (formal rule-based deliberation vs. informal conversation) is somewhat futile as both forms of political deliberation produce beneficial outcomes.

As scholars are building knowledge on what deliberation achieves and how it can benefit democracy, it seems necessary to include an understanding of political deliberation as a communication tool for educating younger citizens and socializing these citizens in deliberative behaviors. A fundamental assumption of deliberative

democracy is that civic competence can be practiced and refined (Warren, 1992). If this is the case, there is ample reason to include deliberative actions as part of a civic education curriculum. As scholars have begun to subject theoretical assumptions of deliberative democracy to empirical verification, additional research needs to explore the beginning of deliberative dispositions in civic education and in the larger realm of political socialization (see McDevitt & Kiousis, 2006). Thus, this study builds on the theoretical and empirical findings of a deliberative democracy framework and extends this knowledge to two agents of political socialization where deliberation is considered most likely to happen: informal peer group interaction and formal school education.

Family and Peer Influence in Adolescent Political Socialization

While there are many social contexts in which adolescents become socialized as citizens or develop their sense of a political "self," the earliest political socialization research identified parents as the primary socialization agent for children. Thus, it is no surprise that a number of political socialization studies over several decades all point to the importance of family communication styles, parental political identification, and parental political participation as key influences in children's political socialization (Chaffee, McLeod, & Wackman, 1973; Saphir & Chaffee, 2002). Research has found that as early as 8 years old, children start to understand politics through the perspective of their parents and make statements or judgments about politics congruent with their parents' views (Easton & Dennis, 1969).

The ability to reason logically, to think abstractly, and to apply such thoughts to concrete situations is better developed in adolescence than childhood. According to Piaget's notion of cognitive development, concrete operation happens from about ages 8 to 11, while formal operations where children are able to mentally manipulate abstract concepts and ideas that serve as a fundamental bases of politics only begins to happen during the ages of 12 to 17 (Brainard, 1978). While it is possible for children from ages 7 to 11 to grasp descriptive concepts such as political interest or even recognition of particular politicians, it is not until later that adolescents develop their ability to think about political matters much as "adults" do. After the rebirth of political socialization research (Niemi & Hepburn, 1995), much of the most recent scholarship in this area has focused on young citizens from 12 to 17, with this work also abandoning the earlier, more descriptive studies in favor of more theoretically grounded explorations of the development of political socialization processes.

However, adolescence is marked as developmentally different from childhood in many ways, including the desire to search for autonomy from one's parents and a pursuit of one's own social identity. Studies have shown that adolescents start to break away from the dominant influence of their parents, seeking an identity

they regard as their own (Shaffer, 2009). As Erikson (1966) stated, "adolescence is a time of trial and experimentation, a time during which the search for identity quickens" (p. 293). This is a time, too, when teenagers start to ask questions about their parents' social and political claims and begin to formulate their own arguments. Marcia (1980) noted that the development of adolescent identity formation relies largely on whether they have explored various alternatives and made firm commitments to an occupation, a religious ideology, or formed political values. In terms of political identity formation, some research has also shown that adolescents can encourage their parents to be more politically engaged (McDevitt, 2005; McDevitt & Chaffee, 2000, 2002). In fact, such efforts to influence parents' political attitudes and engagement are usually accompanied by a shift in the structure of family communication patterns, driven by the adolescent's desire for greater autonomy in the development of one's political self (McDevitt, 2005).

Another consequence of adolescents' autonomy-seeking behaviors can be found in their peer group formation. During this period, most teenagers start to spend more time communicating with peers than with their parents. In developing social identity, one's peer group can serve as a "mechanism for the resolution of identity crisis" (Shaffer, 2009, p. 57). Studies in developmental psychology show that peer influence can be both pro- and anti-social (Ingoldsby, Shaw, Winslow, Schonberg, & Criss, 2006). Also, peer relationships are stronger predictors of general social skills, both during adolescence and later adulthood (Shaffer, 2009). Even though the importance of peer relationships has been found in a number of pro-social contexts, such as sexual education, smoking, and drug use (Gardner & Steinberg, 2005), the political socialization literature has given only limited attention to peer group influence (Campbell, 1980; McDevitt & Kiousis, 2006).

In providing a rationale for the scant analysis of peer group political socialization, Silbiger (1977) has argued that by the time adolescents become decreasingly dependent on formal agents of socialization such as the family and school and interact more frequently and intensely with peers, those in their teen years have already developed a somewhat stable political identity and thus have less need for political socialization. This argument, however, is rather limited in its understanding of the scope of political socialization. The development of one's political identity does not occur in a necessarily fixed progression or maturation that entails the finite acquisition of political or partisan identification or the simple mastery of requisite civic knowledge or understanding of relevant political processes. Indeed, from a political communication perspective, political socialization represents a dynamic process of ongoing political engagement and continued knowledge acquisition and attitude formation, with one's political self in constant refinement through interaction with others.

As one of the early and few efforts to study peer influence in political socialization, Sebert, Jennings, and Niemi (1974) examined the political texture of peer

groups in the frequently cited *Political Character of Adolescence*. When comparing adolescent relationships between family and peers, they found that adolescent-peer interaction had a much greater influence on political issue positions; yet, for party identification, the adolescent-parent influence was greater. In other words, adolescents were more likely to depend on familial cues to anchor their partisan identification, while the influence of peers was more prominent in forming adolescents' political issue positions (see also Tedin, 1980). While the Sebert et al. study is limited in using only correlations to compare the potential influence of socialization agents, it does provide important insight into the independent influence of peer groups, compared to parents, on the formation of adolescents' political identity.

More recently, Da Silva, Sanson, Smart, and Toumbourou (2004) found that peer encouragement and peer civic participation were stronger predictors of Australian adolescents' sense of civic responsibility than parents and school. Similarly, Harell, Stolle, and Quintelier (2008) found that frequent conversations with peers about politics or public issues predicted higher political participation in Belgium and Canada. In the US, Zaff, Malanchuk, and Eccles (2008) found similar results that showed peer support and communication were strongly associated with not only one's concurrent civic engagement but also with future political engagement during young adulthood. Finally, McDevitt and Kiousis (2007) found that in terms of political activism, family and school acted as socialization agents promoting compliant voting (voting the same as one's parents), while peer group discussion fostered greater political activism. These findings all suggest that the peer relationship is not an inconsequential socialization agent with little or no effect on one's political identity and behaviors but instead functions as an independent agent with a specific role in political socialization processes.

Here, two important themes emerge from the extant studies examining the potential influence and benefits of peer group engagement in political socialization. First, peer group interaction can provide empathy and mutual respect, compared with a more hierarchical influence teenagers receive from the advice and instruction of parents and teachers (Tedin, 1980). It can be inferred from the findings of Sebert et al. (1974) that for peers to have a significant influence on political socialization, group members must share a common interest in politics. When group members share some level of political sophistication, politics will be viewed as a discussable topic (Harvey, 1972). Once that environment is set, what happens between peers regarding the discussion of politics may be viewed less as an educational effort but more one of sharing opinions and verifying the validity of one's own views and beliefs, a process that can be very different from talking to one's parents or an authority figure, such as a teacher, about politics. Peer relationships do not have the same hierarchical relationships as does interacting with one's parents or teachers (Shaffer, 2009). In one's peer group environment, no one

is typically above another—as parents or teachers would be—and this more equal relationship with friends can provide a comparatively safer ground for adolescents to discuss politics and public issues.

Another important role of peer groups in political socialization is the possibility of cross-cutting exposure between peer members. Clearly, peer group memberships are not often based on a particular interest in politics, as one's peer interactions may be determined more by such features as academic achievement, sports interest, or perhaps even by popularity or "status" (Harvey, 1972). Yet, such relationships are different from the parental influence where political perspectives are usually inculcated to children. The array of peer group relationships may promote exposure to greater political diversity than the homogeneous characteristics of family communication. Campbell (2007) has theorized that while discussion of political issues is an important activity for all citizens, exposure to competing views and attitudes is especially important for younger citizens as they are forming their own political values and identity. Thus, friendship networks may serve as a useful source of political conversation or discussion for adolescents, one that might include at least some diversity of attitude and opinion.

In sum, while comparatively under-explored within the political socialization literature, peer groups may provide a more egalitarian realm for the testing of one's political views. Also, greater diversity of political thought may be found in everyday peer groups as one's political commitments are not typically a major determinant of adolescent friendships. Such communicative network features would seem to encourage cross-cutting exposure and deliberation within the comfort of a peer group conversation.

School Education and Deliberative Democracy

Another arena where adolescents are socialized politically and exposed to peer groups is at school. Indeed, some scholars claim that adolescents' autonomy in political socialization derives mainly from their formal educational experiences. School civic education curriculum focusing on open discussion and opinion formation has been found to be an effective tool in increasing both political knowledge and political efficacy among adolescents (Meirick & Wackman, 2004; Pasek, Feldman, Romer, & Jamieson, 2008). Calling school education the "incubator of democratic participation," Pasek et al. (2008, p. 29) found that exposure to a school political education program called "Student Voices" improved participants' political efficacy, which in turn fueled long-term increases in political knowledge. Also, an expectation of political discussion among adolescents was found to predict an increase in political news use and political knowledge.

Identifying clear benefits of school education on adolescent political socialization, McDevitt and Chaffee (2002) found that adolescents can serve as motivators

for adults in the home to become more politically engaged. Labeling this phenomenon "trickle-up" socialization, McDevitt and Chaffee argued that school education can encourage students to engage in political conversations with their parents, and this communicative behavior often leads less engaged parents to become more engaged in political matters (McDevitt & Chaffee, 2000).

What school education can do to promote political conversation among friends (peer-to-peer political socialization) outside of the classroom has received much less attention than the "trickle-up" child-to-parent political socialization guided by formal civics curriculum. If school education can encourage adolescents to start a political conversation with their parents at home, we might expect school-based civics education to have a similar influence in making politics and public issues more salient for discussion among peer groups. McDevitt and Kiousis (2006) examined whether deliberative instruction, which was measured through students' participation in classroom debates, would carry over to political discussion with friends. In fact, they found that school instruction on political discussions and debates not only encouraged more political discussion with family members but also with close friends. Further, they found that deliberative education increased willingness to disagree in political conversation, willingness to listen to political opponents, and willingness to test out one's opinions in conversations.

Returning to the dual categorization of goal-oriented political talk and casual political conversation, adolescents talking about politics with their peers in a less structured setting outside the classroom is what Mutz and Martin (2001) and Kim et al. (1999) labeled political conversation. On the other hand, the structured, more formal political discussions that are part of a classroom curriculum, with the goal of reaching a conclusion in class, are considered problem-solving conversation or public deliberation as defined by Schudson (1997) and Burkhalter et al. (2002). School conversation has not only the benefits of face-to-face conversation that Burkhalter et al. argued for but also the availability of expert opinion and knowledge that is present in adults' public deliberation forums (Gastil & Dillard, 1999). That is, school education not only consists of discussion but also the inclusion of factual information that provides a basis for more informed opinion formation and deliberation.

Combining the two arenas of political deliberation, four hypotheses are posited regarding the relationship between two different types of peer interaction, including casual political conversation outside of class vs. formal public deliberation (i.e., political talk during civics education) that occurs in the classroom. It is argued that both types of deliberation, goal-oriented political talk and casual political conversation, serve different but equally important roles in adolescent political socialization. For the influence of casual peer conversation, it is hypothesized that this form of political talk will increase the likelihood of adolescents trying out opinions in different settings affecting increased political efficacy. On the other

hand, extrapolating Mutz's (2006) findings regarding adults' cross-cutting conversation to adolescents, it is hypothesized that peer influence and peer political conversation will not influence political knowledge or one's behavioral political participation but instead will have a positive influence on political tolerance and adolescents' willingness to try out their opinions outside of school and family. Thus, the hypotheses to be tested include:

H1: Adolescents active in deliberative learning activities in class will have higher political knowledge.

H2: Adolescents active in deliberative learning activities in class will be more active in political participation.

H3: Adolescents more active in political conversations with their peers will have higher political tolerance.

H4: Adolescents more active in political conversations with their peers will have higher willingness to share opinions with others.

METHOD

Description of Sample

To test the hypotheses, this study analyzed the second survey of the Future Voters Study (as described in the introduction), fielded between November 5 and December 10, 2008, immediately after the presidential election.

Predictor Variables

Multiple hierarchical regression was employed to test the research hypotheses. In the first block, adolescents' demographic information was entered, including age and political affiliation (1 = Strongly Democrat, 2 = Democrat, 3 = Independent, 4 = Republican, 5 = Strongly Republican).

Then, because it was expected that individual political interest would have a significant influence on the dependent variables of interest in this study, the second block included political interest, measured on a five-point scale (1 = Strongly Disagree, 5 = Strongly Agree) for the single item "I am interested in politics" ($M = 3.00$, $SD = 1.11$). News media use was entered in the third block. News media use was measured on an eight-point scale (0 to 7 days a week) asking how often one watched a national television newscast ($M = 2.37$, $SD = 2.32$), watched a local television newscast ($M = 2.06$, $SD = 2.27$), and read a print copy of a national newspaper ($M = .54$, $SD = 1.34$). To control for parental influence, both

in terms of political conversation and parental political participation, the fourth block included these two family political communication indices. Political conversation with family was a combination of both parents' and children's responses on how often they "talked about news or current events with family members" (r = .37, p < .001; M = 5.27; SD = 1.89). Parental political participation was an index of items including: "Contributed money for a charitable cause," "Wrote a letter or an e-mail to a news organization," "Did volunteer work," "Worked on a community project," and "Contributed money to a political campaign" (Cronbach's α = .72; M = 1.97, SD = 1.21).

The two main predictor variables in this study were outside classroom peer influences, and deliberative learning activities in school. First, peer influence was measured as a three-item index (1 = Strongly Disagree, 7 = Strongly Agree): "Among my friends, it is important to know what's going on in the world," "Among my friends, it is OK to talk about politics," and "Among my friends, it's OK to disagree" (Cronbach's α = .81; M = 3.67, SD = .88). General peer political conversation was measured with a single question asking how frequently they "talked about politics and public issues with friends (M = 4.27, SD = 2.17)." Deliberative learning in school was measured as a four-item index of questions asking youth how often they "followed news as a class assignment," "learned about how government works in class," "discussed/debated politics in class," and "participated in political role playing in class" (1 = Not at all, 7 = Very frequently). The scale reliability for this measure was also very high (Cronbach's α = .89; M = 3.40, SD = 2.01).

Dependent Variables

Political knowledge was an additive index of the following three questions that were put to participants: "Which political party is more conservative?" "Which political party controls the House of Representatives?" and "Which political party did Ronald Reagan belong to when he was president?" For each question, a correct answer was scored 1, while incorrect responses were 0 (M = 2.87, SD = 1.46).

For political participation, principal factors extraction with varimax rotation was first performed on 10 items measuring various political activities. Adolescents were asked their frequency of activity in the last 3 months on eight-point response scales (1 = Not at All, 8 = Very Frequently). The first factor was named *Classic Political Participation* (Variance explained = .48). Items loaded on this factor were "Wrote a letter or email to a news organization," "Worked for a political party or candidate," "Displayed a political campaign button, sticker or sign," "Participated in a political protest activity," "Contributed money to a political campaign," and "Attended a political meeting, rally or a speech" (Cronbach's α = .86; M = 1.41, SD = .97).

The second factor was named *Community Participation* (Variance explained = .15). Items loaded were "Did volunteer work," and "Worked on a community

project" (Cronbach's α = .86; M = 1.72, SD = 1.52). The item "Raised money for charitable cause" was cross-loaded on the first and second factor, so it was deleted. The third factor was *Political Consumerism* (Variance explained = .10) and the items loaded were "Boycotted products or companies that offend my values" and "Bought products from companies because they align with my values" (Cronbach's α = .84; M = 2.80, SD = 2.27).

Finally, political tolerance was measured with a single item asking agreement with "I think it is important to hear others' ideas even when they are different from mine" (1 = Strongly Disagree, 5 = Strongly Agree; M = 3.93, SD = .96). Adolescents trying out their political opinions was measured with two items that asked the frequency with which one "Talked about politics and public issues with someone who disagrees with me," and "Talked about politics and public issues with adults outside my family" (Cronbach's α = .89; M = 3.40, SD = 1.99).

RESULTS

The first hypothesis predicted that there would be a positive influence of in-class deliberative learning activity on political knowledge and political participation. After controlling for demographics, political interest, family influence, deliberative learning did not predict adolescents' level of political knowledge. Interestingly, peer influence did not have any significant influence on political knowledge either. Among the previous blocks, both political conversation with family members (β = .26, p < .001) and parental political participation (β = .12, p < .01) remained as significant predictors of political knowledge even after deliberative learning and peer influence were entered in the model.

The second hypothesis predicted a positive influence of in-class deliberative learning activity on political participation. Here, a different hierarchical regression model was run for the three different participation indices used in this study. First, for classic political participation, deliberative learning remained a positive significant predictor even after peer influence was entered in the model (β = .17, p < .01). Interestingly, peer conversation was a positive and significant predictor of political participation (β = .15, p < .01) but not for other participation variables. In-class deliberative learning activity was a significant predictor for community participation (β = .16, p < .001) and political consumerist activities (β = .16, p < .001). Thus, there was strong support for the second hypothesis. While not posited as a research hypothesis, neither peer influence nor peer conversation had any influence on any participation indices or political knowledge.

The third and fourth hypotheses examined the relationship between open peer environment on political tolerance and the extent to which one was willing to try out political opinions outside of family and school. In terms of the third

Table 1. Hierarchical Regression Model for Adolescents.

	Political Knowledge	Classic Political Participation	Community Participation	Political Consumerism	Political Tolerance	Trying out Opinions
Block 1						
Age	.09	.01	−.01	.06	.05	.14***
Party ID (R)	−.001	−.16	−.08*	−.02	−.08	.02
R^2 Change	.008	.03***	.01	.004	.008	.019**
Block 2						
Political interest	.16**	.26***	.24***	.17***	.30***	.52***
R^2 Change	.14**	.067***	.06***	.03***	.09***	.26***
Block 3						
National television use	−.04	.19***	−.04	−.001	−.06	.02
Local television news	.06	−.05	.03	.11*	.09	.13*
Local newspaper use	−.07	.09*	.15**	.04	.03	.05
R^2 Change	.005	.04***	.02**	.02**	.005	.02***
Block 4						
Family talk about politics and public issues	.24***	−.001	.29	.07	.14**	.48***
Parental political participation	.11**	.41***	.40***	.29***	−.01	.04
R^2 Change	.08***	.156***	.17**	.09***	.015**	.19***
Block 5						
Deliberative learning in school	.07	.155***	.21***	.17***	.10*	.25***
R^2 change	.004	.017***	.03***	.02***	.007*	.04***
Block 7						
Peer Influence	.01	−.053	−.01	.03	.42***	−.04
Peer conversation about politics and public issues	−.01	.153**	.32***	.05	−.04	.78***
R^2 change	.000	.011**	.05***	.002	.12***	.29***
Total R^2	.112***	.316***	.16***	.228***	.24***	.82***

$F(10) = 11.929$*** (*$p < .01$. **$p < .01$; ***$p < .001$).

hypothesis, peer influence was a positive and significant predictor of political tolerance ($\beta = .42$, $p < .001$), while peer conversation was not a significant predictor. Deliberative learning activity was significant when entered in the regression model ($\beta = .10$, $p < .05$), but became insignificant once peer variables were entered. Peer conversation was a strong predictor ($\beta = .78$, $p < .001$) of trying out political opinions outside of family and school along with deliberative learning ($\beta = .10$, $p < .001$) and political conversation with family members ($\beta = .05$, $p < .05$). However, peer influence had no significant impact on the extent to which adolescents were willing to try out political opinions outside of family and school.

DISCUSSION

This study sought to better understand the role of peers in political socialization by examining adolescents' political conversation behaviors. The investigation incorporated different conceptual definitions of deliberative discourse, including more structured political talk as part of in-class political discussions and also informal political conversations found in one's peer group interactions. It was hypothesized that peer group conversation would achieve the benefits reported in previous literature regarding casual, cross-cutting political conversations; and structured, in-class political discussions would have similar effects as formal political talk found in public deliberation forums. Results showed that adolescents' informal peer political conversations influenced their level of political tolerance and likelihood to try out opinions in different settings, whereas political talk in school activity had a positive influence on various types of political participation. Political knowledge was not predicted by either peer group conversation or structured civic learning but was mostly explained by political conversations with family members and parental political participation.

It is impressive that peer group influence and peer group conversation seem to play different roles in adolescents' political socialization. This study suggests that one's peer group has an independent role in political socialization processes apart from family and school. The study's peer group influence index consisted of such items as frequency of talking politics in one's peer group and willingness to accept disagreement of opinion among one's peers. Political heterogeneity and tolerance within one's peer group were a significant predictor of further political tolerance, while none of the school education factors or family influence remained as predictors of the level of political tolerance. This suggests that peer group interaction has an independent role on political socialization, an influence that increases political tolerance among adolescents. For adults, being involved in politically heterogeneous networks significantly influences how much they are open to disagreements and their willingness to engage with people who have opposing perspectives

(Mutz, 2006). For adolescents, while family and school may be acting as more homogeneous socializing networks, one's peers may be more heterogeneous and socialize in ways that family and school do not by fostering greater political tolerance. Also, in terms of political knowledge, it seems possible that the homogeneous characteristics of family aid adolescents in gaining more political knowledge than either school or peer group influence.

Another important finding of this study is the role of peer conversations in adolescents' willingness to test their political opinions outside of family and school. Peer conversation, family conversation, and deliberative learning at school were all significant predictors of political conversation outside of family and school. For political conversation to happen outside the adolescents' familiar zone, they may need the help of those with whom they feel most comfortable in first testing their opinions. Speaking up about politics is a somewhat infrequent and often uncomfortable action to take, as Mutz (2006) suggested for adults. Adolescents are more encouraged to take this uncomfortable, yet necessary, political action with their peers through the political influence from family members, especially parents, and in-class discussion activities from schools.

Finally, adolescents' structured in-class political talk, rather than casual political conversation among peers, predicted their political activities. This finding highlights the importance of deliberative education as part of formal school curricula to encourage adolescents' civic participation. Indeed, it may well be too little, too late, to wait until young citizens reach voting age to begin the process of educating and encouraging civic and electoral participation. Our results provide clear evidence that structured civic education and in-class deliberative activities for adolescents can be crucial in the development of future engaged citizens. Of course, the cross-sectional nature of our data limits the ability to predict future behavior, but previous studies suggest that civic education in adolescence persists until at least early adulthood (Zaff, Malanchuk, & Eccles, 2008). Future efforts to study the effects of school civic education on adolescents' political socialization continuing through adulthood are essential to answer this question of the lasting influence of deliberative education.

As an exploratory study, this investigation is not free from limitations. Many variables used in this study were measured via single item, decreasing the reliability of these measures (including political tolerance and peer group conversations). However, the statistically significant results suggest findings from these indices may be substantive. Also, while many earlier studies include the number of peer group members or the number of members in one's everyday discussion networks to understand the influence of the size of political discussion networks (Moy & Gastil, 2006), this study unfortunately did not include a measure of network size. It can be inferred from the extant literature of adult political behavior, however, that network size may also have an important influence on various political

outcomes, such as discussion frequency or overall political tolerance. For future studies, adolescents' discussion network size should be included to further examine the details of adolescent political deliberation. Finally, in the current study, age was entered as a control variable and found to be a positive and significant predictor of how much adolescents expressed their opinion to others. In other words, there was a difference between older and younger teenagers in terms of how likely they would be to express their opinion about politics. While exploring differences between the political behaviors and attitudes of younger and older teenagers is not the particular focus of the current study, future studies that examine the role of age in deliberation and political discussion might be useful in planning civic and deliberation education curricula.

Despite these limitations, the current study contributes to our knowledge of political socialization by examining the importance of peer groups in the development of political attitudes and behaviors in adolescence. Evidence indicates that peer group environment and peer group conversation about politics are critical in developing political tolerance and willingness to express one's political opinions in less familiar settings. The findings also demonstrate that deliberative learning activities in the classroom serve as the formal political deliberation that increases adolescents' political participation and knowledge. Thus, this study supports the notion that peer group political deliberation—both in-class activity and outside the classroom setting—serves an important role in adolescents' political socialization.

REFERENCES

Brainard, C. J. (1978). *Piaget's theory of intelligence*. Englewood Cliffs, NJ: Prentice-Hall.

Burkhalter, S., Gastil, J., & Kelshaw, T. (2002). A conceptual definition and theoretical model of public deliberation in small face-to-face groups. *Communication Theory, 4*, 398–422.

Campbell, B. A. (1980). A theoretical approach to peer influence in adolescent socialization. *American Journal of Political Science, 24*(2), 324–344.

Campbell, D. E. (2007). Sticking together: Classroom diversity and civic education. *American Politics Research, 35*(1), 57–78.

Chaffee, S. H., McLeod, J., & Wackman, D. (1973). Family communication patterns and adolescents political participation. In J. Dennis (Ed.), *Socialization to politics: A reader* (pp. 349–364). New York, NY: John Wiley.

Chambers, S. (2003). Deliberative democratic theory. *Annual Review of Political Science, 6*(1), 307–326.

Da Silva, L., Sanson, A., Smart, D., & Toumbourou, J. (2004). Civic responsibility among Australian adolescents: Testing two competing models. *Journal of Community Psychology, 32*(3), 229–255.

Delli Carpini, M. X., Cook, F. L., & Jacobs, L. R. (2004). Public deliberation, discursive participation, and citizen engagement: A review of the empirical literature. *Annual Review of Political Science, 7*, 315–344.

Dryzek, J. S. (1994). *Discursive democracy: Politics, policy, and political science*. Cambridge, England: Cambridge University Press.

Easton, D., & Dennis, J. (1969). *Children in the political system.* New York, NY: McGraw-Hill.

Eliasoph, N. (1998). *Avoiding politics: How Americans produce apathy in everyday life.* Cambridge, England: Cambridge University Press.

Erikson, E. (1966). Eight ages of man. *International Journal of Psychiatry, 2,* 281–300.

Gardner, M., & Steinberg, L. (2005). Peer influence on risk taking, risk preference, and risky decision making in adolescence and adulthood: An experimental study. *Developmental Psychology, 29,* 622–632.

Gastil, J., Black, L., & Moscovitz, K. (2008). Ideology, attitude change and deliberation in small face-to-face groups. *Political Communication, 25*(1), 23–46.

Gastil, J., & Dillard, J. P. (1999). Increasing political sophistication through public deliberation. *Political Communication, 16*(1), 3–23.

Harell, A., Stolle, D., & Quintelier, E. (2008, July 3–4). *Network diversity and political participation: A complication or asset?* Paper presented at the Conference on Comparative Perspectives on Political Socialization, Bruges, Belgium.

Harvey, T. G. (1972). Computer simulation of peer group influences on adolescent political behavior. *Midwest Journal of Political Science, 16*(4), 570–602.

Ingoldsby, E. M., Shaw, D. S., Winslow, E., Schonberg, M., & Criss, M. M. (2006). Neighborhood disadvantage, parent-child conflict, neighborhood peer relationships, and early anti-social behavior problem trajectories. *Journal of Abnormal Child Psychology, 34,* 303–319.

Kim, J., Wyatt, R. O., & Katz, E. (1999). News, talk, opinion, participation: The part played by conversation in deliberative democracy. *Political Communication, 16,* 361–385.

Marcia, J. E. (1980). Identity in adolescence. In J. Adelson (Ed.), *Handbook of adolescent psychology* (pp. 159–187). New York, NY: Wiley & Sons.

McDevitt, M. (2005). The partisan child: Developmental provocation as a model of political socialization. *International Journal of Public Opinion Research, 18*(1), 67–88.

McDevitt, M., & Chaffee, S. H. (2000). Closing gaps in political communication and knowledge: Effects of a school intervention. *Communication Research, 27*(3), 259–292.

McDevitt, M., & Chaffee, S. H. (2002). From top-down to trickle-up influence: Revisiting assumptions about the family in political socialization. *Political Communication, 19,* 281–301.

McDevitt, M., & Kiousis, S. (2006). Deliberative learning: An evaluative approach to interactive civic education. *Communication Education, 55*(3), 247–264.

Meirick, P. C., & Wackman, D. B. (2004). Kids Voting and political knowledge: Narrowing gaps, informing votes. *Social Science Quarterly, 85*(5), 1161–1177.

Moy, P., & Gastil, J. (2006). Predicting deliberative conversation: The impact of discussion networks, media use, and political cognitions. *Political Communication, 23,* 443–460.

Mutz, D. C. (2002). The consequences of cross-cutting networks for political participation. *American Journal of Political Science, 46*(4), 838–855.

Mutz, D. C. (2006). *Hearing the other side: Deliberative versus participatory democracy.* Cambridge, England: Cambridge University Press.

Mutz, D. C., & Martin, P. S. (2001). Facilitating communication across lines of political differences the role of mass media. *American Political Science Review, 95*(1), 97–115.

Mutz, D. C., & Mondak, J. J. (2006). The workplace as a context for cross-cutting political discourse. *The Journal of Politics, 68*(1), 140–155.

Niemi, R. G., & Hepburn, M. A. (1995). The rebirth of political socialization. *Perspectives on Political Science, 24*(1), 7.

Pasek, J., Feldman, L., Romer, D., & Jamieson, K. H. (2008). Schools as incubators of democratic participation: Building long-term political efficacy with civic education. *Applied Developmental Science, 12*(1), 26–37.

Sanders, L. M. (1997). Against deliberation. *Political Theory, 25*(3), 347–376.

Saphir, M. N., & Chaffee, S. H. (2002). Adolescents' contributions to family communication patterns. *Human Communication Research, 28*(1), 86–108.

Scheufele, D. A. (2000). Talk or conversation?: Dimensions of interpersonal discussion and their implications for participatory democracy. *Journalism & Mass Communication Quarterly, 77*(4), 727–743.

Schudson, M. (1997). Why conversation is not the soul of democracy. *Critical Studies in Media Communication, 14*(4), 297–309.

Sebert, S. K., Jennings, M. K., & Niemi, R. G. (1974). The political texture of peer groups. In Jennings, M. K., & Niemi, R. G. (Eds.) *The political character of adolescence: The influence of families and schools* (pp. 229–248). Princeton, NJ: Princeton University Press.

Shaffer, D. R. (2009). *Social and personality development* (9th ed.). Boston, MA: Wadsworth.

Silbiger, S. L. (1977). Peers and political socialization. In S. A. Renshon (Ed.), *Handbook of political socialization* (pp. 172–189). New York, NY: Free Press.

Tedin, K. L. (1980). Assessing peer and parent influence on adolescent political attitudes. *American Journal of Political Science, 24*(1), 136–154.

Warren, M. (1992). Democratic theory and self-transformation. *The American Political Science Review, 86*(1), 8–23.

Wyatt, R. O., Kim, J., & Katz, E. (2000). How feeling free to talk affects ordinary political conversation, purposeful argumentation and civic participation. *Journalism and Mass Communication Quarterly, 77*(1), 99–114.

Zaff, J. F., Malanchuk, O., & Eccles, J. S. (2008). Predicting positive citizenship from adolescence to young adulthood: The effects of a civic context. *Applied Development Science, 12*(1), 38–53.

Knowledge Gap IN A Media-Saturated Presidential Election

JOONGHWA LEE, CHANG DAE HAM, AND ESTHER THORSON

With political information now available from all kinds of online content, 24/7 cable news, mobile media, late-night satire, in addition to more traditional news sources such as newspapers and local and network television, it is hard to imagine that any American today would fail to acquire the most basic political knowledge. Indeed, with continuous innovations in digital technology, news and political information are now available constantly via one's smartphone and recirculate and echo endlessly in social networks and blogs. The ubiquity of political communication and news leads us to question whether classic knowledge gaps remain in today's media-saturated environment? The focus of the current study examines adolescent political socialization processes, and our exploration is guided by acknowledged assumptions that parental education and political participation interact with media use to produce knowledge gaps.

In our investigation of the knowledge gap hypothesis it is important to recognize that as innovations in media technology facilitate greater access to news, there is also a simultaneous increase in entertainment content. As Neil Postman (1985) argued more than 25 years ago, citizens may well now be amusing themselves to death, often to the detriment of learning about one's world, including the political world during a high salience U.S. presidential campaign. A more modern version of Postman's lament (e.g., Prior, 2005, 2007) suggests that with the proliferation of communication channels, people have increasing opportunity to avoid news altogether simply by selecting only entertainment or social media.

The first wave of the Future Voters Survey (as described in the introduction) provided an excellent opportunity to examine whether gaps in the political knowledge of young citizens were occurring in our current information environment of 24/7 news and omnipresent digital and entertainment media. Our analysis explores the classic interaction of parental education with media use and availability, comparing the use of television for entertainment and for information. We also examine parental political participation as an independent variable.

KNOWLEDGE GAP HYPOTHESIS

For decades, the knowledge gap theoretical perspective has been used to identify now well-established hypotheses as to how and why people's knowledge differs (Viswanath & Finnegan, 1996). The knowledge gap thesis has particular import for the political sphere as it derives from concerns about social hierarchies and the distribution of information throughout communities and society (Gaziano & Gaziano, 1999; Holbrook, 2002). Within the political realm, work grounded in the knowledge gap hypothesis has described the "haves" and "have-nots" in terms of political knowledge and those more and less likely to participate in the political process.

The major statement of the knowledge gap hypothesis was first articulated by Tichenor, Donohue, and Olien (1970) and posited that as information from the media enters a social system, the preexisting knowledge gap between those of the higher and lower socioeconomic status (SES) increases. Based on previous studies that found a positive relationship between SES and knowledge (e.g., Adams, Mullen, & Wilson, 1969, p. 549), Tichenor et al. (1970) articulated the gap hypothesis:

> As the infusion of mass media information into a social system increases, segments of the population with higher socioeconomic status tend to acquire this information at a faster rate than lower status segments, so that the gap in knowledge between them tends to increase rather than decrease. (pp. 159–160)

Thus, as the hypothesis suggests, it is expected that the gap in knowledge would be relatively greater between higher and lower SES with increased information flow (Donohue, Tichenor, & Olien, 1975; Eveland & Scheufele, 2000; Holbrook, 2002; Liu & Eveland, 2005).

There are five underlying reasons that have been offered to explain why knowledge gaps occur (Tichenor et al., 1970): (1) communication skills: more educated people are more able to use media and interpret media information (Delli Carpini & Keeter, 1996; Grabe, 2000; Tichenor et al., 1970); (2) prior knowledge: more educated people already have better information which will help them elaborate

new information obtained through mass media (Eveland & Scheufele, 2000; Höijer, 1989; Tichenor et al., 1970); (3) relevant social contacts: more educated people have broader interpersonal networks and activities that will provide exposure to additional information (Bonfadelli, 2002; Tichenor et al., 1970; Viswanath, Kosicki, Fredin, & Park, 2000); (4) selective use, acceptance, and storage of information: the level of one's education is highly correlated with voluntary exposure for accessing information via the mass media (Bonfadelli, 2002; Eveland & Scheufele, 2000; Tichenor et al., 1970); and (5) structure of the media system: higher-status people have the finances to acquire information-rich media such as newspapers and new technologies (Bonfadelli, 2002; Eveland & Scheufele, 2000; Tichenor et al., 1970).

These explanations suggest what an expansion of communication technologies might mean for political knowledge gaps. First, *communication skills* and *selective use* may lead to differential use of media, leading to gaps. Second, *prior knowledge*, which would vary by level of education, is a likely determinant of a knowledge gap. Differences in *social participation* would also be expected to lead to gaps. And finally, *media access*, clearly related to economic status, may create barriers to knowledge for many. Although, while education has traditionally been studied as a main factor relating to SES that causes knowledge gaps (Gaziano, 1983, 1997; Liu & Eveland, 2005), other factors such as interest, motivation, and information utility can also be considered factors that might create gaps (Ettema & Kline, 1977; Genova & Greenberg, 1979; Kwak, 1999; Viswanath & Finnegan, 1996).

The knowledge gap hypothesis presumes that there is *already* a certain gap in knowledge status between high and low SES groups, and information provided by the media increases this gap, further exacerbating group differences. The hypothesis implies that any attempts to equalize the distribution of information using the mass media are not only doomed to fail, but also that they actually increase inequality (Dervin, 1980; Ettema & Kline, 1977; Viswanath, Jahn, Finnegan, Hertog, & Potter, 1993). Furthermore, when there is a discrepancy in knowledge distribution, the major impacts of the knowledge gap result in disparities in political knowledge and political participation (Eveland & Scheufele, 2000). Gaziano (1983) has found that knowledge gaps are observed more often when the knowledge in question is in-depth and complex. Understanding political information is important because obtaining political knowledge links to additional economic and social benefits, as well as other political participation indexes such as voting (Delli Carpini & Keeter, 1996; Mastin, 2000).

A number of researchers have studied knowledge gaps in terms of political knowledge, especially focusing on presidential elections (e.g., Eveland & Scheufele, 2000; Holbrook, 2002; Kwak, 1999; Liu & Eveland, 2005). While almost all of the existing studies have been of adult political knowledge, it is also important to investigate children's political knowledge. For youth, parental role is a key factor in

one's political learning (Atkin, 1981; Austin & Pinkleton, 2001; Kraus & Davis, 1976). For example, more political discussion with parents influences the development of children's understanding and perceptions of voting (O'Keefe & Liu, 1980). Therefore, we need to consider parental influence when examining political knowledge in children.

Here we postulate four main factors that affect children's political knowledge difference: media use, education, media access, and social activities. These factors are explored in the framework of both children and parents so that we can investigate parental influence in children's political knowledge gaps. For children's own influence, children's media use is considered; for parental influence, parental education, media access in the home, and political activity are considered. These parental factors can affect their children's attitudes and behaviors in that parents are children's first social learning role models (Bandura, 1989; McDevitt & Chaffee, 2002). Hence, there is a fundamental assumption in the current study that children's political knowledge gap is affected by their parents.

CHILDREN'S MEDIA USE AND CHILDREN'S POLITICAL KNOWLEDGE

Knowledge gap patterns as functions of exposure to different media use have been one of the most critical issues explored in the knowledge gap hypothesis (Kwak, 1999; Viswanath & Finnegan, 1996). There is an assumption that people's media use habits cause knowledge gaps as different social groups and individuals utilize different media to search for and acquire information (Bonfadelli, 2002). As media use increases, so too does one's knowledge of an issue (Fathi, 1973; Greenberg, 1964; Kwak, 1999). Still, when information becomes available and individuals access it via different mass media, inequalities in retaining that information will occur (Holbrook, 2002). In general, the particular media one most often uses will make a difference in knowledge gaps. Newspapers, for example, provide more contextual information and details than television (Eveland & Scheufele, 2000; Graber, 1994). Therefore, we posit that exposure to the structure and the content of newspapers is expected to have a highly positive effect on political knowledge.

H1: There will be a positive main effect of use of newspapers on political knowledge.

For television use, there are specific differences that emerge in the level of information acquired according to people's gratification to pursue information and entertainment (Bonfadelli, 2002). When people use television for the acquisition of news information, they consider television an informative medium like

newspapers; on the other hand, when people watch television largely for entertainment, such use does not appear to boost one's information gathering.

Putnam (1993, 1995) argued that television use has a detrimental effect on knowledge of one's political environment and also limits one's participation with others in improving their communities. In response to this notion, many researchers examined in a more detailed way how television was being used (Fleming, Thorson, & Peng, 2005; Milner, 2002; Norris, 1996; Shah, 1998; Shah, McLeod, & Yoon, 2001); and what they found was that greater use of television for entertainment did indeed damage community participation, as well as knowledge about, and interest in, politics. Still, use of television for news, and indeed interest in news in general, increased knowledge and political interest and participation (McLeod, Scheufele, & Moy, 1999). The existing studies make clear a bifurcation of television's impact on knowledge: negative for entertainment use and positive for informational use. Thus, we posit:

> **H2:** There will be a negative main effect of use of entertainment television on political knowledge.

Furthermore, when individuals use television for information motivation, they are more likely to engage with political issues (Shah, McLeod, & Yoon, 2001); and a number of studies have found that television news does contribute to learning of political information (Chaffee & Frank, 1996; Eveland & Scheufele, 2000; Graber, 1990; Kwak, 1999). We therefore posit:

> **H3:** There will be a positive main effect of use of informational television on political knowledge.

Unlike traditional media use (i.e., use of newspapers and television), it is less clear if political knowledge occurs from using the Internet, and, specifically, news websites. Limited evidence suggests, however, that Internet use for news leads to knowledge gaps in adults (Bonfadelli, 2002). Because the amount of political information from news websites is structured not only by news providers but also by Internet users, such information can be unlimited and may also be homogeneous in political information content (Bonfadelli, 2002). Thus, as one seeks political information via the Internet, they will likely gain much more information than those who do not use the Internet for information acquisition. It seems clear that informational use of the Internet would also be expected to have a positive impact on one's political knowledge. On this front we posit:

> **H4:** There will be a positive main effect of Internet informational use on political knowledge.

PARENTAL EDUCATION AND CHILDREN'S
POLITICAL KNOWLEDGE

Education is often a main factor in the knowledge gap hypothesis (Tichenor et al., 1970), and according to Gaziano (1983, 1997), income differences are strongly correlated with educational differences. Higher education is correlated with more informational media use, as those with higher educations are likely to attain more information and use the knowledge they have acquired in the public sphere (Genova & Greenberg, 1979; Holbrook, 2002; Tichenor et al., 1970; Wade & Schramm, 1969). In adults, education is the most powerful predictor of political knowledge (Bonfadelli, 2002; Liu & Eveland, 2005; O'Keefe & Liu, 1980; Patrick, 1977; Tichenor et al., 1970). Therefore, we include parental education level as another determinant of children's knowledge gap patterns and posit:

> **H5:** There will be a positive main effect of parental education level on children's political knowledge.

Graber (2001) provided evidence that people's information processing with audio-visual stimuli is quicker, easier, and more accurate, which may aid those with lower education levels. Therefore, there is reason to expect an interaction between education and television use for both information and entertainment. Higher education would be expected to ameliorate the negative impact of television entertainment use **(H6a)**, as well as to increase the positive impact of television informational use **(H6b)**.

With increased competition from television, newspapers have shifted their coverage from event-centered reporting toward stories with greater depth, analysis, and complexity (Barnhurst & Mutz, 1997). This characteristic of newspapers makes them more likely to attract high SES groups. These groups are better educated with greater information-processing abilities and more complex preexisting knowledge structures that enable them to process information more quickly and efficiently (Eveland & Scheufele, 2000; Kleinnijenhuis, 1991), abilities that are associated with newspaper use and also with knowledge gaps (Kleinnijenhuis, 1991; Gaziano, 1984, 1997; Griffin, 1990; Loges & Ball-Rokeach, 1993). In other words, newspapers require a certain level of literacy to be useful to news consumers in making political decisions. Therefore, highly educated groups are more likely to use newspapers and to learn political information from television than those who are less educated (Bogart, 1981; McLeod & Perse, 1994). We thus expect education and newspaper use to interact, demonstrating the knowledge gap pattern **(H6c)**.

With the growing number of news providers that are creating news websites, an increasing number of people now acquire their news via the Internet. Since 2006 the number of people who use online news every day has risen from 18%

to 25%. However, this increase is far greater among high rather than low education groups, with 44% of college graduates using online news every day, 30% of those who have attended, but not completed, college doing so, and only 11% of those with a high school education or less accessing online news on a daily basis ("Key News Audiences," 2008). Also, highly educated people use the Internet more actively to satisfy information, rather than entertainment, needs than do less-educated people (Bonfadelli, 2002; Shah, Kwak, & Holbert, 2001). Thus, we expect education and Internet informational use to interact, demonstrating the knowledge gap pattern (**H6d**).

MEDIA ACCESS AT HOME AND CHILDREN'S POLITICAL KNOWLEDGE

Low income is also a potential cause of knowledge gaps through reduced access to media in the home. Low income families are often "information poor" as they are less likely to be able to pay for home access to the Internet (Childers & Post, 1975; Severin & Tankard, 1997). Severin and Tankard (1997) have demonstrated that computer ownership at home is positively related to income. Historically, new communication technologies such as videotape recorders, cable television, home delivery of newspapers, and Internet have all appeared later in low income homes (Severin & Tankard, 1997). Clearly, lack of technology can exacerbate knowledge gaps (Dutta-Bergman, 2005; Lepper, 1985; Parker & Dunn, 1972; Severin & Tankard, 1997).

Hindman (2000) found that the presence of cable television provides more opportunity for children to be exposed to political information than is provided for those with only basic broadcast television. Similarly, the more newspapers delivered to a home, the greater ability a family has to increase its information (Gaziano, 1997). In comparison with traditional media, Internet access is even more critical given the increased information options it provides (e.g., social networks, video, e-mail, and blogs). Anand and Krosnick (2005) argued that the more media accessibility at home, the greater children's political information gathering. Thus, we expected increased political knowledge in children having cable at home (**H7a**), having a newspaper delivered to the home (**H7b**), and having Internet access at home (**H7c**).

Enhanced media accessibility at home may act in the same way enhanced parental education levels do, and thus we expected the knowledge gap interaction between home newspaper access and television use for entertainment (**H8a**), home newspaper access and the effects of television use for information (**H8b**), home Internet access and television use for entertainment (**H8c**), and home Internet access and television use for information (**H8d**).

PARENTAL POLITICAL PARTICIPATION AND CHILDREN'S POLITICAL KNOWLEDGE

Another important source of political information in the home is, of course, parents. Children learn and develop their ability to talk, think, and behave from their parents (Bandura, 1989; McDevitt & Chaffee, 2002). Such learning is particularly important in terms of developing children's political knowledge as political information is rather complicated for children to adopt by themselves (Gaziano, 1983; Kleinnijenhuis 1991). Therefore, children can obtain political knowledge by modeling their parents or socializing with their parents (McDevitt & Chaffee, 2002).

Active parental participation and interest in political activities such as voting and political discussion can itself have a positive impact on children's political interest and knowledge. For example, O'Keefe and Liu (1980) found that when children have political discussions with their fathers, they have higher levels of interest in voting. We thus posit:

> H9: There will be a positive main effect of parental political participation on children's political knowledge.

Finally, media play an important role in providing mobilizing information that triggers actual participation in political activities (Lemert, 1984). An assumption of the current study is that children's media use affects their degree of political knowledge. However, we hypothesize parental political participation may also affect the development of children's political knowledge via children's modeling of parents' behaviors. In this respect, we must consider children's media use and parental political participation simultaneously. In other words, these factors may well interact with each other in causing children's political knowledge gaps. Thus, we posit a knowledge gap interaction pattern between parental political participation and television information use (H10a), parental political participation and newspaper use (H10b), parental political participation and Internet for informational use (H10c), and parental political participation and television use for entertainment (H10d).

METHOD

The hypotheses were tested with the first survey of the Future Voters Study (as described in the Introduction), fielded between May 20 and June 25, 2008.

Measurement of the Variables

One dependent variable (i.e., children's political knowledge) was employed, with four groups of independent variables: (1) children's media use, (2) parent's education level, (3) media access at home, and (4) parent's political participation.

Children's media use included: (1) TV for information, (2) TV for entertainment, (3) reading newspapers, and (4) using the Internet for information. Each variable is measured by asking how many days in the typical week, from 1 day to 7 days, they used each medium. Table 1 summarizes the measures for each variable: TV for entertainment is measured by 10 items, TV for information by six items, newspapers by three items, and Internet information use by four items. All items achieved appropriate levels of reliability based on Cronbach's alpha (see Table 1). Continuously measured data were divided into high and low groups based on a consideration of each variable's distribution. Median scores for each variable were used to divide the variables for categorical level analysis (See Table 2).

Table 1. Variables and Measurements.

Variable	Measurement Item	Measurement Scale	Cronbach's alpha
TV for information	*The Today Show, Good Morning America*, or *The Early News*	None(0) ~ 7days a week (7)	0.77
	National nightly news on CBS, ABC, NBC	None(0) ~ 7days a week (7)	
	Local news about your viewing area	None(0) ~ 7days a week (7)	
	News magazine shows such as *60 Minutes*	None(0) ~ 7days a week (7)	
	CNN cable news program (Lou Dobbs, Larry King)	None(0) ~ 7days a week (7)	
	FOX cable news programs (Bill O'Reilly)	None(0) ~ 7days a week (7)	
TV for entertainment	Primetime reality programs	None(0) ~ 7days a week (7)	0.70
	Primetime comedy programs	None(0) ~ 7days a week (7)	
	Primetime cartoon programs	None(0) ~ 7days a week (7)	
	Primetime drama programs	None(0) ~ 7days a week (7)	
	Late-night TV shows	None(0) ~ 7days a week (7)	
	Game shows	None(0) ~ 7days a week (7)	
	Daytime talk shows	None(0) ~ 7days a week (7)	
	Teen programs	None(0) ~ 7days a week (7)	
	Daytime cartoon programs	None(0) ~ 7days a week (7)	
	MTV programs	None(0) ~ 7days a week (7)	

Newspaper	A print copy of a national newspaper	None(0) ~ 7days a week (7)	0.77
	A print copy of a local newspaper	None(0) ~ 7days a week (7)	
	Your school's student newspaper	None(0) ~ 7days a week (7)	
Internet information	National newspaper website (nytimes.com)	None(0) ~ 7days a week (7)	0.66
	Local newspaper website	None(0) ~ 7days a week (7)	
	Online-only news magazines (*Slate*, *Salon*)	None(0) ~ 7days a week (7)	
	TV news websites (cnn.com, foxnews.com)	None(0) ~ 7days a week (7)	
Parental education level	What was the highest level of school this child's father completed	Some high school (0) ~ More than MA (5)	Merging
	What was the highest level of school this child's mother completed	Some high school (0) ~ More than MA (5)	
TV access at home	What TV channels are available in your household?	Broadcast (0)/More than Basic cable TV (1)	n/a
Newspaper access at home	Is a national or local newspaper delivered to your household?	No subscription (0)/Subscription (1)	n/a
Internet access at home	Do you have access to the Internet at home, what speed?	No home access (0)/Low and High speed (1)	n/a
Parental political participation	Talk about news and current events with family members	Not at all (0)/Very frequently (8)	0.8
	Contributed money for a charitable cause	Not at all (0)/Very frequently (8)	
	Wrote a letter or email to a news organization	Not at all (0)/Very frequently (8)	
	Did volunteer work	Not at all (0)/Very frequently (8)	
	Worked on a community project	Not at all (0)/Very frequently (8)	
	Contributed money to a political campaign	Not at all (0)/Very frequently (8)	
	Attended a political meeting, rally, or speech	Not at all (0)/Very frequently (8)	

	Participated in a political protest activity	Not at all (0)/Very frequently (8)
	Did volunteer work	Not at all (0)/Very frequently (8)
	Worked on a community project	Not at all (0)/Very frequently (8)
Political knowledge	Which political party is more conservative?	Don't know/Democratic/ Republican
	Which political party controls the U.S. House of Representatives?	Don't know/Democratic/ Republican n/a
	Which political party did Ronald Reagan belong to when he was president?	Don't know/Democratic/ Republican

Table 2. Measurement Transformations.

Variable	Measurement Item	Level of groups	Criterion
Children's media use	TV for information	Low/High	Median = 0.60
	TV for entertainment	Low/High	Median = 1.40
	Newspaper	Low/High	Median = 0.67
	Internet information	Low/High	Median = 0.00
Parental education level	Parental education level	Low/Medium/High	1~2/2.5~3.5/4~5
Media access at home	TV access at home	Broadcast/Cable	Only broadcast/basic, premium, pay TV
	Newspaper access at home	No subscription/ Subscription	None/local, national newspaper
	Internet access at home	No Internet/Internet	None/Low-, high-speed Internet
Parental political participation	Parental political activity	Low/High	Median = 2.56

Parental education level was indexed on five-point scales ranging from 0 (some high school) to 5 (some graduate school). Mother's and father's education levels were additively combined. In the case of children with only one parent, the score is weighted, so that they are treated as having both parents who have the same education level of a single parent. For example, a child who has only a mother

who graduated college is treated as the same as a child who has both a college-graduated mother and father. Based on the distribution of the merged score of parents' education level, this variable was divided into high, medium, and low groups (See Table 2). On average, the low-education group includes some high school and high school graduate level, and the high group covers college graduates, with the medium group covering education attainment between the low and high groups.

Media access at home included: (1) TV access at home, (2) Newspaper access at home, and (3) Internet access at home. Each group was dichotomized into two groups, including a media use group versus a non-use group. TV access at home was dichotomized as those who only had broadcast TV and all others who pay for cable TV. Newspaper access at home was differentiated in terms of those who subscribe to a newspaper and those who do not. Internet access at home was also separated into two groups in terms of home access.

Parental political participation was measured by ten items (see Table 1) with a Cronbach's alpha of .80. Each item was measured by nine-point scales, 0 (not at all) to 8 (very frequently). This variable was dichotomized by the median split (median = 2.58) into high and low groups based on visual inspection of the distribution (see Table 2).

Children's political knowledge was indexed by the sum of correct answers to these questions: (1) Which political party is more conservative? (2) Which political party controls the U.S. House of Representatives? (3) Which political party did Ronald Reagan belong to when he was president? Correct responses ranged from 1 to 3 (M = .978, SD = 1.01, N = 1,291).

RESULTS

Analyses of variance were used to test the hypotheses. All results are shown in Table 3. The means and standard deviations for each comparison are shown in Tables 4–1 and 4–2. Knowledge gap patterns are depicted in Figures 1–5.

H1 and H4 suggested that children's newspaper and Internet information use would increase children's political knowledge. These hypotheses were supported for newspaper use [$F (1, 1,255) = 11.77, p < .05$] and also use of Internet for information [$F (1, 981) = 18.51, p < .05$]. H3 suggested that children's information use of television would increase children's political knowledge. This hypothesis was supported [$F (1, 1,257) = 8.81, p < .05$]. H2 suggested that children's entertainment television use would decrease children's political knowledge. This hypothesis was supported [$F (1, 1,255) = 29.53, p < .05$].

H5 suggested a main positive effect of parental education level. This hypothesis was strongly supported [$F (2, 1,272) = 41.82, p < .05$]. To investigate which

Table 3. ANOVA Tests for Each of the Hypotheses.

	Variable and Source	df	MS	F	Partial η^2
H1	Newspaper	1	11.87	11.77***	.01
H2	TV for information	1	6.88	8.81**	.01
H3	TV for entertainment	1	29.28	29.53***	.02
H4	Internet information	1	18.37	18.51***	.02
H5	Parent education	2	39.88	41.82***	.06
	Parental education level	2	42.70	45.11***	.07
	TV for information	1	9.12	9.68***	.01
H6a	Parental education level x TV for information	2	.63	.67	.00
	Parental education level	2	36.71	39.36***	.06
	TV for entertainment	1	19.51	20.92***	.02
H6b	Parental education level x TV for entertainment	2	3.36	3.61**	.01
	Parental education level	2	43.38	46.72***	.07
	Newspaper	1	17.39	18.73***	.01
H6c	Parental education level x Newspaper	2	12.46	13.42***	.02
	Parental education level	2	21.08	22.33***	.04
	Internet information	1	14.92	15.81***	.02
H6d	Parental education level x Internet information	2	3.17	3.36**	.01
H7a	TV access at home	1	.00	.00	.00
H7b	Newspaper access at home	1	27.22	27.43***	.02
H7c	Internet access at home	1	20.55	20.60***	.02
	TV for entertainment	1	22.93	23.64***	.02
	Newspaper access at home	1	26.15	26.96***	.02
H8a	Newspaper access at home x TV for entertainment	1	3.25	3.35[a]	.00
	TV for information	1	6.37	6.46**	.01
	Newspaper access at home	1	30.23	30.64***	.02
H8b	Newspaper access at home x TV for information	1	1.49	1.51	.00
	TV for entertainment	1	4.44	4.54*	.01
	Internet access at home	1	17.94	18.33***	.01
H8c	Internet access at home x TV for entertainment	1	3.00	3.61	.00

	TV for information	1	2.26	2.28	.00
	Internet access at home	1	19.27	19.41***	.02
H8d	Internet access at home x TV for information	1	.69	.69	.00
H9	Parental political knowledge	1	34.56	34.97***	.03
	TV for information	1	3.61	3.67*	.00
	Parental political participation	1	33.30	33.81***	.03
H10a	Parental political participation x TV for information	1	2.84	2.88ᵃ	.00
	Newspaper	1	7.11	7.24**	.01
	Parental political participation	1	35.09	35.72***	.03
H10b	Parental political participation x Newspaper	1	4.09	4.16*	.00
	Internet information use	1	10.03	10.35***	.01
	Parental political participation	1	17.54	18.10***	.02
H10c	Parental political participation x Internet information use	1	.17	.18	.00
	TV for entertainment	1	24.63	25.41***	.02
	Parental political participation	1	32.36	33.38	.03
H10d	Parental political participation x TV for entertainment	1	.01	.01	.00

$^{a}p < .10.$
$^{*}p < .05; ^{**}p < .01; ^{***}p < .001.$

difference mainly affected the significant difference between three levels of parent's education, we employed the Tukey HSD method as a post hoc test as it provides one of the most frequently used and conservative methods with respect to Type I error (Hair, Black, Anderson, & Tatham, 2006). Analysis using the Tukey HSD method at a 95% confident interval revealed the main effect of both differences between low and medium level education and medium and high education were significant ($p < .05$). As parent's education level is increased from low to high through medium, children's political knowledge is also increased.

H6a–H6d posited the knowledge gap patterns for parental education and the four types of media exposure. There was no support for the interaction between informational television use and parental education (H6a). Parental education did interact with newspaper [H6c]; F (1, 1,245) = 13.42, $p < .05$] and Internet information use [H6d]; F (2, 971) = 3.36, $p < .05$], with the typical knowledge gap pattern exhibited (see Figures 2 and 3).

There was also, as hypothesized, a significant interaction between television use for entertainment and parental education. This hypothesis was supported in

Table 4-1. Descriptive Statistics for Interaction Effects.

Parent education	TV for Info	M	SD	n	Parent education	TV for entertainment	M	SD	n
	Low	0.59	0.80	220		Low	0.72	0.93	198
Low	High	0.78	0.97	239	Low	High	0.66	0.87	262
	Total	0.69	0.90	459		Total	0.69	0.90	460
	Low	1.04	1.00	244		Low	1.26	1.01	254
Medium	High	1.12	0.99	241	Medium	High	0.88	0.94	232
	Total	1.08	1.00	485		Total	1.08	1.00	486
	Low	1.23	1.04	164		Low	1.48	1.05	181
High	High	1.47	1.06	144	High	High	1.14	1.04	127
	Total	1.34	1.05	308		Total	1.34	1.05	308
	Low	0.93	0.98	628		Low	1.15	1.04	633
Total	High	1.07	1.03	624	Total	High	0.84	0.95	621
	Total	1.00	1.01	1,252		Total	1.00	1.01	1,254

Parent education	Newspaper	M	SD	n	Parent education	Internet information	M	SD	n
	Low	0.70	0.91	251		Low	0.67	0.90	297
Low	High	0.68	0.89	208	Low	High	0.81	0.88	62
	Total	0.69	0.90	459		Total	0.69	0.90	359
	Low	1.05	1.02	255		Low	1.04	1.00	304
Medium	High	1.12	0.97	229	Medium	High	1.23	1.02	73
	Total	1.08	1.00	484		Total	1.08	1.00	377
	Low	1.02	1.00	164		Low	1.08	1.00	173
High	High	1.69	1.01	144	High	High	1.68	1.11	68
	Total	1.33	1.06	308		Total	1.25	1.06	241
	Low	0.91	0.99	670		Low	0.91	0.98	774
Total	High	1.10	1.03	581	Total	High	1.25	1.07	203
	Total	1.00	1.01	1,251		Total	0.98	1.01	977

TV for information	Newspaper access	M	SD	n	TV for information	Internet access	M	SD	n
	No	0.78	0.91	263		Low	0.95	0.99	574
Low	Yes	1.03	1.02	367	Low	High	0.64	0.84	56
	Total	0.93	0.98	630		Total	0.93	0.98	630
	No	0.86	0.98	274		Low	1.16	1.05	513
High	Yes	1.24	1.04	353	High	High	0.70	0.84	114
	Total	1.07	1.03	627		Total	1.07	1.03	627

		M	SD	n			M	SD	n
	No	0.82	0.95	537		Low	1.05	1.02	1087
Total	Yes	1.13	1.03	720	Total	High	0.68	0.84	170
	Total	1.00	1.01	1,257		Total	1.00	1.01	1,257

TV for entertainment	Newspaper access	M	SD	n	TV for entertainment	Internet access	M	SD	n
	No	0.91	0.96	254		Low	1.20	1.05	570
Low	Yes	1.31	1.06	383	Low	High	0.70	0.89	67
	Total	1.15	1.04	637		Total	1.15	1.04	637
	No	0.74	0.93	284		Low	0.88	0.97	519
High	Yes	0.93	0.96	338	High	High	0.67	0.81	103
	Total	0.85	0.95	622		Total	0.85	0.95	622
	No	0.82	0.95	538		Low	1.05	1.02	1089
Total	Yes	1.13	1.03	721	Total	High	0.68	0.84	170
	Total	1.00	1.01	1,259		Total	1.00	1.01	1,259

TV for information	Parent political participation	M	SD	n	TV for entertainment	Parent political participation	M	SD	n
	Low	0.83	0.95	349		Low	0.98	1.02	296
Low	High	1.06	1.00	276	Low	High	1.30	1.04	338
	Total	0.93	0.98	625		Total	1.15	1.04	634
	Low	0.84	0.95	277		Low	0.70	0.87	331
High	High	1.26	1.05	347	High	High	1.02	1.01	286
	Total	1.07	1.03	624		Total	0.85	0.95	617
	Low	0.83	0.95	626		Low	0.83	0.95	627
Total	High	1.17	1.04	623	Total	High	1.17	1.03	624
	Total	1.00	1.01	1,249		Total	1.00	1.01	1,251

Newspaper	Parent political participation	M	SD	n	Internet information	Parent political participation	M	SD	n
	Low	0.81	0.96	370		Low	0.78	0.94	436
Low	High	1.03	1.01	297	Low	High	1.08	1.00	336
	Total	0.91	0.99	667		Total	0.91	0.98	772
	Low	0.85	0.94	256		Low	1.00	0.99	72
High	High	1.30	1.05	325	High	High	1.38	1.08	133
	Total	1.10	1.03	581		Total	1.24	1.07	205
	Low	0.83	0.95	626		Low	0.81	0.95	508
Total	High	1.17	1.04	622	Total	High	1.17	1.03	469
	Total	1.00	1.01	1,248		Total	0.98	1.00	977

Table 4-2. Descriptive Statistics for Main Effects.

TV for information	Mean	SD	n	Internet information	Mean	SD	n
Low	0.93	0.98	630	Low	0.91	0.98	778
High	1.07	1.03	627	High	1.24	1.07	205
Total	1.00	1.01	1,257	Total	0.98	1.00	983

TV for entertainment	Mean	SD	n	Newspaper	Mean	SD	n
Low	1.15	1.04	637	Low	0.91	0.99	673
High	0.85	0.95	622	High	1.10	1.02	584
Total	1.00	1.01	1,259	Total	1.00	1.01	1,257

TV access	Mean	SD	n	Internet access	Mean	SD	n
No cable	0.98	1.01	298	Low	0.66	0.83	177
Cable	0.98	1.01	993	High	1.03	1.02	1114
Total	0.98	1.01	1,291	Total	0.98	1.01	1,291

Newspaper access	Mean	SD	n
No	0.81	0.94	549
Yes	1.10	1.03	742
Total	0.98	1.01	1,291

Table 5. Results of Post Hoc Tests for Parental Education.

Group Treatment		Mean Difference	Std. Error	95% Confidence Interval	
				Upper Bound	Lower Bound
Low	Medium	- .39***	.06	- .54	- .24
	High	- .63***	.07	- .79	- .46
Medium	Low	.39***	.06	.24	.54
	High	- .24***	.07	- .40	- .07
High	Low	.63***	.07	.46	.79
	Medium	.24***	.07	.07	.40

Note. Dependent Variable: Political knowledge Tukey HSD
***$p < .001$

that use of television for entertainment decreased political knowledge more when parental education level was high rather than low [H6b]; $F (2, 1,248) = 3.61$, $p < .05$]. Figure 3 shows the interaction effect between these variables.

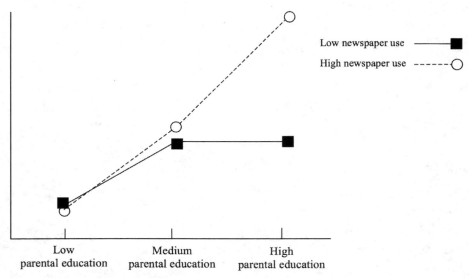

Figure 1. Interaction between newspaper use and parental education.

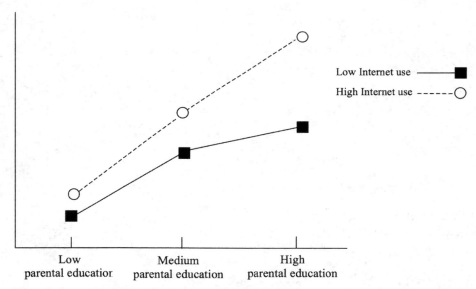

Figure 2. Interaction between Internet use and parental education.

Media Access at Home and Children's Media Use

H7a suggested children's political knowledge would be higher in homes with cable than in those with only broadcast television. This was not supported.

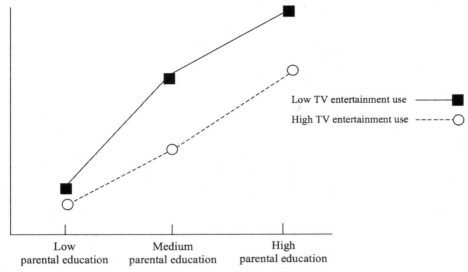

Figure 3. Interaction between children's entertainment television use and parental education.

H7b suggested children's political knowledge would be higher in homes with newspapers than those without. This was supported [F (1, 1,289) = 27.43, $p < .05$].

H7c suggested children's political knowledge would be higher in homes with high speed Internet than those without. This was also supported [F (1, 1,289) = 20.60, $p < .05$].

H8a suggested having home newspaper access would decrease the negative effects on political knowledge of entertainment television use. This was marginally supported and the interaction pattern is shown in Figure 4 [F (1, 1,253) = 3.35, $p < .05$].

H8b suggested that home newspaper access would increase the positive effects of informational television use on political knowledge. This hypothesis was not supported.

H8c suggested that home Internet access would decrease the negative effects on political knowledge of entertainment television use. There was no support for this posited effect.

H8d suggested that home Internet access would increase the positive effects on political knowledge of informational television use. There was also no support for this hypothesis.

H9 suggested there would be a positive main effect of parental political participation on political knowledge. This was strongly supported [F (1, 1,253) = 34.97, $p < .05$].

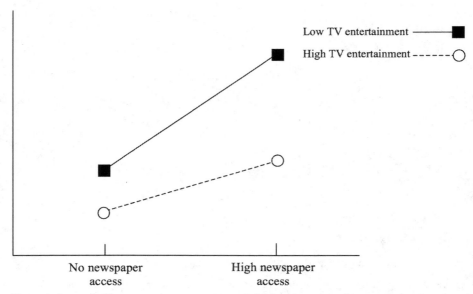

Figure 4. Interaction between newspaper access and children's entertainment use of television.

H10a suggested there would be a knowledge gap pattern for parental political participation and television informational use. There was marginal support for this hypothesis [F (1, 1,245) = 2.88, p < .1].

H10b suggested there would be a knowledge gap pattern for parental political participation and newspaper use. This posited effect was supported [F (1, 1,253) = 4.16, p < .05].

H10c suggested a knowledge gap pattern for parental political participation and Internet news use. This was not supported.

Finally, H10d suggested there would be an ameliorative effect of parental political participation on television use for entertainment. This was not supported.

DISCUSSION

The main effects found within this study were quite strong and in the direction predicted. News use of television and the Internet and reading newspapers all had positive effects on political knowledge. Also as predicted, entertainment use of television had a significant negative effect on political knowledge. The latter finding is important because it is consistent with the findings for adults. More use of entertainment media has negative effects on civic measures ranging from political interest to knowledge to community participation. Postman (1985) and Prior (2005; 2007) were both on the right track when they observed that Americans

often choose entertainment use of media rather than news use that would, presumably, leave citizens—young and old—better informed.

Both of the parental measures also produced strong main effects. Parental education and parental political participation both strongly predicted higher political knowledge in adolescents. The parental education effect has been shown again and again, but the impact of parental political participation is more unusual. McIntosh, Hart, and Youniss (2007) suggested that two processes are involved in this effect. First, participatory parental talk and behaviors provide a direct model to their adolescents for the transmission of these values. Second, as youth actively construct their worlds, including developing their news media habits, they incorporate aspects of their parent's knowledge and values.

With more and more sources of political news now available, we were surprised at the continuing presence of knowledge gaps. Three of four possible interactions between media use by the adolescents and parental education appeared. There was a significant interaction with both Internet news and newspaper use and parental education. Teens with more highly educated parents benefited more from their news use in these two media but not in their use of television news. The lack of a television news effect may occur because it takes less skill to process television news. Here, the teen doesn't have to be a good reader, nor is the complexity of the news as high.

Also of importance is the fact that parental education reduced the negative impact of high television entertainment use. There are many processes that could explain this finding, and certainly it is important to examine this effect in more, micro-level detail. More highly educated parents could be substituting direct informing of their youth who spend more time with entertainment. Or more highly educated parents might be requiring news use, even when entertainment use is high. Or more highly educated parents may have brighter children who learn faster and perhaps make better use of the political information they get from school or from cohorts.

Although having cable access at home had no main effect on political knowledge, both newspaper and high-speed Internet access had strong positive effects. Intriguingly, newspapers in the home interacted with both the negative effect of entertainment use of television (marginally) and with the positive news use of television. It would seem an important lesson that in spite of falling newspaper subscriptions and more and more belief that the Internet can completely replace newspapers, the impact of newspaper use on the adolescents surveyed here was strong. Newspapers aided television's positive effects and ameliorated entertainment's negative effects on political knowledge. Subscribing to a local newspaper would seem an inexpensive but effective way to help youth learn the basics of their political system. There was no interactive effect between television use and presence of the Internet in the home.

Interestingly, there was a strong main effect of parental political participation on adolescent political knowledge. Having participatory parents marginally

interacted with television news use, but did not protect against the negative effects of television entertainment use. Use of newspaper and parental participation interacted in the classic knowledge gap pattern, with a high-participation parental environment enabling youth to learn more from newspaper use than the low-participation parental environment. (Figure 5) Internet news use did not interact with parental political participation. This failure to find an effect may have resulted from adolescents' low use of Internet news.

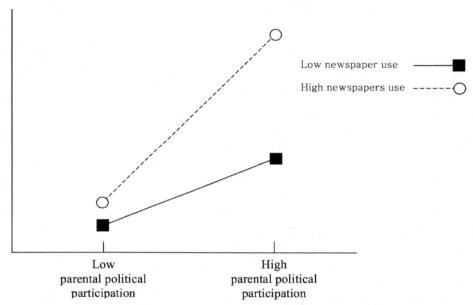

Figure 5. Interaction between parental political participation and children's newspaper use.

The overarching finding of this study is that media and indices of SES continue to produce knowledge gaps. All three of our measures of "enrichment" in the home interacted with news media use to increase the positive impact of media use for the enriched compared with the "non-enriched." The strong positive effect of newspaper use on knowledge was particularly impressive. The strong negative effect of entertainment television was attention-getting because it again suggests how dangerous the media can be when they inundate youth with too many opportunities to amuse themselves.

REFERENCES

Adams, J. B., Mullen, J. J., & Wilson, H. M. (1969). Diffusion of a "minor" foreign affairs news event. *Journalism Quarterly, 46,* 545–551.

Anand, S., & Krosnick, J. A. (2005). Demographic predictors of media use among infants, toddlers, and preschoolers. *The American Behavioral Scientist, 48*(5), 539–561.

Atkin, C. K. (1981). Communication and political socialization. In D. D. Nimmo & K. R. Sanders (Eds.), *Handbook of political communication,* Beverly Hills, CA: Sage.

Austin, E. W., & Pinkleton, B. E. (2001). The role of parental mediation in the political socialization process. *Journal of Broadcasting & Electronic Media, 45*(2), 221–240.

Bandura, A. (1989). Social cognitive theory. In R. Vasta (Ed.), *Annals of child development. Vol. 6. Six theories of child development* (pp. 1–60). Greenwich, CT: JAI Press.

Barnhurst, K. G., & Mutz, D. C. (1997). American journalism and the decline in event-centered reporting. *Journal of Communication, 47*(4), 27–53.

Bogart, L. R. (1981). *Press and the public: Who reads what, when, where, and why in American newspapers.* Hillsdale, NJ: Lawrence Erlbaum.

Bonfadelli, H. (2002). The Internet and knowledge gaps: A theoretical and empirical investigation. *European Journal of Communication, 17*(1), 65–84.

Budd, R. W., MacLean, M. S., & Barnes, A. M. (1996). Regularities in the diffusion of two major news events. *Journalism Quarterly, 43,* 221–230.

Chaffee, S. H., & Frank, S. (1996). How Americans get political information: Print versus broadcast news. *The Annals of the American Academy of Political and Social Science, 546,* 48–58.

Childers, T., & Post, J. A. (1975). *The information-poor in America.* Lanham, MD: Scarecrow Press.

Delli Carpini, M. X., & Keeter, S. (1996). *What Americans know about politics and why it matters.* New Haven, CT: Yale University Press.

Dervin, B. (1980). Communication gaps and inequities: Moving toward a reconceptualization. In M. Voigt & B. Dervin (Eds.), *Progress in communication sciences.* Hillsdale, NJ: Lawrence Erlbaum.

Donohue, G. A., Tichenor, P. J., & Olien, C. N. (1975). Mass media and the knowledge gap: A hypothesis reconsidered. *Communication Research, 2*(1), 3–23.

Dutta-Bergman, M. J. (2005). Access to the Internet in the context of community participation and community satisfaction. *New Media & Society, 7*(1), 89–109.

Ettema, J. S., & Kline, F. G. (1977). Deficits, differences, and ceilings: Contingent conditions for understanding the knowledge gap. *Communication Research, 2*(4), 179–202.

Eveland, W. P., Jr., & Scheufele, D. A. (2000). Connecting news media use with gaps in knowledge and participation. *Political Communication, 17,* 215–237.

Fathi, A. (1973). Diffusion of a happy news event. *Journalism Quarterly, 50,* 271–277.

Fleming, K., Thorson, E., & Peng, Z. (2005). Association membership as a source of social capital: Its links to use of local newspaper, interpersonal communication, entertainment media, and volunteering. *Mass Communication and Society, 8*(3), 219–240.

Gaziano, C. (1983). The knowledge gap: An analytical review of media effects. *Communication Research, 10*(4), 447–486.

Gaziano, C. (1984). Neighborhood newspapers, citizen groups and public affairs knowledge gaps. *Journalism Quarterly, 16,* 556–566, 599.

Gaziano, C. (1997). Forecast 2000: Widening knowledge gaps. *Journalism and Mass Communication Quarterly, 74*(2), 237–264.

Gaziano, E., & Gaziano, C. (1999). Social control, social change, and the knowledge gap hypothesis. In D. P. Demers & K. Viswanath (Eds.), *Mass media, social control, and social change: A macrosocial perspective* (pp. 117–136). Ames, IA: Iowa State University Press.

Genova, B. K. L., & Greenberg, B. S. (1979). Interests in news and the knowledge gap. *Public Opinion Quarterly, 43,* 79–91.

Grabe, M. E. (2000). Cognitive access to negatively arousing news: An experimental investigation of the knowledge gap. *Communication Research, 27*(1), 3–26.

Graber, D. A. (1990). Seeing is remembering: How visuals contribute to learning from television news. *Journal of Communication, 40*(2), 134–155.

Graber, D. A. (1994). Why voters fail information tests: Can the hurdles be overcome? *Political Communication, 11*, 331–346.

Graber, D. A. (2001). *Processing politics: Learning from television in the Internet age.* Chicago, IL: University of Chicago Press.

Greenberg, B. S. (1964). Diffusion of the Kennedy assassination. *Public Opinion Quarterly, 28*, 225–232.

Griffin, R. (1990). Energy in the eighties: Education, communication and the knowledge gap. *Journalism Quarterly, 67*, 554–566.

Hair, J. F., Jr., Black, W. C., Anderson, R. E., & Tatham, R. L. (2006). *Multivariate data analysis* (5th ed.). Upper Saddle River, NJ: Prentice Hall.

Hindman, D. B. (2000). The rural-urban digital divide. *Journalism and Mass Communication Quarterly, 77*(3), 549–560.

Höijer, B. (1989). Television-evoked thoughts and their relation to comprehension. *Communication Research, 16*, 179–203.

Holbrook, T. M. (2002). Presidential campaigns and the knowledge gap. *Political Communication, 19*, 437–454.

Key news audiences now blend online and traditional sources. (2008). Retrieved from http://people-press.org/report/444/news-media

Kleinnijenhuis, J. (1991). Newspaper complexity and the knowledge gap. *European Journal of Communication, 6*, 499–522.

Kraus, S., & Davis, D. (1976). *The effects of mass communication on political behavior.* University Park, PA: Pennsylvania State University Press.

Kwak, N. (1999). Revisiting the knowledge gap hypothesis: Education, motivation, and media use. *Communication Research, 26*(4), 385–413.

Lemert, J. (1984). News context and the elimination of mobilizing information: An experiment. *Journalism Quarterly, 61*, 243–249, 259.

Lepper, M. R. (1985). Microcomputers in education: Motivational and social issues. *American Psychologist, 40*(1), 47–58.

Liu, Y-I., & Eveland, W. P., Jr. (2005). Education, need for cognition, and campaign interest as moderators of news effects on political knowledge: An analysis of the knowledge gap. *Journalism and Mass Communication Quarterly, 82*(4), 910–929.

Loges, W. E., & Ball-Rokeach, S. J. (1993). Dependency relations and newspaper readership. *Journalism Quarterly, 70*, 602–614.

Mastin, T. (2000). Media use and civic participation in the African-American population: Exploring participation among professionals and nonprofessionals. *Journalism and Mass Communication Quarterly, 77*(1), 115–127.

McDevitt, M., & Chaffee, S. (2002). From top-down to trickle-up influence: Revisiting assumptions about the family in political socialization. *Political Communication, 19*, 281–301.

McIntosh, H., Hart, D., & Youniss, J. (2007). The influence of family political discussion on youth civic development: Which parent qualities matter? *PSOnline*, 495–499. Retrieved from www.apsanet.org

McLeod, D. M., & Perse, E. M. (1994). Direct and indirect effects of socioeconomic status on public affairs knowledge. *Journalism Quarterly, 71*, 433–442.

McLeod, J. M., Scheufele, D. A., & Moy, P. (1999). Community, communication, and participation: The role of mass media and interpersonal discussion in local political participation. *Political Communication, 16*, 315–336.

Milner, H. (2002). *Civic literacy: How informed citizens make democracy work*. Hanover, NH: University Press of New England.

Norris, P. (1996). Does television erode social capital? A reply to Putnam. *PS: Political Science and Politics, 27*, 474–480.

O'Keefe, G., & Liu, J. (1980). First-time voters: Do media matter? *Journal of Communication, 30*(4), 112–129.

Parker, E. B., & Dunn, D. A. (1972). Information technology: Its social potential. *Science, 176*, 1392–1398.

Patrick, J. J. (1977). Political socialization and political education in schools. In S. Renshon (Ed.), *Handbook of political socialization*. New York, NY: Free Press.

Postman, N. (1985). *Amusing ourselves to death*. New York, NY: Penguin Books.

Prior, M. (2005). News vs. entertainment: How increasing media choice widens gaps in political knowledge. *American Journal of Political Science, 49*, 577–592.

Prior, M. (2007). *Post-broadcast democracy: How media choice increases inequality in political involvement and polarizes elections*. New York, NY: Cambridge University Press.

Putnam, R. D. (1993). The prosperous community: Social capital and public life. *The American Prospect, 13*, 35–42.

Putnam, R. D. (1995). Tuning in, tuning out: The strange disappearance of social capital in America. *PS: Political Science and Politics, 28*, 664–683.

Severin, W. J., & Tankard, J. W. (1997). *Communication theories: Origins, methods, and uses in the mass media* (4th ed.). White Plains, NY: Longman.

Shah, D. (1998). Civic engagement, interpersonal trust, and television use: An individual level assessment of social capital. *Political Psychology, 19*, 469–496.

Shah, D. V., Cho, J., Eveland, W. P., Jr., & Kwak, N. (2005). Information and expression in a digital age: Modeling Internet effects on civic participation. *Communication Research, 32*, 531–565.

Shah, D. V., Cho, J., Nah, S., Gotlieb, M. R., Hwang, H., Lee, N., … McLeod, D. M. (2007). Campaign ads, online messaging, and participation: Extending the communication mediation model. *Journal of Communication, 57*, 676–703.

Shah, D. V., Kwak, N., & Holbert, R. L. (2001). "Connecting" and "Disconnecting" with civic life: Patterns of Internet use and the production of social capital. *Political Communication, 18*, 141–162.

Shah, D. V., McLeod, J. M., & Yoon, S. H. (2001). Communication, context, and community: An exploration of print, broadcast and Internet influences. *Communication Research, 28*, 464–506.

Tichenor, P. J., Donohue, G. A., & Olien, C. N. (1970). Mass media flow and differential growth in knowledge. *Public Opinion Quarterly, 34*, 159–170.

Viswanath, K., & Finnegan, J. R., Jr. (1996). The knowledge gap hypothesis: Twenty-five years later. In B. R. Burleson (Ed.), *Communication yearbook 19* (pp. 187–227), Thousand Oaks, CA: Sage.

Viswanath, K., Jahn, E., Finnegan, J. R., Jr., Hertog, J., & Potter, J. D. (1993). Motivation and the knowledge gap: Effects of a campaign to reduce diet-related cancer risk. *Communication Yearbook 15* (pp. 115–145). Newbury Park, CA: Sage.

Viswanath, K., Kosicki, G. M., Fredin, E. S., & Park, E. (2000). Local community ties, community-boundedness, and local public affairs knowledge gaps. *Communication Research, 27*(1), 27–50.

Wade, S., & Schramm, W. (1969). The mass media as sources of public affairs, science and health knowledge. *Public Opinion Quarterly, 33*, 197–209.

State Policies FOR Civic Education

The Center for Information & Research on Civic Learning and Engagement (CIRCLE)

PETER LEVINE AND KEI KAWASHIMA-GINSBERG

A number of studies have found that students exposed to high-quality civic learning experiences in K–12 schools gain knowledge, skills, and habits of participation. These opportunities, however, are provided very unequally and inadequately. While all states have policies intended to provide civic education to their students, states' policies vary significantly. Some states require every student to take one or more civics courses and pass state tests; some do neither. All states have adopted certain standards for civic education, yet they differ in content and emphasis. However, the variation in state policies is not related to either the civic learning experiences that students receive or to graduates' knowledge, skills, and habits. Therefore, as we argue in this chapter, the next frontier for those concerned about students' civic education is to address the gap between policies and practices in our schools.

The literature on policies for civic education is not extensive, but several rigorous studies have found the same pattern. In each study, experiencing high-quality civic education (as defined in Gibson & Levine, 2003, and Campaign for the Civic Mission of Schools, 2012) is related to the outcomes that the investigators chose to investigate, usually a combination of students' knowledge of civics and politics and their actual participation or planned engagement in civic life. On the other hand, in none of the studies is there a relationship between state policies and what the students experience in classrooms or what they know and do after graduation.

State policies have been the focus of these studies because the states have primary responsibility for setting content and testing requirements in the United States. Their laws and regulations trump local policies. Despite the increasingly

assertive role of the federal government, it does not have a substantial involvement in curriculum, especially for social studies and especially at the high school level. Because the states set universal standards for public schools within their jurisdictions, they have the potential—and, we believe, the obligation—to address deep inequalities in civic education and civic knowledge by race and class (Kahne & Middaugh, 2009; Levinson, 2012). Thus, if state policies do not affect civic education, the most obvious policy lever is not working.

THE KNIGHT FOUNDATION STUDY

One of the co-authors of the current chapter (Levine) also served as a co-author of a national study that analyzed a 100,000-person survey of current high school students (Lopez, Levine, Dautrich, & Yalof, 2009). Given the interests of the funder, the John L. and James S. Knight Foundation, the survey focused on students' understanding of the First Amendment, their commitment to freedom of speech and the press, and their role as consumers and producers of news. The Knight Foundation study included three scales: support for the First Amendment, knowledge of the First Amendment, and daily news consumption. While these are only some of the topics covered in a typical civics class, they are topics mentioned in state standards, assessed on standardized civics tests, and are certainly among the required outcomes in many states (Godsay, Henderson, Levine, & Littenberg-Tobias, 2012; Levine, 2013). Therefore, we hypothesized that student outcomes would vary depending on whether the state required a relevant course or test.

We modeled the students' outcomes on the three scales as functions of their individual demographic characteristics, extracurricular activities, academic success, exposure to courses that covered the First Amendment, school size and demographics, and state policies, namely: whether the state required a course in civics, whether students were required to accumulate at least three credits in social studies, whether the Constitution was covered in the state standards, and whether the state mandated a social studies test that included civics or American government. We used hierarchical linear modeling (HLM) to model the students as nested in schools within states.

Once all the controls were considered, taking a class that discussed the First Amendment, discussing the role of the media in a class, and being assigned to use the news media were positively related to the outcomes of interest. Overall, the relationships between the state policy variables and the outcomes of interest were not significant. There was a very small negative relationship between a mandatory state test and favorable attitudes toward free speech.

Although the Knight study was a warning that state policies for civic education might not be working, we recognized that the results might not generalize

beyond the survey's specific focus on free speech and freedom of the press. Thus, both authors of this chapter were involved in a second study that used a national survey with different outcomes.

THE NATIONAL YOUTH SURVEY

In the months after the 2012 presidential election, Universal Survey, Inc. recruited 4,483 individuals to participate in a 17-minute random-digit-dialing phone interview. Two-thirds of the respondents came from cell phone numbers and the rest from landline numbers. At least 75 participants came from each of the 50 states and Washington, DC (75–131 per state). Participants of Black and Hispanic backgrounds were slightly oversampled to obtain a large sample of each group (for full survey results see Commission on Youth Voting and Civic Knowledge, 2013).

Statistical models were developed to predict voter turnout, electoral engagement (registering and voting while also following the news), political knowledge (correctly answering items on a short general knowledge quiz), and informed voting, which we defined as registering, voting, answering at least one (out of two) campaign knowledge questions correctly, answering four or more general political knowledge questions correctly, voting consistently with one's personal opinion on a campaign issue of one's choice, and following the news fairly, or very, closely during the election season. As possible predictors of these outcomes, we considered a wide range of factors, including the individuals' demographics and background experiences, their experiences with various forms of civic education in schools, families, and community settings, their current involvement with civic groups, the political climate of their states, and the education and voting laws in force in their states.

As in the Knight Foundation study, high quality civic education (as experienced by individual respondents) was related to desired outcomes. We asked about pedagogical practices that have been recommended by previous scholarship, such as discussing controversial issues in class and conducting community service with a link to the academic curriculum (Gibson & Levine, 2003). The number of these experiences that the respondents recalled from their school careers predicted their informed voting in 2012. Service-learning in high school predicted informed voting in 2012 only if the service-learning involved discussion of "root causes." Interestingly, when service was required without a discussion of root causes, it appeared to have a negative effect on informed voting. Also, being encouraged to vote by a high school teacher predicted electoral engagement in 2012, and being taught about voting in high school predicted political knowledge.

Youth knowledge and engagement varied dramatically by state, but those differences could, in general, be explained mostly in terms of individual-level factors

such as demographics. Some political factors, such as the competitiveness of the election and the voting laws, mattered to a lesser degree, but states' civics course requirements, civics tests, standards, and the content of state social studies tests had no detectable impact on the outcomes of interest in our full HLM models.

Similar results also emerged when Deven Carlson (2012) analyzed four national longitudinal surveys that asked questions about civic education in schools and about post-school civic knowledge and behaviors. His analysis employed several sophisticated analytical techniques, and his conclusions echo what we have thus far reported here:

> The amount of civics instruction received by students has a positive effect on civics achievement; these positive effects were detected at the 4th, 8th, and 12th grade levels. Additionally, the results revealed that the opportunity to participate in applied civic activities—student government, mock trial, and debate—can result in higher levels of civic knowledge and skills among 4th and 8th grade students. However, the data also indicate that civics high school graduation requirements have no effect on the level of civic knowledge and skills of 12th grade students. (p. 205)

THE NATIONAL CIVICS TEACHER SURVEY

For a different perspective on the variation in civics pedagogy and the effects of state policies on civics education, we also surveyed a national sample of teachers. In the months following the 2012 presidential election, CIRCLE worked with the educational marketing firm MDR to survey U.S. high school civics and government teachers. MDR's sample of 8,000 is thought to include approximately half of all the U.S. high school civics and government teachers. We contacted 4,000 of these teachers via U.S. mail with a $2 bill and a letter enclosed inviting them to participate in our survey (which was available online or on paper). About one week later, MDR sent an invitation e-mail, written by CIRCLE, to 4,837 teachers (from the same pool) whose e-mail addresses were available. MDR sent a follow-up e-mail if the teacher opened the initial e-mail but did not click on the embedded survey link. The survey was open from May 10, 2013 to June 1, 2013, and we received a total of 720 responses (four were in paper format). We cannot know how many teachers received one or both solicitations, so the response rate may range from 9.0% to 14.9% (which is higher than the 1–2% rate common for e-mail surveys). Previous studies suggest that the U.S. mail outreach has a positive impact on response rates. Of those who started the survey, 86% finished the last questions in the survey.

The participating teachers were represented proportionately from each region of the US, worked mostly at public high schools (93%), and tended to be more educated than the general teacher population, with 69.9% holding a master's

degree or higher (5.1% held doctoral degrees). Exactly half of the teachers worked in schools where 50% or more of the students were eligible for reduced-price or free-lunch programs. More than one quarter (26.6%) worked in schools where the teachers thought less than half of the students were "college-bound," while 36.4% thought three quarters or more of their students would go to college. Each teacher could provide information about as many as two courses she or he taught in fall of 2012. Well over half of the participating teachers described two courses, resulting in a descriptive sample of 1,034 courses. The main question of interest to us was whether courses that met graduation requirements differed in content, pedagogy, assignments, and activities from electives, and especially from honors or Advanced Placement electives.

We found that the pedagogies that are believed to be most effective (see Campaign for the Civic Mission of Schools, 2012; and Gibson & Levine, 2003) were used more frequently in honors or AP civics/government courses (N = 252) than in graduation-requirement courses that were neither honors nor AP courses. For example, discussing current events happened more frequently in honors or AP civics/government classes (61.5% "almost every day") than in required courses that fit into neither of those categories (50.4% "almost every day"). Furthermore, while almost half of AP/honors students (45%) engaged in political and social issues discussions where they disagreed almost every day, less than one third (30.2%) of graduation requirement courses provided such an environment. Teachers spent significantly more time in AP/honors courses on critical analysis of news items (68.3% one unit or more) than in graduation-required courses (45.4%). These courses, however, did not differ in their use of simulations such as mock elections or coverage of local political issues. They also did not differ on the use of tests or standardized exams.

AP/honors courses appear to cover more contemporary and controversial issues and teach core civic skills such as deliberation. Coverage of controversial topics such as the electoral college and money in politics was also emphasized more in AP/honors courses (72.7% one unit or more) than in graduation-requirement courses (50.2%). Finally, students in graduation-requirement courses spent less time learning how to make decisions together in a group (33.5% one unit or more) than students in AP/honors courses (40.1%). The national teacher survey suggests one reason that state requirements may not yield the desired outcomes is that courses taught and taken to meet civics requirements are not as engaging and relevant to current events as elective courses.

LIMITATIONS

We have posited that civic education "works"—that students who receive high-quality civic education learn desirable skills and knowledge and that they are

often more civically engaged as adults. Yet, state policies for civics do not enhance civic education, and one reason may be that courses taken to meet graduation requirements do not use as many recommended practices as electives do. Before discussing the implications of this thesis, it is worth considering possible grounds for uncertainty with this conclusion.

First, it is possible that state policies have beneficial effects that were missed in these studies because the appropriate outcomes were not measured or because the statistical power was too weak. After all, there are only 50 states, and with the individual state as unit of analysis this places limitations on the analysis. On the other hand, subtle statistical effects would not really suffice. Asking students to spend a semester or more in a civics course is worthwhile only if it makes a substantial and lasting difference, which we should be able to detect in a large national survey.

Second, it is possible that formal civic education does in fact not "work." Overall, the national studies described in this chapter find statistical associations between experiencing civic education in schools and having higher scores on civic knowledge, stronger support for constitutional principles, or more civic engagement. Similar results have also emerged from other studies with strong controls (Campbell, 2008; Niemi & Junn, 2005). But none of these studies utilizes a randomized experiment. Unmeasured factors might explain the association between civic education and civic outcomes; school quality or teacher ability are two such examples. Also, these are all surveys based on respondents' recollections. Instead of measuring whether students actually studied the First Amendment in school, a survey question on that topic only measures whether the respondent recalls the lesson.

Hutchens and Eveland (2009) conducted a careful study of the impact of two recommended practices—debate and discussion of news—in Cleveland public schools and actually found negative impacts. Although that finding does not generalize to all civic education in all schools, it is a reminder that civics teaching and learning may not always be effective. On the other hand, other well-designed evaluations of civic education programs have found positive results. Kahne, Chi, and Middaugh (2006) evaluated CityWorks, a program in Los Angeles that engages students in simulations of interactions with government at the local level. Using a quasi-experimental design, these researchers found stronger gains in commitment to participatory citizenship and justice-oriented citizenship in both statistical and qualitative analyses. Also, McDevitt and Kiousis (2006) evaluated the Kids Voting USA (KVUSA) program and found that students in the study's experimental group maintained gains in civic participation 2 years after the program concluded. Finally, in an experimental evaluation of the civics program Facing History and Ourselves, Boulay, McCormick, and Kliorys (2009) found that students in the treatment group scored higher on all academic and civic outcomes measured, and experimental group students gained greater historical understanding than those

who were in the control group. In this study, professional development also proved effective, raising teacher's efficacy, motivation, sense of accomplishment, engagement, and growth as a teacher.

On the whole, it seems reasonably safe to assume that many students who enroll in a whole course on civics or government learn some of the content. But that raises a difficult question about why the state policies that govern courses, curricula, and assessments do not seem to affect, to any noticeable degree, what students learn.

DO EDUCATION POLICIES AFFECT SCHOOL PRACTICES?

The recent trend in educational reform is to tie student performance and/or teacher effectiveness to accountability measures. Thus, the vast majority of educational reform research concerns the consequences of testing, teacher preparation, and professional development policies within the context of accountability measures. There is some evidence that the accountability system introduced by the No Child Left Behind Act did have a positive impact on student performance on the National Assessment of Education Progress (Hanushek & Raymond, 2004), and a case study found that four states with especially strong teacher certification requirements and professional development systems performed better on standardized tests (Jaquith, Mindich, Chung Wei, & Darling-Hammond, 2011). However, research also suggests that accountability and incentives alone are not enough to change teachers' or students' performance. Rather, any educational policy must be combined with committed leadership, implementation infrastructure, resources, and an accountability system that involves levels and degrees of sanctions followed by support for teacher development, such as providing professional development when a school is placed on probation, and maintaining high quality training by surveying the teachers themselves and creating a locally governed professional-development committee (Jaquith et al., p. 6).

Policies implemented in tandem with an accountability system probably change teacher practice and student performance indirectly. For example, when a school is placed on probation, it may get more district-level support in the form of increased professional development, and master teachers, but there may also be changes in leadership at both the school and district levels, which generate chaotic changes in the schools' practices (Mintrop, 2003). Furthermore, Finnigan and Gross (2007) found that an increase in support and resources that result from "low performing school" status could motivate the teachers and increase their effort in teaching, and many teachers in fact tried to improve their practices. Changing practice, however, often meant that teachers spent more time on test-preparation to improve students' scores (Finnigan & Gross, 2007; Mintrop, 2003). Finally,

sanctions and incentive measures were also found to lower teachers' morale, raising doubts about the sustainability of these actions.

While accountability is very common for math, language arts, and science, it is almost non-existent for civics education policy. Florida's Sandra Day O'Connor Act, passed in 2010, originally included strong accountability measures for civics education that have since been weakened. Research from other subject areas suggests that civic education policies, as they are implemented today, stand little chance of changing student performance in any meaningful way (Jaquith et al., 2011). On the other hand, civic education policies would have an impact on student performance and teacher effectiveness if these policies were in fact tied to a strong accountability system paired with resources and infrastructure.

DISCUSSION

We now turn to explanations of the finding that state civic education policies are not linked to classroom experiences or student outcomes. Understanding the reasons for this policy failure is an important precondition for improving policies.

1. Wrong policies

One possibility is that state policies can work, but no states (or too few to be detectable in a 50-state national study) have adopted helpful policies. For instance, states vary in whether they require students to pass a civics test, but all state tests that do exist are dominated by multiple-choice questions (Godsay et al., 2012). Multiple-choice exams have limitations for assessing higher-order skills and knowledge. In the civics domain, such tests have additional liabilities. For one thing, they cannot test current events, because their development cycle typically takes several years. The existing tests are almost exclusively concerned with historical information and constitutional principles. Perhaps an assessment of students' ability to gather and discuss current news would drive better teaching and would be related to better scores on measures of civic knowledge and engagement. There is no way to know this empirically without experimenting with better assessments at the state or local level.

Likewise, states vary in whether they require a civics or government course. But, in general, the states that require a course require only one course, and often it can be taken in the senior year of high school. By this time in one's high-school education, struggling students may have already dropped out, and college-bound students may no longer be fully engaged in their schoolwork. Requiring more courses that start earlier in one's secondary education might have better effects. Again, experimentation at the state or local level would be necessary to determine possible effects related to the amount and timing of civics and government coursework.

As noted above in our review of results from the national teacher survey, we found recommended teaching methods to be less common in required civics courses and those that did not have AP/honors designation. This, of course, does not mean that a course that is required, or one that does not have AP/honors designation, will necessarily produce weak instruction. However, a state course requirement without high-quality texts and materials, standards, professional development, and relevant assessment may indeed generate low quality instruction and limit civics learning.

Third, all states have standards for civics education, and we have coded them to reveal their variation (Godsay et al., 2012). But despite the differences we identified, states' civics requirements are fairly similar. All state civics standards tend to be very long documents that itemize a number of specific topics to be covered. Whether a topic is included in a state's standards is interpreted as evidence that the state is particularly concerned about a given topic. Thus, legislatures and state education agencies are always eager to add topics yet reluctant to remove them for fear that a particular group or cause advocating on behalf of a given topic or concern will be offended. If, for instance, a state does not specifically name the Civil Rights Movement in its standards, it receives a failing grade from the Southern Poverty Law Center (Southern Poverty Law Center, 2011). This critique of civics standards is fine, but many other groups seem equally eager to pounce on omissions. The result may be standards that are too lengthy and incoherent to be covered in the allotted class time. As a result, in 2013 the National Conference on Citizenship published a new framework for state social studies standards that aims to make them shorter, more coherent, and more challenging (see National Council for the Social Studies, 2013). Perhaps implementation of this framework would help states in adopting more coherent civics standards.

A different issue in judging the effectiveness of states' civic education policies is the harmony of several policies within a given state. A state's curriculum standards will presumably work better if its policies are mutually coherent. For an example of a hypothetical set of policies that seems coherent (at least in theory), imagine testing students on a specific set of skills and topics that are also taught to prospective teachers in teacher education training programs and reinforced for current teachers who take advantage of free professional development (PD) opportunities. In turn, the curriculum for the state's mandatory civics course would be closely aligned to its available educational materials and tests. We would hypothesize that such a mix would work better than the relatively haphazard combinations of requirements, teacher training, tests, and pedagogical materials found in most states. However, every state has chosen a unique mix of policies relevant to civics education. We cannot tell from a 50-state model whether any of these existing combinations are already working or work better than others.

2. Wrong level of policymaking

Another possibility is that the states are the wrong entities to hold responsible for improving civic education. Schools face many conflicting pressures from all directions (state mandates of various kinds, federal laws, local policies, interest groups, the media, teachers' unions, parents, and students, to name just some). School leaders may be unable to satisfy all their stakeholders and therefore free to ignore the limited pressure that they receive from their states to teach civics.

An interesting test case on this front is France, which requires civics courses and tests; and in keeping with its general approach to education policy, France closely prescribes the details of content and pedagogy nationwide. Marc Hooghe and Ellen Claes (2009) observed, "As is usual in France, the content of this course is laid out in full detail by the Ministry of Education. ... [S]chools all over the country follow exactly the same curriculum," and every student faces the same civics exam. The goal is civic equality, which is one of the three great principles of the French Republic. And yet "elite schools tend to prepare their students in the best possible way for these exams," whereas, "For schools that are lowly ranked, there are few incentives for such elaborate preparation, since they know that their pupils will perform poorly anyhow" (p. 231). Even given the very tight and uniform regulations from the center, actual practices vary by socioeconomic class in French schools. This suggests that U.S. states, which have much less direct control over schooling within their borders than the French national government has throughout France, may not be able to reduce variations in civic education by modifying their mandates.

3. Poor implementation

A third possibility is that the policies in place in at least some states are valuable and appropriate, but they are not being well implemented. For instance, perhaps some of the existing state tests would have positive effects if teachers were prepared to teach the content that these tests cover. Unfortunately, in the teacher survey introduced previously in this chapter, we found that the typical civics/U.S. government teacher reported having had just two professional development (PD) experiences in civics, and 18% reported none. Teachers were more likely to receive PD if they taught college-bound students, if their schools had higher daily attendance rates, and if they perceived strong parental support to teach about elections. In other words, the teachers with the most need for PD were least likely to receive it (Commission on Youth Voting and Civic Knowledge, 2013).

Better implementation would undoubtedly cost money, yet the amount of such funding would not have to be very large. The biggest expense of civic education is the teachers' salaries, which are already covered by local school authorities. Additional funding could be used for teacher education (before and during their time in the classroom), and for pilot-testing new curricular and pedagogical approaches that took advantage of the new electronic media and that fit the needs of diverse students. Compared with fields such as literacy and mathematics, civics

has received far less investment for research and development and for teacher education. That may be because literacy and mathematics are subject to frequent, high-stakes testing. Whether or not the testing is beneficial, it often motivates policymakers to spend money on research and implementation. Such motivation is lacking in civics education.

CONCLUSION

It is important not to give up on civics education, because good teaching boosts students' interest, knowledge, and skills for civic engagement. At a time of deep inequality in political and civic participation, schools provide one of the few mechanisms that can generate more equitable and more constructive engagement. States have not forgotten civics: all have standards, and most have course requirements and/or tests. But the policies that states have adopted do not seem to make much difference, and that means that American public schools are not providing high-quality civic education for all our children. States must commit to greater experimentation with new approaches to policymaking for civics education.

REFERENCES

Bar, D. J., & Facing History and Ourselves. (2010). *Continuing a tradition of research on the foundations of democratic education: The national professional development and evaluation project*. Brookline, MA: Facing History and Ourselves National Foundation.

Boulay, B., McCormick, R., & Kliorys, K. (2009). *The Facing History and Ourselves National Professional Development and Evaluation Project, Year 1 Final Report*. Cambridge, MA: ABT Associates.

Campaign for the Civic Mission of Schools. (2012). *Guardian of democracy: The civic mission of schools*. Philadelphia, PA: Author. Retrieved from http://civicmission.s3.amazonaws.com/118/f0/5/171/1/Guardian-of-Democracy-report.pdf

Campbell, D. E. (2008). *Why we vote: How schools and communities shape our civic life*. Princeton, NJ: Princeton University Press.

Carlson, D. (2012). *Out of the classroom and into the voting booth? Analyzing the effects of education on political participation* (Unpublished doctoral dissertation). University of Wisconsin.

Commission on Youth Voting and Civic Knowledge. (2013). *All together now: Collaboration and innovation for youth engagement*. Medford, MA: Center for Information and Research on Civic Learning and Engagement.

Finnigan, K. S., & Gross, B. (2007). Do accountability policy sanctions influence teacher motivation? Lessons from Chicago's low-performing schools. *American Educational Research Journal, 44*(3), 594–629.

Gibson, C., & Levine, P. (2003). *Civic mission of schools*. New York, NY: Carnegie Corporation of New York.

Godsay, S., Henderson, W., Levine, P., & Littenberg-Tobias, J. (2012). *State civic education requirements*. Medford, MA: Center for Information and Research on Civic Learning and Engagement. Retrieved

124 | PETER LEVINE AND KEI KAWASHIMA-GINSBERG

from http://www.civicyouth.org/wp-content/uploads/2012/10/State-Civic-Ed-Requirements-Fact-Sheet-2012-Oct-19.pdf

Hanushek, E. A., Raymond, M. E. (2004). *Does school accountability lead to improved student performance?* (NBER Working Paper No. 10591). Cambridge, MA: National Bureau of Economic Research.

Hooghe, M., & Claes, E. (2009). Civic education in Europe: Comparative policy perspectives from the Netherlands, Belgium and France. In J. Youniss & P. Levine (Eds.), *Engaging young people in civic life*. Nashville, TN: Vanderbilt University Press.

Hutchens, M. J., & Eveland, W. P., Jr. (2009). *The long-term impact of high school civics curricula on political knowledge, democratic attitudes and civic behaviors: A multi-level model of direct and mediated effects through communication* (CIRCLE Working Paper #65). Retrieved from Center for Information and Research on Civic Learning and Engagement website: http://www.civicyouth.org/PopUps/WorkingPapers/WP_65_Eveland.pdf

Jaquith, A., Mindich, D., Chung Wei, R., & Darling-Hammond, L. (2011). *Teacher professional learning in the United States: Case studies of state policies and strategies*. Retrieved from the Learning Forward website: http://learningforward.org/docs/pdf/2010phase3report.pdf

Kahne, J. E., Chi, B., & Middaugh, E. (2006). Building social capital for civic and political engagement: The potential of high school government courses. *Canadian Journal of Education, 29(2),* 289–296.

Kahne, J., & Middaugh, E. (2009). *Democracy for some: The civic opportunity gap in high school* (CIRCLE Working Paper No. 59). Medford, MA: Center for Information and Research on Civic Learning and Engagement.

Levine, P. (2013). *What the NAEP civics assessment measures and how students perform* (CIRCLE Fact Sheet). Retrieved from the Center for Information and Research on Civic Learning and Engagement website: http://civicyouth.org/what-the-naep-civics-assessment-measures-and-how-students-perform/

Levinson, M. (2012). *No citizen left behind*. Cambridge, MA: Harvard University Press.

Lopez, M. H., Levine, P., Dautrich, K., & Yalof, D. (2009). Schools, education policy, and the future of the First Amendment. *Political Communication, 26*(1), 84–101.

McDevitt, M., & Kiousis, S. (2006). *Experiments in political socialization: Kids Voting USA as a model for civic education reform* (CIRCLE Working Paper 49). Medford, MA: Center for Information and Research on Civic Learning and Engagement.

Mintrop, H. (2003). The limits of sanctions in low-performing schools. *Education Policy Analysis Archives, 11*(3), 1–30.

National Council for the Social Studies. (2013). *College, career, and civic life (C3) framework for social studies state standards: State guidance for enhancing the rigor of K–12 civics, economics, geography, and history*. Washington, DC: Author.

Niemi, R. G., & Junn, J. (2005). *Civics education: What makes students learn*. New Haven, CT: Yale University Press.

Smarick, A. (2010). If the feds get tough, Race to the Top might work. *Education Next, 10*(2), 14–22.

Southern Poverty Law Center. (2011). *Teaching the movement: The state of civil rights education in the United States 2011*. Retrieved from the Southern Poverty Law Center website:http://www.splcenter.org/sites/default/files/downloads/publication/Teaching_the_Movement.pdf

Parents AND Children

Parenting Styles IN Political Socialization

How the Path to Political Participation Begins at Home

EDSON TANDOC, ESTHER THORSON, AND MARGARET DUFFY

The pathways of influence from parents to their children are complex in that parental influence is thought to compete with other socialization agents, including the media, the influence of peers, and children's school experiences (Shah, McLeod, & Lee, 2009). The current study is an attempt to shed light on how the influences of these agents interact. In a survey of parents and their children during the 2010 mid-term election in a large Midwest city, we look at two ways that parents mediate their children's media experiences and the role this plays in the causal pathways to development of children's political orientations. Parents can restrict media access in an attempt to protect children from harmful media content. They can also actively mediate their children's media use by suggesting reliable news sources, pointing out what may be wrong with news content, or asking what their children think about the news. These parental mediation styles, evaluative or restrictive, have been studied previously (see, for instance, Austin, 1993; Austin & Pinkleton, 2001; Nathanson, 1999, 2002), but it is not clear how they affect the relationships between parents' and children's political interest, knowledge, and participation.

It should be noted that the effects of parental mediation are not always direct. Though children get their first introductions to news and politics as a result of how parents treat media consumption at home and how they interact with their children around that consumption, children become increasingly exposed to news and politics through a variety of other networks. For instance,

discussions that begin at home are likely to spill over to an adolescent's network of friends, classmates, or teachers. The effects of parental mediation might also directly affect a child's involvement in school activities. These socialization agents might eventually come to be more important than parental effects or even make them disappear in terms of measurable impact on political interest, knowledge, and the various measures of participation as children mature. While parental mediation may continue to affect a maturing person in various ways, effects on political orientation per se may disappear entirely, mediated by other factors. The current study is an attempt to shed light on this complex political socialization pathway that is possibly mediated from the home to the larger political arena.

LITERATURE REVIEW

The study of political socialization finds solid justification through its role in bringing about political participation that is vital in the establishment and survival of democracy (McLeod & Shah, 2009; Scheufele, 2002). For the longest time, political communication studies focused on adults, understandably, because of their capacity to vote (McDevitt, 2006; McDevitt & Chaffee, 2002; McLeod & Shah, 2009). This early focus is probably explained by the initial conceptualization of political participation as measured by the single criterion of voting (Chaffee & Hochheimer, 1985). It is true, however, that one's political identity is not shaped overnight. The process of socialization begins much earlier. Thus, within the past decade, particularly, researchers have started to examine how such political identity is shaped among children and adolescents.

Initial efforts, however, focused on children as mere receivers of influence. School and parents were presumed to unilaterally transmit facts, attitudes, and behavior to passive children and youth (McDevitt, 2006; McLeod & Shah, 2009). McDevitt (2006) described this work by noting: "Children are often seen but not heard in perspectives on political socialization—they frequently reside in theory as quiet and passive receptors of parent influence" (p. 80). This approach was due to assumptions that dominated the area for a while; for instance, that political influence flows only downward (McDevitt & Chaffee, 2002). But a "rebirth" of research re-conceptualized political socialization from the initial "top-down" approach to what McDevitt and Chaffee (2002) characterized as "trickle-up" influence. In general, studies have focused on four agents of political socialization: family, school, media, and peers (Shah et al., 2009), and their effects on three important aspects that shape political identity: political interest, political knowledge, and political participation. We first discuss each of these four socialization agents before defining the three dimensions of political socialization.

Parenting Styles

The central role parents play in influencing their children is beyond question. An important aspect of parenthood that has attracted scholars across various fields is parental authority. Baumrind (1968, 1971a, 1971b) studied three parental styles: permissive, authoritarian, and authoritative. A *permissive parent* avoids exercising control, is not demanding, and is relatively warm (Baumrind, 1971a; Heaven & Ciarrochi, 2008). In contrast, authoritarian and authoritative parents willingly exercise control, but the authoritative parent is more democratic than the authoritarian parent, with the latter focused on asserting established authority (Baumrind, 1968, 1971a). An *authoritarian parent* is someone who "attempts to shape, control, and evaluate the behavior and attitudes of the child in accordance with a set standard of conduct" (Baumrind, 1968, p. 261). In contrast, an *authoritative parent* is "more rational, more issue-oriented, and encourages verbal give and take and shares with the child the reasoning behind her policy" (Baumrind, 1968, p. 261).

Subsequent studies focused on contrasting the effects of these different parental styles. For instance, authoritarian parenting was found to be positively related to political alienation of adolescents (Gniewosz, Noack, & Buhl, 2009). Authoritative parenting is considered the ideal, with children reared by authoritative parents found to be "most self-reliant, self-controlled, explorative" (Baumrind, 1971a, p. 2). Heaven and Ciarrochi (2008), for example, found that parental authoritativeness predicted better school achievement among children in particular subject areas such as religious studies, history, and English. This relationship did not hold in math and science, although the study found that parental authoritativeness was linked to children's conscientiousness in school (Heaven & Ciarrochi, 2008). These effects differed between children and adolescents, however. Baumrind (1968) argued that:

> The imposition of authority by use of power is legitimate in childhood and not in adolescence, because the level of cognitive and moral development of the adolescent is such as to require that he be bound by social contract and moral principles rather than by power. (p. 269)

Parental styles have also been found to affect the political socialization of children. Chaffee, McLeod, and Wackman (1973) conceptualized two dimensions of family communication: socio-oriented and concept-oriented. The socio-oriented dimension emphasizes authority in which children do not challenge parents, nor argue with older people, in order to preserve harmony (Chaffee et al., 1973; Hively & Eveland, 2009). The concept-oriented dimension emphasizes discussions even of opposing views in the family (Chaffee et al., 1973), and therefore facilitates political socialization (Hively & Eveland, 2009; Shah et al., 2009). This classification has been described as family communication patterns. Shah and colleagues (2009)

found that both dimensions played a significant role in the political socialization of adolescents. Concept-oriented family communication predicted civic participation and political consumerism while the interaction between concept- and socio-orientation predicted political participation (Shah et al., 2009). Hively and Eveland (2009) also found that discussion was more frequent among students who came from families high in concept-orientation and low in socio-orientation.

Parental Mediation

The study of parenting styles has reached the study of media use as parents also exercise their authority in terms of their children's media access and consumption. The literature has called this relationship *parental mediation* (Nathanson, 1999, 2002; Valkenburg, Krcmar, Peeters, & Marseille, 1999). The concept of parental mediation has been studied in relation to children's television use (Buijzen, Walma van der Molen, & Sondij, 2007) and, more recently, in Internet use (Lwin, Stanaland, & Miyazaki, 2008). Parental mediation shapes children's attitudes toward television, influencing how they are affected by what they watch (Nathanson, 1999). Three specific parental television mediation styles have been identified: *active mediation,* where parents talk to their children about what they watch; *restrictive mediation,* where parents set rules and regulations about television access; and *co-viewing,* where parents simply watch television with their children (Nathanson, 1999; Valkenburg et al., 1999). Active mediation is referred to as instructive or evaluative mediation in some studies (Valkenburg et al., 1999). For consistency, the current study will call this concept *evaluative parental mediation,* as this phrase also captures parents' practice of encouraging their children to share their opinions even if these may be different from their parents' views. The word "active" in active mediation connotes a conscious effort that is also present among parents who purposely restrict their children's media use to protect them from harmful television content. In the scale they created to define evaluative mediation, Valkenburg and colleagues (1999) asked parents how often they: (a) help the child understand what he or she sees on TV; (b) point out why some things actors do are good; (c) point out why some things actors do are bad; (d) explain the motives of the characters; and (e) explain what something on television really means.

At least one study found that evaluative parental mediation is helpful in reducing feelings of fear, worry, and anger caused by news exposure among younger children (Buijzen et al., 2007). It was also found to be more effective than restrictive, or having no, parental mediation, in lowering online disclosure among preteen children and younger teens (Lwin et al., 2008). Nathanson (1999) also found that both evaluative and restrictive parental mediation were negatively related to television-induced aggression among children, although restrictive mediation

has a curvilinear relationship with aggression where very low and very high levels of restriction were actually positively related to children's aggression. Parental mediation also has unintended effects, especially among adolescents. For instance, Nathanson (2002) found that restrictive parental mediation led to less positive attitudes toward parents and more viewing of restricted content with peers. Teens under restrictive parental mediation also displayed more positive attitudes toward restricted content (Nathanson, 2002). Thus, consistent with Baumrind's (1968) argument about the impact of parental authority among adolescents, Nathanson (2002) concluded:

> Restrictive mediation may be an effective technique prior to adolescence when issues of freedom and independence are not particularly important. However, as children mature, attempts at control may lead them to develop more positive feelings toward restricted content and purposively seek it out whenever they can. (p. 221)

Yet another study found that parents who expressed higher concerns about television-induced aggression and fright were more likely to practice restrictive parental mediation (Valkenburg et al., 1999). Parents with higher levels of education and younger children are more likely to engage in evaluative and restrictive mediation than less-educated parents or those with older children (Valkenburg et al., 1999). Finally, mothers are more likely to engage in evaluative and restrictive mediation than fathers (Valkenburg et al., 1999). In focusing on the effects of evaluative and restrictive parental mediation on children's political socialization, the current study will first explore those factors that might predict a particular parental mediation by answering the following two research questions:

RQ1: What factors affect parental mediation styles?

RQ2: What are the effects of parental mediation styles on the media habits, engagement in political talk, and school participation of adolescents?

In a parallel, but slightly different, conceptualization, Austin and colleagues (Austin, 1993; Austin, Bolls, Fujioka, & Engelbertson, 1999; Austin & Pinkleton, 2001; Fujioka & Austin, 2002) took *parental television mediation* as the active discussion of television content by a parent with his or her child, a discussion that can be either positive or negative. When a parent endorses particular messages, he or she engages in *positive mediation*. When a parent offers counterarguments or contextualization of messages, he or she engages in *negative mediation* (Fujioka & Austin, 2002). Active parental mediation was found to be positively related to frequency of parent-child discussions of politics (Austin & Pinkleton, 2001). Since positive and negative mediation may co-exist (Austin et al., 1999), the current study will use *evaluative parental mediation* as a concept that incorporates a parent's endorsement of, or counterargument against, a message as both involve

active discussion with a child. This is different from *restrictive parental mediation* that limits children's media access.

Hively and Eveland (2009) have examined the socialization effects of parental mediation specifically on news content, calling this concept *parental news mediation*. Their research in this area incorporates a scale that asks parents to rate how often they: (a) watch or read the news with my child; (b) talk about the news with my child; (c) talk with my child to help him or her understand what is on the news; (d) suggest to my child that he or she learn more about something seen in the news; and (e) tell my child when I see something I don't like in the news. These items are similar to what the current study used to measure *evaluative parental mediation*. Hively and Eveland (2009) found that parental news mediation predicted discussion elaboration of news content among students. Since elaboration has been found to predict political knowledge (Beaudoin & Thorson, 2004; Eveland, 2001; Eveland, Marton, & Seo, 2004; Hively & Eveland, 2009), and since knowledge is considered a link between political interest and participation (Moy, Torres, Tanaka, & McCluskey, 2005; Shani, 2006), we hypothesize that evaluative parental mediation of news use, henceforth, *evaluative parental mediation* (EPM), will positively predict political interest, knowledge, and participation. This is in contrast to the predicted negative effects of the restrictive parental news mediation style, or, henceforth, *restrictive parental mediation* (RPM).

Children's Media Use

The concern of parents regarding the media habits of their children is justified by studies that have demonstrated how media affect children. Studies have found that news media use, particularly newspapers (McLeod et al., 1996; Moy et al., 2005), as well as Internet use (Lupia & Philpot, 2005), increased political interest. This impact of news media use, especially newspapers, is also true with political knowledge, even across age groups (Chaffee & Kanihan, 1997; Eveland, McLeod, & Horowitz, 1998). Others have also found that news media use exerts a positive influence on political participation (Chaffee & Hochheimer, 1985; McLeod et al., 1996; McLeod & McDonald, 1985; Shah, McLeod, & Yoon, 2001). Finally, studies have found that newspaper news has a stronger positive influence on political participation than television news (McLeod & McDonald, 1985; Scheufele, Nisbet, Brossard, & Nisbet, 2004), and that hard news was more influential on political participation than soft news (McLeod et al., 1996). Thus, we hypothesize that newspaper and online news use will positively predict our three dependent variables.

Significant research has shown the effects of television use on political citizenship. The study of parental television mediation was a response to fears that television exposure was promoting aggression among children (Nathanson, 1999, 2002).

Television news, however, was found to predict political knowledge (Hively & Eveland, 2009), but television entertainment use was found to be negatively related to both political knowledge and political participation (McLeod & McDonald, 1985; Scheufele, 2000). Though younger viewers identified comedy and late-night television programs as sources of political campaign news, Hollander (2005) found that consumption of these programs led to more recognition rather than recall of campaign information. Prior (2005) found that those who preferred entertainment content became "less knowledgeable about politics and less likely to vote" (p. 587). Thus, we hypothesize that television news use will positively predict—while television entertainment use will negatively predict—political interest, political knowledge, and political participation.

School and Peers

In finding that mass and interpersonal communication variables are significantly related to political knowledge, Eveland (2001) concluded that "communication plays an important role in political socialization." A number of studies, in fact, have found that interpersonal communication with peers and family members is linked to political citizenship. For instance, McDevitt's (2006) analysis of *developmental provocation*, or the restructuring of family communication patterns because of child-parent conversations, argued that a child benefits from "self-understanding" when the child anticipates conversations with parents. Frequency of discussion and a child's network of peers also predict political participation (Eveland & Hively, 2009). We therefore hypothesize that political talk among adolescents will positively predict our three dependent variables.

Finally, we also look at the impact of school, consistent with studies that found school activities have a positive effect on political citizenship (McLeod & Shah, 2009; Shah et al., 2009). Though Hively and Eveland (2009) did not find any effects of school on political knowledge, other studies have demonstrated that particular school initiatives can increase participation. For instance, studies have found positive effects from the inclusion of civics instruction in school through the efforts of the advocacy group Kids Voting USA (McDevitt & Chaffee, 2002; McDevitt & Kiousis, 2006). McDevitt and Kiousis (2006) found that Kids Voting USA "stimulated news attention, cognition, discussion with parents and friends, deliberative dispositions, and civic identity." Thus, we hypothesize that participation in school civics activities will positively predict political interest, political knowledge, and political participation.

The current study looks at the impact of components of at least four main political socialization agents—family, media, peers, and school—on political socialization. The focus on the political socialization of adolescents is important as these emerging citizens are in the stage of their development when parental

and educational influence competes with peer influence and media use (McLeod & Shah, 2009). We now discuss each of our dependent variables and organize our hypotheses in predicting each of them.

From Motivation to Action

When voters come out in droves during elections and inflate voter turnout, pundits traditionally—but wrongly—interpret it as proof of increasing political interest (Glenn & Grimes, 1968). Turnout during elections alone does not accurately measure political interest. Instead, political interest has been defined as a "citizen's willingness to pay attention to political phenomena at the possible expense of other topics" (Lupia & Philpot, 2005, p. 1122). Shani (2006) pointed out the central role of *motivation* in measuring political interest: Any measure should be able to isolate the motivation from its causes and from the behaviors it causes. Thus, political interest can be defined as "the individual's motivation to engage in politics, which consists of two dimensions: the motivation to learn about politics and the motivation to participate in politics" (Shani, 2006). In studying the effects of Internet use on the political interest of young adults, Lupia and Philpot (2005) asked respondents if an online site made them want to learn more about politics, more likely to talk about politics, and more likely to vote. Based on the literature reviewed above that found how parenting style, media uses, engagement in political talk, and school activities lead to political interest, we test the following hypotheses:

> H1: Children's political interest will be:
> a. Positively predicted by evaluative parental mediation
> b. Negatively predicted by restrictive parental mediation
> c. Positively predicted by newspaper use
> d. Positively predicted by online news use
> e. Positively predicted by television news use
> f. Negatively predicted by television entertainment use
> g. Positively predicted by political talk
> h. Positively predicted by involvement in school activities

One of the earliest media studies that looked at both political interest and knowledge found that news media exposure was related to both variables (Atkin, Galloway, & Nayman, 1976). The authors concluded that the respective relationships were reciprocal: for instance, news media exposure increased political interest that motivated more news media exposure (Atkin et al., 1976). An assumption that can be gleaned from their findings, but which the study did not address, is the possible relationship between political interest and political knowledge: interest was motivating news media exposure, which was linked to increased political

knowledge. Political interest, therefore, is an important variable in the study of political communication because of its role in explaining political knowledge and political participation (Shani, 2006). Subsequent studies have also found that thinking about news or even discussion of content, a process called elaboration, leads to increased knowledge (Beaudoin & Thorson, 2004; Eveland, 2001; Eveland et al., 2004; Hively & Eveland, 2009). Traditionally, political knowledge was measured by recall of facts about candidates and the campaign (Atkin et al., 1976); but Eveland and colleagues have conceptualized political knowledge as two-dimensional: issue-stance knowledge and knowledge structure density (KSD), or the "extent to which individuals see connections or relationships among various concepts" (Eveland, 2001; Eveland & Hively, 2009; Eveland et al., 2004). In this study, we focus on recall of campaign facts and political issues as a measure of political knowledge. Thus, we test the following hypotheses, keeping in mind what we know based on the reviewed literature thus far:

H2: Children's political knowledge will be:
 a. Positively predicted by political interest
 b. Positively predicted by evaluative parental mediation
 c. Negatively predicted by restrictive parental mediation
 d. Positively predicted by newspaper use
 e. Positively predicted by online news use
 f. Positively predicted by television news use
 g. Negatively predicted by television entertainment use
 h. Positively predicted by political talk
 i. Positively predicted by involvement in school activities

Political participation is a widely studied measure largely because it is considered to be the culmination of a political process: It measures *action*. Jaeho and McLeod (2007) described political participation as "a mechanism by which citizens can make known to government and politicians their interests and needs and, further, can generate pressure on various elements of the social system to respond" (p. 209). Political interest predicts political participation (see, for instance, Wang, 2007). Yet the link from political knowledge to political participation remains unclear. One study found that media reliance—particularly newspaper and television—predicted participation through increased knowledge (Moy et al., 2005). In the current study, we use three measures of political participation: traditional, or what we will call offline participation; online participation; and community participation. Rejecting the earlier use of voting as a single measure of political participation, more recent studies have used additional behaviors to index political participation, such as campaigning for a candidate, joining street rallies, or donating campaign funds (Brady, Verba, & Schlozman, 1995; Eveland & Hively, 2009; Moy et al., 2005; Wang, 2007). Thus, our analysis will test the following hypotheses:

H3: Children's offline (traditional) political participation will be:
 a. Positively predicted by political interest
 b. Positively predicted by political knowledge
 c. Positively predicted by evaluative parental mediation
 d. Negatively predicted by restrictive parental mediation
 e. Positively predicted by newspaper use
 f. Positively predicted by online news use
 g. Positively predicted by television news use
 h. Negatively predicted by television entertainment use
 i. Positively predicted by political talk
 j. Positively predicted by involvement in school activities

The coming of the Internet also brought about online behaviors, such as e-mailing officials, that have been used to index political participation (Eveland & Hively, 2009). Thus, we also test the following hypotheses:

H4: Children's online political participation will be:
 a. Positively predicted by political interest
 b. Positively predicted by political knowledge
 c. Positively predicted by evaluative parental mediation
 d. Negatively predicted by restrictive parental mediation
 e. Positively predicted by newspaper use
 f. Positively predicted by online news use
 g. Positively predicted by television news use
 h. Negatively predicted by television entertainment use
 i. Positively predicted by political talk
 j. Positively predicted by involvement in school activities

Studies have also created measures of civic participation that include joining community work (McLeod et al., 1996). Thus, finally, we test the following hypotheses:

H5: Children's community participation will be:
 a. Positively predicted by political interest
 b. Positively predicted by political knowledge
 c. Positively predicted by evaluative parental mediation
 d. Negatively predicted by restrictive parental mediation
 e. Positively predicted by newspaper use
 f. Positively predicted by online news use
 g. Positively predicted by television news use
 h. Negatively predicted by television entertainment use
 i. Positively predicted by political talk
 j. Positively predicted by involvement in school activities

Shah and colleagues (2009) found that while family communication had positive effects on political socialization of children, these were "absorbed by the subsequent variables, most notable of which were classroom deliberation, political talk, and civic

messaging" (p. 113). They argued that expressions outside the family mediated the effects of family communication (Shah et al., 2009). Though the study looked at the effects on various forms of participation, it did not examine political interest and political knowledge, which might be mediating the effects on participation. Family communication patterns are also different from the parental mediation styles the current study examines. Thus, we will answer the following research questions:

RQ3: What will happen to the effects of parental news mediation styles when the effects of the other socialization agents, namely media, peer influence, and school, are accounted for?

RQ4: What variables could be mediating the effects of parental styles on adolescents' political interest, knowledge, and participation?

METHOD

Two metropolitan Kansas City school districts provided their high school directories that contained names and addresses of all families of enrolled students. A census-based sample of other school districts in the region was also purchased from Marketing Systems Group. That sample consisted of families that had reported at least one child aged 14–19 in the home.

The cover letter of the survey asked parents to complete the first section of the questionnaire, then hand it to their son or daughter to complete their questions, and then have it returned to the parent so they could complete the final section. The cover letter also indicated that 50 families would be entered into a raffle drawing to win $50 checks. The University Institutional Review Board approved all procedures. Some 8,000 surveys were mailed out 2 days after the November 2010 mid-term election, half from the directories and half from the Marketing Systems Group sample. Because the response level was low, a second mailing of 1,860 surveys to additional randomly sampled addresses from the high school directories was sent on December 15, 2010. The total number of returned surveys from the first mailing was 362, of which 346 were sufficiently completed. The second mailing yielded 53 responses, all of which were sufficiently completed. Therefore, the total number of usable surveys was 399.

Because we used bulk mail, undeliverable mailings were not returned and thus it is not possible to determine how many there were. Assuming all envelopes were successfully delivered to eligible families (which was likely not the case), the response rate was 4%. Clearly, the low response rate means that the results are in no way representative of the Kansas City area. As might be expected, the socio-economic status (SES) of our respondents was higher than the demographic characteristics of metropolitan Kansas City.

Predictor Variables

Evaluative parental mediation (EPM). We asked parents to rate on a seven-point Likert scale how they agreed with each of the following statements: "I talk with my child to help him/her understand what is on the news," "I often encourage my child to follow the news," "I suggest to my child that he/she learn more about the political issues seen in the news," "I often encourage my child to talk about politics," and "I tell my child when I see something I don't like in the news" (Cronbach's α = .84).

Restrictive parental mediation (RPM). Two statements, rated on a seven-point Likert scale, were included: "I restrict the types of shows my kids can watch on television," and "I restrict the types of websites my kids can visit." The two items are strongly correlated ($r(382) = .68; p < .001$).

Newspaper use. Participants were asked the amount of time per week they used the following: "A print copy of a national newspaper (e.g., *New York Times*, *USA Today*)," and "A print copy of the *Kansas City Star* (1: Don't use; 2: Less than 30 minutes; 3: 30 minutes to 1 hour; 4: 1–2 hours; 5: 2–3 hours; 6: 3–4 hours; 7: 4–5 hours; 8: 5 or more hours)." The two items were positively correlated ($r(384) = .32$).

Online news use. Using the same scale as with newspaper use, online news use was measured using the following items: "Amount of time using national newspaper websites (e.g., nytimes.com, usatoday.com)," and "*Kansas City Star* online (KansasCity.com)." The two items were positively correlated ($r(382) = .30$).

TV news use. We asked our teen respondents to indicate how many days a week they watch the following shows: *The Today Show*, *Good Morning America*, or *The Early News*; National nightly news on CBS, ABC, or NBC; local news within their viewing area (5 p.m., 6 p.m., or 10 p.m.); news magazine shows such as *60 Minutes* or *Dateline* (Cronbach's α = .82).

TV entertainment use. We asked our teen respondents to rate how many days per week they watch the following genre of TV shows: Primetime reality programs (e.g., *Survivor*, *American Idol*); primetime comedy programs (e.g., *Two and a Half Men*, *The Office*); primetime cartoon programs (e.g., *Family Guy*, *The Simpsons*); primetime drama programs (e.g., *Grey's Anatomy*, *CSI*); game shows (e.g., *Jeopardy!*, *Wheel of Fortune*); daytime talk shows (e.g., *Oprah*, *The View*); teen programs (e.g., *Hannah Montana*, *iCarly*); daytime cartoon programs (e.g., *SpongeBob SquarePants*, *Scooby-Doo*); and MTV programs (e.g., *Jersey Shore*, *Real World*) (Cronbach's α = .73).

Political talk. We asked our teen respondents to rate on a seven-point Likert scale how frequently they: "Talked about news and current events with family members"; "Talked about news and current events with friends"; "Talked about news and current events with adults outside your family"; "Talked about news and

current events with people who disagree with you"; "Talked to one or more friends who are Democrats about the campaign"; "Talked to one or more friends who are Republicans about the campaign" (Cronbach's α = .92).

School. Participants were asked to rate on a seven-point Likert scale how often they participated in the following school activities: "Followed the news as part of a class assignment"; "Learned about how government works in class"; "Discussed/ debated political or social issues in class"; "Participated in political role-playing in class (e.g., mock trials, elections)"; "Encouraged to make up your own mind about issues in class"; "Analyzed political cartoons in class"; "Spoke your opinion in class even when the topic was controversial"; "Learned about political advertising in class"; "Talked in class about what makes a news story credible"; "Worked with a community organization as part of a class assignment"; and "Helped to register voters as part of a class assignment" (Cronbach's α = .90).

Dependent Variables

Political interest. Three items were used to measure political interest on a five-point Likert scale: "I paid attention to the election campaigns in my state"; "I was interested in the election campaigns in my state"; and "I am interested in politics" (Cronbach's α = .88).

Political knowledge. Political knowledge was an additive index of six questions that asked participants the following questions: "Which political party is more conservative?" "Whose responsibility is it to determine if a law is constitutional or not?" "Do you happen to know if children born to illegal immigrants in the U.S. are automatically U.S. citizens or are they not?" "Do you happen to know if the national unemployment rate is currently closer to 5% or 10% or 15% or 20%?" "In Missouri, what office did Robin Carnahan run for?" and "In Kansas, what office did Jerry Moran run for?" For each question, a correct answer was scored 1, while incorrect responses were 0. The highest score was 6 and the lowest was 0.

Offline participation. We asked our teen respondents to rate on a seven-point Likert scale how frequently they: "Wrote a letter or e-mail to a news organization"; "Contributed money to a political campaign"; "Volunteered for a political party or candidate"; "Attended a political meeting, rally, or speech"; "Worked for a political party or candidate"; and "Displayed a political campaign button, sticker, or sign" (Cronbach's α = .85).

Online participation. We asked our teen respondents to rate on a seven-point Likert scale how frequently they: "Read comments posted by readers on a news website or political blog"; "Posted comments on a news website or political blog"; "Exchanged political e-mails with friends and family"; "Forwarded the link to a political video or news article"; "Received a link to a political video or news article"; "Watched video news stories online"; "Went online to get information about

the November elections"; and "Watched political/candidate videos online" (Cronbach's α = .86).

Community participation. Three items indexed this variable. We asked our teen respondents to rate on a seven-point Likert scale how frequently they: "Raised money for a charitable cause"; "Did volunteer work"; and "Worked on a community project" (Cronbach's α = .85).

Testing Mediation

Though Baron and Kenny's (1986) test for mediation has been widely used, more recent studies have argued that it is insufficient to directly test indirect effects (Hayes, 2009; Preacher & Hayes, 2004, 2008). Two problems are associated with this causal steps approach. First, this approach requires a lot of tests, making it difficult to actually detect an effect. Second, it does not actually quantify what it is supposed to measure, as mediation is just logically inferred (Hayes, 2009). A few alternatives have been proposed, but simulation research has found *bootstrapping* to be among the most powerful methods to detect mediation (Hayes, 2009; Preacher & Hayes, 2008). Bootstrapping does not assume normal distribution, unlike other tests, and it has been used by several studies to test simple and multiple mediation effects (see, for instance, Golec de Zavala & Van Bergh, 2007; Tang & Wu, 2010).

Bootstrapping creates a large sample from the original data (1,000 for this study) through a sampling with replacement strategy. It constructs a confidence interval (95% in this study) around the indirect effect from the distribution that it creates (Dubreuil, Laughrea, Morin, Courcy, & Loiselle, 2009). To establish an indirect effect, the interval must not contain a zero (Dubreuil et al., 2009). The current study uses the SPSS macro that Preacher and Hayes (2008) developed to test multiple mediation effects.

RESULTS

RQ1 asked what factors influence parental mediation styles. Parents' television use positively predicted evaluative parental mediation or EPM ($\beta = .17, p < .05$). Parents' gender ($\beta = .13, p < .05$) and party identification (Republican; $\beta = .15, p < .01$) positively predicted restrictive parental mediation (RPM). Children's age ($\beta = -.20, p < .001$) also negatively predicted RPM. Thus, mothers, Republican parents, and those with younger children tend to restrict their children's media access.

RQ2 asked about the influence of parental mediation styles on the media habits of children. The EPM positively predicted children's online news use ($\beta = .21, p < .001$) and television news use ($\beta = .19, p < .001$). It also positively predicted

children's engagement in political talk (β = .43, p < .001) and participation in school activities (β = .29, p < .001).

The first set of hypotheses examined what influences adolescents' political interest. Hierarchical regression analysis showed that EPM (H1a; β = .16, p < .01), television news use (H1e; β = .13, p < .05), and political talk (H1g; β = .39, p < .001) positively predicted political interest, while television entertainment use (H1f; β = -.17, p < .01) negatively predicted political interest as expected. The predicted effects of RPM (H1b), adolescents' newspaper use (H1c), adolescents' online news use (H1d), and school participation (H1h), are not supported.

The second set of hypotheses examined what factors influence adolescents' political knowledge. Regression results showed that adolescents' political knowledge is positively predicted by political interest (H2a; β = .25, p < .001) and political talk (H2h; β = .23, p < .01). The predicted effects on political knowledge of the parental styles (H2b and H2c), adolescents' media uses (H2d, H2e, H2f and H2g), and engagement in school activities (H2i) are not supported.

The third set of hypotheses examined what predicts adolescents' traditional offline political participation. Hierarchical regression results showed that only adolescents' political talk (H3i; β = .18, p < .05) and school activity participation (H3j; β = .28, p < .001) positively predicted traditional offline political participation as expected. H3h, which predicted a negative effect of adolescents' television entertainment use, is rejected as it instead positively predicted offline participation (H3h; β = .12, p < .05). The predicted effects of political interest and political knowledge (H3a and H3b), parental styles (H3c and H3d), and adolescents' other media uses (H3e, H3f, and H3g) are not supported.

The fourth set of hypotheses examined the factors that influence adolescents' online political participation. The hypotheses that predicted positive effects of political interest (H4a; β = .128, p < .05), online news use (H4f; β = .246, p < .001), political talk (H4i; β = .307, p < .001), and school activity participation (H4j; β = .231, p < .001) are supported. However, the predicted effects of political knowledge (H4b), parental styles (H4c and H4d), and adolescents' other media uses (H3e, H3g, and H3h) are not supported.

Finally, the factors affecting adolescents' community participation were examined. Only political talk (H5i; β = .16, p < .05) and school activity participation (H5j; β = .37, p < .001) positively predicted community participation. The rest of the hypotheses were not supported.

RQ3 asked about what happens to the effects of parental styles when effects of the other socialization agents—including adolescents' media use, political talk and school participation—are taken into account. RPM did not have any effects on any of the dependent variables even when it was tested separately from the evaluative style. Thus, we explore what happens to the effects of EPM. The regression model for political interest showed that the effect of EPM was able to withstand the

effects of the other variables. It seems that evaluative mediation had a strong direct effect on adolescents' political interest. The regression models for both offline and online political participation showed that EPM had no effect at the outset. In contrast, the regression models for political knowledge and community participation start out with EPM exerting a significant positive effect that waned and eventually disappeared when adolescents' media use and, especially, adolescents' political talk were added. These findings are similar to what Shah and colleagues (2009) found, that positive effects of family communication on civic participation and political consumerism were "largely absorbed" by classroom deliberation and political talk. This does not specifically test a mediation model, however. Thus, to answer RQ4, we conducted further analyses and turned to bootstrapping.

Indirect Effects on Political Interest

Evaluative parental mediation (EPM) has a direct effect on political interest. It is possible, however, that some of its effects are also mediated by other factors. To confirm this, we conducted further analyses involving the other variables—TV news use, TV entertainment use, and political talk—that predicted political interest in the regression analyses. Further tests confirmed that some effects of EPM are mediated ($n = 333$). While the direct effect of EPM on political interest was significant ($\beta = .2569$, $p < .001$), the total effect, including indirect effects, had a bigger effect size ($\beta = .5672$, $p < .001$).

To confirm which of the three variables act as mediators, we ran a mediation analysis using bootstrapping. The 95% bias-corrected bootstrap confidence interval (CI) for the effect size of the indirect path through political talk was above zero (.1707 to .3423), indicating it was a significant mediator. Likewise, the indirect path through TV news use was also above zero (.0084 to .0825), indicating it was also a significant mediator. However, TV entertainment was not a mediator (CI: −.0064 to .0592). The model is shown in Figure 1.

Indirect Effects on Political Knowledge

Because only political interest and political talk significantly predicted political knowledge after the effects of the other variables were controlled for, we tested if they could be mediating the effects of EPM on political knowledge. Through additional analyses, we confirmed a mediation model ($n = 316$). The direct effect of EPM on political knowledge is not significant, but a model that looks at the indirect effects through adolescents' political interest and political talk is significant, $\beta = .5469$, $p < .001$. This is further confirmed by bootstrapping analysis. The 95% bias-corrected bootstrap CI for the indirect path through political interest

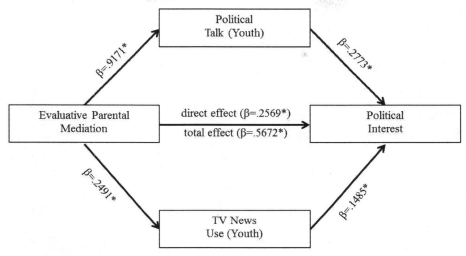

Figure 1. Mediation model from EPM to political interest through political talk and TV news use.

was above zero (.0929 to .2890), indicating it was a significant mediator. Likewise, the indirect path through political talk was .0723 to .2786, indicating it was also a significant mediator (see Figure 2).

Indirect Effects on Offline Participation

To test possible mediation, we tested the three variables that significantly predicted offline participation in the regression model: participation in school activities, TV

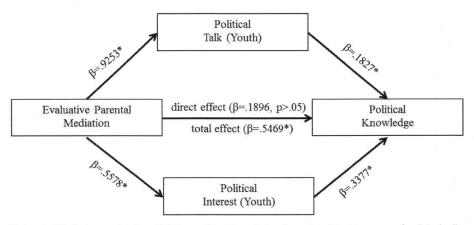

Figure 2. Mediation model from EPM to political knowledge through political interest and political talk.

entertainment use, and political talk among adolescents. Thus, while EPM did not directly predict offline political participation, the mediation model showed an indirect effect through mediators, β = .2439, p < .001 ($n = 335$). We again referred to bootstrapping analyses to test which among the three variables acted as mediators. The 95% bias-corrected bootstrap CIs for the effect size of the indirect path through school (.0328 and .1759) and through political talk (.0292 to .1984) were both above zero, indicating that both were significant mediators. However, TV is not a significant mediator (see Figure 3).

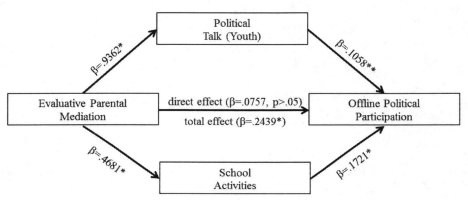

Figure 3. Mediation model from EPM to offline political participation through political talk and school activities.

Indirect Effects on Online Participation

From the regression model, we tested the possible mediation effects of school, political talk, political interest, and adolescents' online news use. In the analyses, we found that while EPM did not have a direct effect on online participation, the indirect effect through mediating variables was significant, β = .3374, p < .001 (n = 342). We again referred to bootstrapping analyses and found that all four variables acted as mediators as their confidence intervals at 95% all lacked a zero value: school (.0381 to .1349); political talk (.1661 to .3622); political interest (.0179 to .1396); and online news use (.0322 to .1167). The model is shown in Figure 4.

Indirect Effects on Community Participation

The regression analyses showed that only political talk among adolescents and school participation predicted community participation. Further analyses showed that while EPM did not have a direct effect on community participation, the indirect effect was significant, β = .4379, p < .001 ($n = 354$). The bootstrapping analyses

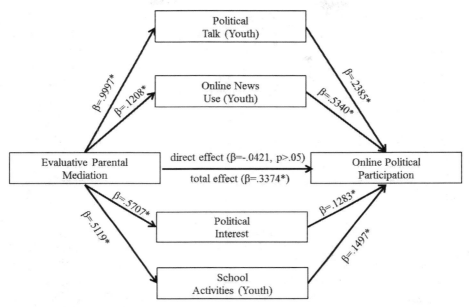

Figure 4. Mediation model from EPM to online political participation.

revealed, however, that at the 95% confidence interval, only school participation was a significant mediator of EPM's effect on community participation (CI:.1100 to .3650). The model is shown in Figure 5.

DISCUSSION

Because this study focused on the effects of various components of at least four political socialization agents, it is not surprising that our regression models accounted for significant portions of the variances of five dependent variables:

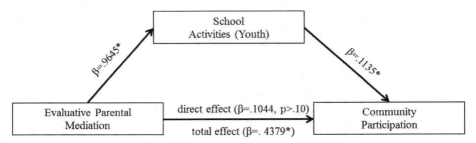

Figure 5. Mediation model from EPM to community participation through school activities.

political interest (41%), political knowledge (25%), offline political participation (25%), online political participation (45%), and community participation (30%), as indicated in Table 1. The findings demonstrate the important roles of these socialization agents in the political awakening and involvement of adolescents.

The analysis showed that mothers and those with younger children tend to engage more in restrictive parental mediation (RPM), which is consistent with the literature (Valkenburg et al., 1999). In contrast, only parents' frequency of television use predicted engagement in evaluative parental mediation (EPM). Thus, while mothers' apparent concern for the harmful effects of the media for their younger children appears to be leading to restriction of children's media access, parents' regular exposure to television content motivates them to guide their children in news consumption, possibly knowing the diverse media content available that includes not only harmful but also helpful messages.

It might be disheartening to note that the EPM, where parents encourage their children to follow and discuss the news, only positively predicts political interest but not knowledge and forms of participation. This finding does not, however, tell the entire story. What our analysis showed is similar to what Shah and colleagues (2009) have found, that effects of family communication disappear when other variables are controlled for. In the current study, however, we examined this complex pathway further by specifically measuring indirect effects from EPM to our dependent variables through possible mediators, something previous studies failed to undertake. The total effects from EPM to all of the dependent variables were all significant (see Figures 1–5). Our analyses found two important mediators: adolescents' engagement in political talk and school activities. The first mediated the relationship between EPM and political interest, knowledge, online and offline participation. The second mediated the relationship between EPM and the three forms of participation. What these findings stress is the important role of parents in encouraging their children to engage in political talk among their peers and in participating in school activities, with both activities enhancing political socialization. Separate regression analyses confirmed this, showing that the evaluative parental mediation style positively predicted adolescents' online news use, television news use, political talk, and participation in school activities. These results are consistent with the literature on parental mediation, which points to how children benefit from an evaluative parental style; and when parents engage their children to discuss news instead of just restricting access, which may lead to the absence of healthy family discussion (Baumrind, 1971b; Chaffee et al., 1973; Nathanson, 2002). In short, our analyses confirmed that the complex pathways of political socialization among adolescents begin at home.

The effect of television entertainment use is noteworthy as it reduced political interest, which is consistent with the literature on its effects on political knowledge (McLeod & McDonald, 1985; Prior, 2005; Scheufele, 2000); but television

Table 1. Regressions Predicting the Five Dependent Variables.

	Political Interest	Political Knowledge	Traditional Participation	Online Participation	Community Participation
Block 1					
Income	.03	.165**	.058	.122*	.149*
Age	.06	.06	−.047	.083	−.06
Gender (F)	−.02***	−.02	.042	.06	.184**
Party ID (R)		.06	−.057	−.077	.036
(Political Interest)	−.13*	.426***	.291***	.439***	.182**
R^2 Change	.055**	.05**	.094***	.222***	.078***
Block 2					
Evaluative Mediation	.363***	.275***	.09	.025	.145*
R^2 Change	.133**	.073***	.007	.001	.018*
Block 3					
Restrictive Mediation	−.021	−.11	.00	−.06	.013
R^2 Change	.000	.01	.00	.003	.000
Block 4					
Newspaper use	.05	.03	.07	−.06	−.035
Online news use	.151**	−.003	.085	.331***	.07
TV news use	.211***	.198**	−.05	.043	.122
TV entertainment use	−.22***	−.17**	.124	−.06	−.13*
R^2 Change	.099***	.04**	.027	.092***	
Block 5					
Political talk	.392***	.33**	.331***	.429***	.37***
R^2 Change	.12***	.073***	.061***	.101***	.075***
Block 6					
School activity participation	.074	.027	.305***	.226***	.383***
R^2 Change	.002	.000	.056***	.031***	.089***
Total R^2	.409	.25	.245	.45	.299

entertainment use also positively predicted traditional political participation. It is surprising to find that television content that is usually devoid of news can lead to increased participation. What may be occurring is the increasing reliance of teens and even adults on news satire programs that blend humor with political commentary, a feature of our changing political media landscape, although our study's measure of television entertainment use clearly excluded these programs. This surprising finding is something that future studies should explore more closely.

Our results also point to the increasing importance of online media in adolescents' political socialization as political identities are shaped and solidified on the web through the increase of political blogs and politicians' reliance on the Internet to mobilize support. Internet users represent an important community to explore, especially as children and teens spend more and more time on social networking sites and online gaming. Though the evaluative parental news style does not directly predict online political participation, it positively predicts adolescents' online news use, a significant factor in adolescents' online participation. It must be stressed, however, that the low response rate is a clear limitation of our study, as is the fact that the respondents come from a higher SES compared to the city average of our population. The low response rate is likely related, at least partially, to the fact that voter turnout in this non-presidential year was quite low—it was only at 41.7% in Kansas City.

CONCLUSION

In this study, we sought to contribute to a greater understanding of the complex political socialization pathways from the home to the larger political arena. It is often taken for granted, if not overlooked entirely, that parents' mediation of their adolescents' media access has significant effects on adolescents' political awakening and development. The easiest thing for parents to do is just switch off the television set and shield children from potentially harmful or difficult-to-understand content. But encouraging children to follow political developments, discussing with them what is on the news, or telling them why an issue is important or irrelevant could have profound impacts that might not be instantly quantified or observed. It is plausible that what is cultivated at home extends to adolescents' interactions with peers and engagement in school work. Thus, the role of parents is central in their adolescents' political socialization that starts with encouraging their children to be interested in politics, to engage in political talk, and to participate in school activities. In short, political socialization indeed begins at home.

An interesting question that the extant literature and the current study have raised is just how long in an individual's socialization does parental influence last? This study looked only at high school students. It is likely that as individuals

mature and start to become more independent, parental influences wane and disappear. For instance, Baumrind (1968) and Nathanson (2002) argued that as adolescents long for independence, parental control may work counter-effectively. It is not far-fetched, though, that early political socialization, which we have demonstrated to be dependent on parental influence—among other factors—serves as a foundation of adult political behavior. This is a challenging but interesting question that future studies should explore.

REFERENCES

Atkin, C. K., Galloway, J., & Nayman, O. B. (1976). News media exposure, political knowledge and campaign interest. *Journalism Quarterly, 53*(2), 231–237.

Austin, E. W. (1993). Exploring the effects of active parental mediation of television content. *Journal of Broadcasting & Electronic Media, 37*(2), 147.

Austin, E. W., Bolls, P., Fujioka, Y., & Engelbertson, J. (1999). How and why parents take on the tube. *Journal of Broadcasting & Electronic Media, 43*(2), 175.

Austin, E. W., & Pinkleton, B. E. (2001). The role of parental mediation in the political socialization process. *Journal of Broadcasting & Electronic Media, 45*(2), 221.

Baron, R. M., & Kenny, D. A. (1986). The moderator-mediator variable distinction in social psychological research: Conceptual, strategic, and statistical considerations. *Journal of Personality and Social Psychology, 51*(6), 1173–1182.

Baumrind, D. (1968). Authoritarian vs. authoritative parental control. *Adolescence, 3*(11).

Baumrind, D. (1971a). Current patterns of parental authority. *Developmental Psychology, 4*(12), 1–103.

Baumrind, D. (1971b). Harmonious parents and their preschool children. *Developmental Psychology, 4*(11), 99–102.

Beaudoin, C. E., & Thorson, E. (2004). Testing the cognitive mediation model. *Communication Research, 31*(4), 446–471.

Brady, H. E., Verba, S., & Schlozman, K. L. (1995). Beyond SES: A resource model of political participation. *The American Political Science Review, 89*(2), 271.

Buijzen, M., Walma van der Molen, J. H., & Sondij, P. (2007). Parental mediation of children's emotional responses to a violent news event. *Communication Research, 34*(2), 212–230.

Chaffee, S., & Hochheimer, J. L. (1985). The beginnings of political communication research in the United States. In E. Rogers & F. Balle (Eds.), *The media revolution in America and in Western Europe* (pp. 267–296). Norwood, NJ: Ablex.

Chaffee, S., & Kanihan, S. F. (1997). Learning about politics from the mass media. *Political Communication, 14*(4), 421–430.

Chaffee, S., McLeod, J. M., & Wackman, D. (1973). Family communication patterns and adolescent political participation. In J. Dennis (Ed.), *Socialization to politics: A reader* (pp. 349–364). New York, NY: John Wiley.

Dubreuil, P., Laughrea, M.-C., Morin, A., Courcy, F., & Loiselle, O. (2009). Social relationships at work: Moderator or mediator of the association between role variables and burnout? *International Journal of Business and Management, 4*(9), 3–16.

Eveland, W. P. (2001). The cognitive mediation model of learning from the news: Evidence from nonelection, off-year election, and presidential election contexts. *Communication Research, 28*(5), 571.

Eveland, W. P., & Hively, M. H. (2009). Political discussion frequency, network size, and "heterogeneity" of discussion as predictors of political knowledge and participation. *Journal of Communication, 59*(2), 205–224.

Eveland, W. P., Marton, K., & Seo, M. (2004). Moving beyond "just the facts:" The influence of online news on the content and structure of public affairs knowledge. *Communication Research, 99*(1), 1–15.

Eveland, W. P., McLeod, J., & Horowitz, E. (1998). Communication and age in childhood political socialization: An interactive model of political development. *Journalism and Mass Communication Quarterly, 75*(4), 699.

Fujioka, Y., & Austin, E. W. (2002). The relationship of family communication patterns to parental mediation styles. *Communication Research, 29*(6), 642–665.

Glenn, N. D., & Grimes, M. (1968). Aging, voting, and political interest. *American Sociological Review, 33*(4), 563–575.

Gniewosz, B., Noack, P., & Buhl, M. (2009). Political alienation in adolescence: Associations with parental role models, parenting styles, and classroom climate. *International Journal of Behavioral Development, 33*(4), 337–346.

Golec de Zavala, A., & Van Bergh, A. (2007). Need for cognitive closure and conservative political beliefs: Differential mediation by personal worldviews. *Political Psychology, 28*(5), 587–608.

Hayes, A. (2009). Beyond Baron and Kenny: Statistical mediation analysis in the new millennium. *Communication Monographs, 76*(4), 408–420.

Heaven, P. C. L., & Ciarrochi, J. (2008). Parental styles, conscientiousness, and academic performance in high school: A three-wave longitudinal study. *Personality and Social Psychology Bulletin, 34*(4), 451–461.

Hively, M. H., & Eveland, W. P. (2009). Contextual antecedents and political consequences of adolescent political discussion, discussion elaboration, and network diversity. *Political Communication, 26*(1), 30–47.

Hollander, B. A. (2005). Late-night learning: Do entertainment programs increase political campaign knowledge for young viewers? *Journal of Broadcasting & Electronic Media, 49*(4), 402–415.

Jaeho, C., & McLeod, D. M. (2007). Structural antecedents to knowledge and participation: Extending the knowledge gap concept to participation. *Journal of Communication, 57*(2), 205–228.

Lupia, A., & Philpot, T. S. (2005). Views from inside the Net: How websites affect young adults' political interest. *The Journal of Politics, 67*(4), 1122–1142.

Lwin, M. O., Stanaland, A. J. S., & Miyazaki, A. D. (2008). Protecting children's privacy online: How parental mediation strategies affect website safeguard effectiveness. *Journal of Retailing, 84*(2), 205–217.

McDevitt, M. (2006). The partisan child: Developmental provocation as a model of political socialization. *International Journal of Public Opinion Research, 18*(1), 67–88.

McDevitt, M., & Chaffee, S. (2002). From top-down to trickle-up influence: Revisiting assumptions about the family in political socialization. *Political Communication, 19*(3), 281–301.

McDevitt, M., & Kiousis, S. (2006). *Experiments in political socialization: Kids Voting USA as a model for civic education reform.* Retrieved from the Center for Information and Research on Civic Learning and Engagement website: http://civicyouth.org/PopUps/WorkingPapers/WP49McDevitt.pdf

McLeod, J. M., Daily, K., Guo, Z., Eveland, W. P., Jr., Bayer, J., Yang, S., & Wang, H. (1996). Community integration, local media use, and democratic processes. *Communication Research, 23*(2), 179–209.

McLeod, J. M., & McDonald, D. (1985). Beyond simple exposure: Media orientations and their impact on political processes. *Communication Research, 12*(1), 3–33.

McLeod, J. M., & Shah, D. V. (2009). Communication and political socialization: Challenges and opportunities for research. *Political Communication, 26*(1), 1–10.

Moy, P., Torres, M., Tanaka, K., & McCluskey, M. R. (2005). Knowledge or trust? Investigating linkages between media reliance and participation. *Communication Research, 32*(1), 59–86.

Nathanson, A. (1999). Identifying and explaining the relationship between parental mediation and children's aggression. *Communication Research, 26*(2), 124–143.

Nathanson, A. (2002). The unintended effects of parental mediation of television on adolescents. *Media Psychology, 4*(3), 207–230.

Preacher, K., & Hayes, A. (2004). SPSS and SAS procedures for estimating indirect effects in simple mediation models. *Behavior Research Methods, Instruments and Computers, 36*, 717–731.

Preacher, K., & Hayes, A. (2008). Asymptotic and resampling strategies for assessing and comparing indirect effects in multiple mediator models. *Behavior Research Methods, 40*, 879–891.

Prior, M. (2005). News vs. entertainment: How increasing media choice widens gaps in political knowledge and turnout. *American Journal of Political Science, 49*(3), 577–592.

Scheufele, D. A. (2000). Talk or conversation? Dimensions of interpersonal discussion and their implications for participatory democracy. *Journalism & Mass Communication Quarterly, 77*(4), 727–743.

Scheufele, D. A. (2002). Examining differential gains from mass media and their implications for participatory behavior. *Communication Research, 29*(1), 46–65.

Scheufele, D. A., Nisbet, M. C., Brossard, D., & Nisbet, E. C. (2004). Social structure and citizenship: Examining the impacts of social setting, network heterogeneity, and informational variables on political participation. *Political Communication, 21*(3), 315– 338.

Shah, D. V., McLeod, J. M., & Lee, N. (2009). Communication competence as a foundation for civic competence: Processes of socialization into citizenship. *Political Communication, 26*(1), 102--117.

Shah, D. V., McLeod, J. M., & Yoon, S.-H. (2001). Communication, context, and community. *Communication Research, 28*(4), 464–506.

Shani, D. (2006). Measuring political interest. *American National Election Studies*. Retrieved from ftp://ftp.electionstudies.org/ftp/anes/OC/2006pilot/dshani.pdf

Tang, C., & Wu, A. (2010). Direct and indirect influences of fate control belief, gambling expectancy bias, and self-efficacy on problem gambling and negative mood among Chinese college students: A multiple mediation analysis. *Journal of Gambling Studies, 26*(4), 533–543.

Valkenburg, P. M., Krcmar, M., Peeters, A. L., & Marseille, N. M. (1999). Developing a scale to assess three styles of television mediation: "Instructive Mediation," "Restrictive Mediation," and "Social Coviewing." *Journal of Broadcasting & Electronic Media, 43*(1), 52.

Wang, S. I. (2007). Political use of the internet, political attitudes and political participation. *Asian Journal of Communication, 17*(4), 381–395.

The Importance OF Family Communication Patterns AND School Civics Experiences

CHANG DAE HAM, JOONGHWA LEE, AND ESTHER THORSON

This study examines how news media exposure, parent-child communication patterns, and political and social discussions and activities independently and interactively influence adolescent political knowledge and interest. Of course, the 2008 presidential election remains a highly significant electoral contest to examine as youth involvement in the election of Barack Obama was particularly high (e.g., Soule & Nairne, 2009).

Much of the work on political participation has concluded that Americans are showing a diminished interest in politics. Since 1960 the overall voting rate has dropped in both presidential and congressional elections (Brody, 1978; Cassell & Luskin, 1988; Keeter, Zukin, Andolina, & Jenkins, 2002). Other political participation behaviors such as petitioning and attending rallies have also decreased (Putnam, 2000). In fact, over the past 4 decades, the voting rate of American youth has dropped more dramatically than all other age groups (see Delli Carpini, 2000). In understanding the apparent reversal in this trend as was witnessed in the 2008 presidential election, adolescents, as future voters, present a critical age cohort for political communication researchers to explore. Among all age groups, in fact, voters between the ages of 18 and 24 were the only group that demonstrated a statistically significant increase in turnout, representing an approximately 4% to 5% increase (an estimated 53–55% youth participation) compared with their turnout in the 2004 presidential election (Soule & Naire, 2009; United States Census Bureau, 2009).

There has been significant scholarly study of the various factors that influence adolescents' political engagement. Mass media are important influencers of

adolescents' political engagement (e.g., McLeod, 2000; Shah, McLeod, & Lee, 2009). Of course, the media environment of adolescents has dramatically changed just within the past decade, mostly because of emerging new media such as broadband Internet and mobile communications. The Internet is clearly established as a dominant medium for youth, represented by the fact that 95% of teens were online in 2012 (Anderson & Raine, 2012). Adolescents gain information, enjoy entertainment content, meet friends, and buy products on the Internet. Of course, television remains a mainstay in the news diet of the young (e.g., Shah, McLeod, & Lee, 2009).

There has also developed an understanding that the parental environment and the school environment are intertwined. McDevitt and Chaffee's (1998, 2002) analyses showed that the children of new immigrants often shared their school experiences about civics and politics with their parents. Much earlier, Chaffee, McLeod, & Atkin (1971) and Chaffee, McLeod, & Wackman (1973) showed that different parental orientations toward communication and discipline of adolescent children had an impact on how news media were employed by the adolescents, their interest in politics, and their political knowledge. Yet basic questions remain as to how parenting styles and school experiences interact to influence political socialization, especially in the age of expanding digital media and mobile news and information sources.

The current study asks a number of important questions that help us understand the role of media use in the rich mix of overall influences on political socialization. Specifically, we ask: (1) How do parental communication patterns influence adolescents' political knowledge and interest? (2) What is the impact of school discussions and other educational activities focused on social and political issues? (3) Are media effects mediated by either parental or school communication experiences? (4) Is there an interaction between either parental communication patterns and media, or between school political experience and media use?

LITERATURE REVIEW

Adolescents' Media Use for News Information

Mass media play an important role in people's perceptions of political issues and information. Although the mass media provide an important source for knowledge of political issues (Delli Carpini & Keeter, 1996; McLeod, Rush, & Friederich, 1968), the effects of media differ depending on the type of medium as well as one's purpose for using the medium. For example, television use for entertainment has been shown to cause decreasing political engagement (Putnam, 2000). Television use for news, however, clearly shows a positive impact (Shah, McLeod, & Lee, 2009). Newspaper use, although low among teenagers, has been found to exert

a positive impact on political knowledge and interest (e.g., Eveland, McLeod, & Horowitz, 1998).

The Internet has emerged as an important additional medium for civic and political engagement (Anderson & Raine, 2012; Lenhart, Purcell, Smith, & Zickuhr, 2010; Pew Internet & American Life Project, 2007). In 2012, 62% of teens online gained news about politics and current topics from the Internet (Anderson & Raine, 2012). Nie and Erbring (2000) found that Internet use was negatively related to time spent with other media, family, and friends, but other studies have found that heavy Internet users were more likely to develop a greater number of social relationships than light users (Uslaner, 2004). Internet use has also been shown to positively affect political participation (Gibson, Howard, & Ward, 2000; Hill & Hughes, 1998; Kraut et al., 2002; Shah, McLeod, & Lee, 2009); however, it has also been shown to affect political engagement negatively or have no effect (Kaye & Johnson, 2002); Kraut et al., 2002; Shah, McLeod, & Lee, 2009). A likely explanation for this inconsistency is the operation of mediating variables such as level of social capital, personal communication efficacy, and motivation to use the Internet (Kavanaugh & Patterson, 2001; Kim & Ball-Rokeach, 2006; Shah, McLeod, & Yoon, 2001). Finally, entertainment Internet use is not positively correlated with indicators of political engagement (Shah et al., 2001).

An important question on this matter is the extent to which youth use the Internet for political communication purposes. According to Livingstone and colleagues (Livingstone, Bober, & Helsper, 2004), adolescents had little interest in political participation on the Internet. On the other hand, Montgomery (2000) reported that adolescents used the Internet to express themselves in public forums. Gibson (2002) has argued that compared with other ages, young people participate more actively in political activities on the Internet. Also, Lin, Kim, Jung, & Cheong (2005) found that the level of Internet use among adolescents is positively related to their involvement in community service. In the same vein, the present study explores the effects of adolescents' Internet news use (i.e., information use) on two aspects of political engagement: political interest and political knowledge. Given the weight of previous research on media use and political knowledge and interest, we expect that:

H1: There will be a positive impact of the three informational media (newspaper, television, and Internet) on adolescent political knowledge and interest.

H2: There will be a negative impact of television used for entertainment on adolescent political knowledge and interest.

School and Adolescent Political Socialization

Recently, studies have introduced a "school-centric" approach to examine the role of family, especially parents, in explaining the political socialization of adolescents.

Defined as "trickle-up" socialization, this view of political participation looks at how children can be the initiators of political discussion within the family. Instead of a top-down parental influence on political socialization, the trickle-up perspective focuses on how school education contributes to the political socialization of adolescents and, by extension, their parents and family.

The assumption behind the trickle-up perspective is that children are not just receptive to civic development provided by their parents, they also proactively socialize with agents outside of the home, especially in school. This socialization then leads to adolescents taking more proactive roles in the political environment within their family, leading to increased parental political involvement.

According to studies examining the effects of the school civics curriculum (McDevitt & Chaffee, 2002), adolescents learn and participate in the political socialization process at school. As their political self-efficacy grows they become initiators of family political communication. Participation in Kids Voting USA, one well-known school intervention to stimulate gains in political development among students in fifth and 12th grade, was linked to higher attention to news media and more frequent discussion with family and friends about politics (Simon & Merrill, 1998) increased political knowledge (Meirick & Wackman, 2004), and increased voter turnout for those 18 and older, averaging about 3% more youth turnout in communities where this program was adopted in schools (Merrill, Simon, & Adrian, 1994). Furthermore, this direct effect of school intervention led to an indirect effect on parental information-seeking, opinion formation, and stimulation of "concept-oriented communication," the type of family discussion environment that stimulated more political sophistication than "socio-oriented communication" (McDevitt & Chaffee, 1998). (Concept- and socio-oriented communication are described more fully in the next section of this chapter.)

Schools can potentially provide social interaction that represents a level of political stimulation and communication that may not be available from parents at home (Kiousis & McDevitt, 2008). For low-SES families, schools can increase the likelihood of activating attention to mass media messages in politics and mitigate social structural disparities outside of the classroom. School interventions such as Kids Voting USA encourage political interest and knowledge (McDevitt, 2005; McDevitt & Chaffee, 2002). While family and home environment are perceived as the primary agents of political socialization, schools have played an important part as a secondary agent, along with mass media exposure (Atkin, 1981). It is thus possible to hypothesize that school political-related activities are a second important factor in predicting the political socialization of adolescence. Based on this literature we expected that:

H3: There will be a positive impact of classroom discussions and lessons on adolescents' political knowledge and interest.

It is not clear that home media use and school experiences interact with each other, but we explored this question via:

RQ1: Will classroom political discussion interact with media use to influence adolescent political knowledge and interest?

Family Communication Patterns

The concept of family communication patterns was first suggested by McLeod and Chaffee (1972) and developed into the Family Communication Pattern Theory (FCPT) by Koerner and Fitzpatrick (2002a, 2002b, 2006). Family Communication Pattern Theory (FCPT) provides a meaningful explanation of the association between parents' and children's communication (e.g., Burleson, Delia, & Applegate, 1995; Reiss, 1981). The basic idea of FCPT is that most shared social reality is created within the family. A family is considered a basic unit that shares the same values, belief structures or "schemata" (Fitzpatrick & Ritchie, 1994; Reiss, 1981). A family's shared schemata is created by the ways in which parents and children interact with each other, and it affects how family members perceive social reality (Koerner & Fitzpatrick, 2002b).

The theoretical framework for FCPT developed with research programs that investigated how parent-child communication patterns affect children's information processing of mass media (Abel, 1976; Chaffee, McLeod, & Atkin, 1971; McLeod & Chaffee, 1972; McLeod et al., 1968, 1972; Stone & Chaffee, 1970). In their research program, McLeod et al. (1972) developed a measurement scale for Family Communication Patterns (FCP), which consisted of two subsequent dimensions: Concept Orientation and Socio-Orientation. Where Concept Orientation occurs, youth are mostly influenced by their parents' ideas and concepts in formation of their information processing and following decision-making. These families prefer open discussions even when family members offer differing opinions. Where Socio-Orientation occurs, families are more likely to prefer harmonious parent-child relationships and discussions will be avoided where different opinions and conflict occur (Baxter, Bylund, Imes, & Scheive, 2005).

FCP patterns have been linked with a variety of other concepts, including self-esteem, self-concept, interpersonal satisfaction, closeness, commitment, and communication appreciation (e.g., Bristol & Mangleburg, 2005; Caruana & Vassallo, 2003; Chan & McNeal, 2003; Hsieh, Chiu, & Lin, 2006; Mukherji, 2005). McLeod, Chaffee, and their colleagues (Chaffee et al., 1971; Chaffee, McLeod, & Wackman, 1973; McLeod & Chaffee, 1972; McLeod et al., 1968; McLeod, Atkin, & Chaffee, 1972; Stone & Chaffee, 1970) were primarily interested in the influence of family communication patterns on information processing outcomes in children, particularly in the areas of political socialization

(Chaffee et al., 1973; McLeod et al., 1968) and media use (i.e., processing of television violence and news stories; Chaffee et al., 1971; McLeod et al., 1972).

Children's political interest and knowledge are also affected by parental as well as self or other environmental, factors. Specifically, parents play an important role in children's political learning (Atkin, 1981; Austin & Pinkleton, 2001). For example, more political discussion with parents influenced children's perceptions about voting (O'Keefe & Liu, 1980). According to the social learning model, the parent-child relationship significantly affects children's perceptions, attitudes, and behavior. Indeed, parents are children's first social role models (Bandura, 1986; McDevitt & Chaffee, 2002). Hence, there is a fundamental assumption in the present study that family communication patterns, Concept and Socio-Orientations, will influence adolescents' political knowledge and political interest. This leads to the expectation that:

H4: There will be a positive impact of both Concept and Socio-Orientations on parental communication patterns on adolescents' political knowledge and interest.

Indicators of Political Engagement

In general, adolescents' political socialization refers to the processes of acquiring basic ideas of political issues, understanding how to elaborate opinions about political issues, sharing opinions with others, and having knowledge about political and civic issues (Kim & Kim, 2007). Political socialization is generally defined as including political interest, political knowledge, political discussion, and political participation (Kim & Kim, 2007; Meadowcroft, 1986). Political knowledge, in fact, is one of the most frequently used indicators of political sophistication and is assumed to positively influence political activity (Delli Carpini & Keeter, 1993; McAllister, 1998). Political interest is another critical indicator of political socialization. Thus, political interest and political knowledge are employed in the current study as basic indicators of adolescents' level of political socialization.

Family Communication Patterns and Media Use

Family communication patterns also influence children's media use. For example, parents may actively mediate children's interpretations of mass media messages such as television news (Austin, Roberts, & Nass, 1990). Chaffee's work in particular has examined the influence of the parent-child relationship on political communication outcomes, suggesting various ways in which media and interpersonal communication within the family interact with each other (Chaffee & Mutz, 1988). Austin (1993) also employed the Concept and

Socio-Orientation measures in a study of adolescents and families and found that parents did not exert a very strong influence in shaping their children's values from television watching largely because parents were uninvolved in their children's television viewing and not likely to control or censor the information received from television. Meyrowitz (1985) also argued that because much of children's television watching was without parents, there was little parental mediation of television's effects.

Additional research has explored the ways that parents seek to influence their children's media usage and interpretation. For example, parents can make media-use rules (Atkin, Greenberg, & Baldwin, 1991; Corder-Bolz, 1980) and they can mediate children's media-watching experiences by active communication with them during viewing (Atkin et al., 1991; Austin, Roberts, & Nass, 1990; Corder-Bolz, 1980; Desmond, Singer, Singer, Calam, & Colimore, 1985). Furthermore, this line of research has found that family communication patterns are influenced by children's media use, and this communication can affect children's interest in public affairs and achievement in school (e.g., Chaffee, McLeod, & Atkin, 1971; Chaffee, McLeod, & Wackman, 1973; Dornbusch, Ritter, Leiderman, Roberts, & Fraleigh, 1987). For example, Atkin, Heeter, & Baldwin (1989) showed that media-content-oriented discussion between parent and children increased if values described in children's television viewing conflicted with the parents' basic values.

Within the past decade, the Internet has emerged as a dominant news medium for adolescents (Anderson & Raine, 2012; Lenhart et al., 2010; Pew Internet & American Life Project, 2007). Adolescents and parents now spend a great deal of time using the Internet, either independently or together. Internet use provides a variety of information about various issues and ideas, including politics. However, there have been very few studies to date as to how parent-child communication patterns are related to Internet information use. Based on existing studies of the influence of television-watching, the current study postulated that family communication patterns will influence children's informational use of the Internet and affect children's political engagement. Thus, we expected that:

H5: There will be a significant interaction between both Concept and Socio-Orientations and media use on adolescents' political knowledge and interest.

METHOD

Dataset

The data analyzed here are from the first survey of the Future Voters Study (as described in the Introduction), executed between May 20 and June 25, 2008.

Measures

This study employed single-item measurement of demographics, including age, gender, race, strength of political partisanship (regardless of whether it was Republican or Democrat); family and household variables including mother's education, father's education, household income, whether there was multi-channel home television access, high-speed Internet in the home; and social integration variables including years of residence, church attendance, and size of the child's friendship network. Descriptive statistics for each variable, including the means, standard deviations, and ranges for all variables, are shown in Table 1.

Media-use variables were measured in terms of how many days in the typical week (0 to 7) the child used TV for information, TV for entertainment,

Table 1. Descriptive Statistics for the Variables.

Variables	M	SD	Min	Max
Outcome variables				
Political knowledge	0.98	1.01	0	3
Political interest	2.78	1.11	1	5
Predictor variables				
Age	14.5	1.62	12	17
Gender (female)	0.49	0.5	0	1
Race (white)	0.81	0.39	0	1
Strength of partisanship	2.95	0.94	1	5
Education (mother)	3.01	1.35	0	10
Education (father)	2.67	1.39	0	10
Income	45.85	6.04	31	57
Multichannel home	0.23	0.42	0	1
High-speed Internet at home	0.69	0.46	0	1
Years of residence	10.59	7.75	0	59
Church attendance	4.75	2.91	1	8
Size of friendship network	4.63	4.79	0	50
TV information use	0.96	1.11	0	7
TV entertainment use	1.6	1.05	0	7
Newspaper use	1.11	1.17	0	7
Internet information use	1.51	1.08	0	7
Classroom deliberation	3.42	1.98	1	8
Socio-orientation	3.02	0.84	1	5
Concept orientation	3.72	0.72	1	5

newspapers, and the Internet for information. A School Activity variable measured how often during the past 6 months the child engaged in the three items listed in Table 2, ranging from not at all (1) to very frequently (8). Family communication was measured in terms of Concept Orientation and Socio-Orientation. The items making up these two scales were scaled on a 1 (*strongly disagree*) to 5 (*strongly agree*) scale. All scale items and the reliability scores for the scales are displayed in Table 2.

Table 2. Variables and Their Measures.

Measurement Item	Measurement Scale	Reliability (Cronbach's alpha)
TV morning news shows like *The Today Show*, *Good Morning America*, or *The Early News*	None(0) ~ 7 days a week (7)	
National nightly network news on CBS, ABC, NBC	None(0) ~ 7 days a week (7)	
Local news about your viewing area	None(0) ~ 7 days a week (7)	0.77
News magazine shows such as *60 Minutes*	None(0) ~ 7 days a week (7)	
CNN cable news program (e.g., Lou Dobbs, Larry King)	None(0) ~ 7 days a week (7)	
FOX cable news programs (e.g., Bill O'Reilly)	None(0) ~ 7 days a week (7)	
Primetime reality programs	None(0) ~ 7 days a week (7)	
Primetime comedy programs	None(0) ~ 7 days a week (7)	
Primetime cartoon programs	None(0) ~ 7 days a week (7)	
Primetime drama programs	None(0) ~ 7 days a week (7)	
Late-night TV shows	None(0) ~ 7 days a week (7)	0.70
Game shows	None(0) ~ 7 days a week (7)	
Daytime talk shows	None(0) ~ 7 days a week (7)	
Teen programs	None(0) ~ 7 days a week (7)	
Daytime cartoon programs	None(0) ~ 7 days a week (7)	
MTV programs	None(0) ~ 7 days a week (7)	
A print copy of a national newspaper	None(0) ~ 7 days a week (7)	
A print copy of a local newspaper	None(0) ~ 7 days a week (7)	0.77
Your school's student newspaper	None(0) ~ 7 days a week (7)	

National newspaper websites (e.g., nytimes.com)	None(0) ~ 7 days a week (7)	
Local newspaper websites	None(0) ~ 7 days a week (7)	
Online-only news magazines (e.g., *Slate*, *Salon*)	None(0) ~ 7 days a week (7)	0.72
TV news websites (e.g., cnn.com, foxnews.com)	None(0) ~ 7 days a week (7)	
Conservative political blogs (e.g., Instapundit, Michelle Malkin)	None(0) ~ 7 days a week (7)	
Liberal political blogs (e.g., Daily Kos, Talking Points Memo)	None(0) ~ 7 days a week (7)	

SCHOOL ACTIVITY

Learn about how government works in class	Not at all (1) ~Very frequently (8)	
Discuss/debate political or social issues in class	Not at all (1) ~Very frequently (8)	0.82
Participate in political role-playing in class	Not at all (1) ~Very frequently (8)	

CONCEPT ORIENTATION

In our family kids learn it's OK to disagree with adults' ideas about the world (adolescents)	Strongly disagree (1) ~ Strongly agree (5)	
In our family kids are often asked their opinions about family decisions (adolescents)	Strongly disagree (1) ~ Strongly agree (5)	
In our family kids are often asked their opinions about family decisions (parents)	Strongly disagree (1) ~ Strongly agree (5)	0.70
In our family kids learn it's OK to disagree with adults' ideas about the world (parents)	Strongly disagree (1) ~ Strongly agree (5)	

SOCIO-ORIENTATION

In our family, kids are taught not to upset adults (parents)	Strongly disagree (1) ~ Strongly agree (5)	
In our family, kids are taught not to upset adults (adolescents)	Strongly disagree (1) ~ Strongly agree (5)	0.71
Kids do not question parents' rules in our family (parents)	Strongly disagree (1) ~ Strongly agree (5)	
Kids do not question parents' rules in our family (adolescents)	Strongly disagree (1) ~ Strongly agree (5)	

Three interaction variables were generated by multiplying each of the significant media variables and School Activity, Concept Orientation, and Socio-Orientation. A total of nine interaction variables were generated to examine the relationship with political interest (TV information x School Activity, TV information x Concept Orientation, TV information x Socio-Orientation, TV entertainment x School Activity, TV entertainment x Concept Orientation, TV entertainment x Socio-Orientation, Internet information x School Activity, Internet information x Concept Orientation, Internet information x Socio-Orientation). To examine the relationship with political knowledge, only three significant interaction variables were tested (TV information x Class, TV entertainment x Class, Internet information x Class).

The dependent variables included adolescents' political knowledge and political interest. Political Knowledge was measured by the sum of correct answers to these questions: (1) Which political party is more conservative? (2) Which political party controls the U.S. House of Representatives? (3) Which political party did Ronald Reagan belong to when he was president? Responses ranged from 0 to 3. Political Interest was measured by two items on a scale from 1 (strongly disagree) to 5 (strongly agree): (1) I am interested in the presidential campaign, and (2) I am interested in politics. The scale for political interest was reliable (Cronbach's $\alpha = .77$).

Data Analyses

The study employed a series of hierarchical multiple regression analyses separately predicting Political Interest and Political Knowledge. In the regressions, conceptually or empirically associated predictor variables were entered in blocks, which entered the regressions in a specified order. In hierarchical regression analysis, the sequence of entering the blocks of variables was based on the assumed mediation among the predictor variables. Specifically, this study first entered the demographic variables, followed by family background, social integration, and then entered the remaining variable blocks by the order of mediating effects among the constructs.

RESULTS

Measurement of Family Communication Patterns (FCP) Dimensions

To identify the dimensions for FCP, an EFA with varimax rotation was run over the eight items. This analysis generated two factors that accounted for about 38.16% of the total variance. Each factor had an eigenvalue above 1.0. Factor 1 was labeled

Socio-Orientation, which reflects the influence of social roles and relationships on children when performing information processing and behaviors. As a result, Factor 1 includes "In our family, kids are taught not to upset adults" and "Kids do not question parents' rules in our family," which explained 19.51% of the total variance. Factor 2 is labeled as Concept Orientation, which indicates parents' influence on children to perform information processing and decision making by open discussion. Factor 2 consists of "In our family kids learn it's OK to disagree with adults' ideas about the world" for both parents and adolescents, which explained 18.66% of the total variance. With only two items to measure each factor, correlation analysis found both factors to be reliable: Factor 1, Socio-Orientation (Cronbach's α = .71); and Factor 2, Concept Orientation (Cronbach's α = .70). After developing each factor variable, a median split was computed in order to create a categorical variable, i.e., High and Low for each dimension. Concept Orientation was divided by the median (Median = 3.75) into high (55.8%) and low (44.2%), and Socio-Orientation was divided by the median value 3.5 into high (52.6%) and low (47.4%).

Tests of the Hypotheses

The hypotheses were tested with a series of hierarchical linear regressions. The first three blocks of each regression involved controls. We used the same control variables as Shah, McLeod, and Lee (2009). Table 3 shows the results for the control variables where Political Knowledge was the dependent variable. As can be seen, nine demographic variables were significant. Knowledge was higher for older youth, males, and whites. Knowledge scores were higher for children with stronger parental partisanship, higher education of mother and father, higher family income, and those whose families attended religious services.

Table 4 shows the results for the control variables where Political Interest was the dependent variable. Fewer demographic variables were significant. Older non-white youth showed more political interest. Also, those whose fathers had more education and whose families attended religious services were more politically interested.

H1 suggested that there would be a positive impact of the three informational media (newspaper, television, and Internet) on Political Knowledge and Interest. As can be seen in Model 4 of Table 3, TV for information use was marginally significant (but positive), however newspaper and Internet for information were not significant. Also, as shown in Model 4 of Table 4, all the media except for newspapers had a significant impact on Political Interest. Informational use of the Internet was significant for Political Interest but not for Knowledge. Thus, there was partial support for H1, with newspaper use failing to show a significant impact.

Table 3. Results of Hierarchical Regression Analysis Predicting Political Knowledge.

Variable	Model 1 (demographics)			Model 2 (family background)			Model 3 (social integration)		
	B	SE(B)	β	B	SE(B)	β	B	SE(B)	β
Age	0.09	0.02	0.14***	0.08	0.02	0.13***	0.09	0.02	0.14***
Gender (female)	-0.13	0.06	-0.07*	-0.15	0.06	-0.07*	-0.17	0.06	-0.08**
Race (white)	0.00	0.08	0.00	-0.05	0.08	-0.02	-0.01	0.08	0.00*
Strength of partisanship	0.20	0.03	0.19***	0.15	0.03	0.14***	0.13	0.03	0.12***
Education (mother)				0.09	0.02	0.11***	0.08	0.02	0.10**
Education (father)				0.13	0.03	0.17***	0.11	0.03	0.15***
Income				0.02	0.01	0.11**	0.02	0.01	0.10**
Multichannel home				0.03	0.07	0.01	0.04	0.07	0.02
High-speed Internet at home				0.00	0.07	0.00	0.03	0.07	0.01
Years of residence							0.00	0.00	-0.01
Church attendance							0.04	0.01	0.11***
Size of friendship network							0.01	0.01	0.07*
R^2	0.06			0.14			0.15		
Adjusted R^2	0.05			0.13			0.14		
Incremental R^2	0.057***			0.078***			0.016***		

[a]$p < .10$
*$p < .05$; **$p < .001$; ***$p < .001$.

Table 3. (Continued)

Variable	Model 4 (media use)			Model 5 (school activity)			Model 6 (family communication)		
	B	SE(B)	β	B	SE(B)	β	B	SE(B)	β
TV information use	0.02	0.01	0.05 [a]	0.02	0.01	0.05 [a]	0.02	0.01	0.05 [a]
TV entertainment use	-0.15	0.06	-0.15**	-0.13	0.06	-0.13*	-0.13	0.06	-0.13*
Newspaper	0.01	0.01	0.02	0.00	0.01	0.01	0.00	0.01	0.01
Internet information use	0.07	0.06	0.07	0.03	0.06	0.03	0.03	0.06	0.03
Classroom deliberation				0.08	0.02	0.16***	0.08	0.02	0.16***
Socio-orientation							0.02	0.04	0.02
Concept orientation							0.00	0.04	0.00
TV information × Classroom deliberation									
TV entertainment × Classroom deliberation									
Internet information × Classroom deliberation									
R^2	0.16			0.19			0.19		
Adjusted R^2	0.15			0.17			0.17		
Incremental R^2	0.011***			0.023***			0.00		

Note. Demographic control variables were entered in each of these models, but not shown.
[a] $p < .10$.
*$p < .05$; **$p < .001$; ***$p < .001$.

Variable	Model 7-1 (interaction)			Model 7-2 (interaction)			Model 7-3 (interaction)		
	B	SE(B)	β	B	SE(B)	β	B	SE(B)	β
TV information use	0.00	0.03	-0.01	0.02	0.01	0.05 [a]	0.02	0.01	0.05 [a]
TV entertainment use	-0.13	0.06	-0.13*	-0.10	0.07	-0.10	-0.13	0.06	-0.13*
Newspaper	0.00	0.01	0.01	0.00	0.01	0.01	0.00	0.01	0.01
Internet information use	0.03	0.06	0.03	0.03	0.06	0.03	0.05	0.08	0.05
Classroom deliberation	0.07	0.02	0.15***	0.10	0.03	0.19***	0.09	0.03	0.18***
Socio-orientation	0.02	0.04	0.01	0.02	0.04	0.02	0.02	0.04	0.02
Concept orientation	-0.01	0.04	0.00	-0.01	0.04	0.00	0.00	0.04	0.00
TV information × Classroom deliberation	0.01	0.01	0.07	–	–	–	–	–	–
TV entertainment × Classroom deliberation				-0.01	0.01	-0.05	–	–	–
Internet information × Classroom deliberation							-0.01	0.01	-0.03
R^2	0.19		0.19	0.19			0.19		
Adjusted R^2	0.17		0.17	0.17			0.17		
Incremental R^2	0.00		0.00	0.00			0.00		

Note. Demographic control variables were entered in each of these models, but not shown.

[a] $p < .10$.

$*p < .0$; $**p < .001$; $***p < .001$.

Table 4. Results of Hierarchical Regression Analysis Predicting Political Interest.

Variable	Model 1 (demographics)			Model 2 (family background)			Model 3 (social integration)		
	B	SE(B)	β	B	SE(B)	β	B	SE(B)	β
Age	0.07	0.02	0.10**	0.07	0.02	0.10**	0.07	0.02	0.11**
Gender (female)	-0.08	0.07	-0.04	-0.09	0.07	-0.04	-0.1	0.07	-0.05
Race (white)	-0.22	0.09	-0.08*	-0.25	0.09	-0.09**	-0.22	0.09	-0.08*
Strength of partisanship	0.03	0.04	0.02	0.01	0.04	0	-0.01	0.04	-0.01
Education (mother)				0.02	0.03	0.02	0.01	0.03	0.02
Education (father)				0.15	0.03	0.18***	0.13	0.03	0.16***
Income				0	0.01	-0.01	0	0.01	-0.01
Multichannel home				-0.07	0.08	-0.02	-0.06	0.08	-0.02
High-speed Internet at home				-0.03	0.08	-0.01	0	0.08	0
Years of residence							0	0	0.02
Church attendance							0.03	0.01	0.08*
Size of friendship network							0.01	0.01	0.03
R^2		0.02			0.05			0.05	
Adjusted R^2		0.01			0.04			0.04	
Incremental R^2		0.017**			0.30***			0.007[a]	

[a]$p < .10$;
*$p < .05$; **$p < .001$; ***$p < .001$.

Variable	Model 4 (media use)			Model 5 (school activity)			Model 6 (family communication)		
	B	SE(B)	β	B	SE(B)	β	B	SE(B)	β
TV information use	0.03	0.01	0.08**	0.03	0.01	0.08**	0.03	0.01	0.08**
TV entertainment use	−0.35	0.07	−0.32***	−0.3	0.07	−0.28***	−0.29	0.06	−0.27***
Newspaper	0.02	0.01	0.05	0.01	0.01	0.03	0.01	0.01	0.03
Internet information use	0.31	0.07	0.30***	0.24	0.06	0.23***	0.23	0.06	0.22***
Classroom deliberation				0.16	0.02	0.29***	0.15	0.02	0.27***
Socio-orientation							0.07	0.04	0.05 [a]
Concept orientation							0.17	0.05	0.11***
R^2		0.09			0.16			0.17	
Adjusted R^2		0.07			0.15			0.16	
Incremental R^2		0.035***			0.072***			0.013***	

Note. Demographic control variables were entered in each of these models, but not shown.

[a] $p < .10$.

*$p < .05$; **$p < .001$; ***$p < .001$.

Table 4. (Continued)

Variable	Model 7-1 (interaction)			Model 7-2 (interaction)			Model 7-3 (interaction)		
	B	SE(B)	β	B	SE(B)	β	B	SE(B)	β
TV information use	-0.04	0.03	-0.1	0.03	0.01	0.08**	0.03	0.01	0.08**
TV entertainment use	-0.29	0.06	-0.27***	-0.27	0.08	-0.25**	-0.29	0.06	-0.27***
Newspaper	0.01	0.01	0.03	0.01	0.01	0.03	0.01	0.01	0.03
Internet information use	0.21	0.06	0.20**	0.23	0.06	0.22***	0.18	0.08	0.17*
Classroom deliberation	0.12	0.02	0.21***	0.16	0.03	0.28***	0.13	0.03	0.23***
Socio-orientation	0.07	0.04	0.05 [a]	0.07	0.04	0.06 [a]	0.07	0.04	0.05 [a]
Concept orientation	0.16	0.05	0.10***	0.17	0.05	0.11***	0.17	0.05	0.11***
TV information × Classroom deliberation	0.03	0.01	0.21*	—	—	—	—	—	—
TV entertainment × Classroom deliberation				-0.01	0.02	-0.03	—	—	—
Internet information × Classroom deliberation							0.01	0.01	0.06
R^2	0.18			0.17			0.17		
Adjusted R^2	0.16			0.16			0.16		
Incremental R^2	0.004*			0			0		

Note. Demographic control variables were entered in each of these models, but not shown.

[a] $p < .10$.

*$p < .05$; **$p < .001$; ***$p < .001$.

Variable	Model 7-4 (interaction)			Model 7-5 (interaction)			Model 7-6 (interaction)		
	B	SE(B)	β	B	SE(B)	β	B	SE(B)	β
TV information use	-0.1	0.03	-0.30**	0.03	0.01	0.08**	0.03	0.01	0.08**
TV entertainment use	-0.28	0.06	-0.26***	-0.48	0.13	-0.45***	-0.29	0.06	-0.27***
Newspaper	0.01	0.01	0.02	0.01	0.01	0.03	0.01	0.01	0.03
Internet information use	0.16	0.07	0.15*	0.23	0.06	0.21***	0.18	0.13	0.17
Classroom deliberation	0.14	0.02	0.25***	0.15	0.02	0.26***	0.15	0.02	0.27***
Socio-orientation	-0.02	0.04	-0.02	-0.03	0.07	-0.02	0.05	0.07	0.04
Concept orientation	0.16	0.05	0.10**	0.16	0.05	0.10**	0.17	0.05	0.11***
TV information × Classroom deliberation	—	—	—	—	—	—	—	—	—
TV entertainment × Classroom deliberation	—	—	—	—	—	—	—	—	—
Internet information × Classroom deliberation	—	—	—	—	—	—	—	—	—
TV information × Socio-orientation	0.08	0.02	0.42***	—	—	—	—	—	—
TV entertainment × Socio-orientation				0.06	0.04	0.21 [a]			
Internet information × Socio-orientation							0.02	0.03	0.05
TV information × Concept orientation									
TV entertainment × Concept orientation									
Internet information × Concept orientation									
R^2	0.19			0.18			0.17		
Adjusted R^2	0.17			0.16			0.16		
Incremental R^2	0.02			0.002[a]			0		

Note. Demographic control variables were entered in each of these models, but not shown.

[a] $p < .10$.

$*p < .05$; $**p < .001$; $***p < .001$.

Table 4. (Continued)

Variable	Model 7-7 (interaction)			Model 7-8 (interaction)			Model 7-9 (interaction)		
	B	SE(B)	β	B	SE(B)	β	B	SE(B)	β
TV information use	-0.21	0.12	-0.60[a]	0.03	0.01	0.08**	0.03	0.01	0.08**
TV entertainment use	-0.29	0.06	-0.27***	-0.33	0.17	-0.30[a]	-0.29	0.06	-0.27***
Newspaper	0.01	0.01	0.03	0.01	0.01	0.03	0.01	0.01	0.03
Internet information use	0.22	0.06	0.21**	0.23	0.06	0.22***	0.2	0.17	0.19
Classroom deliberation	0.15	0.02	0.26***	0.15	0.02	0.27***	0.15	0.02	0.27***
Socio-orientation	0.07	0.04	0.05[a]	0.07	0.04	0.05[a]	0.07	0.04	0.05[a]
Concept orientation	0.1	0.06	0.06	0.15	0.08	0.10[a]	0.16	0.08	0.10*
TV information × Classroom deliberation	–	–	–	–	–	–	–	–	–
TV entertainment × Classroom deliberation	–	–	–	–	–	–	–	–	–
Internet information × Classroom deliberation	–	–	–	–	–	–	–	–	–
TV information × Socio-orientation	–	–	–	–	–	–	–	–	–
TV entertainment × Socio-orientation	–	–	–	–	–	–	–	–	–
Internet information × Socio-orientation	–	–	–	–	–	–	–	–	–
TV information × Concept orientation	0.07	0.04	0.69[a]	–	–	–	–	–	–
TV entertainment × Concept orientation	–	–	–	0.01	0.04	0.04	–	–	–
Internet information × Concept orientation	–	–	–	–	–	–	0.01	0.04	0.03
R^2		0.18			0.17			0.17	
Adjusted R^2		0.16			0.16			0.16	
Incremental R^2		0.003[a]			0			0	

Note. Demographic control variables were entered in each of these models, but not shown.

[a] $p < .10$.

*$p < .05$; **$p < .001$; ***$p < .001$.

H2 suggested that there would be a negative impact of television used for entertainment on adolescent Political Knowledge and Interest. As noted above, this hypothesis was supported for Political Knowledge as well as for Political Interest. Thus H2 was fully supported.

H3 suggested that there would be a positive impact of School Activities on Political Knowledge and Interest. As can be seen in Model 5 of Tables 3 and 4, this was the case. Note, however, that School Activities did not mediate any of the significant media use effects. H3 was fully supported.

H4 suggested there would be a positive impact of both Concept Orientation and Socio-Orientation family communication patterns on Political Knowledge and Interest. As can be seen in Model 6 of Tables 3 and 4, neither Concept Orientation nor Socio-Orientation were significant predictors of Political Knowledge. For Political Interest, however, Concept Orientation was significant and Socio-Orientation was marginally significant. Neither variable mediated the effects of media use or School Activities. H3 was thus partly supported.

H5 suggested that there would be a significant interaction between both Socio- and Concept Orientations and media use on Political Knowledge and Interest. The interactions of any of the media that were significant in Model 4 with parental communication patterns were tested in the multiple level 7s in Tables 3 and 4. Because there were no main effects of either family communication pattern on Political Knowledge, we did not test the interactions. In Table 4, we see that tests of the two significant media effects with parental communication style on political interest showed that there was a significant interaction between TV for information and Socio-Orientation. There were marginally significant interactions between TV for entertainment and Socio-Orientation and TV for information and Concept Orientation.

RQ1 asked whether School Activities would interact with media usage to influence Political Knowledge and Interest. This question was tested for Political Knowledge in Table 3, Models 7–1, 7–2, and 7–3. As can be seen, none of the interactions was significant. The question was tested for Political Interest in Table 4, Models 7–1, 7–2, and 7–3. There was a significant interaction only between School Activities and TV use for information. Thus, an interaction was found only in TV use for information on Political Interest.

For more in-depth understanding, an additional hierarchical regression analysis was executed with the Political Interest as an initial independent variable, after controlling only demographic factors. The result showed that Political Interest significantly predicted Political Knowledge (β = .29; p < .001). More importantly, all variables, except School Activities, were significantly mediated by Political Interest. Neither media use (TV information: β = .03; p > .1; TV entertainment: β = -.07; p > .1; Internet information: β = -.27; p > .1) nor family communication patterns (Socio: β = .00; p > .1 and Concept: β = -.02; p > .1) significantly

influenced Political Knowledge after controlling for Political Interest. Only School Activities was not mediated by political interest, thus exerting a significant direct influence on Political Knowledge (β = .10; p < .01).

DISCUSSION AND CONCLUSION

This study explored both independent and interactive impacts of (1) parent-child communication patterns, (2) politically related school activities, and (3) mass media usage on adolescent political knowledge and interest. In this mass- and Internet-media-saturated era, it is imperative that we carefully examine how media use may interact with the effects of parent/child communication patterns and school experience in adolescents' political socialization.

We look first at the antecedents of political interest. It should be kept in mind that newspaper use in this sample was low. It is not surprising, then, that newspaper use had no significant effects. Both use of the Internet for political information and TV news had significant effects on political interest, and the effects of television were strong enough to be maintained even in the second regression equations. As has been found so frequently in prior studies, television use for entertainment had a negative effect on political interest, even in the second regression.

Interestingly, television news interacted with both the Socio-Orientation and the Concept Orientation patterns of parent/child communication to increase political interest. In the second regression equation, the interaction between television news and Concept Orientation proved to account for more of the variance. These findings suggest that either a home environment where there is emphasis on discussion that allows disagreement as well as parent-child discussion where the emphasis is on agreeing are both familial communicative patterns that encourage adolescent political interest. This finding is supportive of Eveland et al.'s (1998) work that stresses the importance of personal discussion for increasing the value of children's media exposure to news and politics. Our results further support this notion in that both the Socio- and Concept Orientation had significant main effects on political interest, and these were also strong enough to remain even after all the controls were entered in the final regression.

As work by McDevitt and Chaffee (2002) suggested, and Shah, McLeod, and Lee's (2009) research further supported, our results identified a large and positive effect of School Activities, and this variable also remained significant in spite of added controls. The consistent positive effect of school civics education found here is in direct contradiction to the current trend in American public schools that does not require high school civics, and, indeed, the current trend in American public schools to reduce civics education throughout the curriculum in favor of an intense

focus on the fundamental skills of reading, writing, and arithmetic as demanded by "No Child Left Behind" education reform. Even more impressive was the fact that School Activities interacted with television entertainment use to create a positive impact on political interest. This intriguing finding suggests that the negative impact of spending lots of time with television entertainment programming can be lessened when there are active schoolroom civics experiences. How this process occurs should be a focus in future research.

Turning now to political knowledge, past findings were also supported with the results of the present study. Older children and males scored higher in political knowledge. Republican orientation of the parents was associated with higher knowledge, and this effect remained even when income and education were entered as demographic controls. Again, entertainment television had a negative effect on political knowledge. Classroom deliberation enhanced knowledge, again supporting the crucial role of civics education in American schools. However, unlike for political interest, there were no effects of parent/child communication styles, and there were no significant interactions of any type for political knowledge. Because political interest and political knowledge are so highly correlated, it was clear that interest is mediating the effects of parent/child communication and the assorted interactions that we observed.

Interestingly, school deliberation was the only factor that was not mediated by political interest. This supports the strength of impact of youth classroom experience on the development of adolescents' political knowledge. School experiences involving discussions about social and political issues are clearly a key to growing political interest and knowledge by providing role-training and understanding of how our government and political system works. While debates continue regarding the role of civics education in our nation's schools, our findings point to the fact that well-educated students are likely to be the ones who will go on to vote and become actively engaged in politics in America.

REFERENCES

Abel, J. D. (1976). The family and child television viewing. *Journal of Marriage and the Family, 38*, 331–335.

Anderson, J., & Raine, L. (2012). Millennials will benefit and suffer due to their hyperconnected lives. Retrieved from http://pewinternet.org/Reports/2012/Hyperconnected-lives.aspx

Atkin, C. K. (1981). *Mass media information campaign effectiveness.* Beverly Hills, CA: Sage.

Atkin, D. J., Greenberg, B. S., & Baldwin, T. F. (1981). The home ecology of children's television viewing: Parental mediation and the new video environment. *Journal of Communication, 41*(3), 40–52.

Atkin, D., Heeter, C., & Baldwin, T. (1989). Parental mediation: A comparison of pay, basic and noncable homes. *Journalism Quarterly, 33*, 53–67.

Austin, E. (1993). Exploring the effects of active parent mediation of television context. *Journal of Broadcasting & Electronic Media*, *37*(2), 147–159.

Austin, E. W., & Pinkleton, B. E. (2001). The role of parental mediation in the political socialization process. *Journal of Broadcasting & Electronic Media*, *45*(2), 221–240.

Austin, E. W., Roberts, D. F., & Nass, C. I. (1990). Influences of family communication on children's television interpretation processes. *Communication Research*, *17*, 545–564.

Bandura, A. (1986). *Social foundations of thought & action: A social cognitive theory*. Englewood Cliffs, NJ: Prentice-Hall.

Baxter, L. A., Bylund, C. L., Imes, R. S., & Scheive, D. M. (2005). Family communication environments and rule-based social control of adolescents' healthy lifestyle choices. *Journal of Family Communication*, *5*, 209–227.

Bristol, T., & Mangleburg, T. F. (2005). Not telling the whole story: Teen deception in purchasing. *Academy of Marketing Science Journal*, *33*, 79–95.

Brody, R. A. (1978). The puzzle of political participation in America. In A. King (Ed.), *The new American political system* (pp. 287–324). Washington, DC: American Enterprise Institute.

Burleson, B. R., Delia, J. G., & Applegate, J. L. (1995). The socialization of person-centered communication: Parents' contributions to their children's social-cognitive and communication skills. In M. A. Fitzpatrick & A. L. Vangelisti (Eds.), *Explaining family interactions* (pp. 34–76). Thousand Oaks, CA: Sage.

Caruana, A., & Vassallo, R. (2003). Children's perception of their influence over purchases: The role of parental communication patterns. *Journal of Consumer Marketing*, *20*, 55–66.

Cassell, C. A., & Luskin, R. C. (1988). Simple explanations of turnout decline. *American Political Science Review*, *82*(4), 1321–1330.

Chaffee, S. H., McLeod, J. M., & Atkin, C. K. (1971). Parental influence on adolescent media use. *The American Behavioral Scientist*, *14*, 323–340.

Chaffee, S. H., McLeod, J. M., & Wackman, D. B. (1973). Family communication patterns and adolescent's political participation. In J. Dennis (Ed.), *Socialization to politics: A reader* (pp. 349–364). New York, NY: Wiley.

Chaffee, S. H., & Mutz, D. C. (1988). Comparing mediated and interpersonal communication data. In R. P. Hawkins, J. Weimann, & S. Pingree (Eds.), *Advancing communication science: Merging mass and interpersonal processes* (pp. 19–43). Newbury Park, CA: Sage.

Chaffee, S. H., Zhao, X., & Leshner, G. (1994). Political knowledge and the campaign media of 1992. *Communication Research*, *21*, 305–325.

Chan, K., & McNeal, J. U. (2003). Parent-child communications about consumption and advertising in China. *Journal of Consumer Marketing*, *20*(4), 317–334.

Corder-Bolz, C. R. (1980). Mediation: The role of significant others. *Journal of Communication*, *30*(3), 106–118.

Delli Carpini, M. X. (2000). Gen.Com: Youth, civic engagement, and the new information environment. *Political Communication*, *17*, 341–349.

Delli Carpini, M. X., & Keeter, S. (1996). *What Americans know about politics and why it matters*. New Haven, CT: Yale University Press.

Delli Carpini, M. X. D., & Keeter, S. (1993). Measuring political knowledge: Putting first things first. *American Journal of Political Science*, 1179–1206.

Desmond, R. J., Singer, J. L., Singer, D. G., Calam, R., & Colimore, K. (1985). Family mediation patterns and television viewing: Young children's use and grasp of the medium. *Human Communication Research*, *11*(4), 461–481.

Dornbusch, S. M., Ritter, P. L., Leiderman, P. H., Roberts, D. F., & Fraleigh, M. J. (1987). The rela-tion of parenting style to adolescent school performance. *Child Development, 58*(5), 1244–1257.

Eveland, W. P., Jr., McLeod, J. M., & Horowitz, E. M. (1998). Communication and age in childhood political socialization: An interactive model of political development. *Journal of Mass Communi-cation Quarterly, 75,* 699–718.

Fitzpatrick, M. A., & Ritchie, L. D. (1994). Communication schemata within the family: Multiple perspectives on family interaction. *Human Communication Research, 20,* 275–301.

Gibson, R. (2002). Politicians must exploit Internet to win "apathetic" young voters. Retrieved from http://www.esrc.ac.uk/esrccontent/news/september02–3.asp

Gibson, R. K., Howard, P., & Ward, S. (2000). *Social capital, Internet connectedness and political partic-ipation: A four-country study.* Paper presented at the International Political Science Conference, Quebec, Canada.

Hill, K. A., & Hughes, J. E. (1998). *Cyberpolitics: Citizen activism in the age of the Internet.* Lanham, MD: Rowman & Littlefield.

Hsieh, Y, Chiu, H., & Lin, C. (2006). Family communication and parental influence on children's brand attitudes. *Journal of Business Research, 59,* 1079–1086.

Kavanaugh, A. L., & Patterson, S. J. (2001). The impact of community computer networks on social capital and community involvement. *American Behavioral Scientist, 45,* 469–509.

Kaye, B. K., & Johnson, T. J. (2002). Online and in the know: Uses and gratifications of the web for political information. *Journal of Broadcasting & Electronic Media, 46*(1), 54–71.

Keeter, S., Zukin, C., Andolina, M., & Jenkins, K. (2002). *The civic and political health of the nation: A generational portrait.* New Brunswick, NJ: The Center for Information & Research on Civic Learning and Engagement.

Kim, Y. C., & Ball-Rokeach, S. (2006). Community storytelling network, neighborhood context, and neighborhood engagement: A multilevel approach. *Human Communication Research, 32,* 411–439.

Kim, K. S., & Kim, Y. C. (2007). New and old media uses and political engagement among Korean adolescents. *Asian Journal of Communication, 17*(4), 342–361.

Kiousis, S., & McDevitt, M. (2008). Agenda setting in civic development: Effects curricula and issue importance on youth voter turnout. *Communication Research, 35*(4), 481–502.

Koerner, A. F., & Fitzpatrick, M. A. (2002a). Toward a theory of family communication. *Communi-cation Theory, 12,* 70–91.

Koerner, A. F., & Fitzpatrick, M. A. (2002b). Understanding family communication patterns and family functioning: The roles of conversation orientation and conformity orientation. *Commu-nication Yearbook, 26,* 36–68.

Koerner, A. F., & Fitzpatrick, M. A. (2006). Family communication patterns theory: A social cogni-tive approach. In D. O. Braithwaite & L. A. Baxter (Eds.), *Engaging theories in family communi-cation: Multiple perspectives* (pp. 50–65). Thousand Oaks, CA: Sage.

Kraut, R., Kiesler, S., Boneva, B., Cummings, J., Helgeson, V., & Crawford, A. (2002). Internet par-adox revisited. *Journal of Social Issues, 58*(1), 49–74.

Lenhart, A., Purcell, K., Smith, A., & Zickuhr, K. (2010). Social media & mobile Internet use among teens and young adults. Retrieved from http://pewinternet.org/Reports/2010/Social-Media-and-Young-Adults.aspx

Lin, Y., Kim, Y. C., Jung, J.-Y., & Cheong, P. H. (2005). *The Internet and civic engagement of youth: A case of East Asian cities.* Paper presented to Association of Internet Researchers Conference, Chicago, IL.

Livingstone, S., Bober, M., & Helsper, E. J. (2004). *Active participation or just more information? Young people's take up of opportunities to act and interact on the Internet.* London, England: London School of Economics.

McAllister, I. (1998). Civic education and political knowledge in Australia. *Australian Journal of Political Science, 33,* 7–23.

McDevitt, M. (2005). The partisan child: Developmental provocation as a model of political socialization. *International Journal of Public Opinion Research, 18*(1), 67–88.

McDevitt, M., & Chaffee, S. H. (1998). Second chance political socialization: "Trickle-up" effects of children on parents. In T. J. Johnson, C. E. Hays, & S. P. Hays (Eds.), *Engaging the public: How government and the media can reinvigorate American democracy* (pp. 57–66). Lanham, MD: Rowman & Littlefield.

McDevitt, M., & Chaffee, S. H. (2002). From top-down to trickle-up influence: Revisiting assumptions about the family in political socialization. *Political Communication, 19,* 281–301.

McLeod, J. M. (2000). Media and the civic socialization of youth. *Journal of Adolescent Health, 27S* (2), 45–51.

McLeod, J. M., Atkin, C. K., & Chaffee, S. H. (1972). Adolescents, parents, and television use: Self-report and other-report measures from the Wisconsin sample. In G. A. Comstock & E. A. Rubinstein (Eds.), *Television and social behavior, reports and papers: Vol. 3. Television and adolescent aggressiveness* (pp. 239–313). Rockville, MD: National Institute of Mental Health.

McLeod, J. M., & Chaffee, S. R. (1972). The social construction of reality. In J. Tedeschi (Ed.), *The social influence processes* (pp. 50–99). Chicago, IL: Aldine-Atherton.

McLeod, J. M., & Chaffee, S. H. (1973). Interpersonal approaches to communication research. *American Behavioral Scientist, 16,* 469–500.

McLeod, J. M., Rush, R. R., & Friederich, K. H. (1968). The mass media and political information in Quito, Ecuador. *Public Opinion Quarterly, 32,* 575–587.

Meadowcroft, J. M. (1986). Family communication patterns and political development: The child's role. *Communication Research, 13*(4), 603–624.

Meirick, P. C., & Wackman, D. B. (2004). Kids voting and political knowledge: Narrowing gaps, informing votes. *Social Science Quarterly, 85*(5), 1161–1177.

Merrill, B. D., Simon, J., & Adrian, E. (1994). Boosting voter turnout: The Kids Voting Program. *Journal of Social Studies Research, 18,* 2–7.

Meyrowitz, J. (1985). *No sense of place: The impact of electronic media on social behavior.* New York, NY: Oxford University Press.

Montgomery, K. (2000). Youth and digital media: A policy research agenda. *Journal of Adolescent Health, 27S,* 61–68.

Mukherji, J. (2005). Maternal communication patterns, advertising attitudes and mediation behaviors in urban India. *Journal of Marketing Communications, 11,* 247–262.

Nie, N. H., & Erbring, L. (2000). *Internet and society: A preliminary report.* Retrieved from http://www.nomads.usp.br/documentos/textos/cultura_digital/tics_arq_urb/internet_society%20report.pdf

O'Keefe, G. J., & Liu, J. (1980). First-time voters: Do media matter? *Journal of Communication, 30* (Autumn), 122–129.

Pew Internet & American Life Project. (2007). *Online Video: 57% of internet users have watched videos online and most of them share what they find with others* [Press release]. Retrieved from http://www.pewinternet.org/2007/07/25/online-video-proliferates-as-viewers-share-what-they-find-online-57-of-online-adults-watch-or-download-video/

Putnam, R. D. (2000). *Bowling alone: The collapse and revival of American community*. New York, NY: Simon & Schuster.

Reiss, D. (1981). *The family's construction of reality*. Cambridge, MA: Harvard University Press.

Ritchie, L. D. (1991). Family communication patterns: An epistemic analysis and conceptual reinterpretation. *Communication Research, 18,* 548–565.

Shah, D. V., McLeod, J. M., & Lee, N-J (2009). Communication competence as a foundation for civic competence: Processes of socialization into citizenship. *Political Communication, 26*(1), 102–117.

Shah, D. V., McLeod, J. M., & Yoon, S. H. (2001). Communication, context, and community: An exploration of print, broadcast and Internet influences. *Communication Research, 28,* 464–506.

Simon, J., & Merrill, B. D. (1998). Political socialization in the classroom revisited: The Kids Voting program. *The Social Science Journal, 35*(1), 29–42.

Soule, S., & Nairne, J. (2009, January 8–11). *Youth turnout in the 2008 Presidential election*. Paper presented at the Southern Political Science Association, New Orleans. Retrieved from http://www.civiced.org/pdfs/research/SPSASouleFinal.pdf

Stone, V. A., & Chaffee, S. H. (1970). Family communication patterns and source-message orientation. *Journalism Quarterly, 47,* 239–246.

United States Census Bureau. (2009, July 20). *Voter turnout increases by 5 million in 2008 presidential election* [Press release].Retrieved from http://www.census.gov/newsroom/releases/archives/voting/cb09–110.html

Uslaner, E. M. (2004). Trust, civic engagement, and the Internet. *Political Communication, 21,* 223–242.

Predictors OF Youth Voting

Parent-Child Relationships and Young Adult News Use

ROSANNE SCHOLL AND CHANCE YORK

What can families do to help kids grow into young adults who are politically engaged? Young people's *traditional* political engagement is changing in nature and perhaps even declining (Bennett, 2008; Dalton, 2008, 2009). Part of our nation's gradual decline in voting rates overall is a generational shift to young adults who typically vote less frequently than older citizens (Flanigan & Zingale, 2010).Young citizens see their civic duty as somewhat distinct from one's duty to show up at the polls armed with the news information that is the hallmark of a concerned citizen (Wattenburg, 2012). Despite gains in their electoral participation beginning in 2004, young adults still vote at just over half the rate of seniors, and far below the rate at which today's seniors voted when they were young, decades ago (File, 2013).

Among the many proposals for boosting youth political engagement is the idea that citizenship should start at home. Parents are urged to set a good example or to enforce particular media and participation behaviors during childhood; and civics interventions in secondary schools are proposed as a backup to the family (Campbell, 2006; Finkel & Smith, 2011; Galston, 2004). The purpose of this study is to explore relationships between characteristics of an adolescent's family and that same person's later engagement as a young adult voter. Further, we investigate the roles of parent, adolescent, and young adults' media use in their political engagement.

Careful investigation of media and political socialization by families requires data gathered over a long timeframe from both parents and their children. We

use the Panel Study of Income Dynamics (2009; "Merging Family and Individual Data," 2013) and the associated Transition to Adulthood Study (Panel Study of Income Dynamics, 2010) as a nationally representative sample. For clarity, we will refer to people between the ages of 18 and 25 as "young adults." Those same people at the time they were interviewed several years earlier will be referred to as "adolescents." Early adulthood is a critical time in a person's life (Erikson, 1968; Kroger, Martinussen, & Marcia, 2010) when habits are formed and civic identities are forged (Jennings, 2007). It is also a vulnerable time. High residential mobility, economic instability, and a lack of political appeals targeted to youth (Wattenberg, 2012) all put young people at an externally imposed risk of disengagement.

MEDIA AND POLITICAL ENGAGEMENT

Most studies examining media effects on voter turnout focus largely on the role of news and take only a contemporaneous snapshot of effects. In this study, we look at the effects of exposure to a variety of media and investigate both contemporaneous effects of young adults' current media use and the over-time effects of their past use as an adolescent and their parents' use. Media use, especially news media use, is thought to boost political participation via information (Mutz, 2006; Wattenberg, 2012) and awareness (Zaller, 1992). Entertainment media use, on the other hand, may decrease engagement in politics or other aspects of public life, perhaps through time displacement (Putnam, 2000), a focus on the trivial (Postman, 1985; Prior, 2005, 2007), or the production of a belief that the world is a mean place (Putnam, 2000; however, see also Uslaner, 1998). That news media use is related to political engagement is well established; and this study seeks to examine how that link is affected by family socialization.

SOCIALIZING EFFECTS OF FAMILY ENVIRONMENT

Although communication research in socialization dates to the beginning of the field (e.g., Berelson, Lazarsfeld, & McPhee, 1954), there is not enough contemporary research on political socialization during childhood (Sapiro, 2004). Family influences incurred during the adolescent years is a particularly interesting window on socialization because engagement during adolescent years redounds in adulthood (Campbell, 2006; Stolle & Hooghe, 2004). Children and adolescents learn political party identification (Jennings & Niemi, 1968; Kroh & Selb, 2009; Niemi & Jennings, 1991), participation behavior (Beck & Jennings, 1982), and attitudes (Tedin, 1974) from their parents, and through give-and-take discussions they have within the family (McDevitt & Chaffee, 2002). More generally, the adolescent

years are an important period for all kinds of socialization as these are the years when one's identity takes shape (Erikson, 1968, 1980).

At least three models exist for the process or mechanism of family socialization: the impressionable years model, the direct transmission model, and a genetic mechanism. The "impressionable years" model (e.g., Osborne, Sears, & Valentino, 2011) predicts political orientations are unstable during adolescence and crystalize sometime during young adulthood. In this vein, research using a multigenerational panel study beginning in 1965 shows that the formative years inform both partisan identity (Jennings, Stoker, & Bowers, 2009) and participation (Campbell, 2006; Walsh, Jennings, & Stoker, 2004).

Parental political attitudes are also directly "transmitted" to growing children, especially in homes where there are frequent discussions about politics and consistent attitudes across a variety of issues (Jennings, Stoker, & Bowers, 2009). This transmission model also operates via a more subtle route whereby parents start their children off in the political world. Families in which the relationship between parent and child is strong in the early years will continue to exert larger socialization effects as the child becomes a young adult. Weaker socialization results in crystallization later in life (Jennings, Stoker, & Bowers, 2009). Even primary-school-aged children begin to display structured political orientations, although the tendency to display such orientations differs according to socio-demographic characteristics (Van Deth, Abendschön, & Vollmar, 2011).

Researchers operating under the transmission model report results such as a parent's education increases his or her child's likelihood to participate in politics as an adult, and that this effect happens both via providing more politics in the home and also by providing a higher-quality education (Verba, Schlozman, & Burns, 2003). Unfortunately, many studies use demographics of parents to substitute for actual measures of parental behavior, and often these are obtained from the adolescent and not an adult in the family (Jennings, 2007). Recent work suggests yet another intriguing possibility, that political attitudes may be formed by an interaction between genetics and childhood environment (Alford, Funk, & Hibbing, 2005). Across a variety of outcomes, socialization research has found that active parental socialization is related to psychological outcomes such as conscience (Kochanska, 1993), social competence (Eisenberg, Cumberland, & Spinrad, 1998), and self-esteem (Gecas & Schwalbe, 1986), in addition to behavioral outcomes such as physical activity (Pugliese & Tinsley, 2007), alcohol consumption (Barnes, Farrell, & Cairns, 1986), cigarette smoking (White, Johnson, & Buyske, 2000), and academic achievement (Hill & Tyson, 2009).

To affect political engagement, socialization may work consistently with any or all of these models. All three mechanisms—impressionable years, transmission, and genetic heritability—point to the question of whether it is parental attitudes and behaviors that have a direct effect seen years later in young adult voters, or

whether it is adolescent behaviors such as media use that intercede between family influences and adult outcomes.

Contemporaneous Effects

In addition to what is known about the effects of an adult's media use on contemporaneous engagement, quite a bit of research addresses other contemporaneous effects. Socio-demographic characteristics such as race, education, and number of children are known to affect participation, perhaps because they change the costs and benefits of participating (Brady, Verba, & Scholzman, 1995; Schlozman, Verba, & Brady, 2012). Whether a young person is currently enrolled in college is thought to play an important socializing role, as does contemporaneous media use, as discussed previously. The current study will include an exploration of these established contemporaneous determinates of political engagement, along with adolescent media use and family socialization. We predict the following:

> **H1:** *Parental influence:* There will be positive associations between young adults' political engagement and (a) parental media use, (b) parental engagement, and (c) parental discussions about news with adolescents.

> **H2:** *Adolescent media use:* There will be (a) positive effects of adolescent news media use, and (b) negative effects of adolescent entertainment media use on later engagement as a young adult.

METHOD

Panel Study of Income Dynamics and Transition to Adulthood Study

To explore the above research questions, publicly available data from the University of Michigan's 2003 Panel Study of Income Dynamics (PSID) were analyzed. The PSID is a panel study of a representative sample of U.S. citizens and their families. Since 1968 the PSID has periodically collected data regarding the head of household in the individual-level interview, and the head of household's family in the family-level interview. Additionally, starting in 1997, PSID surveyors began collecting more detailed information on children in PSID families, who in 1997 were ages 0 to 12 years old. This information comprises the PSID's Child Development Supplement (CDS), and focuses on child developmental outcomes within the context of family, neighborhood, and school environments. In 2002 the second wave of CDS data was collected on the same kids, now 5 to 18 years old, and their parents (N = 2,907 children) (Panel Study of Income Dynamics, 2010).

Seven years later, in 2009, the follow-up Transition to Adulthood (TA) survey collected data on the same children, who in 2009 were young adults, ages 18 to 25 years. These data assessed young adult psychological development, time use, employment status, and a wide range of other outcomes (N = 1,554 young adults) (Panel Study of Income Dynamics, 2009).

The present study employs data regarding parental demographic characteristics from the 1997 and 2003 PSID main interviews, and parent and child behavioral and media use variables from the 2002 CDS and the 2009 TA (see "Merging Family and Individual Data," 2013). Appropriately weighted, these data provide nationally representative estimates (Freedman & Cornman, 2012). Among the TA sample (N = 904), young adult respondents were used in the present study. These respondents' parents completed the 2003 PSID main interviews and participated in the 2002 CDS parent interview, which provides data regarding parental socialization with their children. Data from the CDS also provide the parents' time diary assessments of their child's frequency of newspaper, television, Internet, and videogame use behavior. Finally, the 2009 TA provides data regarding the young adults' current media consumption patterns.

MEASURES

Parent characteristics. Parental demographic characteristics were included as control variables and derived from the 2003 PSID individual- and family-level data, some of which were carried over from the 1997 PSID panel wave (the means, standard deviations, and ranges for all variables are shown in Table 1). These interviews asked parents to report on demographic characteristics for the year 2002 (e.g., family income in 2002). Parental education was a combined measure of the head of household and spouse's formal years of education. The PSID assesses parental income by summing five variables: head and spouse's taxable income, transfer income, taxable income from all other immediate family members, transfer income of other family members (for example, income from Temporary Assistance for Needy Families), and social security income for the entire family for the year 2002.

This analysis accounted for the possibility that parents' level of civic engagement—for instance, how often the parents volunteered with civic or political action groups or how often they donated to such a group—may influence their children's level of political engagement later in life. This influence may occur via a variety of routes: learning, the parental example during the impressionable years, or direct transmission. To examine aspects of parents' civic engagement, items capturing a range of parent volunteering and donation behaviors were taken from the 2003 PSID main interviews. Seven items comprised the volunteering variable. These items included the number of times in the previous year (2002) the head

Table 1. Descriptive Statistics of Data From the 1997 and 2002 Child Development Survey, 2003 Panel Study on Income Dynamics, and 2009 Transition to Adulthood Supplement.

	Mean or %	Std. Dev.	Min to Max	Year Measured
Parent Characteristics				
Education	22.52	7.95	0 to 34 years combined	2003
Income	$80.14k	104.24	$0 to $205.2 k (in thousands)	2003
Volunteering	7.68	20.41	0 to 204 times last yr, comb*	2003
Donations	$.56k	1.92	$0 to $36.6 k (in thousands)	2003
Newspaper Use	2.45	3.03	0 to 7 days per week	2002
Talk About News w/Child	2.61	1.05	0 = never to 4 = every day	2002
Television Use	6.15	4.73	0 to 24 hours per day	2002
Talk About TV w/Child	71.64%	–	0 = no, 1 = yes	2002
Adolescent Media Use				
Newspaper	0.01	0.04	0 to 0.79 hours per day	2002
Television	2.37	1.76	0 to 13.75 hours per day	2002
Internet	0.19	0.63	0 to 6.21 hours per day	2002
Videogames	0.41	0.94	0 to 15.59 hours per day	2002
Young Adult Characteristics				
Female	50.87%	–	0 = male, 1 = female	1997
Age	21.95	1.94	17.33 to 25.55 years	2009
Black	14.71%	–	0 = not black, 1 = black	1997
Hispanic	12.78%	—	0 = not Hispanic, 1 = Hispanic	1997
Education	13.83	1.49	10 to 18 years	2009
Income	$6.20k	10.99	$0 to $150 thousand	2009
College Student	42.71%	—	0 = not a student, 1 = student	2009
Employed	61.29%	—	0 = not employed, 1 = employed	2009
Children	0.24	0.65	0 to 7 children	2009
Read/Watch News	3.92	1.43	0 = less than monthly, 6 = every day	2009
Entertainment TV	4.49	1.36	0 = less than monthly, 6 = every day	2009
Dependent Variable				
Vote 2008	62.87%	–	0 = no, 1 = yes	2009

Note. N = 903.

*Combined times of head of household and spouse.

of household or his or her spouse had volunteered with religious organizations such as a local church; youth programs such as Boy Scouts of America; programs designed to help senior citizens such as those in local nursing homes, health organizations or clinics; programs or organizations to help the needy; civic or political organizations; or any other type of civic organization. For the parents, these items were combined in an averaged index. Parental charitable donations were derived from 11 items measuring the real dollar amount donated to a particular organization. These items asked respondents how much money they donated to religious, combined purpose funds, the needy, health, educational, youth, arts and culture, community, environmental, international aid and peace, and any other type of organization during the year 2002. All items were combined in an averaged index.

Parental media habits. To measure parental media use habits, four variables from the 2002 CDS parent interview were examined. The first variable, newspaper use, asked parents how often they read the newspaper during the average week, from 0 to 7 days. Talk about news with child was an ordered categorical variable that asked parents how often they talked about current events and news with their child, from never to every day. Television use assessed how many hours a television was on during the average day in the parents' home. Talk about TV with child was a binary measure asking if parents discussed television programming with children while viewing (72% responded "Yes").

Adolescent media habits. Four media use items were assessed using time diary measures maintained by the child's parents and reported in the 2002 CDS file. Parents assessed how much time their teenager used one of four media each day—newspapers, television, Internet, and videogames. These values were converted to hours per day spent on newspaper, television, Internet use, and videogame use. It should be noted that newspaper use was extremely low in comparison with the other measures.

Young adult characteristics. Demographic characteristics of young adults were used in the present analysis primarily as control variables. Two young adult demographic variables—sex and race—were carried over from the 2002 CDS data. The sample was 50.87% female, 14.71% black, and 12.78% Hispanic. The remaining demographic variables were obtained from the 2009 TA. The average age of the sample in 2009 was approximately 22 years. Young adult education measured years of formal education completed. Young adult income was measured by the amount the young adult earned in 2008 from all taxable income, including bonuses, overtime, tips, commissions, or military pay, which was entered into the analysis in thousands of dollars to account for some very highly paid young adults (the maximum income was $150,000). A dummy variable for college student status was also included, asking respondents if they were currently enrolled in a higher education institution (43% were enrolled). Employment assessed whether young adults were currently employed (61%) or not. Finally, respondents were

asked how many biological, adopted, or stepchildren they currently had, with the average less than one.

Dependent variable. Turnout was measured via a question in the 2009 PSID asked of young adults: "Did you vote in the national election last November 2008 that was held to elect the president?" A dichotomous measure of political participation was constructed for those who answered either "yes" or "no" (62.87% reported voting). Responses of "don't know," "no answer," "refused," and "date of birth too late to vote" all resulted in exclusion from the analysis. Because it is based on a self-report, the voting rate is very likely inflated due to the social desirability of voting. However, this bias has been decreasing in recent years (Taylor, 2012).

ANALYSIS

The CDS data are based on an oversample of low-income families, often African Americans. Despite a 1990s additional sample of Hispanic families, differential population growth rates mean the PSID families remain unrepresentative of the growing Hispanic population of the US. Additionally, because the CDS and TA are part of ongoing longitudinal studies, there is the problem of panel attrition. Thus, all subsequent analyses were performed using a CDS sample weight, which was originally created by the inverse of the probability of sample selection and attrition adjustment factor. Using this weight, the CDS and TA data are nationally representative. The dependent variable, voting, is a binary outcome, so a logistic regression with a maximum likelihood estimator was used.

RESULTS

The model was useful in explaining variance in the likelihood that a young adult was one of the 63% who voted in the 2008 presidential election. The percent reduction in error over the "dumb" model is 17.5 and the pseudo R-squared is 0.18 (see Table 2 for results). Among parental characteristics, parents' education (B = 0.040, z = 2.52, p = .016), newspaper use (B = 0.08, z = 2.19, p = 0.027), and frequency of talking about the news with the adolescent (B = 0.21, z = 2.24, p = 0.027) were positively associated with increase in the likelihood of voting. However, TV use (B = 0.01, z = 0.69, p = 0.515) and talking about TV with the adolescent (B = 0.21, z = .92, p = 0.438) were not related to voting.

The effect of adolescent media use on later young adult turnout was more consistently absent. Adolescent newspaper, television, Internet, and videogame use did not affect voter turnout. It should be noted, however, that adolescent use

Table 2. Multivariate Logistic Regression Predicting Young Adult Voter Turnout.

	B	Z
Parent Characteristics		
Education	0.04	2.52*
Income	0.00	−1.94†
Volunteering	0.01	1.36
Donations	0.04	0.73
Newspaper Use	0.08	2.19*
Talk About News with Child	0.21	2.24*
Television Use	0.01	0.69
Talk About TV with Child	0.21	0.92
Adolescent Media Use		
Newspaper	2.70	1.20
Television	−0.07	−1.23
Internet	−0.18	−1.24
Videogames	−0.08	−0.82
Young Adult Characteristics		
Female	0.18	0.87
Age	0.08	1.36
Black	1.17	3.67***
Hispanic	−0.42	−1.16
Education	0.43	5.06***
Income	0.00	0.38
College Student	0.26	1.08
Employed	0.26	1.21
Children	−0.26	−1.73†
Read/Watch News	0.15	2.00*
Entertainment TV	0.02	0.29
Constant	−9.72	−6.24***
N		904
Model Chi-Square		132.83***
Pseudo R^2		18.35%

Note. This analysis was weighted using PSID weights for national representativeness. A Hosmer and Lemeshow goodness of fit statistic (898.69, p = .32) based on unweighted estimates was not significant, suggesting the logistic regression model fit these data well.

† = $p < .10$.

* = $p < .05$; ** $p < .01$; *** $p < .001$ (two-tailed).

of newspapers may have approached a floor effect and thus have no opportunity to show an effect. Further, television and Internet use presumably included both entertainment and news use, and these two may have cancelled each other out.

Finally, contemporaneous effects of some socio-demographic characteristics and media use behaviors occurred. Controlling for other factors, Black young adults had a higher likelihood of voting than non-Hispanic whites (B = 1.17, z = 3.67, p = 0.000). Note that Black youth turnout for the 2008 Obama victory was unusually high, and in the following 2012 election Black turnout exceeded the turnout rate for White voters for the first time (Taylor, 2012). Additional years of education increased the likelihood of voting (B = 0.43, z = 5.06, p = 0.000). The frequency with which a young adult reads or watches the news was positively related to the likelihood of voter turnout (B = 0.15, z = 2.00, p = 0.038), but the frequency of watching entertainment TV was not associated with a change in voting (B = 0.02, z = 0.29, p = 0.87).

Altogether, these results provide support for socialization via parental influence but not via adolescent media use. These panel data measured parents, their adolescent children, and those same children once they became young adults and found positive associations between parental news use and news talk, but no effects of adolescent media use. Thus, we found support for H1a and H1c. We found relationships between being likely to vote and news use of parents and young adults, but not adolescent newspaper use, which was, as we saw, extremely low. Furthermore, the effect of parent and young adult media use was visible for news but not entertainment TV.

DISCUSSION

Much of what scholars know about income mobility is based on the PSID, but this is the first study that has used this landmark, publicly available, multi-generational panel data to explore questions of family socialization and political engagement. We found evidence that young adults are more likely to vote when they grew up in households with parents who read newspapers and talked about news with their teenagers. Teenager's media use was not related to voting later in life, although consuming news as a young adult was. Parental news use in 2002 is weakly correlated with their young adult children's news use in 2009 (r = 0.10, p < 0.001). Many interventions in schools and popular culture are aimed at increasing the political engagement of adolescents, in the hope that they will arrest the decline in the voting rates of 18- to 25-year-olds as they age into that bracket. In light of the current results, pre-emptive efforts that attempt to change the media habits of adolescents may be a case of "trying too hard." These results suggest that a more productive strategy would be to persuade parents to model politically interested

behaviors such as reading newspapers and talking about the news. Young voters will take up these habits when they are eligible and ready to vote.

This study's results are evidence for the often-mentioned socializing role of the family in citizenship. The data are consistent with socialization via a genetic route, during the "impressionable years," or by direct transmission. However, since adolescent media use is not associated with adult voting a few years later, one implication of this study is that it is not the media rules of the household that create an active citizen. Playing videogames or watching TV for hours was not found to have any effect on voting, and neither did Internet use or news use. The lack of effect for informational or for entertainment medias should soothe parents who worry about rearing politically apathetic couch potatoes. Similarly, while having parents who read the news boosts young adult voting, having parents who watch entertainment TV does not depress it. However, a separate study using the same data showed that the media choices of young adults, unlike their voter turnout, are influenced by both parental, and their own adolescent, media use (York & Scholl, 2013).

One important result is the positive coefficient for the indicator variable identifying as African American. Compared with others in the sample, Black young adults were more likely to vote in 2008 after controlling for other factors in the model. Indeed, Black youths in the election of Barack Obama had the highest voting rate of any race/age group in 2008 ("Trends by Race, Ethnicity, and Gender," 2012). Unfortunately, the sample size is not large enough to test whether effects of media use differ across racial groups.

CONCLUSION

Observers who wonder whether "slacktivism" will take the place of voting in our democracy variously blame the political apathy of young people on their parents and on media. This study points to a middle path: parents can help train young people to vote, but not via the behavior of teens. Parents can "lead them to water" by demonstrating reading and talking about the news, but they should not try to "make (teens) drink," as teenage media use does not have an effect on later voting. For democracy, this result seems like good news. It is possible for a young adult to take up political orientations, and benefit from their parents' influence, even after reaching voting age. The effects of political socialization do not stop or become magically frozen in place at age 17½.

The role of college in the political socialization of college-age adults should not be ignored. Being currently enrolled in college did not predict voting, despite the increased visibility of voter registration drives on campuses during the 2008 election cycle. However, the number of years of education of both the young citizen and of his or her parents had a strong effect, consistent with past research.

Future studies should examine whether political socialization and the role of media operate differently in families where the adolescent is college-bound. While both college and families are important socializing agents when it comes to voting, little is known about how they may work together. If they do, then college may be functioning to reduce political engagement mobility, just as its availability or lack of availability is known to perpetuate the economic conditions in families.

For parents who wish to rear engaged citizens, the results of this study should be encouraging. Teens are noticing their parents' civic behaviors, even if not currently emulating them. News use still matters, possibly even for the young voters of a decade from now.

REFERENCES

Alford, J. R., Funk, C. L., & Hibbing, J. R. (2005). Are political orientations genetically transmitted? *American Political Science Review, 99*(2), 153–167.

Barnes, G. M., Farrell, M. P., & Cairns, A. (1986). Parental socialization factors and adolescent drinking behaviors. *Journal of Marriage and the Family, 48*(1), 27–36.

Beck, P. A., & Jennings, M. K. (1982). Pathways to participation. *American Political Science Review, 76*(1), 94–108.

Bennett, W. L. (2008). Changing citizenship in the digital age. In W. L. Bennett (Ed.), *Civic life online: Learning how digital media can engage youth*. Cambridge, MA: MIT Press.

Berelson, B. R., Lazarsfeld, P. F., & McPhee, W. N. (1954). *Voting: A study of opinion formation in a presidential campaign*. Chicago, IL: The University of Chicago Press.

Brady, H. E., Verba, S., & Schlozman, K. L. (1995). Beyond SES: A resource model of political participation. *The American Political Science Review, 89*(2), 271–294.

Campbell, D. E. (2006). *Why we vote: How schools and communities shape our civic life*. Princeton, NJ: Princeton University Press.

Dalton, R. J. (2008). Citizenship norms and the expansion of political participation. *Political Studies, 56*(1), 76–98.

Dalton, R. J. (2009). *The good citizen: How a younger generation is reshaping American politics*. Washington, DC: CQ Press.

Eisenberg, N., Cumberland, A., & Spinrad, T. L. (1998). Parental socialization of emotion. *Psychological Inquiry, 9*(4), 241–273.

Erikson, E. H. (1968). *Identity, youth and crisis*. New York, NY: W. W. Norton.

Erikson, E. H. (1980). *Identity and the life cycle* (Vol. 1). New York, NY: W. W. Norton.

File, T. (2013). *Young-adult voting: An analysis of presidential elections, 1964–2012*. Retrieved from the U.S. Census Bureau website: https://www.census.gov/prod/2014pubs/p20–573.pdf

Finkel, S. E., & Smith, A. E. (2011). Civic education, political discussion, and the social transmission of democratic knowledge and values in a new democracy: Kenya 2002. *American Journal of Political Science, 55*, 417–435.

Flanagan, C., & Levine, P. (2010, Spring). Youth civic engagement during the transition to adulthood. *Transition to Adulthood*. Retrieved from https://www.princeton.edu/futureofchildren/publications/docs/20_01_08.pdf

Flanigan, W. H., & Zingale, N. H. (2010). *Political behavior of the American electorate.* Washington, DC: CQ Press/Sage.

Freedman, V. A., & Cornman, J. C. (2012, April 9). *The Panel Study of Income Dynamics Supplement on Disability and Use of Time (DUST) User Guide.* Retrieved from the Panel Study of Income Dynamics website: http://psidonline.isr.umich.edu/DUST/dust09_UserGuide.pdf# page = 38

Galston, W. A. (2004). Civic education and political participation: The current condition of civic engagement. *PS: Political Science & Politics,* (2), 263–266.

Gecas, V., & Schwalbe, M. L. (1986). Parental behavior and adolescent self-esteem. *Journal of Marriage and the Family, 48*(1), 37–46.

Hill, N. E., & Tyson, D. F. (2009). Parental involvement in middle school: A meta-analytic assessment of the strategies that promote achievement. *Developmental Psychology, 45*(3), 740–763.

Jennings, M. K. (1984). The intergenerational transfer of political ideologies in eight western nations. *European Journal of Political Research, 12*(3), 261–276.

Jennings, M. K. (2007). Political socialization. In R. J. Dalton & H. Klingemann (Eds.), *The Oxford handbook of political behavior* (pp. 29–44). New York, NY: Oxford University Press.

Jennings, M. K., & Niemi, R. G. (1968). The transmission of political values from parent to child. *The American Political Science Review, 62*(1), 169–184.

Jennings, M. K., Stoker, L., & Bowers, J. (2009). Politics across generations: Family transmission reexamined. *Journal of Politics, 71*(3), 782–799.

Kochanska, G. (1993). Toward a synthesis of parental socialization and child temperament in early development of conscience. *Child Development, 64*(2), 325–347.

Kroger, J., Martinussen, M., & Marcia, J. E. (2010). Identity status change during adolescence and young adulthood: A meta-analysis. *Journal of Adolescence, 33*(5), 683–698.

Kroh, M., & Selb, P. (2009). Inheritance and the dynamics of party identification. *Political Behavior, 31*(4), 559–574.

McDevitt, M., & Chaffee, S. (2002). From top-down to trickle-up influence: Revisiting assumptions about the family in political socialization. *Political Communication, 19*(3), 281–301.

Merging family and individual data. (2013). Retrieved from the Panel Study of Income Dynamics website: http://psidonline.isr. umich.edu/Guide/FAQ.aspx?Type = 1

Mutz, D. C. (2006). *Hearing the other side: Deliberative versus participatory democracy.* New York, NY: Cambridge University Press.

Niemi, R. G., & Jennings, M. K. (1991). Issues and inheritance in the formation of party identification. *American Journal of Political Science, 35,* 970–988.

Osborne, D., Sears, D. O., & Valentino, N. A. (2011). The end of the solidly democratic South: The impressionable years hypothesis. *Political Psychology, 32*(1), 81–108.

Panel Study of Income Dynamics. (2009). *The Child Development Supplement: Transition Into Adulthood Study 2009 User Guide.* Retrieved from http://psidonline.isr.umich.edu/CDS/TA09_UserGuide.pdf

Panel Study of Income Dynamics. (2010). *The Panel Study of Income Dynamics Child Development Supplement User Guide for CDS-II.* Retrieved from http://psidonline.isr.umich.edu/CDS/cdsii_userGd.pdf

Panel Study of Income Dynamics, public use dataset. (2013). Retrieved from Panel Study of Income Dynamics website: https://psidonline.isr.umich.edu/

Postman, N. (1985). *Amusing ourselves to death: Public discourse in the age of show business.* New York, NY: Penguin.

Prior, M. (2005). News vs. entertainment: How increasing media choice widens gap in political knowledge and turnout. *American Journal of Political Science, 49*(3), 577–592.

Prior, M. (2007). *Post-broadcast democracy: How media choice increases inequality in political involvement and polarizes elections.* New York, NY: Cambridge University Press.

Pugliese, J., & Tinsley, B. (2007). Parental socialization of child and adolescent physical activity: A meta-analysis. *Journal of Family Psychology, 21*(3), 331–343.

Putnam, R. D. (2000). *Bowling alone: The collapse and revival of American community.* New York, NY: Simon & Schuster.

Sapiro, V. (2004). Not your parents' political socialization: Introduction for a new generation. *Annual Review of Political Science, 7*, 1–23.

Schlozman, K. L., Verba, S., & Brady, H. E. (2012). *The unheavenly chorus: Unequal political voice and the broken promise of American democracy.* Princeton, NJ: Princeton University Press.

Stolle, D., & Hooghe, M. (2004). The roots of social capital: Attitudinal and network mechanisms in the relation between youth and adult indicators of social capital. *Acta Politica, 39*(4), 422–441.

Taylor, P. (2012). The growing electoral clout of Blacks is driven by turnout, not demographics. Retrieved from http://www.pewsocialtrends.org/2012/12/26/the-growing-electoral-clout-of-blacks-is-driven-by-turnout-not-demographics/

Tedin, K. L. (1974). The influence of parents on the political attitudes of adolescents. *The American Political Science Review, 68*(4), 1579–1592.

Trends by race, ethnicity, and gender. (2012). Retrieved from The Center for Information & Research on Civic Learning and Engagement website: http://www.civicyouth.org/quick-facts/235-2/

Uslaner, E. M. (1998). Social capital, television, and the "mean world": Trust, optimism, and civic participation. *Political Psychology, 19*(3), 441–467.

Van Deth, J. W., Abendschön, S., & Vollmar, M. (2011). Children and politics: An empirical reassessment of early political socialization. *Political Psychology, 32*(1), 147–174.

Verba, S., Schlozman, K., & Burns, N. (2003). Family ties: Understanding the intergenerational transmission of participation. In A. S. Zuckerman, *The social logic of politics* (pp. 95–114). Philadelphia, PA: Temple University Press.

Walsh, K. C., Jennings, M. K., & Stoker, L. (2004). The effects of social class identification on participatory orientations towards government. *British Journal of Political Science, 34*(3), 469–495.

Wattenberg, M. P. (2012). *Is voting for young people?* New York, NY: Pearson.

White, H. R., Johnson, V., & Buyske, S. (2000). Parental modeling and parenting behavior effects on offspring alcohol and cigarette use: A growth curve analysis. *Journal of Substance Abuse, 12*(3), 287–310.

York, C., & Scholl, R. (2013, August). *Antecedents to media use: Effects of parent socialization and childhood behavior on consumption patterns during adulthood.* Paper presented at the Association for Education in Journalism and Mass Communication convention, Washington, DC.

Zaller, J. (1992). *The nature and origins of mass opinion.* New York, NY: Cambridge University Press.

Talking Politics AT THE Dinner Table

The Effects of Family Political Communication on Young Citizens' Normative Political Attitudes

BENJAMIN R. WARNER AND COLLEEN WARNER COLANER

In Habermas's (1962) foundational work on the public sphere, he identified the family as a vital institution in the rise of the bourgeois public sphere in 17th-century Europe. Communication in the home trained people in rational critical debate, he argued, and this debate became the foundation of the public sphere. Habermas chronicled the transformation of the family from a social unit to a more exclusively private space and lamented that this transition contributed to the decline of deliberative democracy.

Since Habermas's (1962) original theorizing, many scholars have demonstrated the enduring significance of the family in training and socializing citizens into public civic life (McDevitt & Chaffee, 2002; McDevitt & Ostrowski, 2009; Shah, McLeod, & Lee, 2009). This study examines the role of family communication about politics on the formation of normative political attitudes that are among the most important variables in determining whether children will become active and engaged citizens. Specifically, this study seeks to determine the role of parent-child political communication in forming interest in politics, political information efficacy (PIE), and political cynicism. In what follows, research on family political socialization is briefly summarized, and a study is presented that examines parent/child dyads to determine the influence of family communication on normative political attitudes in young adults.

INTERACTIONAL POLITICAL SOCIALIZATION IN THE FAMILY

Early research in political socialization emphasized the role of family through the Direct Transmission Model and Social Learning Theory. These perspectives suggested passive socialization through parental cueing (e.g., Dalton, 1980; Jennings & Niemi, 1968; Jennings, Stoker, & Bowers, 2009; Verba, Schlozman, & Burns, 2005). However, more recent research has demonstrated the centrality of communication in the socialization process (Andolina, Jenkins, Zukin, & Keeter, 2003; Lauglo, 2011; McDevitt & Chaffee, 2002; McDevitt & Ostrowski, 2009; McLeod & Shah, 2009; Shah, McLeod, & Lee, 2009). While research on passive transmission focused on the transfer of partisan identity from parent to child, much of the interactional approach (e.g., communication mediated socialization) focuses on the development of habits of citizenship. Shah, McLeod, and Lee (2009), for example, found that political and civic engagement were socialized through four dominant agents of communication: the family, school, media, and peer groups. Their findings suggest that media and interpersonal communication are central to political socialization. Of these four agents, the family is especially positioned to provide a safe space for children to experiment with political conversation in a low-risk environment and validate their political identity (McDevitt & Ostrowski, 2009).

While the family is a space for political discussion that can form and confirm political identities, McDevitt has emphasized that factors exogenous to the family can exert significant influence on family communication. A child's media use, for example, can spur child-initiated political communication surrounding presidential elections (McDevitt, 2005); and civics curriculum in schools can provide incentive for children to initiate political communication with their parents (McDevitt & Ostrowski, 2009). As such, the child's intellectual capacity and desire initiate and sustain political conversations in the family (Meadowcroft, 1986). Child-initiated political communication prompts "trickle-up socialization," a process in which political communication initiated by the child spurs a parent to become more informed, attentive, and involved in politics (McDevitt & Chaffee, 2002). Political socialization in the family should thus not be thought of as solely top-down, as is often implied by the transmission perspective, but rather as reciprocal.

The transmission model of political socialization also tended to emphasize the importance of early childhood and imply gradual linear socialization through adolescence. However, interactional models illustrate the importance of political communication in moments of rapid change such as when children begin college or when major political events spur spontaneous conversations within the family (McDevitt & Chaffee, 2002). Scholars have thus been urged to focus on periods of rapid development, such as the transition from high school to college or when major political events are likely to spur significantly more political conversation

than usual (McDevitt & Chaffee, 2002; McLeod & Shah, 2009; Osborne, Sears, & Valentino, 2011; Sears & Valentino, 1997).

Based on previous research about family communication in childhood development, we believe that children who entered college during the fall semester of the 2012 presidential election were in a period of rapid socialization and therefore the parent/child communication dynamic was in its most influential phase. This should be especially true if parents have a strong interest in politics, as similar trends exist when considering other formative topics in the family. For example, families who are more religious tend to talk about religion more with their family members (Mullikin, 2006). Furthermore, parents who are engaged in politics tend to have more engaged children (Andolina et al., 2003; Jennings et al., 2009). Therefore we predict:

> H1a: Parents with higher levels of political interest will have children who report more parent/child political communication.

Though we expect political communication to be higher in families with politically interested parents, we also expect political talk to influence the interest of the child. McDevitt and Chaffee (2002) have demonstrated how child-initiated political communication can spur more engaged parents. We expect this process to work reciprocally such that political communication with parents will also spur greater interest among children—as discussions at home have tended to be associated with greater political interest (McIntosh, Hart, & Youniss, 2007). In other contexts, direct conversations that children are able to recall much later in life exert significant influence on attitude formation (Koenig Kellas, 2010; Medved, Brogan, McClanahan, Morries, & Shepherd, 2006). Research in areas such as religious socialization (Flor & Knapp, 2001), feminist identification (Colaner & Rittenour, in press), and body esteem formation (Giles, Helme, & Krcmar, 2007) shows that parent-child interactions send important messages to children that shape children's identity and behaviors. This process extends to politics as well. Family interactions play an important role in the development of civic engagement (Wilkin, Katz, & Ball-Rokeach, 2009) and political beliefs (e.g., Meadowcroft, 1986). We thus hypothesize:

> H1b: Children who report more parent/child communication will have higher levels of political interest.

While political socialization was initially presented as a top-down process through which the parents' political ideals were transmitted to the child through observational cueing (Jennings & Niemi, 1968), the social interaction perspective illustrates the mediating role of communication in this transmission (McDevitt & Chaffee, 2002; Shah, McLeod, & Lee, 2009). As such, parent-child political

communication is likely the mechanism through which the parent's political interest influences the interest of the child. We hypothesize that:

> **H1c:** A parent's political interest will indirectly influence their child's political interest through political communication between the parent and child.

Political interest is an important civic attitude because interest is likely a prerequisite to sustained and thoughtful engagement in the political process. In addition to political interest, engaged citizens must be confident that they possess the necessary skills and knowledge to be meaningfully engaged in the political process. Kaid, McKinney, and Tedesco (2007) developed a measure of political efficacy that emphasized the informational component (Political Information Efficacy—PIE) to determine whether individuals have sufficient confidence in their political knowledge to be willing to engage in the democratic process. Because families provide a safe space for children to discuss and consolidate their political identities (McDevitt & Ostrowski, 2009), we predict that greater political communication will be associated with higher PIE and that parental interest in politics will have an indirect effect on PIE through communication:

> **H2a:** Children who report more parent/child communication will have higher levels of political information efficacy.

> **H2b:** A parent's political interest will indirectly influence their child's political information efficacy through political communication between the parent and child.

Political interest and political information efficacy are important political attitudes, as they influence the frequency and nature of political engagement. External political efficacy (e.g., whether one believes her or his participation makes a difference in political outcomes) is equally important for a healthy democracy as it can influence political behaviors such as likelihood of voting (Pinkleton, Austin, & Fortman, 1998) and participating in the political process (Scheufele & Nisbet, 2002). If socialization through parental communication generates positive civic attitudes, external political efficacy should be influenced. We thus hypothesize:

> **H3a:** Children who report more parent/child communication will have higher levels of external political efficacy.

> **H3b:** A parent's political interest will indirectly influence their child's external political efficacy through political communication between the parent and child.

In addition to interest and the various facets of efficacy, political cynicism is an important normative political attitude. People who are high in cynicism, for example, are less likely to participate and vote (Kaid, McKinney, & Tedesco, 2000). Because political communication in the family fosters political engagement and participation, and because individuals who are high in cynicism are less likely to

value engagement, we hypothesize that children who have high levels of political communication with their parents will express less political cynicism and that this influence will be indirect through political communication:

> **H4a:** Children who report more parent/child communication will have lower levels of political cynicism.

> **H4b:** A parent's political interest will indirectly influence their child's cynicism through political communication between the parent and child.

Finally, while the preceding hypotheses have been grounded in the assumption that highly interested parents who engage in frequent political communication with their children will foster healthy political attitudes, it is possible that communication between parents and children about politics will transfer the parent's political attitudes regardless of whether or not they promote normative attitudes toward citizenship. In other words, cynical parents may transfer attitudes to their children just as effectively as highly interested or efficacious parents. We therefore hypothesize that the parents' normative political attitudes will indirectly influence the corresponding attitudes of their child through political communication:

> **H5a:** A parent's political information efficacy will indirectly influence their child's political information efficacy through political communication between the parent and child.

> **H5b:** A parent's external political efficacy will indirectly influence their child's external efficacy through political communication between the parent and child.

> **H5c:** A parent's political cynicism will indirectly influence their child's political cynicism through political communication between the parent and the child.

METHOD

Participants and Procedures

Parent/child dyads were recruited by contacting students enrolled at a major public university in the Midwestern United States. Students in a basic public speaking class were offered extra credit to complete a questionnaire and additional extra credit if they recruited one of their parents to complete a separate questionnaire. All participants completed the questionnaire in the 2 months leading up to the 2012 election. This period of time was selected with the belief that politics would be an especially salient point of communication during the peak of the presidential election. A total of 216 students completed the questionnaire; 187 parents completed the second questionnaire for a total of 403 overall respondents. Parent responses were paired with their child, and responses that were either substantially

incomplete or responses that did not contain sufficient information (e.g., incorrect identification codes) to pair with student responses were excluded. The final dataset included 170 complete parent-child dyads and 340 total participants.

The age of the students ranged from 18–22 (M = 19.23, SD = 1.13) and the age of the parents ranged from 35–69 (M = 50.92, SD = 5.39). Of the student participants, 67 (39.4%) identified as male and 102 (60%) identified as female, while 74 (43.5%) of the parents were male and 96 (56.5%) were female. Though there was some discrepancy between the racial/ethnic identification of parents and children, the majority of the sample (82.4% of children and 87.6% of parents) identified as white/Caucasian. A plurality of the students (n = 75, 44.1%) identified with the Republican Party, 47 (27.6%) with the Democratic Party, and 48 (28.2%) identified with a third party or no party. Of the parents, 85 (50%) identified as Republicans, 53 (31.2%) as Democrats, and 32 (18.8%) as not affiliated with either major party.

MEASURES

Political interest. Political interest was measured through a four-item scale that asked respondents to indicate their level of agreement from *strongly agree* (5) to *strongly disagree* (1) on the following items: *I am interested in politics; I follow politics closely; Politics are important to me personally; I have been following the 2012 election.* This measure was reliable for both parents (M = 3.54, SD = 0.87, α = .90) and children (M = 2.76, SD = 1.16, α = .94).

 Political information efficacy. A four-item scale developed by Kaid, McKinney, and Tedesco (2007) was used to measure political information efficacy (PIE). Participants were asked to indicate their level of agreement on a seven-point scale ranging from 1 (*disagree strongly*) to 7 (*strongly agree*) on four statements reflecting one's level of confidence in their political knowledge. The items include: *I consider myself well qualified to participate in politics; I think that I am better informed about politics and government than most people; I feel that I have a pretty good understanding of the important political issues facing our country; If a friend asked me about the presidential election I feel I would have enough information to help my friend figure out who to vote for.* The measure achieved strong reliability for both parents (M = 4.89, SD = 1.29, α = .89) and children (M = 3.71, SD = 1.75, α = .95).

 External efficacy. External efficacy was measured with the four-item political efficacy scale used by Kushin and Yamamoto (2010). Respondents were asked to rate their agreement with the following statements on a seven-point scale ranging from 1 (*disagree strongly*) to 7 (*strongly agree*): *My vote makes a difference; I have a real say in what the government does; I can make a difference if I participate in the election process; Voting gives people an effective way to influence what the government does.*

The measure achieved strong reliability for both parents (M = 4.98, SD = 1.28, α = .90) and children (M = 4.49, SD = 1.53, α = .92).

Cynicism. Political cynicism was measured with a seven-item scale used in previous campaign research (e.g., McKinney & Warner, 2013), with participants responding to a seven-point scale ranging from 1 (*disagree strongly*) to 7 (*strongly agree*). The items include: *Politicians are more interested in power than what people think; Politicians are corrupt; Politicians cannot be trusted; Politicians are too greedy; Politicians always tell the public what they want to hear instead of what they actually plan to do; Politicians are dishonest; Politicians are more concerned about power than advocating for citizens.* The measure has demonstrated strong reliability in research that has utilized this scale (McKinney & Warner, 2013; Warner, Turner-McGowen, & Hawthorne, 2012) and achieved strong reliability for both parents (M = 4.62, SD = 1.13, α = .94) and children (M = 4.43, SD = 1.1, α = .91).

Political communication. Political communication between the parent and child was measured by asking the child their agreement on a seven-point scale ranging from 1 (*disagree strongly*) to 7 (*strongly agree*) with the following seven statements: *It is easy to talk with my parent about politics; I often talk with my parent about politics; Politics is a common topic of conversation in our house; It is natural for politics to come up in conversation with my parent; My parent makes an effort to talk about politics with me; I talk with my parent about our country's problems; I talk with my parent about the presidential candidates.* Items were drawn from previous research (e.g., Austin & Nelson, 1993; Meadowcroft, 1986), and the measure achieved strong reliability (M = 4.04, SD = 1.65, α = .95).

RESULTS

This study sought to test the role played by parents in the political socialization of their children. The first set of hypotheses assessed the influence of a parent on the political interest of the child. H1a predicted that parents who are more interested in politics would have children who report greater parent/child political communication. To test this hypothesis a step-wise linear regression was conducted in which the age, political party, sex, and race/ethnicity of the child were entered in the first block, the political interest of the parent was entered as the independent variable, and the amount of parent/child political communication reported by the child was entered as the dependent variable. The overall regression model explained 20.9% of the variance in parent/child political communication, R^2 = 0.209, $F(6,162)$ = 7.15, $p < .001$. The parent's political interest was the only significant predictor in the model and explained an additional 17.6% of variance above the covariate block, ΔR^2 = 0.176, β = 0.824, standardized β = 0.434.

Children with a highly interested parent were significantly more likely to report increased political communication with their parent.

H1b predicted that increased political communication with a parent would predict higher levels of political interest in the child. To test this, a two-step regression with age, party, sex, and race/ethnicity were entered as covariates and parent/child political communication was entered as the independent variable predicting the child's political interest. The overall regression model explained 46.8% of the variance in the child's political interest, $R^2 = 0.468$, $F(6,162) = 23.78$, $p < .001$. Parent/child political communication was the only significant predictor in the model and explained an additional 43.2% of variance above the covariate block, $\Delta R^2 = 0.432$, $\beta = 0.471$, standardized $\beta = 0.668$. Children who reported increased political communication with a parent were significantly more interested in politics.

H1c predicted that the parent's political interest would have an indirect effect on the child's political interest through parent/child political communication. To test this, a simple mediation model was run using Hayes's (2013) PROCESS procedure. The indirect effect of a parent's political interest on the child's political interest through parent/child political communication was statistically different from zero, as revealed by a 95% bias-corrected bootstrap confidence interval that was entirely above zero (0.240 to 0.521). The effect was such that, as the parent was more interested in politics, the child reported greater political talk and was subsequently more interested in politics. The model coefficients are presented in Table 1.

The second set of hypotheses assessed the parent's influence on the child's political information efficacy (PIE). H2a predicted that children who report increased political communication with their parent would have higher PIE. The overall regression model explained 45% of the variance in the child's PIE, $R^2 = 0.450$, $F(6,162) = 38.59$, $p < .001$. The amount of parent/child political communication was a significant predictor in the model and explained an additional 39.1% of variance above the covariate block, $\Delta R^2 = 0.391$, $\beta = 0.673$, standardized $\beta = 0.636$. Children who reported increased political communication with a parent expressed significantly higher PIE. Sex was also a significant predictor in the model such that female respondents expressed significantly lower PIE, $\beta = -0.758$, standardized $\beta = -0.213$.

H2b predicted that the political interest of the parent would have an indirect effect on the PIE of the student through political communication. A simple mediation model revealed that the indirect effect was statistically different from zero, as is illustrated by the 95% bias-corrected bootstrap confidence interval entirely above zero (0.330 to 0.721). The effect was such that, as the parent was more interested in politics, political communication between the parent and child increased and the child expressed significantly higher PIE as a result. The model coefficients are presented in Table 1.

Table 1. Coefficients for Interactional Socialization of Child's Normative Political Attitudes.

	Political Talk		Child Attitudes	
	Coeff.	SE	Coeff.	SE
H1c			Political Interest	
Parent Interest	0.824***	0.137	0.131	0.087
Political Talk	–	–	0.442***	0.045
constant	2.672	2.178	0.069	1.259
	$R^2 = .209$		$R^2 = .476$	
	$F(6, 162) = 7.147, p < .001$		$F(7, 161) = 20.858, p < .001$	
H2c			PIE	
Parent Interest	–	–	0.285*	0.132
Political Talk	–	–	0.610***	0.069
constant	–	–	–0.438	1.908
			$R^2 = .466$	
			$F(7, 161) = 20.034, p < .001$	
H3c			External Efficacy	
Parent Interest	–	–	0.261*	0.147
Political Talk	–	–	0.181*	0.076
constant	–	–	–2.111	2.116
			$R^2 = .145$	
			$F(7, 161) = 3.906, p < .001$	
H4c			Cynicism	
Parent Interest	–	–	–0.132	0.106
Political Talk	–	–	0.124*	0.055
constant	–	–	5.908***	1.522
			$R^2 = .144$	
			$F(7, 161) = 3.863, p < .001$	

*p <.05; **p < .01; ***p < .001.

The third set of hypotheses assessed the influence of a parent on the child's external political efficacy. H3a predicted that greater political communication between a parent and child would be associated with higher levels of child external efficacy. The overall regression model explained 12.8% of the variance in the child's external efficacy, $R^2 = 0.128$, $F(6,162) = 3.98$, $p = .001$. The amount of parent/child political communication was a significant predictor in the model and explained an additional 6.4% of variance above the covariate block, $\Delta R^2 = 0.064$,

$\beta = 0.238$, standardized $\beta = 0.257$. Children who reported increased political communication with a parent expressed significantly higher external efficacy. Party was also a significant predictor in the model such that Democrats ($\beta = 0.814$, standardized $\beta = 0.238$) and Republicans ($\beta = 0.563$, standardized $\beta = 0.182$) expressed greater external efficacy relative to people who did not identify with a major party.

H3b predicted that the political interest of the parent would have an indirect effect on the external efficacy of the child through political communication. A simple mediation model revealed that the indirect effect was statistically different from zero, as is illustrated by the 95% bias-corrected bootstrap confidence interval entirely above zero (0.014 to 0.315). The effect was such that, as the parent was more interested in politics, political communication between the parent and child increased and the child expressed significantly higher external efficacy. The model coefficients are presented in Table 1.

The fourth set of research questions assessed the influence of a parent on the child's political cynicism. H4a predicted that political communication between a parent and a child would significantly reduce political cynicism. Following the same procedure as above, a two-step regression model was specified. The overall model significantly predicted political cynicism, $R^2 = 0.116$, $F(6,162) = 4.231$, $p = .001$; however, parent/child political communication was only approaching significance ($p = .06$) as a predictor and only explained an additional 2% of variance above the covariate block, $\Delta R^2 = 0.020$, $\beta = 0.095$, standardized $\beta = 0.143$. Furthermore, the prediction went counter to the hypothesis; more talk was marginally associated with higher levels of political cynicism. Most of the explained variance in the regression model resulted from political party affiliation. Democrats ($\beta = -0.906$, standardized $\beta = -0.369$) and Republicans ($\beta = -0.798$, standardized $\beta = -0.360$) were significantly less cynical than those not affiliated with a major party.

H4b predicted that the parent's political interest would have an indirect effect on a child's political cynicism through political communication. A simple mediation model revealed that the indirect effect was statistically different from zero, as is illustrated by the 95% bias-corrected bootstrap confidence interval entirely above zero (0.011 to 0.212). Again, counter to the hypothesis, the effect was such that, as the parent was more interested in politics, political communication between the parent and child increased and the child expressed somewhat more political cynicism. The model coefficients are presented in Table 1.

The fifth set of hypotheses predicted that the normative attitudes held by a parent would transfer to the child through political communication. H5a predicted that a parent's PIE would indirectly influence the child's PIE through political communication. A simple mediation model revealed that the indirect effect was statistically different from zero, as is illustrated by the 95% bias-corrected bootstrap confidence interval entirely above zero (0.140 to 0.409). Parents with higher PIE were more likely to engage in political communication with their children, and

Table 2. Coefficients for Parent/Child Attitude Transference.

	Political Talk		Child Attitudes	
	Coeff.	SE	Coeff.	SE
H5a			PIE	
Parent PIE	0.408***	0.094	0.078	0.084
Political Talk	–	–	0.653***	0.066
constant	4.712*	2.215	0.394	1.892
	$R^2 = .134$		$R^2 = .453$	
	$F(6, 162) = 4.160, p < .001$		$F(7, 161) = 19.050, p < .001$	
H5b			External Efficacy	
Parent E.E.	0.219*	0.100	0.103	0.090
Political Talk	–	–	0.225**	0.070
constant	–1.236	2.041	–1.236	2.041
	$R^2 = .062$		$R^2 = .135$	
	$F(6, 162) = 1.769, p = .109$		$F(7, 161) = 3.602, p < .01$	
H5c			Cynicism	
Parent Cynicism	–0.818	0.115	0.067	0.073
Political Talk	–	–	0.097t	0.098
constant	8.049***	2.325	4.996	1.522
	$R^2 = .037$		$R^2 = .140$	
	$F(6, 162) = 1.016, p = .417$		$F(7, 160) = 3.722, p < .001$	

$^*p < .05; ^{**}p < .01; ^{***}p < .001.$

their children were subsequently more likely to have higher PIE. As can be seen in Table 2, the regression equation explained 45% of variance in the child's PIE score.

H5b predicted that a parent's external political efficacy would transfer to the child through political communication. A simple mediation model revealed that the indirect effect was statistically different from zero, as is illustrated by the 95% bias-corrected bootstrap confidence interval entirely above zero (0.008 to 0.124). The relationship was such that, as a parent expressed higher external efficacy, there was more parent/child communication, and the child subsequently had more external political efficacy. As can be seen in Table 2, the regression equation explained about 14% of the variance in the child's external efficacy.

H5c predicted that a parent's political cynicism would transfer to the child through political communication. A simple mediation model revealed that the indirect effect was not statistically different from zero, the 95% bias-corrected bootstrap confidence interval contained zero (–0.055 to 0.011). H5c was not

supported as there was no relationship between a parent's level of political cynicism and their child's level of political cynicism.

DISCUSSION

The influence of the family in forming and fostering political attitudes has received scholarly attention for decades (e.g., Dalton, 1980; Jennings & Niemi, 1968). While it was initially assumed that family socialization happened through cueing over the course of childhood development (e.g., the Direct Transmission Model), scholars have more recently demonstrated the centrality of communication in this process (McDevitt & Chaffee, 2002). Because communication is likely to be greatest during periods of transition (e.g., late adolescence when children first go away to college) and during periods of great political significance (e.g., presidential elections), these are thought to be the periods of greatest political socialization. This study sought to test the role of parental attitudes and parent/child communication during one of these periods of enhanced socialization by surveying parent/child dyads in the months leading up to the 2012 presidential elections among students entering college. While parents (and parent/child communication) have previously been identified as important influences on political knowledge (Hively & Eveland, 2009) and participation (Lee, Shah, McLeod, 2012; Wilkin, Katz, Ball-Rokeach, 2009), this study extended research on socialization into other normative democratic attitudes. First, our findings suggest that children who are high in political communication with a parent are more likely to be politically interested and have higher political information efficacy. However, family socialization exerted less influence on the external efficacy and political cynicism of the child. Finally, the influence of parental political attitudes on child attitudes was mediated by political communication to such an extent that communication itself was the most significant variable in predicting the normative attitudes of the child. The implications of these findings, along with limitations and directions for future research, are discussed below.

Political communication between a parent and child exerted significant influence on the normative political attitudes expressed by the child. In parent/child dyads where political communication was high children were significantly more interested in politics. The addition of family political communication to the regression equation explained an additional 43% of variance in the political interest of the child. This suggests that political communication in the family is an important factor in determining whether the child will be interested in politics. Political communication exerted similar influence on the PIE of the child. Parent/child dyads high in political communication were significantly more likely to have a child with higher PIE. In fact, the addition of the political communication

variable explained an additional 39% of variance in PIE. In other words, children in families with high political talk were much more likely to express confidence that they possessed the knowledge and ability to participate meaningfully in the political process. This finding supports the belief expressed in previous research that the family unit provides a safe space for children to practice political discussions and experiment with political beliefs (Ekström & Östman, 2013). When families talk about politics, children have a training ground for deliberation that imbues them with the interest and confidence needed to engage in political conversation. Political communication in the home may also serve an instrumental function for the children, providing them information they can call on in future conversations and enabling them to formulate opinions. This foundational knowledge and experience serve these children well for conversations in other settings, as the children have opinions they are interested in expressing and information to present in support of those opinions. In other words, political communication in the family may not only cultivate the confidence children need to become engaged citizens, it may also provide the resources they need to be effective deliberators. While PIE and political interest are only two ingredients for effective citizenship, the results found here are encouraging for politically engaged families and suggest that, to the extent political citizenship can be cultivated in the home, it may spread into more public spaces.

The influence of political communication in the family on the child's external efficacy was smaller—it explained an additional 6% of variance in the external efficacy expressed by the child. This is perhaps evidence that external efficacy is an attitude less subject to influence by communication. While interest may be cultivated through parental interaction, and PIE through the exchange of information and opportunity to rehearse deliberation, external efficacy reflects the child's belief that political activity can effectively intervene in the external world. Children in politically engaged families were somewhat more likely to believe that their political activity could affect meaningful change, but a vast majority of the variance in external efficacy remained unexplained. This suggests that not all normative political attitudes are influenced by the family unit, a finding illustrated even more clearly by the failure to significantly predict variance in cynicism. Children in high political communication families were not significantly less cynical. In fact, children in high communication families that participated in this study were slightly more likely to be cynical, though this finding was only approaching significance. Hence, while high communication families may cultivate politically interested children who are confident in their knowledge and ability to participate, there seems to be only marginal positive influence of family communication on external efficacy and, at best, no influence on cynicism.

This study also found that the political interest of a parent indirectly influenced the political interest and the PIE of the child (and, to a lesser extent,

external efficacy). While McDevitt and Chaffee (2002) demonstrated trickle-up socialization—in which child-initiated political communication can foster greater political activity among parents—our finding suggests that the process is reciprocal and parents who are interested in politics are likely to have families with greater political communication. These families are more likely to produce engaged children with higher PIE and higher political interest.

Political communication also mediated the transfer of parental attitudes to children. This effect was the most significant for PIE, such that parents who were high in PIE were more likely to have high political communication with their child and the child was likely to have higher PIE as a result. This effect was much smaller for external efficacy and not present at all for political cynicism. While this may be evidence of attitude transference through political communication, it is perhaps more likely that PIE is unique in that it is an antecedent for parent/child communication (e.g., parents with higher PIE are more likely to initiate conversations) and also an outcome of greater political communication (e.g., political communication fosters PIE in the child). In other words, the interactional model of political socialization (in which discussion in the family acts as training for deliberative engagement in the public sphere) appears to be better supported by these findings than a transmission model that posits a direct, top-down transfer of political attitudes from parent to child.

This study sought to determine the role of family communication in cultivating normative democratic attitudes. We found that political interest and political information efficacy were strongly influenced by communication in the family. This suggests that children who engage in political communication in the home are more likely to be interested in politics and are more likely to have confidence in their ability to participate in the political process in more public spaces.

While these findings represent important contributions to the scholarly understanding of political socialization in the family, there are important limitations to this research. First, the sample of college students is not generalizable to the population at large. While we sought parent/child dyads containing college students because the transition to college is thought to be a period of rapid socialization, there are still many people who do not attend college and are thus excluded from this study. It is unclear if the transition to adulthood is a period of rapid socialization for all, regardless of college attendance, or if the academic environment is a unique catalyst for socialization. Future research should compare young adults who attend college to those who do not to determine the extent to which the college experience is responsible for initiating rapid socialization. Furthermore, the findings of this study are limited by the cross-sectional nature of the research design. While theory suggests that communication in the family can socialize positive political attitudes, it is possible that socialization occurred

outside of the family (e.g., school, peer networks, media), and this socialization catalyzed political communication in the family. To establish the nature of causality, future studies should employ longitudinal designs to determine whether political communication in the family precedes socialization or, conversely, whether socialization resulting from exposure to the election and/or political experiences in the university setting is spurring greater political communication. Regardless of these limitations, this study demonstrated a strong and substantive connection between political communication in the family and the formation of positive democratic attitudes. Habermas lamented the transition of the family into a private space, but, in spite of his concerns, it appears the family remains a vital space for political communication.

REFERENCES

Andolina, M. W., Jenkins, K., Zukin, C., & Keeter, S. (2003). Habits from home, lessons from school: Influences on youth civic engagement. *PS: Political Science & Politics, 36*, 275–280. doi: 10.1017/S1049096503002191

Austin, E., & Nelson, C. L. (1993). Influences of ethnicity, family communication, and media on adolescents' socialization to U.S. politics. *Journal of Broadcasting & Electronic Media, 37*, 419–435. doi: 10.1080/08838159309364233

Colaner, C. W., & Rittenour, C. E. (in press). "Feminism begins at home": The influence of mother gender socialization on daughter career and motherhood aspirations as channeled through daughter feminist identification. *Communication Quarterly*.

Dalton, R. J. (1980). Reassessing parental socialization: Indicator unreliability versus generational transfer. *The American Political Science Review, 74*, 421–431. Retrieved from http://www.jstor.org/stable/1960637

Ekström, M., & Östman, J. (2013). Family talk, peer talk and young people's civic orientation. *European Journal of Communication, 28*, 294–308. doi: 10.1177/0267323113475410

Flor, D. L., & Knapp, N. F. (2001). Transmission and transaction: Predicting adolescents' internalization of parental religious values. *Journal of Family Psychology, 15*, 627–645. doi: 10.1037//0893-3200.15.4.627

Giles, S. M., Helme, D., Krcmar, M. (2007). Predicting disordered eating intentions among incoming college freshman: An analysis of social norms and body esteem. *Communication Studies, 58*, 395–410. doi: 10.1080/10510970701648608

Habermas, J. (1962). *The structural transformation of the public sphere: An inquiry into a category of bourgeois society*. Cambridge, MA: The MIT Press.

Hayes, A. F. (2013). *Introduction to mediation, moderation, and conditional process analysis: A regression-based approach*. New York, NY: The Guilford Press.

Hively, M. H., & Eveland, W. P., Jr. (2009). Contextual antecedents and political consequences of adolescent political discussion, discussion elaboration, and network diversity. *Political Communication, 26*, 30–47. doi: 10.1080/10584600802622837

Jennings, M. K., & Niemi, R. G. (1968). The transmission of political values from parent to child. *The American Political Science Review, 62*, 169–184. Retrieved from http://www.jstor.org/stable/1953332

Jennings, M. K., Stoker, L., & Bowers, J. (2009). Politics across generations: Family transmission reexamined. *The Journal of Politics, 71,* 782–799. doi: 10.1017/S0022381609090719

Kaid, L. L., McKinney, M. S., & Tedesco, J. C. (2000). *Civic dialogue in the 1996 presidential campaign: Candidate, media, and public voices.* Cresskill, NJ: Hampton Press.

Kaid, L. L., McKinney, M. S., & Tedesco, J. C. (2007). Political information efficacy and young voters. *American Behavioral Scientist, 50,* 1093–1111. doi.1177/0002764207300040

Koenig Kellas, J. (2010). Transmitting relational worldviews: The relationship between mother-daughter memorable messages and adult daughters' romantic relational schemata. *Communication Quarterly, 58,* 458–479. doi: 10.1080/01463373.2010.525700

Kushin, M. J., & Yamamoto, M. (2010). Did social media really matter? College students' use of online media and political decision making in the 2008 election. *Mass Communication & Society, 13,* 608–630. doi: 10.1080/15205436.2010.516863

Lauglo, J. (2011). Political socialization in the family and young people's educational achievement and ambition. *British Journal of Sociology of Education, 32,* 53–74. doi: 10.1080/01425692.2011.527722

Lee, N., Shah, D. V., & McLeod, J. M. (2012). Processes of political socialization: A communication mediation approach to youth civic engagement. *Communication Research, 40,* 669–697. doi: 10.1177/0093650212436712

McDevitt, M. (2005). The partisan child: Developmental provocation as a model of political socialization. *International Journal of Public Opinion Research, 18,* 67–88. doi: 10.1093/ijpor/edh079

McDevitt, M., & Chaffee, S. (2002). From top-down to trickle-up influence: Revisiting assumptions about the family in political socialization. *Political Communication, 19,* 281–301. doi: 10.1080/01957470290055501

McDevitt, M., & Ostrowski, A. (2009). The adolescent unbound: Unintentional influence of curricula on ideological conflict seeking. *Political Communication, 26,* 11–29. doi: 10.1080/10584600802622811

McIntosh, H., Hart, D., & Youniss, J. (2007). The influence of family political discussion on youth civic development: Which parent qualities matter? *PS: Political Science & Politics, 40,* 495–499. doi: 10.1017/S1049096

McKinney, M. S., & Warner, B. R. (2013). Do presidential debates matter?: Examining a decade of campaign debate effects. *Argumentation & Advocacy, 49,* 238–258.

McLeod, J. M., & Shah, D. V. (2009). Communication and political socialization: Challenges and opportunities for research. *Political Communication, 26,* 1–10. doi: 10.1080/10584600802686105

Meadowcroft, J. M. (1986). Family communication patterns and political development: The child's role. *Communication Research, 13,* 603–624. doi: 10.1177/009365086013004005

Medved, C. E., Brogan, S. M., McClanahan, A. M., Morries, J. F., & Shepherd, G. J. (2006). Family and work socializing communication: Messages, gender, and ideological implications. *Journal of Family Communication, 6,* 161–180. doi: 10.1207/s15327698jfc0603_1

Mullikin, P. L. (2006). Religious and spiritual identity: The impact of gender, family, peers and media communication in post-adolescence. *Journal of Communication & Religion, 29,* 178–203.

Osborne, D., Sears, D. O., & Valentino, N. A. (2011). The end of the solidly Democratic South: The impressionable years hypothesis. *Political Psychology, 32*(1), 81–108.

Pinkleton, B. E., Austin, E. W., & Fortman, K. J. (1998). Relationships of media use and political disaffection to political efficacy and voting behavior. *Journal of Broadcasting & Electronic Media, 42,* 34–49. doi: 10.1080/08838159809364433

Scheufele, D., & Nisbet, M. C. (2002). Being a citizen online: New opportunities and dead ends. *The Harvard International Journal of Press/Politics, 7,* 55–75. doi: 10.1177/1081180X0200700304

Sears, D., & Valentino, N. A. (1997). Politics matter: Political events as catalysts for preadult socialization. *American Political Science Review, 91,* 45–65. Retrieved from http://www.jstor.org/stable/2952258

Shah, D. V., McLeod, J. M., & Lee, N. J. (2009). Communication competence as a foundation for civic competence: Process of socialization into citizenship. *Political Communication, 26,* 102–117. doi: 10.1080/10584600802710384

Verba, S., Schlozman, K. L., & Burns, N. (2005). Family ties: Understanding the intergenerational transmission of political participation. In A. S. Zuckerman (Ed.), *The social logic of politics* (pp. 95–114). Philadelphia, PA: Temple University Press.

Warner, B. R., Turner-McGowen, S., & Hawthorne, J. (2012). Limbaugh's social media nightmare: Facebook and Twitter as spaces for political action. *Journal of Radio & Audio Media, 19,* 257–275. doi: 10.1080/19376529.2012.722479

Wilkin, H., Katz, V. S., & Ball-Rokeach, S. J. (2009). The role of family interaction in new immigrant Latinos' civic engagement. *Journal of Communication, 59,* 387–406. doi: 10.1111/j.1460-2466.2009.01421.x

Social Media AND Social Voting IN Latino Families

A Strategic Approach to Mobilizing Youth as Information Leaders

MICHAEL McDEVITT AND SHANNON SINDORF*

A core principle of fairness and equality, "one person, one vote" presumably translates across native and immigrant communities in political enculturation and also across generations in the securing of a participatory ethos. The increasing prominence of young Latino voters in the digital era might nevertheless warrant some rethinking about expressions of American citizenship, something closer to voting on behalf of family and friends lacking the franchise. The presidential campaign of 2012 provided an opportunity to document the capacity of youth to act as *information leaders* in Latino communities in ways that might enhance political voice despite voting restrictions.

In a traditional conception of political voice (Best & Krueger, 2005), ineligible voters fall silent. Within an information-leader sequence, both youth and parents are heard to the extent that the diffusion and reception of information promote awareness about a policy concern of vital importance in immigrant communities. The individual's act of voting is foundational in Constitutional theory, of course, but this participatory mode fails to capture what it is about campaign engagement that might resonate with many immigrant families. Voting becomes meaningful to the extent that it reflects a relational orientation that recognizes

*Much of this chapter is adapted from material published in McDevitt and Butler (2011) and McDevitt and Sindorf (2014). We express gratitude to Peter Levine and Kei Kawashima-Ginsberg at CIRCLE for providing the 2012 survey data and guiding our work with preliminary discussions and analyses. Albert Breitwieser created the designs for Figures 1 and 2.

aspirations of the family. In this view, civic acts such as the sharing of information, and political acts such as voting, are best appreciated as citizenship on behalf of others.

The Pew Research Center reported that 20% of registered voters said they encouraged others to vote in 2012; and 25% heard about how to vote from family and friends through Twitter and social networking (Raine, 2012):

> In all, those who did any ... activities related to getting messages about voting, sending out such messages, or posting their presidential choice on a social media site are part of our calculation of the "social vote" cohort. And that comes to 74% of registered voters. (p. 4)

Promotion of the Development, Relief, and Education for Alien Minors (DREAM) Act in 2012 presented an opportunity to examine how social media and social voting might cast young adults in the role of information leaders. A national version of the DREAM Act would allow youth brought to the country illegally to earn residency status through college attendance or military service. Access to higher education represents a kitchen-table issue of interest to both youth and parents. Furthermore, the non-voting status of younger adolescents and many parents did not lead to a dead end in mobilization. The information leader role implies that youth should take responsibility for acquiring, shaping, and relaying information (McDevitt & Butler, 2011). Regardless of voting status, those sharing and receiving information would have a stake in the outcome of the election and in the fate of the DREAM Act.

To capture *information leading* as an emergent form of citizenship, in this chapter we triangulate findings from three sources: a 2010 study on the information ecologies of adolescents and parents in an immigrant community in Colorado; a national 2012 post-election survey of young adults; and an analysis of campaign strategies focused on access to higher education. We conclude with recommendations for how mobilization efforts in future elections can harness new media by recruiting youth as information leaders.

INFORMATION LEADERS

A construct from the earliest voting studies, the "opinion leader" is a component in a two-step flow of communication—later revised as multistep flow—to explain how voters make up their minds during campaigns (Lazarsfeld, Berelson, & Gaudet, 1948). Opinion leaders tend to devote more attention to news media (step 1), and by virtue of knowledge and expertise gained, possess persuasive influence in interpersonal communication networks (step 2). While prior research has documented youth as opinion leaders in health communication and medical interventions (e.g., Stevens et al., 2006), the present study represents the first application in the context of immigrant families and electoral issue engagement.

Rather than opinion leader, we prefer the term "information leader" to convey a capacity for influence, more broadly conceived, in political communication but also in exchanges that enrich the family as a setting for conversations with life-enhancing implications. Information is interpersonally constructed within cultural boundaries, and, consequently, perspectives on participatory dispositions should account not just for access to technology, but also for a willingness to share political information. While U.S. youth embrace social media across ethnic backgrounds (Rideout, Foehr, & Roberts, 2010), a digital divide emerges in Latino families when considering cell phone and Internet use of native-born children and their foreign-born parents (Livingston, 2010).

Our initial insights on information leading were derived from focus groups and a survey conducted in spring 2010 in an immigrant community in northern Colorado (McDevitt & Butler, 2011). In these focus groups, youth made it clear that there is little overlap between their media worlds and those of their parents. When we asked a group of teenage girls if their parents ventured online, they laughed at the question. One girl playfully mocked her mother trying to text, portraying her with open mouth and twisted thumbs. We found that first-generation adolescents and immigrant parents live mostly in separate information ecologies and that social media can induce a parenting crisis when media use heightens tensions between Latino and Anglo values.

In our survey results, messaging, e-mail, social networking, and iPod/MP3 use correlated with youth civic efficacy, but these activities did not predict political interest or motivation to vote. Internet use correlated with open opinion climate for political expression in school but not open climate in families (McDevitt & Butler, 2011). Consequently, while scholars tout social media as an opportunity to overcome digital divides (e.g., Kahne & Middaugh, 2012), Internet activity does not necessarily translate into Latino family interaction conducive to electoral participation. However, there should be a tremendous upside in mobilization if strategists can devise ways to bridge youth social media with information exchanges in families. Prior scholarship confirms the vital function of interpersonal political communication in families in the cultivation of deliberative orientations conducive to voting (Kim, Wyatt, & Katz, 1999; McDevitt & Kiousis, 2007).

The 2012 Campaign

Findings from the Colorado study motivated our interest in the 2012 presidential campaign as a setting, and access to higher education as an issue, ripe for crystallization of the information leader role. The DREAM Act was initially a bipartisan proposal, introduced in the U.S. Senate on August 1, 2001 (S. 1291). As immigration became an increasingly salient issue for Republicans, and social conservatives championed a hard line against illegal immigration, some members of the GOP found themselves pressed to take a position, and a favorable stance became harder

for Republicans to maintain publicly (Soraghan & Riley, 2002). Senator John Kerry backed the Act in his 2004 run for president, as did then-Senator Barack Obama in 2008, but it was not until 2012 that the proposal emerged as a prominent issue in a presidential campaign. Republicans and Democrats increasingly wooed Latinos, although the GOP stance on the DREAM Act wavered, with Republican Senator Marco Rubio of Florida proposing a watered-down version in April (Weisman, 2012).

We presume that the agency of youth in information exchange is structured by what occurs at both the macro level of campaign communication and in the micro realm of family interaction. That is, information leading should depend on the extent to which the campaigns framed the DREAM Act in ways conducive to issue discussion in the family. Textual analysis of campaign messaging, in combination with a post-election survey of youth, allows us to explore at both levels the factors that might enable or curtail Latino youth as information leaders.

METHOD

Survey

Interviews of citizens ages 18–24 were conducted after the 2012 election by Universal Survey on behalf of the Center for Information & Research on Civic Learning and Engagement (CIRCLE).[1] Interviews began the day after election day and continued through December 21. Approximately two thirds of respondents were contacted via cell phone and the rest through landlines. The survey design oversampled Latinos and African Americans, although the aggregate national sample (N = 4,483) is highly representative. Findings reported below compare political engagement of Latinos (n = 849) to non-Latinos (n = 3,616), Latinos born in the United States (n = 707) to Latinos born elsewhere (n = 100), and Latinos with both parents born in the United States (n = 387) to Latinos with both parents born elsewhere (n = 284).

Respondents answered questions about high school courses, involvement in political activities prior to the campaign, and engagement during the campaign. All respondents answered a core set of 45 items. The entire survey consisted of 90 questions, but to maintain interviews in the range of 15 to 20 minutes, three forms were used, each containing about 75 questions[2]. Our analyses presented here are confined to items with implications for the information leader dynamic. Wording and coding for measures reported in this chapter are provided in the Appendix.

Textual Analysis

Through an analysis of campaign advertisements and messaging strategies as documented in news articles, we examined how the two major parties and activist groups

appealed to Latinos. While we pursued a largely inductive approach in search of emergent themes, the previous study in Colorado focused our attention on implications of campaign strategy for empowering youth as information leaders in immigrant families. As for types of campaigning beyond advertisements, we considered candidate debates and appearances but decided to concentrate on scripted messaging and planned strategies rather than interactions with less control. Also, news articles offered supplemental perspectives on how campaign operatives were contemplating strategies for Latino voter mobilization. To be clear, the present study is not concerned with journalistic motives per se or media framing dynamics and effects.

We retrieved news articles on campaign activities from LexisNexis Academic. Two searches were conducted on all English-language news articles in 2011 and 2012—one containing the terms "DREAM/Dream Act" and "campaign" and "family" or "families" (resulting in 180 articles), and another containing the terms "DREAM/Dream Act" and "campaign" and "social media" or "social networking" or "Facebook" or "Twitter" (producing 47 articles). We reviewed these articles to isolate relevant content. The "family" search yielded 32 articles, and "social media" search an additional nine.

We also examined advertisements in which the DREAM Act was the primary concern in a campaign context. Here, we identified 16 ads that fit this criterion. Only three were from official campaign sources, and these were produced by Obama's team or the Democratic National Committee. The Committee on Political Education (COPE), an activist arm of the Service Employees International Union (SEIU), produced five ads, including the only radio advertisement we identified. While five ads did not directly reference the campaign, they were released during the election cycle. Eleven ads listed websites for organizations that produced the messages, most of them appearing in fine print at the end of videos.

RESULTS

Survey

In our secondary analysis of the 2012 survey, we lack measures of social media behavior, but the data set offers multiple indicators for considering experiences conducive to information leading, allowing for comparisons of young adults in Latino and non-Latino families. With the DREAM Act in mind, Table 1 reports frequencies for the two groups for issue engagement. In the first indicator, respondents identified an issue they "would MOST like for politicians in Washington to do something about." Options included unemployment, federal budget deficit, immigration, gay rights, health-care reform, and abortion rights. Only 5% of non-Latinos chose immigration, compared with 20.5% for Latinos ($p < .001$). Latinos were more likely to support a law that would allow immigrant children

to gain legal residence if they attended college or served in the military ($p < .001$). However, engagement in immigration as a policy issue did not favorably predispose young Latinos to electoral participation compared with concern about other issues. Apart from interest in specific issues, non-Latinos were more likely to vote ($p < .001$) and to be encouraged by their parents to vote ($p < .05$). They were more likely to volunteer for a party or candidate and to be contacted by someone personally to work for, or contribute money to, a party or candidate (both $p < .05$).

Table 1. Frequencies for Issue and Electoral Engagement of Latino and Non-Latino Young Adults.[1]

	Latino	Non-Latino	χ^2
Issue engagement			
Most important issue: immigration	174 (20.5%)	179 (5.0%)	237.11*** ($df = 7$)
Support law allowing legal residence	148 (85.1%)	121 (67.6%)	18.49*** ($df = 1$)
Electoral engagement			
Voted in 2012	429 (50.5%)	2252 (62.3%)	39.64*** ($df = 1$)
Parents encouraged you to vote	431 (78.8%)	1974 (82.5%)	4.09* ($df = 1$)
Volunteered for a party or candidate	45 (7.8%)	254 (10.7%)	4.40* ($df = 1$)
Asked to support a party or candidate	99 (18.0%)	606 (25.1%)	12.72* ($df = 1$)
N	849	3616	

[1] 2012 post-election survey, ages 18–24. CIRCLE.
*$p < .05$; ***$p < .001$.

A supplemental analysis confirmed that immigration issue engagement did not favorably predispose Latinos to electoral participation. Among Latinos who voted, 18.7% selected immigration as the most pressing policy issue, compared with 24.0% choosing this issue among Latino non-voters ($\chi^2 = 3.57$, $df = 1$, $p < .10$).

Table 2 takes a finer-grain look at information-leading experiences with respect to grade completed, family and high school climate for expression, experiences with peers, and media attention. A striking pattern emerges when juxtaposing the home and school as milieu for discussion. Schools appear egalitarian as socializing institutions in discursive democracy. We detected no differences (at $p < .05$) tied to ethnicity for student perceptions that they (1) had a say in how the school was run, (2) could disagree with teachers, (3) were encouraged to express opinions, and (4) felt like they were part of a community. Families, by contrast, harbored inequalities in opportunities for exchanges of political information. Latinos grew up in homes with fewer books ($p < .001$), interacted with parents with less formal education ($p < .001$), conversed less frequently with parents about politics ($p < .01$), and received less encouragement to express opinions ($p < .001$).

Table 2. Means for Information-Leading Experiences of Latino and Non-Latino Young Adults.[1]

| | Latino[2] | | Latino born in U.S. | | Latino w/parents born in U.S.[3] | |
	yes	no	yes	no	yes	no
Respondent education						
Grade completed (1–8)[4]	3.96	4.35***	3.92	4.21†	3.97	3.90
Family climate for expression						
# books in home (1–4)	2.59	3.15***	2.61	2.44	2.82	2.32***
Parent education (1–6)	3.40	4.07***	3.41	3.38	3.84	2.85
Discuss politics w/parent (1–5)	2.43	2.60**	2.54	2.56	2.55	2.48
Parents encourage opinions (1–5)	3.08	3.36***	3.07	2.95	3.21	2.88*
School climate for expression						
Say in how school was run (1–5)	2.72	2.61†	2.73	2.63	2.66	2.89†
Could disagree w/teachers (1–5)	3.59	3.61	3.61	3.58	3.55	3.68
Encouraged opinions (1–5)	3.86	3.81	3.88	3.77	3.83	3.90
Felt part of a community (1–5)	3.45	3.46	3.44	3.53	3.44	3.48
Civic experiences with peers						
Discuss politics w/friends (1–5)	2.54	2.79***	2.56	2.39	2.63	2.43*
# of friends who voted (1–7)	4.65	5.05***	4.63	4.71	4.71	4.55
# groups at school (1–8)	2.47	2.73**	2.43	2.65	2.52	2.32
# groups outside school (1–8)	1.92	1.76	1.91	2.06	2.14	1.58†
Media attention						
News about candidates (1–4)	2.54	2.59	2.51	2.79*	2.53	2.51
N	849	3616	707	100	387	284

[1] 2012 post-election survey, ages 18–24. CIRCLE.
[2] "Are you of Latino or Hispanic origin, such as Mexican, Puerto Rican, Cuban, or some other Spanish background?"
[3] Middle category eliminated (one parent born outside United States) to establish a clear contrast.
[4] range.
†p < .10.
*p < .05; **p < .01; ***p < .001.

Deficits for information leading are also apparent in experiences with peers. While no gaps arise for attention to news about candidates and involvement in groups outside of school, Latinos reported less frequent political discussions with friends (p < .001), fewer friends who voted (p < .001), and participation in fewer groups in high school (p < .01).

Table 2 also disentangles influences of ethnicity from immigrant status of youth and parents. Across the 14 indicators, only media attention signals a significant difference between Latinos born in the United States and those born elsewhere ($p < .05$). Here the advantage goes to immigrant young adults. The politically minded among them apparently appreciate news media in navigating the electoral system. In the final set of comparisons, Latinos with U.S.-born parents benefitted disproportionately with regard to number of books in the home ($p < .001$), parent encouragement to express opinions ($p < .05$), and frequency of discussion with friends ($p < .05$). Considering the results in aggregate, information-leading experiences are most systematically tied to Latino identity rather than immigration status of young adults or their parents.

Textual Analysis

We hardly expect that operatives for Mitt Romney and President Obama would have information leading in mind when devising mobilization strategies. On the other hand, few would dispute the importance of the family in Latino culture, and recent research documents how political contagion in the home engenders activism on immigration (Wilkin, Katz, & Ball-Rokeach, 2009) and dispositions favorable to Latino voting (McDevitt & Butler, 2011). Findings from the 2012 survey nonetheless reveal deficits in family climate and frequency of talking about politics with friends among Latino young adults in general and those with immigrant parents. We consider next the implications of campaign strategy for overcoming these obstacles. Analyses of advertisements and news about campaign strategy generated five themes with relevance to information leading.

An imaginary divide. Social media were generally ignored in advertisements and in news accounts that addressed campaign strategy vis-à-vis the DREAM Act. Only one of the 16 ads mentions social media, a video from Obama that does not address the DREAM Act itself, but rather the Prosecutorial Discretion Initiative, a presidential order that stopped deportation of undocumented immigrants brought into the country as children. Nevertheless, the ad pummels Romney for refusing to express an opinion on the Act. It segues to a *60 Minutes* interview in which the GOP candidate is asked five times to declare his position; he dodges each time. The narrator ends with an appeal to visit "Truth Team" at the campaign website, post on Twitter and Facebook, or donate. While the reference to social media is something more than gratuitous, there is nothing of substance about the act for "dreamers" and their supporters to share.

We should note that the Obama campaign did release a 3-minute web ad that discusses core principles of the DREAM Act. No other ad from Obama or the Democratic National Committee addressed the Act in such a direct fashion. As a web video, the ad was potentially spread through social media, but there was

no encouragement to share the message and no mention was made of Facebook, Twitter, or other networking platforms.

Even if strategists were well aware of the popularity of mobile phones, texting, and instant messaging among Latino youth (Livingston, 2010), they might not have felt confident about how to deploy digital communication in immigrant communities. Or, they might have assumed that social media are insufficiently politicized as a presence in Latino youth culture. If so, the campaigns reified a digital divide in the realm of electoral politics even as social media prevail in the everyday lives of potential voters and future voters.

La familia invisible. We observed a continuum of abstraction in portrayals of working families. Depictions become more detailed in moving right to left, from the Republicans, to Democrats, to COPE/SEIU. Perhaps intentionally, with their core (Anglo) supporters in mind, Republicans typically issued vague messaging when referring to the life experiences of Latinos, as in Romney's statement: "Those who serve in our military and fulfill those requirements, I respect and acknowledge that path" (Parker, 2011). (Notice the juxtaposition of "those" with SEIU's "dreamers.") Latino families were more visible in Democratic support for the DREAM Act, as in Obama's assurance in a television advertisement: "It's our job to protect our families" (Boyer, 2011).

A relationship-centered perspective is conducive to conversations about higher education in intimate settings, such as the family, and in social networking sites that cultivate social capital and collectivist aspiration. By contrast, the Republican penchant for individualistic constructions arrives as a dead end in an information-leader scenario, especially since those the DREAM Act would directly affect cannot themselves vote.

Republican strategists seemed comfortable with a reductionist approach to Latino experiences, portraying them through ideological terms such as "family values" (Feldmann, 2011), "pro-family," and "pro-life" (Leary, 2011). A rigid imagery might derive from uncertainty about how to expand conservative visions of the American Dream to include families with parents who crossed the border illegally. Democratic perspectives appeared more pragmatic, describing the Latino family as a bonded, social unit of shared concerns about jobs, citizenship, and access to higher education.

The immigrant's choice: Success or loyalty. Competing visions of the model immigrant structured much of the campaign discourse: a libertarian view of individualistic, bootstrap success in the economic sector versus a multicultural portrait of family loyalty and cohesion. Progressive advertisements failed to resolve the success-versus-loyalty predicament. Four ads emphasized the innocence of immigrant children, deploying some version of "no fault of their own." This phrase is intended to calm DREAM Act opponents by ensuring them that access to higher education would not reward illicit border crossing. But parents are thrown under

the bus, as "fault" is attributed to them, at least implicitly. Still, parents are ineligible to vote, and the campaigns need not worry about giving offense. In lyrics to "Dream to Belong," a music video produced by Latino activists, only the children are innocent: "We dream to belong/Dreamers hold on/Hold on for every/Child who did nothing wrong/Dreamers hold on/Hold on/To the Dream" (Useche, 2012). An understanding of the immigrant experience in terms of "no fault of their own" divorces the DREAM Act from its community context, making access to higher education a strained topic for family discussion, potentially foreclosing on possibilities for youth to act as information leaders.

Justice, compassion, aspiration. The campaigns tended to rely on one of three frames when incorporating the Act in mobilization efforts: justice, compassion, or aspiration. The justice frame—used exclusively by Republicans—characterized any policy granting legal residency as "amnesty" (Zeleny & Gabriel, 2011). As Romney stated, "For those who come here illegally, the idea of giving them in-state tuition credits or other special benefits I find to be contrary to the idea of a nation of law" (Parker, 2011).

The compassion frame incorporated elements of justice and meritocracy by conveying the DREAM Act as a moral imperative that would extend charity, shelter, and dignity. Marco Rubio argued: "We have these very talented young people in America who find themselves in limbo through no fault of their own" (Lillis, 2012). Prior to leaving the Republican primaries, Newt Gingrich proposed:

> If you've been here 25 years, and you got three kids and two grandkids, you've been paying taxes and obeying the law, you belong to a local church, I don't think we're going to separate you from your family, uproot you forcefully and kick you out. (Zeleny & Gabriel, 2011)

A commonsense, compassionate stance was difficult to uphold in the Republican primaries as candidates fought over the most authentic conservative credentials.

In the aspiration frame, COPE/SEIU adopted "dreamers" as the endearing term for youth striving for access to higher education. While Democratic rhetoric often relied on "no-fault-of-their-own" imagery, references to dreamers were more inclusive in recognizing aspiration in Latino families.

Social voting. In channeling aspiration, activists and elected officials may have reconciled the DREAM Act as an otherwise problematic issue in a campaign context. After all, the people who would benefit cannot vote. Those eligible to cast ballots frequently explained that they were acting on behalf of friends and family. Social voting became particularly apparent in Latino perceptions of immigrant bashing. As Page (2012) noted, "Harsh rhetoric and hardline policies toward illegal immigrants have soured many Latinos toward the GOP, even those who aren't particularly concerned about immigration for themselves and their families" (para. 36). Democratic strategists recognized a social orientation to voting in messaging "designed 'to motivate and educate' Latinos that their votes 'will be the voice

for their undocumented friends, family members and classmates'" (Lillis, 2012, para. 7).

DISCUSSION

Participation in social media potentially empowers Latino youth as information leaders, with promising implications for mobilization during election cycles. In a recent study on how new media shape political participation, Kahne and Middaugh (2012) reported that Internet access "varies only a fraction among the four racial groups we studied—all above 94%" (p. 54). The information leader function is nonetheless curtailed by obstacles identified here and in the Colorado study. Keeping in mind efforts to promote the DREAM Act, and despite widespread issue engagement, young Latinos lagged behind non-Latinos in voting. Latino ethnicity and growing up in families with immigrant parents predicted deficits in family expression and discussion about politics with friends.

Meanwhile, mobilization efforts often ignored the family and social media, while presenting access to higher education in an individualistic/justice frame. In our view, the information leader role is best activated when aspirational themes are coupled with collectivistic portrayals of the immigrant experience. Figure 1 maps representations of Latinos in 2012; we crossed ideological frame (justice, compassion, aspiration) with the cultural dimension (individualistic, collectivistic). Romney's call for "self-deportation" is probably the best (and crudest) example of messaging at the conjunction of justice and individualism (Katz, 2012). Rubio's reference to "chain migration" is also entrenched in law and order, but the fear-based warning is seemingly warranted by a collectivistic orientation. While Obama stressed that immigration reform must "protect our families," we would classify that approach under compassion rather than aspiration. By contrast, portrayal of youth as "dreamers" resonated with Obama's signature slogan from 2008, recycled in 2012 as a bilingual appeal: "Si se puede"/"Yes we can," a message that joins communal with aspirational sentiment.

The DREAM Act is itself aspirational, and a collectivistic strategy would ideally recruit dreamers through social networking. A post-election initiative suggests how social media could have been used to the campaigns' advantage. The Center for Community Change launched a comprehensive, integrated effort involving live events, traditional media, and social media to mobilize support for the Act. The center organized a bus tour to gather personal accounts from dreamers, shared videos on KeepFamiliesTogether.org, and promoted the Act via text messaging (Dickson, 2013). This multi-pronged strategy put faces to a narrative of hope while exploiting the reach of social media in a demographic receptive to the affirmation of sympathetic ties and communal support.

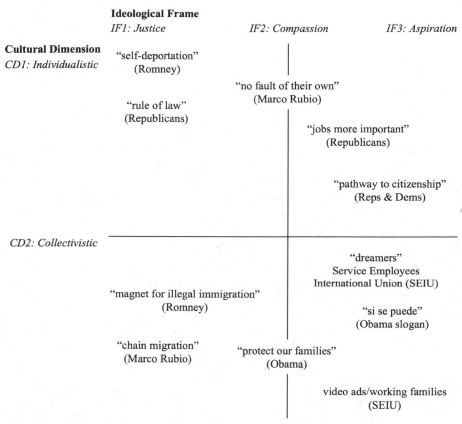

Figure 1. Representation of Latinos in mobilization strategies in 2012.

As illustrated in Figure 2, a synergistic approach to mobilization would account for three factors and the relationships among them: an issue with mobilizing potential, communication initiatives to fully exploit that potential, and the social context in which information is most likely shared. In 2012, the DREAM Act potentially represented a kitchen table concern readily taken up by parents, adolescents, and young adults, represented by the strong issue/family connection depicted in Figure 2. However, themes from analysis of mobilization efforts suggest that the campaigns failed to exploit the potential of social media in promotion of the Act. Meanwhile, findings from the Colorado survey and focus groups imply a disconnect between youth social media use and family interaction, with Latino parents and youth living in disparate information ecologies.

A systematic program of research would be necessary to test the full model as shown in Figure 2, but we hope that the current study demonstrates the value of triangulating findings from surveys, focus groups, and analysis of campaign

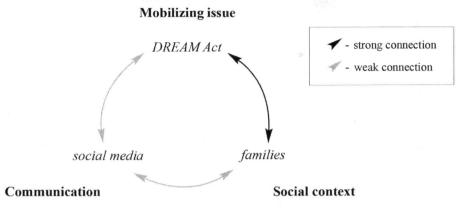

Figure 2. A synergistic perspective on mobilization of information leaders in immigrant families.

strategy. The results call out for replication in future elections and improved measurement to more persuasively document connections between individual-level survey data and media content focused on a mobilizing issue. The 2012 survey did not include direct measures of information-seeking as a motivational orientation, and we lack individual-level measures of social media use and associated political cognition. These limitations curtail inferences about social media use as a cause, effect, mediator, or moderator of information-leading activities.

For now, we can highlight the potential contributions of youth and young adults in a synergistic model, as they connect supply of mobilizing information at the macro level with demand for information and the sharing of information in families and in peer networks. Future elections will undoubtedly see more sophisticated deployment of social media and perhaps more culturally resonant approaches that cast young Latinos in prominent roles. A shift in the perspective of political voice—from individual to social voting, from mass to social media, and from information reception to information leading—should go a long way toward the promotion of active citizenship in the immigrant experience.

NOTES

1. Contact CIRCLE (www.civicyouth.org) for more information on survey design and data-collection.
2. Wording and coding for all items are available from CIRCLE.

REFERENCES

Best, S. J., & Krueger, B. S. (2005). Analyzing the representativeness of Internet political participation. *Political Behavior, 27*(2), 183–216.

Boyer, D. (2011, July 25). DNC targets Hispanic vote with Spanish ad; Buy in 7 states follows GOP spot critical of Obama. *The Washington Times*, A3.

Development, Relief, and Education for Alien Minors Act of 2001, S. 1291, 107th Cong. (2001).

Dickson, V. (2013, February 1). Immigration groups work to put a face on the issue. *PR Week*, pp. 9–11.

Feldmann, L. (2011, November 16). In recession-smacked Nevada, can GOP pry Latino voters from Obama? *The Christian Science Monitor*. Retrieved from http://www.csmonitor.com/USA/Elections/2011/1116/In-recession-smacked-Nevada-can-GOP-pry-Latino-voters-from-Obama

Kahne, J., & Middaugh, E. (2012). Digital media shape youth participation in politics. *Phi Delta Kappan*, *94*(3), 52–65.

Katz, C. (2012, October 29). Say "si" to me! Mitt, Bam chase swing-state Latinos. *New York Daily News*, A12.

Kim, J., Wyatt, R. O., & Katz, E. (1999). News, talk, opinion, participation: The part played by conversation in deliberative democracy. *Political Communication*, *16*(4), 361–385.

Lazarsfeld, P., Berelson, B., & Gaudet, H. (1948). *The people's choice*. New York, NY: Columbia University Press.

Leary, A. (2011, August 7). Hispanic vote key in '12 election. *St. Petersburg Times*, A1.

Lillis, M. (2012, April 21). Democrats jab Romney with Dream Act. *The Hill*. Retrieved from http://thehill.com/homenews/campaign/222901-democrats-jab-romney-with-dream-act

Livingston, G. (2010). *The Latino digital divide: The native born versus the foreign born*. Washington, DC: Pew Research Hispanic Center. Retrieved from http://pewhispanic.org/reports/report.php?ReportID = 123

McDevitt, M., & Butler, M. (2011). Latino youth as information leaders: Implications for family interaction and civic engagement in immigrant communities. *InterActions: UCLA Journal of Education and Information Studies*, *7*(2), Article 2. Retrieved from http://escholarship.org/uc/item/4757z113

McDevitt, M., & Kiousis, S. (2007). The red and blue of adolescence: Origins of the compliant voter and the defiant activist. *American Behavioral Scientist*, *50*(9), 1214–1230.

McDevitt, M., & Sindorf, S. (2014). Casting youth as information leaders: Social media in Latino families and implications for mobilization. *American Behavioral Scientist*, *58*(5), 701–714.

Page, S. (2012, June 25). Latinos strongly backing Obama; But generational shift gives GOP an opening. *USA TODAY*, 1A.

Parker, A. (2011, December 31). Romney says he would veto Dream Act. *The New York Times, The Caucus blog*. Retrieved from http://thecaucus.blogs.nytimes.com/2011/12/31/romney-says-he-would-veto-the-dream-act/

Raine, L. (2012). *Social media and voting*. Washington, DC: Pew Internet & American Life Project.

Rideout, V. J., Foehr, U. G., & Roberts, D. F. (2010). *Generation M²: Media in the lives of 8- to 18-year-olds. A Kaiser Family Foundation study*. Menlo Park, CA: The Henry J. Kaiser Family Foundation.

Soraghan, M., & Riley, M. (2002, September 26). GOP steers clear of hardline stance. *The Denver Post*, A1.

Stevens, S., Leybas-Amedia, V., Bourdeau, B., McMichael, L., & Nyitray, A. (2006). Blending prevention models: An effective substance use of HIV prevention program for minority youth. *Child and Adolescent Social Work Journal*, *23*(1), 4–23.

Useche, A. (2012). *Dream to belong* [Video file]. Retrieved from http://www.youtube.com/watch?v = 6TrU2WAjNmg

Weisman, J. (2012, April 20). Rubio, in appeal to G.O.P.'s conscience, urges compromise on Dream Act. *The New York Times*, A14.

Wilkin, H. A., Katz, V. S., & Ball-Rokeach, S. J. (2009). The role of family interaction in new immigrant Latinos' civic engagement. *Journal of Communication, 59*(2), 387–406.

Zeleny, J., & Gabriel, T. (2011, November 24). Gingrich's words on immigration become a target. *The New York Times*, A24.

APPENDIX

Survey Items

Issue engagement. "If you had to choose, what ONE issue would you MOST like for politicians in Washington to do something about?" Options: unemployment, federal budget deficit, immigration, gay rights, health care reform, abortion rights. "Do you support a law that would allow illegal immigrants brought to the U.S. as children to gain legal resident status if they join the military or go to college?" oppose = 0, support = 1.

Electoral engagement. "In any election some people are not able to vote because they are sick or busy, or have some other reason, and others do not want to vote. Did you vote in the national election held recently?" "Have your parents or guardians ever encouraged you to vote?" "After high school, have you been involved in any of these programs or opportunities? ... volunteering for a political campaign or candidate." "During the past six months, have you been contacted by someone personally to work for or contribute money to a candidate, political party, or any other organization that supports candidates?"

Respondent education. "What is the last grade or class that you completed in school?" none or grade 1 to 8 = 1, high school incomplete = 2, high school graduate = 3, technical or trade = 4, some college or university = 5, college or university graduate = 6, some post graduate = 7, postgraduate or professional degree = 8.

Family climate for expression. "When you were growing up, about how many books were there in your home?" a few (0–10) = 1, enough to fill one shelf (11–25) = 2, enough to fill one bookcase (26–100) = 3, enough to fill several bookcases (more than 100) = 4. "Thinking of a female relative or a parent figure who raised you the most while you were growing up, what was the last year of school this person completed?" no high school = 1, some high school = 2, high school = 3, some college = 4, college graduate = 5, graduate degree or professional school = 6. "How often do you talk about politics with your parents?" never = 1, once a month = 2, a few times a month = 3, a few times a week = 4, daily = 5. "Your parents wanted to hear your opinions about current events and politics, even if they differed from their own." never = 1, rarely = 3, sometimes = 3, often = 4, all the time = 5.

School climate for expression. "Students had a say in how the high school was run." strongly disagree = 1, disagree = 2, neutral = 3, agree = 4, strongly agree = 5. "In general, students could disagree with teachers, if they were respectful." "In general, students were encouraged to express opinions." "Students felt like they were part of a community where people cared about each other."

Civic experiences with peers. "How often do you talk about politics with your friends?" never = 1, once a month = 2, a few times a month = 3, a few times a week = 4, daily = 5. "How many of your friends voted in the election this fall?" none

= 1, hardly any = 2, less than half = 3, about half = 4, more than half = 5, most = 6, almost all = 7. "About how many organized groups or clubs *at school* did you participate in at least once a month?" one group = 1, two = 2, three = 3, four to five = 4, six to nine = 5, 10 or more = 8. "About how many organized groups or clubs *outside of school* did you participate in at least once a month?"

Media attention. "During this year's presidential campaign, how closely were you following the news about candidates?" not closely at all = 1, not very closely = 2, fairly closely = 3, very closely = 4.

Interactions With Peers AND Others

Youngsters' Political Talk With Those Outside School AND Family

The Hierarchy of Political Socialization

MI JAHNG, HANS MEYER, AND ESTHER THORSON

The study of political socialization of children and youth has gone in and out of vogue for the last 100 years. (Niemi, 1973) In the '60s and '70s, most of the focus on causal factors centered primarily on family and secondarily on schools (Niemi, 1973). There was little attention to the possible effects of media. As McLeod and Shah (2009) pointed out, the '90s saw a sharp increase of interest in the role of communication, both interpersonal and mass, in socialization. One of the salient findings of current research is that teenagers, who may be moving away from primary parental influence toward the influences—certainly—of school and also of media content and interactions with others, show a complex of responsiveness to media, interpersonal communication, and the interaction of the two (Hively & Eveland, 2009; McDevitt & Ostrowski, 2009; Mutz, 1998).

Shah and his colleagues (Shah, McLeod, & Lee, 2009) argued that political socialization research must move beyond an examination of knowledge and norms to a consideration of how young people acquire basic motives and skills to participate meaningfully and effectively in public life. The approach we explore in the current study is a test of the assumption that political socialization can be considered a hierarchy of stages of attention, learning, interpersonal communication behaviors, and political participatory behaviors. Piaget (1960) began a highly influential structural approach to child socialization that suggested evolving cognitive structures dictated a fairly predictable rolling out of skills and problem-solving in infancy (sensori-motor), preschool (pre-operational), childhood (concrete operational), and the teen years (formal operational). The cognitive structures interact

with environment in a dialectic where there is assimilation (the child's cognitive structures make the strange and new link with what is known and understood) and accommodation (the child's cognitive structures themselves change processing to fit with input from the environment).

Although we do not directly test whether it is cognitive structures that dictate the look of political knowledge, attitudes, and behaviors in youth, we do think there is movement through stages of political dimensions that themselves reflect increasing complexity. This belief coordinates with a number of other areas of study founded on Piagetian concepts, such as Kohlberg's stages of moral development (see Kohlberg & Hersh, 1977), Kieran Egan's (1997) educational theory, and James Fowler's (1981) stages of faith development.

In general, we posit that a child's knowledge of, and attitudes toward, political entities such as the "president" or "laws" are the most basic units of political socialization and formed earliest (Eveland, McLeod, & Horowitz, 1999). As knowledge becomes more accurate and extensive, the child begins to elaborate on what she learns and to justify her attitudes with arguments she can make to others, usually with family or in school. Particularly with the transition into school, there is exposure to ideas different from those acquired from family, and these must be dealt with. Ideas about political behaviors such as voting, watching a debate, and going to a political rally develop. During this process the child develops beliefs about just how effective her skills are in the political arena, and whether she can make a difference in that arena.

Shah, McLeod, and Lee (2009) captured a significant part of this notion of efficacy in their discussion of "communication competence." This concept refers to a group of highly interrelated variables such as family communication patterns, school communication about politics, news media use, and interpersonal discussion about politics. What we focus on in this study is the notion that media use has important initial effects on political cognitive elaboration by the young person. The effects of that elaboration are reflected in school and family communications about politics, and simultaneously there is a growth in political efficacy. As there is more and more media use, there is more elaboration, and that elaboration is considerably enhanced by the school and family environment variables.

At the top of our particular hierarchy is behavior that represents a branching out beyond the familiar to conversation with people outside those domains, including people that will be likely to disagree with the youth. While our approach posits that this additional political communication competency would influence more energy-consuming activities such as attending rallies, becoming involved in political organizations, and boycotting products considered politically unacceptable (McDevitt & Ostrowski, 2009), our central focus in the current study is on the stages that lead to what we consider a big step in one's political socialization—engagement of the wider political world beyond family and school connections.

LITERATURE REVIEW

Media Influences on Adolescent Political Elaboration and Efficacy

Media can facilitate and activate public opinion expressions and discussions in many ways. Mutz (1998), for example, has argued that media help determine the perception of collective experience that is important to political judgments. Well-informed citizens are more likely to politicize their personal experience because of their high levels of exposure to news media and their interpersonal network that supports this political experience. Adults who seek news were more informed concerning public affairs and more self-efficacious in public actions leading to more public participation (Shah, Cho, Eveland, & Kwak, 2005).

Also according to Mutz (1998), personal experiences and mediated information constitute the realm of potential sources from which we form our political impressions. Much like the observations made by Tocqueville in early U.S. history, Mutz noted that the effect of the news media is to help us contextualize our individual events and experiences. The news weaves discrete events together by putting them into a story characterized by vividness or episodic themes (Iyengar & Kinder, 1987); and because news is presented in such a way, people learn to see their own problems and concerns as part of a broader social pattern (Mutz, 1998). This process contributes to the formation of political attitudes and opinions that one will develop toward a certain event or issue.

Young people must first develop their political ideas and opinions before they actually decide to participate in political actions, including such behaviors as voting and political argumentation (Glynn, Huge, & Lunney, 2009). In fact, young citizens' sense of political self, their civic self-esteem and political efficacy, were found to increase following exposure to media messages that specifically addressed their concerns and incorporated the expression of young citizens' opinions as part of the political message (McKinney & Banwart, 2005). It is also important for adolescents to acquire self-confidence in their own political beliefs through interaction with, and verification of, others' opinions before one develops a willingness to engage in political argumentation. Unwillingness or inability to acquire political information has been found to decrease one's propensity to express opinions and make political decisions (Althaus, 1998, 2003). Also, Kaid, McKinney, and Tedesco (2007) have explored adolescents' political information efficacy, the degree to which young citizens feel they have adequate knowledge and abilities to engage the political process. Their findings show that when adolescents learn from the news media, and especially via political messages framed around issues of greatest concern for young citizens and targeted for this audience using media most often used by youth, such messaging increases adolescents' political efficacy and leads them to express their opinions.

As political information can be gleaned from a diversity of news sources, it is important that we better understand which news media are most helpful for adolescents to elaborate on their own political experiences, and also which news media heighten one's political efficacy. Thus, we hypothesize that the use of news media, for example, newspaper and Internet news, will have a direct effect on adolescents' political elaboration and their political efficacy.

> H1: There will be a direct positive effect of exposure to political news from newspapers, television, and Internet on adolescent political elaboration and political efficacy.

The effects of political discussions in family and school on elaboration and efficacy

For adolescents' interpersonal communication, family communication, especially parental influence, has long been considered an important factor in one's political socialization development (Easton & Dennis, 1969; Hyman, 1959). Called "top-down" socialization, studies linking parental influence to political sophistication of adolescents have explored how parenting instills political trust and allegiance in younger children (McDevitt & Chaffee, 2002). Children from higher socio-economic status families have more political knowledge than those from low SES families, arguably because parents with higher socio-economic status are more prone to talk about politics with their children (McDevitt & Chaffee, 2000; Meirick & Wackman, 2004). McIntosh, Hart, & Youniss (2007) found that parent political knowledge and youth-parent political discussion were important predictors in youth political knowledge. Similarly, when college students perceived the importance of voting in their family to be high, they showed higher intention to vote (Glynn et al., 2009).

It is reasonable to expect that the more parents know and the more they encourage youth to discuss politics, the more they express their opinions and are politically involved, the more about politics children will know and the more likely it is that they will be politically active. However, aside from parental influence, political elaboration and the political efficacy of adolescents may also encourage political discussion in families. McDevitt (2005) found that active processing of information youth acquired from news media had significant effects on adolescents' initiating political discussions with their parents. Also, the adolescents' expectation to participate in political discussions within the family was found to prompt greater reflection on political issues and the practice of opinion expression (McDevitt & Chaffee, 2002). In general, adolescents are more likely to elaborate on political news and have higher political efficacy in a family communication environment where the parents know more about politics, pay more attention to news and politics, and encourage the expression of opinions.

Similarly, school is another realm of adolescents' interpersonal communication where they learn to express their political opinions. Recently, scholars have argued that adolescents have the potential to initiate political conversations within the family via the child's civics education. Called "trickle-up" socialization, students learn about politics from school, through programs such as Kids Voting USA, and, using their new knowledge and political opinions at home with their parents, they motivate their parents to become more politically knowledgeable and active (McDevitt & Chaffee, 2002; Meirick & Wackman, 2004). Also, school intervention was found to mitigate the social structural disparities outside of the classroom through increased political knowledge (Meirick & Wackman, 2004).

The importance of school curricula in adolescents' political development provides exposure to those with whom one might disagree. Schools also potentially provide social interaction that represents a level of political stimulation and communication that may not be available from parents at home (Kiousis & McDevitt, 2008). In the school environment, adolescents are faced with situations where the person who disagrees with them may have a well-developed argument. School-based interventions, such as Kids Voting USA, not only motivate youth to be politically interested and knowledgeable, but such programs and education can also help adolescents develop skills and greater motivation for political discussion in both schools and in the family (McDevitt, 2005; McDevitt & Chaffee, 2002).

Eveland, McLeod, and Horowitz (1999) pointed out that as cognition develops, young people become increasingly able to process the abstract ideas and concepts that serve as the bases for politics. Also, as adolescents' cognitive abilities develop they are better equipped to elaborate on the news and feel more efficacious about their own political opinions. Through this process, adolescents assimilate new ideas, accommodating and confirming these ideas and opinions through interactions with the family and at school. Given the evidence that school curricula and family communication equip adolescents to make political decisions that reflect their attitudes (Meirick & Wackman, 2004), they should therefore come to perceive themselves as more efficacious. Thus we predict:

> **H2:** Elaboration and political efficacy will have a direct positive effect on adolescents' political discussions held in families and schools.

The Role of Elaboration and Efficacy to Move Beyond Family and School

Goodin and Niemeyer (2003) suggested that consideration and reflection of one's opinions and beliefs take place before political discussion, and it is these cognitive processes that are vital in a deliberative democracy. Before verbalizing political positions, one should attempt to develop a clear understanding and arguments to justify opinions (Kosicki & McLeod, 1990). An internal process of weighing

reasons precedes political discussion; and political discussion and other overt political actions should be supplemented by one's "deliberation within" (Goodin, 2000). Elaboration, in other words, is the necessary condition for active and "reasoned" political behavior, from political discussions to voting.

Studies in elaboration and political news seem to support the importance of elaboration before verbalizing one's political opinions. First, the more people elaborated on news and information acquired, the more knowledgeable they were about politics. Numerous studies have found a positive relationship between level of news elaboration and political knowledge (Cappella, Price, & Nir, 2002; Eveland, Cortese, Park, & Dunwoody, 2004; Eveland & Dunwoody, 2002). Also, Hively and Eveland (2009) found that when people elaborated on information acquired through news, their new information was more likely to be connected with prior knowledge. Similarly, even after controlling for motivation for future discussion, elaboration was found to be a strong predictor of political knowledge (Eveland, 2004).

The acquisition and retention of political information have important consequences for individuals' ability and willingness to express opinions and make decisions in a representative democracy (Althaus, 1998). In this vein, and for the current study, we are particularly interested in the political outcomes that follow youth political elaboration and efficacy. For Shah et al. (2009), significant political outcomes included such behaviors as civic and political participation and political consumerism. Shah et al.'s analysis found that these important political behaviors were predicted by adolescents' communication competence; indexed by media news use, particularly news about public affairs via broadcast, print, and online sources, and interpersonal communication; indexed by discussions of public affairs and politics at home, in school, and among peers. McDevitt and Ostrowski (2009) examined the influences of adolescents' confrontational activism, such as showing support for confronting police in a protest, participating in a boycott against a company, and refusing to wear clothes with corporate logos. In the context of youth civic development, confrontational activism emerges through one's civic identity exploration and assertion largely through peer interaction and news use (McDevitt & Ostrowski, 2009, p. 13).

Here, we suggest that discussion outside of family and school is a step toward adolescent political participation. Adolescents' elaboration of politics is likely to go through an assimilation/accommodation process initiated within the family and school. Youth will link what they know and understand about politics to what their friends and their parents think (assimilation), and change beliefs and opinions according to new information acquired that may be different from previously held views (accommodation). Through elaboration and the assimilation/accommodation process that we expect to happen within family and school, adolescents will develop the courage to express their political opinions outside of their familiar

scope. Also, through exposure to news media, as well as confirmation of views from one's family and school interaction, adolescents will develop stronger political efficacy and will therefore have greater confidence to initiate a political discussion, even with someone who might disagree with them or with individuals with whom they have not previously discussed politics. Thus, the final two hypotheses of this study are:

H3: The effects of media exposure on political discussion outside of family and school will be mediated through elaboration and efficacy.

H4: Political elaboration and efficacy will have direct effects on frequency of political discussion outside of family and school, even after controlling for family and school discussion.

METHOD

To test these hypotheses, we used the second survey of the three-panel Future Voters Study (as described in the Introduction) administered November 5 through December 10, 2008, immediately after the presidential election.

RESULTS

The 711 usable responses in the second wave of the study represent nearly equal percentages of children in each age group. The largest group of respondents (19%) were 16, while there were nearly equal percentages of those 13, 14, 15, and 17 (16%, 17%, 18%, and 15% respectively). Smaller numbers of respondents said they were 12 (5%) and 18 (4%). Other demographic variables included in this study were household size and family income, which served to index SES. Household size ranged from 2 to 8, with the largest group having 4 people in their home (36%). Income ranged from $31,000 to $57,000 annually, with the largest percentages in the $47,000 (9%) and $51,000 (14%) categories.

Among the teens, media use differed greatly. While the survey included questions about late-night entertainment, comedy and cartoon programs, this study focused on measures of legacy news media use and created a category for Internet use for news. The most frequently used medium for respondents in the study was local TV news, with more than 68% saying they watched this news at least once a week. Nearly 10% of the respondents said they watched local TV news every day of the week. The next most frequently used news medium was the local newspaper, with 65% saying they read one at least once a week. Nine percent of respondents said they read a local newspaper every day. Another 8% said they

watched a national network newscast every day of the week, while 56% said they had watched the network evening news at least once in the last week.

To determine how the teen respondents used the Internet for news, we created a scale including six questions that asked about how often teens visited local newspaper Web sites, national newspaper Web sites, TV news Web sites, political blogs—both conservative and liberal—political candidates' Web sites, and funny online videos about the candidates (Cronbach's α = .83). Despite the number of measures in the scale, nearly 46% of the respondents said they had not used the Internet for news at all in the last week. The largest percentage of respondents said they had used four of the seven of these news Web sites at least once in the last week (5%).

In addition, we used factor analysis based on principal components analysis to create measures of discussion at home, discussion at school, elaboration, political efficacy, and discussion outside the home. Discussion at home was a combination of a question to the teens about how often they talked about current events with family members and a question to the parents about how often they encouraged their child to talk about politics (R = .37, p < .01). Five statements factored together as discussing politics in school (Cronbach's α = .90): "Followed the news as part of a class assignment," "Learned about how government works in class," "Discussed/debated political or social issues in class," "Participated in political role playing in class," and "Encouraged to make up your own mind about issues in class."

The political efficacy factor included four statements (Cronbach's α = .72): "I am influential among my friends," "My friends often seek my opinion about politics," "I am good at persuading people to see things my way," and "When I talk about politics I try to convince other people I am right." Elaboration (Cronbach's α = .84) included: "I try to connect what I see in the media with what I already know," "I often recall what I see in the media and think about it later," "Talking about politics makes me think more about my beliefs," and "Talking about politics makes me think more about that topic after the conversation." Finally, discussion outside of home (Cronbach's α = .88) included: "Talked about news and current events with friends," "Talked about news and current events with adults outside your family," and "Talked about news and current events with people who disagree with you."

To begin, we tested how the data fit the assumption that political socialization is a hierarchy of stages consisting of attention, learning, interpersonal communication behaviors, and political participatory behaviors (see Figure 1). We created a factor for knowledge by assigning a 1 to correct and 0 to incorrect responses to six questions about the presidential candidates, including which candidate was in the military, which one was divorced, and which one had started his career as a community organizer, and adding them together. We also created a political participation factor by combining eight questions about how frequently the teens participated

in a political campaign; attended a rally, speech, meeting, or protest activity; or worked for a party or candidate (Cronbach's α = .82). We created histograms to show the distribution of responses for knowledge, interest (which was a single 1–5 question of how interested the teens said they were in politics), political efficacy, discussion outside the home and political participation. The distribution of scores suggested larger percentages of respondents had higher knowledge, interest, and efficacy scores than either discussion or participation. In fact, more than 75% of the respondents said they had participated just once in a political activity, while more than 90% got at least one of the knowledge questions correct. Thus there is support for the idea that for the less effortful steps in the hierarchy, more youth get to that level. For the more effortful steps, many fewer report participating at that level.

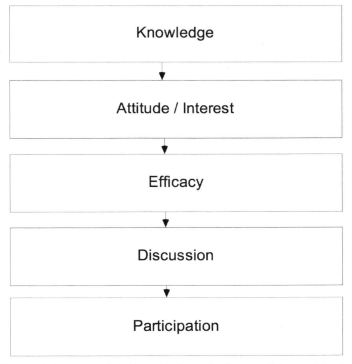

Figure 1. Theorized illustration of the hierarchical steps leading to political participation.

We next tested the effect of media use on elaboration and efficacy. We set up hierarchical regression analyses with elaboration and efficacy as the dependent variables and demographics at the first and the media use variables at the second levels of dependent variables. For elaboration (see Table 1), none of the demographic variables was a predictor in either stage of the model, while local TV, local

newspaper, and Web news use were strong positive predictors. For efficacy (see Table 2), only Web use for news and local TV news had direct effects at the second level, while income was a positive predictor at both levels. These findings suggest support for H1, that exposure to political news from newspapers, television, and Internet news use will have a direct, positive effect on adolescent political elaboration and political efficacy.

Table 1. Summary of Hierarchical Regression Analysis for Variables Predicting Discussion Elaboration (N = 701).

	Model 1			Model 2		
Variable	B	SE B	β	B	SE B	β
Household Size	.023	.026	.035	.012	.024	.018
Income	.006	.005	.040	.013	.005	.094*
Child's Age	.036	.019	.071	.028	.019	.055
National TV News				-.006	.021	-.017
Local TV News				.072	.020	.198**
Local Newspaper				.043	.015	.116**
Web use for news				.153	.041	.149**
R^2		.01			.12	
Adjusted R^2		.00			.11	
F Change		1.918			20.658**	

Table 2. Summary of Hierarchical Regression Analysis for Variables Predicting Discussion Political Efficacy (N = 701).

	Model 1			Model 2		
Variable	B	SE B	β	B	SE B	β
Household Size	.039	.025	.062	.028	.024	.044
Income	.011	.005	.085*	.016	.005	.120**
Child's Age	-.013	.019	-.026	-.024	.018	-.049
National TV News				-.024	.020	-.065
Local TV News				.054	.019	.154**
Local Newspaper				.023	.015	.063
Web use for news				.214	.040	.216**
R^2		.01			.10	
Adjusted R^2		.01			.09	
F Change		3.10*			15.33**	

To travel to the next level of the model and determine the effect of knowledge, elaboration, and efficacy on discussion, we set up a hierarchical regression analysis with the demographic variables at the first level, discussion at home and at school at the second, efficacy and elaboration at the third, and media use at the final stage. This allowed testing the effects of efficacy/elaboration on discussion patterns at home and at school while also testing what variables might lead to increased discussion outside the home (see Table 3).

Table 3. Summary of Hierarchical Regression Analysis for Variables Predicting Discussion Outside of Home and School Elaboration (N = 653).

Variable	Model 1			Model 2			Model 3			Model 4		
	B	$SE\,B$	β	B	$SE\,B$	β	B	$SE\,B$	β	B	$SE\,B$	β
Household Size	.101	.058	.068	.057	.049	.038	.012	.038	.008	.005	.037	.004
Income	.019	.012	.062	.007	.010	.023	−.016	.008	−.049	−.012	.008	−.038
Child's Age	.136	.044	.119**	.118	.037	.104**	.081	.028	.071**	.070	.029	.061*
Political Efficacy				.654	.091	.279**	.330	.072	.141**	.295	.072	.126**
Elaboration				.763	.088	.336**	.142	.074	.063	.136	.074	.060
Discussed in school							.205	.028	.213**	.183	.028	.190**
Discussed with family							.361	.022	.520**	.352	.022	.506**
National TV News										−.013	.032	−.016
Local TV News										.016	.031	.020
Local Newspaper										−.003	.023	−.003
Web news										.274	.066	.117**
R^2	.02			.32			.59			.60		
Adjusted R^2	.02			.31			.59			.60		
F Change	5.55**			144.43**			226.86**			4.88**		

In the final model, which predicts more than 60% of the variance, the only demographic variable that predicts discussion outside the home is the child's age, and it is significant only at the $p < .05$ level. Only efficacy is a strong predictor of discussion in the final model, while elaboration is a strong predictor before adding political discussion at home and school. The only one of the media use

variables, which were entered last after controlling for all other variables, that predicted discussion outside the home is Web use for news. What the stages of the model suggest is that efficacy, discussion at home and at school, and Web use for news have direct positive effects on discussion outside of the home, which offers some support for H4, that political elaboration and efficacy will have direct effects on frequency of political discussion outside of family and school, even after controlling for family and school discussion.

Elaboration falls out of the model as a predictor once discussion at home and discussion at school are added, which suggests partial support for H2, that elaboration and political efficacy will have a direct positive effect on adolescents' political discussion within the family and school. The fact that discussion mediates the effects of elaboration but not efficacy suggests elaboration has a direct positive effect on discussion at home and at school. The effects of efficacy are also mediated ($.141 \beta$ to $.126 \beta$) when adding the discussion at home and school, but the effects are still statistically significant. We tested this further by placing elaboration and efficacy at different stages in the regression analysis and found similar results. This finding follows the assumed hierarchical model we offer in that elaboration is a precursor of discussion and efficacy.

The effects of the Web use for news variable as a predictor in the final stage offer partial support for H3, that the effects of media exposure on political discussion outside of family and school will be mediated through elaboration and efficacy. If you combine this finding with the regression predicting elaboration and efficacy (see Tables 1 and 2) where the media use variables are strong predictors, this study suggests that while media use influences elaboration and efficacy directly, their only direct influence on discussion comes through Web news use. In other words, the legacy news media, such as TV and newspapers, help teens think about politics and feel more confident in their political abilities, but media alone do not motivate them to talk about politics, whether at home, at school, or with others. The direct effect of Web use could be a product of the changes in teen media use behaviors. Even though less than half of the respondents said they did not use the Web for news, the ones that did seemed to use it as a way to discuss with others, even those who did not agree with them.

DISCUSSION

This study found direct positive effects for efficacy, discussion at home, discussion at school, and Web news use on discussion with people outside of the home, including friends and those who disagree. Elaboration and other media use variables, including local TV and newspaper use, had mediated effects on discussion, but direct effects on elaboration and efficacy beliefs (see Figure 2).

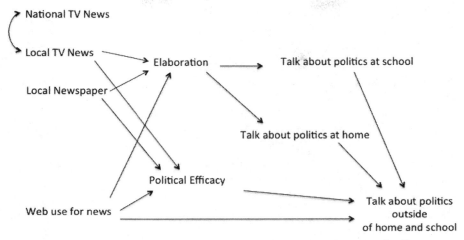

Figure 2. Patterns of impact of hierarchical variables on talking about politics outside of home and school.

Interestingly, online news was found to have direct effects on elaboration and political efficacy but was also found to have direct effects on political discussion outside of family and school. There are several reasons to explain the direct effect of online news use on adolescents' discussion outside of family and school. The interactivity of the online news environment, according to Bachen et al. (2008) may now be the most effective way to participate in civic life. These scholars argue that the ability to work with online interactive features is becoming a central tool for participation and opinion expression. The interpersonal interactivity, especially, involves human-to-human communication through e-mail, chatting, and discussion boards and is consistent with the pedagogical argument that traditional, passive learning techniques, such as memorization and recitation, tend to be ineffective, whereas interactive techniques fostering children's ability to express their opinions, take part in discussions, and simulate real work events are effective for increasing civic knowledge (Kahne & Westheimer, 2003; Niemi & Junn, 1998).

While adolescents may not directly participate in online discussion, they can easily examine others' opinions and thoughts online. As they are exposed to someone they do not know and someone who disagrees with their opinion inside a chat or online discussion room, perhaps, they may become more capable and ready to vocalize their opinion with someone who might disagree with them politically. It can be inferred from the results of this study that the Internet has become a fundamental base for adolescents to reach out to others and share their opinions, as it provides a communicative platform where diverse ideas and opinions are expressed.

Newspapers, local television news, and Web news had a strong influence on elaboration, whereas local television news and Web use had a strong influence on adolescents' political efficacy. It is interesting to note how national television news did not have any influence on either of our variables. One explanation could be the cognitive overload that adolescents may feel when exposed to national television news. Television news is quite brief, compressing a lot of unfamiliar information into a small amount of space or time. It often involves a truncated or highly stylized time frame, giving little sense of either the history or future consequences of the event or issue (Kosicki & McLeod, 1990). With the low levels of political knowledge and information adolescents typically have, it may be hard for them to process the truncated information provided by national television news. When they feel they can't understand the information provided by national television, it may well affect adolescents' perceptions of, or confidence in, their political knowledge and their likelihood to participate in political actions (Kaid et al., 2007).

The effect of elaboration was mediated through family and school discussion on politics, whereas political efficacy had a direct effect on adolescents' ability to speak their opinions outside of home and school. At its most basic level, Bandura (1997) described self-efficacy, or the belief that one's behavior is likely to lead to a desired outcome, as the foundation for action. Whitty and McLaughlin (2007) found that self-efficacy plays a critical role in determining how people will utilize resources available online; and self-efficacy has been found to significantly predict continued participation in online environments, such as discussion or support groups. In an online information environment, the difference between those who post and those who simply read, or "lurk," is stark. In fact, Rafaeli et al. (2004) likened lurkers in the virtual community to those in the political arena who do not participate. In other words, online knowing is not enough. While it can influence how confident a person feels, it alone does not determine action.

One of the important findings of the current study is the hierarchy of stages of attention, learning, interpersonal communication behaviors, and political participatory behaviors we posited, and the examination of adolescents' interpersonal communication behaviors that seem to be the first step out for further political participatory behaviors. Adolescents seem to go through the assimilation and accommodation process when they participate in political discussion at home or at school. Once they connect what they have learned from their parents and family, the adolescents demonstrate a behavioral branching out to discuss politics with someone they are not familiar with. As political discussion in family and school was found in many studies to be an important predictor of knowledge and civic participation, adolescents' political discussion branching out to an unfamiliar environment is very likely to influence a more sophisticated level of political knowledge and greater political participation. Future studies are needed

to examine adolescents' political discussion with the unfamiliar and influence on political participation behaviors.

We acknowledge that examining adolescents' political interest and knowledge in 2008 in the United States likely influenced some of the findings of this study. The 2008 presidential campaign generated more interest than normal, especially among teens. It is possible that the heightened political interest in 2008 provided a safer environment for teens to voice their opinions, compared with other elections. Especially with such great emphasis on youth involvement during the campaign, it is very likely that the process of accommodation in adolescents' political opinion formation and expression was particularly enhanced in 2008.

In the same way, the 2008 presidential campaign may well have heightened adolescents' interest and likelihood to discuss politics not only within the family and school but also with those outside of their familiar scope. Future studies should examine the role of elaboration and political efficacy, and particularly how media choice motives operate within the political socialization hierarchy. The significant negative effect of entertainment media on political knowledge could also be operationalized through more in-depth questions.

Regardless of its limitations, this study's results highlight important implications relating to the political socialization of adolescents. Chiefly, it underscores the importance of political discussion, and the ability of elaboration and political efficacy to influence adolescents' political participation at a higher level of the participation hierarchy. Future research should attempt to understand adolescents' full political development, including the various stages of the socialization hierarchy explored in this chapter. Our findings provide insight into the first steps adolescents take on their journey to becoming more politically informed and engaged.

REFERENCES

Althaus, S. L. (1998). Information effects in collective preferences. *The American Political Science Review, 92*(3), 545–558.

Althaus, S. L. (2003). *Collective preferences in democratic politics: Opinion surveys and the will of the people*. New York, NY: Cambridge University Press.

Atkin, C. (1981). Communication and political socialization. In D. Nimmo & K. Sanders (Eds.), *Handbook of political communication* (pp. 299–328). Beverly Hills, CA: Sage.

Bachen, C., Raphael, C., Lynn, K. M., McKee, K., & Philippi, J. (2008). Civic engagement, pedagogy, and information technology on web sites for youth. *Political communication, 25*(3), 290–310.

Bandura, A. (1997). Editorial. *American Journal of Health Promotion, 12*(1), 8–10.

Cappella, J. N., Price, V., & Nir, L. (2002). Argument repertoire as a reliable and valid measure of opinion quality: Electronic dialogue during campaign 2000. *Political Communication, 19*, 73–93.

Easton, D., & Dennis, J. (1969). *Children in the political system*. New York, NY: McGraw-Hill.

Egan, K. (1997). *The educated mind: How cognitive tools shape our understanding.* Chicago, IL: University of Chicago Press.

Eveland, W. P., Jr. (2004). The effect of political discussion in producing informed citizens: The roles of information, motivation, and elaboration. *Political Communication, 21*(2), 177–193.

Eveland, W. P., Jr., Cortese, J., Park, H., & Dunwoody, S. (2004). How website organization influences free recall, factual knowledge, and knowledge structure density. *Human Communication Research, 30*(2), 208–233.

Eveland, W. P., Jr., & Dunwoody, S. (2002). An investigation of elaboration and selective scanning as mediators of learning from the web versus print. *Journal of Broadcasting & Electronic Media, 46*(1), 34.

Eveland, W. P., Jr., McLeod, J. M., & Horowitz, E. M. (1999). Communication and age in childhood political socialization. *Journalism and Mass Communication Quarterly, 75,* 699–718.

Fowler, J. W. (1981). *Stages of faith: The psychology of human development and the quest for meaning.* San Francisco, CA: Harper & Row.

Glynn, C. J., Huge, M. E., & Lunney, C. A. (2009). The influence of perceived social norms on college students' intention to vote. *Political Communication, 26*(1), 48–64.

Goodin, R., E. (2000). Democratic deliberation within. *Philosophy and Public Affairs, 29*(2), 79–107.

Goodin, R. E., & Niemeyer, S. J. (2003). When does deliberation begin?: Internal reflection versus public discussion in deliberative democracy. *Political Studies, 51,* 627–649.

Hively, M. H., & Eveland, W. P., Jr. (2009). Contextual antecedents and political consequences of adolescent political discussion, discussion elaboration, and network diversity. *Political Communication, 26,* 30–47.

Hyman, H. H. (1959). *Political socialization.* Glencoe, IL: Free Press.

Iyengar, S., & Kinder, D. R. (1987). *News that matters: Television and American opinion.* Chicago, IL: The University of Chicago Press.

Kahne, J., & Westheimer, J. (2003). Democracy and civic engagement-what schools need to do. *Phi Delta Kappan, 85*(1), 34.

Kaid, L. L., McKinney, M. S., & Tedesco, J. C. (2007). Introduction: Political information efficacy and young voters. *American Behavioral Scientist, 50*(9), 1093–1111.

Katz, E., & Lazarsfeld, P. F. (1964). *Personal influence: The part played by people in the flow of mass communication.* New York, NY: Free Press of Glencoe.

Kiousis, S., & McDevitt, M. (2008). Agenda setting in civic development effects of curricula and issue importance on youth voter turnout. *Communication Research, 35*(4), 481–502.

Kohlberg, L., & Hersh, R. H. (1977). Moral development: A review of the theory. *Moral Development, 16*(2), 53–39.

Kosicki, G. M., & McLeod, J. M. (1990). Learning from political news: Effects of media images and information processing strategies. In S. Kraus (Ed.), *Mass communication and political information processing* (pp. 69–83). Hillsdale, NJ: Erlbaum.

McDevitt, M. (2005). The partisan child: Developmental provocation as a model of political socialization. *International Journal of Public Opinion Research, 18*(1), 67–88.

McDevitt, M., & Chaffee, S. (2000). Closing gaps in political communication and knowledge: Effects of a school intervention. *Communication Research, 27*(3), 259–292.

McDevitt, M., & Chaffee, S. (2002). From top-down to trickle-up influence: Revisiting assumptions about the family in political socialization. *Political Communication, 19,* 281–301.

McDevitt, M., & Ostrowski, A. (2009). The adolescent unbound: Unintentional influence of curricula on ideological conflict seeking. *Political Communication, 26*(1), 11–29.

McIntosh, H., Hart, D., & Youniss, J. (2007). The influence of family political discussion on youth civic development: Which parent qualities matter? *Political Science and Politics*, 495–499.

McKinney, M. S., & Banwart, M. C. (2005). Rocking the youth vote through debate: Examining the effects of a citizen versus journalist controlled debate on civic engagement. *Journalism Studies*, 6(2), 153–163.

McLeod, J. M., & Shah, D. V. (2009). Communication and political socialization: Challenges and opportunities for research. *Political Communication, 26*(1), 1–10.

Meirick, P. C., & Wackman, D. B. (2004). Kids Voting and political knowledge: Narrowing gaps, informing votes. *Social Science Quarterly, 85*, 1161–1177.

Milbrath, L. W. (1965). *Political participation: How and why do people get involved in politics?* Chicago, IL: Rand McNally.

Mutz, D. C. (1998). *Impersonal influence.* New York, NY: Cambridge University Press.

Niemi, R. (1973). Political socialization. In J. N. Knutson (Ed.), *Handbook of political psychology.* San Francisco, CA: Jossey-Bass.

Niemi, R., & Junn, J. (1998). *Civic education: What makes students learn?* New Haven, CT: Yale University Press.

Piaget, J. (1960). *The child's conception of the world.* Totowa, NJ: Littlefield, Adams.

Rafaeli, S., Ravid, G., & Soroka, V. (2004, January). De-lurking in virtual communities: A social communication network approach to measuring the effects of social and cultural capital. In *Proceedings of the 37th annual Hawaii international conference on system sciences, 2004.* (pp. 10-pp). IEEE.

Scheufele, D. A. (2000). Talk or conversation?: Dimensions of interpersonal discussion and their implications for participatory democracy. *Journalism and Mass Communication Quarterly, 77*(4), 727–743.

Shah, D. V., Cho, J., Eveland, W. P., & Kwak, N. (2005). Information and expression in a digital age: Modeling Internet effects on civic participation. *Communication Research, 32*(5), 531–565.

Shah, D. V., Cho, J., Nah, S., Gotlieb, M. R., Hwang, H., Lee, ... McLeod, D. M. (2007). Campaign ads, online messaging, and participation: Extending the communication mediation model. *Journal of Communication, 57*, 676–703.

Shah, D. V., McLeod, J. M., & Lee, N. (2009). Communication competence as a foundation for civic competence: Processes of socialization into citizenship. *Political Communication, 26*(1), 102–117.

Weatherford, M. S. (1982). Interpersonal networks and political behavior. *American Journal of Political Science, 26*(1), 117–143.

Whitty, M. T., & McLaughlin, D. (2007). Online recreation: The relationship between loneliness, Internet self-efficacy and the use of the Internet for entertainment purposes. *Computers in Human Behavior, 23*(3), 1435–1446.

From News TO Political Knowledge

The Roles of Elaboration and Discussion

EDSON TANDOC AND ESTHER THORSON

For democracy to survive, political participation among its citizens is paramount. One's inclination to participate in politics, however, is not shaped overnight. Political engagement represents a continuous process that most likely begins in an individual's formative years, and one's political socialization begins much earlier than the voting age. It is true, though, that we cannot expect adolescents to display political behaviors that necessarily model the actions of the supposed "good citizen" that are often articulated in our political communication literature. For instance, adolescents are too young to donate money to political campaigns, attend political rallies on their own, or even exercise the most frequent measure of political participation, that of voting during elections.

Though political attitudes are understandably unstable at younger ages, political knowledge represents a measurable aspect of political socialization even among young people (Eveland, McLeod, & Horowitz, 1998). Our attention to political knowledge among adolescents rests on the assumption that such knowledge may well lead to political participation. While the political socialization literature does not entirely agree on whether or not political knowledge among adolescents leads to future political participation, at least one study has demonstrated that political knowledge among adults ultimately influences propensity to vote (Valentino, 2007). Of course, learning about politics can work both ways. While acquiring relevant news regarding election campaigns may motivate one to vote, hearing endless information, including political bickering among candidates, might also turn people off from voting or participating in the electoral process. We realize

too that political participation, even among adolescents, might find avenues for expression beyond voting. A final assumption that guides the current study is that political knowledge developed in one's formative years can shape one's political identity and interest that persists across time. The focus of the current study seeks to understand the complex relationship involving adolescents' attention to political news, their consideration or elaboration of information acquired and discussion of political information with others, and, ultimately, the attainment of political knowledge.

LITERATURE REVIEW

Usually examined within the context of election campaigns, political knowledge has been conceived as an "individual's possession of accurate information about political actors, issues and events relevant to a campaign for public office" (Atkin, Galloway, & Nayman, 1976, p. 231). Political knowledge is more than the recall of facts about candidates. It also includes an understanding of the links between candidates and their issue positions (Atkin et al., 1976). This dichotomy is parallel to what Eveland and colleagues have identified as the two basic dimensions of political knowledge: issue-stance knowledge and knowledge structural density (KSD), or the understanding of connections and relationships among concepts (Eveland, 2001; Eveland & Hively, 2009; Eveland, Marton, & Seo, 2004). A central question, therefore, is: What factors influence the political knowledge of adolescents?

News Media and Political Knowledge

A thoroughly explored area in the political socialization literature is the effects of news media on political knowledge. A number of studies have found that one's communication patterns and activity with others affect political knowledge rather than the other way around (Eveland et al., 1998; Eveland, Hayes, Shah, & Kwak, 2005). Also, in general, the consumption of so-called "hard news" has been found to increase political knowledge (McLeod et al., 1996). Specifically, exposure to newspapers (Chaffee & Kanihan, 1997; Eveland et al., 1998; Kim, 2008), television news (Hively & Eveland, 2009), and Internet news use (Kim, 2008; Xenos & Moy, 2007) affects higher political knowledge levels. Indeed, the impact of news media use, especially newspapers, holds for political knowledge across ages (Chaffee & Kanihan, 1997; Eveland et al., 1998). For instance, television news use was found to predict political knowledge among adolescents (Hively & Eveland, 2009).

The effect of the news media on political knowledge is not always direct, however (Eveland, 2002). Consistent with the psychology literature, other factors such as information processing are important determinants of whether or not learning

will take place during media exposure. Information processing has assumed different names in the political socialization literature, including such terms as active reflection (Eveland et al., 1998) and elaboration (Eveland, 2001, 2004; Eveland & Dunwoody, 2002); and in most studies it has been found to be a significant predictor of political knowledge.

Elaboration occupies an important role in the effects of news media use on knowledge, driven largely by Eveland's (2001, 2002) cognitive mediation model (CMM) of learning from news. Eveland (2001) argued that surveillance motivations increase news attention and elaboration, both of which increase political learning from the news. In a later study, Eveland (2004) found that the effects of political discussion on political knowledge are also mediated by forms of elaboration.

Elaboration of News

The concept of elaboration is at the heart of the elaboration likelihood model (ELM), a theory of persuasion (Petty, Brinol, & Priester, 2009; Petty & Cacioppo, 1986). However, Eveland's (2001, 2002, 2004) theorizing of CMM and collaborative work (Eveland et al., 1998; Hively & Eveland, 2009) has never linked the concept of elaboration of news to the assumptions of ELM. In brief, ELM describes two routes to persuasion: central and peripheral. Our joining these two theoretical perspectives suggests that high elaboration leads to central processing while low elaboration takes the peripheral route for persuasion (Petty & Cacioppo, 1986). In ELM, elaboration is defined as "the extent to which a person carefully thinks about issue-relevant information" (Petty & Cacioppo, 1986, p. 7). Attitudes and behavioral consequences formed through the central route tend to be more permanent (Petty et al., 2009).

In the context of political learning from the news, Eveland (2001) defined elaboration as "the process of connecting new information to other information stored in memory, including prior knowledge, personal experiences, or the connection of two new bits of information together in new ways" (p. 573). The concept of elaboration is an integral process to Eveland's (2001) CMM, which posits that surveillance gratifications lead to news attention and elaboration, which in turn lead to political knowledge. The model contradicts earlier hypotheses that news attention directly leads to learning from the news, and that motivations, particularly surveillance gratifications, trigger news attention. In a later study, Beaudoin and Thorson (2004) sought to expand the model by including other gratifications—including guidance and anticipated interaction—as precursors to news media reliance. Wei and Lo (2008) also included news exposure as a predictor of elaboration, arguing that news exposure leads to news attention. But news exposure, attention, and reliance are not sufficient to produce learning. The pieces

of information gathered first have to be processed. As Beaudoin and Thorson concluded, "elaboration and news reliance are important steps in political learning." Thus, what we know from studies that have theorized how the impact of news media use on political knowledge is mediated by news elaboration leads us to the following hypothesis:

> **H1:** Use of the following news media among adolescents will predict
> elaboration.
> a. Newspaper
> b. TV news
> c. Online news

Eveland (2004) further classified two types of elaboration of news content: anticipatory elaboration and discussion-related elaboration. Anticipatory elaboration happens when an individual expects future discussions about news content while discussion-generated elaboration occurs as individuals are discussing—the act of discussion itself forces information processing (Eveland, 2004). Various studies strongly suggest that elaboration mediates the path from the news media to political knowledge (Beaudoin & Thorson, 2004; Eveland, 2001, 2004; Eveland & Dunwoody, 2002). These studies, however, have looked at the elaboration process only among adults.

Interpersonal Discussion and the News

Eveland (2004) found that while frequency of discussion about politics has an effect on political knowledge, the effect is actually mediated by discussion's effect on elaboration. This finding has demonstrated the viability of the concept of discussion-generated elaboration as a predictor of political knowledge. When tested among adolescents, however, discussion elaboration was found to be unrelated to factual knowledge, although it was positively related to knowledge structure, as adolescents might still not be as experienced as adults in terms of translating discussions into specific pieces of factual information (Hively & Eveland, 2009). Still, the same study provided evidence that the frequency of discussion was a stronger predictor of both factual knowledge and knowledge structure about politics among adolescents (Hively & Eveland, 2009).

At issue with Eveland's conceptualization of discussion-generated elaboration is the difficulty in measuring the concept. Eveland's (2004) approach was to infer that the kind of elaboration that predicted political knowledge was discussion-generated because frequency of discussion predicted elaboration. Thus, Hively and Eveland (2009) used measurement items that combined the concepts of discussion and elaboration in their survey of adolescents (e.g., when I talk with others about something in the news, I often relate what they say to my own experiences). Here, what Eveland and colleagues have done is to no longer uncover what predicts elaboration of news

but to instead distinguish a particular kind of elaboration that presupposes news media use. In the current study, we maintain the conceptual boundaries between news discussion and news elaboration. Therefore, we test the following hypotheses:

H2: Use of the following news media among adolescents will predict news discussion.
a. Newspaper
b. TV news
c. Online news

H3: The following will mediate the effects of news media use on political knowledge.
a. News elaboration
b. News discussion

RQ1: Which is the stronger predictor of political knowledge: elaboration or discussion?

Testing the Cognitive Mediation Model

In summary, what we attempt in this study is a test of Eveland's (2001, 2002) cognitive mediation model in the context of the political socialization of adolescents. A difference in our approach is that we start with news use (instead of motivations of news use, the effects for which the triggering of news use have been sufficiently studied) and compare elaboration and discussion (instead of combining them into discussion-generated elaboration). For adolescents whose cognitive potentials are still developing, it is worthwhile to examine every path of information processing that they take, particularly elaboration and discussion. Finally, a major difference in our test is the utilization of a three-wave panel study that will help us theorize a stronger case for causal inferences.

A panel study involves responses from the same set of individuals at more than one point in time. In comparison with other survey designs, the panel "is a superior design for explaining change" (Shoemaker & McCombs, 2003, p. 233). An advantage of using panel data is the ability to argue for causal relationships, which require, among other considerations, (a) establishing appropriate time order (the cause precedes the effect); and (b) ruling out alternative explanations (Shoemaker & McCombs, 2003).

METHOD

This study is based on all three waves of the Future Voters Study (as described in the Introduction). The complete responses as of Time 2 served as our demographic reference. The average age of the adolescents measured at Time 2 (though

we included only ages 12–17 at Wave 1, with some participants turning 18 by Wave 2) is 14.93 years (*SD* = 1.68). Of the 682 respondents that remained as of Time 2, some 39% identified themselves as Democrats, while 30% identified themselves as Republicans. The sample is almost evenly split in terms of gender (50.3% females) and is predominantly White (80.5%).

Time 1 Predictors

The advantage of using panel data for analysis—a rarity in the study of political socialization research even in projects that actually generated panel data—is the ability to make a stronger case for causal inferences (Eveland et al., 2005; Eveland, Shah, & Kwak, 2003; Eveland & Thomson, 2006). Given the habitual nature of media use, it is appropriate to measure it at Time 1. Thus, we are measuring the entire cognitive mediation process at Time 1 and will explore if it can predict political knowledge not only at Time 1 but also at Times 2 and 3. However, in order to ascertain that our Time 1 measures are stable, we also examine if each of our scales at Time 1 correlated with their measurements at Times 2 and 3.

Online news use. This is an additive index of three items. Respondents were asked the number of days (0–7) they consumed (a) national newspaper websites, (b) local newspaper websites, and (c) TV news websites. Because 63% of the respondents reported not using online news at all, the data were not normally distributed. For that reason, the data were adjusted using log transformations to approximate normality. Because we are comparing online news use with other forms of news media consumption, we also transformed the two other additive indices. This scale at Time 1 is correlated with both Time 2 (r (365) = .30, p < .001) and Time 3 (r (365) = .34, p < .001) measures.

Newspaper use. This is an additive index of two items. Respondents were asked the number of days they consumed (a) a print copy of a national newspaper and (b) a print copy of a local newspaper. This was also transformed. The scale at Time 1 is correlated with both Time 2 (r (365) = .53, p < .001) and Time 3 (r (365) = .44, p < .001) measures.

TV news use. This is an additive index of four items. Respondents were asked the number of days they consumed (a) national nightly news on CBS, ABC, or NBC, (b) local news in their viewing area, (c) CNN cable news programs, and (d) Fox cable news programs. Like the newspaper and online news use indices, this was also transformed. The scale at Time 1 is likewise correlated with both Time 2 (r (365) = .59, p < .001) and Time 3 (r (365) = .60, p < .001) measures.

News elaboration. We measured elaboration using two items: (a) "I try to connect what I see in the media to what I already know" and (b) "I often recall what

I encounter in the media later on and think about it." The two items are strongly correlated, r (674) = .64, p < .001. The scale at Time 1 is correlated with both Time 2 (r (365) = .48, p < .001) and Time 3 (r (365) = .42, p < .001) measures. Since the variable is normally distributed, we did not transform it.

News discussion. We created a scale of news discussion from four items. Child respondents rated how frequently they talked (0–7 days a week) about news and current events with: (a) family members, (b) friends, (c) adults outside your family, and (d) with people who disagree with you. The scale is reliable (Cronbach's α = .90). The scale at Time 1 is likewise strongly correlated with both Time 2 (r (365) = .75, p < .001) and Time 3 (r (365) = .78, p < .001) measures. Since the variable is also normally distributed, we did not transform it.

Political Knowledge

Political knowledge was measured in each of the three waves. We used different sets of questions to measure factual knowledge (see below), and therefore these scales are only as good as the questions that composed them (Delli Carpini & Keeter, 1993). Nevertheless, we expected the three indicators of knowledge to be correlated if they were measuring the same concept. Indeed, we found that political knowledge as measured at Time 3 was correlated with the political knowledge measures we used at Time 2 (r (358) = .37, p < .001) and even at Time 1 (r (358) = .47, p < .001). Political knowledge at Time 1 was also correlated with political knowledge at Time 2 (r (682) = .29, p < .001).

Time 1. This measure of knowledge was based on number of correct answers to the following questions: "Which party controls the U.S. House of Representatives?" "Which party did Ronald Reagan belong to when he was president?" And "Which presidential candidate is more likely to help the environment?" The average score was 1.03 (SD = .99) out of 3 points.

Time 2. This measure was based on the number of correct answers in identifying the presidential candidate (i.e., Obama or McCain) who: (a) opposed a timetable for withdrawal from Iraq, (b) supported raising taxes on the wealthiest Americans, (c) has an adopted daughter from Bangladesh, (d) has not served in the U.S. military, (e) has been divorced, and (f) began his political career as a community organizer. The average score was 3.18 (SD = 1.62) out of 6 points.

Time 3. This measure was based on the number of correct answers that identified the political party that: (a) controls the U.S. Congress, (b) recently had a member switch to the opposing party, (c) Ronald Reagan belonged to, (d) Bill Clinton belonged to, (e) Joe Lieberman belongs to, (f) is against human cloning, (g) favors more state power, and (h) favors stricter environmental standards. The average score was 4.09 (SD = 1.89) out of 8 points.

RESULTS

Our hypothesized model suggests that the effects of media use on political knowledge are mediated by their direct effects on both elaboration and discussion. Furthermore, we hypothesized that the effects of elaboration on political knowledge are both direct and mediated by discussion. To establish causal links, we measured this process at Time 1 and sought to predict political knowledge not only at Time 1 but also at Times 2 and 3, so that the process as we hypothesize it precedes the dependent variable in Times 2 and 3. To test these hypothesized paths, we conducted path analysis using the AMOS software. We first ran correlation analyses to check if any of our demographic variables—age, gender, race, and household income—have positive relationships with political knowledge. Only income showed a positive relationship. Thus, we controlled for its effects on political knowledge across all models.

In the following models, news use did not have direct effects on knowledge based on the models that yielded the best fit with the data. We confirmed this pattern by running separate regression analysis looking at whether or not news media uses predict political knowledge when tested by themselves. We confirm that there was an absence of any direct effects from news media uses to any of the political knowledge measures from Times 1 to 3, except for newspaper use at Time 1, which was a positive predictor of political knowledge also at Time 1 (β = .103, t = 2.406, p < .05). However, that model (F(3, 626) = 3.343, p < .05) explained less than 2% of the variance in political knowledge at Time 1. This confirms what we find in the following models, that the effects of media use on political knowledge, at least among adolescents, are mediated by their effects on news elaboration and discussion.

We first tested our hypothesized model in predicting political knowledge at Time 1. Our final hypothesized model presented in Figure 1 fits the data well, X^2 (5) = 10.97, p > .05. The root mean square error of approximation (RMSEA) is less than .03; PCLOSE = .896. Looking at the standardized regression weights and controlling for the effects of income, all of our hypothesized relationships were significant. The media variables predicted both elaboration and discussion. Though news discussion (β = .204, p < .001) appeared to be a stronger predictor of political knowledge at Time 1 than elaboration (β = .082, p < .05), elaboration had both direct and indirect effects (through discussion; β = .314, p < .001). Thus, the total effect of elaboration on political knowledge is .082 + (.314 *.204), which is 0.146, still lower than that of news discussion (see Figure 1). An alternative model that we tested reversed the direction of mediation, from news discussion to elaboration, but this resulted in a poor fit.

However, these results refer to the process and its effect within Time 1. Testing causal inferences in a panel study uses variables measured at an earlier period to

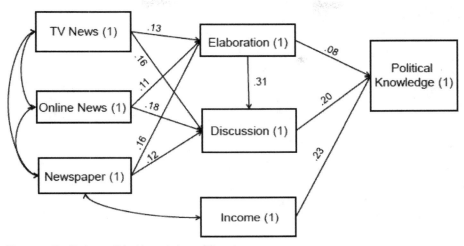

Figure 1. Predicting political knowledge at Time 1.

predict variables that were measured afterward to establish appropriate time order. Thus, we tested the same hypothesized model, the process measured at Time 1, in predicting political knowledge at Time 2 (see Figure 2). The model again fits the data well, X^2 (5) = 9.764, p > .05. The root mean square error of approximation (RMSEA) is less than .03; PCLOSE = .928. Again, controlling for income, all the hypothesized paths are significant, from media use to elaboration and discussion to knowledge. The direct effect of news discussion on knowledge (β = .136, p < .001) is slightly stronger than that of elaboration (β = .117, p < .01), but again,

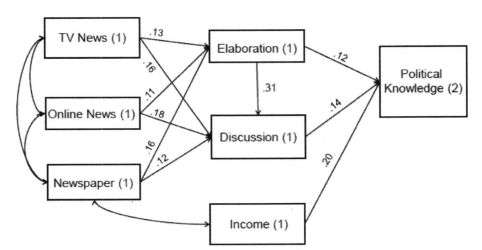

Figure 2. Predicting political knowledge at Time 2.

elaboration also has an indirect effect through discussion (.315 *.136 = .043) on top of its direct effect of .12.

Finally, we also tried to test the hypothesized model with political knowledge at Time 3. This will be the political knowledge scores of our respondents almost a year after we have measured their media uses, elaboration, and discussion levels at Time 1. Interestingly, our hypothesized model still worked (see Figure 3). The model again fits the data well, X^2 (5) = 11.386, p > .01. The root mean square error of approximation (RMSEA) is .031; PCLOSE = .883. Most of the hypothesized relationships were significant, except for the direct effect of elaboration on political knowledge, which disappeared during Time 3. Still, elaboration had an indirect effect through news discussion, and news discussion at Time 1 still had a direct effect on political knowledge even at Time 3, β = .215, p < .001.

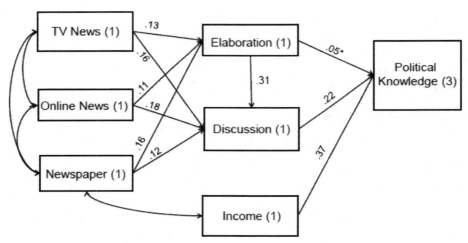

Figure 3. Predicting political knowledge at Time 3.

To compare whether or not our hypothesized process is better explained within each wave—that is, that the mediation process operates at a single time point best rather than across time periods—we also ran the hypothesized model within each time period (see Table 1). The models within Time 1 and Time 3 fit the data well. What is interesting is that the lowest X^2 value we found from all the models we tested is in the model where we predicted Time 2 political knowledge using Time 1 variables. The model that included the process at Time 1 and predicted the dependent variable at Time 2 provided the best fit.

In terms of hypothesis testing, we find that both H1 and H2 are supported. News media uses—newspaper, TV news, and online news—predicted both news elaboration and news discussion across Times 1, 2, and 3. News use is habitual and

Table 1. Path Analysis Models Within Each Time.

	Predicting	Time 1	Time 2	Time 3
Newspaper	Elaboration	.158	.094	.016*
TV		.134	.147	.250
Online		.106	.111	.073*
Newspaper	Discussion	.118	.102	.022
TV		.157	.096	.159
Online		.184	.156	.191
Elaboration Discussion	Knowledge	.082	.077*	.113
Elaboration Through		.204	.189	.158
News Discussion		.314	.367	.375
χ^2		10.968*	16.904	10.157*
df		5	5	5
RMSEA		.030	.043	.028
PCLOSE		.896	.656	.918

*$p > .05$.

therefore it is not surprising that measures at Time 1 will predict both mediators until Time 3. H3a, which predicted that elaboration will mediate the effects of news media use on political knowledge, is supported in both Times 1 and 2 but not in Time 3, as elaboration did not predict political knowledge at Time 3. H3b is also fully supported, as news discussion predicted political knowledge from Times 1 to 3.

RQ1 compared elaboration and discussion in terms of predicting political knowledge. Our findings here showed that discussion was a better and more consistent predictor of political knowledge. While elaboration at Time 1 predicted political knowledge at Times 1 and 2, it was no longer a significant predictor of Time 3 knowledge. In contrast, news discussion at Time 1 was a significant predictor of political knowledge measured at Times 1, 2, and 3.

Furthermore, in each wave, news discussion exerted a stronger direct effect than did elaboration. What we found in our supported model is how the elaboration's effect on political knowledge is also mediated by its effect on discussion. It is not that the relationship of one is stronger than the other, but that elaboration leads to discussion, which leads to political learning.

DISCUSSION

Our results support the cognitive mediation model that looks at how the influence of media use on political knowledge is mediated by elaboration and discussion

about the news among adolescents. Specifically, we find that the more adolescents think about the news and the more they talk about it with family members and peers, regardless of whether they agree or disagree with them, the more politically knowledgeable they become. The effect apparently does not wane easily. In our analysis, we examined this process at Time 1 and measured its effects on political knowledge 6 months later (Time 2) and a full year later (Time 3). The advantage of a panel study is that it provides a stronger argument for causal inferences as well as the ability to uncover a pattern. In summary, what we found is that news media use alone does not exert consistent direct effects on political knowledge.

However, news media use predicts news elaboration and news discussion, which both lead to political learning. News elaboration also predicts news discussion among adolescents. While our hypothesized process operates within each wave, the best fitting model is where we predicted knowledge at Time 2 using processes that were measured at Time 1. This makes sense, considering that news media use, as we have discussed, is a habit. Thus, measuring media use at an earlier timeframe does not drastically vary when the same uses are measured at Time 2 (unless there is an intervening event). The advantage of measuring media use at Time 1 is being able to control for order, as the counter-assumption that political learning also drives media use (such as adolescents who learn about politics want to learn more) can be ruled out. Time 2 political knowledge was measured right after the 2008 elections, while Time 1 news media use, elaboration and discussion were measured 6 months before.

A possible explanation, which future studies should explore, is the role of heightened interest in the elections during Time 2. However, our model, when tested within Time 2 variables (e.g., news use at Time 2 predicting knowledge at Time 2), showed the weakest fit (compared with the within Time 1 and within Time 3 models, as well as compared with our time-ordered models). These findings, we believe, strengthen our argument that the process of cognitive mediation is a good predictor of political knowledge among adolescents because the best fit we found was with the time-ordered model.

The results also showed a stronger direct effect of news discussion than news elaboration on political knowledge. This is consistent with what Hively and Eveland (2009) found using a different measure, that frequency of discussion was a stronger predictor of knowledge than elaboration. However, in contrast with Eveland's (2004) finding that frequency of discussion predicts elaboration among adults, we found the opposite direction among adolescents, that elaboration predicts discussion (and when we tested the alternative model, it resulted in a bad fit). Among adolescents who are at a stage when they can be particularly inquisitive, thinking about things leads them to ask questions that may then spur further discussions. It is also possible that adolescents at school, whose self-esteem is still malleable, will internalize their ideas first before they talk to others. Once they

have thought about a political topic or issue, this elaboration provides them with the confidence to engage others in discussions.

When adolescents talk about what they see in the news, they apparently learn more about it. When they think about the news, not only do they talk about it, but they also learn more about it. This process and finding are consistent with previous studies. Across our panel data, the effect of elaboration in Time 1 waned over time and was no longer a significant predictor of political knowledge in Time 3, which implies that the effects of elaboration on learning are time-bound, if not more immediate. Learning seems to take place just after adolescents think about what they see in the news. However, the indirect effects of learning on political knowledge through discussion remained consistent. In contrast, engaging in discussions, itself apparently a habit that is developed across time, showed more lasting effects on political knowledge. Talking or thinking, at least among adolescents, is a false dichotomy. The path that leads to political knowledge actually involves both thinking and talking. Adolescents learn both ways, just as Eveland and Thomson (2006) found among adults. Furthermore, the more adolescents think about the news, the more they talk about it with others, and the more they learn.

CONCLUSION

In subsequent work on the cognitive mediation model, Eveland and Thomson (2006) and Eveland and Hively (2009) have shifted their focus more to political discussion and less from news elaboration, the former being a stronger predictor of political knowledge. But what we found here confirms what Eveland and Thomson found, that both thinking and talking—about the news, for this study—contribute to political learning, even among adolescents. Just like Eveland and Thomson, we also used a three-wave panel study that brings us "closer to demonstrating causality" than do cross-sectional surveys (p. 535). However, we acknowledge that our study is constrained by several factors. First, the responses we analyzed are based on self-reports. While the items we used to measure our concepts have been tested in previous studies, accurately measuring intangible concepts such as elaboration is always a challenge. Second, we have to interpret our findings within the context of a presidential election period, and one that captured significant attention even for adolescents. It is possible that the process of political learning works differently in non-election periods.

These limitations notwithstanding, we believe our efforts contribute to a clearer understanding of the complex process of political learning among adolescents. An important implication of our findings is how encouraging adolescents to think about the news and talk about it with family members and peers will

contribute to their political learning. Thus, future studies should also explore the role of parental encouragement and school influences on the process of news elaboration and news discussion. Our study is in support of what previous studies have established. What we learned here, though, is how both thinking and talking lead to learning. What we should learn in the future is how to encourage thinking and talking, especially among adolescents.

REFERENCES

Atkin, C. K., Galloway, J., & Nayman, O. B. (1976). News media exposure, political knowledge and campaign interest. *Journalism Quarterly, 53*(2), 231–237.

Austin, E. W. (1993). Exploring the effects of active parental mediation of television content. *Journal of Broadcasting & Electronic Media, 37*(2), 147.

Austin, E. W., Bolls, P., Fujioka, Y., & Engelbertson, J. (1999). How and why parents take on the tube. *Journal of Broadcasting & Electronic Media, 43*(2), 175.

Austin, E. W., & Pinkleton, B. E. (2001). The role of parental mediation in the political socialization process. *Journal of Broadcasting & Electronic Media, 45*(2), 221.

Baron, R. M., & Kenny, D. A. (1986). The moderator-mediator variable distinction in social psychological research: Conceptual, strategic, and statistical considerations. *Journal of Personality and Social Psychology, 51*(6), 1173–1182.

Beaudoin, C. E., & Thorson, E. (2004). Testing the cognitive mediation model. *Communication Research, 31*(4), 446–471.

Chaffee, S., & Kanihan, S. F. (1997). Learning about politics from the mass media. *Political Communication, 14*(4), 421–430.

Delli Carpini, M. X., & Keeter, S. (1993). Measuring political knowledge: Putting first things first. *American Journal of Political Science, 37*(4), 1179–1206.

Dubreuil, P., Laughrea, M.-C., Morin, A., Courcy, F., & Loiselle, O. (2009). Social relationships at work: Moderator or mediator of the association between role variables and burnout? *International Journal of Business and Management, 4*(9), 3–16.

Eveland, W. P. (2001). The cognitive mediation model of learning from the news: Evidence from non-election, off-year election, and presidential election contexts. *Communication Research, 28*(5), 571.

Eveland, W. P. (2002). News information processing as mediator of the relationship between motivations and political knowledge. *Journalism & Mass Communication Quarterly, 79*(1), 26–40.

Eveland, W. P. (2004). The effect of political discussion in producing informed citizens: The roles of information, motivation, and elaboration. *Political Communication, 21*(2), 177–193.

Eveland, W. P., & Dunwoody, S. (2002). An investigation of elaboration and selective scanning as mediators of learning from the web versus print. *Journal of Broadcasting & Electronic Media, 46*(1), 34–53.

Eveland, W. P., Hayes, A. F., Shah, D. V., & Kwak, N. (2005). Understanding the relationship between communication and political knowledge: A model comparison approach using panel data. *Political Communication, 22*(4), 423–446.

Eveland, W. P., & Hively, M. H. (2009). Political discussion frequency, network size, and "heterogeneity" of discussion as predictors of political knowledge and participation. *Journal of Communication, 59*(2), 205–224.

Eveland, W. P., Marton, K., & Seo, M. (2004). Moving beyond "just the facts": The influence of online news on the content and structure of public affairs knowledge. *Communication Research, 99*(1), 1–15.

Eveland, W. P., McLeod, J. M., & Horowitz, E. M. (1998). Communication and age in childhood political socialization: An interactive model of political development. *Journalism & Mass Communication Quarterly, 75*(4), 699–718.

Eveland, W. P., Shah, D. V., & Kwak, N. (2003). Assessing causality in the cognitive mediation model. *Communication Research, 30*(4), 359–386.

Eveland, W. P., & Thomson, T. (2006). Is it talking, thinking, or both? A lagged dependent variable model of discussion effects on political knowledge. *Journal of Communication, 56*(3), 523–542.

Feldman, L., & Price, V. (2008). Confusion or enlightenment? *Communication Research, 35*(1), 61–87.

Fujioka, Y., & Austin, E. W. (2002). The relationship of family communication patterns to parental mediation styles. *Communication Research, 29*(6), 642–665.

Gaziano, C., & McGrath, K. (1986). Measuring the concept of credibility. *Journalism Quarterly, 63*(3), 451–462.

Golec de Zavala, A., & Van Bergh, A. (2007). Need for cognitive closure and conservative political beliefs: Differential mediation by personal worldviews. *Political Psychology, 28*(5), 587–608.

Hayes, A. (2009). Beyond Baron and Kenny: Statistical mediation analysis in the new millennium. *Communication Monographs, 76*(4), 408–420.

Hayes, A., & Preacher, K. (2011). *Indirect and direct effects of a multicategorical causal agent in statistical mediation analysis.* Unpublished manuscript.

Hively, M. H., & Eveland, W. P. (2009). Contextual antecedents and political consequences of adolescent political discussion, discussion elaboration, and network diversity. *Political Communication, 26*(1), 30–47.

Huckfeldt, R., Mendez, J. M., & Osborn, T. (2004). Disagreement, ambivalence, and engagement: The political consequences of heterogeneous networks. *Political Psychology, 25*(1), 65–95.

Kim, S.-H. (2008). Testing the knowledge gap hypothesis in South Korea: Traditional news media, the internet, and political learning. *International Journal of Public Opinion Research, 20*(2), 193–210.

McClurg, S. (2006). Political disagreement in context: The conditional effect of neighborhood context, disagreement and political talk on electoral participation. *Political Behavior, 28*(4), 349–366.

McLeod, J. M., Daily, K., Guo, Z., Eveland, W. P., Bayer, J., Yang, S., & Wang, H. (1996). Community integration, local media use, and democratic processes. *Communication Research, 23*(2), 179–209.

Meyer, P. (1988). Defining and measuring credibility of newspapers: Developing an index. *Journalism Quarterly, 65*(3), 567–588.

Mutz, D. C. (2002a). The consequences of cross-cutting networks for political participation. *American Journal of Political Science, 46*(4), 838.

Mutz, D. C. (2002b). Cross-cutting social networks: Testing democratic theory in practice. *The American Political Science Review, 96*(1), 111.

Mutz, D. C., & Mondak, J. J. (2006). The workplace as a context for cross-cutting political discourse. *Journal of Politics, 68*(1), 140–155.

Nathanson, A. (1999). Identifying and explaining the relationship between parental mediation and children's aggression. *Communication Research, 26*(2), 124–143.

Nathanson, A. (2002). The unintended effects of parental mediation of television on adolescents. *Media Psychology, 4*(3), 207–230.

O'Keefe, D. J. (2002). *Persuasion: Theory and research* (2nd ed.). Newbury Park, CA: Sage.

Petty, R. E., Brinol, P., & Priester, J. (2009). Mass media attitude change: Implications of the elaboration likelihood model of persuasion. In J. Bryant & M. B. Oliver (Eds.), *Media effects: Advances in theory and research* (3rd ed.). New York, NY: Routledge.

Petty, R. E., & Cacioppo, J. T. (1986). *Communication and persuasion: Central and peripheral routes to attitude change.* New York, NY: Springer-Verlag.

Preacher, K., & Hayes, A. (2004). SPSS and SAS procedures for estimating indirect effects in simple mediation models. *Behavior Research Methods, Instruments and Computers, 36*, 717–731.

Preacher, K., & Hayes, A. (2008). Asymptotic and resampling strategies for assessing and comparing indirect effects in multiple mediator models. *Behavior Research Methods, 40*, 879–891.

Priester, J. R., & Petty, R. E. (2003). The influence of spokesperson trustworthiness on message elaboration, attitude strength, and advertising effectiveness. *Journal of Consumer Psychology, 13*(4), 408–421.

Shani, D. (2006). *Measuring political interest.* Retrieved from American National Election Studies website: ftp://ftp.electionstudies.org/ftp/anes/OC/2006pilot/dshani.pdf

Shoemaker, P., & McCombs, M. (2003). Survey research. In G. Stempel, D. Weaver, & G. C. Wilhoit (Eds.), *Mass communication research and theory.* London, England: Pearson Education.

Tang, C., & Wu, A. (2010). Direct and indirect influences of fate control belief, gambling expectancy bias, and self-efficacy on problem gambling and negative mood among Chinese college students: A multiple mediation analysis. *Journal of Gambling Studies, 26*(4), 533–543.

Valentino, L. (2007). Does political knowledge increase turnout? Evidence from the 1997 British general election. *Public Choice, 131*(3–4), 387.

Valkenburg, P. M., Krcmar, M., Peeters, A. L., & Marseille, N. M. (1999). Developing a scale to assess three styles of television mediation: "Instructive Mediation," "Restrictive Mediation," and "Social Coviewing." *Journal of Broadcasting & Electronic Media, 43*(1), 52.

Wei, R., & Lo, V.-h. (2008). News media use and knowledge about the 2006 U.S. midterm elections: Why exposure matters in voter learning. *International Journal of Public Opinion Research, 20*(3), 347–362.

Xenos, M., & Moy, P. (2007). Direct and differential effects of the internet on political and civic engagement. *Journal of Communication, 57*(4), 704–718.

Communication Norms, Contexts OF Socialization, AND Youth Civic Development

NAM-JIN LEE, DHAVAN V. SHAH, AND JACK M. McLEOD

Scholars and researchers working on political socialization have long recognized the importance of communication in socializing young people into competent and active citizens. In particular, a growing body of recent scholarship draws our attention to how interdependent communication processes located in the family, schools, media, and peer networks, jointly and independently, cultivate civic norms and competencies among young people (McLeod, 2000; Shah, McLeod, & Lee, 2009; Shah, Thorson, Wells, Lee, & McLeod, 2014). Turning away from the static functionalism that emphasized the acquisition of skills and norms for the maintenance of a political system, this recent wave of research on youth socialization has shifted its focus onto how young citizens develop key capacities and motives that are necessary to participate meaningfully and effectively in civic life (Bennett, 2008; McLeod & Shah, 2009). This view highlights the centrality of communicative phenomena in the home, at school, among peers, and through media in the growth of citizens' democratic competencies and engagement motivations.

Notably missing in this rising interest in the communicative aspect of youth socialization processes, however, is any serious scholarly attempt to examine the role of various communication norms in influencing youth communication behavior in various sites of political socialization. The neglect of communicative norms is particularly noticeable in comparison with considerable bodies of research that incorporated social norms in the examination of communication intervention (e.g., Borsari & Carey, 2013; Rimal & Real, 2003, 2005); public opinion (e.g.,

Glynn & Huge, 2007; Price & Oshagan, 1995; Neuwirth & Frederick, 2004); and voting behavior (e.g., Glynn, Huge, & Lunney, 2009), to name just a few.

The main purpose of this chapter is to illuminate the value of incorporating communication norms into our examination of the communicative socialization process. Communication norms, which pertain to family, peer groups, online networks, or any other social groups, regulate the form, the content, and the processes of communication allowed within a social group (or network). Like any other type of norms, those who violate the communication norms are often sanctioned by ridicule or exclusion, while those who conform are more socially integrated (Adler & Adler, 1995; Turner, 1991). We view communication norms as an important bridging concept that links various sites of political socialization with the communicative processes that lead to active civic and political engagement among youth. We also argue that communication norms can play a role in opening up or closing off the pathways to civic life. As an illustration of the importance of communication norms in promoting civic and communication competence, we analyze panel data collected from a national sample of adolescents ages 12–17.

COMMUNICATION NORMS AND YOUTH SOCIALIZATION

The emergence of the communication-centered perspective on youth socialization was spurred by the movement away from early functionalist political socialization models, which viewed the developing youth as a passive recipient of information and norms from family, school, and media (McLeod, 2000). The emerging communication perspective views adolescents as active participants in their own socialization, seeking personal identity through information, interaction in peer networks, and experiences that may involve engagement with social issues (McDevitt & Chaffee, 2002). The early focus on political outcomes was broadened to include processes that are vital to active civic engagement in civil society as well as to political participation. The processes of discussion and deliberation—thoughtful processing of information, listening to diverse points of view, and working out compromises—are no less important than adoption of attitudes supportive of the political system.

The communicative perspective of youth socialization chiefly concerns how various communication practices (e.g., individuals' media practices and discussions in the home, at school, or among peers) provide young people with opportunities to develop relevant skills, knowledge, and capacities that are essential for actively engaging in civic and political life. Many scholars have used the notion of *communication mediation* as a framework for clarifying the effects of such communication practices on civic engagement. The concept of *communication mediation* situates communication as a key set of processes intervening between the private "life world" in which young people are embedded and their public behavior as

public citizens. In this framework, youth consumption of public affairs media and engagement in various modes of discussion translate, amplify, shape, and direct the impact of social structural location, cultural and sub-cultural forms, and other background factors on young citizens' understanding and participation in democratic societies (Sotirovic & McLeod, 2001).

In particular, scholars further developed this idea of communication mediation into *citizen communication mediation models*, wherein communication among adolescent citizens, both face-to-face and online, mediates the effects of news media use on civic engagement (Shah, Cho, Eveland, & Kwak, 2005). The sequential order of the mediating process from media use, to citizen communication, and to civic engagement has been well supported by past studies using both adult samples (e.g., Cho et al., 2008; Pan, Shen, Paek, & Sun, 2006; Shah et al., 2005, 2007) and adolescent samples (Lee, Shah, & McLeod, 2013).

We believe this idea of communication mediation needs to be extended to include various communication norms present in young people's everyday lives (i.e., family, peer networks, schools, and various online and offline communities). To illustrate this point and to situate our discussion of communication norms in a broader context of communicative youth socialization, we draw together various ideas and concepts central to youth socialization in the theoretical model presented in Figure 1. This model considers the major factors located in the family, peers, and schools that shape the communication mediation process as well as the individual, social-structural, and contextual forces that affect these more immediate influences on socialization.

The outer ring of the model contains factors considered exogenous to youth socialization: demographics, motivations, background orientations, and contextual and structural variables. These are the factors that often condition or moderate the effects of other factors thought to influence participatory engagement. At the center of the model are the mediating factors that channel the effects of variables from the outer rings onto civic and political engagement: informational media use and political expression and discussion.

The logic of this process remains intact regardless of whether media use and political talk occur through conventional or online channels. The middle ring of variables features the communicative aspects of three key sites of socialization into civic life: school, family, and peers. We believe communication norms prevailing in these sites significantly shape the communication mediation process. Democratic norms in the family or among peers can foster skills, capacities, and motivations necessary for engaging in the search of relevant political information and the exchange of opinions among citizens on public issues in their communities, thereby strengthening or weakening the possibility of active and meaningful participation in the political process. In this way, communication norms can influence the process in which young citizens develop democratic competencies and acquire motivations to engage in public life.

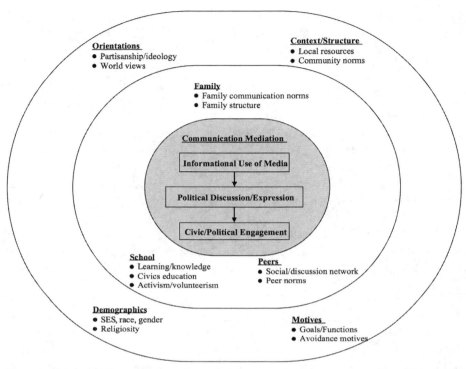

Figure 1. Communication mediation process creating communication competence among adolescents.

Social Norms and Communication Norms

Norms represent rules and expected patterns of behavior among members of a group or a social network (Turner, 1991). They describe and evaluate an appropriate and desirable behavior and prescribe what ought to be done in a specific situation. Individuals who violate norms often face various enforcement mechanisms including negative sanctions of isolation. Shared norms are characteristics of all groups. They reside in a culture, in social groups and organizations, in smaller primary groups, and also in individuals' perceptions (Cialdini & Goldstein, 2004; Price & Oshagan, 1995). In addition to describing and prescribing a preferred mode of conduct, norms express social values, and normative judgments are inherently value judgments. As Turner (1991) noted,

> the idea of a norm conveys a feeling of "oughtness" about certain behaviors; there are things that we ought to see, believe, feel, and do (whether we want to or not; there is an element of moral obligation, duty, right, justice). (p. 3)

There are three major motivations or incentives that encourage normative behaviors. First, people are motivated to adhere to social norms to cultivate social

approval and acceptance. By meeting the positive expectations of group members, individuals maintain their social relationship with others around them and avoid negative sanctions (ridicule, censure, threats of isolation, etc.) associated with a violation of norms. In other words, people's fundamental need to fit in with others leads them to conform to social obligation or pressure (Cialdini & Goldstein, 2004; Turner, 1991). Second, norms can also function as a useful perceptual guideline or a heuristic device for appropriate behavior, especially when situations are ambiguous and uncertain. They provide a frame of reference through which people interpret their environment and generate appropriate responses to it. As Hogg and Abrams (1988) stated, social norms "simplify, render predictable, and regulate social interaction. Without them social life would be unbearably complex and stressful: the individual would collapse beneath the tremendous cognitive overload involved in interaction" (p. 159). Third, norms play an important function for social identification. Norms not only represent an expected mode of conduct but also "a group prototype that describes and prescribes beliefs, attitudes, feelings, and behaviors that minimize ingroup differences and maximize outgroup differences" (Terry, Hogg, & White, 2000, p. 72). Norms define and enhance a common identity (Hogg & Reid, 2006).

We understand communication norms as a specific type of social norm prevalent in a social group or network. They regulate the content and processes of communication occurring among group members. For example, peer groups and families develop norms about what topics can be discussed and in what manner such discussion needs to be conducted. Communication norms may also prescribe what kinds of media people are expected to consume, what kinds of media are appropriate to be used in internal communication among peers or family members.

Like other norms, communication norms arise to control behavior in the absence of formal laws or strongly sanctioned societal norms. In this situation of uncertainty and ambiguity, norms provide some guidance for proper behavior. Family communication processes and partisan political discussion are thought by many to be "private" within the family, and thus we have no agreed-on rules of socialization. Families and other groups thus develop their own patterns, consciously or not, which are not random but reflect experiences of members, particularly of parents in family settings. Such discussion norms function to provide predictability for group processes as well as stability, harmony, and decision-making efficiency.

Since Sherif's (1936) classic experimental study examining how norms arise through group interaction and serve as a frame of reference, and Newcomb's (1943) study of students with conservative backgrounds developing more progressive attitudes under the influence of the liberal college community, social psychological studies established that group norms regulate individual behavior through various mechanisms including socialization, conformity, anticipation of social sanctions, and social identification. In the field of communication, the notion of social

norms has been applied in many different domains including health-risk behavior, public opinion contexts, and adoption of new communication technologies (e.g., Cho, 2011; Crandall, Eshleman, & O'Brien, 2002; Glynn & Huge, 2007; Postmes, Spears, & Lea, 2000; Rimal & Real, 2005), providing the underpinnings for theoretical perspectives such as spiral of silence, theory of planned behavior, and impersonal influence.

Where the study of social norms has been examined at the intersection of communication and socialization, much remains to be done. First, the majority of past research on social norms has focused on their influence on antisocial, deviant, and health-compromising behaviors such as smoking, alcohol use, drug use, and risky sexual behaviors (Allen & Antonishak, 2008; Borsari & Carey, 2001; Kobus, 2003). This predominant focus on the "dark side" of social norms is understandable as these behaviors directly relate to individual and social welfare. Indeed, a great deal of effort has been exerted to minimize undesirable influences of social pressure. The positive contribution of social norms for youth development has been relatively neglected. Little research has been done on the possibility that norms cultivate habits that may be conducive to communication competence as well as to civic competence.

Second, the role of communication in normative processes has been understudied. When communication is seriously considered in research concerning normative behavior, it is usually conceived of as a channel through which norms are transmitted among members of a group or as a conduit through which social norms exercise influence on individuals' behaviors (Lapinski & Rimal, 2005). In other words, past research viewed communication as part of the enforcing mechanism. It has rarely examined communication as a target behavior regulated by norms.

Third, past research on social norms relied narrowly on the social-psychological mechanism of conformity rooted in the desire for social support and the fear of social isolation. It rarely considered the possibility that social norms can encourage young people to collaborate with their peers to explore their identities and to develop their understanding of the social world. In particular, social and normative pressure may prompt youth to engage in self-reflection and to refine and revise their own political understanding. To the extent that communication norms induce people to engage in cognitive elaboration and reflection by bringing social pressures into intrapersonal deliberation and interpersonal conversations, they can be a constructive and positive force in youth development. Communication norms pertaining to family, peer groups, schools, or online communities may either put in place or break down barriers to the processes leading to participation.

The Contexts of Political Socialization

Contemporary models of political socialization locate adolescence and young adulthood as the key periods of development but also assume political and civic

learning continue throughout the life course. In particular, adolescence is a period when political orientations and media habits are formed, which can have a lasting impact on civic and political life (Beck & Jennings, 1982). Compared to young adults, adolescents are under greater influence of social and cultural institutions as they interact with their political environments. This requires any attempt to understand the roles of communication norms in adolescent socialization to take into account influences of various socializing sites including the family, schools, and peer groups.

Family communication norms. Research on family communication norms identified two discrete dimensions of family communication norms: socio-oriented and concept-oriented (Chaffee, McLeod, & Wackman, 1973). Families high on the socio-dimension stress harmony, conformity, and deference to authority in parent-child relationships. Socio-orientated families may strive to avoid controversy and disagreement by steering family discussion away from controversial topics that may lead to confrontation. Those high on the concept dimension emphasize the free and open exchange of ideas and welcome conversational disagreement (Fitzpatrick & Richie, 1994). Children in a concept-oriented family are encouraged to express themselves and engage in discussion and reflection without many restrictions on topics discussed (McLeod & Chaffee, 1972). This norm of concept orientation opens young people to the exploration of opposing perspectives and rewards open discussion as a norm, which they are inclined to seek in school settings and peer interactions. Indeed, concept orientation has been shown to promote active discussion beyond the family and to encourage people to value being informed, seek information, and then share their views.

Peer communication norms. The importance of peer groups for youth socialization has been well recognized (Corsaro & Eder, 1995; Feigenberg, King, Barr, & Selman, 2008). Typically homogeneous in terms of age and gender, the peer group plays a powerful role in developing social norms about interaction and behavior. Young people who belong to peer groups that value knowledge and discussion of public affairs content are likely to be encouraged to develop habits and competencies that enable them to process media content more actively (e.g., identifying biases and false information in news) and reflectively (later thinking about information they consumed in news).

Peer norms that value being tolerant of disagreement should generate opportunities for contentious discussion in which adolescents air divergent viewpoints. Even anticipation of disagreeable discussion and greater accountability to peers who disagree should encourage adolescents embedded in such peer groups to engage in increased mental activities to reevaluate, refine, and potentially revise their own political positions. Such reflections on their own political understanding in light of diverse opinions should help them form more informed and

considered opinions, facilitating active and enlightened engagement in their civic and political lives.

Communication norms prevalent in different socializing sites are often consistent with each other, resulting in a reinforcement of a particular pattern of social interaction, discussion, and communication behavior. For instance, McDevitt and Kiousis (2006) found that deliberative norms that students learn in a classroom diffuse to families and peer groups. Similarly, norms valuing tolerance for disagreement in a peer network were bolstered by family discussion norms emphasizing openness and disagreement (McLeod & Lee, 2012). The experience of learning how to reflect and deliberate on controversial social issues also encourages youth to be more receptive to future opportunities for engaging in deliberative processes through news consumption and discussion. Through this interplay of normative influences from schools, peers, and family, communication norms and skills are reinforced, reproduced, and internalized, laying the foundation for sustained news consumption habits and political discussion. In this way, democratic communication norms nurture continued political learning and sustained patterns of civic and political activism throughout the life course. Indeed, past research demonstrated the crucial role of civic norms and orientations in converting adolescent experiences into civic activism in adulthood (Beck & Jennings, 1982).

However, young people may also experience competing, or even conflicting, communication norms, generating tension that they need to cope with as they navigate these different sites of their "lifeworld." For instance, norms valuing tolerance for disagreement in a peer network can be contradicted by family discussion norms emphasizing harmony and consensus. There may be a myriad of individual or structural factors determining how such conflicting social norms interact to influence youth civic development. As our society becomes more diverse and young people can now easily carve out their own social network, virtual or actual, there should be systematic efforts to uncover the interplay between competing norms.

DATA AND METHODS

To illustrate the significance of communication norms for youth civic development and engagement, we analyzed data from the third and final wave ($n = 575$) of the Future Voters Study (as described in the Introduction). To see if our final panel might be subject to selection bias, we compared this final panel of respondents with those who completed only the first wave survey ($n = 517$), and also with the second wave respondents whose responses were discarded due to mismatches of their personal information between the first two waves of data collection ($n = 163$). We found that these three groups of respondents were equivalent to each other in terms of most demographic characteristics and major variables.

To test our arguments about the roles played by norms in encouraging the communicative socialization process, we first created single-item measures of demographics (age, sex, race, strength of partisanship), family background (household income, mother's education levels), and community integration (years of residence, church attendance, and size of friendship network). We also constructed an abbreviated set of measures for family communication norms (concept-oriented and socio-oriented family communication norms). Two groups of communication-related variables were constructed. The first group addressed news consumption (TV news viewing, newspaper reading, online news reading, news attention, and news reflection). The other group concerned public affairs discussion (frequency of public affairs discussion, discussion reflection, and discussion integration, which refers to the integration of consumed news content into discussion). Finally, we created measures of civic participation. For full question wording of all the included survey question items, descriptive statistics of all of these variables, and reliability estimates for the multi-item measures, see the online appendix available at www.journalism.wisc.edu/~dshah/resources.htm.

RESULTS

To take full advantage of our panel data, we used lagged-dependent variable regression models that included prior values of the outcome variable as an independent control variable. By taking into account lagged values of the outcome variables, these models predict the level of a given outcome variable at Time 2 while controlling for the value of that variable at Time 1. As such, this panel model provides unbiased estimates of the effects of communication norms by adjusting for any initial differences in relevant communication activities, including news consumption and political discussion (Finkel, 1995; Halaby, 2004).

After entering the corresponding lagged dependent variable as a control, we enter all the other predictors in a series of blocks made up of variables sharing common characteristics. The sequence of entering the blocks of variables into the regression models was based on the mediating relationships theorized to exist among the predictors. After accounting for our background variables, we entered the block of communication norms in the family and among peers, followed by news use, and then interpersonal discussion in the regression models.

Predicting News Consumption and Discussion

Table 1 summarizes the results from a series of lagged dependent variable models that were run to predict five variables: frequencies of consuming TV news, newspaper, and online news; news attention; and news reflection. Not surprisingly,

the lagged outcome variables that were measured in Wave 1 were found to be the strong and consistent predictors of the outcome variables at Wave 2 for all outcomes related to news consumption, attention, and reflection (all p values are < .001). These stability coefficients accounted for considerable amounts of the variances in the outcome variables, ranging from 23.4% for online news to 34.3% for TV news. The entry of our 11 background variables explained relatively small amounts of additional variance: 1.0% for news reflection to 6.5% for TV news. Even after the contributions of both the lagged outcomes and the block of our 11 background variables were taken into account, our four variables comprising the block of communication norms produced a strong incremental impact on our five news outcome variables. Although this block explained relatively modest amounts of incremental variances in the frequency of various forms of news consumption (1.5% to 3.4%), it contributed considerably more to news attention (11.2%) and reflection (13.1%).

This result was largely a function of the highly significant and consistently positive relationships with peer norms centering on the value of being informed, with the one exception being the lack of a relationship with the frequency of online news consumption. Peer norms representing tolerance of disagreement predicted news reflection. In addition, concept-oriented family communication was positively related to TV news viewing frequency and news reflection. Socio-orientation was also predictive of TV news viewing among adolescents.

Table 2 presents the results from a series of models predicting the frequency of public affairs discussion, the level of reflection occurring after such discussion, and the level of integration of consumed news content into discussion. Unfortunately, we did not have measures for discussion reflection and discussion integration in Wave 1 and therefore could not perform a lagged-dependent variable regression for these two outcomes. For discussion frequency, the lagged measure from Wave 1 was the strongest predictor of discussion frequency at Wave 2. The block of our background variables also accounted for sizable amounts of the variances in the three discussion-related variables (4.3% to 7.3%). More important, however, is the predictive power of the block of communication norms. This four-variable block added a considerable amount of incremental variance: 9.1% to discussion frequency, 24.4% to discussion reflection, and 22.0% to discussion integration. Two peer norms—valuing being informed and allowing for disagreement—were found to be the biggest contributors of these discussion variables. In addition, the block of news use accounted for additional variance in these discussion outcomes, ranging from 1.7% to 3.2%. Among the news consumption variables, the frequency of online news use was the most consistent predictor of the discussion-related outcome variables.

A few conclusions can be drawn from the analyses presented in Table 1 and Table 2. First, these analyses make a strong case for the importance of

Table 1. Results of Regression Models Predicting News Use (Frequency, Attention, and Reflection).

	Frequency of TV news viewing	Frequency of newspaper reading	Frequency of online news reading	News attention	News reflection
Lagged values of outcome variables					
Freq. of TV news viewing	.54***	—	—	—	—
Freq. of newspaper reading	—	.53***	—	—	—
Freq. of online news reading	—	—	.44***	—	—
News attention	—	—	—	.39***	—
News reflection	—	—	—	—	.36***
Incremental R^2 (%)	34.3***	32.3***	23.4***	29.1***	27.3***
Background variables					
Age	-0.02	0.04	0.06	0.08	0.07*
Sex (female)	0.02	-0.06#	-0.05	-0.04	0.01
Race (white)	-0.07	-0.02	0.01	-0.02	-0.00
Race (black)	0.08#	0.06	0.17***	0.13**	0.03
Strength of partisanship	0.10**	-0.02	0.05	0.07*	-0.02
Mother's education	-0.01	-0.07#	-0.01	-0.04	0.03
Household income	-0.08*	-0.01	0.00	-0.01	-0.00
Years of residence	-0.04	-0.06	0.00	0.05	-0.03
Church attendance	-0.02	0.04	-0.01	0.03	0.04
Number of friends	-0.07*	0.02	-0.06	-0.07*	-0.05
Academic performance	-0.08*	0.04	0.02	0.01	0.03
Incremental R^2 (%)	6.5***	2.3#	4.4**	5.3***	1.0

Table 1. (Continued)

	Frequency of TV news viewing	Frequency of newspaper reading	Frequency of online news reading	News attention	News reflection
Communication Norms					
Concept–oriented family comm.	0.08*	0.01	0.05	0.08*	0.06
Socio–oriented family comm.	0.08*	0.01	0.07#	0.00	0.04
Peer norm valuing being informed	0.14***	0.17***	0.08#	0.31***	0.28***
Peer norm allowing disagreement	−0.01	−0.04	0.00	0.05	0.15***
Incremental R^2 (%)	3.4***	2.3**	1.5*	11.2***	13.1***
Total R^2 (%)	44.2	36.8	29.3	45.6	41.9
Number of observations	536	529	536	538	539

Note. Entries are standardized OLS regression coefficients in the final models where all the predictors were entered.

$*p \leq .05$; $\# p \leq .10$; $**p \leq .01$; $***p \leq .001$.

Table 2. Results of Regression Models Predicting Public Affairs Discussion (Frequency, Reflection, and News Integration).

	Frequency of discussion	Discussion reflection	Discussion integration
Lagged values of outcome variables			
Freq. of discussion	.33***	–	—
Incremental R^2 (%)	27.7***	—	—
Background variables			
Age	0.04	0.07#	-0.01
Sex (female)	0.07#	0.02	0.00
Race (white)	0.07	-0.09#	-0.10#
Race (black)	-0.01	-0.10*	-0.06
Strength of partisanship	0.11**	0.09*	0.08*
Mother's education	0.01	-0.01	-0.01
Household income	0.03	0.01	-0.02
Years of residence	-0.02	0.00	0.06
Church attendance	0.02	0.09*	0.01
Number of friends	-0.04	-0.03	-0.01
Academic performance	0.05	0.10**	0.09*
Incremental R^2 (%)	4.3**	9.4***	7.3***
Communication Norms			
Concept–oriented family comm.	0.08*	0.02	0.04
Socio–oriented family comm.	0.02	0.04	-0.02
Peer norm valuing being informed	0.09*	0.26***	0.31***
Peer norm allowing disagreement	0.21***	0.28***	0.18***
Incremental R^2 (%)	9.1***	24.4***	22.0***
News Use			
TV news	0.04	0.05	0.07#
Newspaper	0.06#	0.07#	0.06
Online News	0.14***	0.07#	0.12**
Incremental R^2 (%)	3.1***	1.7*	3.2**
Total R^2 (%)	44.2	35.5	32.6
Number of observations	532	533	533

Note. Entries are standardized OLS regression coefficients in the final models where all the predictors were entered.

$*p \leq .05$; $\# p \leq .10$; $**p \leq .01$; $***p \leq .001$.

communication norms for promoting various communicative competencies including news consumption and political discussion. The predictive power of communication norms dominated the block of background variables for most outcome variables. Second, communication norms are more strongly related with reflective and integrative communication behaviors (i.e., news reflection, discussion reflection, and discussion integration) than they are with simple frequencies of news consumption and discussion. Third, it appears that peer communication norms are more potent than family communication norms in predicting the outcome variables among adolescents.

Developmental Considerations and Communication Norms

Moving from childhood to adulthood, adolescence is marked by a rapid development in intellectual and social abilities. In order to consider developmental dynamics across the different phases of adolescence, we first divided our adolescent sample into two age groups: a subsample of adolescents aged 12–14 and one aged 15–17. Given our findings about the strong predictive power of communication norms for reflective communication behavior, we focused on three outcome variables: news reflection, discussion reflection, and discussion integration. Table 3 presents three regression models separately predicting the three reflective and integrative communication outcomes, broken down by the age groups.

Although most of the results replicated the patterns presented in the previous analyses across the two age groups, one noticeable difference emerged. When we looked at our adolescent participants at their early adolescence (12–14) and at their late adolescence (15–17) separately, our two peer commutation norm variables exhibited different patterns of relationships with our three outcome variables. For younger adolescents, the peer norm valuing being informed is a consistent predictor of all three reflective communication behaviors; however, the peer norm allowing for disagreement was predictive only of discussion integration. By contrast, among older adolescents, both types of peer norms were strongly associated with the three outcome variables. This pattern of findings suggests the influence of peer norms is subject to a developmental trajectory for adolescents' ability to tolerate disagreement and contestation.

Communication Norms and Pathways to Engagement

Our final set of analyses addressed the possibility that pathways to civic engagement are dependent on peer communication norms. Accordingly, this analysis examined whether or not peer norms moderate some of the structural relationships between commutation activities and civic engagement theorized by a communication mediation framework. Structural Equation Modeling (SEM), which

Table 3. Results of Regression Models Predicting News Reflection and Discussion Reflection, by Age Groups.

	News reflection		Discussion reflection		Discussion integration	
	12–14	15–17	12–14	15–17	12–14	15–17
Lagged values of outcome variable						
Freq. of TV news viewing	.35***	.32***	–	–	–	–
Background variables						
Age	−0.00	0.01	0.01	0.07	0.00	−0.02
Sex (female)	−0.06	0.05	−0.03	0.03	−0.08	0.08
Race (white)	−0.02	−0.04	−0.07	−0.16#	−0.11#	−0.13
Race (black)	0.01	0.03	−0.10	−0.11	−0.05	−0.07
Strength of partisanship	−0.06	−0.07	−0.01	0.10#	0.05	0.05
Mother's education	−0.05	0.09#	0.01	−0.02	−0.01	−0.02
Household income	−0.01	0.04	−0.03	0.04	−0.06	0.02
Years of residence	−0.01	−0.03	−0.02	0.02	0.09#	0.03
Church attendance	0.04	0.00	0.11*	0.04	−0.02	0.02
Number of friends	−0.05	−0.05	−0.05	−0.03	0.06	−0.09
Academic performance	0.06	−0.01	0.07	0.07	0.10	0.07
Communication Norms						
Concept–oriented family comm.	0.06	0.04	−0.04	0.02	0.05	0.02
Socio–oriented family comm.	0.02	0.02	0.04	0.05	0.06	−0.13*
Peer norm valuing being informed	0.27***	0.21***	0.28***	0.17**	0.28***	0.28***
Peer norm allowing disagreement	0.04	0.20***	0.25***	0.18**	0.08	0.21***
News Use						
TV news	0.07	0.00	0.04	0.00	0.02	0.09
Newspaper	0.03	0.07	0.05	0.03	0.04	0.05
Online News	−0.13	0.01	0.04	0.01	0.05	0.12*
Discussion						
Frequency of discussion	0.17**	0.15*	0.23***	0.30***	0.21***	0.11#
Total R^2 (%)	48.1	43.8	45.9	36.5	36.3	36.5
Number of observations	274	257	275	257	27.5	257

Note. Entries are standardized OLS regression coefficients in the final models where all the predictors were entered.

$^*p \leq .05$; # $p \leq .10$; $^{**}p \leq .01$; $^{***}p \leq .001$.

analyzes the relationships among variables as chains of direct and indirect linear links, enables us to test not only our hypothesized communication mediation process, but also the possibility that this set of mediating relationships may vary

depending on a third variable—in this case, peer norms allowing disagreement. Figure 2 presents two SEM models run with two groups of respondents—those perceiving low levels (i.e., below average) of the peer discussion norm allowing disagreement and those perceiving high levels of this norm.

A. Peer norms allowing disagreement = Low

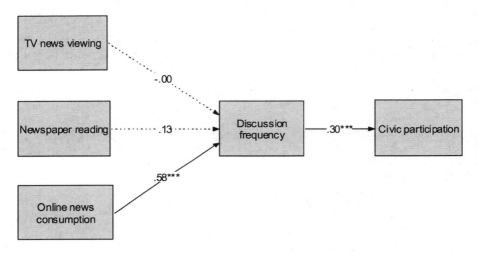

B. Peer norms allowing disagreement = High

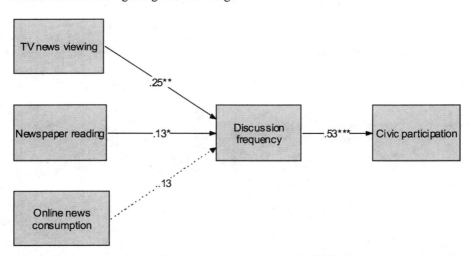

Figure 2. Structural equation models of communication mediation leading to civic participation.

The pair of SEM models address the relationships of the following two groups of variables with civic engagement: informational media use (TV news, newspaper reading, and online news consumption) and interpersonal discussion. This analysis represents a version of communication mediation, wherein communication among citizens mediates the effects of news media use on civic engagement (Shah et al., 2005). For the sake of simplicity, none of the exogenous control variables is displayed, although they were included in the models.

As Figure 2 shows, the basic communication mediation holds across the two subgroups. That is, public affairs discussion mediates the effects of news consumption onto civic participation. However, we also found some notable differences of those mediating relationships between the two groups. Among adolescents who did not believe that their friends appreciated disagreement and contestation, the two variables representing traditional news media (both TV news watching and newspaper reading) are not significantly linked with public affairs discussion (see Panel A of Figure 2). In contrast, online news consumption was strongly associated with the frequency of public affairs discussion, which in turn is related to a boost in civic participation. Among adolescents who believe that their friends are tolerant of disagreeable discussion, both forms of traditional news use were significantly associated with public affairs discussion, whereas online news consumption was not. The link between discussion and civic participation was particularly robust. The strength of this discussion-participation link was significantly greater in the subsample of adolescents who believe their peers are tolerant of disagreement than among those who do not. In sum, the results of this SEM analysis suggest that communication norms powerfully shape pathways to civic engagement, with peer norms valuing open and contentious discussion moderating the communication mediation process.

CONCLUSIONS

The concept of communicative social norms has been vastly underappreciated in political socialization research. This chapter represents an attempt to demonstrate the promise this concept holds for explaining how various social sites of political socialization are interdependent and how they, independently and jointly, contribute to youth civic engagement. In particular, communication norms connect these different contexts of youth socialization with the communication mediation processes. As we illustrated, communication norms powerfully regulate a range of communicative behaviors and activities constituting the key elements of communication mediation. More specifically, we showcased that communication norms valuing being informed and open discussion activate and strengthen communication mediation.

In addition, democratic communication norms encourage young people to be more reflective and thoughtful consumers of news and public affairs information

and to integrate what they watch and read in news media with the face-to-face discussions they have with those around them. Our analysis indicates that family communication norms and peer norms are highly correlated, which suggests youth may seek out and prefer to join peer groups with communication norms similar to those of their families. Taken together, these results suggest that communication norms established in the family shape whether young people consume news media in a more active and reflective way, talk about politics with peers, and entertain disagreement and diverse perspectives they encounter in such discussions.

REFERENCES

Adler, P. A., & Adler, P. (1995). Dynamics of inclusion and exclusion in preadolescent cliques. *Social Psychology Quarterly, 52*, 299–310.

Allen, J. P., & Antonishak, J. (2008). Adolescent peer influences: Beyond the dark side. In M. J. Prinstein & K. A. Dodge (Eds.), *Understanding peer influence in children and adolescents* (pp. 141–160). New York, NY: The Guilford Press.

Beck, P. A., & Jennings, M. K. (1982). Pathways to participation. *American Political Science Review, 76*, 94–108.

Bennett, W. L. (2008). Changing citizenship in the digital age. In W. L. Bennett (Ed.), *Civic life online: Learning how digital media can engage youth* (pp. 1–24). Cambridge, MA: The MIT Press.

Borsari, B., & Carey, K. B. (2001). Peer influences on college drinking: A review of the research. *Journal of Substance Abuse, 13*, 391–424.

Chaffee, S. H., McLeod, J. M., & Wackman, D. B. (1973). Family communication patterns and adolescent political participation. In J. Dennis (Ed.), *Socialization to politics: A reader* (pp. 349–364). New York, NY: Holt, Rinehart & Winston.

Cho, H. (2011). Theoretical intersections among social influences, beliefs, and intentions in the context of 3G mobile services in Singapore: Decomposing perceived critical mass and subjective norms. *Journal of Communication, 61*(2), 283–306.

Cho, J., Shah, D. V., McLeod, J. M., McLeod, D. M., Scholl, R. M., & Gotlieb, M. R. (2008). Campaigns, reflection, and deliberation: Advancing an O-S-R-O-R model of communication effects, *Communication Theory, 19*, 66–88.

Cialdini, R., & Goldstein, N, J. (2004). Social influence: Compliance and conformity. *Annual Review of Psychology, 55*, 591–621.

Corsaro, W. A., & Eder, D. (1995). Development and socialization of children and adolescents. In K. S. Cook, G. A. Fine, & J. S. House (Eds.), *Sociological perspectives on social psychology* (pp. 421–451). Boston, MA: Allyn & Bacon.

Crandall, C. S., Eshleman, A., & O'Brien, L. T. (2002). Social norms and the expression and suppression of prejudice: The struggle for internalization. *Journal of Personality and Social Psychology, 82*, 359–378.

Feigenberg, L. F., King, M. S., Barr, D. J., & Selman, R. L. (2008). Belonging to and exclusion from the peer group in schools: Influences on adolescents' moral choices. *Journal of Moral Education, 37*, 165–184.

Finkel, S. E. (1995). *Causal analysis with panel data*. Thousand Oaks, CA: Sage.

Fitzpatrick, M. A., & Ritchie, L. D. (1994). Communication schemata within the family: Multiple perspectives on family interaction, *Human Communication Research, 20*, 275–301.

Glynn, C. J., & Huge, M. E. (2007). Opinion as norms: Applying a return potential model to the study of communication behaviors. *Communication Research, 34*(5), 548–568.

Glynn, C. J., Huge, M. E., & Lunney, C. A. (2009). The influence of perceived social norms on college students' intention to vote. *Political Communication, 26*, 48–64.

Halaby, C. N. (2004). Panel models in sociological research: Theory into practice. *Annual Review of Sociology, 30*, 507–544.

Hogg, M. A., & Abrams, D. (1988). *Social identifications: A social psychology of intergroup relations and group processes.* London, England: Routledge.

Hogg, M. A., & Reid, S. A. (2006). Social identity, self-categorization, and the communication of group norms. *Communication Theory, 16*, 7–30.

Kobus, K. (2003). Peers and adolescent smoking. *Addiction, 98*, 37–55.

Lapinski, M. K., & Rimal, R. N. (2005). An explication of social norms. *Communication Theory, 15*, 127–147.

Lee, N., Shah, D. V., & McLeod, J. M. (2013). Processes of political socialization: A communication mediation approach to youth civic engagement. *Communication Research, 40*, 669–697.

McDevitt, M., & Chaffee, S. H. (2002). From top-down to trickle-up influence: Revisiting assumptions about the family in political socialization. *Political Communication, 19*, 281–301.

McDevitt, M., & Kiousis, S. (2006). Deliberative learning: An evaluative approach to interactive civic education communication education. *Communication Research, 55*, 247–264.

McLeod, J. M. (2000). Media and civic socialization of youth. *Journal of Adolescent Health, 27*, 45–51.

McLeod, J. M., & Chaffee, S. (1972). The construction of social reality. In J. S. Tedeschi (Ed.), *The social influence processes* (pp. 50–99). Hawthorne, NY: Aldine.

McLeod, J. M., & Lee, N. (2012). Social networks, public discussion, and civic engagement: A socialization perspective. In H. Semetko & M. Scammell (Eds.), *The Sage handbook of political communication* (pp. 197–208). Thousand Oaks, CA: Sage.

McLeod, J. M., & Shah, D. V. (2009). Communication and political socialization: Challenges and opportunities for research. *Political Communication, 26*, 1–10.

Neuwirth, K., & Frederick, E. (2004). Peer and social influence on opinion expression: Combining the theories of planned behavior and the spiral of silence. *Communication Research, 31*(6), 669–703.

Newcomb, T. M. (1943). *Personality and social change.* New York, NY: Holt, Rinehart, and Winston.

Pan, Z., Shen, L., Paek, H., & Sun, Y. (2006). Mobilizing political talk in a presidential campaign: An examination of campaign effects in a deliberative framework. *Communication Research, 33*, 315–345.

Postmes, T., Spears, R., & Lea, M. (2000). The formation of group norms in computer-mediated communication. *Human Communication Research, 26*(3), 341–371.

Price, V., & Oshagan, H. (1995). Social-psychological perspectives on public opinion. In T. Glaser & C. T. Salmon (Eds.), *Public opinion and the communication of consent* (pp. 177–206). New York, NY: Guilford.

Rimal, R. N., & Real, K. (2003). Understanding the influence of perceived norms on behaviors. *Communication Theory, 13*(2), 184–203.

Rimal, R. N., & Real, K. (2005). How behaviors are influenced by perceived norms. *Communication Research, 32*(3), 389–414.

Shah, D. V., Cho, J., Eveland, W. P., & Kwak, N. (2005). Information and expression in a digital age: Modeling Internet effects on civic participation. *Communication Research, 32*, 531–565.

Shah, D. V., Cho, J., Nah, S., Gotlieb, M. R., Hwang, H., Lee, N., ... McLeod, D. M. (2007). Campaign ads, online messaging, and participation: Extending the communication mediation model. *Journal of Communication, 57*, 676–703.

Shah, D. V., McLeod, J. M., & Lee, N. (2009). Communication competence as a foundation for civic competence: Processes of socialization into citizenship. *Political Communication, 26*, 102–117.

Shah, D. V., Thorson, K., Wells, C., Lee, N., & McLeod, J. M. (2014). Civic norms and communication competence: Pathways to socialization and citizenship. In K. Kenski & K. H. Jamieson (Eds.), *The Oxford handbook of political communication*. Oxford, England: Oxford University Press.

Sherif, M. (1936). *The psychology of social norms*. New York, NY: Harper & Brothers.

Sotirovic, M., & McLeod, J. M. (2001). Values, communication behavior, and political participation. *Political Communication, 18*, 273–300.

Terry, D. J., Hogg, M. A., & White, K. A. (2000). Group norms, social identity, and attitude-behavior relations. In D. J. Terry & M. A. Hogg (Eds.), *Attitudes, behavior, and social context: The role of norms and group membership* (pp. 67–93). Hillsdale, NJ: Erlbaum.

Turner, J. C. (1991). *Social influence*. Milton Keynes, England: Open University Press.

Youth AND Political Knowledge

Measurement OF Political Knowledge IN American Adolescents

ESTHER THORSON, SEOYEON KIM, AND JOONGHWA LEE

The purpose of the study reported in this chapter is to examine three subscales of a political knowledge test administered to high school students immediately after a November 2010 state election. Civics, Issue, and Political Player knowledge were related in different patterns to the variables that have most commonly been identified as stimuli for political learning: school-based political experiences, political discussions with others, news media exposure, and time spent with entertainment television. Our results support previous work on the assessment of citizens' political knowledge, specifically Delli Carpini and Keeter's (1996) argument that it is not theoretically useful to employ political knowledge scales that include a variety of unrelated questions about government structure and function, campaign issues, and candidates. The current analysis also extends research in this area as we focus specifically on the assessment of political knowledge among adolescents.

MEASUREMENT OF POLITICAL KNOWLEDGE IN AMERICAN ADOLESCENTS

What young people know about politics has long been considered a significant indicator of their progress toward becoming effective citizens, able to participate in political decision-making and to vote consistently with their own values and beliefs. Yet too often the operationalization of political knowledge is psychometrically poor, with scales including a randomly chosen set of questions, and with

little attention to reliability or any form of validity (see critiques by Delli Carpini & Keeter, 1996; Eveland & Hively, 2009). These deficiencies have certainly been apparent in many studies of youth political socialization in spite of efforts to improve and better understand the operationalization of political knowledge (e.g., Torney-Purta, 2002, 2004). When it is not clear just what is being measured in these indices of political socialization, it is particularly difficult to compare findings across studies. Also, it is not clear what the relationships are between political knowledge and causal variables such as political discussion and networking, school-based political experiences, the influence of parental features and parenting styles, and the influence of news and entertainment media consumption. With these limitations, theory building is severely hampered.

In the current study, we follow the example of Delli Carpini and Keeter (1996), who undertook extensive study of the dimensions of political knowledge and concluded that it is important to distinguish three types of knowledge: Civics (knowledge of what government does and how it works), Political Players (candidates, parties), and Issues (where candidates and parties stand on various issues). Delli Carpini and Keeter first looked at a variety of texts, including school curricula, a survey of political scientists, and research content to see what components had been included previously in measurements of political knowledge. After concluding that the above three components were central, they tested these components on data gathered from several National Election Studies. These researchers emphasized the importance of keeping the three dimensions separate, even though they were highly correlated with each other; and they also emphasized the importance of correlating the dimensions with other measures of political responses. In spite of this very useful work, however, studies of youth political knowledge have continued to use aggregated sets of different types of questions (e.g., McDevitt, 2006).

Eveland and Hively (2009) suggested that rather than asking just factual questions, it is important to consider the level of "structural density" of knowledge in youth. They operationalized structural density in terms of how related (from not at all to very closely related) six concepts were (terrorism, fuel prices, economy, taxes, education, and the environment). They assumed that the more youth perceived concept interrelationships, the stronger the structure of their political cognition. It should be noted, however, that they also employed an extensive measure of political players, which was operationalized as the total correct identification of 13 political figures. There were differences in what variables predicted the two measures of knowledge (structural density and political players). Both measures were predicted by gender, exposure to national TV news, and frequency of political discussion (although males were higher for political players and females were higher for structural density). But structural density was also predicted by discussion elaboration (e.g., after I talk with others about politics I think more about

the discussion later; and integrating it with my own thoughts); whereas political players was not. Interestingly, the amount of variance accounted for in the political players scale was far greater than that for the structural density variable.

What is lacking in the existing political knowledge research is analysis of youth political knowledge in terms of the three dimensions identified by Delli Carpini and Keeter (1996). This is the task we take up here. Although the data we analyze contain only two questions for each of the three categories of knowledge (leading to a three-point scale for each knowledge dimension), we hypothesize that there will be different predictors of the three kinds of political knowledge and that they in turn will relate differently to our criterion variable, adolescents' political participation. Furthermore, we posit that a combined six-item scale of general political knowledge misrepresents what we learn from the three subscales.

THREE KINDS OF POLITICAL KNOWLEDGE

In the political election during which our study was conducted, the major emphasis was on candidates for the U.S Senate, and therefore we asked multiple-choice questions about the winners in both those races (Political Players; and two different states were involved). One of the goals of school curricula, of course, is to teach about political offices and the two-party system (Civics). Thus we asked which party is more conservative (Republican or Democrat) and whose responsibility it was to decide if a law was Constitutional or not (Supreme Court). Finally, we asked about two national issues (Issues) that were part of the media coverage in the two relevant states in both of these national races: illegal immigration and the approximate current level of the unemployment rate nationally. We expect that all three of the subscales will be highly and positively inter-correlated and will correlate most highly with our overall knowledge measure (**H1**).

The theoretical perspective guiding this research suggests demographic variables, structural variables such as school and family, and communication behaviors, both mediated and interpersonal, combine in complex ways that lead to knowing about politics, government, and the issues in a specific election. We were particularly interested in whether an intensive school experience would impact our measures of knowledge, which has been found in past research using combined factual questions as the measure of knowledge (e.g., McDevitt, 2006; McDevitt & Chaffee, 2000, 2002). Research has also shown that coordination of political stories across media has a powerful effect on general citizen knowledge (e.g., Denton, Thorson, & Coyle, 1998; Thorson, Ognianova, & Coyle, 1998). And, of course, the news media have also been shown to be important sources of information as well as motivation to participate in politics (e.g., Gibson, Howard, & Ward, 2000; Hill & Hughes, 1998; Kraut et al., 2002). We look next at what we might find

regarding adolescents' political knowledge and expected relationships between our predictor variables and the three knowledge subscales.

LITERATURE REVIEW

Demographics and Three Types of Political Knowledge

There is significant evidence that both adolescent and adult males are more knowledgeable about political facts than females (Frazer & MacDonald, 2003; Verba, Burns, & Schlozman, 1997). However, as noted previously, Eveland and Hively (2009) found that females scored higher on their knowledge Structural Density measure. Still, on this front, we expect males to show higher scores on all three knowledge scores.

Harp, Bachmann, Rosas-Moreno, & Loke (2010) found in a national survey of youth aged 12–17 that African American youth watch the most television news, Hispanics second most, and Caucasians the least. Once there was a computer available in the home, however, Caucasian youth were more likely than African American youth to use it for news. As online news use is higher for Caucasians in this study, this might lead us to predict that Caucasians will show higher knowledge scores on all three scales. On the other hand, although the Harp study did not measure political knowledge, it did report that African American youth were more active in participating in civic behaviors, following political news, and talking about politics with others. With news media use a significant predictor of knowledge, it may well be that African Americans will show higher knowledge scores than Caucasians. Thus we have two competing hypotheses about race and political knowledge. Also, it is clear that older youth have higher levels of political knowledge than do younger ones (Eveland & McLeod, 1998; Eveland, McLeod, and Horowitz, 1998). Finally, Eveland and Hively's (2009) analysis showed males with higher issue knowledge scores than females. Based on these findings, we hypothesized that:

H2: Males will show higher knowledge scores than females on all three measures.

H3: African Americans will show higher knowledge scores than Caucasians on all three measures.

H4: Older youth will show higher knowledge scores than younger youth on all three measures.

Parent/Youth Communication

The earliest thinking regarding the role of parent/child communication about politics was focused on how parents were able to convey their own partisanship to

their children (e.g., Niemi, 1973). As the field developed, the notion of "parenting styles" emerged as an important perspective, and was found to have a major impact on all aspects of child and adolescent growth, and certainly an impact on the communication of political attitudes and behaviors within the family. The earliest of these studies focused on nurturing vs. controlling or restrictive approaches by the parents (e.g., Freud, 1933; Rogers, 1960). In the 1970s, Chaffee and McLeod (1973; Chaffee, McLeod, & Atkin, 1971) published a number of influential studies about family communication patterns (FCPs). These researchers were interested in how habitual FCPs influenced the child's subsequent communication and social relationships as she ventured out into the world. Their research was particularly concerned with the development of communication "competencies and adaptabilities" (Chaffee, 1972). Eventually, their analysis identified four types of FCPs. First, children were encouraged to explore issues and come to their own conclusions (pluralistic); second, children were not to question their parents' orientations or think for themselves (protective); third, neither of these two approaches characterized the family communication environment (laissez-faire); and, fourth, both approaches (pluralistic and protective) were present (consensual). Children from protective families were less likely to be politically active when they were older (Sheinkopf, 1973), and watched television more and read newspapers less (Chaffee, McLeod, & Atkin, 1971). Children from pluralistic families scored high on measures of political knowledge, spent less time with television, and their media use was often quite different from their parents' (Chaffee, McLeod, & Atkin, 1971). Finally, children in consensual homes paid lots of attention to the news but scored low on political knowledge (Dimmick, 1976). Chaffee (1972) argued that family impact on children's political socialization will be particularly strong compared with the impact of other structural variables like schools and media because the family influence varied less over time than the other two structural variables. He also argued that while parents do not directly influence their children's political views, they do mediate how media information about politics is processed (Chaffee & Yang, 1990).

In another influential approach, Baumrind (1967, 1970) identified three kinds of parental control relationships: permissive, authoritarian, and authoritative. For Baumrind, the focus of the authoritative parent is to help children "self-regulate" their own behavior and choices in ways that are socially responsible. The authoritarian parent emphasizes obeying rules but does not emphasize the reasoning behind those rules. Finally, permissive parents pay less attention to children in general and provide lots of freedom but little direction within that freedom. Children of authoritative parents tend to be more socially confident and see themselves as more intelligent and able compared to peers who come from non-authoritative backgrounds. Children of authoritarian parents were more likely to be politically alienated (Gniewosz, Noack, & Buhl, 2009), while children of permissive parents

tend to have poorer social skills and interact with peers less (Weiss & Schwarz, 1999).

Austin and her colleagues (e.g., Austin, 1993; Austin, Bolls, Fujioka, & Engelbertson, 1999; Austin, Roberts, & Nass, 1990) looked specifically at family communication patterns associated with watching television. This research found that parents who did lots of television viewing did more co-viewing with their children (Austin & Pinkleton, 2001). Interestingly, they identified four co-viewing styles reminiscent of the Chaffee and McLeod family communication patterns. Non-mediator parents seldom talk about television with their children, optimists speak positively about television programming when co-viewing, cynics express skepticism about television content, and selectives speak both positively and nega-tively about television content. These findings suggest it is important to ask about co-viewing experiences that children have when political content is encountered while watching television.

Nathanson's (1998) work with parental mediation of television viewing has slightly different categories that include active (or "evaluative") mediation where parents talk with children about what they are watching; restrictive mediation, where parents set rules about television viewing; and co-viewing, which involves parents watching television with the children. Parents, especially those with higher levels of education and younger children, most often utilize combinations of eval-uative and restrictive mediation (Valkenburg, Krcmar, Peeters, & Marseille, 1999).

Particularly relevant for the present study is the work of Eveland and Hively (2009). As noted, they developed a structural density measure of youth political knowledge and showed that it was highly related to two interpersonal commu-nication measures: how frequently youth talked with others about politics and how much they elaborated on those conversations. However, these researchers did not look at school interpersonal communication, and work by McDevitt & Kiousis (2006) points out that civics knowledge is best predicted by exposure to school curricula. Regarding the parent/child relationship and adolescents' political knowledge, we predict that:

> H5: Parent/child conversations about politics will be positively associated with all three measures of political knowledge.

Adolescents' News Media Use for Political Information

Clearly, mass media play an important role in people's perceptions of political issues and information, and it is well established that mass media serve as import-ant sources of knowledge for political issues and political players (Delli Carpini & Keeter, 1996; McLeod, Rush, & Friederich, 1968). Media effects vary as a func-tion of the motivation for using them. Television use for news clearly shows a

positive impact on political knowledge (Shah, McLeod, & Lee, 2009). Newspaper use, although low among teenagers, still shows a positive impact on political knowledge and interest in adults (e.g., Eveland et al., 1998). Putnam (1995, 2000), however, has argued that television diminishes citizens' willingness to participate in their own communities. In response to this claim, a number of researchers have explored in a more detailed way television's effects on civic and political engagement (Fleming, Thorson, Peng, 2005; Milner, 2002; Norris, 1996; Shah, 1998; Shah, McLeod, & Yoon, 2001). In general, these studies have found that use of television for entertainment does indeed reduce community participation, as well as knowledge about, and interest in, politics.

Eveland (2004) suggested that what gratifications people sought from the media (i.e., information, entertainment, connectivity) drive their information processing of media content. For example, the person seeking information will attend more closely to news items on politics and likely elaborate on those items. The person seeking connectivity may attend primarily to content that would make good fodder for social conversation. For example, this individual might be more inclined to watch the late evening satire news programs. However, there is some evidence to suggest that entertainment programming such as *The Daily Show* and *The Colbert Report* is actually associated with more political participation and higher political knowledge (e.g., Baumgartner & Morris, 2006; Young & Hoffman, 2009).

The Internet has, of course, emerged as an important additional medium for civic and political engagement (Pew Internet, 2006). While Nie and Erbring (2000) found that Internet use was negatively related to time spent with other media, family, and friends, still other studies found that heavy Internet users were more likely to have social relationships than light users (Uslaner, 2004). Internet use has been shown to positively affect political participation (Gibson, Howard, & Ward, 2000; Hill & Hughes, 1998; Kraut et al., 2002); however, it has also been shown to affect political engagement negatively or to have no effect at all on engagement (Johnson & Kaye, 2003 Kraut et al., 2002). A likely explanation for this inconsistency is the operation of mediating variables such as level of social capital, personal communication efficacy, and motivations to use the Internet (Kavanaugh & Patterson, 2001; Kim & Ball-Rokeach, 2006; Shah et al., 2001). Finally, entertainment Internet use is not positively correlated with indicators of political engagement (Shah et al., 2001).

An important question particularly pertinent for the current study is the extent to which youth use the Internet for political communication. According to Livingstone and his colleagues, adolescents had little interest in political participation on the Internet (Livingstone & Bober, 2004; Livingstone, Bober, & Helsper, 2004). On the other hand, Montgomery (2000) reported that adolescents used the Internet to express themselves in public forums; and, compared to other

ages, young people are actively participating in political activities on the Internet. Lin, Kim, Jung, & Cheong (2005) found that adolescents' level of Internet use is positively related to their degree of involvement in community service, especially when they used the Internet for gaining information about community affairs. In this vein, among the various usage patterns of the Internet and outcomes of media effects, the current study focuses on the effects of adolescents' Internet news use (i.e., information use) on two aspects of political engagement: political interest and political knowledge.

Based on the existing research it seems that knowledge of political issues and political players should be predicted by news media exposure. However, we would expect the impact of news media to be low for civics knowledge. Therefore we hypothesize:

H6: News media consumption via television, newspapers, and the Internet will have a positive effect on Issues and Political Players knowledge, but less effect on Civics knowledge.

H7: Consumption of entertainment media will have a negative effect on all three types of political knowledge.

School-Based Communication Effects

School experiences represent another realm of adolescents' interpersonal communication where political learning takes place. School interventions have been found to mitigate the social structural disparities outside of the classroom through increased political knowledge (Meirick & Wackman, 2004). Yet school curricula vary in terms of how effective they are at instilling knowledge in youth (Torney-Purta, 2002, 2004) with some programs simply teaching historical "facts" about government. Other civics education programs are less common, at least in the US, but involve much more elaborate activity. For example, Kids Voting USA is a school intervention that emphasizes participatory activities such as serving as poll judges on election day, school-wide mock elections, and critiquing and discussing political advertisements in class. The lessons also often ask the youth to involve their parents in discussion about politics. McDevitt and his colleagues have shown impressive long and short-term gains associated with these experiences, both in terms of political knowledge and voting even in years after the curriculum experience. Kids Voting USA exposure has been linked to higher attention to news media and more frequent discussion with family and friends about politics (Simon & Merrill, 1998), increased political knowledge (Meirick & Wackman, 2004), and increased voter turnout averaging approximately 3% increased turnout in communities where the Kids Voting USA curriculum was adopted in the schools (Merrill, Simon, & Adrian, 1994). This school intervention also led to

indirect effects on parents, including parent's information seeking, opinion forma-
tion, and stimulation of concept-oriented communication (McDevitt & Chaffee,
2000) in which there is more democratic give and take between parent and child.
Thus, schools can potentially provide social interaction for youth that may not be
available from parents at home (Kiousis & McDevitt, 2008). These differences in
types of public school civics curricula suggest that it is important to ask how much
active participation and discussion youth experience in politically related school
communication. Because of the multi-dimensional impact of active political cur-
ricula, we expect that:

> **H8:** School experiences that involve active participation and active discussion will have a
> positive impact on all three measures of political knowledge.

We also expect that there will be differential relationships among the three mea-
sures of political knowledge and political participation. Civics information, given
that it is primarily knowledge about the structure and function of government
institutions, would not be expected to have a particular relationship with par-
ticipation in electoral politics such as voting or political campaign interest or
involvement. While all American public school students are required to take some
form of government, social studies, or civics courses, these courses probably do not
emphasize any linkage between the structure of government and engagement as a
citizen, with the possible exception of emphasizing voting (Torney-Purta, 2004).
But learning about political players and election issues would be more likely to
generate an interest in, and possible involvement with, current campaigns and
elections. Individuals, including adolescents, might be more likely to volunteer for
a political party or candidate, attend a political meeting, or wear a political cam-
paign button. Any of these activities would presumably be associated more with
learning who the candidates are and where they stand on the issues. Therefore we
expect that:

> **H9:** Civic knowledge will not correlate with political participation, but knowledge of
> political players and issues will.

Finally, as we suggested previously, we believe all three measures of political knowl-
edge will strongly correlate with each other and load on a single factor (see Delli
Carpini & Keeter, 1996). But we also suggest that looking only at the conglom-
erate scale will be misleading in terms of both predictor and validator variables.

METHOD

The hypotheses were tested in a state/local off-year election in Kansas City,
Missouri, and its suburbs in November 2010. In the Kansas City metropolitan

area, both Kansas and Missouri races are relevant. In the Kansas U.S. Senate race, Republican Jerry Moran beat newcomer Democrat Lisa Johnston 70% to 26%. Although the Republican primary was hotly contested, the lack of competition in the fall election itself meant little excitement was generated by the race. Voter turnout for the Kansas 2010 elections was just under 42%, compared with a 61% Kansas turnout in the 2008 presidential race.

In the Missouri U.S. Senate race, Republican Roy Blunt defeated Democrat Robin Carnahan by 54% to 41%. This race was more hotly contested and featured a large number of televised attack ads from both sides. Voter turnout for the Missouri 2010 elections was approximately 47%, compared with a 69% Missouri turnout in the 2008 presidential race.

Nationally, in 2010 there was much less turnout among voters aged 18–29 (only about 11%), compared with the 51% turnout among 18–29-year-olds in the 2008 presidential election. In general, then, the 2010 elections in the metropolitan Kansas City area can be characterized as fairly low involvement. Exploring adolescents' engagement in these elections, however, remains useful, because, as Zhao and Chaffee (1995) pointed out, it is important to explore political socialization processes across a variety of geographic locations in different kinds of political races.

Two metropolitan Kansas City school districts provided their high school directories that contained names and addresses of all families of enrolled students. A census-based sample of other school districts in the region was also purchased from Marketing Systems Group consisting of families that had reported at least one child aged 14–19 in the home. In the initial mailing, half the surveys went to directory addresses and half went to addresses in the purchased sample.

The cover letter of the survey asked parents to fill out the first section of the questionnaire, then hand it to their son or daughter to complete a middle section, and then have it returned so parents could complete the final section. The cover letter also indicated that 25 families would be entered into a raffle draw to win $50 checks. The University Institutional Review Board approved all procedures. A total of 8000 surveys were mailed out 2 days after the November 2010 mid-term election, half from the directories and half from the Marketing Systems Group. Because the initial response level was low, a second mailing of 1860 surveys to additional randomly sampled addresses from the high school directories was sent on December 15, 2010. The total number of returned surveys from the first mailing was 362, of which 344 were sufficiently completed. The second mailing yielded 53 additional responses, all of which were sufficiently completed. Therefore, the total number of useable surveys was 397.

Because we used bulk mail, undeliverable mailings were not returned and thus it is not possible to determine how many of the mailed surveys were never delivered. Assuming all envelopes were successfully delivered to eligible families (which

was very likely not the case), the overall response rate was 4%. Clearly the low response rate means that the results are in no way representative of the Kansas City area. As might be expected, the socio-economic status (SES) of our respondents was higher than the demographic characteristics of metropolitan Kansas City.

Participants

Of the 397 adolescents who participated in the survey, 52.1% (n = 207) were females, while 47.6% (n = 189) were males. There was one missing (0.3%) in the response for gender identification. The majority of participants (86.9%, n = 345) were White, while 6.5% (n = 26) were African American, 5.0% (n = 20) were other races (Native American, Asian, Pacific Islander, and multi-racial), and 1.5% of the responses (n = 6) for race were coded as missing. Of the participants aged 14 through 19, the mean age was 15.9 years.

Data Analyses

First-order correlations were used to examine the hypothesized relationships among the three subscales of political knowledge and the conglomerated political knowledge measure. Relationships between predictor variables and the three political knowledge subscales were tested using hierarchical regression analysis that allows ordering conceptually and empirically hypothesized variables and entering them into different blocks. Two sets of variables, demographics (age, gender, and race) and child political interest, were controlled in the first blocks. Next we entered school political experiences, parent/child conversations about politics, and media use (news media use: TV, print, and online/entertainment media use).

Gender was dummy coded as 0 = female and 1 = male; race was dummy coded as 0 = African American and 1 = Caucasian for correlation, and all the three races (Caucasian, African American, and other) were dummy coded by setting Caucasian as the comparison group; parent education (mother's education and father's education) was also dummy coded as 1 = some high school, 2 = graduated high school, 3 = graduated trade school, 4 = graduated college, and 5 = MA, MS, PhD, MD, JD; categories for household income ranged from under $20,000 (1) to $100,000 or more (8).

Measures

"Children's political interest" was measured using three items asking how much a child agrees or disagrees with statements regarding political interest. The responses ranged from "strongly disagree (1)" to "strongly agree (5)."

"School political experiences" was measured using 11 items asking respondents to indicate the frequency of politics-related activities in school (e.g., learning about government in class, analyzing political cartoons in class) during the past 6 months. The responses ranged from "not at all (0)" to "very frequently (7)."

"Parent/child conversations about politics" was measured with eight items taken from two different sets of questions. For the first four items, the parents reported how much they agree with statements describing their parent-child conversation patterns. Here, the response scale ranged from "strongly disagree (1)" to "strongly agree (5)." The adolescents completed the other four items by indicating how frequently he or she engaged in politics-related conversations with a parent during the past 6 months, and the response scale ranged from "not at all (0)" to "very frequently (7)." The eight-point scale for the child report was recoded into a five-point scale to match the scale used for the parent report.

News media use and entertainment media use were measured as part of overall "media use." News media use was classified in terms of media types: "TV news," "print news," and "online news." "TV news" was created with six items measuring how many days an adolescent watched TV news programs, and responses ranged from "None (0)" to "7 days (7)." "Print news" and "online news" were generated using multiple items asking the amount of time each day an adolescent used the particular news medium. Here, responses ranged from "don't use (0)" to "5 or more hours (7)." Ten items measured consumption of "entertainment media use" by having children indicate the number of days in a typical week they watched various entertainment TV programs. The responses ranged from "none (0)" to "7 days (7)." Table 1 lists the items that make up each variable, along with the reliability coefficient for each measure.

"Political knowledge" was measured by combining six items measuring the subtypes of political knowledge: Civics, Political Players, and Issues (two items for each subtype of political knowledge). The index of overall political knowledge was gained by taking the mean score of the six items. Civics was measured by asking: "Which political party is more conservative?" and "Whose responsibility is it to determine if a law is constitutional or not?" Issues was measured with "Do you happen to know if children born to illegal immigrants in the U.S. are automatically U.S. citizens or are they not?" and "Do you happen to know if the national unemployment rate is currently closer to 5% or 10% or 15% or 20%?" Political Players was measured with "In Missouri, what office did Robin Carnahan run for?" and "In Kansas, what office did Jerry Moran run for?" Each correct answer was scored 1, while each incorrect answer was scored 0. Thus, the highest possible score for overall political knowledge was 6 and the possible lowest score was 0, while the possible score for each subtype of political knowledge ranged from 0 to 2.

"Political participation" was measured by six items asking respondents to indicate how frequently during the past 6 months he or she had engaged in:

Table 1. Theoretical Variables and Their Operationalization.

Variable	Item	Reliability (Cronbach's α)
Political interest	I paid attention to the election campaigns in my state	
	I was interested in the election campaigns in my state	.88
	I am interested in politics	
School political experiences	Followed the news as part of a class assignment	
	Learned about how government works in class	
	Discussed/debated political or social issues in class	
	Participated in political role-playing in class (mock trials, elections)	
	Was encouraged to make up my own mind about issues in class	
	Analyzed political cartoons in class	.90
	Spoke your opinion in class even when the topic was controversial	
	Learned about political advertising in class	
	Talked in class about what makes a news story credible	
	Worked with a community organization as part of a class assignment	
	Helped to register voters as part of a class assignment	
Parent/child conversations		
Parent report	I often encourage my child to talk about politics	
	I talk with my child to help him/her understand what is on the news	
	I suggest to my child that he/she learn more about the political issues seen in the news	
	I am willing to listen to my child's political opinion even if it's different from mine	.78
Child report	Talked about news and current events with family members	
	Tried to talk a parent into supporting any candidate or party	
	Asked a parent a question about a political issue	
	Encouraged a parent to vote in the November election	
TV news	*The Today Show*, *Good Morning America*, or *The Early News*	
	National nightly news on CBS, ABC, or NBC	

Table 1. (Continued)

Variable	Item	Reliability (Cronbach's α)
	Local news about your viewing area (5 p.m., 6 p.m., or 10 p.m.)	.81
	News magazine shows such as *60 Minutes* or *Dateline*	
	CNN cable news programs (Anderson Cooper)	
	Fox cable news programs (Bill O'Reilly)	
Print news	A print copy of a national newspaper (*New York Times, USA Today*)	r = .32
	A print copy of the *Kansas City Star*	
Radio news	Conservative talk radio (Rush Limbaugh, Michael Savage)	
	News programming on NPR (*All Things Considered*)	.63
	News reports on music radio	
	Christian television and radio programs (700 club)	
Online news	National newspaper websites	
	Online–only news magazines	
	Conservative political blogs	
	Liberal political blogs	.71
	TV news websites	
	Political candidates' websites	
Entertainment media	Primetime reality programs (*Survivor, American Idol*)	
	Primetime comedy programs (*Two and a Half Men, The Office*)	
	Primetime cartoon programs (*Family Guy, The Simpsons*)	
	Primetime drama programs (*Grey's Anatomy, CSI*)	
	Late night TV shows such as David Letterman and Jay Leno	.73
	Game shows (*Jeopardy!, Wheel of Fortune*)	
	Daytime talk shows (*Oprah, The View*)	
	Teen programs (*Hannah Montana, iCarly*)	
	Daytime cartoon programs (*SpongeBob, Scooby–Doo*)	
	MTV programs (*The Jersey Shore, Real World*)	

"contributing money to a political campaign," "volunteering for a political party or candidate," "attending a political meeting, rally, or speech," "working for a political party or candidate," "displaying a political campaign button, sticker, or sign," and "attending a political protest activity." The responses ranged from "not at all (0)" to "very frequently (7)."

RESULTS

As shown in Table 2, overall political knowledge was high with a mean of 3.59, S.D. = 1.65 (out of 6). The Issue knowledge items were also high (M = 1.45 out of 2; SD = .66) and only slightly lower for government information (M = 1.31 out of 2; SD = .76). Scores were lowest for the names of the Kansas and Missouri

Table 2. Descriptive Statistics for Variables.

Variables	M	SD	Min	Max
Outcome variables				
Political knowledge	3.59	1.65	0	6
Knowledge about government	1.31	.76	0	2
Knowledge about political issues	1.45	.66	0	2
Knowledge about candidates	.86	.82	0	2
Predictor variables				
Age	15.90	1.23	14	19
Gender (female = 0)	.48	.50	0	1
Race				
White (reference)				
African American	.07	.05	0	1
Other	.05	.22	0	1
Political interest	2.82	1.13	1	5
School political experiences	2.62	1.65	0	7
Parent/child conversations	2.84	.79	.81	5
Media use				
TV news	.98	1.20	0	7
Print news	.44	.63	0	3.50
Radio news	.50	.72	0	6.25
Online news	.22	.42	0	3.75
Entertainment TV	1.25	1.00	0	5.38

winning Senators (i.e., candidate knowledge; M = .86 out of 2, SD = .82). Participation in politics was also low (M = .45; SD = .98). News media use was not high, as the mean number of days per week youth watched a TV news show was .98 (out of 7). Mean time spent with print news per day was .44 (where 0 = none and 1 = less than 30 minutes). On the same scale mean time spent with online news was .22.

Table 3 shows first order correlations. As predicted (H1), all three subscales were positively related to each other and, of course, highly related to the conglomerated scale. Males scored higher than females (H2) only on Political Players. For the other subscales there were no differences. Race was significantly associated with Civics (H3) as African Americans scored lower than Caucasians (β = −.12, p < .05). Older youth had higher Civics scores than younger youth (H4), but the other two subscales showed no age differences.

Also as predicted, parent-child conversations had a positive relationship with all three subscales (H5); but the correlations for Civics and Political Talk were higher than for Issues. Perhaps most interesting was the fact that the three measures of news consumption (H6: TV news, newspapers, online news) were significantly correlated only with Political Players. Also somewhat surprising was that entertainment media time was negatively related only to Civics (H7), and unrelated to Issues and Political Players. As predicted, school communication had a significant positive relationship with Civics (H8), but it also had a positive relationship with Political Players. Finally, only Political Players was correlated with participation (H9).

Examination of the correlations in Table 3 shows that the correlations with the conglomerated scale result from impact of the subscales. If a predictor variable has a relationship with just one subscale, the conglomerated scale will have a relationship with that predictor only if the single relationship is strong enough to drive it. For example, age is related to Civics; but that relationship was not strong enough to produce a correlation between age and the conglomerated scale. The correlation between TV News and Political Players, however, was strong enough that there was an overall significant correlation between the conglomerate scale and TV news, even though the other subscales were not related. What this means, then, is that it is important to distinguish among types of political knowledge but they are clearly driven by different predictor variables.

We look finally, therefore, not at regressions predicting overall knowledge of political facts but at the three regressions predicting Civics, Issue, and Political Player knowledge. Those regressions are shown in Tables 4, 5, and 6. The regression predicting Civics (see Table 4) accounted for 24% of the variance. Some of the linkages represented by the first-order correlations were retained, but school experience and political talk with others were no longer significant. Political interest remained significant and positive and entertainment television remained

Table 3. Correlations Among All Outcome and Predictor Variables.

	PK	GK	IK	CK	AGE	GEN	AA	OTH	PI	SPE	PCC	TVN	PRN	RAN	ONN	ETV
PK	1															
GK	.76***	1														
IK	.66***	.32***	1													
CK	.75***	.33***	.21***	1												
AGE	.09	.11*	.06	.03	1											
GEN	.12*	.00	.10	.15**	-.03	1										
AA	-.17**	-.18***	-.13*	-.08	.13*	-.05	1									
OTH	-.10	-.13*	-.07	-.03	-.01	.08	-.06	1								
PI	.39***	.32***	.12*	.38***	.07	.16**	-.02	-.04	1							
SPE	.21***	.19***	.03	.21***	.10*	-.04	.02	.00	.42***	1						
PCC	.32***	.27***	.12*	.30***	.07	.06	-.03	-.01	.57***	.58***	1					
TVN	.12*	-.01	.04	.21***	.00	.12*	.21***	-.01	.34***	.21***	.29***	1				
PRN	.08	.03	-.01	.14**	-.01	.08	.04***	-.03	.25***	.24***	.20***	.35***	1			
RAN	.00	.03	-.13**	.08	.01	.02	.17**	.03	.25***	.30***	.25***	.29***	.22***	1		
ONN	.02	-.04	-.07	.12*	.07	.07	.20***	-.00	.30***	.36***	.28***	.41***	.33***	.49***	1	
ETV	-.18***	-.27***	-.08	-.06	-.06	-.03	.33***	.04	-.04	-.00	-.05	.41***	.10*	.22***	.24***	1

$*p < .05; **p < .01; ***p < .001.$
PK: Political knowledge; GK: Government knowledge; IK: Issue knowledge; CK: Candidate knowledge; AGE: Age; GEN: Gender; AA: African American; OTH: Other; PI: Political interest; SPE: School political experiences; PCC: Parent/child conversations; TVN: TV news; PRN: Print news; RAN: Radio news; ONN: Online news; ETV: Entertainment TV.

significant and negative. What this means, of course, is that variables such as school experience are sharing variance with many of the demographic controls, and they are so highly correlated with our variables of interest that they swamp their effects.

Table 5 shows the regression for Issue knowledge. It accounted for a much smaller percentage of the variance (9%) than we found for Civics. Political interest is just about all one needs to know to predict Issue knowledge. Here, the effect of political talk disappears. Political interest and political talk are correlated .42, while political interest and school experiences are correlated .52. Clearly, what is needed is a mediation model where these effects are mediated through the development of political interest.

Finally, Table 6 shows the regressions for knowledge of Political Players. It accounts for 19% of the variance. Again, we find that political interest is the big predictor. The effects of school experience, political talk with others, and TV news, print news, and online news all disappear. Political interest is correlated .34 with TV news, .25 with print news, and .30 with Internet news use.

DISCUSSION

Delli Carpini and Keeter's (1996)—now 20 years old—critique of how we measure adult political knowledge is clearly relevant to how we measure political knowledge in adolescents. Although the present study can be criticized for utilizing two-item scales for its knowledge subscales, the intercorrelations between these knowledge measures and measures of interpersonal, school-based, and news mediated communication about politics demonstrates their viability. It was also the case that we could account for a significant amount of variance in the measures with the regression analyses. While it might be desirable to expand the items in these subscales (and perhaps add other categories of political knowledge, such as, for example, cognitive structural integration as measured by Eveland and Hively (2009)), the point made clearly here is that an "overall" measure of political knowledge leads us to misunderstand the communication processes that lead to knowing about politics.

Our overall measure, which included government structure information, information about current political issues, as well as about winners and losers in current political races, was, like so many other measures in political socialization research, a collection of largely unrelated "factoids." We did not know which of the items were covered in school political curricula or in the political news in any media venue. But what became clear in our analysis was that when the composite scale was broken into components, those components were differentially related to specific communication variables.

Table 4. Results of Hierarchical Regression Analysis Predicting Civics Knowledge.

Variable	Model 1			Model 2			Model 3			Model 4		
	B	SE	β	B	SE	β	B	SE	β	B	SE	β
Demographics												
Age	.08	.03	.14**	.08	.03	.13**	.08	.03	.13**	.07	.03	.12*
Gender (female)	-.09	.07	-.06	-.08	.08	-.05	-.08	.08	-.05	-.07	.08	-.05
Race												
White (reference)												
African American	-.37	.16	-.12*	-.37	.16	-.13*	-.37	.16	-.12*	-.18	.17	-.06
Other	-.27	.17	-.08	-.27	.17	-.08	-.28	.17	-.08a	-.30	.17	-.09a
Mother's education	.02	.04	.03	.02	.04	.03	.03	.04	.04	.03	.04	.04
Father's education	.09	.04	.15*	.09	.04	.15*	.09	.04	.14*	.07	.04	.11a
Income	.04	.02	.09	.04	.02	.09	.03	.02	.09	.03	.02	.08
Political interest	.19	.03	.30***	.18	.04	.29***	.17	.04	.25***	.17	.04	.27***
School experiences				.02	.03	.03	.02	.03	.00	.02	.03	.04
Parent/child conversation							.08	.06	.08	.08	.06	.08
Media use												
TV news										.02	.04	.04
Print news										-.05	.06	-.04
Online news										-.19	.10	-.11a
Entertainment media										-.10	.05	-.13*
R^2		.209			.210			.214			.241	
Adjusted R^2		.191			.189			.190			.209	
F for R^2 change		11.182***			.399			1.420			3.009*	

[a]$p < .10$.
*$p < .05$; **$p < .01$; ***$p < .001$.

Table 5. Results of Hierarchical Regression Analysis Predicting Issues Knowledge.

Variable	Model 1			Model 2			Model 3			Model 4		
	B	SE	β	B	SE	β	B	SE	β	B	SE	β
Demographics												
Age	.06	.03	.12*	.06	.03	.12*	.06	.03	.12*	.06	.03	.12*
Gender (female)	.09	.07	.07	.08	.07	.06	.08	.07	.06	.08	.07	.06
Race												
White (reference)												
African American	−.25	.15	−.10	−.24	.15	−.09	−.23	.15	−.09	−.21	.16	−.08
Other	−.17	.16	−.06	−.17	.16	−.06	−.18	.16	−.06	−.18	.16	−.06
Mother's education	.04	.04	.07	.04	.04	.07	.05	.04	.09	.05	.04	.09
Father's education	−.02	.04	−.03	−.02	.04	−.03	−.02	.04	−.04	−.02	.04	−.04
Income	.04	.02	.12[a]	.04	.02	.12	.04	.02	.11[a]	.04	.02	.12[a]
Political interest	.04	.03	.07	.06	.03	.10	.04	.04	.04	.02	.04	.04
School experiences				−.03	.02	−.07	−.05	.03	−.12[a]	−.04	.03	−.10
Parent/child conversation							.12	.06	.14[a]	.11	.06	.13[a]
Media use												
TV news										.04	.04	.08
Print news										−.06	.06	−.06
Online news										−.11	.10	−.07
Entertainment media										−.01	.04	−.01
R^2	.063			.067			.077			.086		
Adjusted R^2	.041			.042			.049			.047		
F for R^2change	2.852**			1.226			3.712[a]			.808		

[a] $p < .10$.
* $p < .05$. ** $p < .01$. *** $p < .001$.

Table 6. Results of Hierarchical Regression Analysis Predicting Political Players Knowledge.

Variable	Model 1			Model 2			Model 3			Model 4		
	B	SE	β	B	SE	β	B	SE	β	B	SE	β
Demographics												
Age	.00	.03	.01	.00	.03	.00	.00	.03	.00	.00	.03	.01
Gender (female)	.07	.08	.04	.08	.08	.05	.08	.08	.05	.06	.09	.04
Race												
White (reference)												
African American	-.18	.18	-.05	-.18	.19	-.06	-.18	.19	-.05	-.24	.19	-.07
Other	-.04	.19	.01	.03	.19	.01	.03	.19	.01	.03	.19	.01
Mother's education	-.03	.04	-.04	-.03	.04	-.04	-.03	.04	-.04	-.02	.04	-.03
Father's education	-.03	.04	.05	.03	.04	.05	.03	.04	.04	.04	.04	.05
Income	.02	.03	.06	.02	.03	.05	.02	.03	.05	.02	.03	.05
Political interest	.28	.04	.39***	.26	.04	.37***	.24	.04	.34***	.22	.05	.31***
School experiences				.02	.03	.04.	.00	.03	.01	.00	.03	-.00
Parent/child conversation							.09	.07	.09	.07	.07	.07
Media use												
TV news										.06	.04	.09
Print news										.03	.07	.02
Online news										.03	.11	.02
Entertainment media										-.01	.05	-.01
R^2	.175			.176			.180			.188		
Adjusted R^2	.155			.154			.156			.154		
F for R^2 change	8.936***			.596			1.567			.826		

$p < .10.$
$^{*}p < .05; ^{**}p < .01; ^{***}p < .001.$

Parent-child conversations were positively related to all three subscales, but more so for Civics and Political Players knowledge. At least in the 2010 midterm election, this may have occurred because parents were talking with their children about their school experiences and that enhanced their Civics knowledge. And there may have been more conversations about who won these two big U.S. Senate races, which would have increased the likelihood of Political Players knowledge. The only knowledge that was enhanced by political news exposure was Political Players. This makes sense in that it seems likely that there were lots of (especially) TV news stories about the two Senate races, especially in the Kansas City area, and the salience of the information was probably hard to miss even with sporadic and light viewing. Particularly in TV, but also in newspapers and online news (which was probably either TV or print newspaper sites), there would have been only a few focused stories on our two issues, the citizenship status of children of illegal immigrants and the national unemployment rate. Of course, these issues were part of the dialogue of the Senate races, but this discussion would have been less salient than knowledge of the candidates themselves and their party affiliation.

It is also intriguing that entertainment TV significantly damaged only Civics knowledge. We suspect this reflects the general negative impact of media entertainment time on time spent with homework and studying (e.g., Sharif & Sargent, 2006). Actually, our Issues and Political Players items were of sufficiently high presence during the election that the youth may have picked them up incidentally (e.g., Erdelez, 1997). More difficult questions added to these scales would seem likely to increase the negative impact of time spent with entertainment media.

School experiences were related to both Civics and Political Players knowledge, which is probably consistent with the likelihood that government, civics, and political science courses in high schools would touch on major state candidate races, as well as focusing on government structure and function. In future research, especially as it looks to further evaluation of active political curricula such as Kids Voting USA (e.g., McDevitt & Chaffee, 2000), it will be important to compare specifics of what youth are encountering in relevant high school courses.

The same can be said of the fact that political participation was only related to Political Players knowledge. It was not correlated with amount of school experiences. We suspect this was because the teachers at the schools from which we drew our sample reported that they did not spend much time with the fall 2010 election as this was not a national or presidential election and in fact was of little interest to either the students or the teachers themselves.

Of course our sub-sample scales were highly correlated with each other, but the fact that their relationships with other variables were so different shows that they certainly were not measuring the same achievement of knowledge. Based on

these results, we recommend looking very carefully at the body of current research on "youth political knowledge," as much of this research has used random and unrelated political fact questions. In future work exploring our youngest generation's learning of what they need to know to be citizens and voters, it is crucially important to develop psychometrically and logically sound measures of the different kinds of "political knowledge."

A major caveat in this study was, of course, our low response rate. Even with the offer of the chance to win one of 25 $50 checks, which would provide a much higher expected payout rate than most state lotteries, the response rate was very low. Clearly, the obtained sample was skewed toward higher SES, more Republicans (46% as opposed to 22% Democrats and 18% Independents), and 79% of the parents claimed to have voted in the election when turnout in both states was less than 50%. It will be crucial to determine a better way to reach a wider range of respondents in future research.

REFERENCES

Atkin, C. (1981). Communication and political socialization. In D. Nimmo & K. Sanders (Eds.), *Handbook of political communication* (pp. 299–328). Beverly Hills, CA: Sage.

Austin, E. (1993). Exploring the effects of active parent mediation of television context. *Journal of Broadcasting & Electronic Media, 37*(2), 147–159.

Austin, E. W., Bolls, P., Fujioka, Y., & Engelbertson, J. (1999). How and why parents take on the tube. *Journal of Broadcasting and Electronic Media, 43,* 175–192.

Austin, E. W., & Pinkleton, B. E., (2001). The role of parental mediation in the political socialization process. *Journal of Broadcasting & Electronic Media, 45,* 221–240.

Austin, E. W., Roberts, D. F., & Nass, C. I. (1990). Influences of family communication on children's television interpretation processes. *Communication Research, 17,* 545–564.

Baumgartner, J., & Morris, J. S. (2006). *The Daily Show* effect: Candidate evaluation, efficacy, and American youth. *American Politics Research, 32*(3), 341–367.

Baumrind, D. (1967). Child care practices anteceding three patterns of preschool behavior. *Genetic Psychology Monographs, 75,* 43–88.

Baumrind, D. (1970). Socialization and instrumental competence in young children. *Young Children, 26,* 104–119.

Chaffee, S. H. (1972). The interpersonal context of mass communication. In F. G. Kline & P. J. Tichenor (Eds.), *Current perspectives in mass communication research* (pp. 95–120). Beverly Hills, CA: Sage.

Chaffee, S. H., McLeod, J. M., & Atkin, C. K. (1971). Parental influence on adolescent media use. *The American Behavioral Scientist, 14,* 323–340.

Chaffee, S. H., McLeod, J. M., & Wackman, D. B. (1973). Family communication patterns and adolescent's political participation. In J. Dennis (Ed.), *Socialization to politics: A reader* (pp. 349–364). New York, NY: Wiley.

Chaffee, S. H., & Yang, S. (1990). Communication and political socialization. In O. Ichilov (Ed.), *Political socialization for democracy* (pp. 137–158). New York, NY: Columbia University Teachers College Press.

Delli Carpini, M. X. (2000). Gen.Com: Youth, civic engagement, and the new information environment. *Political Communication, 17*, 341–349.

Delli Carpini, M. X., & Keeter, S. (1996). *What Americans know about politics and why it matters.* New Haven, CT: Yale University Press.

Denton, F., Thorson, E., & Coyle, J. (1998). Effects of a multimedia public journalism project on political knowledge and attitudes. In E. Lambeth, P. Meyer, & E. Thorson (Eds.), *Assessing public journalism.* Columbia, MO: University of Missouri Press.

Dimmick, J. (1976). Family communication and TV program choice. *Journalism Quarterly, 53*, 720–723.

Erdelez, S. (1997). Information encountering: A conceptual framework for accidental information discovery. In P. Vakkari, R. Savolainen, & B. Dervin (Eds.), *Information seeking in context: Proceedings of an international conference on research in information needs, seeking and use in different contexts* (pp. 412–421). London, England: Taylor Graham.

Eveland, W. P., Jr. (2004). The effect of political discussion in producing informed citizens: The roles of information, motivation, and elaboration. *Political Communication, 21*, 177–193.

Eveland, W. P., & Hively, M. H. (2009). Political discussion frequency, network size, and "heterogeneity" of discussion as predictors of political knowledge and participation. *Journal of Communication, 59*(2), 20.

Eveland, W. P., Jr., & McLeod, J. M. (1998). Communication and age in childhood political socialization: An interactive model of political development. *Journalism & Mass Communication Quarterly, 75*(4), 699–718.

Eveland, W. P., Jr., McLeod, J. M., & Horowitz, E. M. (1998). Communication and age in childhood political socialization: An interactive model of political development. *Journalism and Mass Communication Quarterly, 75*, 699–718.

Fleming, K., Thorson, E., & Peng, Z. (2005). Associational membership as a source of social capital: Its links to use of local newspapers, interpersonal communication, entertainment media, and volunteering. *Mass Communication and Society, 8*(3), 219–240.

Frazer, E., & MacDonald. (2003). Sex differences in political knowledge in Britain. *Political Studies, 5*(1), 67–83.

Freud, S. (1933). *New introductory lectures in psychoanalysis.* New York, NY: Norton.

Gibson, R. K., Howard, P., & Ward, S. (2000). *Social capital, Internet connectedness and political participation: A four-country study.* Paper presented at the International Political Science Conference, Quebec, Canada.

Gniewosz, B., Noack, P., & Buhl, M. (2009). Political alienation in adolescence: Associations with parental role models, parenting styles and classroom climate. *International Journal of Behavioral Development, 33*(4), 337–346.

Harp, D., Bachmann, I., Rosas-Moreno, T. C., & Loke, J. (2010). Wave of hope: African American youth use media and engage more civically, politically than Whites. *Howard Journal of Communications, 21*(3), 224–246.

Hill, K. A., & Hughes, J. E. (1998). *Cyberpolitics: Citizen activitism in the age of the Internet.* Lanham, MD: Rowman & Littlefield.

Johnson, T. J., & Kaye, B. K. (2003). A boost or bust for democracy? How the web influenced political attitudes and behaviors in the 1996 and 2000 presidential elections. *The Harvard International Journal of Press/Politics, 8*(3), 9–34.

Kavanaugh, A. L., & Patterson, S. J. (2001). The impact of community computer networks on social capital and community involvement. *American Behavioral Scientist, 45*, 469–509.

Kaye, B. K., & Johnson, T. J. (2002). Online and in the know: Uses and gratifications of the web for political information. *Journal of Broadcasting and Electronic Media, 46*(1), 54–71.

Kim, Y. C., & Ball-Rokeach, S. (2006). Community storytelling network, neighborhood context, and neighborhood engagement: A multilevel approach. *Human Communication Research, 32,* 411–439.

Kiousis, S., & McDevitt, M. (2008). Agenda setting in civic development: Effects of curricula and issue importance on youth voter turnout. *Communication Research, 35*(4), 481–502.

Kraut, R., Kiesler, S., Boneva, B., Cummings, J., Helgeson, V., & Crawford, A. (2002). Internet paradox revisited. *Journal of Social Issues, 58*(1), 49–74.

Lin, Y., Kim, Y. C., Jung, J.-Y., & Cheong, P. H. (2005). *The Internet and civic engagement of youth: A case of East Asian cities.* Paper presented to Association of Internet Researchers Conference, Chicago, Illinois.

Livingstone, S., & Bober, M. (2004). *UK children go online: Surveying the experiences of young people and their parents.* London, England: London School of Economics and Political Science.

Livingstone, S., Bober, M., & Helsper, E. J. (2004). *Active participation or just more information? Young people's take up of opportunities to act and interact on the Internet.* London, England: London School of Economics.

McDevitt, M. (2006). The partisan child: Developmental provocation as a model of political socialization. *International Journal of Public Opinion Research, 18*(1), 67–88.

McDevitt, M., & Chaffee, S. (2000). Closing gaps in political communication and knowledge: Effects of a school intervention. *Communication Research, 27*(3), 259–292.

McDevitt, M., & Chaffee, S. (2002). From top-down to trickle-up influence: Revisiting assumptions about the family in political socialization. *Political Communication, 19,* 281–301.

McDevitt, M., & Kiousis, S. (2006). Deliberative learning: An evaluative approach to interactive civic education. *Communication Education, 55*(3), 247–264.

McLeod, J. M., & Chaffee, S. H. (1973). Interpersonal approaches to communication research. *The American Behavioral Scientist, 16*(4), 469.

McLeod, J. M., Eveland, W. P., Jr., & Horowitz, E. M. (1998). Going beyond adults and voter turnout: Evaluating a socialization program involving schools, family and media. In T J. Johnson, C. E. Hays, & S. P. Hays (Eds.), *Engaging the public: How government and the media can reinvigorate American democracy* (pp. 217–234). Lanham, MD: Rowman and Littlefield.

McLeod, J. M., Rush, R. R., & Friederich, K. H. (1968). The mass media and political information in Quito, Ecuador. *Public Opinion Quarterly, 32,* 575–587.

Meirick, P. C., & Wackman, D. B. (2004). Kids Voting and political knowledge: Narrowing gaps, informing votes. *Social Science Quarterly, 85*(5), 1161–1177.

Merrill, B. D., Simon, J., & Adrian, E. (1994). Boosting voter turnout: The Kids Voting Program. *Journal of Social Studies Research, 18,* 2–7.

Miller, A. S. (1992). Are self-proclaimed conservatives really conservative? Trends in attitudes and self-identification among the young. *Social Forces, 71,* 195–210.

Milner, H. (2002). *Civic literacy: How informed citizens make democracy work.* Hanover: University Press of New England.

Montgomery, K. (2000). Youth and digital media: A policy research agenda. *Journal of Adolescent Health, 27S,* 61–68.

Nathanson, A. (1998). Identifying and explaining the relationship between parental mediation and children's aggression. *Communication Research, 26,* 124–143.

Nie, N. H., & Erbring, L. (2000, February 17). Internet and society: A preliminary report. *Stanford Institute for the Quantitative Study of Society.* Retrieved from http://www.nomads.usp.br/documentos/textos/cultura_digital/tics_arq_urb/internet_society%20report.pdf

Niemi, R. (1973). Political socialization. In Jeanne N. Knutson (Ed.), *Handbook of political psychology*. San Francisco, CA: Jossey-Bass.

Norris, P. (1996). Does television erode social capital? A reply to Putnam. *PS: Political Science & Politics, 29*(03), 474–480.

Patterson, T. (2007, July). Young people and news. Joan Shorenstein Center on the Press, Politics and Public Policy. Retrieved from http://www.hks.harvard.edu/presspol/research/carnegie-knight/young_people_and_news_2007.pdf

Pew Internet & American Life Project. (2006). Online Video: 57% of internet users have watched videos online and most of them share what they find with others. Retrieved from http://www.pewinternet.org/2007/07/25/online-video-proliferates-as-viewers-share-what-they-find-on-line-57-of-online-adults-watch-or-download-video/

Putnam, R. D. (1995). Tuning in, tuning out: The strange disappearance of social capital in America. *PS: Political science & politics, 28*(04), 664–683.

Putnam, R. D. (2000). *Bowling alone: The collapse and revival of American community*. New York, NY: Simon & Schuster.

Rogers, C. R. (1960). *A therapist's view of personal goals*. Wallingford, PA: Pendle Hill.

Sheinkopf, K. (1973). Family communication patterns and anticipatory socialization. *Journalism Quarterly, 50*, 24–30.

Shah, D. V. (1998). Civic engagement, interpersonal trust and television use: An individual level assessment of social capital. *Political Psychology, 19*, 469–496.

Shah, D. V., McLeod, J. M., & Lee, N. (2009). Communication competence as a foundation for civic competence: Processes of socialization into citizenship. *Political Communication, 26*(1), 102–117.

Shah, D. V., McLeod, J. M., & Yoon, S. H. (2001). Communication, context, and community: An exploration of print, broadcast and Internet influence. *Communication Research, 28*, 464–506.

Sharif, I., & Sargent, J. D. (2006). Association between television, movie and video game exposure and school performance. *Pediatrics, 118*(4), 1061–1070.

Simon. J., & Merrill, B. D. (1998). Political socialization in the classroom revisited: The Kids Voting program. *Social Science Journal, 35*, 29–42.

Thorson, E., Ognianova, E., & Coyle, J. (1998). Evaluation of the audience impacts of two civic journalism projects in a small midwestern town. In E. Lambeth, P. Meyer, & E. Thorson (Eds.), *Assessing public journalism*. Columbia, MO: University of Missouri Press.

Thorson, D., Thorson, F., Thorson, E., & Coyle, J. (1998). Effects of a multimedia public journalism project on political knowledge and attitudes. In E. Lambeth, P. Meyer, & E. Thorson (Eds.), *Assessing public journalism*. Columbia, MO: University of Missouri Press.

Torney-Purta, J. (2002). The school's role in developing civic engagement: A study of adolescents in twenty-eight countries. *Applied Developmental Science, 6*(4), 203–212.

Torney-Purta, J. (2004). Adolescents' political socialization in changing contexts: An international study in the spirit of Nevitt Sanford. *Political Psychology, 25*(3), 465–478.

Uslaner, E. M. (2004). Trust, civic engagement, and the Internet. *Political Communication, 21*, 223–242.

Valkenburg, P. M., Krcmar, M., Peeters, A. L., & Marseille, N. M. (1999). Developing a scale to assess three styles of television mediation: Instructive mediation, restrictive mediation, and social coviewing. *Journal of Broadcasting & ElectronicMedia, 43*(1), 52–67.

Verba, S., Burns, N., & Schlozman, L. (1997). Knowing and caring about politics: Gender and political engagement. *Journal of Politics, 59*, 1051–1072.

Weiss, L. H., & Schwarz, J. C. (1996). The relationship between parenting types and older adolescents' personality, academic achievement, adjustment, and substance use. *Child Development, 67*(5), 2101–2114.

Young, D. G., & Hoffman, L. (2009). *An experimental exploration of political knowledge acquisiton from* the Daily Show *versus CNN Student News.* American Political Science Association Annual Meeting, Toronto. Retrieved from http://papers.ssrn.com/sol3/papers.cfm?abstract_id = 1451400

Zhao, X., & Chaffee, S. (1995). Campaign advertisements versus television news as sources of political issue information. *Public Opinion Quarterly, 59*, 41–65.

Political Knowledge AND Participation IN Teens

During Low and High Political Interest Periods of a Presidential Election

ESTHER THORSON, MI JAHNG, AND MITCHELL S. McKINNEY

This study examines how the three structural variables most closely associated with political socialization—family, school, and child demographics—along with news media exposure and cognitive attitudinal features of the youth predict political knowledge and political participation during three time periods surrounding a presidential election: 6 months before the 2008 presidential election, 6 weeks immediately following the election, and 6 months after the election. All three surveys of the Future Voters Study (as described in the Introduction) were employed, and thus the data involve the same parents and children, but at three time points. As might be expected, self-reported political interest during these three time periods was highest right after the election, and lower before the election and 6 months after the election. This longitudinal panel study provides an excellent opportunity to examine factors that are known to affect political knowledge and participation under very different political involvement levels.

Of course, given our analysis involved repeated measures administered to the same parents and children at each time point, with the inevitable dropout over time, there are the usual challenges of longitudinal data. Fortunately, however, there was remarkable consistency in sample measures across time.

A MODEL OF POLITICAL SOCIALIZATION

The model of political socialization guiding this research posits a process that traverses from social structural variables through media exposure and cognitive/

attitudinal variables to political knowledge and participation. This model is related to recent theorizing of political socialization (e.g., Hively & Eveland, 2009; Shah, McLeod, & Lee, 2009), but approaches cognitive/attitudinal variables differently and articulates differing types of political participation.

Political socialization is the process by which young people learn and develop responses to their polity: knowing about it, developing attitudes toward its various aspects, and participating in its fundamental processes (with activities such as voting, attending rallies, or commenting online, etc.). Clearly, political responses include a wide variety of indicators. The most typical are interest in politics, knowledge about politics, and participation through behaviors that have been classified as "political." But there are many other possible variables that are of clear significance to the political socialization process, including amount of politically focused talk with others, classroom-based political curriculum, connecting about politics with others online, community volunteering, and what has been called political consumerism (Stolle & Houghe, 2004; Vogel, 2004).

Parental Impact

Family communication, especially parental influence, has long been considered an important factor in determining the political socialization of adolescents (Easton & Dennis, 1969; Greenstein, 1965; Hyman, 1959). Studies in political socialization of adolescents have typically conceptualized it as a top-down process in which children acquired political attitudes, information, and behaviors from their parents through observation and modeling (Butler & Stokes, 1974; McDevitt, 2005). Parent's party affiliation, for example, has been a strong indicator of the children's partisanship, with adolescents most likely to claim the party affiliation of their parents (Desmond & Donohue, 1981; McDevitt, 2005).

Parental political activity level has also been found to be a strong indicator of how politically involved the children will be (Desmond & Donohue, 1981). Parents with higher socioeconomic status were found to talk more to their children about politics, leading the children to have more political knowledge than those in low SES families (Kim & Kim, 2007; McDevitt & Chaffee, 2000; McLeod & Chaffee, 1973; Meirick & Wackman, 2004).

More recently, McIntosh, Hart, and Youniss (2007) found that parental political knowledge and youth-parent political discussion were important predictors of youth political knowledge. That is, the knowledge of the parent was transmitted to the youth, and its effect was increased by parent-child political discussion.

These findings lead us to expect that the more the parents know and the more they encourage youth to discuss politics, express their opinions, and be politically involved, the more political knowledge and the higher the political participation the child will exhibit. We summarize these expectations in two hypotheses:

H1: Parental political talk and participation level will account for significant variance in youth political knowledge.

H2: Parental political talk and participation level will account for significant variance in youth political participation.

Political Education at School

Schools can potentially provide social interaction that represents a level of political stimulation and communication that may not be available from parents (Kiousis & McDevitt, 2008). For low SES families, schools can help children surmount the problem of being less exposed to mass media political messages. School interventions, such as Kids Voting USA, encourage future voters to be politically interested and knowledgeable, leading to more motivated discussions in both school and family (McDevitt, 2005; McDevitt & Chaffee, 2002). While family and home environment are perceived as the primary agents of political socialization, school has played an important part as a secondary agent, along with mass media exposure (Atkin, 1981). Thus:

H3: Experience with political curricula at schools will account for significant variance in youth political knowledge.

H4: Experience with political curricula at schools will account for significant variance in youth political participation.

News Media

Although mass media are an important source for knowledge of political issues (Delli Carpini, 2000; McLeod, Rush, & Friederich, 1968), the effects of media vary depending on type of medium as well as the purpose to which that medium is put. For example, television use for entertainment has been criticized as the cause of decreasing political engagement (Putnam, 1993, 2000). Television use for news, on the other hand, clearly shows a positive impact on both political knowledge and participation (Shah, McLeod, & Lee, 2009). Thus we suggest:

H5: Television news use will be positively associated with political knowledge.

H6: Television news use will be positively associated with political participation.

Newspaper use, although low among teenagers, has nevertheless been shown to be a powerful predictor of youth political knowledge and participation (e.g., Eveland, McLeod, & Horowitz, 1998). Thus:

H7: Newspaper exposure will be positively associated with political knowledge.

H8: Newspaper exposure will be positively associated with political participation.

The Internet has also emerged as an important additional medium for civic and political engagement (Pew Internet, 2006). Nie and Erbring (2000) found that Internet use was negatively related to time spent with other media, family, and friends, yet other studies have found heavy Internet users were more likely to have greater numbers of social relationships than light users (Uslaner, 2006). Also, a number of studies have found that Internet use positively affects political participation (Gibson, Howard, & Ward, 2000; Hill & Hughes, 1998; Kraut et al., 2002). On the other hand, Internet use sometimes negatively affects political engagement, or has occasionally been found to have no impact at all on engagement (Johnson & Kaye, 2003; Kraut et al., 2002). A likely explanation for this inconsistency is the operationalization of mediating variables such as level of social capital, personal communication efficacy, and motivation to use the Internet (Kavanaugh & Patterson, 2001; Shah, McLeod, & Yoon, 2001). Finally, entertainment Internet use is not positively correlated with indicators of political engagement (Shah et al., 2001).

An important news media variable is the extent to which youth use the Internet for political communication. According to Livingstone and his colleagues, adolescents have typically shown little interest in political participation via the Internet (Livingstone & Bober, 2004; Livingstone, Bober, & Helsper, 2004). Yet in contrast to this finding, however, young people have been shown to actively participate in political activities on the Internet (Gibson et al., 2000). Lin, Kim, Jung, and Cheong (2005) found that adolescents' level of Internet use is positively related to their involvement in community service, especially when they used the Internet for acquiring community information. In this vein, among the various Internet usage patterns and outcomes of media effects, this study focuses particularly on the effect of adolescents' Internet news use (i.e., information use) on two aspects of political engagement: political interest and political knowledge. Thus we suggest:

H9: Internet news use will be positively associated with political knowledge.

H10: Internet news use will be positively associated with political participation.

Cognitive/Attitudinal Variables

Civic mindedness is a concept most closely associated with Habermas's (2006) idea of the public sphere. Dahlberg (2001) posited that the concept involved six features, including two that were measured in the current study. The first is a sense of autonomy from government and economic power. To measure this autonomy we included two items: "to be a good citizen you need to stand up for your values," and "people should speak up when they oppose our government's actions." The second is "respectful listening," which we operationalized with "I think it is

important to hear others' ideas even if they are different from mine." To these items, however, we added a sense of civic responsibility, measured with "I think it is important to get involved in improving my community," and "Those who are well off should help those who are less fortunate." Zukin, Keeter, Andolina, Jenkins, and Delli Carpini (2009) argued that civic mindedness is part of a constellation of attitudes strongly associated with both political knowledge and participation. Thus we posit:

H11: Those high in civic mindedness will have greater political knowledge.

H12: Those high in civic mindedness will show greater political participation.

Persuasion Efficacy

Starting with the two-step flow paradigm (Katz & Lazarsfeld, 1964), and developed extensively in consumer research, has been the concept of personal persuasion of others (e.g., Childers, 1986; Gatignon & Robertson, 1985). Often, persuasion was operationalized by asking people to identify those who influenced them to purchase brands. An interesting alternative to this measure, however, is asking people themselves whether they influence others. The extent to which individuals report they do influence others is what we have labeled persuasion efficacy. We posit that those high in persuasion efficacy would be more likely to want to engage in politics in general, certainly to talk to others about politics, but perhaps also to participate at more extensive levels of political participation such as putting signs in their yards or wearing a button, as well as to engage in consumer politics such as advocating for, or boycotting, products. Hence we suggest:

H13: Those high in persuasion efficacy will have greater political knowledge.

H14: Those high in persuasion efficacy will show greater political participation.

Elaboration

The ability to think deeply about politics begins in adolescence (Eveland, 2001, 2004) as young people start to process the abstract ideas and concepts that serve as the bases for politics. Eveland and Dunwoody (2002) defined cognitive elaboration as connecting separate pieces of information, whether from memory or from new material being input, into a larger whole that provides a framework for understanding. Elaboration in terms of media use occurs when information from media sources is collected by the individual and compared with prior knowledge, allowing the individual to construct new frameworks for understanding the world. Elaboration thus is positively associated with knowledge acquisition.

Different media play different roles in elaboration. With the Web, it appears that the benefits that come with rich interconnected information resources enhance frequent users' ability to elaborate on what they are consuming, whereas with less-frequent Web users the richness and wealth of information serve to confuse users and thus hinders elaboration (Eveland, Marton, & Seo, 2004). Newspapers have been found to be strongly associated with elaboration; and how media are used also matters, as use for information and surveillance is positively associated with elaboration compared with use for entertainment (Beaudoin & Thorson, 2004; Eveland, 2001).

Studies in elaboration and political news seem to support the importance of elaboration on verbalizing political opinions. First, the more people elaborated on the news they consumed, the more knowledgeable they were about politics. In fact, positive relationships between the level of news elaboration and political knowledge have been found in a number of studies (Cappella, Price, & Nir, 2002; Eveland, Cortese, Park, & Dunwoody, 2004; Eveland & Dunwoody, 2002). Also, Hively and Eveland (2009) found a strong relationship between discussion elaboration and structured knowledge. When people elaborated on the news, their knowledge was more likely to be connected with what they already knew. Similarly, even after controlling for motivation to discuss politics in the future, elaboration was found to be a strong predictor of political knowledge (Eveland, 2004).

Given these findings, we predict:

H15: Greater elaboration will increase political knowledge.

H16: Greater elaboration will be associated with higher political participation.

Response Variables

Political knowledge. Political knowledge is usually measured in terms of the number of factual questions people can answer about candidates and issues in an election. As we were examining three distinct time points throughout the campaign cycle, including 6 months following the presidential election, our knowledge questions were different at each time, designed to determine how well the youth had managed to pick up salient information circulating at that time about the election.

Political talk. Political talk is an important aspect of deliberative democracy (Habermas, 2006), and relevant political talk should include all manner of political conversations, discussions or arguments. In fact, we think these types of political conversations happen well before adolescents decide to take action on political activities, and therefore it is important that adolescents learn to talk about politics with others.

Traditional political participation. Verba, Nie, and Kim (1978) defined political participation as the "legal activities by citizens that are more or less directly

aimed at influencing the selection of government personnel and/or the actions they take." These measures usually include such activities as voting, campaign contributions, and participating in a political protest.

Charity activity. Zukin et al. (2009) suggested that hands-on participating with others with a goal of contributing to the public good is closely related to more specific political participation. Even though what we categorize as charity activity may be seen as different from politics, such activity can have an important influence on political issues such as public safety, education, and community development. McKinney, Kaid, and Bystrom (2005, p. 6), for example, argued that the driving force of democracy can be found in citizens' many acts of joining, volunteering, serving, attending, meeting, participating, giving, and perhaps most importantly, cooperating with others. For them, the simple yet important act of periodic voting is not the core value or practice fueling democracy. Instead, the actions of volunteerism are the common sites where our civic dialogues take place. Unlike traditional political campaign participation, volunteer activities involve attention to one's local community and its needs. Thus, we argue that charity and volunteer activity are also an important aspects of political socialization.

Political consumerism. Stolle, Hooghe, and Micheletti (2005) defined consumer politics as the selection of products "based on political or ethical considerations, or both" (p. 267) (see also Micheletti, Follesdal, & Stolle, 2003). Consumer politics is part of a broader activity that Bennett (1998) referred to as "lifestyle" politics, in which people participate in more informal groups that share similar interests. In fact, Zukin et al. (2009) found that more Americans were involved in some kind of consumer activism than in any other type of political activity except voter registration and voting (p. 77).

METHOD

The hypotheses were tested with all three waves of the Future Voters Study (as described in the Introduction). The first wave of survey responses was gathered between May 20 and June 25, 2008; the second wave was fielded between November 5 and December 10, 2008 (immediately after the presidential election); and the third wave of data was collected from May to June, 2009, 6 months after the presidential election.

Predictor Variables

Political conversation with family was a combination of both parents' and children's responses on how often they "talked about news or current events with family members." A political curricula at schools index was created from five items:

"Followed the news as part of class assignment," "Learned about how government works in class," "Discussed/debated political issues in class," "Participated in political role-playing in class (mock trials, elections)," and "Encouraged to make up your own mind in class." Parents' political participation index was a five-item measure of activities that included: "Contributed money for a charitable cause," "Wrote a letter or an e-mail to a news organization," "Did volunteer work," "Worked on a community project," and "Contributed money to a political campaign."

Adolescents were asked about the number of days in a typical week they watched or read TV news, newspapers, and online news. *Television news* was a composite three-item index of responses to viewing local television news, network television news, and morning television news programs (e.g., *The Today Show*, *Good Morning America*, or *The Early News*). *Print News* was a composite two-item index of responses to reading a print copy of a local newspaper and the school's student newspaper. Finally, *Online News* was a three-item composite index of reading/viewing national newspaper websites, local newspaper websites, and TV news websites.

For our cognitive/attitudinal variables, the following were indexes comprising statements measured on five-point Likert scales (1 = Strongly Disagree; 5 = Strongly Agree). *Civic Mindedness* was created with three items: "I think it is important to get involved improving my community," "I think it is important to hear others' ideas even if they are different from mine," and "People should speak up when they oppose government's actions." *Persuasion efficacy* was a two-item index: "I am influential among my friends," and "My friends often seek my opinion about politics." *Elaboration* was computed with two items: "I try to connect what I see in the media to what I already know," and "I often recall what I encounter in the media later on and think about it" (see Table 1 for reliabilities and correlations).

Criterion Variables

Political participation. Principal factors extraction with varimax rotation was performed on 14 items measuring various political activities across three waves. Adolescents were asked the frequency of activity in the last 3 months on eight-point response scales (1 = Not at all, 8 = Very Frequently). The first factor was named *Classic Political Participation* (variance explained Wave 1 = .26, Wave 2 = .28, Wave 3 = .33). Items loaded on this factor were "Wrote a letter or e-mail to a news organization," "Worked for a political party or candidate," "Displayed a political campaign button, sticker or sign," "Participated in a political protest activity," "Contributed money to a political campaign," and "Attended a political meeting, rally, or a speech."

The second factor was *Political Talk* (variance explained Wave 1 = .17, Wave 2 = .18, Wave 3 = .19). The items loaded on this factor were "Talked about news

Table 1. Reliabilities Estimates and Descriptive Statistics for Composite Indexes.

Composite Variables	No. of items in index	Cronbach's alpha	Mean (SD)
Parent Civic Participation (scale: 1–8)	5	.73 (W1)	3.06 (1.23)
		.72 (W2)	2.57 (1.46)
		.77 (W3)	2.75 (1.97)
School Political Education (scale: 1–8)	5	.86 (W1)	3.51 (1.89)
		.90 (W2)	3.55 (2.01)
		.92 (W3)	3.46 (1.97)
Civic Mindedness (scale: 1–5)	3	.65 (W1)	3.97 (0.64)
		.66 (W2)	3.86 (7.49)
		.61 (W3)	3.91 (.71)
TV News (scale: 0–7)	3	.78 (W1)	1.53 (1.84)
		.77 (W2)	1.77 (1.80)
		.82 (W3)	1.85 (1.85)
Print (scale: 0–7)	3	.66 (W1)	1.11 (1.20)
		.72 (W2)	1.27 (1.46)
		.65 (W3)	1.13 (1.21)
Online News Sites (scale: 0–7)	3	.66 (W1)	0.51 (1.00)
		.72 (W2)	.57 (1.05)
		.65 (W3)	.52 (1.00)
Classic Political Campaign Participation (scale: 1–8)	6	.85 (W1)	1.32 (1.05)
		.87 (W2)	1.41 (.98)
		.90 (W3)	1.40 (1.04)
Political Talk Outside of Family (scale: 1–8)	3	.87 (W1)	3.26 (1.82)
		.88 (W2)	3.70 (1.94)
		.89 (W3)	3.24 (1.83)
Charity Activities (scale: 1–8)	3	.85 (W1)	3.14 (2.05)
		.85 (W2)	2.83 (1.93)
		.86 (W3)	3.03 (2.05)
Political Consumerism (Scale 1–8)	2	.78 (W1)	1.76 (1.55)
		.84 (W2)	1.72 (1.53)
		.86 (W3)	1.88 (1.63)

Two-item Variables	Pearson's r	p-value	Mean (SD)
Family Political Talk (scale: 1–8)	.41 (W1)	<.001	5.09 (2.10)
	.37 (W2)		5.27 (1.90)
	.45 (W3)		4.74 (1.86)
News Elaboration (scale: 1–5)	.63 (W1)	<.001	4.00 (.94)
	.65 (W2)		3.34 (.92)
	.66 (W3)		3.27 (0.82)
Persuasion Efficacy (scale: 1–5)	.38 (W1)	<.001	2.73 (.94)
	.47 (W2)		2.79 (.97)
	.48 (W3)		2.68 (.99)

and current events with friends," "Talked about news and current events with adults outside your family," and "Talked about news and current events with people who disagree with you."

A third factor was *Charity Activities* (variance explained Wave 1 = .16, Wave 2 = .16, Wave 3 = .16). Items loaded were "Did volunteer work," "Worked on a community project," and "Raised money for charitable cause."

The fourth factor was *Political Consumerism* and the items loaded were "Boycotted products or companies that offend my values," and "Bought products from companies because they align with my values" (variance explained Wave 1 = .12, Wave 2 = .12, Wave 3 = .13).

We asked *General Political Knowledge* questions, such as information on the presidential candidate for the second wave, or identifying which party controls the congress in all three waves. Wave 1 had eight questions; Wave 2 had three, and Wave 3 had six questions in total. Although the questions were slightly different in wording across different waves, they all asked about the political candidates, former presidents, and political parties. Correct and incorrect answers were then added to create a political knowledge scale (Wave 1 M = 4.11 SD = 1.99; Wave 2 M = .98 SD = 1.01; Wave 3 M = 3.43 SD = 1.82).

RESULTS

The three wave panel data we used for analysis had the same issue with every panel study: participants dropping out of subsequent panels. To deal with this problem before we compared our hierarchical regression models across three different times, we calculated the frequency of several demographic variables and examined whether there were any stark differences in the sample characteristics (see Table 2). All the demographic variables we used—including parents' gender, parents' political affiliation, parents' education level, the type of school the child attends, and the child's gender and political affiliation—were found to be remarkably similar across all three waves, providing us with the justification to claim that any differences we find in different waves are not likely a result of differences in the sample characteristics.

The next step in our analysis was to test the influence of structural variables and cognitive variables on different types of political participation and political knowledge. Here, we set up hierarchical regression models for each wave predicting different types of political participation and political knowledge with demographics at the first level; political conversation with family members, school education, and parents' political participation at the second level; the media use variables at the third level (structural variables); and civic mindedness, persuasion efficacy, and elaboration at the last level (cognitive/attitudinal variables). Total R^2

Table 2. Sample Demographics of Wave 1, Wave 2, Wave 3.

Variable	Categories		Wave 1 N (Valid %)	Wave 2 N (Valid %)	Wave 3 N (Valid %)
Gender	Parent	Male	212 (16.5)	115 (16.3)	69 (18.4)
		Female	1075 (83.5)	592 (83.7)	307 (81.6)
	Child	Male	629 (50.5)	343 (49.2)	181 (49.1)
		Female	617 (49.5)	354 (50.8)	188 (50.9)
Race	Parent	White	1059 (85)	580 (84.8)	307 (85.3)
		Black	106 (8.5)	59 (8.6)	29 (8.1)
		Native American	10 (.8)	8 (1.2)	2 (.6)
		Asian	17 (1.4)	10 (1.5)	10 (2.6)
		Pacific Islander	3 (.3)	2 (.3)	2 (.6)
		Multi-Racial	50 (4.0)	25 (3.7)	10 (2.8)
	Child	White	988 (80.9)	552 (81.2)	291 (81.1)
		Black	103 (8.4)	63 (9.3)	31 (8.6)
		Native American	10 (.8)	8 (1.2)	2 (.6)
		Asian	17 (1.4)	10 (1.5)	10 (2.8)
		Pacific Islander	7 (.6)	2 (.3)	2 (.6)
		Multi-Racial	96 (7.9)	45 (6.6)	23 (6.4)
Political Affiliation	Parent	Strong Democrat	76 (8.0)	43 (6.4)	19 (5.3)
		Democrat	373 (32.1)	202 (30.1)	106 (29.4)
		Independent	302 (29.0)	173 (25.7)	100 (27.8)
		Republican	383 (25.4)	205 (30.5)	108 (30.0)
		Strong Republican	97 (5.5)	49 (7.3)	27 (7.5)
	Child	Strong Democrat	43 (3.9)	54 (8)	18 (5)
		Democrat	339 (30.7)	217 (32.1)	88 (24.5)
		Independent	401 (36.3)	196 (29.0)	149 (41.5)
		Republican	274 (24.8)	172 (25.4)	88 (24.5)
		Strong Republican	48 (4.3)	37 (5.5)	16 (4.5)
Type of school	Public School		1081 (86.0)	602 (86.9)	314 (85.6)
	Private School		67 (5.3)	32 (4.6)	18 (4.9)
	Religious School		43 (4.3)	32 (4.6)	19 (5.2)
	Home School		55 (4.4)	27 (3.9)	16 (4.4)

(Continued)

Table 2. (Continued)

Variable	Categories	Wave 1 N (Valid %)	Wave 2 N (Valid %)	Wave 3 N (Valid %)
Mother Education	Some High School	55 (4.3)	26 (3.7)	16 (4.3)
	Graduated High School	562 (44.3)	305 (43.6)	153 (41.1)
	Graduated Trade School	138 (10.9)	85 (12.2)	43 (11.6)
	Graduated College	410 (32.3)	223 (31.9)	120 (32.3)
	MA, MS, JD, PhD, MD	103 (8.1)	60 (8.6)	40 (10.8)
Father's Education	Some High School	127 (10.5)	69 (10.4)	33 (9.5)
	Graduated High School	515 (42.4)	276 (41.6)	137 (39.5)
	Graduated Trade School	148 (12.2)	85 (12.8)	41 (11.8)
	Graduated College	297 (24.5)	169 (25.5)	100 (28.8)
	MA, MS, JD, PHD, MD	127 (10.5)	65 (9.8)	36 (9.5)
Total		1291	711	376
Missing		77 (6%)	47 (6.6%)	19 (5%)

for all different models across three different waves ranged from .17 to .62, suggesting a large variance explained by our model (see Tables 3, 4, 5).

For Wave 1, we simply entered the blocks of variables described above; but for Waves 2 and 3, we entered as a control the value of that variable in the previous wave. For example, in the equation for campaign participation, we controlled youth campaign participation from Wave 1. Thus for Waves 2 and 3 we are examining *change* in the dependent variables from the prior wave.

The first hypothesis predicted the influence of parental political talk with family and parents' political participation on youth political knowledge. Across all three waves, political conversation with family members significantly and positively influenced youth political knowledge. However, parents' political participation activities did not influence youth political knowledge (see Tables 3, 4, 5).

Our second hypothesis predicted that parental political conversation with family and parents' political participation would increase youth political participation. The second (or third) block in the hierarchical regression model all showed a significant increase in R^2 across three waves. For campaign engagement, family political talk did not predict classic campaign engagement across all three waves. However, parental political participation significantly influenced youth classic campaign engagement. Youth political talk was significantly predicted by family political conversation in all three waves, but parents' political participation did not

Table 3. Hierarchical Regression Model for Wave 1.

	Classic Campaign Engagement	Political Talk Outside of Family	Charity Activities	Political Consumerism	Political Knowledge
Block 1					
Gender (F)	.03	.05	.09**	.06	-.07*
Age	.03	.14***	.06*	.07*	.13***
Party ID ®	-.07*	.001	.05	-.004	.19***
R^2 Change	.006	.02***	.02***	.009*	.06***
Block 2					
Political Talk with Family	.004	.51***	.05	.12***	.22***
Political Education at School	.19***	.27***	.24***	.20***	.11**
Parent Political Participation	.31***	-.01	.41***	.20***	.03
R^2 Change	.17***	.45***	.30***	.16***	.09***
Block 3					
Television News Use	.06*	.11***	.08**	.04	-.03
Newspaper Use	.11***	.11***	.09**	.01	.002
Online News Use	.26***	.05*	.01	.15***	.03
R^2 Change	.10***	.03*	.02***	.02	.001
Block 4					
Civic Mindedness	-.12***	-.003	.13***	.03	-.04
Persuasion Efficacy	.16***	.13***	.10***	.04	.09**
Elaboration	.04	.05**	.03	.08*	.11**
R^2 Change	.03***	.19***	.03***	.01***	.020***
Total R^2	.30***	.52***	.36***	.20***	.17***

$^*p < .05$; $^{**}p < .01$; $^{***}p < .001$.

predict youth political conversation outside of family. Parents' political participation significantly predicted Charity Activity in all waves, but political conversation with family did not. Political Consumerism was only predicted by political talk and parental political participation in Wave 1, but not in the other waves. Thus, H2 was partially supported (see Tables 3, 4, 5).

Our next set of hypotheses concerned the influence of political education at school on youth political participation and knowledge. Our third hypothesis predicted that youth political knowledge would be significantly influenced by political education at

Table 4. Hierarchical Regression Model for Wave 2.

	Classic Campaign Participation	Political Talk Outside of Family	Charity Activities	Political Consumerism	Political Knowledge
Block 1					
Classical Campaign Participation (Wave 1)	.46***				
Political Talk Outside of Family (Wave 1)		.48***			
Charity Activities (Wave 1)			.60***	.41***	
Political Consumerism (Wave 1)	.21	.23***	.36***	.17***	.32***
General Political Knowledge (Wave 1)					.10***
R^2 Change					
Block 2					
Gender (F)	−.04	.07*	.05	.02	.003
Age	.04	.05	−.05	.03	.09*
Party ID (R)	−.01	.01	−.03	.07	−.04
R^2 Change	.003	.01	.005	.006	.010
Block 3					
Political Talk with Family	.001	.40***	−.02	−.09	.17**
Political Education at School	.24***	.29***	.20***	.24***	.10*
Parent Political Participation	.16***	.002	.26***	.07	.10*
R^2 Change	.10***	.30***	.10***	.05***	.08***
Block 4					
Television News Use	−.06	−.03	−.05	.01	−.03
Newspaper Use	.09	.02	.11**	−.01	−.11*
Online News Use	.30***	.10**	.05	.14**	.003
R^2 Change	.09***	.01**	.02**	.02*	.01

	Classic Campaign Participation	Political Talk Outside of Family	Charity Activities	Political Consumerism	Political Knowledge
Block 5					
Civic Mindedness	–.03	.06	–.04	–.54	–.02
Persuasion Efficacy	.09*	.08**	.04	.08	.03
Elaboration	.06	.04	.07	–.05	.08
R^2 Change	.01*	.01***	.005	.006	.006
Total R^2	.41***	.57***	.48***	.24***	.20***

*p < .05; **p < .01; ***p < .001.

Table 5. Hierarchical Regression Model for Wave 3.

	Classic Campaign Participation	Political Talk	Charity Activity	Political Consumerism	Political Knowledge
Block 1					
Classical Campaign Participation (Wave 2)	.44***				
Political Talk Outside of Family (Wave 2)		.46***			
Charity Activity (Wave 2)			.61***		
Political Consumer-ism (Wave 2)				.41***	
General Political Knowledge (Wave 2)					.38***
R^2 Change	.19***	.22***	.37***	.17***	.14***
Block 2					
Gender (F)	–.03	–.03	–.03	.05	–.04
Age	.003	.07	–.05	.01	.09
Party ID (R)	–.06	–.01	–.005	.01	.09
R^2 Change	.004	.01	.004	.002	.02
Block 3					
Political Talk With Family	–.07	.48***	.01	.09	.18**
Political Education at School	.19**	.27***	.22***	.24***	–.07

(Continued)

Table 5. (Continued)

	Classic Campaign Participation	Political Talk	Charity Activity	Political Consumerism	Political Knowledge
Parent Political Participation	.28***	−.06	.41***	.09	.008
R^2 Change	.11***	.30***	.20***	.11***	.03*
Block 4					
Television News Use	.14*	.09*	.07	.03	−.06
Newspaper Use	−.01	−.03	.02	.03	−.03
Online News Use	.06	.13**	.04	.008	−.02
R^2 Change	.02*	.03**	.01	.003	.01
Block 5					
Civic Mindedness	−.14*	−.02	.10*	.04	−.004
Persuasion Efficacy	.02	.07	−.10*	.12*	−.04
Elaboration	.03	.15*	−.28**	−.10	.08
R^2 Change	.01	.02*	.03***	.01	.01
Total R^2	.34***	.56***	.62***	.29***	.20***

$*p < .05; **p < .01; ***p < .001.$

school. This was partially supported. For Wave 1 and Wave 2, political education at school significantly and positively influenced youth general political knowledge but did not reach significance at Wave 3. School political education also significantly predicted all four of the participation indices, supporting H4 of our study.

We next examined the influence of news media on political knowledge and participation. The R^2 change for our news media block in the hierarchical model was significant for classic campaign engagement and political talk for Wave 1, all political participation variables in Wave 2, and campaign engagement and political talk in Wave 3. None of the news media variables predicted political knowledge, except newspaper use negatively predicted the general political knowledge on Wave 3, thus failing to support H5, H7, and H9. Television news use positively influenced classic campaign engagement, political talk, and charity activity in Wave 1, but only classic campaign engagement and political talk in Wave 3. Thus, H6 was partially supported.

Newspaper use predicted campaign engagement, political talk and charity activity in Wave 1, only community engagement in Wave 2, and failed to predict any political participation indices for Wave 3, thus partially supporting H8. Finally, for the media block, online news use significantly predicted campaign engagement, political talk, and political consumerism in Waves 1 and 2, but only predicted political talk for Wave 3, partially supporting H10.

Our final set of hypotheses dealt with the cognitive/attitudinal variables, including civic mindedness, persuasion efficacy, and news elaboration. The final block of the hierarchical regression model had significant R^2 change for all dependent variables on Wave 1, only classic campaign engagement and political talk in Wave 2, and political talk and charity activities in Wave 3.

Inconsistent with H11, civic mindedness failed to predict political knowledge in any of the three waves. In fact, civic mindedness negatively predicted classic campaign activities and positively predicted charity activity in Wave 1 and Wave 3, providing only partial support for H12.

Persuasion efficacy positively predicted political knowledge in Wave 1, but did not have any influence in the other two waves, thus providing only limited support for H13. Persuasion efficacy did positively influence different types of political participation indices, including campaign participation, political talk, and charity activity in Wave 1; campaign participation and political talk in Wave 2; and was negatively related to charity activity in Wave 3, thus providing mixed support for H14.

Finally, elaboration only predicted political knowledge in Wave 1. It did not positively predict any political participation variables except political consumerism in Wave 1 and political talk in Wave 3, and elaboration was negatively related to charity activity in Wave 3. Thus there was little support for H15 and H16.

DISCUSSION

There are three highly significant findings in the study. First, in spite of participant loss over the year-long time period examined, the variables examined here were quite stable, even though political interest immediately after the 2008 presidential election was significantly higher than 6 months prior or after. Second, although there were some variations in the exact pattern of predictions of political knowledge and participation, the family, school, media, and three cognitive/attitudinal variables predicted these outcomes well. And third, the criterion variables are predicted by quite different combinations of the structural and process variables. "Political engagement" is clearly not a monolith but a cluster of knowledge and behaviors.

In Wave 1, family political talk, school political education, persuasion efficacy and elaboration accounted for 11% of the variation in political knowledge. In Wave 2, where we were predicting change in political knowledge from prior time periods, the structural variables family political talk, school political education, and parent political participation were the significant predictors. In Wave 3, only the political talk variable remained significant. This is likely because the effects of the knowledge levels at the prior time periods had captured most of the effects

of the other variables. Overall, this finding demonstrates the great influence of political family talk on political knowledge, regardless of the timeframe with the current political process.

Our findings concerning political knowledge contrast with the pattern of findings for traditional campaign participation. The structural variables of school political education and parent participation are consistent predictors of the youth's participation in all three waves. In Wave 1, television, print, and online news exert a strong positive impact on participation, although print effects disappear in Waves 2 and 3 and the effects of the other two media are weaker. Civic mindedness has a negative effect on political participation, supporting the notion of Zukin et al. (2009) who claimed that charity activity and political participation are actually alternative approaches to civic engagement. As we would expect, then, civic mindedness generally has a highly positive effect on charity activity. It is interesting that so many of the variables combine to affect political participation, regardless of wave. This suggests that multiple influences are needed to raise political participation levels.

Family political talk and school political education consistently predict youth political talk. Like political participation, exposure to the mass media is important in Wave 1, but their effects are diminished in Waves 2 and 3, again probably because their effects are captured with the prior-time-period controls. Persuasion efficacy and elaboration have very large effects on political talk in Wave 1 although their effect is diminished in Waves 2 and 3.

School, parent participation, television and newspaper, civic mindedness and elaboration are important predictors of charity activity in Wave 1. The school and parent participation effects remain strong in Waves 2 and 3, but the effects of the other variables are lessened and somewhat inconsistent. Again, it appears that the structural variables remain strong influences even on changes in charity behavior.

Political consumerism in Wave 1 is significantly affected by all three structural variables—family talk, school, and parental participation—and also strongly influenced by online news use. School and online news remain significant at Wave 2, but at Wave 3, online news effects disappears. The fact that online news is so important for political consumerism is consistent with the idea that these behaviors are more individualistic and may occur earlier for youth who spend time online.

The next step with this line of research should be a more detailed analysis of the interactive relationships among the structural and process variables. Multicollinearity among those variables is clearly a problem and will need to be sorted out in a way beyond the scope of the present study. Still, the findings from this study strongly suggest that across a full year's ups and downs in political interest, youth knowledge and participation and its antecedents remain fairly stable and consistently interrelated.

REFERENCES

Atkin, C. (1981). Communication and political socialization. In D. Nimmo & K. Sanders (Eds.), *Handbook of political communication* (pp. 299–328). Beverly Hills, CA: Sage.

Beaudoin, C. E., & Thorson, E. (2004). Testing the cognitive mediation model: The roles of news reliance and three gratifications sought. *Communication Research, 31*(4), 446–471.

Bennett, W. L. (1998). The uncivil culture: Communication, identity and the rise of lifestyle politics. *PS: Political Science and Politics, 31*(4), 740–761.

Butler, D., & Stokes, D. (1974). *Political change in Britain* (2nd ed.). London, England: Macmillan.

Cappella, J. N., Price, V., & Nir, L. (2002). Argument repertoire as a reliable and valid measure of opinion quality: Electronic dialogue during campaign 2000. *Political Communication, 19*, 73–93.

Childers, T. L. (1986). Assessment of the psychometric properties of an opinion leadership scale. *Journal of Marketing Research, XXIII*, May, 184–188.

Dahlberg, L. (2001). Computer-mediated communication and the public sphere: A critical analysis. *Journal of Computer-Mediated Communication, 7*, 1–15. Retrieved from http://www.ascusc.org/jcmc/vol7./issue1/dahlberg.html

Delli Carpini, M. X. (2000). Gen.Com: Youth, civic engagement, and the new information environment. *Political Communication, 17*, 341–349.

Desmond, R., & Donohue, T. (1981). The role of the 1976 televised presidential debates in the political socialization of adolescents. *Communication Quarterly, 29*(4), 302–308.

Easton, D., & Dennis, J. (1969). *Children in the political system.* New York, NY: McGraw-Hill.

Eveland, W. P. (2001). The cognitive mediation model of learning from the news. *Communication Research, 28*(5), 571–601.

Eveland, W. P. (2004). The effect of political discussion in producing informed citizens: The roles of information, motivation, and elaboration. *Political Communication, 21*(2), 177–193.

Eveland, W. P., Jr., Cortese, J., Park, H., & Dunwoody, S. (2004). How website organization influences free recall, factual knowledge, and knowledge structure density. *Human Communication Research, 30*(2), 208–233.

Eveland, W. P., & Dunwoody, S. (2002). An investigation of elaboration and selective scanning as mediators of learning from the web versus print. *Journal of Broadcasting & Electronic Media, 46*(1), 34.

Eveland, W., Marton, K., & Seo, M. (2004). Moving beyond "just the facts": The influence of online news on the content and structure of public affairs knowledge. *Communication Research, 31*(1), 82–108.

Eveland, W. P., McLeod, J. M., & Horowitz, E. M. (1998). Communication and age in childhood political socialization: An interactive model of political development. *Journalism & Mass Communication Quarterly, 75*, 699–718.

Gatignon, H., & Robertson, T. S. (1985). A propositional inventory for new diffusion research. *Journal of Consumer Research, 11*(4), 849–867.

Gibson, R. K., Howard, P., & Ward, S. (2000). *Social capital, Internet connectedness and political participation: A four-country study.* Paper presented at the International Political Science Conference, Quebec, Canada.

Greenstein, F. (1965). *Children and politics.* New Haven, CT: Yale University Press.

Habermas, J. (2006). Political communication in media society: Does democracy still enjoy an epistemic dimension? The impact of normative theory on empirical research. *Communication Theory, 16*, 411–426.

Hill, K. A., & Hughes, J. E. (1998). *Cyberpolitics: Citizen activism in the age of the Internet.* Lanham, MD: Rowman & Littlefield.

Hively, M. H., & Eveland, W. P., Jr. (2009). Contextual antecedents and political consequences of adolescent political discussion, discussion elaboration, and network diversity. *Political Communication, 26,* 30–47.

Hyman, H. H. (1959). *Political socialization.* Glencoe, IL: Free Press.

Johnson, T. J., & Kaye, B. K. (2003). A boost or bust for democracy? How the web influenced political attitudes and behaviors in the 1996 and 2000 presidential elections. *The Harvard International Journal of Press/Politics, 8*(3), 9–34.

Katz, E., & Lazarsfeld, P. F. (1964). *Personal influence: The part played by people in the flow of mass communication.* New York, NY: Free Press of Glencoe.

Kavanaugh, A. L., & Patterson, S. J. (2001). The impact of community computer networks on social capital and community involvement. *American Behavioral Scientist, 45,* 469–509.

Kim, K. S., & Kim, Y. C. (2007). New and old media uses and political engagement among Korean adolescents. *Asian Journal of Communication, 17*(4), 342–361.

Kiousis, S., & McDevitt, M. (2008). Agenda setting in civic development. *Communication Research, 35*(4), 481–502.

Kraut, R., Kiesler, S., Boneva, B., Cummings, J., Helgeson, V., & Crawford, A. (2002). Internet paradox revisited. *Journal of Social Issues, 58*(1), 49–74.

Lin, Y., Kim, Y. C., Jung, J.-Y., & Cheong, P. H. (2005). *The Internet and civic engagement of youth: A case of East Asian cities.* Paper presented at the Association of Internet Researchers Conference, Chicago, Illinois.

Livingstone, S., & Bober, M. (2004). *UK children go online: Surveying the experiences of young people and their parents.* London, England: London School of Economics and Political Science.

Livingstone, S., Bober, M., & Helsper, E. J. (2004). *Active participation or just more information? Young people's take up of opportunities to act and interact on the Internet.* London, England: London School of Economics.

McDevitt, M. (2005). The partisan child: Developmental provocation as a model of political socialization. *International Journal of Public Opinion Research, 18*(1), 67–88.

McDevitt, M., & Chaffee, S. (2000). Closing gaps in political communication and knowledge: Effects of a school intervention. *Communication Research, 27*(3), 259–292.

McDevitt, M., & Chaffee, S. (2002). From top-down to trickle-up influence: Revisiting assumptions about the family in political socialization. *Political Communication, 19,* 281–301.

McIntosh, H., Hart, D., & Youniss, J. (2007). The influence of family political discussion on youth civic development: Which parent qualities matter? *PSOnline,* 495–499. Retrieved from www.apsanet.org

McKinney, M. S., Kaid, L. L., & Bystrom, D. G. (2005). The role of communication in civic engagement. In M. S. McKinney, L. L. Kaid, D. G. Bystrom, & D. B. Carlin (Eds.), *Communicating politics: Engaging the public in democratic life.* New York, NY: Peter Lang.

McLeod, J. M., & Chaffee, S. H. (1973). Interpersonal approaches to communication research. *American Behavioral Scientist, 16,* 469–500.

McLeod, J. M., Rush, R. R., & Friederich, K. H. (1968). The mass media and political information in Quito, Ecuador. *Public Opinion Quarterly, 32,* 575–587.

Meirick, P. C., & Wackman, D. B. (2004). Kids voting and political knowledge: Narrowing gaps, informing votes. *Social Science Quarterly, 85,* 1161–1177.

Micheletti, M., Follesdal, A., & Stolle, D. (2003). *Politics, products, and markets: Exploring political consumerism.* New Brunswick: Transaction.

Montgomery, K. (2000). Youth and digital media: A policy research agenda. *Journal of Adolescent Health, 27S*, 61–68.

Nie, N., & Erbring, L. (2000). Internet and society. *Stanford Institute for the Quantitative Study of Society.*

Pew Internet & American Life Project. (2006). Online video: 57% of internet users have watched videos online and most of them share what they find with others. Retrieved from http://www.pewinternet.org/PPF/r/219/report_display.asp

Putnam, R. D. (1993). The prosperous community: Social capital and public life. *The American Prospect, 13*, 35–42.

Putnam, R. D. (2000). *Bowling alone: The collapse and revival of American community.* New York, NY: Simon & Schuster.

Shah, D. V., McLeod, J. M., & Lee, N. (2009). Communication competence as a foundation for civic competence: Processes of socialization into citizenship. *Political Communication, 26*(1), 102–117.

Shah, D. V., McLeod, J. M., & Yoon, S. H. (2001). Communication, context, and community: An exploration of print, broadcast and Internet influences. *Communication Research, 28*, 464–506.

Stolle, D., & Houghe, M. (2004). Consumers as political participants? Shifts in political action repertoires in western societies. In M. Micheletti, A. Follesdal, & D. Stolle (Eds.), *Politics, products and markets: Exploring political consumerism* (pp. 265–288). New Brunswick, NJ: Transaction.

Stolle, D., Hooghe, M., & Micheletti, M. (2005). Politics in the supermarket: Political consumerism as a form of political participation. *International Political Science Review, 26*(3), 245–269.

Uslaner, E. M. (2006). The civic state: Trust, polarization, and the quality of state government. In J. Cohen (Ed.), *Public opinion in state politics* (pp. 142–162). Stanford, CT: Stanford University Press.

Vallone, R. P., Ross, L., & Lepper, M. R. (1985). The hostile media phenomenon: Biased perception and perceptions of media bias in coverage of the Beirut massacre. *Journal of Personality and Social Psychology, 49*, 577–585.

Verba, S., Nie, N. H., & Kim, J. O. (1978). *Participation and political equality: A seven nation comparison,* New York, NY: Cambridge University Press.

Vogel, D. (2004). Tracing the American roots of the political consumerism movement. In M. Micheletti, A. Follesdal, & D. Stolle (Eds.), *Politics, products and markets: Exploring political consumerism* (pp. 83–100). New Brunswick, NJ: Transaction.

Zukin, C., Keeter, S., Andolina, M., Jenkins, K., & Delli Carpini, M. X. (2009). *A new engagement: Political participation, civic life and the changing American citizen.* Oxford, England; New York, NY: Oxford University Press.

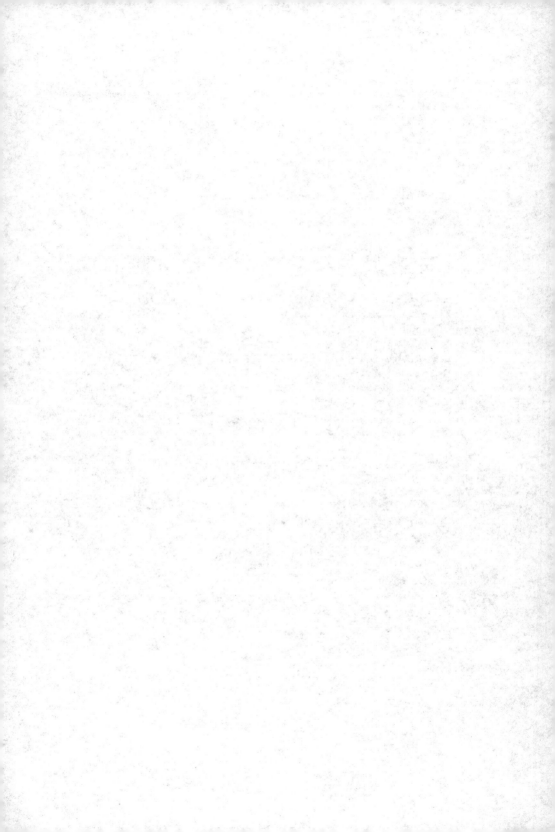

Political Socialization Patterns IN Younger AND Older American Adolescents

HANS MEYER, MI JAHNG, AND ESTHER THORSON

In the 2008 presidential election, an estimated 23 million 18- to 29-year-olds voted, representing the second-largest turnout of youth voters in U.S. history (Circle, 2008). It should be noted, however, that youth (18–29) voter turnout in 2012 (45%) declined from 2008 (51%; America Goes to the Polls, 2013). In 2008, more than 65% of all youth voted for President Barack Obama. It is inappropriate to exclusively attribute this record number of young votes to the charismatic young candidate who made history by being elected the nation's first African American president. In fact, political socialization, the process that leads young people to learn about, think about, and participate in a democracy, began long before any of these young citizens were eligible to vote.

The goal of the study reported in this chapter is to explore how political socialization changes over time during the teen years, and whether the causal processes that drive it also change over time. Using the first survey of the Future Voters Study (as described in the Introduction) fielded in the spring of 2008, about six months before the general election, we examine the factors that lead children ages 12–18 to participate politically, either online or offline, and how their age affects the process. We define political socialization as a network of responses in cognitive, affective, and behavioral dimensions. We focus on the differential impact of structural, demographic, and cognitive variables on this network of responses while differentiating two groups of young respondents: "tweens" (aged 12–14) and "teens" (aged 15–17).

LITERATURE REVIEW

Adolescent Development of a Political Self: Influence of Family, School and News Media

Eveland, McLeod, and Horowitz (1998) found age to be a significant predictor for political knowledge. As children get older, the influence of news media exposure on political knowledge is greater for older rather than younger children. News media, however, are just one factor in political knowledge acquisition. Other developmental aspects of adolescence need to be explored if we wish to understand the process of political socialization. Foremost among these factors are political identity development and a sense of political efficacy.

Early studies in political socialization assumed the political system or society and its socialization agents were relatively effective in transmitting certain basic political values or information; and that the individual absorbed these values and information without much personal interpretation (Easton & Dennis, 1969; Greenstein, 1965; Jennings & Niemi, 1968; Torney-Purta, 1995). These studies failed to consider the fact that adolescents typically go through a phase (or several) where they critically question what parents and school teach. Kiousis, McDevitt, and Wu (2005) found that adolescents themselves can play an active role in their political identity formation once motivated to follow news and participate in conversations, thereby refuting the transmission model of political socialization. Jennings and Niemi (1974) also found the parent-adolescent correlation in terms of political opinion was low, indicating parents' political views did not necessarily pass directly to their teenagers.

Erikson's (1966) theory of development states that an identity search begins in early adolescence, influencing internal and external experiences and leading to commitment to particular values and beliefs. Many adolescents while going through the stage of searching for their identity will question parents' instructions and seek autonomous decisions. Marcia (1980) found that adolescent identity formation can lead to commitments regarding occupation, a religious ideology, or political values. Adolescents' efforts to influence their parents can cause a shift in the structure of family communication, reflecting the child's desire for autonomy (McDevitt, 2005).

Also, identity search leads to a greater emphasis on peers and peer interaction. McDevitt and Kiousis (2007) found that in terms of political activism, family and school acted as socialization agents promoting compliant voting, while peer group discussion fostered political activism. These results suggest political socialization is not necessarily a process of inculcation and enculturation controlled by adults. When the autonomy-seeking of adolescence is affected by peer interaction, self-identification with unconventional citizenship and activism are possible outcomes.

Early political socialization literature did not address the possibility that the political voices of adolescents may also influence the parents. McDevitt and Chaffee (2002) defined youth influencing adults as "trickle-up politicization" and found there are ample possibilities for adolescents to not merely follow their parents' political identification and political behavioral patterns. Socialization—or actually re-socialization—of the parents is also possible. The environment that makes this trickle-up influence possible is school.

Schools potentially foster social interaction that provides a level of political stimulation and communication that may not be available from parents at home (Kiousis & McDevitt, 2008). School civics interventions, such as the Kids Voting USA program, were found to not only encourage adolescents' political interest and knowledge but also helped lead adolescents to a more motivated discussion in school (McDevitt, 2005; McDevitt & Chaffee, 2002). Thus, it is possible to expect that even for politically active teenagers who follow their parents' political actions and party identification, school will provide the type of public sphere where these young citizens can be exposed to and influenced by different arguments. Exposure to political diversity, which may not be available within a family environment, can also act as a motivator for teenagers to vary from their parents' political beliefs and orientations.

Younger teens or tweens are likely to still be in the stage of asking questions about political values, or even be at the foreclosure stage, which Marcia (1980) defined as being committed to some identity without going through the crisis of deciding what really suits them best. In addition, tweens may also feel politics is removed from their everyday lives. By late adolescence, many young women and men achieve a sense of identity (Shaffer, 2009). Not only are older adolescents likely to feel more of a need to affiliate, commit, and feel responsible to politics (Sherrod, Flanagan, & Youniss, 2002), but they will also have had ample time to go through all the possible options in their search for a political identity. They may reach a stage where they personally commit to certain political values. In fact, family communication patterns were no longer related to older adolescents' level of political interest, or political knowledge (Meadowcroft, 1986), implying that once children gain adequate skills, they are able to internalize, comprehend fully, and act in ways of their own. If anyone in this age group shows identical political perspective with their parents, they have most likely chosen to follow their parents' point of view, instead of merely doing or believing what they have been told.

The news media play a crucial role for adolescents who actively ask questions about their political values and identities. Media, in fact, may help adolescents start to seek autonomy and independence from their parents and look for sources outside of family. Adoni (1979) argued mass media serve as socializing agents by providing a direct link to the content adolescents need to develop political values and contribute to the social contexts where they can exercise value orientations.

Today, the Internet provides a direct outlet that can be used whenever there is a need for information, and it has been found to be the most often used political news outlet for adolescents (Gross, 2004).

As the capacity to think about political matters develops in adolescence (Eveland, McLeod, & Horowitz, 1998), young people start to mentally process the abstract ideas and concepts that serve as the bases for politics. As adolescents' cognitive ability enables them to elaborate on the news and feel efficacious about their political opinion, they are likely to go through the process of not only discovering what they believe in terms of politics but also understanding what others' perspectives are. Initially, family communication and parental participation may guide adolescents to be exposed to political information. Later, it may help build interest in political behavior. School curricula, such as the Kids Voting program, and the news they decide to follow, can equip adolescents to make political decisions that reflect their own attitudes (Meirick & Wackman, 2004).

Based on the preceding literature and findings, we thus expect:

H1: For teens, school-based political experiences and news media use will be significant predictors of political knowledge, traditional political participation, and online political participation, while family communication and parental political participation will not.

H2: For tweens, family communication and parental political participation will be significant predictors of political knowledge, traditional political participation, and online political behavior, while school and news media use will not.

Development of Political Efficacy

Another important psychological aspect of political socialization is the development of political efficacy. Political efficacy is conceptually defined as "the feeling that political and social change is possible, and that an individual citizen can play a part in bringing about the change" (Campbell, Gurin, & Miller, 1954). Political efficacy is recognized to contain two separate components: internal efficacy, referring to beliefs about one's own competence to understand and to participate effectively in politics; and external efficacy, which refers to beliefs about the responsiveness of governmental authorities and institutions to citizens' demands (Kenski & Stroud, 2006).

Many studies have tried to identify the antecedents of political efficacy. Focus group interviews by Wells and Dudash (2007) suggested many young voters do not feel they have enough knowledge to participate in politics, thereby demonstrating a connection between political knowledge and political efficacy. Gniewosz, Noack, and Buhl (2009) found that supporting and transparent parent-child interactions and an open, transparent, and positive classroom climate were negatively related

to adolescents' political alienation. Gniewosz et al., defined political alienation as citizens' subjective feelings about their abilities to affect the political system's performance at the individual level and identified four dimensions of political alienation, including: (a) political powerlessness, (b) political meaninglessness, (c) political normlessness, and (d) political isolation. Finally, the type of news media adolescents use has also been found to influence their level of political efficacy. Late-night TV shows (Hoffman & Thompson, 2009), campaign messages, political advertising, and debates (Kaid, McKinney, & Tedesco, 2007) directly targeted to young voters (McKinney & Banwart, 2005) increased adolescents' and college students' political efficacy.

Political efficacy is also an important predictor of adolescents' current and future political participation. Hoffman and Thompson (2009) found political efficacy significantly mediated the effects of late-night TV viewing on civic participation, such as joining student government, debate clubs, and similar youth organizations, or volunteering for neighborhood or civic group activities. Vecchione and Caprara (2009) argued efficacy predicted donations to political associations, contacting politicians, or working for a political party. Similarly, the Rock the Vote campaign on MTV increased college students' intention to vote (McKinney & Banwart, 2005). While civic and political participation as a teenager is not the same as voting as an adult, these behaviors in early adolescence not only predicted participation in late adolescence but also the level of civic engagement in young adulthood after youth reached the age to vote (Zaff, Malanchuk, & Eccles, 2008).

On the other hand, political cynicism reflects low external efficacy (Baumgartner & Morris, 2006; Hoffman & Thompson, 2009). Cynicism and decreased external political efficacy have been found to detract from current and future political activities, especially for adolescents (Kaid et al., 2007; Rodgers, 1974). Studying what could influence the political efficacy and cynicism of black children, Rodgers (1974) found increased political knowledge correlated positively with political cynicism and decreased political efficacy. Bandura (2006) claimed people who generally believe they can achieve desired changes through their collective voice and view their governmental system as trustworthy tend to participate actively in conventional political activities, whereas the apathetic are more likely to be disaffected. While Rodgers's study did not examine whether these African American adolescents showed high voting rates in adulthood, he did try to explain the lower political participation rate of young African Americans through their low political efficacy and high political cynicism.

Studies examining the role of political efficacy on political socialization have not addressed the question of "when" political efficacy starts to develop. In fact, this matter represents one of the primary research questions the current study seeks to address. It can be inferred from the studies linking political knowledge and political efficacy that teens who have a better understanding of and enough

information about politics would feel more efficacious compared to tweens. However, based on the political cynicism research, it is also possible that teens have learned that the political activities in which they participate or the future votes they cast might not make much difference, resulting in increased political cynicism and leading them to feel less efficacious. Some studies do show that naïve belief in and admiration towards politicians that was found to be high in early elementary school years diminished by the time children went to middle school (Easton & Dennis, 1969; Greenstein, 1965). Because of the mixed results regarding the age difference in political efficacy, we propose the following hypotheses:

> **H3:** Political efficacy will be a stronger predictor of political participation, both online and off, for teens than tweens.

On the other hand, it can be inferred from the literature that the level of political efficacy that teens or tweens feel will mediate the relationship between education from socialization agents and their participation in political activities. Thus, we believe:

> **H4:** Political efficacy will mediate the influence of family communication, parental political participation, and school education on political socialization (offline and online political participation).

METHODS

The first survey of the Future Voters Study (as described in the Introduction) was utilized for analysis in this chapter. It was fielded between May 20 and June 25, 2008. In all, the study examines 1,291 teens between the ages of 12 and 17. We divided respondents into two age groups: tweens, aged 12–14, with 614 participants, and 617 teens between the ages of 15–17.

Confirmatory factor analysis was used to create scales to measure independent and dependent variables. Political knowledge was indexed with three questions: "Which political party is more conservative?" "Which political party controls the House of Representatives?" "Which political party did Ronald Reagan belong to when he was president?" A correct answer was scored 1, while incorrect responses were 0. On a scale of 0–3, tweens had a mean score of less than 1, while teens' mean was 1.11.

Efficacy was measured with two questions that asked how influential the respondents thought they were among their friends and how often their friends sought their opinions. The questions had a statistically significant correlation at the $p < .01$ level.

Online political participation combined questions about how often the young citizens used the following Internet features to discuss politics: social networking

sites, news Web sites, political blogs, e-mail, text messages, and online videos (Cronbach's α = .86). Offline political participation was an aggregation of questions about how frequently they did volunteer work, contributed money to a campaign, attended rallies or speeches, worked for candidates or displayed a candidate's button or sticker (Cronbach's α = .82).

RESULTS

The analysis began with independent samples t-tests to identify possible differences between tweens and teens (see Table 1). There were statistically significant mean differences for four variables: Internet news use, learning about politics in school, political knowledge and online political participation. For all four, teens had higher scores than tweens. Teens used the Internet more for news and said they learned more about politics in school than tweens. They also had significantly greater political knowledge and higher online political participation.

To test H1 and H2 regarding the different variables that predict political knowledge, traditional, and online political participation for tweens and teens, linear regressions were employed. Knowledge (see Table 2) for both tweens and teens was predicted by parental income and education, and talking about politics with the family. In both equations, approximately 15% of the variance was accounted for. Thus the prediction about what would predict knowledge in teens (H1) was not supported. However, H2 was correct in predicting that family communication would account for knowledge in tweens but was not accurate in predicting a significant effect of parental political participation. The literature suggested family communication would be a significant predictor for tweens and not necessarily for teens. It also suggested teens' political discussion at school and media use would significantly predict their knowledge.

For online political participation (see Table 3), there was partial support for H2 and H1. Newspaper use (β = .14, p < .01), Internet news use (β = .1, p < .05), and family talk (β = .12, p < .01) were all significant predictors for tweens, along with learning about politics in school (β = .2, p < .01), which was contrary to H1. For teens, learning about politics in school was the most significant predictor (β = .23, p < .01), which supported H1, but family talk was also statistically significant at the p < .01 level with a β = .17.

The pattern of partial support for H1 and H2 continued in the analyses for offline political participation (see Table 4). Tween participation was predicted most strongly by parental political involvement, which supported H2. But learning about politics in school was also significant, along with Internet news use, which was inconsistent with H2. For teens, TV news use, Internet news use, and learning about politics in school (β = .22) were significant predictors, which supported H1;

Table 1. Independent Samples T–tests Between Tweens (12–14) and Teens (15–18) on Perceived News Bias, Political Knowledge, Online Political Participation, and Offline Political Participation.

	Tween		Teen			
	N	Mean	N	Mean	t	df
Household Size	614	4.1547 (1.26588)	617	4.0535 (1.24658)	–1.414	1229
Income	614	45.5163 (6.03083)	617	46.2934 (5.91222)	2.283	1229
Parent's mean education	613	2.8858 (1.01621)	615	2.8911 (.98374)	.092	1226
TV News use (local and network)	611	1.486 (1.6309)	616	1.565 (1.7102)	.833	1225
Newspaper use	608	2.1069 (2.78146)	614	2.5277 (2.82988)	2.621	1220
Internet news use	610	.7852 (1.81621)	615	1.0439 (2.05059)	2.336**	1223
Parental political involvement	611	3.4239 (1.77325)	611	3.4464 (1.79454)	.220	1220
Family Communication	614	5.0627 (1.78097)	617	5.1783 (1.82666)	1.124	1229
Learned about politics in school	611	3.3307 (1.81179)	615	3.6697 (1.94501)	3.157**	1224
Political knowledge scale	614	.8893 (.94934)	617	1.1135 (1.05533)	3.918**	1229
Political Efficacy	613	2.6436 (.91365)	614	2.7695 (.94475)	2.374	1225
Online Political Participation	609	1.4828 (.90327)	614	1.6661 (1.03492)	3.300**	1221
Offline Political Participation	609	1.8440 (1.01646)	614	1.9153 (1.03100)	1.218	1221

Note. Standard Deviations appear in parentheses below means.
**$p < .01$

but parent political involvement and family communication were also significant, which was inconsistent with H1.

H3 posited that efficacy would predict political participation more for teens than tweens. Actually, however, efficacy predicted online participation for both groups (see Table 5). It also predicted offline political participation for both

Table 2. Linear Regression Analysis Predicting Knowledge for Tweens (12–14) and Teens (15–17) (N = 1,291).

Variable	Tweens			Teens		
	B	SE(B)	β	B	SE(B)	β
Household Size	.006	.029	.007	−.002	.033	−.002
Income	.016	.007	.100*	.026	.008	.144**
Parent's mean education	.149	.041	.160**	.195	.046	.182**
TV News use (local and network)	−.004	.025	−.008	.003	.025	.005
Newspaper use	.018	.015	.052	−3.405E-5	.015	.000
Internet news use	.004	.022	.007	.021	.021	.042
Parental Political Involvement	−.013	.022	−.025	−.021	.025	−.035
Family Communication	.112	.023	.209**	.114	.027	.196**
Learned about politics in school	.067	.023	.128	.039	.024	.071
R^2		.154			.165	
Adjusted R^2		.141			.152	

$* = p < .05; ** = p < .01.$

Table 3. Linear Regression Analysis Predicting Online Political Participation for Tweens (12–14) and Teens (15–17) (N = 1,291).

Variable	Tweens			Teens		
	B	SE(B)	β	B	SE(B)	β
Household Size	−.008	.026	−.011	.025	.030	.030
Income	.004	.006	.026	−.004	.007	−.025
Parent's mean education	−.032	.036	−.036	−.024	.043	−.023
TV News use (local and network)	.048	.021	.085*	.051	.023	.083*
Newspaper use	.025	.013	.077*	−.013	.014	−.035
Internet news use	.131	.020	.252**	.144	.020	.286**
Parental Political Involvement	.082	.019	.160**	.095	.023	.164**
Family Communication	.034	.020	.067	.058	.024	.102*
Learned about politics in school	.115	.020	.229**	.092	.022	.172**
R^2		.296			.260	
Adjusted R^2		.285			.249	

$* = p < .05; ** = p < .01.$

groups (see Table 6), and thus there was no support for H3. Comparing Tables 3 and 5, it can be seen that adding efficacy to the equation increased the variance accounted for in online political participation. Comparing Tables 4 and 6, it can be seen that adding efficacy improved the prediction of offline political participation.

Table 4. Linear Regression Analysis Predicting Offline Political Participation for Tweens (12–14) and Teens (15–17) (N = 1,291).

Variable	Tweens			Teens		
	B	SE(B)	β	B	SE(B)	β
Household Size	.019	.027	.024	.031	.028	.037
Income	.001	.006	.006	.007	.007	.039
Parent's mean education	-.060	.037	-.060	-.061	.041	-.058
TV News use (local and network)	.057	.022	.090*	.059	.022	.097**
Newspaper use	.026	.014	.070	.009	.013	.026
Internet news use	.067	.021	.116**	.075	.019	.149**
Parental Political Involvement	.250	.020	.436**	.231	.022	.399**
Family Communication	.005	.021	.008	-.022	.023	-.039
Learned about politics in school	.142	.021	.252**	.116	.021	.218**
R^2		.398			.328	
Adjusted R^2		.389			.318	

$* = p < .05; ** = p < .01.$

Table 5. Linear Regression Analysis Predicting Online Political Participation for Tweens (12–14) and Teens (15–17) While Adding Efficacy to the Model (N = 1,291).

Variable	Tweens			Teens		
	B	SE(B)	β	B	SE(B)	β
Household Size	-.007	.025	-.010	.015	.029	.018
Income	.004	.006	.027	-.004	.007	-.021
Parent's mean education	-.026	.036	-.029	-.025	.042	-.024
TV News use (local and network)	.048	.021	.085*	.046	.023	.076*
Newspaper use	.018	.013	.055	-.018	.014	-.051
Internet news use	.123	.020	.235**	.151	.019	.301**
Parental Political Involvement	.074	.019	.145**	.100	.023	.173**
Family Communication	.025	.020	.048	.046	.024	.081
Learned about politics in school	.099	.020	.198**	.077	.022	.146**
Efficacy	.155	.037	.156**	.132	.040	.121**
R^2		.316			.281	
Adjusted R^2		.304			.269	

$* = p < .05; ** = p < .01.$

Table 6. Linear Regression Analysis Predicting Offline Political Participation for Tweens (12–14) and Teens (15–17) While Adding Efficacy to the Model (N = 1,291).

Variable	Tweens			Teens		
	B	SE(B)	β	B	SE(B)	β
Household Size	.020	.026	.025	.028	.028	.033
Income	.001	.006	.008	.008	.007	.046
Parent's mean education	−.055	.037	−.055	−.065	.040	−.063
TV News use (local and network)	.057	.022	.090**	.057	.022	.095**
Newspaper use	.021	.014	.057	.007	.013	.019
Internet news use	.060	.021	.103**	.074	.018	.148**
Parental Political Involvement	.244	.020	.426**	.232	.022	.404**
Family Communication	−.003	.021	−.004	−.033	.023	−.059
Learned about politics in school	.130	.021	.231**	.096	.021	.182**
Efficacy	.119	.039	.106**	.161	.039	.147**
R^2		.408			.341	
Adjusted R^2		.398			.330	

$* = p < .05; ** = p < .01.$

Table 7 shows the variables that predict political efficacy itself. The equation for tweens predicted more of the variance (17%) than did the equation for teens (10%). Family communication and learning about politics in school were strong predictors in both equations, but in the tweens equation, newspaper use, Internet news use, and parental political participation were also important. Thus, for the younger group, there is more parental influence, that is, both parental political involvement and family communication are significant; and the effects of news use are important for tweens, whereas they disappear in the equation for the older youth.

H4 suggested that efficacy and knowledge mediate the effects of parental participation, family communication and school experiences for teens and tweens on offline and online political participation. Path models were employed to test the hypothesis (see Figures 1–4). The various models were adjusted for the best fit. The results showed that for both tweens and teens with offline political participation, efficacy had the largest standardized regression weight. The chi square divided by degrees of freedom (CMIN) statistic was 32.905 for tweens and 26.887 for teens. Although high, both were less than the CMIN for the independence model, which accounts for all paths equally. The RMSEA statistic was .230 for tweens and .207 for teens, which was also high, but both numbers were once again less than the independence model and suggested a good fit. Thus, as can be seen in Figures 1 and 2, efficacy, but not knowledge, mediated the relationship with offline participation.

Table 7. Linear Regression Analysis Predicting Political Efficacy for Tweens (12–14) and Teens (15–17) (N = 1,291).

Variable	Tweens			Teens		
	B	SE(B)	β	B	SE(B)	β
Household Size	-.008	.028	-.011	.000	.030	-.001
Income	-.001	.007	-.009	-.009	.007	-.055
Parent's mean education	-.045	.039	-.050	.022	.043	.023
TV News use (local and network)	.002	.023	.003	-.013	.023	-.024
Newspaper use	.046	.014	.140**	.007	.014	.020
Internet news use	.053	.021	.105*	.015	.020	.032
Parental Political Involvement	.046	.021	.090*	-.025	.023	-.047
Family Communication	.063	.022	.121**	.090	.024	.174**
Learned about politics in school	.102	.022	.202**	.112	.022	.231**
R^2		.182			.116	
Adjusted R^2		.170			.103	

$* = p < .05; ** = p < .01.$

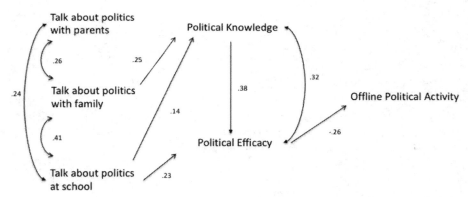

Figure 1. Path analysis model examining the mediation effects of knowledge and efficacy on offline political participation for tweens (N = 607) showing only significant paths ($p < .001$).

When testing for online participation, the path models suggest that for both tweens and teens, efficacy had the largest standardized regression weight. Thus, as can be seen in Figures 3 and 4, efficacy, but not knowledge, mediated the relationship with online participation. Knowledge, however, was the key predictor of efficacy, and the negative intercorrelation between the two variables suggests that knowledge causes efficacy and not the other way around. The model also suggests knowledge is largely built through friend and family discussions and not through school, which predicts only efficacy and not knowledge.

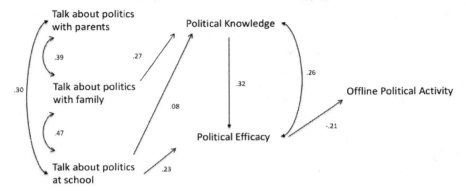

Figure 2. Path analysis model examining the mediation effects of knowledge and efficacy on offline political participation for teens (N = 604) showing only significant paths (p < .001).

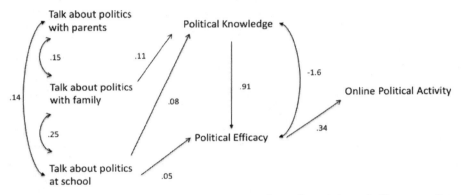

Figure 3. Path analysis model examining the mediation effects of knowledge and efficacy on online political participation for tweens (N = 607) showing only significant paths (p < .001).

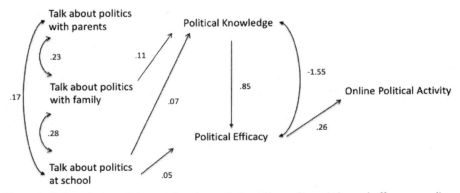

Figure 4. Path analysis model examining the mediation effects of knowledge and efficacy on online political participation for teens (N = 604) showing only significant paths (p < .001).

DISCUSSION

The goal of this study was to test a model that accounts for many of the factors leading to political socialization. As the literature suggests, there is no single issue that will lead youth to become politically active, especially before they can even vote. A discussion of socialization needs to include demographic, media, school, and psychological variables, yet it also cannot discount the importance of a child's age. The maturation process affects how much young people learn and trust the sources of their knowledge. It also impacts how successful they think they will be in applying their political knowledge.

First, our study suggests that age helps determine how children learn about politics and what media sources they will choose. Teens, or those aged 15–17, are more likely to turn to the media for information about politics, as the literature suggests, because they are trying to find their own way in the world. They are also more likely to use the Internet to participate politically, as our study suggests. Younger children, or tweens, will rely more on family, especially as they try to learn about the political process.

As children apply their knowledge, the influence of family and even school is not enough. They have to believe their actions will make a difference, that they or the candidates they choose to support will be successful. Political self-efficacy mediates the effect that parents, school, and even the media can have on whether children choose to participate in politics. Efficacy, in fact, is such a strong mediating variable that it might determine the political socialization process. Translating knowledge to action requires this belief, which is a product of school, family, and media.

We believe efficacy is the reason we found only partial support for many of the hypotheses the extant literature suggested. The path models suggested that teens and tweens follow a similar path to action. Almost everyone starts by following in their parents' political footsteps. This can lead to talking as a family about politics and can inform political discussions at school. Each of these socialization elements works together to inculcate in tweens and teens the desire to gain political knowledge. But simply learning facts and talking about politics at school and at home is not enough. That knowledge must lead tweens and teens to believe in the system and to think they can make a difference. Strong political education programs, such as Kids Voting USA, helped instill this belief in young people. Findings from the current study suggest it is important for political education in schools and at home to revolve around self-efficacy if the goal is to create children who will become actively involved in politics. Even online, where participation is as easy as clicking a button or adding something to a Facebook page, self-efficacy determines a person's likelihood to act.

We understand that the models tested in this study do not account for all of the variables that lead to self-efficacy. The low fit statistics suggest that other factors

are at play. The models also do not account for demographics, such as income, which the regressions suggest are significant. Further studies should adjust the model to determine what other factors influence knowledge and efficacy formation. These factors could include previous political experiences or success and the impact of other factors, such as peer influence or attention to people in the media, including celebrities who are politically active.

However, we think the significant path between efficacy and participation and the large adjusted R2 scores of the regression equations suggest that efficacy plays a crucial role in adolescents' political socialization. Schools and parents could help adolescents become more interested and participate in politics if they focus their efforts on helping these individuals believe they can make a difference. This belief in one's ability to make a difference might be just enough to engage our youngest citizens, no matter their age.

REFERENCES

Adoni, H. (1979). The functions of mass media in the political socialization of adolescents. *Communication Research, 6*(1), 84–106.

America goes to the polls. (2013). Retrieved from http://www.nonprofitvote.org/documents/2013/09/america-goes-to-the-polls-2012-voter-participation-gaps-in-the-2012-presidential-election.pdf

Bandura, A. (2006). Adolescent development from an agentic perspective. In F. Pajares & T. C. Urdan (Eds.), *Self-efficacy beliefs of adolescents.* Greenwich, CT: Information Age.

Baumgartner, J., & Morris, J. S. (2006). The Daily Show effect: Candidate evaluations, efficacy, and American youth. *American Politics Research, 34*(3), 341–367.

Campbell, A., Gurin, G., & Miller, W. E. (1954). *The voter decides.* Evanston, IL: Row, Peterson.

Circle (2008). Youth turnout rate rises to at least 52%. Accessed at http://civicyouth.org/youth-turnout-rate-rises-to-at-least-52/

Easton, D., & Dennis, J. (1969). *Children in the political system.* New York, NY: McGraw-Hill.

Erikson, E. H. (1966). Ontogeny of ritualization in man. *Philosophical Transactions of the Royal Society of London. Series B, Biological Sciences, 251*(772), 337–349.

Eveland, W. P., Jr., McLeod, J. M., & Horowitz, E. (1998). Communication and age in childhood political socialization: An interactive model of political development. *Journalism & Mass Communication Quarterly, 75*(4), 699–718. doi: 10.1177/107769909807500406

Gniewosz, B., Noack, P., & Buhl, M. (2009). Political alienation in adolescence: Associations with parental role models, parenting styles and classroom climate. *International Journal of Behavioral Development, 33*(4), 337–346. doi: 10.1177/0165025409103137

Greenstein, F. I. (1965). *Children and politics.* New Haven, CT: Yale University Press.

Gross, E. F. (2004). Adolescent Internet use: What we expect, what teens report. *Journal of Applied Developmental Psychology, 25*(6), 633–649. doi: 10.1016/j.appdev.2004.09.005

Haas, C. (2008). The Obama campaign—social media. Retrieved from http://www.barackobama.com.

Hoffman, L. H., & Thompson, T. L. (2009). The effect of television viewing on adolescents' civic participation: Political efficacy as a mediating mechanism. *Journal of Broadcasting and Electronic Media, 53*(1), 3–21. doi: 10.1080/08838150802643415

Jennings, M. K., & Niemi, R. G. (1968). The transmission of political values from parent to child. *The American Political Science Review, 62*(1), 169–184.

Jennings, M. K., & Niemi, R. G. (1974). *Political character of adolescence: The influence of families and schools*. Princeton, NJ: Princeton University Press.

Kaid, L. L., McKinney, M. S., & Tedesco, J., C. (2007). Introduction: Political information efficacy and young voters. *American Behavioral Scientist, 50*(9), 1093–1111.

Kenski, K., & Stroud, N. J. (2006). Connections between Internet use and political efficacy, knowledge, and participation. *Journal of Broadcasting & Electronic Media, 50*(2), 173–192. doi: 10.1207/s15506878jobem5002_1

Kiousis, S., & McDevitt, M. (2008). Agenda setting in civic development effects of curricula and issue importance on youth voter turnout. *Communication Research, 35*(4), 481–502.

Kiousis, S., McDevitt, M., & Wu, X. (2005). The genesis of civic awareness: Agenda setting in political socialization. *Journal of Communication, 55*(4), 756–774. doi: 10.1111/j.1460-2466.2005.tb03021.x

Marcia, J. E. (1980). Identity in adolescence. In J. Adelson (Ed.), *Handbook of adolescent psychology*. New York, NY: Wiley.

McDevitt, M. (2005). The partisan child: Developmental provocation as a model of political socialization. *International Journal of Public Opinion Research, 18*(1), 67–88. doi: 10.1093/ijpor/edh079

McDevitt, M., & Chaffee, S. (2002). From top-down to trickle-up influence: Revisiting assumptions about the family in political socialization. *Political Communication, 19*, 281–301. doi: 10.1080/0195747029005501

McDevitt, M., & Kiousis, S. (2007). The red and blue of adolescence: Origins of the compliant voter and the defiant activist. *American Behavioral Scientist, 50*(9), 1214–1230. doi: 10.1177/0002764207300048

McKinney, M. S., & Banwart, M. C. (2005). Rocking the youth vote through debate: Examining the effects of a citizen versus journalist controlled debate on civic engagement. *Journalism Studies, 6*(2), 153–163. doi: 10.1080/14616700500057171

Meadowcroft, J. M. (1986). Family communication patterns and political development. *Communication Research, 13*(4), 603–624. doi: 10.1177/009365086013004005

Meirick, P. C., & Wackman, D. B. (2004). Kids Voting and political knowledge: Narrowing gaps, informing votes. *Social Science Quarterly, 85*(5), 1161–1177. doi: 10.1111/j.0038-4941.2004.00269.x

Rodgers, H. R., Jr. (1974). Toward explanation of the political efficacy and political cynicism of black adolescents: An exploratory study. *American Journal of Political Science, 18*(2), 257–282.

Shaffer, D. R. (2009). *Social and personality development* (9th ed.). Belmont, CA: Wadsworth.

Sherrod, L. R., Flanagan, C., & Youniss, J. (2002). Dimensions of citizenship and opportunities for youth development: The what, why, when, where, and who of citizenship development. *Applied Developmental Science, 6*(4), 264–272. doi: 10.1207/S1532480XADS0604_14

Torney-Purta, J. (1995). Psychological theory as a basis for political socialization research. *Perspectives on Political Science, 24*(1), 23. doi: 10.1080/10457097.1995.9941862

Vecchione, M., & Caprara, G. V. (2009). Personality determinants of political participation: The contribution of traits and self-efficacy beliefs. *Personality and Individual Differences, 46*, 487–492. doi: 10.1016/j.paod.2008.11.021

Wells, S. D., & Dudash, E. A. (2007). Wha'd'ya know?: Examining young voters' political information and efficacy in the 2004 election. *American Behavioral Scientist, 50*(9), 1280–1289. doi: 10.1177/0002764207300053

Zaff, J. F., Malanchuk, O., & Eccles, J. S. (2008). Predicting positive citizenship from adolescence to young adulthood: The effects of a civic context. *Applied Development Science, 12*(1), 38–53. doi: 10.1080/10888690801910567

Media Changes

Young Citizens' Use OF Digital AND Traditional Political Information

J. BRIAN HOUSTON AND MITCHELL S. McKINNEY

If there is one constant in the modern American political environment, it is the continual evolution of the political news and information landscape. The United States was founded on the printed word, and since that time different forms of communication technologies have emerged on the American political scene affecting the ways citizens communicate and learn about politics (Pfau, Houston, & Semmler, 2007; Prior, 2007). In fact, the rate of political news source change appears to be accelerating. Cable and satellite television, the Internet, and now cell phones and smartphones have provided more diverse, tailored, and dynamic political information sources. As these new information forms have emerged and spread, the audience for older and more traditional forms of political information (e.g., newspapers, broadcast television news) has declined (Pew Research Center, 2010, 2011).

The current research attempts to make sense of the changing political news and information landscape by exploring young citizens' political media use during a presidential campaign. We focus on the use of political news sources by young citizens because youth are the segment of society that most readily adopts new information technologies (Pew Research Center, 2010, 2011). Thus the current news use patterns of young citizens may portend what will constitute established and traditional information use patterns in the future. In this study we examine how the different political news and information sources used by young citizens are related to each other, and how that use is associated with political ideology, interest, and efficacy.

THE CHANGING POLITICAL NEWS AND
INFORMATION LANDSCAPE

The characteristics and implications of the changing political news and information landscape are of particular interest to mass communication researchers because information is considered essential for a healthy democracy (Bimber, 2003). Political information is necessary because a democracy requires knowledgeable citizens (Delli Carpini & Keeter, 1996). While existing research has documented linkages between use of different political information sources and political knowledge (e.g., Bennett, Flickinger, & Rhine, 2000; Eveland, Hayes, Shah, & Kwak, 2005), it seems that as soon as researchers begin to gain an overall understanding of the political information landscape, the technologies that comprise this landscape shift and evolve, presenting fundamental challenges to our overall state of understanding of citizens' political information use. For example, theoretical perspectives such as Prior's (2007) post-broadcast model address the changing media landscape and its effect on political knowledge and participation, suggesting that more media choice results in greater differences in knowledge and behavior between the politically interested and uninterested. While these results support the notion that changing media use patterns among citizens matter, Prior's work focuses only on broadcast TV, cable TV, and Internet use. Unfortunately, in the current media landscape these broad swaths of media use may not be specific enough to provide a full understanding of modern media effects. The rapid political information source change that we are experiencing affects not only the claims that can be made about effects resulting from use of political information sources, but it also creates challenges for operationalization of research in this area.

For example, as recently as a decade ago a researcher might be able to ask citizens about the frequency of their "Internet use" related to political news and produce meaningful results. But a concept such as "Internet use" in today's political information environment is not sufficiently descriptive. For example, does using the Internet to gain political news mean accessing a conventional newspaper web site such as USA Today.com, or does it mean visiting partisan blogs such as Daily Kos.com, or does it mean gleaning political content from friends and family members' status updates on social networking sites such as Facebook.com, or does it mean receiving news via search engine results on sites such as Google.com, or does it mean watching user-provided political videos on YouTube.com? Or does it mean all of these things, or some combination thereof? Are all of these activities sufficiently similar that "Internet use" would appropriately capture them? In today's political information landscape this seems unlikely.

These are the questions that news practitioners and researchers are faced with in the current information environment. To help gain a better understanding of these questions, it is necessary to generate empirical insight into the patterns of

political news usage that occur within this diverse body of sources and to examine how these patterns of use are related to political attitudes. The current study is a preliminary attempt to generate such knowledge. The research described here explores political information source use and political correlates of that use among young citizens aged 18–29.[1] Studying the political news consumption of young citizens is a logical first step in sorting out the current political information landscape because youth are typically the first segment of society to most broadly embrace the use of new information technologies (Jones & Fox, 2009). Therefore, patterns of political news source usage among youth (and related effects) portend changes that will spread across society as new technologies are further adopted. To explore these usage patterns, we propose our first research question:

RQ1: What are the patterns of young citizens' political information source use?

In the current political news environment—which is characterized by unprecedented choice—use of different political information sources may be related to a citizens' political ideology and political interest. In fact, the suggestion that more choice in the political information environment may lead to citizens selecting information that fits with their existing political beliefs and values is a significant concern among political information scholars (Sunstein, 2007). Selective exposure theory predicts that political partisans will only, or will primarily, choose attitude-conforming media sources (Garrett, 2009). A potential consequence of selective exposure is that as partisans select only media that conforms to their existing ideology they may become more extreme in their attitudes, resulting in increased political polarization across the electorate (Sunstein, 2007). A related issue is political information choice among citizens who are less interested in politics. When the media landscape was less diverse it may have been more difficult for those not interested in politics to avoid political information completely (Prior, 2007). Now, with the plethora of media choices in today's information landscape, those who are less interested in politics may find it quite easy to turn the channel when political news comes on the television or to avoid websites that cover politics when online. The question that follows from this new reality is what political information sources are used by less politically interested citizens? It is possible that, for example, less interested citizens prefer to get their political information from sources whose primary purpose is to entertain rather than inform (such as soft news, late-night comedy, or television talk shows; (Baum & Jamison, 2006; Xenos & Becker, 2009). We explore the relationship between political news source use and both political ideology and political interest through the following research question:

RQ2: What is the relationship between young citizens' political information source use and (a) political ideology and (b) campaign interest?

Finally, an important issue related to political news source choice is how use of different sources is related to political efficacy. In our analysis we examine two

related forms of political efficacy. First, the concept of external political efficacy has been defined as an individual's feeling that he or she has the ability to influence the political process (Campbell, Gurin, & Miller, 1954). From a normative perspective, external political efficacy is an important variable because it has been found to predict political participation (Campbell, Converse, Miller, & Stokes, 1960; Rosenstone & Hansen, 1993). Also, because the current study seeks to understand young citizens' use of political news sources, we find the construct of political information efficacy to be particularly relevant to our analysis. Grounded in important theoretical links with general political efficacy, political information efficacy is an attitudinal construct that taps one's feelings of confidence in the political knowledge they possess (Kaid, McKinney, & Tedesco, 2007). Thus, while external political efficacy is an individual's belief that his or her actions or behaviors will influence the political process, political information efficacy is defined as the "level of confidence one has in his or her political knowledge and that one possesses sufficient knowledge to engage the political process through such behaviors as voting" (McKinney & Rill, 2009, p. 397). We address these two conceptualizations of political efficacy through the following research question:

RQ3: What is the relationship between young citizens' political information source use and (a) external political efficacy and (b) political information efficacy?

METHOD

To better understand young citizens' use of political information sources during a presidential campaign, survey data were collected during the general election phase of the 2008 presidential election. The data reported in this study were collected as part of a larger national campaign communication study and were collected during a 3-week period from September 26 to October 15, 2008.

Participants

The respondents in this study consisted of 1,752 undergraduate students from 18 universities from throughout the nation. Participation was voluntary and participants received course, or extra, credit for completing the study. The total sample consisted of 970 women (55%) and 766 men (44%) whose mean age was 20 years (with ages ranging from 18 to 29). Sixty-five individuals over the age of 29 participated in this research project but were not included in the analysis. The sample was 63.2% Caucasian (n = 1,107), 15.3% Spanish/Hispanic (n = 268), 8.3% African American (n = 146), 5.3% multi-racial (n = 92), 6.3% Asian/Pacific Islander (n = 111), 0.4% Native American (n = 7), and 1.2% (n = 21) did not report their race/ethnicity.

Measures

A profile of young citizens' *political information diet* was constructed by asking respondents to indicate how frequently they used specific sources to obtain their information about political candidates and the 2008 presidential election. Respondents indicated their frequency of using 27 different sources of political information (see Table 1 on p. 363 for items), with responses ranging from 0 (*never*) to 5 (*a lot*). The political information sources included in this measure were identified through a review of relevant literature and reports examining dominant sources of political information (e.g., Horrigan, 2007; Pew Research Center, 2008; Pfau, Houston, & Semmler, 2007).

Political ideology was assessed by asking respondents to place themselves on a scale ranging from 1 (*extremely liberal*) to 10 (*extremely conservative*; $M = 4.90$, $SD = 2.21$). Participants were also asked if they were registered to vote, with possible responses of yes (86.5%) or no (13.5%). Interest in the political campaign was assessed by asking: "How interested would you say you are in the presidential campaign?" with possible responses ranging from 1 (*not interested at all*) to 5 (*very interested*; $M = 4.05$, $SD = 1.05$). *External political efficacy* was measured with two items: "Whether I vote or not has no influence on what politicians do" and "People like me don't have any say about what the government does," with possible responses ranging from strongly disagree to strongly agree on a five-point scale ($M = 3.62$, $SD = .99$, $\alpha = .64$, $r = .48$).

Lastly, a four-item scale was used to measure *political information efficacy* (PIE). Participants were asked to indicate their level of agreement (using a five-point scale from *strongly disagree* to *strongly agree*) on four statements reflecting one's level of confidence in their political knowledge (including "I consider myself well-qualified to participate in politics," "I think that I am better informed about politics and government than most people," "I feel that I have a pretty good understanding of the important political issues facing our country," and "If a friend asked me about the presidential election, I feel I would have enough information to help my friend figure out who to vote for" ($M = 3.55$, $SD = .98$, $\alpha = .85$).

Analysis

To identify young citizens' political information use patterns, exploratory factor analysis using principal axis factoring (PAF) was conducted. In contrast to principal component analysis (PCA), which is meant to reduce the number of analyzed variables to the lowest number, "PAF explicitly focuses on the common variance among … items and, therefore, focuses on the latent factor" (Henson & Roberts, 2006, p. 398). Following the factor analysis, all items that loaded on a young citizen's

political information factor were averaged to create a score for that factor. Pearson correlations were calculated to explore associations between the political information factor, political ideology, and campaign interest. Political information factor scores were also used as the second block of independent variables (the first block included sociodemographic and political attitude control variables) in hierarchical regression models that included external political efficacy and political information efficacy as dependent variables.

RESULTS

RQ1: Young Citizens' Political Information Factors

RQ1 sought to determine how use of different political information sources was related, and this question was addressed using exploratory factor analysis. The Kaiser-Meyer-Okin measure of sampling adequacy was .88 and Bartlett's test of Sphericity was significant, $\chi^2(351) = 15,198$, $p < .001$, thus justifying the factor analysis. The factor analysis was based on a correlation matrix of all variables. Oblique factor rotation with Promax method was used to identify factors. Oblique rotation methods do not require factors to be independent of each other (Park, Dailey, & Lemus, 2002). Factor extraction—based on both the Kaiser-Guttman criterion of Eigenvalues greater than 1.00 and a visual inspection of the Scree plot (Floyd & Widaman, 1995)—resulted in seven factors that explained 60.98% of the variance (see Table 1). After the factors were extracted, the individual factors were examined and named based on the political information sources that were included in each factor. So, for example, the factor that included the political information sources of newspapers, online; newspapers, print copy; news magazines; and news websites was named News (print/online) because the factor included an overall pattern of both print and online news use. For young citizens, the political information factor with the most frequent use was labeled the Engaged Millennials factor ($M = 2.49$, $SD = .98$, $\alpha = .73$), followed by News (print/online; $M = 2.38$, $SD = 1.19$, $\alpha = .75$), Entertainment ($M = 2.09$, $SD = 1.42$, $\alpha = .71$), TV News ($M = 2.03$, $SD = 1.17$. $\alpha = .69$), Political Web 2.0 ($M = 1.39$, $SD = 1.24$, $\alpha = .78$), Political Junky ($M = 1.15$, $SD = 1.00$, $\alpha = .72$), and Political Websites ($M = 0.99$, $SD = 1.08$, $\alpha = .73$).

RQ2: Young Citizens' Political Information Factors, Political Ideology, and Campaign Interest

See Table 2 for correlations between young citizens' use of political information factors and political ideology and campaign interest.

Table 1. Young Citizens' Political Information Factors.

I obtain information about politics and candidates from ...	News (print/online)	TV News	Engaged Millennials	Political Web 2.0	Political Websites	Political Junky	Entertainment
Newspapers, online	.78						
Newspapers, print copy	.65	.12					
News magazines	.53				.10	.18	
News websites	.44		.31				
Local TV news		.83					
National broadcast TV news		.59	.30	−.15			
Morning TV news/talk shows		.47			.10	.14	
Cable TV news		.21	.73		−.10		
Televised debates	.18		.61				
TV news talk shows	−.22		.52			.23	.23
Political advertising on TV		.28	.33	.28	−.15		
Rallies or public events			.29		.18	.14	
Speaking with others face-to-face	.22		.29	.28	−.23		
Social networking websites				.83			
Cell phones	−.12			.77	−.11	.18	
YouTube				.67	.13		
Internet search engines	.15			.57			
Speaking with others online				.39		.14	
Political blogs/websites					.94		
Personal blogs/websites			−.14	.24	.68		
Political candidate websites	.10		.30		.36		−.13
Political radio talk shows						.84	
Radio news	.22		−.14		−.14	.70	
Sunday morning political talk programs			.15		.16	.42	
C-SPAN			.17		.14	.39	
TV late-night shows		.14					.83
Political entertainment programs		−.20	.15				.68

Note. Entries are factor loadings for each individual political information source. Small coefficients (< .10) are omitted.

Table 2. Political Information Factors and Political Ideology and Interest Correlations.

Political Information Factors	Political Ideology (Conservative)	Campaign Interest
News (print/online)	−.05*	.34**
TV News	.12**	.12**
Engaged Millennials	.01	.41**
Political Web 2.0	−.04	.13**
Political Websites	−.08	.24**
Political Junky	.10**	.20**
Entertainment	−.16**	.14**

Note. Entries are correlations between political information factors and political ideology and campaign interest. * $p < .05$; ** $p < .01$.

RQ3: Young Citizens' Political Information Factors and Political Efficacy

Hierarchical regression with two blocks of variables was calculated to explore RQ3. The first block of variables included sociodemographics and political attitude variables, while the second block included the political information factors. External political efficacy and political information efficacy were the dependent variables (see Table 3 for results).

DISCUSSION

This research explored how young citizens' uses of different political information sources during a presidential campaign were related to each other and also to political ideology, interest, and efficacy. Exploratory factor analysis revealed the ways in which information source usage grouped together. The political information factor that emerged from our factor analysis and was used more frequently by young citizens was the *Engaged Millennial* factor. This factor included traditional political information sources (debates, televised advertising, cable television news) as well as engaged citizen activities (attending rallies or public events, speaking with others face-to-face). Therefore, this factor comprises traditional and engaged citizen sources of political information. That such a construct would be the most frequently used source of political information for young citizens is encouraging from a normative democratic perspective in that it illustrates that young citizens—even given the changing political information landscape—are still most inclined to attain their political information from traditional and engaged sources. It is also worth noting that use of cable news (cable TV news and TV news talk shows), as

Table 3. Political Information Factors and Political Efficacy.

	External Political Efficacy	Political Information Efficacy
Demographics and Political Interest		
Age	–.03	.07**
Gender	.09**	–.14**
Political Ideology	.04	.02
Registered to vote	–.03	–.01
Campaign Interest	.22**	.44**
R^2	.09	.33
Political Information Factors		
News (print/online)	.08**	.12**
TV News	–.01	–.15**
Engaged Millennials	.10**	.16**
Political Web 2.0	–.04	–.01
Political Websites	.03	.05*
Political Junky	.05	.03
Entertainment	–.06*	.02
Incremental R^2	.03	.06
Final R^2	.12	.39
Model (df) F	(12, 1487) 16.65**	(12, 1498) 79.04**

Note. Entries are final standardized coefficients from ordinary-least-squares regression.
* $p < .05$; ** $p < .01$.

opposed to more traditional national or local broadcast television news, loaded as part of this political information factor. Thus, it appears that *cable* television news has become the *traditional* television news for young citizens.

The second most frequently used political information factor was **News (print/ online)**. This information factor is also more traditional in nature than might be expected, in that it mostly includes web and print versions of what used to be exclusively print news. This result indicates that for young citizens, news is news, whether it appears on paper or on the Internet. It should also be noted that television news (of any variety) does not load with this factor. Therefore, for young citizens, print news is the same whether it is paper-based or electronic, but it is not the same, nor is it as frequently used, as broadcast television news.

Following News (print/online), **Entertainment** was the next most frequently used political information source. This result illustrates the appeal of programs such as *The Daily Show* as a political information source for young citizens, but

it also indicates that use of entertainment media for political information is isolated (this factor includes only two entertainment sources). Moreover, while the Entertainment political information factor was significantly associated with the other political information factors, the average correlation for the Entertainment factor with other political information factors was the weakest of all the factors (r^2 = .26). Therefore, while use of entertainment media (or at least use of late-night political comedy) may be associated with political knowledge (National Annenberg Election Survey, 2004), this use is not strongly associated with use of other political information sources among young citizens; and the notion that political entertainment media might be a gateway source to other more traditional media sources (Feldman & Young, 2008; Xenos & Becker, 2009) is not fully supported by these results.

Television News was the next most frequently used political information source. The TV News factor includes local, national broadcast, and morning TV news but does not include cable news. While cable television news is associated with the most frequently used political information factor (Engaged Millennial), use of these other more traditional forms of television news occurs less frequently and is not associated with any other political information source use. Therefore, it appears that traditional TV news is a more isolated source of political information for young citizens.

The next political information factor is *Political Web 2.0*. This factor includes the newest forms of political information, such as social networking, online video, and cell phones. These dynamic forms of information technology are often touted as offering the most promise for a participatory democracy (Shirky, 2008; Trippi, 2008), but at least during the 2008 presidential election they were not used by young citizens as frequently as were more traditional forms of technology. As with all new successful information technologies, use of these sources may increase over time, but the lack of dependence on these newest sources for political information during the 2008 election was still somewhat surprising. Additionally, if one assumed that all Internet-based political information sources would load together into a single factor, this result illustrates the error of this assumption. According to our results, using online newspapers or consulting political websites for political information is not the same as using social networking websites. Therefore, lumping all online sources together does not accurately reflect the patterns of young citizens' online political information source use. A final observation about the Political Web 2.0 factor is that it does not include any "news" sources. Thus, if young citizens are getting their political information primarily from Web 2.0 sources, this information is likely to be social (recommended or cited by friends, family, or colleagues through an online social network) or viral (spread across the Internet as a result of popularity), which is quite different than depending on political information sources that employ traditional journalism gate-keeping

mechanisms for determining what constitutes news and for framing that news. Understanding the implications of receiving political information via these new mechanisms should be explored through future research (Holbert, Garrett, & Gleason, 2010).

The two least-frequently used political information source factors were *Political Junky* and *Political Websites*. Both of these political information factors include sources designed for those most interested in politics and/or partisans. Overall, young citizens did not gravitate toward these sources. Also, the Political Websites factor includes Internet-based sources of political information (blogs and websites), yet these sources are not frequently utilized by young citizens. As mentioned previously, this should caution assumptions that young citizens are automatically likely to use newer political information sources.

Moving beyond patterns of political information source use, we were also able to examine how this use was associated with political ideology, interest, and efficacy. Our results indicate that use of particular political information factors was associated with young citizens being more conservative (TV News, Political Junky) or more liberal (News [print/online], Entertainment), while a few of the factors were not associated with ideology (Engaged Millennials, Political Web 2.0, Political Websites). These results fit with selective exposure theory, which predicts use of specific political information forms will be associated with political partisanship (Garrett, 2009). That the Engaged Millennial political information factor (the most frequently used factor) was not related to political ideology should provide at least some comfort to scholars who worry about fragmentation and polarization in the current media environment.

Use of every political information factor in this study was significantly associated with interest in the presidential campaign. Therefore, as young citizens are more interested in the presidential campaign they are more likely to use all of the political information factors. It is possible that the relationship between interest and political information use is reinforcing (Slater, 2007), so that interest drives use, which in turn increases interest. Given the results, though, the question remains as to where young citizens who are less interested in politics get their political information in the new information landscape. Because none of the political information factors was associated with less campaign interest, our findings shed no light on this question. It may be that our survey questions (asking respondents where they get their information *about the presidential election*) results in an underreporting from less interested young citizens who don't realize they are getting political information at all. It may be that, for example, even if young citizens watch a skit on *Saturday Night Live* about the presidential candidates, they don't consider this (or realize it to be) political information. Future research should conduct more detailed exploration of the relationship between campaign interest and political information use.

Finally, we examined the determinants of political information efficacy and external political efficacy through multiple regression analysis (see Table 3). The Engaged Millennial political information factor was positively associated with both external political efficacy and political information efficacy, illustrating a link between use of more traditional and participatory sources of political information and political efficacy. Use of the News (print/online) political information factor was also positively associated with both external political efficacy and political information efficacy, supporting the importance of the "iron core" of political information (Jones, 2009).

Conversely, the TV news factor (local and national TV news) was negatively associated with political information efficacy, suggesting that young citizens who received their political information largely from TV news were less likely to be confident in their mastery of political content. This is a disconcerting finding that begs further investigation. It seems a reasonable expectation that the more young citizens watched broadcast or local television news the more those young citizens would be confident in their knowledge about political issues, but our results indicate otherwise. Perhaps the generally "objective" or balanced nature of traditional television news leaves young viewers uncertain as to what to think about politics. Conversely, the generally more partisan nature of cable news may alleviate this uncertainty in young citizens. Or perhaps there are other reasons that broadcast or local television news is less effective at conveying political information that results in young citizens feeling confident that they understand that information. For example, reductions in news staff and the ability of, particularly, local television news to report on politics have resulted in qualitative changes to news content that may result in less efficacy among TV news viewers. Future research should further explore reasons for less efficacy being related to use of television news.

Lastly, we found that use of the Entertainment political information factor was negatively related to external political efficacy. Therefore, as young citizens watched more television late-night talk shows or political entertainment programs, they were less likely to feel that their participation in the political process would make a difference. This is problematic from a normative perspective as it means viewers of these programs may potentially be turned off from the democratic process. The positive relationship between Entertainment use and inefficacy may be due to the satirical or mocking nature of comedy programs, which typically make fun of, or denigrate, political actors or events. Previous research has found that viewers of *The Daily Show* possessed higher levels of political knowledge than viewers of other more traditional news programs (National Annenberg Election Survey, 2004), but also more cynicism about the U.S. electoral system (Baumgartner & Morris, 2006). So a young citizen might know who the Senate Majority Leader is, for example, but at the same time feel that her vote on election day doesn't make a difference either in determining the winner of that election or

influencing the course of action chosen by that winner once elected. If such a situation exists then it would be a waste of democratic human capital, in that young citizens who have the knowledge to participate in the democratic process choose not to because they perceive that such participation does not make a difference.

Limitations

As with any research project, this study has several limitations. The first limitation is that this project utilized a convenience sample of young adults, and therefore we cannot claim that our results definitively represent all young citizens in America. However, even though our sample was not random, because we were able to survey a large number of youth from more than a dozen sites across the United States, we believe the sample is sufficiently rich and varied to provide meaningful results. The second limitation is that this project utilized a cross-sectional design with respondents self-reporting their use of political information sources. A longitudinal design would have provided more evidence for effects of political information use, and methods other than respondent self-report may have provided a more precise measure of usage of political information. Future researchers are encouraged to employ such designs and methods in order to generate additional understanding about the patterns and effects of young citizens' political information use. Finally, while this project examined the association of media use and various political outcomes, it is important to remember that other factors (such as education, family, and peers) play an important role in socializing young citizens (McDevitt & Chaffee, 2002; Schudson, 1998). Research projects that examine the full range of socializing agents, such as the many chapters included as part of this book, are recommended.

Practical Implications

Beyond contributing to the academic literature on young citizens' media use, our results have practical implications for news producers. First, the pattern of young citizens, political information use that we identified indicates that youth do not perceive differences between print and online news. While older individuals may continue to think about differences in print newspapers and the web versions of print news, use of political information by young citizens does not break down into these categories. Therefore, when creating news for young citizens (and also for older citizens as these trends expand to other age groups and as younger citizens become older citizens) news producers should consider the content of political news as one issue and the delivery mechanism of that content as another. In other words, in the emerging media environment there are no newspaper news and online news, there is instead simply one "news" that is delivered via a variety of platforms.

A related implication of our findings is that for young citizens, cable TV news constitutes traditional TV news. Even for the engaged or more traditional pattern of young citizen political information use (the Engaged Millennials factor), the most frequent source of televised political information was cable TV news and television talk shows. News producers thinking about future patterns of media use should be aware of this tendency to use cable-style TV news. Future research should further explore the preference for cable TV news, which may be the result of cable TV news' accessibility (i.e., cable news generally runs for 24 hours a day whereas broadcast TV news is available only during a specific time slot), content, style, or other reasons.

Thirdly, our results indicate that just because political information is online doesn't mean that youth will use that content. One might assume that youth will gravitate toward any information that is digitalized, but our results illustrate that not all online political information sources are automatically used by youth. As online, social, and mobile media sources proliferate, gaining users' attention in the new media landscape is becoming more competitive. News producers should be aware that simply putting information on Twitter, for example, does not mean youth will engage with that content.

CONCLUSION

The basic premise that guided this project was that, given the multiplicity of political information sources and media available in the media landscape, it is short-sighted to assume that conventional patterns of political information use occur. This premise was supported by our results, which should be useful to news producers as they continue to adapt their content for delivery to users. Our results mean that, for example, just because a young citizen accesses political information via a Facebook link, it doesn't automatically mean that user will also visit other political news websites. The patterns of young citizen political information use are mixed across platforms in ways that one may not intuit. Moreover, the patterns described here will likely shift as even newer technologies are introduced into the political information landscape. Ongoing empirical work will be needed to maintain our understanding of the dynamics of political information use as the media landscape continues to evolve.

NOTE

1. In selecting the age range for this study, we followed The Center for Information & Research on Civic Learning and Engagement (2008) and Keeter, Horowitz, & Tyson (2008), both of which considered the ages of 18–29 to constitute young voters.

REFERENCES

Baum, M. A., & Jamison, A. S. (2006). The *Oprah* effect: How soft news helps inattentive citizens vote consistently. *The Journal of Politics, 68*, 946–959.

Baumgartner, J., & Morris, J. S. (2006). *The Daily Show* effect: Candidate evaluations, efficacy, and American youth. *American Politics Research, 34*, 341–367. doi: 10.1177/1532673X05280074

Bennett, S. E. (2009). Who listens to Rush Limbaugh's radio program and the relationship between listening to Limbaugh and knowledge of public affairs, 1994–2006. *Journal of Radio & Audio Media, 16*, 66–82. doi: 10.1080/19376520902847980

Bennett, S. E., Flickinger, R. S., & Rhine, S. L. (2000). Political talk over here, over there, over time. *British Journal of Political Science, 30*, 99–119.

Bennett, W. L., & Iyengar, S. (2008). A new era of minimal effects? The changing foundations of political communication. *Journal of Communication, 58*, 707–731. doi: 10.1111/j.1460-2466.2008.00410.x

Bimber, B. (2003). *Information and American democracy: Technology in the evolution of political power.* New York, NY: Cambridge University Press.

Campbell, A., Converse, P. E., Miller, W. E., & Stokes, D. E. (1960). *The American voter.* New York, NY: John Wiley & Sons.

The Center for Information & Research on Civic Learning and Engagement (CIRCLE). (2008, December 19). *Young voters in the 2008 presidential election.* Medford, MA: Tufts University. Retrieved from: http://www.civicyouth.org

Campbell, A., Gurin, G., & Miller, W. E. (1954). *The voter decides.* Evanston, IL: Row Peterson.

Davis, R., & Owen, D. (1998). *New media and American politics.* New York, NY: Oxford University Press.

Delli Carpini, M. X., & Keeter, S. (1996). *What Americans know about politics and why it matters.* New Haven, CT: Yale University Press.

Eveland, W. P., Hayes, A. F., Shah, D. V., & Kwak, N. (2005). Understanding the relationship between communication and political knowledge: A model comparison approach using panel data. *Political Communication, 22*, 423–446.

Feldman, L., & Young, D. G. (2008). Late-night comedy as a gateway to traditional news: An analysis of time trends in news attention among late-night comedy viewers during the 2004 presidential primaries. *Political Communication, 25*, 401–422.

Floyd, F. J., & Widaman, K. F. (1995). Factor analysis in the development and refinement of clinical assessment instruments. *Psychological Assessment, 7*, 286–299.

Garrett, R. K. (2009). Politically motivated reinforcement seeking: Reframing the selective exposure debate. *Journal of Communication, 59*, 676–699. doi: 10.1111/j.1460-2466.2009.01452.x

Henson, R. K., & Roberts, J. K. (2006). Use of exploratory factor analysis in published research: Common errors and some comment on improved practice. *Educational and Psychological Measurement, 66*, 393–416.

Holbert, R. L., Garrett, R. K., & Gleason, L. S. (2010). A new era of minimal effects? A response to Bennett and Iyengar. *Journal of Communication, 60*, 15–34. doi: 10.1111/j.1460-2466.2009.01470.x

Horrigan, J. B. (2007, May 6). *A typology of information and communication technology users.* Retrieved from Pew Research Center website: http://www.pewinternet.org/2007/05/06/a-typology-of-information-and-communication-technology-users/

Jones, A. (2009). *Losing the news: The future of the news that feeds democracy.* New York, NY: Oxford University Press.

Jones, S., & Fox, S. (2009, January 28). *Generations online in 2009.* Retrieved from Pew Research Center website: http://www.pewinternet.org/2009/01/28/generations-online-in-2009/

Kaid, L. L., McKinney, M. S., & Tedesco, J. C. (2007). Political information efficacy and young voters. *American Behavioral Scientist, 50,* 1093–1111.

Katz, E., & Lazarsfeld, P. F. (1955). *Personal influence: The part played by people in the flow of mass communications.* New York, NY: The Free Press.

Keeter, S., Horowitz, J., & Tyson, A. (2008, November 12). *Young voters in the 2008 election.* Retrieved from the Pew Research Center website: http://www.pewresearch.org/2008/11/13/young-voters-in-the-2008-election/

Kutner, M., Nachtsheim, C., & Neter, J. (2004). *Applied linear regression models* (4th ed.). New York, NY: McGraw-Hill.

McDevitt, M., & Chaffee, S. (2002). From top-down to trickle-up influence: Revisiting assumptions about the family in political socialization. *Political Communication, 19,* 281–301.

McKinney, M. S., & Rill, L. A. (2009). Not your parents' presidential debates: Examining the effects of the CNN/YouTube debates on young citizens' civic engagement. *Communication Studies, 60,* 392–406. doi: 10.1080/10510970903110001

National Annenberg Election Survey (NAES). (2004). Daily Show *viewers knowledgeable about presidential campaigns, National Annenberg Election Survey shows* [Press release]. Retrieved from http://www.annenbergpublicpolicycenter.org/daily-show-viewers-knowledgeable-about-presidential-campaign/

Park, H. S, Dailey, R., & Lemus, D. (2002). The use of exploratory factor analysis and principal components analysis in communication research. *Human Communication Research, 28,* 562–577.

Pew Research Center. (2008, January 11). *Internet's broader role in campaign 2008.* Retrieved from the Pew Research Center website: http://www.pewtrusts.org/en/research-and-analysis/reports/2008/01/11/internets-broader-role-in-campaign-2008

Pew Research Center. (2010, September 12). *Americans spending more time following the news.* Retrieved from http://www.people-press.org/2010/09/12/americans-spending-more-time-following-the-news/

Pew Research Center. (2011, January 4). *Internet gains on television as public's main news source.* Retrieved from http://www.people-press.org/2011/01/04/internet-gains-on-television-as-publics-main-news-source/

Pfau, M., Houston, J. B., & Semmler, S. M. (2007). *Mediating the vote: The changing media landscape in U.S. presidential campaigns.* Lanham, MD: Rowman & Littlefield.

Prior, M. (2007). *Post-broadcast democracy: How media choice increases inequality in political involvement and polarizes elections.* New York, NY: Cambridge University Press.

Rosenstone, S. J., & Hansen, J. M. (1993). *Mobilization, participation, and democracy in America.* New York, NY: Macmillan.

Scheufele, D. A. (2002). Examining differential gains from mass media and their implications for participatory behavior. *Communication Research, 29,* 46–65.

Schudson, M. (1998). *The good citizen: A history of American civic life.* Cambridge, MA: Harvard University Press.

Shirky, C. (2008). *Here comes everybody. The power of organizing without organizations.* New York, NY: Penguin Press.

Slater, M. D. (2007). Reinforcing spirals: The mutual influence of media selectivity and media effects and their impact on individual behavior and social identity. *Communication Theory, 17*, 281–303. doi: 10.1111/j.1468-2885.2007.00296.x

Sobieraj, S., & Berry, J. M. (2011). From incivility to outrage: Political discourse in blogs, talk radio, and cable news. *Political Communication, 28*, 19–41.

Sunstein, C. R. (2007). *Republic.com 2.0*. Princeton, NJ: Princeton University Press.

Trippi, J. (2008). *The revolution will not be televised: Democracy, the Internet, and the overthrow of everything* (2nd ed.). New York, NY: Harper.

Xenos, M. A., & Becker, A. B. (2009). Moments of Zen: Effects of *The Daily Show* on information seeking and political learning. *Political Communication, 26*, 317–332. doi: 10.1080/10584600903053569

Developing Media Preferences IN A Post-Broadcast Democracy

STEPHANIE EDGERLY AND KJERSTIN THORSON

Today's media environment provides individuals with a wide array of media to choose from. Sports enthusiasts have multiple websites and television channels to satisfy their thirst for specific types of sports content, as do fans of reality shows, documentaries, and even news and public affairs enthusiasts. The rapid increase in media choice over the past 2 decades has generated increased scholarly concern for the role of individual preferences in determining exposure to diverse forms of media content (Mindich, 2005; Patterson, 2008; Prior, 2007). When greater media choice exists, preferences are more predictive of media viewing behavior (Cho, Gil de Zuniga, Rojas, & Shah, 2003; Youn, 1994). Recent studies suggest that preferences for specific types of content as well as levels of political interest are growing in importance as predictors of news consumption in particular (Baumgartner & Morris, 2010; Morris, 2005; Prior, 2007; Rittenberg, Tewksbury, & Casey, 2012; Strömbäck, Djerf-Pierre, & Shehata, 2012).

Given this concern with media preferences, there is an increasing call for research that explores the origins of preferences for news or entertainment content. This chapter takes a media socialization approach to understanding the emergence of preferences for news versus entertainment television content. In what follows, we trace the development of preferences for news and entertainment television content among 12–17-year-olds over the run-up to the 2008 presidential election. Our goal is to explore which factors in the lives of youth are most important in the development of news interest as well as to explore how such interests are shaped by the election context itself.

LITERATURE REVIEW

The study of media preferences has a long history, exemplified by uses and gratifications research (Katz, Blumler, & Gurevitch, 1973/4; Rubin, 2002). Underlying this framework is the belief in an active audience whose media decisions are motivated by specific non-uniform preferences toward content. For example, Rubin (1983) found that exposure to television news is driven by two different "viewer types"—individuals who prefer news and use the television for information-seeking and non-escapism purposes, and individuals who prefer entertainment and habitually use television exposure to pass the time. In other words, television users do not use the television in the same way—a statement that rings true especially when individuals have hundreds of television channels to choose from. By emphasizing the role of individuals in selecting certain types of media content over others, uses and gratifications is a useful framework for explaining media exposure and effects in the post-broadcast system (Ruggiero, 2000).

Markus Prior's (2007) work on the links between media choice and political learning has received a great deal of attention, focusing this stream of research on the binary preference for news or entertainment. Prior argued that individuals with access to cable television or the Internet are better able to satisfy their preferences for either news or entertainment content. And these results have political consequences: Prior found that people's relative preference for entertainment (over news) interacts with media access to predict gaps in political knowledge. According to Prior, increased media choice enables individuals who prefer entertainment to strategically avoid news content—rendering incidental exposure to political information (and learning) a relic of the past. Extending this argument is research finding that adults with a relative preference for entertainment exhibit lower levels of political participation—both offline and online (Bakker & de Vreese, 2011). Prior's argument even holds when using the preference for social welfare news (e.g., crime, community health) instead of a general entertainment preference (Rittenberg et al., 2012).

That said, we as yet know little about the origins of Prior's key variable of interest, "relative entertainment preference" (REP). REP is the extent to which an individual prefers entertainment content over news content and is generally measured as a ratio taking into account the extent of entertainment content an individual chooses in their television media diet as well as the extent of their news viewing. Prior (2007) argued that REP is a static, dispositional variable. He found that demographics only weakly predict REP and offered little additional speculation as to the source of interest in news versus entertainment content. We take inspiration from this gap in research and turn our attention to explicating the development of REP from within the literature of political socialization.

Where Do News Preferences Come From?

Research suggests that the development of specific preferences can occur well before adulthood (Prior, 2010). According to Roberts and Foehr (2004), as children reach adolescence their media preferences become less fragmented, "their tastes and interest broaden, a wider variety of content types begin to appeal to them, and they increasingly spread their program selections out over the full array of available choices" (p. 71). Given that adolescents spend on average 7.2 hours a day consuming media (4.5 hours of this is with television programing), by the time they reach adulthood, many have a long history of making media choices (Rideout, Foehr, & Roberts, 2010). And much of this decision-making is independent: nearly three quarters of adolescents report having a television in their bedroom (49% have cable or satellite access from their bedroom television), while only a quarter (28%) report having rules about how much television they can watch (Rideout et al., 2010).

One approach to exploring the origins of media preferences is by focusing on the time period of pre-adulthood and the factors that shape media selection patterns. Attitudes and habits learned during adolescence, such as the preference for news, set a trajectory for future behavior (Eckstein, Noack, & Gniewosz, 2012) that may carry well into adulthood. Research on political socialization more broadly has shown that events that occur during adolescence can shape political behavior much further on in the life course (Jennings, 2002). Secondary analysis of a survey tracing high school seniors from 1963 to 1997 showed that high school news use predicted adult rates of voting participation (Thorson, 2011).

A recent wave of interest in political socialization offers a body of theory and empirical findings we can draw on to sketch a model for the development of news media preferences among youth (Jennings, Stoker, & Bowers, 2009; Linimon & Joslyn, 2002; McLeod & Shah, 2009). Here, communication processes are at the center of political socialization outcomes. Existing empirical work shows that key socializing experiences happen across multiple spheres of socialization—in particular, the family, schools, peers, and media use.

Early political socialization researchers assumed that analyses of parent-child dyads would demonstrate empirically their belief that political attitudes were simply handed down from parents to children much like family heirlooms. These assumptions were not met, as studies of political attitudes in families over time failed to show the expected strong correlations within dyads (Jennings & Niemi, 1981). However, studies of socialization continue to show that parents serve as models for the types of attitudes and behaviors that are preferable and expected. Parents who are strong partisans, for example, are more likely to have children who develop a strong sense of partisanship as well as engage in some forms of political participation (Jennings et al., 2009). In the case of encouraging news consumption,

news media use behaviors can be modeled (e.g., parents reading a newspaper at breakfast), or certain forms of media use can be explicitly discussed by parents who engage in television co-viewing (Paavonen, Roine, Pennonen, & Lahikainen, 2009) or who place restrictions on children's media consumption (Valkenburg, Krcmar, Peeters, & Marseille, 1999). We expect that those parents who model more news-seeking behavior and encourage news use will have children with a lower relative entertainment preference. That is, their children will have *a higher proportion of news* in their television media diet. Given that increased media access has been linked in previous research to a higher relative entertainment preference (Prior, 2007), we also expect that parents who restrict television access or monitor its use will have children with a lower preference toward entertainment.

Parents are not the only sphere of influence that matters for socialization outcomes. Recent studies examining schools as socializing agents emphasize these institutions as potential sites for deliberative political discussion and opportunities to practice civic skills (as part of civics curricula and during engagement in associations such as student government and media). McDevitt and colleagues show across a series of studies the value of a civic or deliberative classroom for democratic outcomes (see also Hess, 2009). School curricula that offer students opportunities to discuss and debate issues in the classroom produce students with a higher level of news use (Kiousis, McDevitt, & Wu, 2005; McDevitt & Chaffee, 2000). Civic classrooms are especially valuable for those students who lack parental modeling of political behavior. Therefore, we expect that civic classroom activities will be influential in youth developing media use preferences that are less dominated by entertainment content.

Peers, too, are important in the development of political norms and behaviors. Peer groups can channel the influence of schools and parents in a variety of ways, primarily through interpersonal conversation. For example, McDevitt and Kiousis (2007) argued that systematically different socialization outcomes emerge depending on whether the influence of school-based civics interventions is channeled through the home or by peer groups. Other recent research suggests that the influence of peers on democratic engagement depends on the norms that emerge within distinct social groups (Mindich, 2005; Thorson, 2011). We therefore expect that belonging to a peer group in which news is valued and a subject of conversation will be associated with a lower relative entertainment preference.

Finally, we expect that the way youth make use of digital and social media will also be closely related to the emergence of relative entertainment preference. A series of studies have shown that youth who encounter political content via social media are more likely to engage in forms of political participation as well as other online information-seeking activities (Ekström & Östman, 2013; Gil de Zúñiga, Jung, & Valenzuela, 2012; Park, Kee, & Valenzuela, 2009). We expect that these normatively positive effects will also be linked to REP, such that youth who

encounter more political content via social media will also be more likely to have a higher level of news content in their television diet.

A National Election Environment

Media preferences are shaped by election contexts. Valentino and Sears (1998) showed that political socialization is not a steady process but rather occurs in fits and starts, depending on the political objects made salient by the broader communication environment. We expect presidential elections to serve as socializing events for news media preferences. During national elections, not only does the amount of news content increase around a single common topic (the day-to-day happenings of the campaigns), but many citizens also feel a pressure to engage with this type of information. Hardy and Scheufele (2009) found that levels of political talk increase as elections near. Further, Boczkowski, Mitchelstein, and Walter (2012) found that the "most viewed" news stories on a series of websites shifted to include more public affairs information over the course of the 2008 election.

Our data analyzed in this chapter explore the role of the 2008 presidential campaign in particular. The 2008 Obama campaign was widely hailed as one that effectively connected with and energized youth (Lipka, 2008). In addition, the 2008 election was marked by the rise of online multimedia content devoted to politics, both serious and satirical. A survey of 12–17-year-olds conducted by the Cable & Telecommunications Association for Marketing in early 2008 indicated that adolescents watched more video clips about news and politics (42%) than celebrities and gossip (25%) (Eggerton, 2008). Given the youth focus of the 2008 election in particular and the effects of elections in general on public attention to politics, there is reason to expect a decrease in REP as the election nears. However, we cannot discount the competing expectation that media preferences reflect something more like a dispositional variable, stable over time. Prior (2007) argued that during "normal times" we should expect "that content preferences are stable and exogenous to media use and the media environment" (p. 286). Our use of data collected during the 2008 election and the focus on adolescent media preferences provide two critical tests of these competing hypotheses.

MEASURES

We use data from the first two surveys in the three-panel Future Voters Study (as described in the Introduction) to explore the various forces that shape adolescents' media preferences. In line with other research, we focus on media exposure patterns as a window into individuals' preferences (Boczkowski et al., 2012; Prior,

2007). The robust battery of television measures in the Future Voters Study enable us to focus specifically on television viewing and preferences by developing outcome measures previously validated by Prior's work on REP.

Relative Entertainment Preference

To construct a measure of relative entertainment preference, we first needed a measure of total entertainment exposure and total news exposure. Entertainment viewing was derived from five questions asking youth the number of days in a typical week they consume primetime reality programs, primetime comedy programs, primetime cartoon programs, primetime drama programs, and game shows. *Total entertainment viewing* was constructed by summing the responses to the five questions. The same entertainment items were used in Wave 1 ($M = 8.49$, $SD = 6.26$) and Wave 2 ($M = 8.63$, $SD = 6.17$). News viewing was derived from five questions asking youths to report the number of days in a typical week they consumed TV news shows at school, broadcasting nightly news, local news, CNN news programs, and Fox news programs. *Total news viewing* was then constructed by summing responses to the five questions. The same news items were used in Wave 1 ($M = 5.38$, $SD = 5.62$) and Wave 2 ($M = 6.11$, $SD = 6.20$).

Relative entertainment preference (REP) was constructed by calculating the ratio of entertainment viewing divided by entertainment viewing plus news viewing (e.g., Prior, 2007; Rittenberg et al., 2012). The resulting REP measure ranged from 0 to 1, with a higher REP score representing a higher relative preference for entertainment TV programs. REP was calculated separately for Wave 1 ($M = .65$ $SD = .26$) and Wave 2 ($M = .62$, $SD = .25$).

Predictor Variables

Parents. Our models include several measures concerning parental influence in their child's television viewing experience. For Wave 1, parents indicated on a five-point scale from "strongly disagree" (1) to "strongly agree" (5) the extent to which they encouraged their child to follow the news ($M = 3.54$, $SD = 1.06$), restricted the types of television shows their child watches ($M = 3.48$, $SD = 1.22$), and talked to their child about television programs they watch together ($M = 3.82$, $SD = 1.02$). The questions were each treated as single items and included in Wave 1 models. For Wave 2, parents were asked the extent to which they encouraged their child to follow the news ($M = 2.76$, $SD = 1.01$) and expected their child to follow the news ($M = 2.94$, $SD = 1.09$). A three-item index measuring television co-viewing was included. Parents indicated how often in the past 3 months they watched television with their child to monitor content, to

intervene if necessary, and because of a common interest. Answers were given on an eight-point scale from "not at all" (1) to "very frequently" (8), and averaged to create an overall measure of parental co-viewing (M = 5.3, SD = 2.21, *Cronbach's alpha* = .86).

A measure of parental news exposure was also included, but only for Wave 2. Parents indicated how many days in the typical week they watched broadcast nightly news, local news, and cable news. Answers from the three questions were averaged to create an overall measure of parental news exposure (M = 3.47, SD = 1.92, Cronbach's alpha = .69).

Youth variables. The adolescents were asked several questions about their social environment and the role that news content plays. The same items were used in Wave 1 and Wave 2. Youths indicated their level of agreement with the statement, "Among my friends it is important to know what's going on in the world." Responses were on a five-point scale ranging from "strongly disagree" (1) to "strongly agree" (5) (Wave 1: M = 3.37, SD = 1.05; Wave 2: M = 3.53, SD = 1.06). A measure of current events talk was calculated by averaging how often youths talked about news/current events with: family members, friends, adults outside their family, and people who disagreed with them. Responses were on a seven-point scale ranging from "not at all" (1) to "very frequently" (8) (Wave 1: M = 3.54, SD = 1.84, Cronbach's alpha = .89; Wave 2: M = 3.96, SD = 1.90, Cronbach's alpha = .81).

Two measures of social media use were created. The first explicitly asked youth about social media use for political purposes. Respondents indicated how often in the past 3 months they did the following on Facebook, Myspace, or other social media sites: displayed your political preferences on a profile, became a fan of a politician, joined a political group or cause, used a news or political app or widget, and exchanged political views on a discussion board or group wall. Responses to the five questions ranged from "never" (1) to "regularly" (4) and were averaged to create an overall measure of political social media use (Wave 1: M = 1.19, SD = .44, Cronbach's alpha = .86; Wave 2: M = 1.28, SD = .55, Cronbach's alpha = .85). The second measure asked about creating and circulating social media content. Youth respondents indicated how often in the past 3 months they had shared their photos/videos online and updated a blog or online journal. Responses to the two questions were averaged to create an overall measure of social media content creation (Wave 1: M = 1.89, SD = 1.01, inter-item correlation = .65; Wave 2: M = 1.73, SD = 1.0, inter-item correlation = .67).

To account for the role that classroom activities may play, the presence or absence of a "civics curriculum" (Hess, 2009) was measured by asking adolescents to rate how often they: followed news as part of a class assignment, learned about government, debated political/social issues, participated in political role-playing, and were encouraged to make up their own mind about issues. Answers to the

five questions were given on an eight-point scale ranging from "not at all" (1) to "very frequently" (8) and averaged to create an overall measure of civics curriculum exposure (Wave 1: M = 3.51, SD = 1.89, Cronbach's alpha = .83; Wave 2: M = 3.55, SD = 2.0, Cronbach's alpha = .90).

Three questions gauging youth attitudes toward politics and the news media were also included. Responses were given on a five-point scale, ranging from "strongly disagree" (1) to "strongly agree" (5). To measure perceptions of news media bias, youths rated their level of agreement with the statement, "Most news converge is biased against my views" (Wave 1: M = 2.66, SD = .95; Wave 2: M = 2.76, SD = 1.02). To measure levels of political distrust, youths indicated their agreement with the statement, "Most politicians can't be trusted" (Wave 1: M = 2.59, SD = 1.15; Wave 2: M = 3.0, SD = 1.12). Political interest was measured by youths' agreement with the statement, "I am interested in politics" (Wave 1: M = 2.59, SD = 1.15; Wave 2: M = 3.0, SD = 1.12).

Controls. Lastly, several demographic measures were asked in Wave 1 and included in all models as stable control variables. From the parents' portion of the questionnaire, mother's education (*Median* = high school graduate) and cable access within the household (74% have cable or satellite access) were controlled for. From the youths' portion of the questionnaire, age (M = 14.5), gender (50.1% female), and race (80.1% white) were included in all models.

RESULTS

Our first set of analyses explores how socialization variables shape the emergence of relative entertainment preference. We begin by drawing on data from the first wave of the three-panel study to test these relationships cross-sectionally. We constructed a hierarchical block regression model to test the predictive power of four blocks of variables. The first block contained control variables; the second block contained parental influence variables, and the third and fourth blocks included youth attitudes and social/school influence, respectively.

Results from the Wave 1 cross-sectional model indicate that all blocks except the first significantly explain variance in REP. This finding is consistent with Prior (2007), who observed that REP is minimally associated with demographic variables. In fact, the only significant relationship in the first block was between access to cable television and a greater REP. For the second model—adding parental influence variables—we found that restricting a child's television viewing and encouraging a child to follow news was related to a lower relative entertainment preference. Youth political interest is also negatively related to REP, as were attitudes about news bias (marginally). However, the role of political interest is largely channeled through peer and school influence—the interest variable becomes

Table 1. Predicting REP (Wave 1).

	Model 1 St. beta	Model 2 St. beta	Model 3 St. beta	Model 4 St. beta
Block 1: Controls				
Mother's education	.038	.057#	.071*	.072*
Cable access	.070*	.064*	.065*	.072*
Youth age	-.002	-.015	.002	.018
Youth gender (female)	-.003	.000	-.015	-.007
Youth race (non-white)	.045	.054#	.062*	.079**
Block 2: Parental influence				
Restricting television	—	-.111**	-.104**	-.095**
Co-viewing	—	-.008	-.002	.020
Encourage news exposure	—	-.141***	-.101**	-.057#
Block 3: Youth attitudes				
Political interest	—	—	-.160***	-.050
Political distrust	—	—	.019	.028
News bias	—	—	-.058#	-.045
Block 4: Youth social & classroom factors				
Friends value news	—	—	—	-.089**
Talk about news	—	—	—	-.146***
Political social media use	—	—	—	-.099**
Social media content creation	—	—	—	.067*
Civics curriculum	—	—	—	-.066#
Incremental change in R^2 (%)	—	3.3***	2.7***	4.6***
Total Adjusted R^2 (%)	.3	3.6***	6.3***	10.9***
N	1002	1002	1002	1002

$p \le .1$.
* $p \le .05$; ** $p \le .01$; *** $p \le .001$.

non-significant when we add the final block to the model. The final block—social and school influence—explained the largest amount of variance in REP (4.6%). Those youth whose peers value current event knowledge were more likely to have a lower REP. Civics curriculum also (marginally) facilitated this. Interestingly, the regression model revealed that online social media use has a mixed impact on REP levels. Social media use that is explicitly political was related to a lower (i.e., more "newsy") REP, while social media content creation in general was related to a higher REP.

The Malleability of Youth Preferences

Our next set of analyses explores youth media preferences over time. The panel data allow us to test whether REP shifts from Wave 1, gathered in the midst of the presidential primary, to Wave 2, just following the election. Results from a matched pair t-test reveal a significant decline in REP from Wave 1 ($M = .67$, $SD = .26$) to Wave 2 ($M = .63$, $SD = .25$) (t (486) = 3.39, $p < .001$), suggesting that adolescents' preferences moved a small, but significant, distance toward news preference. These findings offer some support for the view that entertainment and news preferences are not stable during an election period.

To explore this further, we next examine the predictors of REP change. We constructed a hierarchical regression model predicting REP in Wave 2 similar to the cross-sectional model but now also controlling for Wave 1 REP in the first block. This represented a stricter test of significance for the other variables in the model (to reach significance variables must contribute to REP above and beyond past REP levels). We also included a variable reflecting parents' news exposure measured in Wave 2, a factor not available in the Wave 1 data.

Results reveal several factors are related to change in REP levels. Only the first three regression blocks significantly explained additional change in REP. In contrast to the Wave 1 cross-sectional models, the last block of social and class-room variables was not a factor in REP *movement*. In the first model, gender (marginally) and race were related to change in REP. Females demonstrated an increased relative entertainment preference while non-white youth demonstrated a decrease (toward news consumption). Parents also play an important role in REP change. By far the most consistent pattern of results was between parents' level of news exposure and change in REP: parents who consume news have children who decreased their REP. A decrease in REP was also related to parental expectations about news and co-viewing habits. However, these relationships became non-significant when we added the blocks of youth-related variables. For variables from the third block, only political interest was related to REP change, and only upon entry. In the final model, the variable concerning youth access to cable television becomes a positive predictor of REP. None of the social and classroom variables added in the final block was a significant predictor of REP change.

The results of the change model indicate that parents have a primary role in the shift of youth news preferences from before to immediately after the campaign. On the other hand, the ratio nature of the REP outcome variable may be clouding our understanding of a change in youth media preferences. The results so far tell us that REP (i.e., the proportional space that entertainment takes up in youths' media diet) decreased. This change can represent two distinct media preference scenarios: (1) youth news exposure stayed constant, while their levels of entertainment exposure decreased; or (2) youth news exposure increased, while

Table 2. Predicting REP in Wave 2, Controlling for REP in Wave 1.

	Model 1 St. beta	Model 2 St. beta	Model 3 St. beta	Model 4 St. beta
Block 1: Controls				
Mother's education	.033	.046	.055	.054
Cable access	.044	.064	.077*	.076#
Youth age	.041	.036	.046	.048
Youth gender (female)	.079#	.085*	.079*	.086*
Youth race (non-white)	-.118***	-.118**	-.113**	-.117**
Youth wave 1 REP	.462***	.377***	.365***	.360***
Block 2: Parental influence				
Expect news exposure	—	-.08#	-.052	-.045
Encourage news exposure	—	-.067	-.041	-.025
Co-viewing	—	-.08#	-.070#	-.054
Parent's news exposure	—	-.22***	-.221***	-.216***
Block 3: Youth attitudes				
Political interest	—	—	-.138***	-.073
Political distrust	—	—	-.011	.003
News bias	—	—	-.005	-.006
Block 4: Youth social & classroom factors				
Friends value news	—	—	—	-.047
Talk about news	—	—	—	-.072
Political social media use	—	—	—	.011
Social media content creation	—	—	—	.021
Civics curriculum	—	—	—	-.054
Incremental R² (%)	—	7.7***	1.2*	.3
Total Adjusted R² (%)	25.9***	33.6***	34.8***	35.1***
N	442	442	442	442

$p \leq .1$.
* $p \leq .05$; ** $p \leq .01$; *** $p \leq .001$.

entertainment exposure stayed constant. The descriptive statistics provide some insight into which of these scenarios was likely occurring. Between Waves 1 and 2, total entertainment viewing remained stable ($M = 8.65$ vs. $M = 8.52$; $t(564) = .56$, n.s.). Total news viewing, however, significantly increased ($M = 5.15$ vs. $M = 5.91$) after the election ($t(544) = -3.46, p < .001$). Given that news exposure is the source of REP change, our final analysis examines the predictors of news viewing change.

Table 3. Predicting News Viewing in Wave 2, Controlling for News Viewing in Wave 1.

	Model 1 St. beta	Model 2 St. beta	Model 3 St. beta	Model 4 St. beta
Block 1: Controls				
Mother's education	-.061#	-.056#	-.060#	-.066*
Cable access	.003	-.031	-.038	-.043
Youth's age	-.018	-.023	-.033	-.042
Youth's gender (female)	-.052	-.045	-.038	-.056#
Youth's race (non-white)	-.200***	-.159***	.152***	.145***
Youth's Wave 1 news viewing	.581***	.439***	.426***	.395***
Block 2: Parental influence				
Expect news exposure	—	.072*	.036	.030
Encourage news exposure	—	.052	.020	-.011
Co-viewing	—	.073*	.067*	.055#
Parent's news exposure	—	.296***	.309***	.304***
Block 3: Youth attitudes				
Political interest	—	—	.148***	.050
Political distrust	—	—	.049	.033
News bias	—	—	.027	.018
Block 4: Youth social & classroom factors				
Friends value news	—	—	—	.037
Talk about news	—	—	—	.063
Political social media use	—	—	—	.155***
Social media content creation	—	—	—	-.010
Civics curriculum	—	—	—	.068#
Incremental R^2 (%)	—	10.7***	2.1***	3.3***
Total Adjusted R^2 (%)	39.7***	50.4***	52.5***	55.8***
N	492	492	492	492

$p \le .1$.
* $p \le .05$; ** $p \le .01$; *** $p \le .001$.

The Uptake of News

A four-block hierarchical linear regression model was constructed to predict youth total news viewing in Wave 2, while controlling for Wave 1 total news viewing. The first block contained the control variables and past (Wave 1) total news viewing. The second, third, and fourth blocks contained the same items as the REP change model.

Results from the news change model revealed several subtle differences from the REP change model. First, the role of parents in youth media decisions remains consistent. As seen in model 2, parental co-viewing, parental expectations to follow the news, and parents' own news exposure were all related to more news viewing by youths. The expectation to follow news, however, became non-significant when accounting for variables in the later blocks. In model 3, political interest was positively related to increased news viewing, but the relationship did not hold in the final model. The biggest difference from the REP change model involved the significant influence of the fourth block of variables. Results show that political social media use and civic curriculum (marginal) were significant predictors of increased news viewing among youth.

DISCUSSION

Today's youth are actively developing media preferences against the backdrop of the increasingly complex media environment. They are learning which types of media content they prefer and doing so in an environment marked by increased choice. This chapter focused on a specific slice of overall youth media preferences: the ratio of news to entertainment in their television consumption. This variable rose to importance following Prior's (2007) work on the role of REP in promoting increased inequalities in political knowledge and participation. As media choice grows, preferences become more important.

A chief concern among many media scholars is that young people are turning their backs on news content (Mindich, 2005; Patterson, 2008). If news holds little interest, then individuals have many other media options that better satisfy their desires. Media preferences can then be seen as a key conditional force to understanding the democratic implications of the high-choice media environment. This, naturally, begs the question of where media preferences come from. As one means of exploring such a question, this chapter examined the roots of a relative entertainment preference among adolescents and the factors that shape it.

Results from the cross-sectional model suggest multiple spheres are important in shaping youth preferences for entertainment over news. It is not just parents, though they play an important role in the development of media preferences. Also at work are social and classroom factors that make news a more relevant part of youths' daily lives. As news becomes more embedded in youth activities—through social media, classroom curriculum, or informal conversations with others—the preferences for news over entertainment is established. Mindich (2005) found many young adults do not follow the news because they perceive it to have little value in their lives. Results for this study speak to the various pathways in which news takes hold and becomes more relevant in the lives of adolescents.

We also find that our preference models are low in explanatory power. In line with the findings of Prior (2007) and Rittenberg et al. (2012), a relative entertainment preference is not a stand-in for demographic variables or any other among an array of variables included in this study. This raises the question as to what variables remain unaccounted for in our models. Our study focused on television and REP, following Prior but also in recognition that television remains the most used medium among youth (Rideout et al., 2010). Still, our dependent variables are a vast oversimplification of the media environment through which today's youth are navigating. We also need to consider how preferences function across media platforms. Can we assume that a person with a high *television* relative entertainment preference also uses their mobile phone in such a manner? As the media landscape increases to include more platforms for engagement with news and entertainment content, determining media preference becomes a more complicated, yet important, matter.

It should also be noted that our approach diverges from others working in this area who argue that the blurring of lines between news and entertainment content provides opportunities for the less politically interested to run across political information "by accident" (Baum, 2003). Our analysis did not include television programs such as *The Daily Show* that include both news and entertainment in the presentation of current events. As such, hybrid news-entertainment media may provide a "gateway" to news consumption. Youth who are more entertainment-focused may use this type of television content as a way to engage with campaign information in an entertaining manner.

This limitation notwithstanding, our results do indicate youth REP is a somewhat malleable construct, one that is responsive to the changing media and political environment. During the 2008 election campaign, adolescent media preferences changed and became significantly more news-oriented. As the media environment became more saturated with election activity, adolescents adjusted their preferences accordingly. Thus, the assumption that media preferences are stable is highly questionable, at least for a youth sample. Even with increased opportunity to tune out the election campaign, many adolescents chose to increase their relative intake of television news. This finding corroborated research arguing that adults engage more with current events information during election times (Boczkowski et al., 2012; Hardy & Scheufele, 2009). We find that youth are not immune to the change in the media information environment that a national presidential election brings, despite the fact that they are not yet of voting age.

In turning to the predictors of preference changes over the course of the election, we see that parents play the primary role of moving the needle of relative entertainment preference. Specifically, parental modeling plays a key role in youth media preferences becoming "newsier." Parents who consume news had children who significantly decreased their REP over the course of the election. Our results

also indicate that parental expectations to follow news and co-viewing can also lower REP. We also find that political uses of social media are positively linked to increased news viewing during the election. As a number of studies have begun to show, those youth who encounter political content on social media—whether intentionally or incidentally—display a range of more participatory outcomes.

The current media environment is characterized by abundant media choice and there are few indicators of this trend slowing down. Adolescents represent a group of media consumers that are growing up with the requirement to adapt to the constantly shifting media environment. This chapter sheds some initial light on the processes through which adolescent preferences for news are formed and altered. Results point to the responsiveness of media preferences and the different spheres—parents, schools, peers, and the election environment—in this process. As adolescents enter adulthood, we expect media preferences will continue to be shaped by various spheres, while at the same time playing a critical role in determining the democratic implications of increased media choice.

REFERENCES

Bakker, T. P., & de Vreese, C. H. (2011). Good news for the future? Young people, Internet use, and political participation. *Communication Research, 38*, 451–470.

Baum, M. A. (2003). Soft news and political knowledge: Evidence of absence or absence of evidence? *Political Communication, 20*, 173–190.

Baumgartner, J., & Morris, J. S. (2010). MyFaceTube politics: Social networking web sites and political engagement of young adults. *Social Science Computer Review, 28*, 24–44.

Boczkowski, P. J., Mitchelstein, E., & Walter, M. (2012). When burglar alarms sound, do monitorial citizens pay attend to them? The online news choices of journalists and consumers during and after the 2008 U.S. election cycle. *Political Communication, 29*, 347–366.

Cho, J., Gil de Zuniga, H., Rojas, H., & Shah, D. V. (2003). Beyond access: The digital divide and Internet uses and gratifications. *IT & Society, 1*(4), 46–72.

Eckstein, K., Noack, P., & Gniewosz, B. (2012). Attitudes toward political engagement and willingness to participation in politics: Trajectories through adolescence. *Journal of Adolescence, 35*, 485–495.

Eggerton, J. (2008). Ctam study: Teens watching mostly short-form videos. *Broadcasting & Cable.* Retrieved from http://www.broadcastingcable.com/article/113191-CTAM_Study_Teens_Watching_Mostly_Short_Form_Videos.php

Ekström, M., & Östman, J. (2013). Information, interaction, and creative production: The effects of three forms of Internet use on youth democratic engagement. *Communication Research, 42*, 796–818. doi: 10.1177/0093650213476295

Gil de Zúñiga, H., Jung, N., & Valenzuela, S. (2012). Social media use for news and individuals' social capital, civic engagement and political participation. *Journal of Computer Mediated Communication, 17*(3), 319–336.

Hardy, B. W., & Scheufele, D. A. (2009). Presidential campaign dynamics and the ebb and flow of talk as a moderator: Media exposure, knowledge, and political discussion. *Communication Theory, 19*, 89–101.

Hess, D. (2009). *Controversy in the classroom.* New York, NY: Routledge.

Jennings, M. K. (2002). Generation units and the student protest movement in the United States: An intra- and intergenerational analysis. *Political Psychology, 23*(2), 303–324.

Jennings, M. K., & Niemi, R. G. (1981). *Generations and politics: A panel study of young adults and their parents.* Princeton, NJ: Princeton University Press.

Jennings, M. K., Stoker, L., & Bowers, J. (2009). Politics across generations: Family transmission reexamined. *The Journal of Politics, 71,* 782–799.

Katz, E., Blumler, J. G., & Gurevitch, M. (1973/74). Uses and gratifications research. *The Public Opinion Quarterly, 37* (Winter), 509–523.

Kiousis, S., McDevitt, M., Wu, X. (2005). The genesis of civic awareness: Agenda setting in political socialization. *Journal of Communication, 55,* 756–774.

Linimon, A., & Joslyn, M. R. (2002). Trickle up political socialization: The impact of Kids Voting USA on voter turnout in Kansas. *State Politics & Policy Quarterly, 2,* 24–36.

Lipka, S. (2008). Young voters overwhelmingly favored Obama, swinging some battleground states. *The Chronicle of Higher Education, 55,* A21.

McDevitt, M., & Chaffee, S. H. (2000). Closing gaps in political communication and knowledge: Effects of a school intervention. *Communication Research, 27,* 259–292.

McDevitt, M., & Kiousis, S. (2007). The red and blue of adolescence: Origins of the compliant voter and the defiant activist. *American Behavioral Scientist, 50,* 1214–1230.

McLeod, J. M., & Shah, D. V. (2009). Communication and political socialization: Challenges and opportunities for research. *Political Communication, 26,* 1–10.

Mindich, D. T. Z. (2005). *Tuned out: Why Americans under 40 don't follow the news.* New York, NY: Oxford University Press.

Morris, J. S. (2005). The Fox News factor. *Press/Politics, 10* (3), 56–79.

Paavonen, E. J., Roine, M., Pennonen, M., & Lahikainen, A. R. (2009). Do parental co-voewing and discussions mitigate TV-induced fears in young children? *Child: Care, Health & Development, 35,* 773–780.

Park, N., Kee, K., & Valenzuela, S. (2009). Being immersed in social networking environment: Facebook groups, uses and gratifications, and social outcomes. *CyberPsychology & Behavior, 12*(6), 729–733.

Patterson, T. E. (2008). Young people flee from the news, whatever the source. *Television Quarterly, 38,* 32–35.

Prior, M. (2007). *Post-broadcast democracy.* New York, NY: Cambridge University Press.

Prior, M. (2010). You've either got it or you don't? The stability of political interest over the life cycle. *The Journal of Politics, 72,* 747–766.

Rideout, V. J., Foehr, U. G., & Roberts, D. F. (2010). Generation M2: Media in the lives of 8- to 18-year-olds. *Kaiser Family Foundation.* Retrieved from http://kff.org/other/event/generation-m2-media-in-the-lives-of/

Rittenberg, J., Tewksbury, D., & Casey, S. (2012). Media preferences and democracy: Refining the "relative entertainment preference" hypothesis. *Mass Communication & Society, 15,* 921–942.

Roberts, D. F., & Foehr, U. G. (2004). *Kids & media in America.* New York, NY: Cambridge University Press.

Rubin, A. M. (1983). Television uses and gratifications: The interaction of viewing patterns and motivations. *Journal of Broadcasting, 27,* 37–51.

Rubin, A. M. (2002). The uses-and-gratifications perspective of media effects. In J. Bryant & D. Zillmann (Eds.), *Media effects: Advances in theory and research* (pp. 525–548). Mahwah, NJ: Erlbaum.

Ruggiero, T. E. (2000). Uses and gratifications theory in the 21ˢᵗ century. *Mass Communication & Society, 3*, 3–37.

Strömbäck, J., Djerf-Pierre, M., & Shehata, A. (2012). The dynamics of political interest and news media consumption: A longitudinal perspective. *International Journal of Public Opinion Research.* Retrieved from http://ijpor.oxfordjournals.org/content/early/2012/06/18/ijpor.eds018

Thorson, K. (2011). *Finding gaps and building bridges: Mapping youth citizenship.* Unpublished manuscript.

Valentino, N. A., & Sears, D. O. (1998). Event-driven political communication and the pre-adult socialization of partisanship. *Political Behavior, 20*, 127–154.

Valkenburg, P. M., Krcmar, M., Peeters, A. L., & Marseille, N. M. (1999). Developing a scale to assess three types of television mediation: "Instructive mediation," "restrictive mediation," and "social coviewing." *Journal of Broadcasting & Electronic Media, 43*, 52–66.

Youn, S. (1994). Program type preference and program choice in a multichannel situation. *Journal of Broadcasting & Electronic Media, 38*, 465–475.

Is Dangerous News Use Dangerous?

The Impact of Safe and Dangerous News Use on Political Socialization

EDSON TANDOC, ESTHER THORSON, MI JAHNG, EUNJIN KIM, AND MARGARET DUFFY

There is no disagreement that news use, in general, exerts some influence on political participation. For instance, newspapers were found to be more influential than television news in terms of increasing participation (McLeod & McDonald, 1985; Scheufele, Nisbet, Brossard, & Nisbet, 2004). Also, hard news is more influential than soft news (McLeod et al., 1996). But news is far from homogeneous.

The growth of news and opinion media sources in particular, from cable channels to Internet sources, has brought greater concern that Americans are becoming increasingly polarized politically (Stroud, 2008, 2010; Tsfati & Cappella, 2005). Some news organizations now make it entirely possible for one to create a media diet of almost purely liberal or purely conservative news, depending on one's ideological partisanship. This is what we call *safe news use*. This construction of a protective silo of news and opinion that most likely generates a fairly consistent political viewpoint is also expected to affect young people as they develop their perspectives of the world. While the literature is saturated with how news use per se affects political socialization, existing research has not examined the possible impact of safe news use. Consumers of news, however, may also be exposed to news that is counter to one's own views, or what we refer to as *dangerous news use*. This chapter explores the impact of these two types of news use on political interest, political knowledge, and two forms of political participation among adolescents: offline and online political participation.

LITERATURE REVIEW

Studying the political socialization of adolescents is important as these individuals are in a period when they are confronted not only by their own curiosities about the world around them but also by the competing influences from their family, friends, school, and the media (McLeod & Shah, 2009; Shah, McLeod, & Lee, 2009). Numerous studies have found that news media use exerts a significant influence on political socialization (Chaffee & Hochheimer, 1985; McLeod et al., 1996; McLeod & McDonald, 1985; Shah, McLeod, & Yoon, 2001). Local media use, for example, strongly predicts political interest (McLeod et al., 1996); and Internet use also increases political interest among young adults (Glenn & Grimes, 1968). Shani (2007) defined political interest as one's "motivation to engage in politics, which consists of two dimensions: the motivation to learn about politics and the motivation to participate in politics." Newspaper and television news use has also been found to increase political interest and knowledge (Atkin, Galloway, & Nayman, 1976).

Additional studies have found that newspapers exert a stronger positive influence on political participation than television news (McLeod & McDonald, 1985; Scheufele et al., 2004); and McLeod and colleagues (1996) found that hard news was more influential than soft news in terms of increasing participation. In fact, television entertainment use was directly but negatively related to political participation (Scheufele, 2000). The Internet overshadows traditional media, however, in predicting higher levels of interpersonal trust and civic participation, especially among younger people (Shah et al., 2009). Studies that measured participation have looked at traditional political participation as well as community participation (McLeod et al., 1996; Moy, Torres, Tanaka, & McCluskey, 2005; Wang, 2007). The rise of the Internet as a tool to foster social community has also brought about a new avenue for political participation through online mechanisms (Eveland & Hively, 2009). Yet, a key question remains as to how news use affects these varied forms of political socialization?

Biased News

The importance of the news, not only for political participation but also for a functioning society in general, spotlights the importance of maintaining sound news values, the most argued of which is objectivity (Ericson, 1998; Tuchman, 1972, 1973). It is usually prescribed that journalists shield their outputs from their own biases. Nevertheless, most scholars argue objectivity in the news is simply a myth (Gans, 1980; Shoemaker & Reese, 1991; Tuchman, 1972, 1978). Tuchman (1972), in fact, argued that objectivity is just a ritual journalists employ—in the form of getting sides to a story, using quotation marks, presenting supporting

evidence—all processes to elude the dangers of criticism and libel. Others have argued that news is the product of journalists' biases, introduced through the ways in which they frame their stories, highlighting one aspect while ignoring another (Berner, 1992; Ericson, 1998).

The question of objectivity is more salient with opinionated or biased news where journalists clearly inject their own viewpoints in presenting issues. Opinionated newspaper columns, radio shows, television programs, and political blogs teem with the biases of the people presenting the so-called news. It has become much easier in today's media environment for partisans to expose themselves only to information sources that are consistent with their views. For such partisans, a stream of contradictory messages framed in a supposedly objective manner by the mainstream news media becomes alienating, if not repulsive (Stroud, 2008, 2010). Entman (2007) has classified news bias in three ways: distortion bias, content bias, and decision-making bias and offers a definition focusing on content bias that is defined as the "consistent patterns in the framing of mediated communication that promote the influence of one side in conflicts over the use of government power" (p. 166).

The popularity and proliferation of biased news and identified partisan news organizations through cable television and the Internet have made it easier for people to only select those media outlets that share what they believe in (Stroud, 2010; Tsfati & Cappella, 2005). Consumers increasingly select news media products based on their political predispositions (Stroud, 2008). Our notion of *safe news use* parallels the discussion found in the existing literature of individuals' preference for news that favors one's own political viewpoint (e.g., Eveland & Hively, 2009; Mutz, 2002a). For instance, it is logical to assume that people who identify as Republicans will largely use conservative media whose content is consistent with their political views and identity. In this way, one's viewpoints are shielded or safe from opposing content.

There is value in being exposed to a diverse range of viewpoints, however, and benefits for engaging in *dangerous* discussions. Eveland and Hively (2009) defined dangerous discussions as "discussions that conflict with the views or characteristics of the ego," yet this concept exists in the literature under various names: cross-cutting (Mutz, 2002a, 2002b; Mutz & Mondak, 2006), disagreement (Feldman & Price, 2008), or dangerous discussion (Eveland & Hively, 2009). In the current study, we extend the concepts of safe and dangerous interpersonal discussions to also capture exposure to mass communication. Mutz and Martin (2001) found that the mass media provide a more dominant source for cross-cutting exposure than interpersonal communication channels. Thus, *dangerous news use* refers to the use of news media whose contents are contrary to one's partisanship. For instance, Republicans' use of liberal media is considered *dangerous news use* because it exposes one to opposing viewpoints.

Elaboration of News

One underlying goal of news is to make people think. Thus, elaboration of political news and issues is an important aspect of the political socialization process, enabling adolescents to mentally process the abstract ideas and concepts that serve as the bases for politics (Eveland, McLeod, & Horowitz, 1998). Studies have sought to identify the links between exposure to news and political knowledge. Eveland (2004) has suggested that the process of elaboration of news content might provide an explanation for the acquisition of political knowledge. Elaboration is defined as "the process of connecting new information to other information stored in memory, including prior knowledge, personal experiences, or the connection of two new bits of information together in new ways" (Eveland, 2001, p. 573). Beaudoin and Thorson (2004) argued that "elaboration and news reliance are important steps in political learning." Therefore, the first potential danger of reliance on safe news use is its possible negative impact on elaboration. Homogeneous content that is consistent with one's own perspectives might hinder one's processing of news because there is an assumption that these contents are already aligned with what one believes. Mutz and Mondak (2006) found that exposure to views opposite to one's own increases familiarization with the rationales of others' views, which involves a process of elaboration. Thus, our study tests the following hypotheses:

H1: Safe news use negatively predicts elaboration.

H2: Dangerous news use positively predicts elaboration.

In a study involving three different surveys, Eveland (2001, 2004) found that elaboration was positively related to political knowledge. Beaudoin and Thorson (2004) also found that elaborative processing has a significant path to political knowledge. There can be two types of elaboration of news content: anticipatory elaboration and discussion-related elaboration. Eveland (2004) argued these two types of elaboration help explain how news use could increase political knowledge. First, anticipatory elaboration occurs when an individual expects future discussion about the news content while discussion-generated elaboration occurs during a discussion—the act of discussion itself forces information processing (Eveland, 2004). Thinking about political news might also lead directly to participation. Thus, we also test the following hypotheses:

H3: Elaboration of news content positively predicts:
 a. Political interest
 b. Political knowledge
 c. Offline political participation
 d. Online political participation

Within the literature there is disagreement regarding the effects of being exposed to *dangerous discussion*. Studies have found that dangerous discussion reduces political knowledge (Feldman & Price, 2008) and increases ambivalence toward political candidates and issues, thus reducing political participation (Huckfeldt, Mendez, & Osborn, 2004; Mutz, 2002a). Feldman and Price (2008) have argued that people in like-minded networks acquire more knowledge in frequent discussions than those who are in diverse networks. Here, an explanation could be that dangerous discussion may result in arguments that hamper knowledge acquisition (Feldman & Price, 2008). Though frequency of discussion predicts participation, discussion diversity has been shown to have a negative relationship with participation; and the frequency of *safe* discussion instead predicts political participation (Eveland & Hively, 2009). McClurg (2006) also found that while discussion increases electoral political activity, disagreement decreases such activity.

Feldman (2011) has identified three competing models to explain the effects of opinionated news use. First, the polarization model argued that opinionated news use has strong direct effects in intensifying attitude differences among opposing partisans. The resistance model argued that awareness of media bias would lead to critical processing (Feldman, 2011; Kyun Soo & Yorgo, 2007; Vallone, Ross, & Lepper, 1985). For instance, Tsfati (2003) found that people who distrusted the media rejected the mediated climate of opinion. The hostile media effect, where partisans view the news media as biased against their own beliefs, is linked to the third-person effect: A potential source of worry is the perception of others as less informed and thus vulnerable to wrong information supplied by the news media (Choi, Yang, & Chang, 2009; Gunther & Liebhart, 2006; Vallone et al., 1985). Finally, the direct persuasion model argued that opinionated news users adopt the perspective of the message regardless of their prior leanings (Druckman & Parkin, 2005).

While Feldman (2011) has found support for the direct persuasion model, opinionated news use can very well be biased toward or against one's viewpoint. It is therefore critical to study the possible divergent effects of opinionated news when it is consistent with one's viewpoint and also when it is inconsistent with one's viewpoint. This is where we think the second danger of safe news use lurks. Opinionated news use is linked to political participation. For instance, political blog readers were the most likely to be politically active compared with non-bloggers and bloggers who read non-political content (Lawrence, Sides, & Farrell, 2010), and this finding holds regardless of exposure to divergent viewpoints (Lawrence et al., 2010). But what happens if someone just uses opinionated news that is consistent with their political views—or safe news use? Thus, we test the following hypotheses:

H4: Safe news use negatively predicts:
 a. Political interest
 b. Political knowledge
 c. Offline political participation
 d. Online political participation

Stroud (2010) found that selective exposure contributed to political polarization, which is defined as the "strengthening of one's original position or attitude." It is likely that people who identify as Republicans will be more likely to seek out Fox News for their political news, which is identified as a conservative news outlet. But today's crowded media landscape also ensures that even partisans will likely be exposed to opinionated news that runs contrary to their own views (Scheufele et al., 2004; Stroud, 2008, 2010).

Thus, several studies have found that engaging in dangerous discussion increases familiarization with the rationales of opposing viewpoints (Mutz, 2002b); provides increased awareness of rationales for others' views (Mutz & Mondak, 2006); leads to reduced attitude uncertainty (Pattie & Johnston, 2008); increases political efficacy (Pattie & Johnston, 2008); and increases political tolerance (Mutz, 2002b; Mutz & Mondak, 2006; Pattie & Johnston, 2008). The frequency of dangerous discussion was also found to predict knowledge structure density, defined as "the extent to which individuals see connections or relationships among various concepts within the political domain—issues, individuals, or organizations" (Eveland & Hively, 2009, p. 212). Thus, we hypothesize that:

H5: Dangerous news use positively predicts:
 a. Political interest
 b. Political knowledge
 c. Offline political participation
 d. Online political participation

The hypotheses we have proposed based on the extant literature are summarized in Figure 1, a conceptual model that seeks to explain the impact of safe and dangerous news use on the political socialization of adolescents.

METHOD

The data analyzed in this chapter are drawn from the second wave of the three-panel Future Voters Study (as described in the Introduction) administered November 5 through December 10, 2008, immediately after the presidential election. In order to test our hypotheses about safe and dangerous news use, we only included in our analyses teens who identified themselves as either Democrats or Republicans, resulting in a final sample size of 480 adolescents, 271 of whom identified themselves as Democrats and 209 as Republicans.

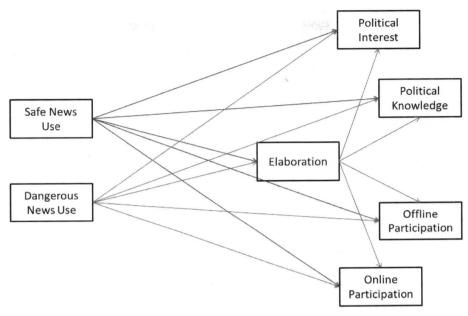

Figure 1. Hypothesized model.

Predictor Variables

Elaboration. Three items measured on a five-point Likert scale (strongly disagree to strongly agree) indexed elaboration. These statements are: "I try to connect what I see in the media with what I already know," "I often recall what I see in the media and think about it later," and "Talking about politics makes me think more about my beliefs." The three items were factor analyzed with Varimax rotation resulting in one factor solution (Cronbach's α = .79).

Safe news use. This refers to using media outlets consistent with one's political orientation. Therefore, for those who identified themselves as Democrats, we coded the following as safe news use: news satire programming (e.g., *The Daily Show*, *The Colbert Report*) and Liberal political blogs (e.g., Daily Kos, Talking Points Memo). The two types of news sources were correlated (r = .21, p < .001). Similarly, for adolescents who identified themselves as Republicans, the following were considered safe news outlets: Fox cable news programs (e.g., Bill O'Reilly, Hannity & Colmes); conservative talk radio (e.g., Rush Limbaugh, Michael Savage); and conservative political blogs (e.g., Instapundit, Michelle Malkin). The scale was reliable (Cronbach's α = .74). Respondents were asked how many days per week they used each of these news sources.

Dangerous news use. The same strategy was employed in creating this variable, which refers to using news outlets contrary to one's political orientation.

Therefore, for self-identified Republicans, we coded the following as dangerous news use: news satire programming (e.g., *The Daily Show, The Colbert Report*) and Liberal political blogs (e.g., Daily Kos, Talking Points Memo). For Democrats, the following referred to dangerous news outlets: Fox cable news programs (e.g., Bill O'Reilly, Hannity & Colmes); conservative talk radio (e.g., Rush Limbaugh, Michael Savage); and conservative political blogs (e.g., Instapundit, Michelle Malkin).

The adolescents responding to our survey had very low levels of news use, which is understandable considering the demographic of typical news consumers. Still, we found that safe news use (M = 0.44, *SD* = .88) was slightly more common than dangerous news use (M = .38, *SD* = .92) among the adolescents who participated in the survey.

Dependent Variables

Political interest. This was measured by respondents' ratings on a five-point Likert scale on a single item: "I am interested in politics."

Political knowledge. This was measured in terms of the number of correct answers to identifying the presidential candidate (i.e., Obama or McCain), and which candidate had each of these six features: opposed a timetable for withdrawal from Iraq, supported raising taxes on the wealthiest Americans, has an adopted daughter from Bangladesh, has not served in the U.S. military, has been divorced, and began his political career as a community organizer.

Offline political participation. Factor analysis with Varimax rotation was performed on 15 items measuring various political activities. Participants were asked to rate how often they did specific activities in the last 3 months on an eight-point response scale (1 = Not at all, 8 = Very frequently). The first factor was named *offline political participation* (Cronbach's α = .91) and included the following items: "Wrote a letter or e-mail to a news organization," "Worked for a political party or a candidate," "Displayed a political campaign button, sticker, or sign," "Participated in a political protest activity," "Contributed money to a political campaign," and "Attended a political meeting, rally or a speech."

Online political participation. The second factor included the following: "Forwarded the link to a political video or news article," "Received a link to a political video or news article," "Exchanged political e-mails with friends and family," "Watched political candidate videos online," "Sent or received a text message about politics," "Watched video news stories online," and "Read comments posted by readers on a news website or political blog." The scale was reliable (Cronbach's α = .90).

Results

This study used path analysis using the structural equation modeling software AMOS in order to test each of the hypotheses we proposed as well as the conceptual model based on the reviewed literature (see Figure 1). The hypothesized path analysis model fits the data well. We subsequently dropped non-significant pathways for the final model, $\chi^2 (6) = 9.92, p > .05; RMSEA = .04, PCLOSE = .656; CFI = .99; TLI = .98$.

H1 predicted that safe news use negatively leads to elaboration. This hypothesis is rejected, as safe news use positively leads to elaboration, $\beta = .11, p = .07$ (see Table 1 for the standardized regression weights). H2 predicted that dangerous news use positively leads to elaboration. This hypothesis is supported, $\beta = .10, p = .09$. Tested separately, both dangerous and safe news use are strong positive predictors of elaboration, but their effects weaken when they are tested together. This result is potentially due to the high correlation between them, $r (460) = .63, p < .01$.

Table 1. Standardized Regression Weights.

			Estimate
Elaboration	←	Dangerous News	.098
Elaboration	←	Safe News	.105
Interest	←	Elaboration	.520
Offline Part	←	Elaboration	.122
Knowledge	←	Safe News	.185
Offline Part	←	Safe News	.137
Interest	←	Dangerous News	.158
Knowledge	←	Dangerous News	-.122
Offline Part	←	Dangerous News	.444
Online Part	←	Elaboration	.101
Online Part	←	Dangerous News	.085
Online Part	←	Interest	.075
Online Part	←	Knowledge	.096
Online Part	←	Offline Part	.561

H3 predicted that elaboration of news content will positively predict: (a) political interest, (b) political knowledge, (c) offline political participation, and (d) online political participation. H3a is supported, $\beta = .52, p < .01$. Elaboration increases political interest; however, it does not lead to factual political knowledge, and thus H3b is not supported. H3c and H3d are both supported, as elaboration

leads to increased offline ($\beta = .12$, $p < .01$) and online participation ($\beta = .10$, $p < .05$).

H4 predicted that safe news use will have negative direct effects on (a) political interest, (b) political knowledge, (c) offline political participation, and (d) online political participation. H4a is not supported while H4b is rejected. Safe news use does not lead to political interest, but it positively predicts political knowledge, $\beta = .19$, $p < .01$. H4c is also rejected, as safe news use positively predicts offline political participation, $\beta = .14$, $p < .01$. H4d is not supported, as there was no direct relationship between safe news use and online participation.

H5 predicted that dangerous news use will have positive direct effects on: (a) political interest, (b) political knowledge, (c) offline political participation, and (d) online political participation. H5a is supported—dangerous news use increases political interest, $\beta = .16$, $p < .01$. H5c and H5d are also both supported, as dangerous news use also positively predicted offline ($\beta = .44$, $p < .01$) and online political participation ($\beta = .09$, $p < .05$). Interestingly, however, H5b is rejected, as dangerous news use significantly predicted—albeit negatively—factual political knowledge among adolescents, $\beta = -.12$, $p < .05$.

The final model (see Figure 2) also reveals interesting interrelationships between the four dependent variables outside the proposed hypotheses. First,

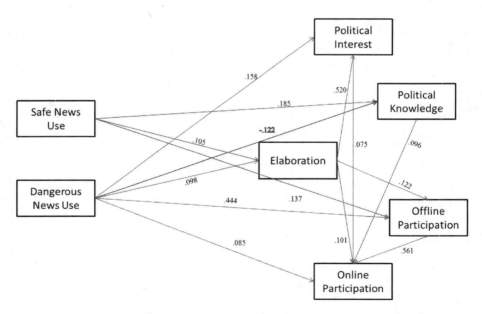

The hypothesized path analysis model fits the data well, χ^2 (6) = 9.92, p > .05; RMSEA = .04, PCLOSE = .656; CFI = .99; TLI = .98.

Figure 2. Final path analysis model.

political interest predicted online political participation ($\beta = .08$, $p < .07$), but not knowledge and offline political participation. This makes sense, since online participation is more accessible for adolescents compared with offline political participation. Factual political knowledge predicted online political participation ($\beta = .10$, $p < .01$) but not offline political participation. Offline political participation also leads to online political participation ($\beta = .56$, $p < .01$). (The standardized regression weights for the significant paths are summarized in Table 1.)

DISCUSSION

In this study, we have extended the exploration of safe and dangerous political discussions to also include exposure to mass communication, specifically to opinionated news among adolescents. We expected that safe news use would negatively predict elaboration of news content as exposure to disagreement, and not to consonant views, might be better in triggering thinking. These data did not support our hypotheses. Though elaboration predicted political interest, it did not predict political knowledge, contrary to Eveland's (2004) earlier findings. A contribution of our study, however, is the positive effect of elaboration on online political participation, something that previous studies have not explored.

Both safe and dangerous news use positively predicted elaboration. This supports the assumption that exposure to news—the partisanship of the source notwithstanding—triggers thinking about the news. However, impact on elaboration is stronger when safe and dangerous news use is tested separately. This is potentially due to issues of collinearity. But this also points to the potential effect of how competing perspectives—from those consistent with one's views to those contradictory to one's orientation—can lead to cognitive overload that might hinder, or discourage, elaboration. This finding is something that future studies should explore in greater detail.

Contrary to our expectations, safe news use positively predicted political knowledge and offline political participation. In contrast, dangerous news use negatively predicted political knowledge but increased political interest, online and offline political participation. First, our findings highlight the previously demonstrated relationship between political interest and political knowledge. In some instances, these relationships are found to be negatively related, as knowing more about the political system might well alienate individuals from politics, especially amid the many controversies and attack-oriented appeals that mark political rivalries. Second, the contrasting effects of safe and dangerous news use on political knowledge also warrant future study. It appears that for adolescents, viewing news that is consistent with their political identification leads to greater learning about politics, indicating that a consistent political information environment might be

more conducive for learning. This finding also suggests that political information consistent with existing schemas may be easier to process as related schemas are more readily accessible. Finally, the presence of a link between dangerous news use and political interest, which is absent with safe news use, points to the possibility of how disagreements and debates can foster a more exciting experience that might lead one to be more interested in politics, although this interest and excitement might well come at the expense of political learning. Indeed, our final model (see Figure 2) did not find a significant link between political interest and political knowledge.

Dangerous news use predicts both online and offline participation. Along these lines, Pattie and Johnston (2008) found that exposure to disagreement reduced attitude uncertainty. In arguing that disagreement is healthy, Pattie and Johnston noted: "The more we encounter and argue about divergent views, the more tolerant we become, the surer of our own views we are, and the more empowered we feel" (p. 689). Thus, we argue that exposure to dangerous news, or to news biased against one's opinion, reinforces one's political stand and this encourages participation. Second, the third-person effect that is linked to the hostile media effect may well be motivating people to participate more. If a partisan views the news as biased against one's own belief—and this happens with dangerous news use—a potential source of worry is the perception of others as less informed and thus vulnerable to "wrong" information from the news media (Choi et al., 2009; Gunther & Liebhart, 2006; Vallone et al., 1985). This perception could lead partisans to act, and therefore participate, more.

The possibility that dangerous news use may lead to greater political participation should not devalue safe news use. Our study found that safe news use positively predicted political knowledge as well as offline political participation (although in a much weaker magnitude compared with dangerous news use), contrary to our initial expectations. Feldman and Price (2008) argued that exposure to dissonant information might increase confusion or ambivalence. Thus, people in like-minded networks acquire more knowledge in frequent discussions than those who are in diverse networks (Feldman & Price, 2008). It is also plausible that adolescents exposed to news that is biased in favor of their views become more comfortable, and therefore receptive, of the pieces of information and opinions these trusted news sources communicate. This process could be facilitating greater political knowledge acquisition. However, in the current study, political knowledge did not predict traditional political participation. A high level of political knowledge does not necessarily lead to increased participation. As argued previously, learning about politics may include knowing about political bickering and nasty attacks that might turn adolescents away from politics.

We acknowledge that our operationalization of safe and dangerous news use is limited to party identification. Yet, this approach is consistent with Eveland and

Hively's (2009) study of safe, dangerous, and diverse political discussions. We realize too that views opposite to one's own could also be found even in news outlets that share one's political partisanship. A Republican watching Fox News might still find some of its views and news disagreeable. What is safe and dangerous news might also depend on one's perceived social and cultural identity, and this is a consideration that future studies should be mindful of. Still, we believe that our findings further our understanding of the effects of opinionated news. We cannot conceptualize biased news as a mere opinionated piece. An opinion that resonates with some people may be repulsive to others, and the effects of such news will also be different. In the end, our findings demonstrate that exposure to both safe and dangerous news is important, especially in the political socialization of adolescents.

REFERENCES

Atkin, C. K., Galloway, J., & Nayman, O. B. (1976). News media exposure, political knowledge and campaign interest. *Journalism Quarterly, 53*(2), 231–237.

Beaudoin, C. E., & Thorson, E. (2004). Testing the cognitive mediation model. *Communication Research, 31*(4), 446–471. doi: 10.1177/0093650204266098

Berner, R. T. (1992). *The process of writing news*. Boston, MA: Allyn & Bacon.

Chaffee, S., & Hochheimer, J. L. (1985). The beginnings of political communication research in the United States. In E. Rogers & F. Balle (Eds.), *The media revolution in America and in Western Europe* (pp. 267–296). Norwood, NJ: Ablex.

Choi, J., Yang, M., & Chang, J. J. (2009). Elaboration of the hostile media phenomenon. The roles of involvement, media skepticism, congruency of perceived media influence, and perceived media opinion climate. *Communication Research, 36*(1), 54–76.

Druckman, J. N., & Parkin, M. (2005). The impact of media bias: How editorial slant affects voters. *Journal of Politics, 67*(4), 1030–1049. doi: 10.1111/j.1468-2508.2005.00349.x

Entman, R. M. (2007). Framing bias: Media in the distribution of power. *Journal of Communication, 57*(1), 163–173. doi: 10.1111/j.1460-2466.2006.00336.x

Ericson, R. V. (1998). How journalists visualize fact. *Annals of the American Academy of Political and Social Science, 560*, 83–95.

Eveland, W. P. (2001). The cognitive mediation model of learning from the news: Evidence from nonelection, off-year election, and presidential election contexts. *Communication Research, 28*(5), 571.

Eveland, W. P. (2004). The effect of political discussion in producing informed citizens: The roles of information, motivation, and elaboration. *Political Communication, 21*(2), 177–193. doi: 10.1080/10584600490443877

Eveland, W. P., & Hively, M. H. (2009). Political discussion frequency, network size, and "heterogeneity" of discussion as predictors of political knowledge and participation. *Journal of Communication, 59*(2), 205–224. doi: 10.1111/j.1460-2466.2009.01412.x

Eveland, W. P., McLeod, J. M., & Horowitz, E. M. (1998). Communication and age in childhood political socialization: An interactive model of political development. *Journalism & Mass Communication Quarterly, 75*(4), 699–718.

Feldman, L. (2011). The opinion factor: The effects of opinionated news on information processing and attitude change. *Political Communication, 28*(2).

Feldman, L., & Price, V. (2008). Confusion or enlightenment? *Communication Research, 35*(1), 61–87. doi: 10.1177/0093650207309362

Gans, H. (1980). *Deciding what's news: A study of CBS Evening News, NBC Nightly News,* Newsweek *and* Time. New York, NY: Random House.

Glenn, N. D., & Grimes, M. (1968). Aging, voting, and political interest. *American Sociological Review, 33*(4), 563–575.

Gunther, A. C., & Liebhart, J. L. (2006). Broad reach or biased source? Decomposing the hostile media effect. *Journal of Communication, 56*(3), 449–466. doi: 10.1111/j.1460-2466.2006.00295.x

Huckfeldt, R., Mendez, J. M., & Osborn, T. (2004). Disagreement, ambivalence, and engagement: The political consequences of heterogeneous networks. *Political Psychology, 25*(1), 65–95. doi: 10.1111/j.1467-9221.2004.00357.x

Kyun Soo, K., & Yorgo, P. (2007). Study of partisan news readers reveals hostile media perceptions of balanced stories. *Newspaper Research Journal, 28*(2), 99–106.

Lawrence, E., Sides, J., & Farrell, H. (2010). Self-segregation or deliberation? Blog readership, participation, and polarization in American politics. *Perspectives on Politics, 8*(01), 141–157. doi: 10.1017/S1537592709992714

McClurg, S. (2006). Political disagreement in context: The conditional effect of neighborhood context, disagreement and political talk on electoral participation. *Political Behavior, 28*(4), 349–366. doi: 10.1007/s11109-006-9015-4

McLeod, J. M., Daily, K., Guo, Z., Eveland, W. P., Bayer, J., Yang, S., & Wang, H. (1996). Community integration, local media use, and democratic processes. *Communication Research, 23*(2), 179–209. doi: 10.1177/009365096023002002

McLeod, J. M., & McDonald, D. G. (1985). Beyond simple exposure: Media orientations and their impact on political processes. *Communication Research, 12*(1), 3–33. doi: 10.1177/0093650 85012001001

McLeod, J. M., & Shah, D. V. (2009). Communication and political socialization: Challenges and opportunities for research. *Political Communication, 26*(1), 1–10. doi: 10.1080/1058460080 2686105

Moy, P., Torres, M., Tanaka, K., & McCluskey, M. R. (2005). Knowledge or trust? Investigating linkages between media reliance and participation. *Communication Research, 32*(1), 59–86. doi: 10.1177/0093650204271399

Mutz, D. C. (2002a). The consequences of cross-cutting networks for political participation. *American Journal of Political Science, 46*(4), 838.

Mutz, D. C. (2002b). Cross-cutting social networks: Testing democratic theory in practice. *The American Political Science Review, 96*(1), 111.

Mutz, D. C., & Martin, P. S. (2001). Facilitating communication across lines of political differences the role of mass media. *American Political Science Review, 95*(1), 97–115.

Mutz, D. C., & Mondak, J. J. (2006). The workplace as a context for cross-cutting political discourse. *Journal of Politics, 68*(1), 140–155. doi: 10.1111/j.1468-2508.2006.00376.x

Pattie, C., & Johnston, R. (2008). It's good to talk: Talk, disagreement and tolerance. *British Journal of Political Science, 38*(4), 677.

Scheufele, D. A. (2000). Talk or conversation? Dimensions of interpersonal discussion and their implications for participatory democracy. *Journalism & Mass Communication Quarterly, 77*(4), 727–743.

Scheufele, D. A., Nisbet, M. C., Brossard, D., & Nisbet, E. C. (2004). Social structure and citizenship: Examining the impacts of social setting, network heterogeneity, and informational variables on political participation. *Political Communication, 21*(3), 315– 338.

Shah, D. V., McLeod, J. M., & Lee, N. (2009). Communication competence as a foundation for civic competence: Processes of socialization into citizenship. *Political Communication, 26*(1), 102–117. doi: 10.1080/10584600802710384

Shah, D. V., McLeod, J. M., & Yoon, S.-H. (2001). Communication, context, and community. *Communication Research, 28*(4), 464–506. doi: 10.1177/009365001028004005

Shani, D. (2007). Analysis of interest in politics items from the 2006 pilot. *ANES Pilot Study Report No, 11892.*

Shoemaker, P., & Reese, S. (1991). *Mediating the message: Theories of influences on mass media content.* New York, NY: Longman.

Stroud, N. (2008). Media use and political predispositions: Revisiting the concept of selective exposure. *Political Behavior, 30*(3), 341–366. doi: 10.1007/s11109-007-9050-9

Stroud, N. (2010). Polarization and partisan selective exposure. *Journal of Communication, 60*(3), 556–576. doi: 10.1111/j.1460-2466.2010.01497.x

Tsfati, Y. (2003). Media skepticism and climate of opinion perception. *International Journal of Public Opinion Research, 15*(1), 65–82. doi: 10.1093/ijpor/15.1.65

Tsfati, Y., & Cappella, J. N. (2005). Why do people watch news they do not trust? The need for cognition as a moderator in the association between news media skepticism and exposure. *Media Psychology, 7*(3), 251–271.

Tuchman, G. (1972). Objectivity as a strategic ritual: An examination of newsmen's notion of objectivity. *American Journal of Sociology, 77,* 660–678.

Tuchman, G. (1973). Making news by doing work: Routinizing the unexpected. *The American Journal of Sociology, 79*(1), 110–131.

Tuchman, G. (1978). *Making news: A study in the construction of reality.* New York, NY: Free Press.

Vallone, R. P., Ross, L., & Lepper, M. R. (1985). The hostile media phenomenon: Biased perception and perceptions of media bias in coverage of the Beirut massacre. *Journal of Personality and Social Psychology, 49*(3), 577–585. doi: 10.1037/0022-3514.49.3.577

Wang, S. I. (2007). Political use of the internet, political attitudes and political participation. *Asian Journal of Communication, 17*(4), 381–395. doi: 10.1080/01292980701636993

The Origins OF Media Perceptions

Judgments of News Accuracy and Bias Among Adolescents

PORISMITA BORAH AND DHAVAN SHAH

During presidential campaigns, questions of news media accuracy and bias become the focus of much attention and debate. Given that news media coverage is related to public opinion about the presidential candidates (Domke et al., 1997), contenders are determined to ensure that media coverage does not favor their opponents. Despite claims to the contrary, research has found limited evidence of the existence of political media bias during presidential campaigns. Although some suggest a slight liberal bias in terms of sound bites during the 1992 and 1996 campaigns (Lowry & Shidler, 1998), other research has found little or no consistent political bias (Johnson, 1993; Watts, Domke, Shah, & Fan, 1999). Rather than an ideological bias, news values of conflict and the use of horse-race coverage of the campaigns may encourage a front-runner bias in coverage (Johnson, 1993).

Nonetheless, perceptions of media bias are a fixture of modern electoral politics. This perception has risen consistently across and within campaigns, with perceptions of a liberal bias rising most dramatically. One explanation for the increase in perceptions of poor media performance is that it is not actual bias that drives these perceptions, but media coverage of political elites' accusations of bias (Watts et al., 1999). Others assert that there is also an interpersonal dimension to these perceptions, as those with homogeneous communication networks are more likely to perceive inaccuracy and bias in political media coverage, all other things being equal. In the current study, we explore potential sources of these perceptions in the socialization of young people into citizenship during their adolescent years.

Perceptions of news accuracy and bias formed during adolescence may have lifelong implications for news consumption and civic socialization. Beliefs that media are slanted in opposition to one's views or inaccurate in their portrayals of reality may not only reduce conventional news consumption but also alter the types of news media that are consumed. Perceptions of media may also alter how information from these sources is processed, especially among young people, who have less well-developed political schema. To explore these issues, we analyze data collected from our national Future Voters Study panel survey of 12–17-year-olds and their parents (as described in the Introduction). This chapter will first incorporate relevant literature from political socialization, news credibility, and mass media to inform our research questions and hypotheses. Next, our analysis examines how demographic, political orientation, family communication, school curriculum, informational variables, and reflection shape judgments of news credibility among American youth, our future voters.

EVALUATING NEWS CREDIBILITY

When thinking about evaluations of the media, perceptions of its credibility are among the most important. Media outlets have to be concerned about how their content is received, especially because ratings of credibility play an important role in viewership patterns (Flanagin & Metzger, 2000; Gaziano, 1988). Media credibility is typically considered a multi-dimensional concept, drawing from several different aspects of coverage, such as trustworthiness and expertise, fairness, balance, completeness, concern for community, separation of opinion and fact, bias, and accuracy (Fico, Richardson, & Edwards, 2004; Flanagin & Metzger, 2000; Gaziano & McGrath, 1986; Greer, 2003; Johnson & Kaye, 1998; Meyer, 1988). Meyer's (1988) news credibility scale, which uses five dimensions: fairness, completeness, bias, accuracy, and trustworthiness, has been used in many different studies and thus has been validated across a wide variety of sources (Fico et al., 2004; Greer, 2003).

The majority of these studies have looked at evaluations of news credibility among adults, including both college students and the general population. However, credibility has not been studied among an adolescent population, whose perceptions of the news may differ. This study, therefore, first tests whether two of the most widely and consistently used components—perceptions of media accuracy and media bias—are related among young adults as components of news media credibility (Gaziano, 1988; Gaziano & McGrath, 1986; Johnson & Kaye, 1998). Thus, our first hypothesis predicts:

H1: Perceptions of media accuracy and bias will be significantly correlated among adolescents.

Parent-Child Communication

Parent-child communication is one of the most "pervasive forces" in the development of adolescents (Chaffee, McLeod, & Wackman, 1973, p. 349). A two-dimensional model has been formulated consisting of socio-oriented and concept-oriented relations. In the concept-oriented family, children are encouraged to express their beliefs and challenge others (Chaffee et al., 1973), while in socio-oriented families, children are encouraged to get along with others for harmonious social relations. (See also Chapters 7, 8, and 10 in the current volume.)

Family communication patterns, including perceived norms of what type of parent-child communication is acceptable and the frequency of political talk, can also contribute to the political socialization process (Merelman, 1973). Specifically, communication in concept-oriented families, rather than socio-oriented families, has been found to enhance adolescent political development (Shah, McLeod, & Lee, 2009). Scholarly research has found that adolescents raised with concept-oriented norms tend to be more interested in politics, more knowledgeable about politics, and tend to discuss politics more frequently than adolescents from socio-oriented families (McLeod & Chaffee, 1972). Research demonstrates that children who are encouraged to express themselves in spite of being at odds with their parents tend to also be more politically engaged (McLeod, Shah, & Lee, 2009). Concept-oriented adolescents are also more active and successful in school and tend to participate more in politically related school activities (Chaffee et al., 1973). Thus, past research clearly indicates the important role family communication patterns play—specifically, concept-oriented norms—in political socialization of young minds. Hence we propose that family communication patterns will have an influence on how adolescents perceive the media and we ask our first research question:

> RQ1: How does concept-oriented family environment influence adolescents' news credibility perception?

School Curriculum

School curriculum can also be a significant contributor to the political socialization process. Scholars have started examining the relationships between course activities and classroom environment with several socialization outcomes (Campbell, 2005; Gimple, Lay, & Schuknecht, 2003; Torney-Purta, 2002). Recent studies have examined specific classroom activities, not mere exposure to a civics course, to gain a clearer picture of the role educational curriculum has in the political socialization process. For example, research conducted in 22 Philadelphia-area high schools found that curriculum including deliberative discussions, community

projects, and informational use of the Internet produced increased levels of knowledge, efficacy, and following/discussing politics (Feldman, Pasek, Romer, & Hall Jamieson, 2007). Similarly, Torney-Purta (2002) found open political discussion in the classroom enhanced the effects of civics education. Multiple discussion activities in the classroom promote learning and also encourage students to be engaged outside of the classroom (Campbell, 2005; McDevitt & Kiousis, 2004). Based on the available literature, we think school curriculum may very well influence how teens perceive the media and therefore posit our second research question:

> RQ2: How does school curriculum influence adolescents' news credibility perception?

The "Echo Chamber"

Jamieson and Cappella (2008) described the "echo chamber" as a bounded, enclosed media space that captures the "ways messages are amplified and reverberate through the conservative opinion media" (p. 76). The "echo chamber" has the potential to magnify messages and create a secluded environment, where the message is unlikely to be counter argued. This "echo chamber" also creates a common frame of reference and positive feedback loops for its audience (Jamieson & Cappella, 2008). As a result, "echo chamber" variables would influence perceptions about the media, especially considering the discourse about "liberal media" in many of the conservative media sources.

Although radio has been less studied than print and television, political talk radio may provide an "echo chamber" in which individuals have their political preconceptions reinforced. Political talk radio listeners tend to be more politically active (Hofstetter, 1998); more likely to contact an elected official (Pan & Kosicki, 1997); distrust political institutions (Pfau et al., 1998); and hold biased perceptions of political figures and their stand on issues (Cappella & Jamieson, 1997). Focusing on the relationship of news credibility judgments with conservative talk radio listening, we hypothesize as follows:

> H2: News credibility will be lower among adolescents who listen more to conservative talk radio than among adolescents who listen less to such content.

Cable news programs generally embrace a more combative style of news punditry and interpretation—a style that has been linked to decreased perceptions of democratic legitimacy for opponents, lessened trust in democratic systems, and competing preferences for news style (Forgette & Morris, 2006; Mutz, 2007; Mutz & Reeves, 2005). Scholars (DellaVigna & Kaplan, 2007; Groseclose & Milyo, 2005; Morris, 2005) often suggest Fox News is biased toward the right. Moreover, Fox News often criticizes the mainstream media for having a liberal bias. As a result,

Fox News should have a significant influence on teens' media perceptions and we therefore hypothesize:

H3: News credibility will be lower among adolescents who watch more Fox News than among adolescents who watch less.

Unlike much of the traditional media, not all the content on the Internet conforms to norms of objectivity. Blogs are but one example, as many are meant to be deliberately persuasive in their arguments. Furthermore, many blogs view themselves as watchdogs to the mainstream media and deliberately critique the mainstream media for their content (McKenna & Pole, 2008). This deliberate attempt on the part of much of the blogosphere to correct some of the perceived problems in the mainstream media, often through direct criticism of the news or of particular content (McKenna & Pole, 2008), is likely to affect perceptions of mainstream news credibility. These critiques are particularly prevalent on the Right, where conservative bloggers often rail against the liberal bias of the media. If perceptions of the media are driven primarily by elite cues (Watts et al., 1999), these accusations about the lack of mainstream media credibility will be more frequent on conservative sources such as blogs. We therefore hypothesize that:

H4: News media credibility will be lower among more frequent conservative blog readers, than among adolescents who read conservative blogs less frequently.

Interpersonal discussion of politics is often at the heart of scholarly discussions about democratic citizenship (Schudson, 1998). Individuals often get their preferences and perceptions through interpersonal channels, with members of their social network serving as trusted sources. Of course, trusted sources can also reinforce existing preferences if those sources are concordant with one's ideology or political orientation. Along these same lines, Eveland and Shah (2003) pointed out that research on misperceptions of public opinion, such as the literature on spiral of silence and pluralistic ignorance, proves helpful in understanding perceptions of media. Their analysis found that overall amount of discussion does not have a significant influence of media bias, but discussion with ideologically similar individuals is positively related to perceptions of media bias. Although the authors examined only media bias perceptions in their study, interpersonal communication could have an important influence on news credibility as a whole. This leads us to hypothesize the following, even when controlling for the overall level of discussion and party ID:

H5: News credibility will be lower among adolescents who have high levels of discussions with like-minded individuals than among adolescents who have low levels of discussions with like-minded individuals.

Mass Media

Beyond the media channels included within the "echo chamber" variables, other media are also likely to play a role in influencing their own perceptions. Media play an important socializing role and are thought to affect perceptions of reality (Gerbner, Gross, Morgan, & Signorielli, 1994; Noelle-Neumann, 1993). In addition, perceptions of media bias may be driven in large part by media's coverage of elite accusations of bias (Domke et al., 1997; Watts et al., 1999). This process will likely be exacerbated among youth, who have less experience with the political process than adults. Therefore, it seems important to look at the influence of the media in determining judgments of media credibility.

But discussions of credibility differ greatly across various media outlets, as there is no consensus about levels of media credibility. Some research has suggested that people find print news the most credible (Flanagin & Metzger, 2000), suggesting those that consume it may share these perceptions. Print news formats continue to reflect many of the traditional values that dominated the news industry. In particular, print news adheres to norms of balance and objectivity (Kovach & Rosenstiel, 2001), meaning that people are more likely to be exposed to both sides of political argumentation, a feature often lacking in interpersonal communication (Mutz, 2007; Mutz & Martin, 2001). These norms that dominate print news coverage should influence adolescents such that:

> **H6:** News media credibility will be higher among more frequent newspaper readers, than among adolescents who read newspapers less frequently.

Furthermore, broadcast television news adapts to similar guidelines in producing news that is balanced and non-partisan (Cunningham, 2003; Forgette & Morris, 2006). Hence, we hypothesize that:

> **H7:** News media credibility will be higher among more frequent broadcast news consumers, than among less frequent broadcast news consumers.

Turning to news sources online, despite the diversity of news available, most people continue to visit the popular traditional news networks' online sites. Therefore, the same norms of objectivity and fairness that govern much of their offline content should be continued online—and may continue to inform individuals' attitudes and decisions about political discussion. We therefore hypothesize that:

> **H8:** News media credibility will be higher among more frequent online news consumers than among less frequent online news consumers.

Reflection

McLeod et al. (1999) found the ability to reflect played a mediating role between interpersonal discussion and participation in deliberative forums and also between local media use and participation in deliberative forums. These authors suggest that reflection plays a key role in mentally piecing together information gained from the media or discussion into a more tenable fashion. Similarly, Kosicki and McLeod (1990) identify the ability to reflect as a strategy people use to cope with and make sense of information messages. Reflection of news media is likely to have an influence on how individuals perceive the news media. Therefore we ask:

RQ3: How does reflection influence adolescents' news credibility perception?

Finally, we can see that there is value in testing the relationships that emerge between these agents of socialization and the perceptions of news credibility. However, to more clearly examine these relationships, we also wanted to investigate how those variables predict change. Our panel study gave us an opportunity to test these hypotheses to determine whether the same factors that lead teens to adopt these values and behaviors also encourage their change during the 2008 election, which becomes especially important to study with the implication that political socialization occurs most strongly during the election context (Sears & Valentino, 1997). Therefore, we ask our last research question:

RQ4: Do our independent variables (home environment, school curriculum, "echo chamber," news media use and reflection) predict change in the perceptions of news credibility?

METHODS

Survey Design and Sampling

To test our hypotheses and answer the research questions posed by this study, we use data from the first two waves of the Future Voters Study three-survey panel (as described in the Introduction). The first wave was gathered between May 20 and June 25, 2008, and the second wave was gathered from these same respondents between November 5 and December 10, 2008, again using a four-page mailed questionnaire.

Measurement: Independent Variables

Concept. Concept-oriented family communication pattern was measured by averaging parent and child responses on a five-point scale (1 = *strongly disagree* to 5 =

strongly agree) to the following item: "In our family, kids learn it's OK to disagree with adults' ideas about the world." Responses from the adolescent and parent participants were combined to create an index of the concept-oriented family communication pattern (r^2 = .40; M = 3.70, *S.D.* = .84 for Wave 1; r^2 = .42; M = 3.82, *S.D.* = .84 for Wave 2).

School curriculum. School curriculum was captured by a mean scale of four items, reflecting how often respondents reported on an eight-point scale (1 = *strongly disagree* to 8 = *strongly agree*) that they engaged in the following activities in school: (1) learned about how government works, (2) discussed/debated political or social issues in class, (3) participated in political role playing in class (mock trials, elections), and (4) were encouraged to make up their own mind about issues in class (α = .84, M = 3.58, *S.D.* = 1.95 for Wave 1; α = .88, M = 3.65, *S.D.* = 2.06 for Wave 2).

Echo chamber variables. We employed four different variables in our "echo chamber" variable: conservative talk radio, Fox News, conservative blogs, and "safetalk." Conservative talk radio was measured by asking respondents how often they consumed "conservative talk radio" (M = .27, *S.D.* = 1.01 for Wave 1; M = .35, *S.D.* = 1.14 for Wave 2). This item was measured on an eight-point scale indicating the number of days in a week ranging from 1 day to 7 days. Fox News use was captured by the frequency of participants' use of Fox cable news (M = .35, *S.D.* = 1.14 for Wave 1; M = .45, *S.D.* = 1.28 for Wave 2). Conservative blog use (M = .09, *S.D.* = .59 for Wave 1; M = .19, *S.D.* = .85 for Wave 2) was measured by participants' use of conservative blogs. To measure "safetalk" (M = 4.92, *S.D.* = 2.10 for Wave 1; M = 4.54, *S.D.* = 2.16 for Wave 2), we reverse coded the item where respondents answered on an eight-point scale how often they "talked about news and current events with people who disagree with you" where (1) stood for "not at all" and (8) for "very frequently." Here, we standardized "safetalk" and our "total talk" (M = 3.70, *S.D.* = 1.89, for Wave 1; M = 4.11, *S.D.* = 1.92, for Wave 2) variable. The total talk variable measured participants' talk with "friends," "family," and "people who agree with you." We then created a multiplicative variable of the two terms so that a higher score meant more homogenous talk.

Media use variables. We used three different media use variables—newspaper use, broadcast news use, and online news use. All news use items were measured on an eight-point scale indicating the number of days in which respondents had engaged in the behavior in an average week, ranging from 0 to 7 days. Newspaper use was measured with two items asking participants to answer how often they consume a print copy of a national paper and of a local paper (r^2 = .30, M = 1.16, *S.D.* = 1.43 for Wave 1; r^2 = .34, M = 1.30, *S.D.* = 1.45 for Wave 2). For broadcast news, participants were asked to answer how often they watch national nightly news and local news (r^2 = .68, M = 1.78, *S.D.* = 1.96 for Wave 1; r^2 = .72, M = 1.78, *S.D.* = 1.97 for Wave 2). Online news use averaged two items, asking respondents

how often they visited the websites of national newspapers and television stations ($r^2 = .39$, $M = .51$, $S.D. = 1.04$ for Wave 1; $r^2 = .47$, $M = .53$, $S.D. = 1.08$ for Wave 2).

Reflection. Reflection was measured by averaging two items on a five-point scale (1 = *strongly disagree* to 5 = *strongly agree*), with items including: "I try to connect what I see in the media to what I already know" and "I often recall what I encounter in the media later on and think about it" ($r^2 = .63$, $M = 3.24$, $S.D. = .94$ for Wave 1; $r^2 = .65$, $M = 3.34$, $S.D. = .91$ for Wave 2).

Demographics. Basic demographic variables such as age ($M = 14.5$, $S.D. = 1.61$), gender (49.5% females), and annual household income ($M = 15.82$, $S.D. = 6.03$, on a scale of 1 to 27 where 1 is less than $5,000 and 27 is greater than $300,000) were included as controls. Income was the measure of family income answered by the child's parent.

Party ID. To measure party ID, respondents were asked "of the two major political parties, which of the following best describes your party affiliation?" They answered on a five-point scale from (1) strong Democrat to (5) strong Republican ($M = 1.95$, $S.D. = .94$, for Wave 1).

Political interest. Interest in politics was measured by the item "I'm interested in politics" on a five-point scale (1 = *strongly disagree* to 5 = *strongly agree*), ($M = 2.60$, $S.D. = 1.14$ for Wave 1).

Dependent variables. The two outcome variables for this study were measures of *news accuracy* and *news bias*. We capture both these variables with single-item measures. To capture news accuracy, participants were asked to decide whether "Most information in the news is accurate." This question was measured on a five-point scale from (1) *strongly disagree* to (5) *strongly agree* ($M = 2.70$, $S.D. = 1.05$ for Wave 1; $M = 2.54$, $S.D. = .99$ for Wave 2). Similarly news bias was also a single item measure asking participants to respond to, "Most news coverage is biased against my views" on a five-point scale from (1) *strongly disagree* to (5) *strongly agree* ($M = 2.66$, $S.D. = .94$ for Wave 1; $M = 2.76$, $S.D. = 1.01$ for Wave 2).

RESULTS

Before testing our hypotheses about the relationship between media perception and the independent variables, we first examined the relationship between ratings of perceptions of media accuracy and media bias. Our first hypothesis predicted that news media accuracy and bias would be significantly correlated among young adults. Running a simple correlation between these two variables reveals that the correlation of $r = -.010$ is not significant ($p < .71$). Therefore, we rejected H1 and conclude that among our sample of young adults, perceptions of news media accuracy and bias are not related. Thus, it did not make sense to combine these two measures to create a single scale measuring news media credibility. We had

planned to create this scale to mimic findings among adults where these two variables are related (Fico et al., 2004; Meyer, 1988) to test our subsequent hypotheses and research questions. Instead, a series of regression analyses were run separately for each of these variables to test their influences.

We conducted three regression models with seven blocks of variables predicting both our outcome variables. First, we examined a cross-section at time 1 (May 2008); a cross-section at time 2 (November 2008); and we conducted a model predicting the change in the outcome between the two time periods using a subtractive measure (outcome variable at time 1 subtracted from outcome variable at time 2). The panel design of our data gave us a unique opportunity to examine how our outcome variables changed over time. Scholars have debated over the different models to examine change (for example, Finkel, 1995), and we used a straightforward method to compare these three models helping us understand our results (Borah, Edgerly, Vraga, & Shah, 2013). With our final model, we are able to examine the factors that predict change in our outcome variables over the course of the election cycle. The final model also provides a comparison with our two cross-sectional models. We include the independent variables as well as the Wave 1 value of our dependent variable so that we are able to isolate the change occurring over the course of the election. The confidence in the findings from the present project is increased as the hypotheses are tested and compared among three different models. The seven blocks of variables consisted of demographics, political orientations, interpersonal conversations, family patterns, school curricula, echo chamber variables, media use, and cognitive engagement.

Cross-Sectional Models for News Accuracy

Altogether, our variables explain 18.8% of the variance in predicting perception of news accuracy in the first wave. Age was the only demographic variable significantly related to the outcome variable. As the youth got older, they perceived the news as less accurate. The second block consisted of political orientations including party identification and political interest. Party identification ($B = -.051$, $p < .05$) was significant, such that Republicans perceived the news to be less accurate than Democrats. The last control variable, political interest, was positively related to news accuracy ($B = .072, p < .05$).

Besides the control variables, we tested our hypotheses with five blocks of independent variables. Our next block consisted of a single variable to examine the influence of the concept-oriented family communication pattern. The results show that belonging to a family emphasizing concept-oriented communication significantly predicted a higher perception of news accuracy ($B = .013, p < .05$). The fourth block also includes only a single variable: school curriculum. Findings did not show a significant relationship. Our next block consisted of "echo chamber" variables.

Among these variables, conservative radio had a (B = -.113, p < .001) negative relationship with news accuracy. To test our hypotheses about news media use, we entered a sixth block of variables, which included broadcast news use, newspaper news use, and online news use. Both broadcast news (B = .101, p < .001) and newspaper news use (B = .038, p < .05) were positively related to perceived news accuracy.

Our final block in the model examined the role of reflection. Here, we found that reflection was positively related to perception of news accuracy (B = .188, p < .001). A similar cross-sectional model was conducted to examine perceived news accuracy in the second wave. This model explained 18.4% of the variance and demonstrated very similar patterns. One difference that stood out in the second wave, however, was that "safe talk" had a negative influence (B = -.149, p < .01) on news accuracy.

Cross-Sectional Models for News Bias

We next tested the same set of hypotheses, looking at the perception of news bias. In Wave 1, our variables explain 17.1% of the variance in predicting news bias in teens. Examining these variables more closely, among the demographic variables we find that age (B = .068, p < .01) produces a significant positive relationship with news bias. Thus as youth age they perceive more bias. The second block of variables included political orientations. Both party identification (B = .081, p < .001), such that Republicans perceived the news as more biased than Democrats, and political interest (B = .179, p < .001) positively influence the perception of news bias. Thus those with greater political interest perceive more news bias.

Beyond these control variables, we also tested the same set of hypotheses predicting news bias as those for news accuracy. We examined the concept-oriented family communication pattern, which does not have a significant influence on news bias. Similar to news accuracy, school curriculum also does not have a significant influence on news bias. The fifth block added the echo chamber variables to the model. In this case, both conservative radio (B = .069, p < .01) and Fox News use (B = .037, p < .05) are positively related to news bias. Next, among the news media variables, broadcast news (B = -.031, p < .05) is negatively related to news bias. The last block, reflection of the media, did not have any influence on news bias.

We tested the same cross-sectional model with the Wave 2 variables. This model explained 16.1% of the variance and again demonstrated similar patterns.

Change Model for News Accuracy

To conduct the change model, we used the raw difference score of the outcome variable. Our variables explain 40.4% of the total variance. Among the two blocks of controls, only party identification (B = -.095, p < .001) demonstrated

Table 1. Regression Analysis Predicting News Accuracy in Cross Sectional Wave 1; Cross Sectional Wave 2; and Change Over Time.

	Cross sectional Wave 1	Cross sectional Wave 2	Change
Wave 1 News Accuracy			−.645***
Demographics			
Age	−.067*	−.041	.001
Female	.003	−.036	.052
Income	−.059	.020	.033
Political Orientations			
Republican	−.051*	−.087*	−.095***
Political Interest	.072*	.096*	.067
Family Patterns			
Concept-Oriented Family Communication Patterns	.013*	.085*	.033*
School Environment			
School Curriculum	.010	.037	.005
Echo Chamber Variables			
Conservative Radio	−.113***	−.030*	−.047*
Fox News	−.024	−.018	−.016
Conservative Blog	.022	.104	.029
Safe Talk	−.032	−.149**	−.085*
Media Use			
Broadcast News	.101***	.107*	.026*
Newspaper News	.038*	.071**	.037*
Online News	.017	.004	.097
Cognitive Engagement			
Reflection	.179***	.116**	.055*
Total Adjusted R^2	.188***	.184***	.404***
Number of Cases	1043	480	574

* $p < .05$; ** $p < .01$; *** $p < .001$.

a significant relationship. Similar to the patterns demonstrated in the cross-sectional models, Republicans perceived the news as less accurate than Democrats. Also, concept-oriented family communication ($B = .033$, $p < .05$) had a positive influence on news accuracy. Among the "echo chamber" variables both conservative radio ($B = -.047$, $p < .05$) and "safe talk" ($B = -.085$, $p < .05$) use have a negative

Table 2. Regression Analysis Predicting Bias in Cross Sectional Wave 1; Cross Sectional Wave 2; and Change Over Time.

	Cross sectional Wave 1	Cross sectional Wave 2	Change
Wave 1 Bias			-.602***
Demographics			
Age	.068**	.002	.003
Female	.029	.024	.015
Income	-.011	.090	.012
Political Orientations			
Republican	.081***	.163***	.101***
Political Interest	.179***	.113***	.140***
Family patterns			
Concept-Oriented Family Communication Patterns	.041	.073	.054
School Environment			
School Curriculum	.018	.035	.063
Echo Chamber Variables			
Conservative Radio	.069**	.115**	.061*
Fox News	.037*	.182***	.048*
Conservative Blog	.014	.005	.015
Safe Talk	.027	.029	.052
Media use			
Broadcast News	-.031*	-.114**	-.007
Newspaper News	-.051	.010	.001
Online News	-.012	.043	.032
Cognitive Engagement			
Reflection	.064	.109	.024
Total Adjusted R^2	.179***	.161***	.355***
Number of Cases	1043	480	574

$* p < .05; ** p < .01; *** p < .001.$

influence on news accuracy. Next, the media use variables show that broadcast news ($B = .026, p < .05$), newspapers ($B = .037, p < .05$), and online news ($B = .097, p < .05$) have a positive influence on the change in perception of news accuracy over the course of the election. The final block demonstrates the positive influence of reflection ($B = .055, p < .05$) on news accuracy.

Change Model for News Bias

Similarly, we tested the change model for perceptions of news bias. The predictor variables explained 35.5% of the total variance. Among the control variables, party identification (B = .101, p < .001) and political interest (B = .140, p < .001) had a positive influence on news bias. Similar to the cross-sectional model, conservative talk radio (B = .061, p < .05) and Fox News (B = .048, p < .05) had a positive influence on perceptions of news bias.

It is also important to note that we included the measure of the outcome variable from Wave 1 (in May of 2008) in the model predicting change. News accuracy from Wave 1 has a significant, and the largest, coefficient in the first change model (B = -0.645, p < .001). Similarly in the second change model, news bias from Wave 1 had a negative effect (B = -0.602, p < .001) on change in news bias. In both models, the negative impact suggests that those with a high level of news accuracy in May were less likely to experience change over the course of the campaign, highlighting a ceiling effect in news accuracy levels. Similarly, the negative influence in the second model indicates ceiling effects in news bias.

DISCUSSION AND CONCLUSIONS

Our study set out to understand the origins of media perceptions by conducting a survey of adolescents between the ages 12 to 17. Employing two of the most common indicators of media credibility among adults (Gaziano, 1988; Gaziano & McGrath, 1986; Meyer, 1988), accuracy and bias, we first tested whether these indicators would correlate as predicted among our adolescent population. This did not prove to be the case. Among adolescents, accuracy and bias are not significantly related. There are many potential explanations for this null finding. The participants in our study are still in their formative years, being socialized into their understanding of the world and of the media within it. Therefore, it may be unreasonable to expect that they view the world, including perceptions of media credibility, the same way their parents might. As these adolescents age and grow closer to the adult population, we would expect that they would come to share many of the same conceptions of the media, including what constitutes "credibility," as the adults from previous studies.

Because perceived accuracy and bias were not significantly related among this population, we could not combine them to directly test our research questions and hypotheses for credibility. Instead, we chose to run two separate but matching regression models to look at the effects of each of our predictors on perceived accuracy and bias separately. In this way, we can begin to understand what drives adolescents' perceptions of the media. We also ran a third model to test change in the outcome variables during the course of the election.

Given that adolescents are younger than the population most frequently studied with regards to media credibility—college students or adults—we expected that as these youth get older, their perceptions of media credibility would decrease. Indeed, this is what we find. Older adolescents rated the media as less accurate and more biased than their younger counterparts. This change is probably directly linked to the socialization process: as children grow older, their own opinions of the media are likely to fall in line with those of adults, who typically express relatively low levels of media credibility (Johnson & Kaye, 1998; Kohut et al., 2005). This change may also be linked to adolescents' increased involvement in the political world as they age. The literature on hostile media bias shows that it is a phenomenon prevalent among highly partisan, involved citizens (Giner-Sorolla & Chaikan, 1994; Gunther, 1992; Gunther & Christen, 2002; Perloff, 1989), so as the adolescents' level of involvement increases as they age and become a part of the political process, so their ratings of media credibility suffer.

Looking beyond demographic differences, we expected that certain political variables would be related to perceptions of media credibility. The adolescents who have already identified themselves as Republicans are more likely to perceive the media as biased and less accurate. The relationship between Republican identification and perceptions of media bias is understandable since there is a perception of "liberal bias" of the mainstream media (Kohut, Doherty, & Dimock, 2007; Watts et al., 1999). Besides party identification we also examined the influence of political interest on both our outcome variables. In our sample, political interest increases perceptions of media accuracy as well as perceptions of bias. This seemingly contrary finding deserves further explanation. With their greater political interest, these adolescents are most likely to be exposed to a variety of media content (Katz, 1957; Lazarsfeld, Berelson, & Gaudet, 1948; Robinson, 1976). This increased exposure to the media perhaps enables these engaged youth to develop a more nuanced picture of the media, thereby enabling them to recall examples of both accuracy and bias in the content. Furthermore, they may be more likely to be able to recall specific examples of media content, enabling them to consider both biased and accurate samples in making their judgment.

Next, we examined the influence of two of the most important socializing forces, home environment and school curriculum. Our findings show that adolescents growing up in a concept-oriented home environment perceived the news media as more accurate. Prior research has shown the importance of concept-oriented values in the political socialization process of adolescents; specifically, in regard to political development, increased interest in politics, knowledge about politics (Chaffee et al., 1973), and political engagement (McLeod & Shah, 2009). Our findings add to this line of research by demonstrating that concept-oriented values could influence perceptions of media accuracy.

We also wanted to examine the role that exposure to more homogeneous environments might play in perceptions of media credibility. Discussion of the "echo chamber" suggests that people exposed to a more homogeneous environment would strengthen their opinions and become more polarized. In the context of American politics, there is often a division between Republicans and Democrats. We find that youth who listen to more conservative talk radio and view more Fox News are more likely to perceive the media as less credible, both in terms of accuracy and bias. Given that conservatives are more likely to claim a hostile media bias from the "liberal press" and that elite cues are largely responsible for this perception (Watts et al., 1999), exposure to concentrated doses of conservative opinion is likely to relate to perceptions of the media as less accurate and more biased. Among the "echo chamber" variables we also find that "safe talk" relates to media credibility, such that more "safe talk" causes adolescents to perceive the media as more biased. Our findings support previous research by Eveland and Shah (2003) on the importance of safe talk to perceptions of bias.

Our findings of media use variables demonstrate interesting patterns. Specifically, broadcast news and newspaper use cause higher perceptions of news accuracy. For perceptions of media bias, we find that broadcast news is negatively related to perceptions of bias. Finally, we expected that among a young adolescent population, the Internet would be a significant source of information and affect perceptions of the media. Surprisingly, none of our Internet use variables—newspaper or television websites—is related to perceptions of media accuracy or bias. This result could be because of our measures of the outcome variables. Both measures of accuracy and bias talk about media in general, and it is possible that participants could exclude online media sources when they think about media in general. We also find that reflection about the media causes adolescents to perceive the media as more accurate.

Our study has some limitations that need to be addressed. The biggest limitation is that both our dependent variables are single-item measures, heightening the possibility of measurement error. However, both items are high on face validity, and other research has made important contributions using single-item dependent variables (Eveland & Shah, 2003). Furthermore, common limitations of cross sectional survey research apply to our study as well—our findings cannot be considered causal. For instance, in case of the "echo chamber" media variables, whether it is people who read these sources that end up thinking that the media is not credible, or whether it is people who are unsatisfied with the media and turn to more congenial sources, is something we cannot determine. Despite these limitations, our study finds some very interesting results throwing new light in the area of media perceptions.

Our finding that perceptions of news media accuracy and bias are not related among adolescents is both a limitation and a contribution of our study. While it

requires us to use single-item measures for our dependent variables and prevents us from fully testing our hypotheses about credibility, it is also one of the most important findings. Credibility clearly does not have the same meaning for the adolescents in this study, given that our two measures of credibility are commonly used among adult populations (Gaziano & McGrath, 1986; Meyer, 1988). Future research should examine more closely what comprises credibility in the minds of young adults as well as its predictors.

Overall, our study makes a significant contribution to the literature on media perceptions by exploring the predictors of perceptions of accuracy and bias in adolescent minds. This is the formative stage where individuals learn to think about important issues about the media and politics. Research on news credibility—both bias and accuracy—shows that there are fundamental consequences of these perceptions. Most importantly, credibility ratings are linked to people's news use habits (Flanagin & Metzger, 2000; Gaziano, 1988). Therefore, if youth already perceive the media as biased and inaccurate, this could have long-term effects on their news consumption and civic and political participation. The news media bias research shows that perceptions of bias could lead to increased polarization and perceptions of hostility in public opinion toward their group (Gunther, 1988). Scholars have also pointed out that hostile media perception could be the basis of many social behaviors, voting patterns, or even opinion expression (Gunther, Christen, Liebhart, & Chia, 2001).

Understanding perceptions of accuracy is also important. In a democracy, much importance is placed on having a free press to inform the public and help citizens make up their minds on political issues. If the public does not trust the information, it leaves open normative questions about the value of the press and the ability of people to make rational decisions. Clearly, understanding not only what levels of credibility exist but how and when perceptions of credibility form is critical to both journalism and the democratic process. Our study takes the first step in examining the antecedents to these processes that crystallize into much stronger perceptions as individuals age. This study demonstrates the primary roles of political interest, family communication patterns, "echo chamber" variables, and media use in forming perceptions of news accuracy and news bias. Future research should improve on some of the measurement weaknesses and explore these important relationships further.

REFERENCES

Borah, P., Edgerly, S., Vraga, E., & Shah, D. (2013). Hearing and talking to the other side: Antecedents of cross-cutting exposure in adolescents. *Mass Communication and Society, 16*(3), 391–416.

426 | PORISMITA BORAH AND DHAVAN SHAH

Campbell, D. E. (2005). *Voice in the classroom: How an open classroom environment facilitates adolescents' civic development* (Working Paper 28). Retrieved from the Center for Information & Research on Civic Learning and Engagement website: http://civicyouth.org/circle-working-paper-28-voice-in-the-classroom-how-an-open-classroom-environment-facilitates-adolescents-civic-development/

Cappella, J., & Jamieson, K. (1997). *Spiral of cynicism: The press and the public good.* New York, NY: Oxford University Press.

Carmines, E. G., McIver, J. P., & Stimson, J. A. (1987). Unrealized partisanship: A theory of dealignment. *The Journal of Politics, 49*(2), 376–400. doi: 10.2307/2131306

Chaffee, S., McLeod, J., & Wackman, D. (1973). Family communication patterns and adolescent political participation. In J. Dennis (Ed.), *Socialization to politics: A reader* (pp. 391–410). New York, NY: John Wiley.

Cunningham, B. (2003). Re-thinking objectivity. *Columbia Journalism Review, 42*(2), 24–32.

DellaVigna, S., & Kaplan, E. (2007). The Fox News effect: Media bias and voting. *Quarterly Journal of Economics, 122,* 1187–1234. doi: 10.1162/qjec.122.3.1187

Domke, D., Fan, D. P., Fibison, M., Shah, D. V., Smith, S. S., & Watts, M. D. (1997). News media, candidates and issues, and public opinion in the 1996 presidential campaign. *Journalism and Mass Communication Quarterly, 74*(4), 718–737. doi: 10.1177/107769909707400405

Eveland, W., & Scheufele, D. (2000). Connecting news media use with gaps in knowledge and participation. *Political Communication, 17,* 215–237. doi: 10.1080/105846000414250

Eveland, W. P., & Shah, D. V. (2003). The impact of individual and interpersonal factors on perceived news media bias, *Political Psychology, 24*(1), 101–117. doi: 10.1111/0162-895X.00318

Feldman, L., Pasek, J., Romer, J., & Hall Jamieson, K. (2007). Identifying best practices in civic education: Lessons from the student voices program. *American Journal of Education, 114,* 75–99. doi: 10.1086/520692

Fico, F., Richardson, J. D., & Edwards, S. M. (2004). Influence of story structure on perceived story bias and news organization credibility. *Mass Communication & Society, 7*(3), 301–318. doi: 10.1207/s15327825mcs0703_3

Finkel, S. E. (1995). *Causal analysis with panel data.* Thousand Oaks, CA: Sage.

Flanagin, A. J., & Metzger, M. J. (2000). Perceptions of Internet information credibility. *Journalism and Mass Communication Quarterly, 77*(3), 515–540. doi: 10.1177/107769900007700304

Forgette, R., & Morris, J. S. (2006). High-conflict television news and public opinion. *Political Research Quarterly, 59,* 447–456. doi: 10.1177/106591290605900312

Gaziano, C. (1988). How credible is the credibility crisis? *Journalism Quarterly, 65,* 267–278, 375.

Gaziano, C., & McGrath, K. (1986). Measuring the concept of credibility. *Journalism Quarterly, 63,* 451–462.

Gerbner, G., Gross, L., Morgan, M., & Signorielli, N. (1994). Growing up with television: The cultivation perspective. *Media effects: Advances in theory and research.* Hillsdale, NJ: Lawrence Erlbaum.

Gimple, J. G., Lay, J. C., & Schuknecht, J. E. (2003). *Cultivating democracy.* Washington, DC: Brookings Institution Press.

Giner-Sorolla, R., & Chaiken, S. (1994). The causes of hostile media judgments. *Journal of Experimental Social Psychology, 30,* 165–180. doi: 10.1006/jesp.1994.1008

Greer, J. (2003). Evaluating the credibility of online information: A test of source and advertising influence. *Mass Communication and Society, 6*(1), 11–28. doi: 10.1207/S15327825MCS0601_3

Groseclose, T., & Milyo, J. (2005). A measure of media bias. *Quarterly Journal of Economics, 120,* 1191–1237. doi: 10.1162/003355305775097542

Gunther, A. (1988). Attitude extremity and trust in media. *Journalism Quarterly, 65*(2), 279–287.

Gunther, A. (1992). Biased press or biased public? Attitudes toward media coverage of social groups. *Public Opinion Quarterly, 56*(2), 147–167. doi: 10.1086/269308

Gunther, A., & Christen, C. (2002). Projection or persuasive press? Contrary effects of personal opinion and perceived opinion and perceived news coverage on estimates of public opinion. *Journal of Communication, 52*(11), 177–195. doi: 10.1093/joc/52.1.177

Gunther, A., Christen, C., Liebhart, J., & Chia, C-Y. (2001). Congenial public, contrary press and biased estimates of the climate of opinion. *Public Opinion Quarterly, 65*, 295–320. doi: 10.1086/322846

Hofstetter, R. (1998). Political talk radio, situational involvement and political mobilization. *Social Science Quarterly, 79*, 273–286.

Hwang, H., Schmierbach, M., Paek, H., Gil de Zuniga, H., & Shah, D. V. (2006). Media dissociation, Internet use, and anti-war political participation: A case study of political dissent and action against the war in Iraq. *Mass Communication & Society, 9*, 461–483. doi: 10.1207/s15327825mcs0904_5

Jamieson, K. H., & Cappella, J. N. (2008). *Echo chamber: Rush Limbaugh and the conservative media establishment.* Oxford, England: Oxford University Press.

Johnson, T. J. (1993). Filling out the racing form: How the media covered the horse race in the 1988 primaries. *Journalism and Mass Communication Quarterly, 70*(2), 300–310. doi: 10.1177/107769909307000206

Johnson, T. J., & Kaye, B. K. (1998). Cruising is believing?: Comparing Internet and traditional sources on media credibility measures. *Journalism and Mass Communication Quarterly, 75*(2), 325–340. doi: 10.1177/107769909807500208

Katz, E. (1957). The two-step flow of communication: An up-to-date report on a hypothesis. *Public Opinion Quarterly, 21*(1), 61–78. doi: 10.1086/266687

Kohut, A., Allen, J., Keeter, S., Doherty, C., Dimock, M., Funk, C., … Turner, T. (2005). *Online newspaper readership countering print losses: Public more critical of the press, but goodwill persists.* Washington, DC: The Pew Research Center for the People and the Press.

Kohut, A., Doherty, C., & Dimock, M. (2007). *Views of press values and performance: 1985–2007.* Washington, DC: The Pew Research Center for the People and the Press.

Kosicki, G. M., & McLeod, J. M. (1990). Learning from political news: Effects of media images and information-processing strategies. In S. Kraus (Ed.), *Mass communication and political information processing.* Hillsdale, NJ: Lawrence Erlbaum.

Kovach, B., & Rosenstiel, T. (2001). The elements of journalism. *What newspeople should know and the public should expect.* New York, NY: Crown.

Lazarsfeld, P. F., Berelson, B., & Gaudet, N. (1948). *The people's choice: How the voter makes up his mind in a presidential campaign.* New York, NY: Duell, Sloan, and Pearce.

Liker, J. K., Augustyniak, S., & Duncan, G. J. (1985). Panel data and models of change: A comparison of first difference and conventional two-wave models. *Social Science Research, 14*(1), 80–101.

Lowry, D. T., & Shidler, J. A. (1998). The sound bites, the biters, and the bitten: A two-campaign test of the anti-incumbent bias hypothesis in network TV news. *Journalism and Mass Communication Quarterly, 75*(4), 719–729. doi: 10.1177/107769909807500407

McDevitt, M., & Kiousis, S. (2004, September). *Education for deliberative democracy: The longterm influence of Kids Voting USA* (Working Paper 22). Retrieved from the Center for Information & Research on Civic Learning and Engagement website: http://eric.ed.gov/?id = ED498897

McKenna, L., & Pole, A. (2008). What do bloggers do? An average day on an average political blog. *Public Choice, 134*, 97–108.

McLeod, J. M., & Chaffee, S. H. (1972). The construction of social reality. In J. Tedeschi (Ed.), *The social influence processes* (pp. 50–99). Chicago, IL: Aldine.

McLeod, J., Scheufele, D., & Moy, P. (1999). Community, communication and participation: The role of mass media and interpersonal discussion in local political participation. *Political Communication, 16*, 315–336. doi: 10.1080/105846099198659

McLeod, J. M., Scheufele, D. A., Moy, P., Horowitz, E. M., Holbert, L., Zhang, ... Zubric, J. (1999). Understanding deliberation: The effects of discussion networks on participation in a public forum. *Communication Research, 26*, 743–774. doi: 10.1177/009365099026006005

McLeod, J. M., Shah, D., & Lee, N. (2009). Communication competence as a foundation for civic competence: Processes of socialization into citizenship. *Political Communication, 26*(1), 102–117. doi: 10.1080/10584600802710384

Merelman, R. M. (1973). The structure of policy thinking in adolescence: A research note. *American Political Science Review, 67*(1), 161–166.

Meyer, P. (1988). Defining and measuring credibility of newspapers: Developing an index. *Journalism Quarterly, 65*, 567–588. doi: 10.1177/107769908806500301

Morris, J. (2005). The Fox News factor. *The International Journal of Press/Politics, 10*(3), 56–79. doi: 10.1177/1081180X05279264

Mutz, D. C. (2007). How the mass media divide us. In P. S. Nivola & D. W. Brady (Eds.), *Red and blue nation? Volume one* (pp. 223–248). Washington, DC: Brookings Institute Press.

Mutz, D. C., & Martin, P. S. (2001). Facilitating communication across lines of political difference: The role of mass media. *The American Political Science Review, 95*(3), 97–114.

Mutz, D. C., & Reeves, B. (2005). The new videomalaise: Effects of televised incivility on political trust. *American Political Science Review, 99*, 1–15. doi: 10.1017/S0003055405051452

Niemi, R. G., & Jennings, M. K. (1991). Issues and inheritance in the formation of party identification. *American Political Science Review, 35*(4), 970–988. doi: 10.2307/2111502

Noelle-Neumann, E. (1993). *The spiral of silence: Public opinion, our social skin.* Chicago, IL: University of Chicago Press.

Pan, Z., & Kosicki, G. (1997). Talk show exposure as an opinion activity. *Political Communication, 14*, 371–88. doi: 10.1080/105846097199380

Perloff, R. (1989). Ego-involvement and the third person effect of televised news coverage. *Communication Research, 16*(2), 236–262. doi: 10.1177/009365089016002004

Pfau, M., Moy, P., Holbert, R., Szabo, E., Lin, W., & Zhang, W. (1998). The influence of political talk radio on confidence in democratic institutions. *Journalism and Mass Communication Quarterly, 75*, 730–745. doi: 10.1177/107769909807500408

Plutzer, E. (2002). Becoming a habitual voter: Inertia, resources, and growth in young adulthood. *The American Political Science Review, 96*(1), 41–56. doi: 10.1017/S0003055402004227

Robinson, J. P. (1976). Interpersonal influence in election campaigns: Two step-flow hypotheses. *Public Opinion Quarterly, 40*(3), 304–319. doi: 10.1086/268307

Roch, C. H. (2005). The dual roots of opinion leadership. *Journal of Politics, 67*(1), 110–131.

Schudson, M. (1998). *The good citizen: A history of American civic life.* New York, NY: The Free Press.

Sears, D. O., & Valentino, N. A. (1997). Politics matters: Political events as catalysts for preadult socialization. *American Political Science Review, 91*(1), 45–65.

Shah, D. V., Cho, J., Eveland, W. P., Jr., & Kwak, N. (2005). Information and expression in a digital age: Modeling Internet effects on civic participation. *Communication Research, 32*, 531–565. doi: 10.1177/0093650205279209

Shah, D. V., Cho, J., Nah, S., Gotlieb, M. R., Hwang, H., Lee, N., … McLeod, D. M. (2007). Campaign ads, online messaging, and participation: Extending the communication mediation model. *Journal of Communication, 57*, 676–703. doi: 10.1111/j.1460-2466.2007.00363.x

Shah, D. V., McLeod, J. M., & Lee, N. (2009). Communication competence as a foundation for civic competence: Processes of socialization into citizenship. *Political Communication, 26*, 102–117. doi: 10.1080/10584600802710384

Shah, D. V., & Scheufele, D. A. (2006). Explicating opinion leadership: Nonpolitical dispositions, information consumption, and civic participation. *Political Communication, 23*(1), 1–22. doi: 10.1080/10584600500476932

Torney-Purta, J. (2002). A school's role in developing civic engagement: A study of adolescents in twenty-eight countries. *Applied Developmental Science, 6*, 203–212. doi: 10.1207/S1532480 XADS0604_7

Vallone, R. P., Ross, L., & Lepper, M. R. (1985). The hostile media phenomena: Biased perception and perceptions of media bias in coverage of the Beirut massacre. *Journal of Personality and Social Psychology, 49*, 577–585. doi: 10.1037//0022-3514.49.3.577

Watts, M. D., Domke, D., Shah, D. V., & Fan, D. P. (1999). Elite cues and media bias in presidential campaigns: Explaining public perceptions of a liberal press. *Communication Research, 26*(2), 144–175. doi: 10.1177/009365099026002003

The Impact OF News "Voice" ON Adolescent Political Efficacy

JEREMY LITTAU, LIZ GARDNER, AND ESTHER THORSON

This study focuses on the impact of the style in which news is communicated, a dimension that we call "voice." We suggest voice is critically important to the process by which young teens acquired political knowledge and exhibited political efficacy in the 2008 presidential election. To provide a rationale for this study, we integrate a number of literature areas under the explanatory context of the Media Choice Model (Thorson & Duffy, 2006), an extensive elaboration of the uses and gratifications approach. Although the central focus of the model is on how the impact of media use is mediated through people's motivations for using media, it also posits that "voice" is a crucial filter for these processes. As background, we look at what is known about the following influences on political socialization: exposure to television, print, and Internet news, and whether that information occurs in the context of classic news "authoritative" voice; "opinionated" voice like that in blogs or opinionated news like the Fox News Channel; or directly from the politicians themselves, a voice we call "direct to the consumer," a phrase borrowed from the advertising literature. We also examine what is known about the relationship between political knowledge and efficacy.

LITERATURE REVIEW

Self-Efficacy and Media Use

The notion of self-efficacy, defined as the belief that one can effectively act on knowledge or beliefs in the performance of a given task, has its roots in Bandura's

(1986) seminal work on social cognitive theory. Bandura posited that efficacy was a main factor in determining how an individual would behave based on the acquisition of knowledge, as efficacy is a critical part of a person's own sense of motivation to choose. An individual with high efficacy would feel empowered to apply knowledge in a way that creates action, whereas a low-efficacy individual would typically feel helpless or lost on a given task. Knowledge is an important component in, and a high predictor of, efficacy, but it is not the sole component in its creation.

Bandura (1997) found that the truth or falsity of knowledge was not as important as how an individual feels about the knowledge. In that sense, self-efficacy is a step past knowledge, where individuals have been empowered to not only consume information but also to analyze it. Self-efficacy judgments primarily come from experience about a person's own accomplishments performing the task in the past, observations of others performing the task, persuasion that happens as a result of others, and a person's emotional or physiological state (Bandura, 1997; Staples, Hulland, & Higgins, 1998).

The notion of self-efficacy has been applied across several disciplines. In terms of political communication, research has focused on how information consumers absorb knowledge in a way that leads them to believe they can cause change by becoming politically engaged. Information and knowledge are necessary steps toward increasing one's sense of efficacy, and thus news media play a vital role (Pateman, 1970). Scholars have differentiated between "internal efficacy," which refers to people's beliefs about their ability to understand and participate in political action, and "external efficacy," which focuses on whether people believe their individual or collective political activity truly can change the way politicians and government officials behave (Balch, 1974; Niemi, Craig, & Mattei, 1991).

Communication researchers have tied social cognitive theory to uses and gratifications theory in an effort to show media effects on self-efficacy. Media exposure influences decisions about self-efficacy because individuals reevaluate expectations about likely outcomes based on knowledge acquired (LaRose, Mastro, & Eastin, 2001) Some media, such as the Internet, have been found to increase internal efficacy because the medium provides wide-ranging access to information about politics, candidates, and important issues in public life (Johnson & Kaye, 2003). The ability to deliberate and exchange ideas through media has been found to be a driver of higher self-efficacy because it increases the knowledge an individual has about others' lives external to the self (Meraz, 2006). Reliance on a particular medium (i.e., television vs. newspapers) increases the impact that use of that medium has on a user's self-efficacy (Miller & Reese, 1982).

As a smaller subset of overall media use, the use of news media creates ties between people and fosters attitudes of democratic efficacy by enabling one to learn about, and empathize with, their fellow citizens through the acquisition of

knowledge (Curran, 2005). Thorson (2005) noted that news mobilizes civic attitudes by keeping citizens informed about what is going on in their communities and, ideally, providing solutions or areas of action that provide ways in which consumers can act upon the information. Thorson also noted that news use is positively associated with both internal and external efficacy and thus helps to promote prosocial behaviors in communities. Others have found that political self-efficacy plays a critical role for younger users when it comes to civic behaviors such as voting (Kaid, McKinney, & Tedesco, 2007).

Adolescents and News Use: A Uses and Gratifications Framework

Many studies of media use employ uses and gratification theory (Blumler & Katz, 1974), an audience-based approach to mass communication theory that understands media use from the perspective that people have specific psychological, social, and information gratifications that they fulfill by using the media that best suit their purposes.

As Katz (1959) pointed out, beyond basic physiological needs for survival, people have communication needs. Humans choose the communication act that best gratifies that need. The communication behavior may occur face to face or it may be mediated with a communication medium (newspapers, radio, television, smartphone, and so on). As new media are introduced into their environment, humans will pick and choose among the alternatives, tending to head toward that communication act that maximally satisfies their particular need.

Katz, Blumler, and Gurevitch (1974) suggested that uses and gratifications research should focus on a handful of central concepts, including: (a) the social and psychological origins of (b) needs that generate (c) expectations of (d) the mass media or other communication sources, which lead to (e) different media choices, resulting in (f) gratification of the needs. Rosengren (1974) added two important additional aspects of the process: (g) individual differences such as demographics and lifestyles, and (h) particular situations in which the needs must be filled. Unlike many competing theories of media use, this approach assumes that media users are active, picking and choosing so as to maximize desired gratifications.

The uses and gratifications approach has led to the development of several taxonomies of communication needs. Excellent summaries of the large literature on communication need articulation can be found in Rubin (1983, 1994) and in Ruggiero (2000). The theory has been applied to aid understanding of the antecedents of choice of every medium, including newspapers (Elliott & Rosenberg, 1987); television (Babrow, 1987; Conway & Rubin, 1991); and the newer media such as cable television (Heeter & Greenberg, 1985); e-mail (Dimmick, Kline, & Stafford, 2000); and most recently the Internet (Beaudoin & Thorson, 2004; Kaye & Johnson, 2002; Papcharissi & Rubin, 2000; Rodgers & Thorson, 2000).

Uses and gratifications theory has also been used in models that attempt to identify how people choose one medium over another. A good example is Lacy (2000), who suggested that five communication needs (surveillance, diversion, social-cultural interaction, decision making, and self-understanding) combine with other variables such as quality of news and media features (such as cost) to determine how much time people will spend with various media.

Eveland (2004) developed a useful uses-and-gratifications-based approach to understanding how people use media specifically to obtain political information. Much of this model can be applied to the question of youth media choices. Eveland suggested that different gratifications focus attention toward media differently. For example, if there is an entertainment gratification sought, individuals may favor attention to the kind of candidate behavior lampooned on *Saturday Night Live* or late-evening satire shows such as *The Daily Show* and *The Colbert Report*. If an information gratification is sought, individuals may favor attention to differences in candidate positions on major issues as described in newspapers or cable news programs.

Given past research indicating that efficacy functions in part based on an individual's level of knowledge (Bandura, 1997), it would be expected that knowledge would have a direct impact on efficacy for young media consumers. Therefore, we predict the following:

H1: Political knowledge will have a strong and direct positive impact on political efficacy.

Furthermore, because knowledge is considered a critical factor in creating political self-efficacy and because media relate variably to knowledge, it should be expected that different media play varying roles in building efficacy through knowledge. Past research has shown that television is a weak predictor of knowledge compared with other media such as newspapers or the Web (Shah, McLeod, & Yoon, 2001). Thus the relationship between media choice, knowledge, and political self-efficacy should vary depending on media. Therefore, we predict:

H2: Time spent with television, because it involves both entertainment and news time, is likely to have a negative impact on knowledge, and through knowledge, on efficacy.

Elaboration

Eveland (2004) also posited that gratifications influence the information processing of political news. Again, those who seek entertainment may spend few cognitive resources on candidate positions, while those who seek information will elaborate much more on those positions and how they relate to their own values and beliefs.

Eveland and Dunwoody (2001) defined cognitive elaboration as connecting separate pieces of information, whether it is from memory or material being processed, into a larger whole that provides a framework for understanding. Elaboration in terms of media use then occurs when information from media is collected by the individual and compared with prior knowledge, thus enabling the individual to construct new frameworks for understanding the world. Elaboration, therefore, is positively associated with knowledge (Eveland, Shah, & Kwak, 2003).

Different media play different roles in elaboration. With the Web, it appears that the benefits that come with rich interconnected information resources benefit frequent users' ability to elaborate on what they are consuming, whereas with less frequent users the wealth of information might serve to confuse users and thus hinder elaboration (Eveland, Marton, & Seo, 2004). Newspapers have been found to be strongly associated with elaboration; and how the media are used also matters, as use for information and surveillance is positively associated with elaboration compared with use for entertainment (Beaudoin & Thorson, 2004; Eveland, 2001). Given these findings, we predict:

H3: Time spent with newspapers will have a positive impact on elaboration and through elaboration on knowledge.

H4: Internet news use will have a positive impact on elaboration and through elaboration on knowledge.

The Media Choice Model

A main and persistent criticism of uses and gratifications theory is that while the theory does explain media choice, it does little to help predict which media a person will choose given a certain set of needs (Ruggiero, 2000). In a related variation of uses and gratifications approaches, the Media Choice Model (Thorson & Duffy, 2006) addresses how people, both adults and teens, choose media. The Media Choice Model suggests that new media features (immediacy, mobility, ease of use, presence of video or audio, dependence on text) influence the way people fill their communication needs and develop preferred patterns of media use but modify those patterns as the media environment changes. It also suggests that voice used in the news has a significant impact on what media one may choose to obtain their news.

Arnett, Larson, and Offer (1995) emphasized that adolescent use of media is highly active, as it is perceived to be in uses and gratifications, and seems to follow patterns of human development as teens learn to seek out concepts of self and their place in social contexts. In the introduction to a special issue of *Journal of Youth and Adolescence* the authors overviewed how important it is to understand

youth as being active selectors of media, just as they take an active role in creating and defining many of the relationships in their lives, including schools, parents, significant others, and so on (e.g., Lerner & Kaufman, 1985; Scarr, 1993; Scarr & McCartney, 1983).

Eveland, McLeod, and Horowitz (1998) reviewed the literature on the relationship between media exposure and political interest, two variables that have reciprocal relations. Nevertheless, the preponderance of findings suggests that the dominant causal direction is from media exposure to political interest. Although there is not much research to guide the connection to gratifications, it would seem that the motives would be as likely to mediate the effects of media exposure on political interest as suggested for political knowledge.

Voice

Thorson and Duffy's (2006) media choice model, which extends uses and gratifications theory to the online environment, identifies several types of news stories from which readers can choose. In their model, these different types are referred to as "voices." Traditional, authoritative news is but one option. People may instead prefer "opinionated" news, from the popular, conservative Fox News Channel to blogs of every type, or "collaborative" news, in which journalists report working closely with their audience or readers as sources to cover a story. Opinionated news may resonate particularly well with younger audiences. A 2005 Carnegie Foundation report (Brown, 2005) claimed that young audiences prefer to obtain news from a source whose politics and attitudes are known and made clear. The report points to the high perceived credibility of self-proclaimed "fake news" host Jon Stewart and rapidly increasing use of blogs for "news" among adolescents as signs of the rising popularity of non-traditional opinionated news formats. In a political election, it is also the case that candidates can speak directly to the public through advertising, promotional materials, and all kinds of website content such as official campaign sites and blogs. In the advertising literature, when it became legal for pharmaceutical companies to start talking directly to consumers rather than through medical professionals such as doctors, the advertising was dubbed "direct-to-consumer" or DTC (e.g., see Calfee, 2002).

A great deal of research has focused on how DTC affects consumers, and two findings from this body of work are particularly salient for the current study. First, consumers find the advertising directed towards them quite compelling and convincing and are likely to act on it (e.g., Bell, Kravitz, & Wilkes, 1999; Mehta & Purvis, 2003; Perri & Nelson, 1987; Williams & Hensel, 1995). Second, the information in DTC ads about what each advertised drug does is easily and accurately learned by consumers (Alperstein & Peyrot, 1993). Given the richness of

our research understanding regarding DTC, it seemed useful to label as DTC those political messages that are delivered directly to the consumer. Thus DTC voice represents political voices that the consumer or citizen receives without the intervention of news filtering.

Given previous research on the impact of authoritative news voice (Coleman & Thorson, 2002; Thorson & Thorson 2006), demonstrated impacts of DTC advertising on learning and behavior, and youth preferences for opinionated news, we predict the following effects of news voices:

H5: Authoritative news voice will have a positive impact on both elaboration and knowledge.

H6: DTC voice will have a positive impact on knowledge and perhaps also on efficacy.

H7: Opinionated news will have a strong positive impact on knowledge and perhaps also on efficacy.

METHOD

Survey Data Collection

This study utilized the second wave of the Future Voters Study three-survey panel (as described in the Introduction). These data were gathered between November 5 and December 10, just after the 2008 presidential election.

Measures and Analyses

To examine the hypotheses outlined above and investigate the relationship between media choice, news voices, political knowledge, elaboration, and political efficacy among a sample of teens, our analyses relied on hierarchical linear regressions. Multiple models combined sets of independent variables to predict knowledge and efficacy. The first model tested demographic variables including age, household size, parent's marital status, years in current residence, and parent's income, as well as political affiliation (Strongly Democrat, Democrat, Independent, Republican, Strongly Republican).

The second hierarchical regression model added media choices, including newspaper, television, and Internet use. Exploratory factor analysis using principal components extraction with Varimax rotation determined three dimensions of media choice among nine items that respondents rated in terms of their everyday media use. The first factor included three items, "Reading a newspaper for entertainment," "Reading a newspaper to find out what's happening in the world," and "Reading a newspaper to have something to talk about," which were combined to

create a newspaper use scale (α = .91). Television and Internet use factors included three similar items each, replacing "Reading a newspaper" with "Watching television" and "Using the Internet," respectively. Each trio of items was combined to create scales for TV use (α = .74) and Internet use (α = .80).

The next model added information voices, specifically authoritative, opinionated, and "direct-to-consumer" voices. Exploratory factor analysis using principal components extraction with Varimax rotation determined three profiles of news voice among 13 items that respondents rated in terms of weekly media consumption. The first factor, labelled authoritative voice (α = .72), comprised six types of content: print and online versions of national newspapers such as the *New York Times* or *USA Today*, local newspapers, the teen's school student newspaper (print or online), and TV news websites such as cnn.com. Four items loaded onto the second factor, opinionated news voice (α = .79), including: conservative and liberal political blogs, conservative talk radio, and humorous Internet videos about political candidates such as those from *The Daily Show* or *Saturday Night Live*. Finally, three items loaded on a third factor, representing direct-to-consumer, or DTC, voice (α = .75) and included: political candidates' websites, ads where presidential candidates attack each other, and ads where candidates give the viewer reasons to vote for them.

The next model added elaboration. This composite variable indicated how much respondents agreed with the following three statements: "I try to connect what I see in the media to what I already know," "I often recall what I encounter in the media later on and think about it," and "Among my friends, it's important to know what's going on in the world" (α = .76). When predicting political efficacy, an additional model added the teen's political knowledge, measured by a series of six factual questions about the 2008 presidential candidates, and included: "Which candidate ..." (response options: McCain, Obama, Neither, Both, No Answer) "Opposes a timetable for withdrawal from Iraq; Supports raising taxes on the wealthiest Americans; Has an adopted daughter from Bangladesh; Has not served in the U.S. military; Has been divorced; Began his political career as a community organizer." The mean score for this additive scale was 3.80 out of 6 (*S.D.* = 1.6). Political knowledge also functioned as a dependent variable for select analyses, as indicated in the results section.

Our primary dependent variable was political efficacy. This composite variable was computed from five items identified by exploratory factor analysis using principal components extraction and Varimax rotation. The items indicated how much respondents agreed with five statements, including: "I am influential among my friends," "My friends often seek my opinion about politics," "I am good at persuading people to see things my way," "When I talk about politics I try to convince other people I am right," and "To be a good citizen, you need to stand up for your values" (α = .71).

RESULTS

In all, we examined data from 698 adolescents ages 12–18. Age was distributed fairly evenly, with the exception of the youngest and oldest teen respondents. Approximately 8% were age 12, 16% age 13, 17.5% age 14, 18% age 15, 19.5% age 16, 15% age 17, and 5% age 18. Given the nearly equal distribution of age in the first wave of the survey, small groupings at the age endpoints likely reflect the aging of panel participants across waves, with the youngest respondents moving into the second age category and the oldest moving into the age-18 (adult) group, which we did not include in the current sample of teens and adolescents. The teenagers split somewhat evenly into political party affiliations: 40% identified as Democrat, 30% as Republican, and 29% as Independent.

Income, which was measured as a self-reported, open response ranged from $31,000 to more than $57,000, with an average of more than $45,000. The mean household size was four people, and families lived in their current homes an average of 11 years, with a range from 0 to 59 years. A large majority of teens (76%) came from families with married parents or domestic partners, while 13% and 3% had divorced or separated parents, respectively; and 6.9% lived with parents who said they were never married. Thus, three quarters of the teens came from two-parent households, similar to the U.S. Census Bureau national average of 68% (Vespa, Lewis, & Kreider, 2013).

In terms of media choice, the adolescents were, unsurprisingly, heavier consumers of television and Internet media than of newspapers. Comparing the composite media choice variables outlined in the Method section, averages were higher for television viewing and Internet use ($Mtelevision$ = 9.29; $Minternet$ = 9.06) than for newspaper reading (M = 5.69).

The first regression analysis (see Table 1) predicted political knowledge from four groups of independent variables representing media choice, entered hierarchically to compute four regression models: demographics and political affiliation, media choices, information voices, and elaboration. The complete model, which included all predictors, explained 12% of the variance in knowledge. In this full model, only age, parent's income, television choice (negative), elaboration, and DTC voice directly influenced knowledge. This finding lends support to H2, which predicted general television use (i.e., choice) would directly and negatively impact knowledge. Internet choice nearly reached significance in both reduced and complete models, lending partial support to H4. Yet Internet use influenced knowledge directly, counter to predictions in H4 that Internet use would operate through elaboration on knowledge. Newspaper choice had no discernable relationship with political knowledge among these teens, contradicting H3. Even the raw correlation between newspaper use and knowledge was not significant (r = -.073, p = .078). Newspaper reading, however, was the sole media choice predictor of

Table 1. Hierarchical Regression Predicting Teen Respondents' Political Knowledge (N = 698).

	Model 1 Demographics			Model 2 Media Choice			Model 3 Information Voice			Model 4 Elaboration		
	b	se_b	β	b	se_b	β	b	se_b	β	b	se_b	β
Age	.113	.040	.119**	.113	.041	.119**	.12	.041	.127**	.11	.041	.117**
Political affiliation	.007	.067	.004	-.019	.067	-.013	-.024	.067	-.016	-.037	.067	-.025
Household size	.014	.054	.012	.016	.054	.013	.015	.054	.013	.005	.053	.004
Parents' marital status	.121	.057	.108*	.120	.057	.108*	.127	.057	.114*	.101	.057	.090
Years in current residence	.008	.009	.041*	.011	.009	.051	.01	.009	.051	.011	.009	.055
Parents' income	.081	.013	.302**	.077	.013	.288**	.078	.013	.291	.074	.013	.275
TV use				-.049	.025	-.110*	-.057	.025	-.127*	-.052	.024	-.116*
Newspaper use				-.015	.024	-.032	-.004	.027	-.009	-.014	.027	-.030
Internet use				.030	.017	.086	.03	.017	.087	.032	.017	.093
News voice: Authoritative							-.024	.017	-.082	-.028	.017	-.096
News voice: Opinionated							.005	.018	.016	.000	.018	.001
News voice: DTC							.045	.018	.114*	.037	.018	.093*
Elaboration										.293	.087	.149**
R^2	0.094			0.107			0.122			.142		
Adjusted R^2	0.083			0.091			0.101			.119		
F for R^2 change	8.751			2.44			2.859			11.187		
	(p = .000)			(p = .064)			(p = .037)			(p = .001)		

*p < .05; **p < .01.

elaboration, determined by a hierarchical regression analysis of demographics and political affiliation, media choices and news voices on elaboration (final adjusted $R^2 = .097$). Thus, H3, which proposed a positive impact of newspaper choice on elaboration, was supported, while H2 and H4, which proposed similar influences of television and Internet choices, were not.

Turning to news voices, opinionated and direct-to-consumer (DTC) but not authoritative voice predicted elaboration, while only DTC voice was significant in the knowledge model. Thus, H5, which predicted a direct influence of authoritative voice on both elaboration and knowledge, was unsupported on both counts. Predictions that DTC voice (H6) would positively impact knowledge were confirmed, but similar expectations for opinionated voice (H7) were not.

The second hierarchical regression analysis (see Table 2) predicted political efficacy from five cumulative blocks of predictor variables: demographics and political affiliation, media choice, information voices, elaboration, and political knowledge. The full model explained 41.9% of the variance in efficacy. Significant direct predictors in the complete model included opinionated voice, elaboration, knowledge, and age. This supports H1, which predicted a direct positive impact of knowledge on efficacy, and H7, which predicted a direct effect of opinionated voice on efficacy. H6, which proposed that DTC voice would directly influence efficacy, was not supported. General television use, a significant predictor of political knowledge, failed to reach significance in the efficacy model, indicating that knowledge fully mediates the impact of television viewing on efficacy, as predicted in H2. Newspaper use was significant when entering only demographic, political affiliation, and media choice variables, but adding elaboration to the model completely mediated the impact of newspaper use on efficacy. General Internet use remained significant after adding elaboration but only approached significance once knowledge was added to the model, indicating that knowledge, but not elaboration, mediates the impact of Internet use on efficacy. Elaboration was by far the strongest predictor of efficacy; and this full model would significantly explain 10.7% (adjusted R^2) of the variance in efficacy without elaboration, compared to 41.9% explained by including elaboration.

To summarize, of the media and voice variables, only opinionated voice had a direct effect on efficacy. All media effects were mediated through either knowledge or elaboration, which were the strongest predictors of efficacy (H1 supported). Television use negatively predicted knowledge and indirectly influenced efficacy through knowledge (H2 supported). Time with newspapers positively predicted elaboration but was not significant for knowledge (H3 partially supported). General Internet use nearly had a direct effect on knowledge but did not predict elaboration (H4 partially supported). When looking specifically at the effects on efficacy, newspaper and Internet choice were mediated by opinionated and DTC voice. Authoritative voice was not significantly associated with knowledge

Table 2. Hierarchical Regression Analysis Predicting Teen Respondents' Political Efficacy (N = 698).

	Model 1 Demographics			Model 2 Media Choice			Model 3 Info Voice			Model 4 Elaboration			Model 5 Pol. Knowledge		
	b	se_b	β	b	se_b	β	b	se_b	β	b	se_b	β	b	se_b	β
Age	-.02	.11	-.01	-.07	.10	-.03	-.06	.10	-.03	-.16	.08	-.07*	-.19	.08	-.08*
Political affiliation	.04	.17	.01	.10	.17	.03	.15	.17	.04	.02	.13	.01	.03	.13	.01
Household size	.34	.14	.12*	.28	.14	.010*	.27	.14	.09	.16	.11	.05	.16	.11	.05
Parents' marital status	.39	.15	.14**	.35	.15	.13**	.31	.14	.11*	.04	.12	.02	.02	.12	.01
Years in current residence	.02	.02	.03	.01	.02	.02	.01	.02	.01	.01	.02	.02	.01	.02	.02
Parents' income	.07	.03	.10*	.08	.03	.13*	.07	.03	.10*	.02	.03	.04	.01	.03	.01
TV use				-.01	.06	-.01	-.03	.06	-.03	.02	.05	.02	.03	.05	.03
Newspaper use				.18	.06	.15**	.10	.07	.09	.00	.06	.00	.00	.06	.00
Internet use				.08	.04	.10	.05	.04	.06	.07	.04	.08*	.06	.04	.07
News voice: Authoritative							.00	.04	-.01	-.04	.03	-.06	-.04	.03	-.05
News voice: Opinionated							.14	.05	.17**	.08	.04	.10*	.08	.04	.10*
News voice: DTC							.11	.05	.11*	.03	.04	.03	.02	.04	.02
Elaboration										2.95	.18	.61**	2.89	.18	.60**
Political knowledge													.22	.09	.09*
R^2	0.025			0.062			0.103			0.429			0.436		
Adjusted R^2	0.013			0.045			0.081			0.414			0.419		
F for R^2 change	2.089			6.515			7.522			279.516			5.85		
	($p = .053$)			($p = .000$)			($p = .000$)			($p = .000$)			($p = .016$)		

*$p < .05$; **$p < .01$.

or elaboration (H5 not supported). DTC voice positively predicted knowledge and indirectly influenced efficacy through elaboration (H6 supported). Opinionated voice directly predicted efficacy but not knowledge (H7 partially supported). Given these findings, we predict the following conceptual model (see Figure 1).

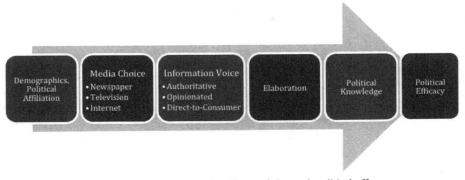

Figure 1. Conceptual model on the impact of media on adolescent's political efficacy.

DISCUSSION

This study extends our understanding of adolescents' political socialization by introducing the concept of information "voice" as a driver of political knowledge and efficacy. Previous research (e.g., Johnson & Kaye, 2003; Thorson, 2005) has identified links between media use (including news use, specifically), knowledge, and efficacy. This investigation approached media influence from two dimensions drawn from the Media Choice Model (Thorson & Duffy, 2006): media choice, including general newspaper, television, and Internet use; and voice, including authoritative, opinionated, and direct-to-consumer (DTC) voices.

Regression analyses with data from a nationwide survey of nearly 700 teenagers indicate that the style, or voice, in which media deliver their content may directly impact how much their adolescent audiences learn about politics and how much they feel empowered to act on that knowledge. Opinionated information voice, such as that heard on conservative or liberal blogs, directly and positively predicted political efficacy. The direct-to-consumer voice, such as ads where political candidates address their audience, directly and positively predicted political knowledge.

While media choice and voice contributed to the variance in efficacy, elaboration and knowledge remained the strongest predictors in the complete model (see Table 2). This aligns with previous findings linking elaboration to knowledge and knowledge to efficacy (Bandura, 1997; Meraz, 2006; Staples, Hulland, & Higgins,

1998). Including elaboration in the efficacy model nearly quadrupled the amount of variance explained. This strong, direct effect of elaboration on efficacy is unsurprising given that elaboration, or thinking about the information one encounters, should lead to greater knowledge, which theory links closely with efficacy.

The results of this study present an opportunity to build theory as it relates to uses and gratifications and media choice. In the context of media use and political engagement, which is the natural outgrowth of political self-efficacy, scholars have posited that certain media choices, such as television, are tools that result in a lowering of political self-efficacy (Putnam, 1993). Critics have responded that the reasons for use, such as information versus entertainment, have more to do with engagement than the medium itself (Shah et al., 2001). The new findings from this research demonstrate that the manner in which the content is presented (opinionated vs. authoritative, for example) also matters when it comes to building self-efficacy in adolescent users. Our results indicate that the voice component of the Media Choice Model is a fruitful approach to examining media effects in political socialization. In particular, opinionated and direct-to-consumer (DTC) information voice resonated with young media consumers and seemed to do the most, of all media variables, at creating knowledge and a sense of empowerment that leads towards action, compared with an authoritative voice.

While the results of this study represent an early attempt to build this area of theory within the uses and gratifications perspective, we found direct links to knowledge and efficacy from two of the three voices proposed. Specifically, opinionated voice predicted efficacy, and DTC predicted knowledge. The direct influence of opinionated media content on teens' efficacy, combined with previous research noting youth preference for opinionated news and information such as blogs and *The Daily Show* (Brown, 2005), suggests a trend among younger audiences away from traditional, authoritative information toward a format where opinions are encouraged. Not only do adolescents appear to prefer this content, they appear to gain a sense of empowerment from it as well.

The direct influence of DTC media content on teens' political knowledge indicates that teenagers are listening when political candidates speak directly to them. This finding mimics extensive research demonstrating the effectiveness of DTC pharmaceutical advertising in terms of audience learning and action (e.g., Mehta & Purvis, 2003; Peyrot, Alperstein, Van Doren, & Poli, 1998) but extends the concept of DTC voice to political communication as well. Just as pharmaceutical companies have succeeded by speaking directly to their consumers, it appears that politicians are similarly educating future voters by speaking directly to their audiences.

From a practical standpoint, the findings in this study seem to confirm, albeit in a different way, some of the implications found in research related to public journalism. Researchers have long noted the heavy use of conflict and horse-race

frames in covering politics (McCombs & Shaw, 1974). Public journalism advo-
cates have argued journalism has not been structured in a way that helps citizens
make decisions necessary in self-governing societies such as a democracy (Rosen
& Merritt, 1994). By presenting the news in the form of "he said, she said" conflict
frames, the news focuses only on who is arguing, debating, or disagreeing and thus
doesn't provide the sense-making tools for citizens to decide who should win those
arguments or debates. In addition, the heavy focus on horse-race frames for news,
which emphasizes which candidate is winning or prevailing rather than why their
ideas should be prevailing, turns politics into competition rather than something
that can provide solutions for the citizenry (Lambeth, Meyer, & Thorson, 1998;
Poindexter & McCombs, 2001). In short, public journalism advocates argue these
forms of news presentation actually erode trust in government and a news con-
sumer's sense that they can change their community or nation by participation,
and this is the heart of political self-efficacy.

The findings from this study suggest something similar. Authoritative news
sources, which "tell" the user what the news is without analysis that enables the
user to come to a solution, might inform younger users but do little to spur the
necessary thought processes needed to turn knowledge into action by way of effi-
cacy. On the other hand, material that critics might call "biased" because it is
opinionated or comes directly from a candidate provides adolescent users with
more than mere information. The results from our model indicate, with relation
to Internet or newspaper use, that this type of news presentation is related to
the adolescent user's ability to take that knowledge and feel confident enough in
their grasp of the issue that they feel able to act on it or try to convince others of
what they know. Recall that this sense of political self-efficacy is highly related to
whether or not a young person votes in an election. It appears that news and infor-
mation voice that offer opinion and analysis do more to create the self-efficacy
needed for these pro-social behaviors than does the traditional authoritative style
of information dissemination.

In addition to implications that involve engaging young audiences in ways
that promote civic behaviors, another practical implication of this research is that
it provides some clues as to how news content can be structured in ways that reach
younger readers. Recall that past research has demonstrated young users' appetite
for news and information presented in a way that shows opinion and bias so that
the information is known (Brown, 2005). Given that news producers, particularly
newspapers, have been unsuccessful in attracting young users to their product,
it would seem that news messages that contain more opinion and analysis, and
perhaps even unfiltered content directly from candidates, might be beneficial to
content producers as they try to attract adolescent consumers.

As with any research, this study has limitations. The sample used here involved
adolescent media users; and while there are very good theoretical reasons to think

that the results here would be similar to that found in adults, it is possible that the results might be different. Perhaps adolescents typically are at a stage of development where they rely more on the opinions of others than adults when it comes to understanding and acting on what they know of the world around them. Future research could go beyond mere age differences and explore stages of cognitive development as another variable in the model we have described here.

REFERENCES

Alperstein, N., & Peyrot, M. (1993). Consumer awareness of prescription drug advertising. *Journal of Advertising Research, 33*(4), 50–56.

Arnett, J., Larson, R., & Offer, D. (1995). Beyond effects: Adolescents as active media users. *Journal of Youth and Adolescence, 24*(5), 511–518.

Atkin, C. (1981). Communication and political socialization, In D. Nimmo & K. Sanders (Eds.), *Handbook of political communication* (pp. 299–328). Beverly Hills, CA: Sage.

Babrow, A. S. (1987). Student motives for watching soap operas. *Journal of Broadcasting and Electronic Media, 31*(3), 309–321.

Balch, G. I. (1974). Multiple indicators in survey research: The concept "sense of political efficacy." *Political Methodology, 1*(2), 1–43.

Bandura, A. (1986). *Social foundations of thought and action: A social cognitive theory.* Englewood Cliffs, NJ: Prentice-Hall.

Bandura, A. (1997). *Self-efficacy: The exercise of control.* New York, NY: Freeman.

Beaudoin, C. E., & Thorson, E. (2004). Testing the cognitive mediation model: The roles of news reliance and three gratifications sought. *Communication Research, 31*(4), 446–471.

Bell, R. A., Kravitz, R. L., & Wilkes, M. W. (1999). Direct-to-consumer prescription drug advertising and the public. *Journal of General Internal Medicine, 14*(November), 651–657.

Blumler, J., & Katz, E. (1974). Utilization of mass communication by the individual. In J. G. Blumler & E. Katz (Eds.), *The uses of mass communication: Current perspectives on gratifications research* (pp. 71–92). Newbury Park, CA: Sage.

Brown, M. (2005). Abandoning the news. *Carnegie Reporter, 3*(2). Retrieved from https://www.carnegie.org/publications/carnegie-reporter-vol-3no-2/

Butler, D., & Stokes, D. (1974). *Political change in Britain* (2nd ed.). London, England: Macmillan.

Calfee, J. (2002). Public policy issues in direct-to-consumer advertising of prescription drugs. *Journal of Public Policy and Marketing, 21*(2), 174–194.

Coleman, R., & Thorson, E. (2002). The effects of news stories that put crime and violence into context: Testing the public health model of reporting. *Journal of Health Communication, 7*(5), 401–425.

Conway, J. C., & Rubin, A. M. (1991). Psychological predictors of television viewing motivation. *Communication Research, 18*(4), 443–463.

Curran, J. (2005). What democracy requires of the media. In G. Overholser & K. Jamieson (Eds.), *The press* (pp. 120–140). New York, NY: Oxford University Press.

Diddi, A., & LaRose, R. (2006). Getting hooked on news: Uses and gratifications and the formation of news habits among college students in an Internet environment. *Journal of Broadcasting and Electronic Media, 50*(2), 193–210.

Dimmick, J., Kline, S., & Stafford, L. (2000). The gratification niches of personal e-mail and the telephone. *Communication Research*, 27(2), 227–248.

Easton, D., & Dennis, J. (1969). *Children in the political system*. New York, NY: McGraw-Hill.

Elliott, W. R., & Rosenberg, W. L. (1987). The 1985 Philadelphia newspaper strike: A uses and gratifications study. *Journalism Quarterly*, 64(4), 679–687.

Eveland, W. (2001). The cognitive mediation model of learning from the news. *Communication Research*, 28(5), 571–601.

Eveland, W. P., Jr. (2004). The effects of political discussion in producing informed citizens: The roles of information, motivation, and elaboration. *Political Communication, 21*, 177–193.

Eveland, W. P., Jr., & Dunwoody, S. (2001). Applying research on the uses and cognitive effects of hypermedia to the study of the World Wide Web. In W. B. Gudykunst (Ed.), *Communication yearbook 25* (pp. 79–113). Mahwah, NJ: Lawrence Erlbaum.

Eveland, W., Marton, K., & Seo, M. (2004). Moving beyond "just the facts": The influence of online news on the content and structure of public affairs knowledge. *Communication Research, 31*(1), 82–108.

Eveland, W. P., Jr., McLeod, J. M., & Horowitz, E. M. (1998). Communication and age in childhood political socialization: An interactive model of political development. *Journalism & Mass Communication Quarterly, 75*, 699–718.

Eveland, W., Shah, D., & Kwak, N. (2003). Assessing causality in the cognitive mediation model: A panel study of motivations, information processing and learning during campaign 2000. *Communication Research, 30*, 359–386.

Fleming, K., Thorson, E., & Peng, Z. (2005). Associational membership as a source of social capital: Its links to use of local newspapers, interpersonal communication, entertainment media, and volunteering. *Mass Communication and Society, 3*, 219–240.

Greenstein, F. (1965). *Children and politics*. New Haven, CT: Yale University Press.

Haste, H., & Torney-Purta, J. (1992). Introduction. In H. Haste & J. Torney-Purta (Eds.), *The development of political understanding: A new perspective* (pp. 1–10). San Francisco, CA: Jossey-Bass.

Heeter, C., & Greenberg, B. S. (1985). Cable and program choice. In D. Zillmann & J. Bryant (Eds.), *Selective exposure to communication* (pp. 203–224). Hillsdale, NJ: Lawrence Erlbaum.

Hess, R. D., & Torney, J. (1968). *The development of political attitudes in children*. Chicago, IL: Aldine.

Hyman, H. H. (1959). *Political socialization*. Glencoe, IL: Free Press.

Johnson, T., & Kaye, B. (2003). A boost or a bust for democracy? How the web influenced political attitudes and behaviors in the 1996 and 2000 presidential elections. *Harvard International Journal of Press/Politics, 8*(3), 9–34.

Kaid, L., McKinney, M., & Tedesco, J. (2007). Political information efficacy and young voters. *American Behavioral Scientist, 50*(9), 1093–1111.

Katz, E. (1959). Mass communication research and the study of popular culture. *Public Communication, 2*, 1–6.

Katz E., Blumler, J. G., & Gurevitch, M. (1974). Utilization of mass communication by the individual. In J. G. Blumler & E. Katz (Eds.), *The uses of mass communications: Current perspectives on gratifications research* (pp. 19–32). Beverly Hills, CA: Sage.

Kaye, B. K., & Johnson, T. J. (2002). Online and in the know: Uses and gratifications of the Web for political information. *Journal of Broadcasting and Electronic Media, 46*(1), 54–71.

Kim, K. S., & Kim, Y. C. (2007). New and old media uses and political engagement among Korean adolescents. *Asian Journal of Communication, 17*(4), 342–361.

Lacy, S. (2000). Commitment of financial resources as a measure of quality. In R. G. Picard (Ed.), *Measuring media content, quality, and diversity: Approaches and issues in content research* (pp. 25–50). Turku, Finland: Suomen Akatemia.

Lambeth, E., Meyer, P., & Thorson, E. (1998). *Assessing public journalism.* Columbia, MO: University of Missouri Press.

LaRose, R., Mastro, D., & Eastin, M. S. (2001). Understanding Internet usage: A social-cognitive approach to uses and gratifications. *Social Science Computer Review, 19*(4), 395–413.

Lerner, R. M., & Kaufman, M. B. (1985). The concept of development in contextualism. *Developmental Review, 5,* 309–333.

McCombs, M., & Shaw, D. (1974). The agenda-setting function of mass media. *Public Opinion Quarterly, 36,* 176–185.

McIntosh, H., Hart, D., & Youniss, J. (2007). The influence of family political discussion on youth civic development: Which parent qualities matter? *Political Science and Politics, 40*(3), 495–499.

McLeod, J. M., & Chaffee, S. H. (1972). The construction of social reality. In J. Tedeschi (Ed.), *The social influence processes* (pp. 50–99). Chicago, IL: Aldine Atherton.

McLeod, J. M., Scheufele, D. A., & Moy, P. (1999). Community, communication, and participation: The role of mass media and interpersonal discussion in local political participation. *Political Communication, 16,* 315–336.

Meadowcroft, J. M. (1986). Family communication patterns and political development: The child's role. *Communication Research, 13*(4), 603–624.

Mehta, A., & Purvis, S. C. (2003). Consumer response to print prescription drug advertising. *Journal of Advertising Research, 43*(2), 194–206.

Meirick, P. C., & Wackman, D. B. (2004). Kids voting and political knowledge: Narrowing gaps, informing votes. *Social Science Quarterly, 85*(5), 1161–1177.

Meraz, S. (2006). Analyzing political conversation on the Howard Dean candidate blog. In M. Tremayne (Ed.), *Blogging, citizenship, and the future of media* (pp. 59–82). New York, NY: Routledge.

Merrill, B. D., Simon, J., & Adrian, E. (1994). Boosting voter turnout: The Kids Voting program. *Journal of Social Studies Research, 18,* 2–7.

Miller, M., & Reese, S. (1982). Media dependency as interaction: Effects of exposure and reliance on political activity and efficacy. *Communication Research, 9*(2), 227–248.

Milner, H. (2002). *Civic literacy: How informed citizens make democracy work.* Hanover, NH: University Press of New England.

Niemi, R., Craig, S., & Mattei, F. (1991). Measuring internal political efficacy in the 1988 national election study. *American Political Science Review, 85*(4), 1407–1413.

Norris, P. (1996). Does television erode social capital? A reply to Putnam. *Political Science and Politics, 29*(3), 474–480.

Papcharissi, Z., & Rubin, A. (2000). Predictors of Internet use. *Journal of Broadcasting and Electronic Media, 44*(2), 175–196.

Pateman, C. (1970). *Participation and democratic theory.* New York, NY: Cambridge University Press.

Perri, M., & Nelson, A. (1987). An exploratory analysis of consumer recognition of direct-to-consumer advertising of prescription medications. *Journal of Health Care Marketing, 7*(1), 9–17.

Peyrot, M, Alperstein, N. M., Van Doren, D., & Poli, L. G. (1998). Direct-to-consumer ads can influence behavior. *Marketing Health Services, 18*(2), 26–32.

Poindexter, P. M., & McCombs, M. (2001). Revisiting the civic duty to keep informed in the new media environment. *Journalism Quarterly, 78*(1), 113–126.

Putnam, R. D. (1993). The prosperous community: Social capital and public life. *The American Prospect, 13*, 35–42.

Putnam, R. D. (1995). Tuning in, turning out: The strange disappearance of social capital in America. *Political Science and Politics, 28*(4), 664–683.

Rodgers, S., & Thorson, E. (2000). The interactive advertising model: How users perceive and process online ads. *Journal of Interactive Advertising, 1*(1).

Rosen, J., & Merritt, D. (1994). *Public journalism: Theory and practice.* Dayton, OH: Kettering Foundation.

Rosengren, K. E. (1974). Uses and gratifications: A paradigm outlined. In J. G. Blumler & E. Katz (Eds.), *The uses of mass communications: Current perspective on gratifications research* (pp. 269–286). Beverly Hills, CA: Sage.

Rubin, A. M. (1983). Television uses and gratification: The connections of viewing patterns and motivations. *Journal of Broadcasting and Electronic Media, 27*, 37–51.

Rubin, A. M. (1994). Media uses and effects: A uses-and-gratifications perspective. In J. Bryant & D. Zillmann (Eds.), *Media effects: Advances in theory and research* (pp. 417–436). Hillsdale, NJ: Erlbaum.

Ruggiero, T. (2000). Uses and gratifications theory in the 21st century. *Mass Communication & Society, 3*(1), 3–37.

Scarr, S. (1993). Biological and cultural diversity: The legacy of Darwin for development. *Child Development, 64*, 1333–1353.

Scarr, S., & McCartney, K. (1983). How people make their own environments: A theory of genotype environment effects. *Child Development, 54*, 424–435.

Shah, D. V., Cho, J., Eveland, W. P., Jr., & Kwak, N. (2005). Information and expression in a digital age: Modeling Internet effects on civic participation. *Communication Research, 32*, 531–565.

Shah, D. V., Cho, J., Nah, S., Gotlieb, M. R., Hwang, H., Lee, N., ... McLeod, D. M. (2007). Campaign ads, online messaging, and participation: Extending the communication mediation model. *Journal of Communication, 57*, 676–703.

Shah, D. V., McLeod, J. M., & Yoon, S.-H. (2001). Communication, context, and community: An exploration of print, broadcast, and Internet influences. *Communication Research, 28*, 464–506.

Simon. J., & Merrill, B. D. (1998). Political socialization in the classroom revisited: The Kids Voting program. *Social Science Journal, 35*, 29–42.

Staples D., Hulland, J., & Higgins, C. (1998). A self-efficacy theory explanation for the management of remote workers in virtual organizations. *Journal of Computer-Mediated Communication, 3*(4).

Thorson, E. (2005). Mobilizing citizen participation. In G. Overholser & K. Jamieson (Eds.), *The press* (pp. 203–220). New York, NY: Oxford University Press.

Thorson, E., & Duffy, M. (2006). *Citizenship and use of traditional and new media for information and entertainment.* Paper presented at the annual meeting of the International Communication Association, Dresden, Germany.

Thorson, E., & Thorson, K. (2006). *Choice of news media sources in the new media landscape: The crucial 18–34 demographic.* Paper presented at the annual meeting of the Association for Education in Journalism and Mass Communication, San Francisco, CA.

Vespa, J., Lewis, J. M., & Kreider, R. M. (2013). America's families and living arrangements: 2012. *Current Population Reports*, P20–570, U.S. Washington, DC: U.S. Census Bureau.

Williams, J. R., & Hensel, P. J. (1995). Direct-to-consumer advertising of prescription drugs. *Journal of Health Care Marketing, 15*(1), 35–41.

Environmental Political, Civic Engagement AND Political Consumerism Among Youth

ROBERT H. WICKS AND MYRIA ALLEN

The hotly contested and spirited Democratic presidential primaries of 2008 generated considerable interest, featuring a race lasting until June that included African American Barack Obama and former First Lady Hillary Rodham Clinton contesting the Democratic nomination. Senator John McCain secured the Republican nomination in March and selected Alaska Governor Sarah Palin as his running mate. In the general election, Obama and running mate Joe Biden would eventually secure 365 electoral votes—and the White House—to 173 for the McCain and Palin ticket. The economy quickly became the central theme of the general election campaign; however, two key issues that Obama chose to focus on included universal health care and environmental concerns.

Barack Obama's list of environmental initiatives was long and detailed, including government investment of $15 billion a year over 10 years to promote clean energy and green jobs ("Transcript of," 2008), development of cellulosic ethanol made from wood chips and prairie grass (Russert, 2008), regulating animal feeding operations to curtail pollution ("The Blueprint," 2008), promoting fuel efficiency standards ("Des Moines," 2007), reducing mercury and lead to protect community health ("President Bush," 2008), and promoting Great Lakes environmental restoration efforts ("Updated," 2008). Obama's interest in the environment went back many years; and, in fact, during his college days at Columbia University, he worked as an environmental activist promoting recycling in Harlem (Wilson, 2007). Also, during his time as a community organizer in Chicago, he arranged to have asbestos sealed off or removed from a housing project (Mendell, 2007). Obama linked his passion for environmentalism to his religious faith, stating:

One of the things I draw from the Genesis story is the importance of us being good stewards of the land, of this incredible gift. And I think there have been times where we haven't been [good stewards], and this is one of those times where we've got to take the [climate change] warning seriously. And part of what my religious faith teaches me is to take an intergenerational view, to recognize that we are borrowing this planet from our children and our grandchildren. ("Democratic Candidates," 2008)

In this chapter, we take up Barack Obama's call for "an intergenerational view" and focus specifically on environmental concerns as they relate to youth. The United Nations Children's Fund (UNICEF) warned that the young who inhabit our planet today will bear the brunt of temperature increases. Children born in 2014 will be 18 in 2032—their first opportunity to vote in a presidential election—and 36 in 2050 when the impacts of climate change are projected to be in full swing. The Intergovernmental Panel on Climate Change (IPCC) released a report, co-authored by 259 scientists from 39 countries, entitled *Climate Change 2013: The Physical Science Basis* (2013) describing a "very high" probability of continued environmental changes by the late 21st century in the following areas: increased temperatures and more heat waves over most land areas; increased frequency, intensity, and/or amount of heavy precipitation; increased intensity and duration of drought; increased intense tropical cyclone activity; and increased extreme high sea levels. Also, the United Nations Secretary General identified climate change as the major, overriding environmental issue of our time.

On the question of climate change, scientists are unequivocal as "Ninety-seven percent of climate scientists agree that climate-warming trends over the past century are very likely due to human activities, and most of the leading scientific organizations worldwide have issued public statements endorsing this position" ("Global Climate," 2013). While a large majority of Democrats (84%) and a majority of Republicans (61%) believe humans are responsible for climate change, only 25% of Tea Party Republicans believe this is the case ("GOP Deeply," 2013). Information presented through political channels often paints a confusing and puzzling picture of environmental concerns. Most people on this issue seem unable or unwilling to engage in personal action, potentially because they are more attuned to the climate science bickering and "spin" by climate change disbelievers appearing frequently in the news rather than evidence supporting climate change that may appear more frequently in scientific journals.

In keeping with the theme of this volume, we focus our analysis on youth and explore those variables that are associated with whether or not one identifies as an environmentalist. We believe that the different positions people adopt in relationship to the environment may be explained by two competing paradigms. First, the Dominant Social Paradigm (DSP) assumes that the planet will be spared from environmental harm as technologies are developed and that people are smart enough to correct environmental damage. Alternatively, the New Environmental

Paradigm (NEP) seeks environmental protection through limits on industrial and population growth, along with the recognition that our potential planetary demise is directly correlated with human-influenced interactions. As such, the DPS embraces a laissez-faire (if not aggressive) natural "resource" utilization approach while the NEP favors active engagement in managing a balance (if not reduction) in natural "resource" utilization. Indeed, in its most radical form, the NEP challenges the idea that nature should be viewed as a resource that exists for human use.

In this chapter we seek to identify action-oriented behaviors potentially associated with environmental awareness and engagement. We then consider variables that are theorized to be related to identifying oneself as an environmentalist. The dependent variables we examine include: (1) political engagement, (2) civic engagement, and (3) political consumerism. The independent variables are: (1) demographics, (2) discussion of news, (3) civic education, (4) attitudes about citizenship, (5) online social activity, and (6) online political engagement. We first investigate which of these independent and dependent variables are correlated with *environmental self-identification*. Then we present three models using hierarchal multiple regression to determine whether, and to what extent, civic and political engagement and political consumerism are related to the independent variables in the models. These are important issues to investigate in the interest of determining what paths may be taken to encourage more environmental awareness and engagement among youth.

LITERATURE REVIEW

Environmentalism

Environmentalism is defined as a willingness to take actions with pro-environmental intent (Stern, 2000) and represents the broad philosophy guiding environmental movements; it is directed toward conserving and protecting natural resources and ecosystems (Dietz, Fitzgerald, & Shwom 2005). Citizen concern for the environment has wavered over time (Cox, 2012) although the environmental movement remains an active and vibrant force in the United States (Dunlap, 2008). Environmentalism's diversity makes it a difficult topic to study because philosophies guiding environmental movements are shaped not only by interest groups focused on national environmental policy, but also by groups ranging from radical environmentalists to citizen participants (Schlosberg & Bomberg, 2008). Members of environmental groups, especially those from larger, more formal, groups, often seek to influence the political process through lobbying, engagement, and education (Cox, 2012). Also, citizens unaffiliated with environmental groups often enact their values through their lifestyle choices.

Dominant Social Paradigm (DPS) versus New Environmental Paradigm (NEP)

The DSP has been a part of the main belief system in the Western world for at least two centuries and is made up of opposition to environmental regulation that hinges on several main political, economic, and technological assumptions (Shafer, 2006). The DSP stresses politically limited government intervention, private property rights, and economic individualism. Accordingly: (a) all things detrimental can be resolved with continued pursuit of technological and industrial advancement, (b) the ensuing economic growth will dilute any dissatisfaction with social and environmental problems, and, (c) the political representatives in office are there for the benefit of the people and their country, and they, and only they, have the capability to handle policies that affect society as a whole.

The NEP emerged over the past few decades to challenge the DSP as continued economic growth challenged ecological sustainability (Shafer, 2006). The roots of the larger environmental movement can be traced to the publication of Rachel Carson's *Silent Spring* in 1962, which documented how pesticides such as DDT were entering the biosphere and not only killing insects but also entering the food chain and harming public health. The movement expanded in the 1970s as a series of environmental disasters shed light on ecological fragility. The NEP, first advanced by Dunlap (2008), is concerned with the state of our understanding of nature and our relation to it. Those who are guided by the NEP seek environmental protection and procurement through limitations on industrial and population growth, along with the recognition that planetary demise is directly caused by human interactions with their surrounding natural landscapes. Without intervention, ecological threats will grow to where human intervention will be incapable of solving environmental problems such as global warming.

The DSP and NEP represent societal paradigms, yet at the individual level, environmentalism may be rooted in values conveyed through religion, altruistic tendencies, self-interest, traditionalism, and even openness to change (Dietz et al., 2005). Stern (2000) proposed a value-belief-norm theory wherein altruistic personal moral norms are activated in people with pro-environmental beliefs who perceive that particular conditions threaten those they care about and believe that they can act to avert those consequences. Personal environmental norms and the predisposition for pro-environmental action can be influenced by information that shapes these beliefs. Attitudes and intent, however, do not completely explain behavior. Many environmentally significant behaviors are matters of personal habit or routine. Other behaviors are highly constrained by income or infrastructure. Sometimes the behaviors follow from non-environmental concerns (e.g., to save money, or even to confirm a sense of personal competence).

In sum, the topic of environmentalism received coverage during the 2008 presidential campaign due in part to the candidacy of Barack Obama. Despite widespread agreement across the scientific world that the planet faces significant environmental challenges, many citizens—including youth—appear to be unaware or unconcerned. The DSP embraces laissez faire practices operating under the assumption that technological and political solutions will prevent environmental harm. The NEP, on the other hand, encourages active engagement requiring intervention and activism. We next discuss the variables that may lead to self-identification as an environmentalist.

RESEARCH QUESTIONS

Dependent Variables

The dependent variables analyzed in this study are (1) political engagement, (2) civic engagement, and (3) political consumerism. *Political engagement* is "activity that has the intent or effect of influencing government action—either directly by affecting the making or implementation of public policy or indirectly by influencing the selection of people who make those policies" (Verba, Schlozman, & Brady, 1995, p. 38). It includes any action oriented to influence the formal political system, such as voting, writing to political representatives, working for political parties or candidates, attending public debates or meetings over policy or issues, or involvement in social movements or protests (Dalton, 2008). For example, youth who use the Internet to convince their peers to engage in more pro-environmental behavior are often more politically engaged (Allen, Wicks, & Schulte, 2013). Our first research question asks:

> **RQ1:** Are self-identified environmentally engaged youth prone to be more politically engaged?

Civic engagement refers to volunteer and service activities geared to helping others and creating a good society (Zukin, Keeter, Andolina, Jenkins, & Delli Carpini, 2006). Civic engagement benefits others, going beyond self-interest or the interest of one's immediate family (Ramakrishnan & Bloemraad, 2008), and includes working for charities, religious, or community service organizations; volunteerism; fundraising; and aiding in environmental, disaster, or social relief efforts (e.g., Eliasoph, 2011). Regarding youth civic engagement we ask:

> **RQ2:** Are self-identified environmentally engaged youth prone to be more civically engaged?

Political consumerism involves taking action most often in the form of boycotting and buycotting. Micheletti and Stolle (2008) defined a boycott as asking consumers

to reject products by not purchasing them, while buycotts involve "politically-motivated shopping" where "labeling schemes and shopping guides" such as "green, organic, and fair trade" are used to make purchase decisions (pp. 750–751). Youth who use the Internet to convince their peers to be more pro-environmental appear to engage in more political consumerism (Allen et al., 2013). Thus, we ask:

RQ3: Are self-identified environmentally engaged youth prone to engage in more political consumerism?

Independent Variables

The independent variables in our study include (1) demographics, (2) discussion of news, (3) civic education, (4) attitudes toward citizenship, (5) online social activity, and (6) online political engagement.

Much of the extant literature focuses on specific *demographic factors* associated with youth political and civic involvement (e.g., Settle, Bond, & Levitt, 2011). Variables such as gender, age, race, religion, and household income are commonly included. Youth from higher socioeconomic backgrounds have the resources that facilitate political and civic engagement. In fact, Fisher (2012) noted that young people from higher socioeconomic status families also tend to talk about politics more regularly, vote more frequently, and are more politically engaged. While women are less likely to participate in organized political and civic activities, young women are more likely than young men to vote (The Center for Information & Research, 2013).

Youth who consume news media are more likely to *discuss political information* with their parents and participate civically and politically (Boyd, Zaff, Phelps, Weiner, & Lerner, 2011). Shah, Cho, Eveland, and Kwak (2005) asserted that political information distributed through both online and traditional channels stimulates interpersonal political discussion leading to enhanced civic participation. However, more recent political socialization models have replaced a "top-down" transmission approach with one that emphasizes the child as an active participant (McDevitt, 2006).

Feldman, Pasek, Romer, and Jamieson (2007) reported that *civic education*, including political discussion in class, completing class projects or assignments, and obtaining political news or information on the Internet, has a positive effect on the likelihood of youth following and discussing politics. Kahne, Crow, and Lee (2013) also found that civic education leads to civic and political engagement. Open discussion of issues in class enabling youth to express their opinions facilitates youth political engagement. As Sherrod, Flanagan, and Youniss (2002, p. 264) argued, citizenship is the "outcome variable" in the interdisciplinary field of youth engagement. Community involvement is key to adolescents' development

into citizens. Young people view citizenship as doing what is expected, following laws, or being obedient (Flanagan, Syvertsen, Gill, Gallay, & Cumsille, 2009).

The Internet and digital media facilitate *social online engagement*. These technologies make information instantly and easily accessible, facilitating new types of civic and political action among youth (Bennett, 2008; Shah et al., 2005). Young people's personal and cognitive connections can be enhanced via digital communication, which is the norm for social relations among youth (Skierkowski & Wood, 2012, p. 753). Because youth use digital technology for their social relations, they may be more likely to use it for political and civic engagement as well (Jennings & Zeitner, 2003). Interests in political and environmental news and consumerism are important factors in use of social networks to encourage peers to be more concerned about the environment (Allen et al., 2013).

The Internet and mediated devices facilitate *political online engagement*. Dudash and Harris (2011) found that young adults ages 18 to 30 equated being politically involved with finding information, being knowledgeable about politics, knowing the views of major candidates, and voting based on information they had acquired online. Youth prefer participatory social media that facilitate individual expression, organize civic or political action with peers, and enable them to contribute to the digital body of knowledge (Bennett, Wells, & Freelon, 2011). Finally, time spent on the Internet is an important factor influencing use of social networks to encourage peers to be more concerned about the environment (Allen et al., 2013).

METHOD

Survey data were collected from the first wave of the Future Voters Study (as described in the Introduction), fielded between May 20 and June 25, 2008.

Measures

The dependent variables, including civic engagement, political engagement, and political consumerism, were measured on an eight-point scale ranging from 1 (*Not at All*) to 8 (*Very Frequently*). See Table 1 for the items included on each scale. Because the literature review suggested there could be overlap between political and civic engagement activities, a principal component factor analysis with Varimax rotation was performed on these items along with the political consumerism items (Zukin et al., 2006). The predicted three-factor solution emerged and the scales were internally consistent (see Table 1).

Self-report data were gathered for the independent variables by combining responses to items. The independent variables included online direct engagement

Table 1. Factor Analysis (Varimax Rotation) Identifying Dependent Variables.

	Factor Loadings
Political Engagement (Eigenvalue = 4.01; α = .87)	
Worked for a political party or candidate	.90
Attended a political meeting, rally, or speech	.86
Contributed money to a political campaign	.86
Displayed a political campaign button, sticker, or sign	.73
Civic Activities (Eigenvalue = 1.76; α = .85)	
Did volunteer work	.89
Worked on a community project	.89
Worked to raise money for a charitable cause	.80
Political Consumerism (Eigenvalue = 1.19; α = .78)	
Boycotted products or companies that offend my values	.82
Bought products from companies that align with my values	.73

(measured by combining responses to four items), online/social media (five items), discuss news and politics (four items), school civic activities (five items), and attitudes toward citizenship (four items). Principal component factor analysis with Varimax rotation was performed to test whether these items comprised five separate factors as intended. This analysis did suggest the intended five-factor solution with alphas between .77 and .89 (see Table 2). The last independent variable, environmental self-identification, was measured with a single item, "I consider myself to be an environmentalist." All items were measured on an eight-point scale with 1 (*Not at All*) to 8 (*Very Frequently*), except for the online/social media variable [i.e., 1 (*Never*) to 4 (*Regularly*)] and environmental self-identification [i.e., 1 (*Strongly Disagree*) to 5 (*Strongly Agree*)].

RESULTS

Initially, one-way ANOVAs were calculated for all dependent and independent variables based on level of self-identification as being an environmentalist. A little more than a third (37.3%) of the respondents answered Strongly Disagree or Disagree and were classified as low (M = 1.57), 39% were classified as ambivalent (M = 3.00), and 23% either Agreed or Strongly Agreed and were classified as high (M = 4.31). Table 3 reports the results of the ANOVA. In every case the self-identified environmentalists scored significantly higher than the other two groups, and therefore all three of our research questions were answered in the affirmative. The test's

Table 2. Factor Analysis (Varimax Rotation) Identifying Independent Variables.

	Factor Loadings
Correlates of Engagement	
Civic Education Activities (Eigenvalue = 3.32; α = .86)	
Followed the news as part of a class assignment	.74
Learned about how government works in class	.82
Discussed/debated political or social issues in class	.83
Participated in political role-playing in class (mock trials elections)	.70
Been encouraged by teachers to make up my own mind about issues in class	.74
Discuss News and Politics (Eigenvalue = 1.98, α = .89)	
Talked about news and current events with family members	.80
Talked about news and current events with friends	.84
Talked about news and current events with adults outside of the family	.80
Talked about news and current events with people who disagree with me	.77
Attitudes toward Citizenship (Eigenvalue = 1.35, α = .77)	
Being a good citizen requires that you know about political issues	.74
Being a good citizen requires that you take action supporting your values	.78
Being a good citizen requires that you volunteer in your community	.77
Being a good citizen requires that you vote in important elections	.77
Correlates of Online Engagement	
Online Social Media Activities (Eigenvalue = 6.77; α = .86)	
Displayed your political preferences on your profile	.78
Joined a "cause" or political "group"	.80
Used a news or politics application/widget	.79
Became a "fan" or "friend" of a politician	.79
Exchanged political views on a discussion board or group wall	.78
Online Direct Engagement (Eigenvalue = 1.58; α = .86)	
Exchanged political e-mails with family and friends	.78
Received a link to a political video or news article	.84
Watched political/candidate videos online	.71
Forwarded a link to a political video or news article	.84

power, however, was greatest for political consumerism, discuss news, civic engagement, and attitudes toward citizenship. In order to see if self-identification as an environmentalist was actually linked to other environmental attitudes, that variable

Table 3. Dependent and Independent Variables by Environmental Self-Identification.

Variables	Environmental Self-Identification				
	No	Ambivalent	Yes	F	η2
Political engagement	1.18$_a$	1.38$_b$	1.55$_c$	8.15***	.023
	(.63)	(.97)	(1.29)		
Civic engagement	2.85$_a$	3.00$_a$	3.85$_b$	13.38***	.037
	(1.89)	(2.03)	(2.14)		
Political consumerism	1.47a	1.66a	2.37b	19.10***	.053
	(1.23)	(1.39)	(1.95)		
Discuss news	3.16a	3.46a	4.12b	14.67***	.042
	(1.67)	(1.83)	(1.82)		
Civic education	3.34a	3.57a	3.97b	5.48**	.016
	(1.76)	(1.94)	(1.98)		
Citizenship	3.63a	3.71a	4.01b	12.42***	.034
	(.89)	(.68)	(.80)		
Online social activity	1.13a	1.21a	1.29b	6.83***	.019
	(.33)	(.48)	(.55)		
Online political engagement	1.35a	1.49a	1.76b	.633**	.018
	(.93)	(1.13)	(1.49)		

Note. Standard deviations appear in parentheses below means. Means with differing subscripts within rows are significantly different at the $p < .05$ based on Scheffe's post hoc paired comparisons.
* = $p < .05$; ** = $p < .01$; *** = $p < .001$.

was correlated with two items appearing on the Future Voters Study survey two: "The things that humans do can really hurt the natural environment" ($r = .20$, $p < .000$), and "The problems with the environment are not as bad as some people say" ($r = -.27$, $p < .000$). These correlations were in the expected direction and were significant, suggesting that those who self-identified as an environmentalist held a certain value set commonly associated with the DSP.

The dependent variables of civic engagement, political engagement, and political consumerism were each entered into hierarchical regression analyses. The first step included the demographic variables (i.e., gender, age, race, religion, and household income). The second step included the independent variables: (1) discuss news and politics, (2) civic education activities at school, (3) attitudes toward citizenship, and (4) environmental self-identification. The third and final step included, (5) online/social media activities, and (6) online political engagement. The regressions enabled investigation of the research questions, placing self-identification as an environmentalist along with other factors potentially influencing our dependent variables.

Civic Engagement

The demographic variables explained almost 1% of the variance in the civic engagement dependent variable ($F = 2.495, p > .05$). Only gender ($\beta = .091, p < .05$) was significant. In regression 2 ($F = 23.77, p < .000$), the variance explained increased to 24% after the three independent variable engagement scales and self-identification as an environmentalist were added (R^2 change $= .23$, significance of change $= .000$). The scales associated with news and political discussion ($\beta = .24, p < .000$), school civic education activities ($\beta = .252, p < .000$), attitudes toward citizenship ($\beta = .075, p < .05$), and self-identification as an environmentalist ($\beta = .096, p < .01$) were all significant. The final model ($F = 21.65, p < .000$) revealed that age ($\beta = -.075, p < .05$), news and political discussion ($\beta = .193, p < .000$), participation in school civic education activities ($\beta = .227, p < .001$), attitudes toward citizenship ($\beta = .074, p < .05$), self-identification as an environmentalist ($\beta = .091, p < .01$), and online political engagement ($\beta = .152, p < .000$) were all significant. This third model explained 25.8% of the variance in civic engagement ($F (11, 642) = 21.65$, $p < .000$, n = 653, significance of change $= .000$) and thus provided strong support for Research Question 1.

Political Engagement

The demographic variables explained barely 1% of the variance in the political engagement dependent variable ($F = 2.15, p = .058$). In regression 2 ($F = 11.04$, $p < .000$), the variance explained increased to 12% after including the three engagement scales and self-identification as an environmentalist (R^2 change $= .117$, significance of change $= .000$). Whether or not the family was religious ($\beta = .073, p < .05$), news and political discussion ($\beta = .237, p < .000$), school civic education activities ($\beta = .148, p < .001$), and self-identification as an environmentalist ($\beta = .077, p < .05$) were all significant. The final model 3 ($F = 34.55, p < .000$) revealed that discussion of news and politics ($\beta = .087, p < .05$), online/social media engagement ($\beta = .192$, $p < .000$), and online political engagement ($\beta = .421, p < .000$) were significant. This third model explained 36.1% of the variance in political engagement ($F (11, 642) = 34.55, p < .000$, n = 653, significance of change $= .000$), and indicated that while self-identification as an environmentalist is important, other factors become more important, providing limited affirmative support for Research Question 2.

Political Consumerism

The demographic variables explained barely over 2% of the variance in the political consumerism dependent variable ($F = 3.90, p = .01$). Race/ethnicity ($\beta = .124$,

$p < .01$) and age (β = .096, $p < .05$) were significant. In regression 2 (F = 15.23, $p < .000$), the variance explained increased to 16% after including the three engagement scales and self-identification as an environmentalist (R^2 change = .146, significance of change = .000). Race/ethnicity (β = .104, $p < .01$), news and political discussion (β = .239, $p < .000$), school civic education activities (β = .105, $p < .05$), attitudes toward citizenship (β = .095, $p < .05$), and self-identification as an environmentalist (β = .110, $p < .01$) were all significant. The final model 3 (F = 25.089, $p < .000$) revealed race/ethnicity (β = .085, $p < .01$), news and political discussion (β = .124, $p < .01$), attitudes toward citizenship (β = .094, $p < .01$), self-identification as an environmentalist (β = .097, $p < .01$), and online political engagement (β = .381, $p < .000$) were significant. This third model explained 28.9% of the variance in political consumerism (F (11, 641 = 25.09, $p < .000$, n = 653, significance of change = .000), and provided strong affirmative support for Research Question 3. A one-way ANOVA was used to investigate differences by race/ethnicity in political consumerism, and there were significant differences between each of the three groups according to the Scheffe post-hoc tests: White Americans (M = 1.69, SD = 1.42), African Americans (M = 2.46, SD = 2.20), and Other (M = 1.90, SD = 1.74) (F (2, 1209) = 12.02, $p < .000$).

Summary of Findings

In every case, youth identifying themselves as environmentalists scored higher on all the independent and dependent variables listed in Table 3. Power was greatest for political consumerism, discussion of news, civic engagement, and attitudes toward citizenship. Furthermore, those who self-identify with environmentalism agreed that "the things humans do can really hurt the natural environment" and disagreed that "the problems with the environment are not as bad as some people say." Thus, it appears that youth who self-identify as environmentalists are beginning to understand the complexities we face as global warming intensifies.

In answering our three research questions, strong support exists for the role of environmentalist self-identification for civic engagement and political consumerism but less for political engagement. The regression model for civic engagement revealed that age, news and political discussion, participation in school civic education activities, attitudes toward citizenship, self-identification as an environmentalist, and online political engagement were significant. Concerning political engagement, discussion of news and politics, online/social media engagement and online political engagement were significant. With respect to political consumerism, news and political discussion, attitudes toward citizenship, self-identification as an environmentalist, and online political engagement were significant.

DISCUSSION

Imminent Concerns

In preparation for the release of the IPCC's 2013 report, the children's charity UNICEF was among the non-governmental organizations (NGOs) present that urged governments to heed the report's warning. UNICEF warned that it would be our youngest who will bear the brunt of temperature increases. The youth in our study will be middle-aged by 2050 when the worst impacts of climate change, including extreme heat waves, expanded diseases, malnutrition, and economic losses, are in full swing. The universally accepted scientific perspective convincingly suggests that the planet is environmentally at risk. As such, more must be done to alert youth to the dangers of inaction, and we look to the data from this study to discern what variables correlate with environmental self-identification. Democratic presidential candidate Barack Obama attempted to make the environment part of the public discussion by arguing for government investment in clean energy and green jobs consistent with the NEP perspective; however, during his first term in office, pressures associated with the economy dominated public discourse. Meanwhile, climate change skeptics, Tea Party activists, and vested interests continue to spread disinformation, causing confusion and resulting in an inactive citizenry (Cox, 2012).

Our data reveal that only 23% of those polled agreed or strongly agreed with the statement, "I consider myself to be an environmentalist." Perhaps more striking, 37% either disagreed or strongly disagreed, and 39% were ambivalent. The fact that more than three quarters of the young citizens have little interest in environmentalism is puzzling. This may be an artifact, if not the direct result, of the societal debate between the DSP and the NEP. Even adult voters are skeptical of scientific evidence concerning global warming, with fewer than one quarter of the most conservative citizens saying they believe it is a problem. While our data did not test this, it is certainly conceivable that the chasm between one perspective that the world will heal itself and another that suggests proactive intervention is needed may help explain this divide.

Recommendations

In light of the IPCC report, the DSP perspective is clearly outmoded. The NEP perspective advocates a new way of thinking about the planet and our relationship with it. Schools may wish to place more emphasis on teaching students about environmental issues, but this approach also appears to be problematic. There is some indication that many states will adopt a curriculum recommended by the Next Generation Science Standards, a group that oversees state education

curricula. This environmental curriculum, although weaker than originally proposed, includes information about how "*human activities, such as the release of greenhouse gases from burning fossil fuels, are major factors in the current rise in Earth's mean surface temperature (global warming)*" ("Climate Change Now," 2013). But universal curricular adoption may not be a feasible solution, as individual states control their science curriculum. Indeed, in 2013 the Nebraska State Board of Education discussed removing curriculum requirements to teach high school students about climate change ("School Board," 2013). This presents an issue for local action.

Young people are increasingly using online media to mobilize for environmental activism (see Allen et al., 2013, for a review of that literature), and the mainstream media are aware of, and documenting, this interest. For example, *Step It Up* 2007, an online initiative started at Middlebury College in Vermont, surprised even environmental writers as the initiative sparked a grassroots movement that went viral on the Internet ("Changing Planet," 2011). Few parents engage in pro-environmental socialization (Allen et al., 2013), and the political environment poses problems for relying on public school curricula to address environmentalism. Still, students are mobilizing, especially online. Future research is needed that identifies factors that socialize young people as they navigate the political and media environment in support of pro-environmental initiatives.

Our data reveal important correlates of political and civic engagement and political consumerism, particularly discussion of news and politics, attitudes toward citizenship, and environmental self-identification. As youth grow into adulthood, they can express their environmental opinions at the ballot box; and they will be in a position to enact or enable governmental laws and social policies that facilitate the transition to a greener planet. In addition, as their consumer strength increases, youth should recognize that boycotting environmentally unfriendly firms and buying products from environmentally responsible firms can have an impact.

REFERENCES

Allen, M. W., Wicks, R. H., & Schulte, S. (2013). Online environmental engagement among youth: Influence of parents, attitudes and demographics. *Mass Communication and Society, 16,* 661–686. doi: 10.1080/15205436.2013.770032

Bennett, W. L. (2008). Changing citizenship in the digital age. In W. L. Bennett (Ed.), *Civic life online: Learning how digital media can engage youth* (pp. 1–24). Cambridge, MA: MIT Press.

Bennett, W. L., Wells, C., & Freelon, D. (2011). Communicating civic engagement: Contrasting models of citizenship in the youth web sphere. *Journal of Communication, 61,* 835–856. doi: 10.1111/j.1460-2466.2011.01588.x

The blueprint for change: On environment (2008, February 2). Retrieved from http://www.ontheissues.org/Archive/Blueprint_Obama_Environment.htm

Boyd, M. J., Zaff, J. F., Phelps, E., Weiner, M. B., & Lerner, R. M. (2011). The relationship between adolescents' news media use and civic engagement: The indirect effect of interpersonal communication with parents. *Journal of Adolescence, 34,* 1167–1179. doi: 10.1016/j.adolescence.2011.07.004

Carson, R. (1962). *Silent spring.* Boston, MA: Houghton Mifflin.

Census Bureau regions and divisions with state FIPS codes. (2012). Retrieved from http://www2.census.gov/geo/pdfs/maps-data/maps/reference/us_regdiv.pdf

The Center for Information & Research on Civic Learning & Engagement. (2013). *The youth vote in 2012.* Retrieved from http://www.civicyouth.org/wp-content/uploads/2013/05/CIRCLE_2013FS_outhVoting2012FINAL.pdf

Changing Planet Town Hall Meeting. (2011, January 25). Retrieved from http://www.nbclearn.com/changingplanet/cuecard/52983

Climate change 2013: The physical science basis. (2013). Retrieved from the Intergovernmental Panel on Climate Change website: http://www.ipcc.ch/report/ar5/wg1/#.UpExhu_nbIU

Climate change now included in US curriculum. (2013). *RT.* Retrieved from http://rt.com/usa/climate-change-curriculum-school-653/

Cox, R. (2012). *Environmental communication and the public sphere* (2nd ed.). Thousand Oaks, CA: Sage.

Dalton, R. J. (2008). *The good citizen: How a younger generation is reshaping American politics.* Washington, DC: CQ Press.

Democratic candidates compassion forum, April 13, 2008: On environment. (2008, April 13). Retrieved from http://www.ontheissues.org/Archive/2008_Dems_Compassion_Forum_Environment.htm

Des Moines Register Presidential debate—Democrats [Transcript]. (2007, December 13). Retrieved from http://transcripts.cnn.com/TRANSCRIPTS/0712/13/se.01.html

Dietz, T., Fitzgerald, A., & Shwom, R (2005). Environmental values. *Annual Review of Environment and Resources, 30,* 335–372. doi: 10.1146/annurev.energy.30.050504.144444

Dudash, E. A., & Harris, S. (2011). New kids on the block: My first time in a political community. *American Behavioral Scientist, 55,* 469–478. doi: 10.1177/0002764211398074

Dunlap, R. E. (2008). The new environmental paradigm scale: From marginality to worldwide use. *Journal of Environmental Education, 40,* 3–18.

Eliasoph, N. (2011). *Making volunteers: Civic life after welfare's end.* Princeton, NJ: Princeton University Press.

Feldman, L., Pasek, J., Romer, D., & Jamieson, K. H. (2007). Identifying best practices in civic education: Lessons from the student voices program. *American Journal of Education, 114,* 75–100. doi: 10.1086/520692

Fisher, D. R. (2012). Youth political participation: Bridging activism and electoral politics. *Annual Review of Sociology, 38,* 119–137. doi: 10.1146/annurev-soc-071811-145439

Flanagan, C., Syvertsen, A. K., Gill, S., Gallay, L. S., & Cumsille, P. (2009). Ethnic awareness, prejudice, and civic commitments in four ethnic groups of American adolescents. *Journal of Youth and Adolescence, 38,* 500–518. doi: 10.1007/s10964-009-9394-z

Global climate change: Vital signs of the planet. (2013). Retrieved from http://climate.nasa.gov/evidence/

GOP deeply divided over climate change. (2013). Retrieved from http://www.people-press.org/2013/11/01/gop-deeply-divided-over-climate-change/

Jennings, K. M., & Zeitner, V. (2003). Internet use and civic engagement: A longitudinal analysis. *Public Opinion Quarterly, 67,* 311–334. doi: 10.1086/376947

Kahne, J., Crow, D., & Lee, N.-J. (2013). Different pedagogy, different politics: High school learning opportunities and youth political engagement. *Political Psychology, 34*, 419–441. doi: 10.1111/j.1467-9221.2012.00936.x

McDevitt, M. (2006). The partisan child: Developmental provocation as a model of political socialization. *International Journal of Public Opinion Research, 18*, 67–88. doi: 10.1093/ijpor/edh079

Mendell, D. (2007). *Obama: From promise to power.* New York, NY: HarperCollins.

Micheletti, M., & Stolle, D. (2008). Fashioning social justice through political consumerism, capitalism and the Internet. *Cultural Studies, 22*, 749–769. doi: 10.1080/09502380802246009.

President Bush signs Obama's mercury export ban into law. (2008, October 15). Retrieved from http://www.ban.org/ban_news/2008/081015_mercury_export_ban_signed_into_law.html

Ramakrishnan, S. K., & Bloemraad, I. (2008). Introduction: Civic and political inequalities. In S. K. Ramakrishnan & I. Bloemraad (Eds.), *Civic hopes and political realities: Immigrants, community, organizations, and political engagement* (pp. 1–42). New York, NY: Russell Sage Foundation.

Russert, T. (2008, May 4). Meet the Press: 2008 "Meet the Candidates" series. Retrieved from http://www.ontheissues.org/2008_Meet_the_Press.htm

Schlosberg, D., & Bomberg, E. (2008). Perspectives on American environmentalism. *Environmental Politics, 17*, 187–199. doi: 10.1080/09644010801936073

School board considering the elimination of climate change from curriculum. (2013). Retrieved from http://nebraskansforpeace.org/school_board_curriculum_change

Settle, J. E., Bond, R., & Levitt, J. (2011). The social origins of adult political behavior. *American Politics Research, 39*, 239–263. doi: 10.1177/1532673X10382195

Shafer, W. E. (2006). Social paradigms and attitudes toward environmental accountability. *Journal of Business Ethics, 65*, 121–147.

Shah, D. V., Cho, J., Eveland, W. P., Jr., & Kwak, N. (2005). Information and expression in a digital age: Modeling Internet effects on civic participation. *Communication Research, 32*, 531–565. doi: 10.1177/0093650205279209

Sherrod, L. R., Flanagan, C., & Youniss, J. (2002). Dimensions of citizenship and opportunities for youth development: The *what, why, when, where* and *who* of citizenship development. *Applied Developmental Science, 6*, 264–272. doi: 10.1207/S1532480XADS0604_14

Skierkowski, D., & Wood, R. M. (2012). To text or not to text? The importance of text messaging among college-aged youth. *Computers in Human Behavior, 28*(2), 744–756. doi: 10.1016/j.chb.2011.11.023

Stern, P. C. (2000). Toward a coherent theory of environmentally significant behavior. *Journal of Social Issues, 56*, 407–424.

Transcript of second McCain, Obama debate. (2008, October 7). Retrieved from http://www.cnn.com/2008/POLITICS/10/07/presidential.debate.transcript/

Updated: Barack Obama proposed $5 billion trust fund for Great Lakes (2008, September 16). Retrieved from http://www.mlive.com/news/kalamazoo/index.ssf/2008/09/barack_obama_proposes_5_billio.html

Verba, S., Schlozman, K. L., & Brady, H. E. (1995). *Voice of equality: Civic volunteerism in American politics.* Cambridge, MA: Harvard University Press.

Wilson, J. K. (2007). *Barack Obama: This improbable quest.* Boulder, CO: Paradigm.

Zukin, C., Keeter, S., Andolina, M., Jenkins, K., & Delli Carpini, M. X. (2006). *A new engagement? Political participation, civic life, and the changing American Citizen.* New York, NY: Oxford University Press.

Contributors

Myria W. Allen (PhD, University of Kentucky) is professor in the Department of Communication at the University of Arkansas, Fayetteville. Her research interests include youth and environmental communication, corporate sustainability, and organizational communication. Allen is the author of one book (*Strategic Communication for Sustainable Organizations: Theory and Practice*, Springer, 2015), and author/co-author of more than 40 articles in journals spanning at least five disciplines.

Porismita Borah (PhD, University of Wisconsin-Madison) is assistant professor of Communication in the Edward R. Murrow College of Communication, Washington State University. Porismita's research interests include political communication and emerging communication technology. To learn more about Porismita's work, visit her website at http://porismitaborah.com/

Colleen Warner Colaner (PhD, University of Nebraska) is assistant professor in the Department of Communication at the University of Missouri. She studies how communication creates and sustains diverse family structures and experiences, including adoptive families, feminist family values, and families with differing social identities such as religion and politics. Her research has appeared in national and specialty outlets such as *Communication Monographs*, *Communication Research*, *Sex Roles*, and *Journal of Family Communication*.

Stephanie Edgerly (PhD, University of Wisconsin-Madison) is assistant professor in the Medill School of Journalism, Media, Integrated Marketing Communications at Northwestern University. Her research focuses on explaining the forces that shape media selections decisions. She is particularly interested in the news socialization process, the blurring of news and entertainment media, and the sharing of news over social media websites.

Liz Gardner (PhD, University of Missouri) is currently an unaffiliated scholar. Her research focuses on strategic health communication, particularly on creating health messages that increase health literacy and positive health outcomes for underserved populations. She also holds research interests in media psychology, media literacy, and representations of gender in media. Professionally, she has significant experience in the public relations field, specializing in health care public relations.

Chang-Dae Ham (PhD, University of Missouri) is assistant professor of the Charles H. Sandage Department of Advertising at the University of Illinois at Urbana-Champaign. His research interests include persuasion, persuasion knowledge, third-person perception, and behavioral theories across various digital advertising and communication media. Chang-Dae is the co-author of articles appearing in advertising, social psychology, and interdisciplinary journals.

J. Brian Houston (PhD, University of Oklahoma) is associate professor in the Department of Communication and co-director of the Disaster and Community Crisis Center (http://dcc.missouri.edu) at the University of Missouri. His research focuses on communication at all phases of disasters and on the mental health effects and sociopolitical consequences of community crises.

Mi Rosie Jahng (PhD, University of Missouri) is assistant professor at Wayne State University. Her research interest is in political communication and crisis communication with specific focus on activists' use of social media to engage and promote their causes to the general public and other organizations.

Kei Kawashima-Ginsberg (PhD, Loyola University Chicago) is director of CIRCLE (Center for Information and Research on Civic Learning and Engagement) at Tufts University's Jonathan M. Tisch College of Citizenship and Public Service. Her research interests are in youth civic development and women in leadership, especially among marginalized groups.

Eunjin (Anna) Kim (PhD, University of Missouri) is assistant professor in the Temerlin Advertising Institute at Southern Methodist University. Her research focuses on advertising and persuasion, media effects, and branding. Her work has been published in *Cyberpsychology, Behavior, and Social Networking*, *Mobile Media & Communication*, and *Marketing Letters*.

Seoyeon Kim is a PhD student in the School of Journalism and Mass Communication at the University of North Carolina-Chapel Hill. Her research focuses on communication campaigns. She has worked for communication consulting company Enzaim Health as a healthcare PR consultant.

Joonghwa Lee (PhD, University of Missouri) is assistant professor in the Communication Program at the University of North Dakota. His research examines the use of interactive and new media in strategic communication. His research has been published in several peer-reviewed journals, including *New Media & Society*, *Journal of Interactive Advertising*, *Cyberpsychology, Behavior, and Social Networking*, among others.

Nam-Jin Lee (PhD, University of Wisconsin-Madison) is associate professor in the Department of Communication at the College of Charleston. His main research areas include youth socialization, media framing, and public deliberation. He is particularly interested in pursuing research on how democratic deliberation works as a process rooted in people's cognitive and communicative activities and on how the quality and quantity of mediated political communication and of political talk facilitate or constrain this process.

Glenn Leshner (PhD, Stanford University) is the Gaylord Family Endowed Chair in Journalism and professor in the Gaylord College of Journalism and Mass Communication at the University of Oklahoma. He is also affiliated with the Center for Applied Social Research at OU. His research interests include media psychology, health communication, and biometrics. Leshner has authored/co-authored more than 120 journal articles, conference papers, book chapters, invited writings, and encyclopedia entries.

Peter Levine (DPhil, University of Oxford) is associate dean for Research and Lincoln Filene Professor of Citizenship & Public Affairs in Tufts University's Jonathan M. Tisch College of Citizenship and Public Service. His research focuses on civic engagement in the United States. He is the author of *We Are the Ones We Have Been Waiting for: The Promise of Civic Renewal in America* (2013), five other scholarly books on philosophy and politics, and a novel.

Jeremy J. Littau (PhD, University of Missouri) is assistant professor of Journalism and Communication in the Weinstock Center for Journalism at Lehigh University. His research interests include multimedia, social media, online communities, audience choice, social movements, and civic engagement. Littau is the author or co-author of two book chapters and seven articles in major mass communication journals.

Michael McDevitt (PhD, Stanford University) is professor of Media, Communication and Information at the University of Colorado Boulder. His research

interests include political communication, political socialization, and journalism studies. He is currently a Visiting Scholar at Stanford in the Center on Adolescence.

Mitchell S. McKinney (Ph.D., University of Kansas) is Professor and Chair of Communication and Director of the Political Communication Institute at the University of Missouri. He is co-author/editor of seven books, including Communication in the 2008 U.S. Election: Digital Natives *Elect a President* (2011), and *alieNATION: The Divide & Conquer Election of 2012* (2014).

Jack McLeod (PhD, University of Michigan) is professor emeritus at the School of Journalism at the University of Wisconsin, where he taught for 38 years. His research focuses on political communication, mass media effects, public opinion, and the role of media in broadening democratic participation. He is winner of AEJMC's Deutschmann Award and he has advised more than 70 doctoral students.

Hans K. Meyer (PhD, University of Missouri) is associate professor at the E. W. Scripps School of Journalism at Ohio University. His research focuses on how journalists and editors create community through online forums, citizen journalism, and other outreach efforts. After nearly a decade as a community journalist and editor, he currently serves as co-editor of *Community Journalism* and the *Web Journal of Mass Communication Research.*

Rosanne M. Scholl (PhD, University of Wisconsin-Madison) is an unaffiliated scholar. Her research focuses on media effects on democratically important outcomes, such as civic engagement and economic attitudes. She has served as head of the Communication Theory and Methodology Division of the Association for Education in Journalism and Mass Communication.

Dhavan V. Shah (Ph.D., University of Minnesota) is the Louis A. & Mary E. Maier-Bascom Professor in the School of Journalism and Mass Communication at the University of Wisconsin-Madison. He is Director of the Mass Communication Research Center and Scientific Director in the Center for Health Enhancement System Studies. Shah is co-author of *News Frames and National Security: Covering Big Brother* (2015).

Shannon Sindorf (PhD, University of Colorado Boulder) conducts research on political talk conducted via digital media, deliberative democracy theory, expertise studies, the American West, and popular culture.

Edson C. Tandoc, Jr. (PhD, University of Missouri) is assistant professor at the Wee Kim Wee School of Communication and Information at the Nanyang Technological University in Singapore. His research focuses on the sociology of message construction in the context of news and social media. His papers

have won awards at international conferences, and his research has appeared in major communication and journalism journals, such as *Cyberpsychology, Behavior and Social Networking; Computers in Human Behavior; Journalism: Theory, Practice and Criticism; Journalism Studies;* and *New Media & Society.*

Esther Thorson (Ph.D., University of Minnesota) is professor of media economics, innovation, and entrepreneurism in Journalism at Michigan State University. She is co-author/editor of eight books, including *Theories of Advertising* (2012), and *Persuasion Ethics Today* (2016).

Kjerstin Thorson (PhD, University of Wisconsin-Madison) is assistant professor in Journalism at Michigan State University. Her research explores the effects of digital and social media on political engagement, activism and persuasion, especially among youth. Recent research projects have investigated political uses of Facebook, video activism in the Occupy Movement, and the contributions of media use in shifting conceptions of politics among young adults.

Benjamin R. Warner (PhD, University of Kansas) is assistant professor in the Department of Communication at the University of Missouri. He studies the influence of campaign communication and digital media on political attitudes and beliefs. He is particularly interested in attitude reinforcement and has studied the polarizing effects of partisan media, social media, and presidential debates. His research has appeared in outlets such as *American Behavioral Scientist, Communication Studies, Communication Quarterly, Computers in Human Behavior,* and various other journals and books.

Robert H. Wicks (PhD, Michigan State University) is professor of Communication and adjunct professor of Political Science at the University of Arkansas, Fayetteville, where he is also director of the Center for Communication and Media Research. His research interests include political communication, political and civic engagement, media and politics, and media cognition/information processing. Wicks is the author of one book (*Understanding Audiences: Learning to Use the Media Constructively*, LEA, 2001), and the author/co-author of more than 40 articles and book chapters appearing in major communication, journalism, and interdisciplinary journals.

Chance York (PhD, Louisiana State University) is assistant professor of Mass Communication in the School of Journalism and Mass Communication at Kent State University. He studies youth, media, and politics. To learn more about Chance's work, visit his website at http://www.chanceyork.com